Italian Gothic Sculpture

Italian Gothic Sculpture c. 1250–c. 1400 examines the sculpture produced in a variety of genres and media throughout the Italic peninsula, from the late medieval period until the beginning of the early modern era. Arguing that Italian Gothic sculpture is neither a provincial offshoot of northern Gothic art nor a mere preparation for the Early Renaissance, Anita Moskowitz demonstrates that this body of artworks is distinguished by a unique visual language and syntax. Tracing the developments of Italian sculpture, from Nicola Pisano's arrival in Tuscany around 1250 through the end of the fourteenth century, this volume surveys developments in Central Italy as well as those in Naples, Campania, Lombardy, and the Veneto. This study incorporates the most recent scholarly findings, including archival and archaeological discoveries and restoration and conservation efforts. *Italian Gothic Sculpture* also addresses broad questions of politics, patronage, and piety – topics that offer new ways of looking at and thinking about works of art.

Anita Fiderer Moskowitz is professor of art history at the State University of New York, Stony Brook. A recipient of fellowships from the National Endowment for the Humanities, the ACLS, and I Tatti, Harvard University's Center for Renaissance Studies in Florence, she is the author of *The Sculpture of Andrea and Nino Pisano* and *Nicola Pisano's Arca di San Domenico and Its Legacy*.

Italian Gothic Sculpture

c. 1250–c. 1400

ANITA FIDERER MOSKOWITZ

State University of New York at Stony Brook

CAMBRIDGE
UNIVERSITY PRESS

WITHDRAWN

PUBLISHED BY THE PRESS SYNDICATE OF THE UNIVERSITY OF CAMBRIDGE
The Pitt Building, Trumpington Street, Cambridge, United Kingdom

CAMBRIDGE UNIVERSITY PRESS
The Edinburgh Building, Cambridge, CB2 2RU, UK http://www.cup.cam.ac.uk
40 West 20th Street, New York, NY 10011–4211, USA http://www.cup.org
10 Stamford Road, Oakleigh, Melbourne 3166, Australia
Ruiz de Alarcón 13, 28014 Madrid, Spain

First published 2001

Printed in the United States of America

Typefaces Aldus 10/13 pt. and Clairvaux *System* Quark XPress[R] [GH]

A catalogue record for this book is available from the British Library.

Library of Congress Cataloguing-in-Publication Data
Moskowitz, Anita Fiderer, 1937–
Italian Gothic sculpture,: c. 1250–c. 1400/Anita Fiderer Moskowitz.
p. cm.
Includes bibliographical references and index.
ISBN 0-521-44483-7
1. Sculpture, Italian. 2. Sculpture, Gothic – Italy. I. Title.

NB613.M68 2001
730′.945′0902 – dc 21
99-057210

Publication of this book has been aided by a grant from the
Millard Meiss Publication Fund of the College Art Association. [MM]

ISBN 0 521 44483 7 hardback

For Stefan and Culver

Contents

List of Illustrations

Preface and Acknowledgments

Italian art during the period bounded by Nicola Pisano's arrival in Tuscany sometime prior to 1260 and the early 1400s seems often to exist in a state of limbo, characterized either as continuing medieval traditions or as advancing teleologically toward the achievements of the Renaissance. Despite John Pope-Hennessy's statement in the opening pages of his masterful book *Italian Gothic Sculpture*, that "Gothic in Italy evolved . . . as an independent language with a syntax, grammar and vocabulary of its own," students continue to learn that this art belongs to a "Proto-Renaissance" or "The First Stage of the Renaissance"; alternatively, the monuments are presented as offshoots of French Gothic art. And even Pope-Hennessy, who in the beginning of his book claimed for the sculpture a unique identity, in the closing words of that same book asserted that Italian Gothic sculpture "forms a prologue . . . to the central chapter of Renaissance art."

These views, perhaps valid from the perspective of the fifteenth and sixteenth centuries, fail to do justice to the aims and achievements of Italian Gothic art. Although one would not wish to deny the contributions made by the masters of our period to the Renaissance, or the impact of the north on Italy, this book will explore the era's own, and surely self-conscious, goals as expressed in sculpture and architectural-sculptural ensembles, an exploration that involves questions of typology, patronage, context, the tendency toward "eclecticism" and the "vernacular," and, most important, regional developments. Indeed, rather than exclusively privileging individual artists, the material in this book has been structured by regional divisions within which artists or artistic currents find their place.

This study has been written both for students and for scholars in related fields who, while generally acknowledging the significance and originality of late-thirteenth- and especially fourteenth-century painting – the painting of Pietro Cavallini, Duccio, Giotto, Simone Martini, and the Lorenzetti brothers – often reveal a bias against the sculpture of these masters' contempo-

raries. Yet the technically outstanding, deeply moving narratives on the pulpits of Nicola and Giovanni Pisano in Pisa, Siena, and Pistoia, the dramatic sculptures from the facade of Florence cathedral by Arnolfo di Cambio, the lyrical bronze door reliefs of the Florentine Baptistry by Andrea Pisano, and the nuanced expressiveness suggesting moral dilemmas seen on the corner reliefs of the Palazzo Ducale in Venice, to mention only a few of the masterpieces of this era, are among the most powerful, visually appealing, and intellectually significant sculptural ensembles of any period. In the design of cathedral facades, which had to answer to ecclesiastical, civic, and aesthetic demands informed by local tradition as well as foreign influences, the variety of solutions is nothing less than astonishing, given their close chronology. And in the conception of sepulchral monuments, one of the most important and costly expressions of private patronage during the late Duecento and the Trecento, social class, profession, wealth, and the political milieu in which the patron was immersed were determining factors in the development of varied and original solutions to satisfy both spiritual and earthly concerns.

With the exception of two texts that are highly specialized and to a large extent out of date, there has been no in-depth English language study of Italian Gothic sculpture. The texts are the above-mentioned *Italian Gothic Sculpture* by John Pope-Hennessy (Phaidon, first published in 1955, reissued in 1972, and again in 1985 and 1996, these last altered only by an appendix with new bibliography) and John White's *Art and Architecture in Italy, 1250–1400* (Penguin, first published in 1966 and moderately updated in 1987, this last reprinted without changes or additions in 1993 and encompassing sections on painting, sculpture, architecture, and the minor arts). Both authors focus primarily on questions of style and attribution; neither takes into account recent scholarship on every aspect of Italian Gothic sculpture, from archival documentation, archaeological finds, restoration and conservation efforts, and iconography, to broad questions of politics, patronage, and piety – all issues that have offered new ways of looking at and thinking about the works. Both books lack any discussion, for instance, of the role played by the rising mendicant orders in the sudden proliferation of monumental, sculptured tombs during the late thirteenth and early fourteenth centuries. Despite mendicant legislation prohibiting sumptuous funerary monuments in their churches, these places were the preferred burial sites for large numbers of people, as attested by numerous Wills and legacies. Furthermore, virtually every iconographic innovation in the repertory of motifs in Italian sepulchral art of these years appears in a Dominican or Franciscan setting. No discussion of tomb sculpture, a major source of commissions for stonemasons and a significant vehicle for the expression of both piety and worldly concerns, is complete if it focuses exclusively on style and is not informed by an awareness of such factors as patronage and social setting.

Aside from the books just mentioned, and older but important Italian surveys, such as Pietro Toesca's *Il Medioevo* and *Il Trecento* (Turin, 1927 and 1951, respectively) and Adolfo Venturi's fourth volume of *Storia dell'Arte Italiana* (Milan, 1906), students and scholars must rely on college-level texts such as Frederick Hartt's *Italian Renaissance Art*, which covers painting, sculpture, and architecture of the twelfth through sixteenth centuries, and the numerous paperback undergraduate textbooks, most of which give short shrift to the sculpture of this period. During the past few decades, however, there has been a groundswell of significant scholarship in this field, as the bibliography – albeit a "selected" bibliography of cited works – at the end of this book will indicate. Numerous monographs and catalogues on individual artists – three on Andrea Pisano alone – have appeared one after the other, while studies of broad topics such as Sienese, Lombard, and Venetian sculpture have made essential contributions. Among the exciting new developments in the field are reconstructions of large ensembles based on the examination of dismantled monuments from an archaeological point of view, including precise measurements of site and fragments; and attributional revisions following cleaning and restoration, some of which reveal authorship or dates. Archival research has informed us of patronage, expenses, and sometimes programs. The investigations of nonart historians have offered valuable perspectives: For example, knowledge concerning attitudes toward death and concerns for the afterlife as expressed in testamentary documents and legacies, has provoked new interpretations of groups of monuments; while deeper awareness of historical circumstances has broadened our understanding of the interaction between patron and artist, propaganda and creativity. Such findings are often published in Italian conference proceedings or other highly specialized texts and are frequently difficult to access in the English-speaking world. The same holds true of studies of regional sculp-

ture, published at times in provincial journals available only locally (not only is there as yet no international system of Interlibrary Loan, but within Italy itself such a system is lacking).

Even among the more accessible publications of general interest, high production costs – in part the result of new technologies that allow for enhanced formats and images – make their purchase by university and other libraries problematic. A recent phenomenon in Italian publishing is the series "Mirabilia Italiae," over-size tomes that include volumes of texts by specialists and an "Atlas" of photographic documentation, including new and, for the most part, superb color prints. An example is that edited by Diane Finiello Zervas, entitled *Orsanmichele a Firenze/Orsanmichele Florence* (Modena, 1996, two volumes), with text in Italian and English; the arrangement is such that one can visually follow the architecture and its decoration around and within the building, stopping at points of interest to read the relevant scholarly essays. Also of recent interest is the ongoing publication of the *Enciclopedia dell'Arte Medievale*, edited by Angiola Maria Romanini. Each entry, written by a specialist in the respective field, summarizes scholarship concerning the artist, monument, typology, or theme with which it is concerned. It, too, includes superb color illustrations. At this writing volume 9 has appeared. Despite the fact that, as with all such corpora, it is likely to become out of date in a fairly short time, with its excellent illustrations and dense discussions it will remain an extremely useful reference. Indeed, the increase in scholarship has made it virtually impossible for an individual to remain au courant; hardly a month passes without some important new study appearing in print, often providing information that dismantles earlier attributions or reconstructions. Many of these studies now need to be placed within a larger context that embraces the entire field of Italian Gothic sculpture.

In this book we begin, in Chapter 1, with issues basic to the study of Italian sculpture, both of our period and beyond. This introductory material, familiar to most art historians, will be of greatest interest to students: There are short sections on the political and social realities of the peninsula and the extent to which these differed from region to region, followed by brief discussions concerning the religious and intellectual milieus that inform the art of our period. This is followed by a section on the place of the artist in Italian society, workshop practices, and materials and techniques in the

making of sculpture. A fourth section sets out the artistic background for the development of Italian Gothic sculpture by surveying trends in Italian Romanesque and in contemporary sculpture north of the Alps. The means by which sculptural currents are imported are discussed, as is the pervasiveness and significance of the classical heritage.

Chapter 2 (Central Italy c. 1250–c. 1310) begins with the arrival of Nicola Pisano in Tuscany from southern Italy c. 1260 or a little earlier. Considered by Vasari to be one of the *primi lumi* in the revival of art, Nicola built upon his experience in Apulia of classicizing and French-inspired sculpture, now invigorated with direct and intimate acquaintance with the many ancient remains in Pisa, and created a series of sculptures that to his contemporaries came as close to the standards and ideals of the ancients as had been seen since antiquity itself. Nicola's sculpture, in turn, provided the source and impetus for the development of his two major assistants, his son Giovanni and the Florentine Arnolfo di Cambio.

Although the discussion of Giovanni Pisano brings us into the early fourteenth century (the Pisa Pulpit was completed in 1315), Chapter 3 (Pisan and Sienese Sculpture to 1330) necessarily overlaps the previous chapter chronologically; it focuses, however, on sculptors who, while often influenced by Giovanni, adhered more closely to the great lyrical style of Trecento painting in Siena. The following chapter (Trecento Florence and Pisa) turns first to the major masters of the early Trecento and then to a discussion of developments during midcentury, arguing that a variety of moods and modes – not a homogeneous "post–Black Death" style – can be seen to exist side by side. The Tuscan-centric bias prevalent in Trecento studies has resulted in a tendency to ignore or minimize the accomplishments of regions considered outside the mainstream, including Naples, Lombardy, and the Veneto, the subjects of Chapters 5 through 7. Venetian sculpture, for instance, has been characterized either as old-fashioned or as worthy only to the extent it reveals Tuscan influences. The chapters on regional sculpture will not ignore the interaction with currents emanating from Tuscany or Rome but will view artistic production from the point of view of *their* patrons and artists, frequently concerned with alternative issues. The Neapolitan royal court, the signorial or ducal dynasties in Lombardy, and the oligarchic republic of Venice all exploited the possibilities of architecture and sculpture, among other cultural arti-

facts, to enhance their ambitions, promote their leadership and sovereignty, and express their ideals. In the Veneto, especially, there is a notable willingness, even desire, to investigate a wider range of human physiognomy and experience than is generally found in Central Italy. Taking into account the most recent scholarship, then, the issues to be addressed concerning each work (or sometimes groups of works) of art include: Who commissioned it and why? What was its function? How did its formal qualities, its siting, and its iconographic content serve the needs of those who commissioned and used it? Thus, although the book will focus on sculpture, the issues of function, patronage, and architectural milieu in many cases relate the sculptures to contemporary painting and architecture.

The next chapter in this study deals with groups or types of monuments, namely pulpits, church facades, and tombs. The discussion of pulpits involves their functions, distinguishing between the ambos employed for the reading of the Gospels and Epistles and those primarily used for preaching; here the role of the mendicant orders is featured, as are innovations in form and iconography. A section on the cathedral facade compares architectural decoration in France and Italy – in particular, the differing concepts concerning the relationship and integration of sculpture and architecture. Finally, there is an investigation of the typology of sepulchral monuments, including discussion of the tombs of saints, ecclesiastical tombs, royal tombs, and tombs of laymen.

In the final section (Chapter 9) issues are raised concerning methodology in the field of Italian sculpture, a discussion that, like the Introduction, will be of particular interest to students and nonspecialists: Thus there is a short section on connoisseurship, the problem of attributions, and the archaeological and scientific tools employed in seeking solutions to various problems. Case studies involving the development of an artist's oeuvre, the difference between a forgery and an imitation, and a hypothetical reconstruction of a dismantled or partially dispersed monument are offered, with indications of the kind of detective work involved and the sometimes tentative nature of a scholar's conclusions.

It would not be fair to the reader to avoid mention of what is *excluded* in this study and what its limitations are. Not every work documented or attributed to every artist is mentioned, although references to fuller studies are offered in the Notes. In the text proper I have avoided, with only a few exceptions, dealing extensively with

issues of attribution for the reasons indicated in Chapter 9. However, I make no apologies for discussing style per se (apart from its role in the making of attributions), for offering formal analyses, particularly in relation to expressive content, and for evoking an appreciation of the aesthetic component of works of art, aspects too often forgotten or undermined in much current art historical discourse. I insist that the eye remain focused on the material object, created not only to satisfy specific worldly and/or spiritual demands but also, in the majority of cases, to appeal to a sense of beauty, however that is defined. Finally, there are occasions when I speculate on, and attempt to evoke, the visual and kinetic experience of a contemporary observer confronting, moving toward, or walking around a monument in a continuum of changing environmental conditions, including light and sound.

The reader will notice that many issues discussed in the text, and not just ones involving attributions, remain unresolved. I have attempted to avoid treating as fact hypotheses or convictions entrenched by convention but not necessarily supported by documentation or early sources: An example is the pertinence to the tomb of Henry VII of the sculptures by Tino di Camaino and his workshop in Pisa, which may have originated in a different context.

A major problem has been one of selection. The sheer quantity of production, the extremely high quality of craftsmanship, and the conceptual richness and degree of experimentation could easily have led to the choice of countless alternative objects as foci of discussion, or the illustration of alternative details of a major monument that no one would exclude, say a Pisano pulpit. Limitations of space and on the number of photographs have necessitated painful choices. Regrettably, on occasion it has been necessary to refer to works not illustrated or to details not visible in the published image. For the reasons indicated earlier I have assiduously avoided, however – perhaps to a fault – selecting works on the basis of their influence on or as setting precedents for the Renaissance.

I also have made no distinction between "monumental" and "minor" art. It is true that in some parts of Italy goldsmiths or ivory-carvers received separate training and belonged to completely different guilds, separate as well from stone- or wood-carvers, with little professional crossover. Such crossover, however, did exist in Central Italy, and in any case, the distinctions between minor and monumental are essentially mod-

ern constructs with relatively little validity for the Gothic sculptor and his patron; thus discussions of ivories, goldsmithwork, and wood carving share the stage with stone and bronze sculpture.

The section on typologies examines those categories of monuments that are among the most manageable or extensively studied. Others that might have been chosen and that indeed are in need of further investigation include civic fountains, holy water fonts, ciboria, carved marble altarpieces, and objects for private devotion. It is hoped that many of the unresolved issues alluded to in the text will pique curiosity and stimulate further exploration.

To have undertaken a broad yet scholarly survey of Italian Gothic sculpture was a daunting task I should not have had the temerity to undertake were it not for the interest of Cambridge University Press and the encouragement of friends and colleagues. First, I would like to thank Beatrice Rehl, Fine Arts editor of Cambridge University Press, for sustaining interest in the project over many long years and for her insightful critiques at various stages of its development, both of an editorial and an art historical nature. Countless scholars, directly or indirectly, have informed my thinking, but several have been especially generous in offering knowledge, criticism, and advice. Two in particular took on the almost thankless task of reading through an earlier version of the entire manuscript, offering critical but essential commentaries, and spurring me to rethink numerous issues and recheck many facts: To Debra Pincus and Gary Radke my gratitude is boundless for these acts of friendship and esteem. I would like to thank Dorothy Glass for reading the section on Romanesque sculpture, and for lively and always fruitful exchanges. It is with gratitude and pleasure that I acknowledge the assistance and input of others: Joanne Gitlin Bernstein, Caroline Bruzelius, Martha Dunkelman, Jack Freiberg, Julian Gardner, Valentino Pace, John Paoletti, Peter Rockwell, Anne Markham Schultz, the late and much mourned Wendy Stedman Sheard, Marvin Trachtenberg, Christin Van Aul, and Jack Wasserman. Needless to say, any errors of fact or interpretation are mine alone.

The following individuals deserve acknowledgment and thanks for expediting in a variety of ways my study of and access to materials useful to this project: in L'Aquila, Calcedonio Tropea and his staff at the Museo Nazionale d'Abruzzo; at Carrara Sto. Stefano, Don Armandolo Rizzioli; in Genoa, Clario di Fabio of the Museo di Sant'Agostino; in Pisa, Diego Guidi of the Opera Primaziale Pisana, Gianfranco Miglaccio of the Archivio Fotografico, and Mariagiulia Buressi, Soprintendente; also in Pisa, Umberto Ascani and Alessandro Canestrelli of the Azienda di Promozione Turistica; and in Troia, Don Rolando Mastrulli.

To provide the reader with the necessary photographic documentation was an arduous, frustrating, and indeed overwhelming task. Photographs were obtained by purchase, loan, commission, rental, outright gift, and in a few cases (reluctantly, because of my limitations as a photographer!) by shooting objects myself. Many persons have been generous in assisting me: Photographs for publication or study were kindly provided by Roberto Bartolini of the University of Siena, Enrico Colnaghi of Foto Perotti, Milan, Alan Darr of the Detroit Institute of Art, Janos Eisler of the Budapest Museum of Fine Arts, Massimo Medica of the Museo Civico Medievale in Bologna, Giovanni Moretti of the Biblioteca Comunale di Fabriano, Max Seidel of the Kunsthistorisches Institut in Florence, and Fulvio Zuliani of the Università degli Studi di Padova. Others who generously provided images were David Finn in New York, Ernesto Panzo di Biumo in Milan, Mrs. Franco Maria Ricci in Milan, and Gianfranco Spinazzi in Venice. Obtaining photographs was cordially facilitated by Clario Di Fabio of the Museo di Sant'Agostino in Genoa, Gianni Paestri at the Palazzo Ducale, Venice; Giorgio Marini and Paola Marini of the Civici Musei e Gallerie d'Arte of Verona, Fabrizio Pietropaolo of the Soprintendenza Beni Artistici in Verona, Giuseppe Rampazzo of Il Messaggero di Sant'Antonio – Edizioni in Padua, and Don Sergio Pacciani of the Museo di Sto. Stefano al Ponte in Florence. Of the photographs commissioned especially for this book, the majority are by Ralph Lieberman; I wish to thank him for producing, often under difficult lighting conditions and entailing numerous bureaucratic requirements, the many fine images reproduced here.

Hearty thanks are due Giorgio Bonsanti, Soprintendente of the Opificio della Pietra Dura, who greatly facilitated the acquisition of photographs in Florence, and Valentino Pace, who was most generous in providing me with illustrations of several objects and useful contacts for the acquisition of others. Permission to reproduce line drawings was kindly given by Gustavo Cuccini, Gert Kreytenberg, Caroline Olam, and Angiola Maria Romanini. I would like to thank Ann-Marie

Light for technical assistance with several images, and Jody Cutler for skillful help with the final preparation and organization of the manuscript and illustrations.

I am deeply appreciative of the assistance given by librarians and museum personnel, in particular of the Metropolitan Museum of Art, the New York Public Library, and the libraries of Columbia University; the Interlibrary Loan office of the State University of New York at Stony Brook; Harvard University's Center for Renaissance Studies (the Villa I Tatti), the Kunsthistorisches Institut, and the Biblioteca Nazionale in Florence; the Archivio di Stato, the Biblioteca Apostolica Vaticana, and the Biblioteca Hertziana in Rome; the Centro di Studi Tedeschi, the Biblioteca Marciana, the Biblioteca Correr, and the Fondazione Cini in Venice; and the Civica Biblioteca d'Arte in the Castello Sforzesco, Milan.

Neither the assistance of friends and colleagues nor my great enthusiasm for this enterprise would have sufficed for its realization without the necessary material support that I was fortunate enough to obtain: I offer my heartfelt thanks to the National Endowment for the Humanities for support in the form of a Fellowship, a Summer Stipend, and a Travel to Collections Grant. The photographic campaign received generous funding through a Villa I Tatti/Lila Acheson Wallace–Reader's Digest Grant. I am also grateful to the College Art Association for the award of a Millard Meiss publication grant, to the Samuel H. Kress Foundation, and to Paul Armstrong, Dean of the College of Arts and Sciences of the State University of New York at Stony Brook, for contributing funds that made possible the extensive photographic documentation.

It is in the nature of art historical activity to find analogies, sometimes even far-fetched ones, and I shall indulge myself in one or two. Most sculptural enterprises during the Italian Gothic period were fundamentally collaborative and often familial in nature, and the same may be said of this study: The product of many contributions, this book is indebted not only to friends, colleagues, and predecessors but also to members of my family. In fact, to have listed my husband Martin as co-author on the title page would not be too far off the mark. He has been intimately involved in every stage of the book's development and realization – visual, conceptual, practical, and logistic; and he shared in every frustration and pleasure that the project entailed. To adequately acknowledge a collaboration that, in a very real sense, goes back more than forty years would take another volume.

If the tensions between earthly and spiritual determine much of Italian Gothic art, those between personal and scholarly have informed much of my life; and in both cases the equilibrium sought and found have resulted in the most satisfying solutions. It seems appropriate then, since my first book, on Andrea and Nino Pisano, was dedicated to my husband, and my second, on the Arca di San Domenico, to my children and their spouses, that this, my third, be dedicated to my grandchildren.

Italian Gothic Sculpture

Introduction

GEOGRAPHY AND POLITICS

The Italian peninsula, that "fair land that the Apennines divide and the sea and Alps surround,"[1] is topographically one of the most varied regions in the world. Within its natural boundaries of sea and mountains lies an area of approximately 116,000 square miles, a little smaller than California, that includes in close proximity precipitous mountain chains and their valleys, lakes and rivers, plains and forests, and, of course, an extremely long shoreline of sandy or rocky beaches. The peninsula's geography has profoundly affected the development of Italian civilization and culture. The relative isolation of its many pockets of populated areas encouraged, indeed necessitated, local development and identities. Italy as a nation did not exist until the mid–nineteenth century; indeed, few persons of the thirteenth and fourteenth centuries living on the peninsula had heard the word "Italy" or thought of themselves as Italians.[2] Even today language, customs, cuisine, and other traditions differ from town to town, and especially from region to region so that often allegiances tend to be local rather than national.

During the late Middle Ages the political situation was hardly less varied, for it saw the development of vastly different governmental structures in the north, in Central Italy, in the Papal States, and in Naples and the south, and within these regions there were further subdivisions in which political and economic power resided. Northern Italy, for instance, comprised three or four major powers and several lesser states. Most of these (the rival maritime republics of Genoa and Venice are the main exceptions) were ruled by hereditary dynasties or lordships, including the often rivalrous and territorially ambitious Visconti of Milan, Scaligeri of Verona, and Carrara of Padua. Venice, in contrast, was a republican oligarchy with a duke (the doge) elected by a ruling council. Despite its republican system, Venice succeeded in establishing a vast maritime empire throughout the Adriatic, Ionian, and Aegean Seas, and in the thirteenth century it controlled ports as far away as Constantinople.

In contrast to the prevailing feudal system of the north, in which the leading dynasties claimed their powers as vassals of the Holy Roman Emperor (illusionary heir of the ancient Roman Empire), much of Central Italy was characterized by communal governments controlling not only the towns but the surrounding rural countryside (the *contado*). Each tended to be aligned with either the party of the Guelfs supporting the papacy or that of the Ghibellines supporting the Holy Roman Empire, the latter determined to assert imperial authority over the peninsula and elsewhere in Europe and to limit the temporal power of the papacy. Not only were neighboring cities in opposite camps – Guelf Florence near Ghibelline Pisa, Siena, and Arezzo – but within each town factions arose in favor of one or the other party.

Leadership and power in these communal governments were generally held not by the nobility but by oligarchies composed of members of the merchants', manufacturers', and bankers' trades. The republics, in defense against the territorial expansion of their neighbors or attempting expansion themselves, were constantly at war with each other. And within the city-states themselves, the nobility continually threatened to take power away from the merchant classes while the latter consistently and brutally exploited their laborers; real and potential rebellions were put down ruthlessly.[3] Even among members of the same class, internecine rivalries were endemic during this period; in addition, alliances could be formed across classes when it was in the interest of a particular faction to do so. This volatile situation sometimes stimulated artistic competition and achievement, but it could also deplete resources otherwise available for civic and ecclesiastic embellishment.

A large area of Central Italy, referred to as the Papal States, was under the nominal control of the pope, for in addition to claiming universal spiritual and ecclesiastical authority, the Church continually attempted to expand its secular power. By the late thirteenth century the Papal States included parts of Romagna (including Bologna), southern Tuscany, and a strip surrounding Rome, extending north to the Marche of Ancona and south to include Campania.[4] The papacy's temporal power reached its peak under Pope Innocent III (pope from 1198 to 1216), but it soon found itself in conflict with the Holy Roman Emperor Frederick II Hohenstaufen (d. 1250), who sought to establish a universally supreme secular power. This conflict between pope and emperor continued into the succeeding century and characterized much of Italian, as well as European, political and military history.

Papal claim to secular authority in France resulted in fierce defiance on the part of the French king Philip II, which led to the humiliation (and possibly indirectly the death) of Pope Boniface VIII in 1303. Boniface's successor, Benedict XI (1303–4), was the last Italian pope for more than seventy years: Between 1305 and 1378 all the popes were Frenchmen. In 1308 Clement V transferred the papal court to Avignon, thus initiating the so-called Babylonian Captivity of the papacy.[5] With the displacement of the papacy and its curia, Rome lost its cultural primacy, not to be regained until the fifteenth century.

Finally, in contrast to the numerous autonomous communes of Central Italy and the seignorial rulerships of the north, the south was relatively monolithic. Earlier on it had been a stronghold of the empire under the Hohenstaufen dynasty. But then Charles of Anjou entered Italian politics, having been elected Senator of Rome (an office he held from 1265 to 1278) and having received an invitation by the French pope Urban IV (1261–64), an invitation seconded after the latter's death by his successor Clement IV, to accept the throne of the Kingdom of Sicily (which comprised a good part of the southern half of the peninsula, in addition to the island itself), wresting it if necessary from Frederick II's son Manfred. It was only after the Battle of Benevento in 1266, however, in which Manfred was killed, that Charles ascended the throne to become king of Sicily.

Until well into the fifteenth century, when it came under the dominion of Spain, most of the Kingdom of Sicily remained under French rule.[6]

The geographic and political divisions just outlined have their counterparts, as we shall see, in the regional artistic currents that developed, and flourished or declined, during the period 1250 to 1400. Furthermore, the volatile patterns of political systems and allegiances required varying strategies that went beyond the military and diplomatic to include artistic and cultural enterprises. If these were often vehicles to further political aims, such projects were also expressions of profound changes in the economic, social, religious, and intellectual life of the period.

ECONOMIC GROWTH, SOCIORELIGIOUS FACTORS, AND THE INTELLECTUAL MILIEU

Following the trans-European commercial revolution of the eleventh century, the economy in large parts of the Italian peninsula accelerated to an unprecedented degree, especially during the thirteenth and fourteenth centuries. This holds true notwithstanding the plagues and other crises of the latter part of the Trecento. Due to its geographic position between the Near East and transalpine Europe, Italy served as a commercial and financial link for both the production and consumption of goods in both regions, becoming thus a leader in the economic development of the West. The growth of its own industrial and commercial activities, notably wool manufacture and the production of luxury fabrics, as well as the development of banking in Central Italy, resulted in an accumulation of wealth that formed the precondition for an increase in the demand for art. Indeed, during the period under study, the production and acquisition of art became itself a notable economic activity as is evident from the sheer number of buildings, sculptures, paintings, liturgical furnishings, and associated accoutrements that proliferated to a previously unknown degree.[1]

These developments are closely connected to the demographic movement away from the countryside and its agrarian-based economy to the cities, whose population growth by the mid–fourteenth century had been exponential (see pp. 31, 63, 131f.). This affected not only people's lifestyles in general but also their cultural practices and artistic demands. As Richard Goldthwaite has observed, "[t]he city, with its monetized marketplace, was inherently a place of constant social change and uprootedness, much more than the countryside. In the urban setting traditional religious values had to confront new attitudes and notions; and what was often an ensuing clash generated new kinds of concerns and practices – forcing the merchant, for instance, to deal with his insecurity and guilt through penance and charity, and the poor to seek solace in religious devotions."[2] Civic, social, and above all ecclesiastical institutions developed to meet the needs of these new masses. Major among the institutions catering to the urban population were the mendicant orders that were established in the thirteenth century, including but not limited to the Dominicans and Franciscans. Not only were new houses founded all over Italy, but these groups frequently expanded to include women in the Second Order and laity as Tertiaries, further increasing the number of architectural and associated enterprises.

The period also saw the rise of confraternities, which answered to the needs of a lay urban populace that wished to take some control over both its practice of piety and the rituals of sacred life (the giving of charity, the burial of the dead, the devotion to cult saints, and penitence, among others). At first organized rather loosely, confraternities increasingly became institutional in nature, generally focusing either on devotional or penitential exercises. The needs of the laity were further served by guilds, those professional service societies that eventually, at least in Tuscany, came to play prominent roles in civic government and ecclesiastic patronage. Since religious activities were central to both guilds and confraternities, these institutions all required chapels, oratories, paintings, and shrines.

Not surprisingly, with religious fervent expressed in movements that in many ways lay outside the official sacramental church, the church itself, sometimes in response to very local needs such as those of the parish, but frequently in connection with the growing sense of civic identity and pride, developed its own expansion of services and associated apparatuses. Indeed, the church's physical plant at the turn of the fourteenth century had reached "boom proportions." The competition in cathedral facades is a direct manifestation of this phenomenon.[3]

All of this activity required the production of art and architecture, as well as material goods not falling into the modern category of "art." Italian masters and artisans answered to these needs; but also, through the variety and skill of their manufacture, they served in turn to stimulate the demand for liturgical and devotional

objects. Frescoes and altarpieces became such ubiquitous elements within ecclesiastic, monastic, and governmental spaces that by the fourteenth century Italians lived in a "pictorial world much more dense with images than that known by most other Europeans."[4]

More than during earlier periods, people were searching for a direct rapport with God, which led to a notable "rise of devotionalism."[5] Changes in spiritual expectations and pious practices in turn required new and a greater variety of concrete objects.[6] Whereas earlier on, for example, the world of religious goods was directed primarily toward the needs of the clergy in the performance of their liturgical functions, the new devotional practices, including the veneration of relics, devotion to Mary, meditations on the Passion of Christ, and pilgrimages, required appropriate material objects, such as crucifixes, reliquaries, monstrances, chalices, patens, candlesticks, bells and books, as well as altars, lecterns, and pulpits, many incorporating figural and narrative embellishment. These, as well as panel paintings, elaborate shrines, tombs, and votive objects – informed now by new concepts of the nature of God, the accessibility of saints, and the validity of personal interaction with the deity – served to enhance one's personal, empathetic identification with God and the saints, increasingly sought and encouraged by mendicant spirituality.[7]

Indicative of these changes is the proliferation of sepulchral monuments. Shifts in attitudes toward death may in part explain this phenomenon: Now Purgatory came to be conceived as a specific location in which one's state of existence was of variable duration. To control the latter, such practices as seeking indulgences and paying for commemorative masses became far more common than earlier. Commemorative masses required altars, and the obligation of heirs toward the deceased of their family and of the clergy to perform their contractual responsibilities regarding suffrage for the dead encouraged the commissioning of highly visible tombs. The desire for divine intercession was often expressed in tomb sculpture by showing the deceased presented to the Virgin by a favorite saint. For all these reasons, the period under study is characterized by an enormous proliferation of church furnishings, chapel altarpieces, large sculptured groups, shrines, and grandiose tombs – many of which form the subject of the chapters that follow. They may be seen as the visible concomitants not only of the increase in private and ecclesiastic wealth but also of a burgeoning of intensity in devotional piety and in the available options for its expres-

sion. Those options were profoundly influenced by developments in the intellectual sphere.

The Scholastic tradition that had matured in the thirteenth century, based on a new acquaintance with classical texts (particularly those of Aristotle), impelled a reevaluation of classical learning. The greatest of the medieval scholastics was the Dominican theologian Thomas Aquinas (d. 1274), whose *Summa Theologica* offered a compendium of the major theological issues of his day, with the pros and cons of each thesis and their logical resolutions. During his lifetime the Dominicans and Franciscans witnessed a significant rise in the numbers of their devotees; this increase was spurred both by the vigorous promotion of the cults of their respective founders and by the contents of sermons preached from urban pulpits and much enhanced by the charisma of their preachers. In contrast to the emphasis on transcendental experience of the earlier Middle Ages, the mendicants fostered a more direct, empathetic relationship between human beings and God and his saints. Such attitudes penetrated not only into the fields and the *botteghe* (artisan workshops) but also into the study chambers of theologians and scholars; indeed, it both influenced, and was paralleled by, the incipient humanism of the Trecento. Thus, while Aristotelian logic and natural philosophy had become part of the university curriculum by the early fourteenth century,[8] early humanists such as Petrarch had little immediate use for the abstract if intellectual acrobatics of medieval scholastics and their systematization of "immutable truths." Instead, these intellectuals turned to the study of the ancient orators and poets and of Latin syntax and grammar with the aim of retrieving a language that had the power to move, to persuade, and to delight. The function of language was, in Petrarch's words, to "accuse, to excuse, to console, to irritate, to placate souls, to move to tears and to remove them, to light fires of anger and to extinguish them, to color facts, to avert infamy, to transfer blame, to arouse suspicions – these are the proper work of orators."[9] Petrarch and his humanist followers elevated human personality and emotion beyond the dichotomies of medieval tradition, such as those based on the concepts of virtue versus vice, the active versus the contemplative life, or reason versus revelation, to a new autonomy with infinitely more subtle and varied expressive and behavioral options.

The expanded body of knowledge, and the attempts to synthesize Christian and classical learning, found expression in the new themes and naturalistic motifs

that abounded in painting, illumination, and sculpture, and in religious and civic iconography. The impact of early humanism, reinforced (and probably influenced) by mendicant spirituality, is seen in the new concern for empirical observation, the acceptance of the validity of human experience and emotion, and the esteem for individual achievement.[10] Each of these – for example, the depiction of landscape with its flora and fauna, the exploration of the subtleties of human and divine inter-action, and the expression through visual devices of wealth and power – were given varying emphases, depending on local traditions and the specific concerns of individual patrons. Thus, if in early Trecento Florence, Siena, and Orvieto there is a special concentration on the portrayal of space and the naturalistic depiction of rural and urban landscape (Figs. 149, 152, 153), in mid- to late-Trecento Venice and Verona sculptors were more concerned with the exploration of nuances of facial and gestural signs (Figs. 331–36).

These three intertwining currents – Scholasticism, mendicant spirituality, and Trecento humanism – inform many of the developments of the artistic culture of the Italian Gothic period. Indeed, together with the histori-cal, economic, and social phenomena outlined earlier, they form the warp and woof against which emerge the era's patterns of sculptural production. Within these broader patterns, however, typological and stylistic vari-ations resulted from the traditions – which might be in harmony or in tension – in which sculptor and patron were embedded. As will become apparent, the creative impulses and conjoined visions of both artistic master and patron ultimately determined the form and con-tents of the projects and monuments that will engage us in the pages that follow.

THE PRACTICE OF SCULPTURE

During the Middle Ages and Early Renaissance the artist was a *craftsman*, not a special individual sepa-rated from others by a vision and a calling. Although the records are fragmentary, it would seem that by the early to mid–thirteenth century artists (like all other craftsmen, as well as merchants) had to belong to guilds *(arti)* in order to function professionally.[1] The guilds were legally constituted organizations that determined standards for professional standing and controlled prices, fees, and wages. They protected the interests of the profession as well as their members' prerogatives: For example, in some cities and during some periods

foreign stonemasons were excluded from working in the city. This was true in Venice during the late four-teenth and fifteenth centuries when native masters were also prohibited from accepting commissions else-where. Venetian guilds tended to be strictly associations of craftsmen whereas those in Florence were often cor-porate patrons of artworks as well, and the more impor-tant of the Florentine guilds even played a role in the communal government.[2] In Venice it was not uncom-mon for a stonemason to be a tradesman dealing in the quarrying and shipment of material, whereas in Flo-rence and Rome sculptors obtained their stone from the quarry owners. In Siena the commune itself might own quarries, but in any case all quarries within its territor-ial jurisdiction, whether publicly or privately owned, had to be made available to the Opera del Duomo, the administrative body in control of the cathedral works.[3]

In Venice the practitioners of carving in stone, or in wood, or casting in bronze belonged to completely sepa-rate guilds and there was little crossover from one material to another. In contrast, although bronze work-ers in Florence belonged to a separate guild, stone- and wood-carvers belonged to a single guild, the *Arte di pietra e legname*, whose members also included carpen-ters. Indeed, it is generally true that the separation of the arts did not exist in the Middle Ages and Early Renaissance, as it did in subsequent periods. In Tuscany, an individual trained as a painter could also become a sculptor, as did Orcagna; a painter might provide designs for sculptors, as did Agnolo Gaddi for the reliefs on the Loggia dei Lanzi; and a painter might also serve as an architect, as did Giotto. Tuscan sculptors in stone were often trained as goldsmiths, might readily work in wood, and occasionally became accomplished in bronze-work, as was the case with Andrea Pisano, who later became head architect (or Capomaestro) of the Cam-panile of Florence. Sculptors could be called upon to make not only statues, tombs, and liturgical furnishings but coats-of-arms, inscriptions, and architectural orna-mentation.

Although the commission was accepted, the design conceived – always in consultation with the patron – and the labor allocated by the head of the workshop, the production of art was a collaborative venture. The bot-tega (the workshop) itself consisted of the master, one or several assistants who might be guild professionals in their own right, and apprentices, usually adolescents who had completed their elementary education and now spent four or five years learning their trade. The

tasks of an apprentice began with the preparation of materials, but gradually the young man was given increased responsibilities as he matured and became more adept. Thus, at first an apprentice might be called upon merely to chisel away the excess background of a relief or the superfluous material surrounding what would become the figure in a sculpture carved in the round. Then he might graduate to the execution of the less important parts of the work and eventually be given the responsibility for major elements in the design. Apprentices always strove to imitate the techniques and style of their masters. Originality did not become an artistic value until the sixteenth century, and any innovations during the Middle Ages and Early Renaissance occurred within – or sometimes despite – the firm pressures of technical, iconographic, and formal traditions. At some point an apprentice would be ready to apply for entrance into a guild and might himself become the head of a bottega.[4]

It was not unusual for a son to follow in the profession of his father and eventually to take over the latter's workshop. There are many examples of this succession, such as Nicola and his son Giovanni Pisano, Andrea Pisano (no relation to the earlier pair) and his sons Nino and Tommaso, and Camaino di Crescenzio and his son Tino; Tino, however, did not take over his father's Sienese workshop but apparently followed Giovanni Pisano to Pisa.[5] The workshops of Venetian sculptors, too, were often family affairs, as is the case for painters' shops. The brothers Dalle Masegna were sons of a sculptor Antonio,[6] and the Campionesi of Lombardy represent both a sculptural tradition and a number of family workshops (see pp. 199f.).

For major public ecclesiastic projects, in particular the building and decoration of the cathedral, the commune established the Opera del Duomo, whose function it was to administer the finances and organize and control the progress of work by way of its selected master or masters.[7] The Operaio was the administrative head, the Capomaestro (occasionally, there were more than one), the artistic director. The latter, in turn, hired the stonemasons and sculptors who ranged from fully accredited *maestri* to simple laborers. Sienese documents reveal that without express permission of the Opera del Duomo, neither masters nor humble masons could accept work outside of the Duomo shop, and even then only for a project that concerned the commune, that is, not for a private patron.

In the Central Italian republics, ultimate decision-making authority was vested in the commune by way of the Operaio, but decisions were made in close consultation with the town's bishop. Indeed, the honor and prestige of the city, which would be manifested by a grand, beautiful cathedral unrivaled by those of other cities, was seen to be in the interests of both church and state. Ad hoc citizens' committees were formed, with members from each of the town's districts (the *contrade*), to discuss specific problems or to mediate between opposing views; occasionally "foreign" experts – from another town or region – were called in as advisers. A case in point is ducal Milan, where final authority for the construction of the Duomo (the cathedral) rested with members of the Fabbrica (the administrative supervisors), who consulted architects from across the Alps (see pp. 228ff.).

In contrast to the construction and decoration of French cathedrals, for which itinerant masters and artisans temporarily resided where their services were in demand, work on Italian cathedrals followed a different practice. In Italy, even though the Capomaestro might be sought from elsewhere, most of the masons and sculptors working for the Opera del Duomo were citizens of the town in which they worked. This difference between the journeymen of France and the native craftsmen who lived and might even own property in their towns in Italy resulted in a different working process and differing end results: Rather than several platoons of laborers, each under a separate head-master, often mass-producing the latter's models, Italian stone-carvers were given more individual freedom. As a result, the artistic level of Italian cathedral sculpture could be uneven. If the craftsmanship was less homogeneous than that seen north of the Alps, the system also allowed for more personal development and the realization of individual styles.[8]

Evidence from the Duomo of Siena – and this probably holds true for large-scale public ecclesiastic enterprises elsewhere – shows that the building and its embellishment were financed from a variety of sources. These sources included generous indulgences offered by the bishop (a common means of obtaining ecclesiastic funds), legacies in Last Wills and Testaments, donations, and the considerable profits generated from the sale of votive candles. In times of need, a head tax might be instituted. The Opera del Duomo also had access to important free resources, such as the marble needed for the cathedral, that had to be "donated" by the quarry owners, the wood by owners of forests, and the beasts

of burden by those who possessed such within the city's jurisdiction. Thus, the community as a whole not only gave enthusiastic moral and patriotic support to the erection of its grandiose cathedral, they willy-nilly contributed the material means for its realization. In every sense of the word, the building and decoration of a cathedral was a communal enterprise.

Marble and other types of stone, as well as bronze, tended to be reserved for the most important public monuments, both ecclesiastic and secular. Stone carving required the excavation and hauling of the material by mule-drawn carts, or by ship, from the quarry to the workshop. Frequently the stone was blocked out to its approximate dimensions to save the expense of lugging unnecessary weighty material long distances. Obtaining and transporting stone, especially marble, from a quarry was an expensive proposition. For this reason, a medieval stone-carver sometimes – indeed, frequently – employed antique stones, reusing a slab that formed a pagan sarcophagus or a block that formed part of an ancient wall. The reverence for antiquity during our period was extremely selective, and if an ancient piece of marble did not lend itself to reinterpretation with Christian meaning or re-employment in a practical way (for example, a pagan sarcophagus reused for Christian burial), it was seen as a readily available quarry block. As we shall see, such *spolia* were employed by Arnolfo di Cambio for his ciborium in San Paolo fuori le mura, Rome.

A variety of stone-carving tools were available to the late-thirteenth- and fourteenth-century stonemason, which were essentially the same as those employed in antiquity (Fig. 1).[9] The tools used included the punch, the claw-toothed and the flat-toothed chisel of various sizes, and the drill, the use of which was common during antiquity but then became rare before the thirteenth century. We do not know exactly to what extent sculptors made use of drawings as models. The earliest extant examples date from the fourteenth century, and they appear to be "contract drawings" submitted to the patron; in such cases the artist was legally obliged to adhere to the drawing's form and/or its iconographic indications.[10] A detailed drawing for a polygonal pulpit for the Duomo of Orvieto (Fig. 372) may well have functioned as such a contract drawing. Unfortunately, few drawings are extant that can be associated with specific sculptures. Documentary references, however, suggest that sculptors did work on the basis of preliminary drawings on parchment or paper, or full-scale drawings on prepared walls, perhaps in the sculptor's own work-

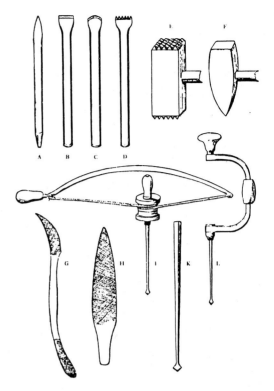

2. Sculptors' tools: (A) point or punch, (B) flat chisel, (C) bull-nosed chisel, (D) claw-chisel, (E) *boucharde*, (F) pointed hammer, or trimming hammer, (G, H) rasps, (I) running-drill, (K) drill, (L) auger

1. Carving tools used in antiquity (after R. Wittkower, *Sculpture. Processes and Principles*, Penguin Books, 1977; copyright Margot Wittkower, 1977. Reproduced by permission of Penguin Books Ltd.).

shop. In addition, documents attest to the use of three-dimensional models in wood or plaster, submitted for approval and employed as the basis of execution of columns and capitals in stone; possibly, these models existed for figural sculpture as well.[11] Finally, we know that during the second half of the Trecento painters were called upon to design figures for sculptors, and these must have been two-dimensional images.[12]

Whatever the model, at some point the contours must have been drawn directly on the stone, which was then roughed out to the general shape of the design with the pointed punch and the chisel driven by a mallet. Sometimes a drill was used to create a series of small holes that, when connected, produced a contour. After the form was roughed out, further definition was achieved by way of increasingly fine-toothed chisels. Decorative patterns and curls were often made using a drill. A final step involved polishing the form with various abrasives such as pumice and straw. Although wooden statues were invariably fully painted, stone fig-

ures and architectural ornament received more limited polychromy. Only the eyes, lips, and inner surfaces of drapery such as a mantle might be colored, while the hair and hemlines or drapery borders of a marble figure might be gilded.

A sculpture could be in the round or in relief depending on its context. If a figure was carved as a separate piece but intended for a niche or to be placed against a wall, a laborsaving device was to leave in the rough those parts that would not be visible; often one sees a drapery fold that is fully developed in the front gradually lose its definition as it moves around toward the rear of the form. In the case of relief sculpture there is no clear-cut division between high and low relief, and even within a single slab there might be gradations from high to low, as on some reliefs on the facade of Orvieto (Figs. 157–58). Large figures or surfaces had to be made in several pieces, and although the joints might be masked, they are sometimes quite visible. Regarding at least one large enterprise, in the case of the facade reliefs of Orvieto cathedral (Figs. 156–60) the naked eye can clearly see the jigsaw-puzzle-like pieces that make up the reliefs on its piers. Close examination also reveals that within a single panel different motifs were brought to varying stages of completeness and finish. Thus, it is evident that there was a division of labor, with some masters specializing in trees, others in faces, and still others in architectural motifs (see p. 127).

Bronze, an alloy of copper and tin (it may also contain lead and zinc), was employed extensively in antiquity, but during the Middle Ages its use tended to be limited to military purposes. With the growth of a mercantile economy during the late thirteenth and especially the fourteenth century, and the increasing interest in monumental sculpture, the use of bronze was revived. The execution of a sculpture in bronze required an extremely complex and expensive process.[13] To save on material, reduce the dangers of airholes developing during pouring, and prevent uneven cooling that might cause cracks on the surface, a bronze sculpture of any but miniature size was made by a technique called the *cire perdue*, or lost wax method. Among the problems faced by the sculptor of bronze was the fact that he had to achieve a very precise *negative* impression in a substance that would record and preserve the form of the positive model; that would be strong enough to resist the great weight-pressure of descending molten metal during the pouring; that would be porous enough for escaping gases to permeate; and that would be fragile enough to be easily removed without danger to the cast metal. The versatile substance that satisfied all these requirements was clay.

To create such a bronze, a sculptor first modeled in wax, or in clay if the object was to be cast with a hollow interior, a form that was close in shape to the final piece (Fig. 2). If initially shaped in clay, this mass was then covered with a layer of wax, modeled, and carefully worked so that the thickness and surface was as close as possible to that of the desired final object; only the smallest details or patterns were left for later when they could be better achieved by incising directly on the cast bronze. Again in the case of a hollow cast, small metal pins were punched through the wax into the core, to later connect it with the final casing in order to keep the inner core and outer shell separated by the exact thickness of the wax. Here and there strategically placed wax rods would project from the wax modeled surface to form vents for the escape of gas and gates or tubes into which the molten bronze was poured. This wax coating, together with the wax rods, in turn, were encased in another layer of clay so that a "sandwich" was formed, consisting of wax between two layers of clay; these layers were connected with the pins that acted like toothpicks separating the bread layers in a sandwich. When the clay was solid and dry, the form was heated to melt and displace the wax (hence, the "lost wax" method), thus leaving either a simple hollow mold or a solid core and outer negative shell connected by the pins. Into this mold molten bronze was poured. It was extremely important to fill the negative mold *completely* with the molten bronze, leaving no voids to flaw the final work. After the bronze cooled and hardened, the clay encasement was broken or cut away, leaving a form that closely approximated, but was considerably rougher than, the form produced by the wax before it was melted. The pins were cut away, as were the bronze rods resulting from the pouring and venting tubes. The final steps, which were painstaking and could take at least as long as the earlier stages, involved chasing, that is, filing away the remains of the metal rods and polishing the rough surface and imperfections that inevitably resulted. Then the surface would be incised, punched, or chiseled with patterns or other details. A bronze work might, finally, receive a patina and/or gilding. A patina was created by covering the bronze with a solution, say, of copper nitrate, and then heating the piece until the desired color was achieved and allowing it to cool. Details of the work might be gilded, either by

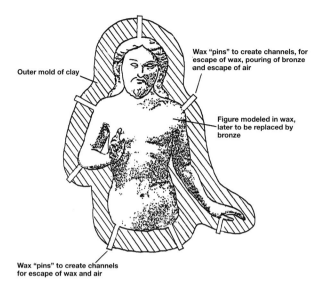

Outer mold of clay

Wax "pins" to create channels, for escape of wax, pouring of bronze and escape of air

Figure modeled in wax, later to be replaced by bronze

Wax "pins" to create channels for escape of wax and air

2. Lost wax method [author].

adhering a thin layer of gold directly on the surface or by the preferred and more durable method, fire gilding, in which gold and mercury are applied to the bronze surface; the whole is then heated in a furnace, and the mercury evaporates in (highly toxic) fumes, leaving the gold bonded to the bronze surface. When cool, the gilt surfaces were burnished. A large piece had to be cast hollow in part for economic as well as technical reasons, as indicated earlier; indeed, the larger the unit the greater the danger of casting flaws. As we see, bronze casting was a complex, difficult, and dangerous occupation. For these reasons it was a relative rarity during our period, but it carried strong associations with antiquity and was highly valued.

Wood, besides being used for various types of furnishings such as pulpits and choir stalls, was often the preferred medium for sculptures in parish churches because it was less expensive, more easily worked, and more readily amenable to lifelike and attractive coloration than marble. The portability of a wood sculpture and the possibility of including movable parts, such as hinged arms on a Virgin (Fig. 165) or a Christ figure, allowed for its use in processions and liturgical drama. A figure of Christ, for example, could serve first as the Crucified, and then as part of a Lamentation or Deposition. Both visual and literary evidence suggest that such statues, whose effect of human vulnerability resulted from the realistic coloration of flesh and blood, were particularly effective in inducing not just empathy but religious ecstasy.[14]

Wood statues were generally carved from logs of a fruit or nut wood, chosen because of their hard and fine-grained quality. If it was to be a full figure (rather than, say, a reliquary bust), limbs and the head were frequently made of separate pieces. To make a wooden statue, the sculptor scooped out of the log a deep hollow in what was to become the rear of the figure. This step helped prevent the cracking or splitting of the outer surfaces, which would dry and thus shrink more rapidly than the interior if left intact. The hollow was later masked with a separate piece of wood carved to conform to the curvature of the statue's front and sides. The head, if carved separately, would also be hollowed out beginning at the base of the neck. Many of the standard woodworking tools still in use today were employed to carve the statue, which was then covered with a layer of gesso, sometimes laid upon fabric applied to its surface. The gesso served to mask any joints that should not be visible, to seal the pores of the wood, necessary for the application of paint, and, sometimes, to add some modeled details such as hair tresses or the definition of certain features. The final step was the application of polychromy, including gilding; for this the normal techniques for panel painting in tempera were employed. This step was generally carried out not by the sculptor but by a painter who sometimes signed the work.[15]

While all media required skill in design, it was equally important for the master to understand the nature of the material and how it could be exploited. Thus, although grain pattern was not a factor in the design of a wooden sculpture, because the final product was to be completely covered with gesso and paint, the grain of ivory could very much enhance the effects of modeling and therefore would be taken into account. Ivory, an extremely precious material, is the hardest organic substance known. Unfortunately, there is little documentary information regarding the technique of ivory carving during our period, although the tools used for it were likely similar (but requiring, undoubtedly, more frequent sharpening) to those employed by carvers of wood.[16] Unlike wood figures, however, but like marble sculpture, those in ivory were never completely polychromed; only selected details were highlighted with color or gold to enhance the beauty of the ivory itself.[17] When expensive ivory was not available or when the object was for secular rather than religious use, such as a box for jewelry, bone from any available animal or hippopotamus teeth were employed using similar carving techniques. Although specialized skills undoubtedly were necessary, on rare occasions a master of stonecarving could, as in the case of Giovanni Pisano, also

produce a masterpiece of ivory (see Fig. 105 and p. 81).

We have noted that one and the same artist could be skilled in a number of crafts, and this was especially true in Tuscany, where many stone-carvers were trained as goldsmiths. Indeed, the goldsmith requires a broader range of knowledge – including aspects of metallurgy and chemistry, and design and modeling techniques – and mastery of more manual and instrumental operations than probably any other kind of artist.[18] While the art of the goldsmith involves the assembly of many, usually small, parts in a variety of materials – including precious and semiprecious stones and opaque and translucent enamels – some of those parts could include three-dimensional figures whose monumentality belies their miniature size. An especially impressive example is the Giottesque Madonna on the shrine of San Savino in Orvieto (Figs. 3, 4).[19]

The two basic techniques of working in gold and silver were forging with a hammer against a resilient substance such as pitch, and casting. For the latter, the lost wax process was used in a procedure similar to, but of course on a smaller scale than, that employed for bronze statues. Pieces that would make up the whole were connected by means of riveting or soldering. Decorative enhancement (and sometimes figural detail) was achieved through engraving or the use of punches (the latter by means of a technique similar to that employed by panel painters to decorate halos and increase the refraction of light on the gold's surface), as well as through repoussé and chasing. The fact that gold is a substance essentially incorruptible and powerfully evocative of transcendence made it especially appropriate for liturgical objects such as altars, tabernacles, and reliquaries. It is perhaps in the making of reliquaries, however, such as that of San Savino in Orvieto (Figs. 3, 4), that the skills of a sculptor of monumental figures were called on the most.

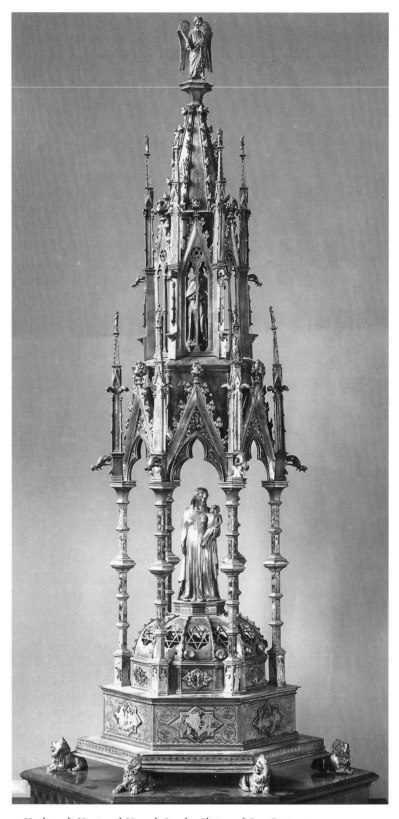

3. Ugolino di Vieri and Viva di Lando: Shrine of San Savino, 1330s? Orvieto. Museo dell'Opera del Duomo [Alinari/Art Resource, New York].

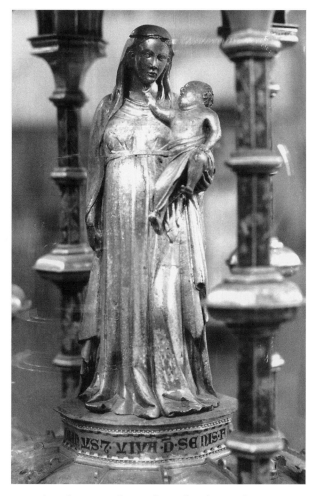

4. Ugolino di Vieri and Viva di Lando: Shrine of San Savino, detail. Orvieto, Museo dell'Opera del Duomo [author].

ITALIAN GOTHIC SCULPTURE: THE BACKGROUND

Three factors, interrelated in ways that are not easy to define, combined to stimulate the development of Italian Gothic sculpture: the revival of monumental stone sculpture in Italy during the Romanesque period; the influence of the new naturalism, expressiveness, and decorative quality of French Gothic art; and the pervasive physical remains of ancient architecture and sculpture, newly apprehended and appreciated – in part because of the first two factors.

Italian Romanesque Sculpture

The importance of the physical remains of ancient architecture and sculpture cannot be overemphasized: In many parts of Italy, and especially in Tuscany and Rome, there was uninterrupted contact with the rather abun-

dant remains of Roman civilization. However, just as government and politics during the twelfth and thirteenth centuries were characterized by diverse systems (imperial and Norman in the south, papal or communal in the center, and cities that were semiautonomous in the north), the sculpture created during the period was marked by regional developments, and these, among other stylistic factors (such as the varying strength of the Byzantine tradition or of Islamic influence), reveal differing attitudes toward or uses of the antique. Despite regional differences, however, and probably due to the survival and continuous contact with antique remains, Italian Romanesque figural sculpture contrasts strongly with the elongated, twisting, expressive figures and the tendency toward abstract linearity seen in much of French Romanesque sculpture, particularly in the region of Burgundy.[1] More so than elsewhere, Romanesque in Italy is characterized by an emphasis on mass and volume, stable verticals and horizontals, and simple, legible gestures. Indeed, well before Nicola Pisano's classicism, Romanesque sculpture, especially in Lombardy, Tuscany, and Campania, had turned to Late Antique and Early Christian models for technical guidance in the carving of reliefs in stone and marble, and also as formal exempla that could help fulfill the new needs, in a more stable and intellectually motivated society, for monumental imagery on portals and church furnishings.[2]

Among the most active Romanesque stonemasons were the so-called *maestri campionesi*. The denomination Campionesi has conventionally been employed to indicate various workshops of architects, stone-carvers, and sculptors originally from the Campione region of northern Italy and Switzerland, which extends from Lugano to the Lombard lakes.[3] The production of the Campionesi shared certain stylistic traits such as an emphasis on the volumetric block and a static, hieratic figure style (Fig. 5). Their expertise in stone carving, as well as their particular mode of treating the material, came to be in demand elsewhere, and so the workshops spread out to other regions during the second half of the twelfth century and continued to flourish, especially in Lombardy, well into the fourteenth century.

As early as c. 1110, the first continuous narrative, probably inspired by those of Roman historical friezes, was created by the northern Italian sculptor Wiligelmo in Modena (Fig. 6). Around 1135 Wiligelmo's successor, Niccolò, employed large-scale niche figures on the jambs of the cathedral of Ferrara, where he also used the tympanum as a field for figural relief (Fig. 7), thus creating,

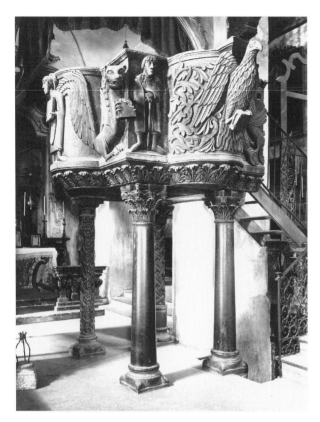

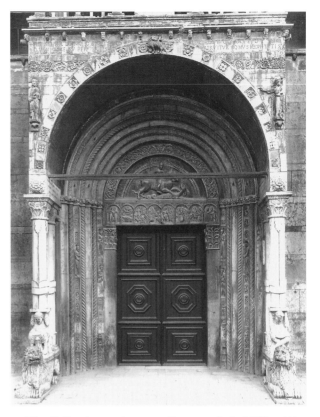

5. Pulpit. Basilica di San Giulio, early eleventh century. Lago d'Orta (Novara) [Alinari/Art Resource, New York].

7. Niccolò: Facade portal, c. 1135. Ferrara cathedral [Alinari/Art Resource, New York].

6. Wiligelmo: Genesis scenes, c. 1110. Modena cathedral [Alinari/Art Resource, New York].

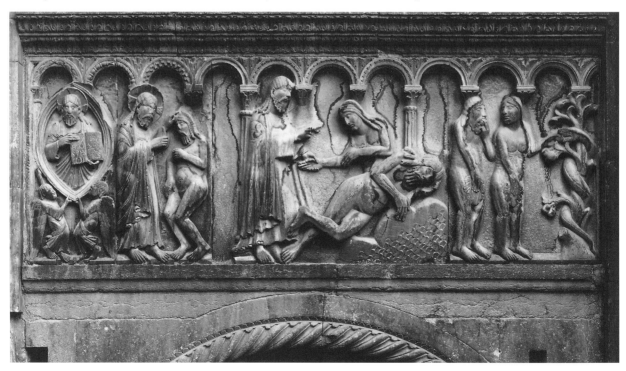

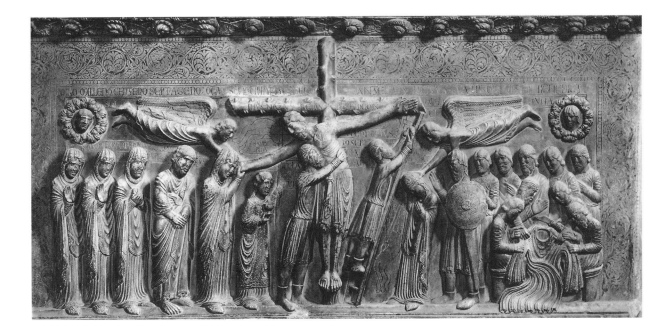

8. Benedetto Antelami: *Deposition,* last quarter of the twelfth century. Parma cathedral [Alinari/ Art Resource, New York].

and perhaps anticipating, devices that would flourish both in Italy and France during the succeeding period.

Benedetto Antelami, whose familial origins are probably also in the Campione region, is the greatest Italian sculptor of the transition from Romanesque to Gothic and the most important master whose name has come down to us prior to Nicola Pisano.[4] His work, datable during the last quarter of the twelfth century, includes the powerful Deposition relief (Fig. 8) (originally part of a church furnishing such as an ambo or altar frontal), a series of imposing sculptures on the Baptistry of Parma (Fig. 9), and two niche figures in Fidenza (Fig. 10). On the Baptistry, whose iconography derives largely from French precedents, there is introduced into Italy something of the comprehensiveness of the sculptural programs characteristic of French cathedrals.[5] Furthermore, his works reveal a new sense of humanity, which may also have been inspired by northern sculpture. However, the master imposed a personal interpretation that reveals his native inclinations informed by classical art: Rejecting the elegance and refinement of contemporary French craftsmen, Antelami preferred an emphasis on robust volumes, and although his sculptures are not less intense emotionally than those of his northern colleagues, they have a reserve and quietude that is entirely his own.

From the mid–twelfth century Lombard masters appear in Tuscany, where the preference for planar architecture incorporating geometric intarsia patterns at first discouraged the development of architectural sculpture. Instead, interior liturgical furnishings, in particular pulpits, would seem to have satisfied any impulses toward sculptural decoration. Thus we find a certain master Guglielmo creating a new type of pulpit for the cathedral of Pisa between 1159 and 1162 (later displaced to Cagliari; see p. 360 n. 5). In its original form Guglielmo's pulpit was composed of a marble parapet embellished with vigorous narrative reliefs, based on Late Antique and Byzantine sculpture, showing scenes from the life of Christ. The two lecterns were supported by figural triads (Fig. 367) and the columns rested on lions. It remains open to discussion whether Guglielmo's sources, in addition to antique remains, included sculpture in Provence or whether the influences moved in the opposite direction.[6] In any case, Guglielmo established an enduring pulpit type; furthermore, native Tuscans soon adopted his classicizing figure style, as for example Biduino, to whom a portal from San Leonardo al Frigido, now in the Cloisters of the Metropolitan Museum of Art (Fig. 11), has been ascribed.[7]

Another master coming from a family of stonemasons of Lombard origin, Guido Bigarelli da Como, was active around the middle of the thirteenth century, first in the Pisa Baptistry, where he executed the octagonal baptismal font in 1246 (Fig. 26), and then in Pistoia, where he created a pulpit for San Bartolomeo in Pantano, signed and dated 1250 (Fig. 366).[8] The Pisa Bap-

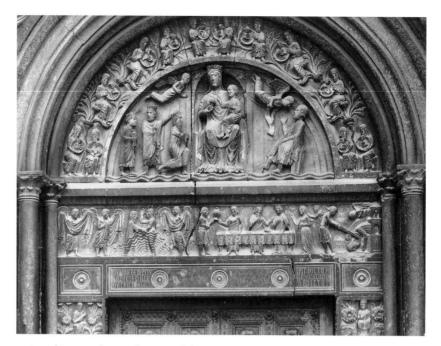

9. Benedetto Antelami: *Adoration of the Magi,* last quarter of the twelfth century. Parma, Baptistry [Alinari/Art Resource, New York].

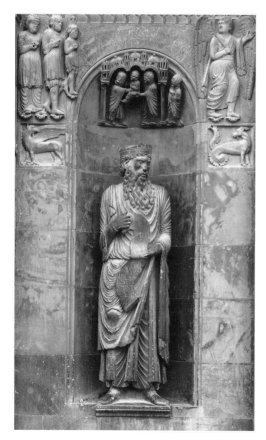

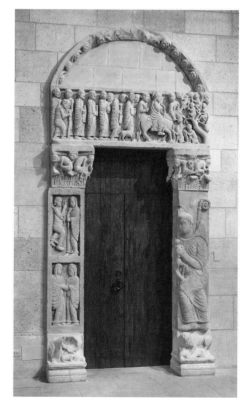

10. Benedetto Antelami: *David,* last quarter of the twelfth century. Fidenza Cathedral [Alinari/Art Resource, New York].

11. Biduino(?): Portal from San Leonardo al Frigido, last quarter of the twelfth century. New York, Metropolitan Museum of Art [The Metropolitan Museum of Art. Purchase, 1962. The Cloisters Collection (62.189)].

tistry font reveals an extraordinary precision of carving in the floral and figural details, all against a background of colored geometric intarsia patterns; the result is nothing less than an explosion of plastic and chromatic effects.[9] His Pistoia pulpit is more restrained, and like many other Tuscan thirteenth-century examples, adopts the structure of Guglielmo's pulpit, which was still to be seen in the cathedral.[10]

The Milieu of Frederick II

During the first half of the thirteenth century in the region of Apulia in southern Italy two distinct tendencies are apparent, both connected with the court of the Holy Roman Emperor Frederick II, and both forming the immediate background for the new developments in Tuscany with the arrival of Nicola Pisano. The first tendency is seen in the sculpture that embellished the monumental Gate of Capua, completed in 1239. Although closely related to the Italian Romanesque tradition seen elsewhere, the sculpture shows, indeed flaunts, a more direct and literal imitation of classical models. This massive towered bridgehead was, in fact, the gateway along the Via Appia from Rome, which marked the entrance to Frederick's domain, the Kingdom of Sicily, separating it from Rome and the papal territories to the north. Although only the tower bases remain to give some impression of the original gateway, early drawings and descriptions indicate the stunning visual effect a visitor from Rome would have encountered approaching Capua: a seemingly impenetrable mass faced with marble and opulently embellished with sculpture (Fig. 12). The impression must have been powerfully reminiscent of ancient imperial monuments such as the towered gateways piercing the city walls of ancient Rome. The sculptural program, restricted to the gate proper between the two huge towers, combined antique spoils and modern, thirteenth-century imitations of ancient sculptures. These included three-dimensional busts in roundels, possibly representing the emperor's legal counselors, as well as an allegorical female bust and another bust probably representing Zeus (Figs. 13 and 14). In addition, a seated figure of the emperor himself (Fig. 15), possibly the first monumental stone portrait in a secular setting since antiquity, was placed in a central niche flanked by two ancient *spolia*, figures of Apollo and Diana. The sculptural program was directed toward the visual expression of Frederick's political and ideological agenda, toward which his coinage, legal code, cere-

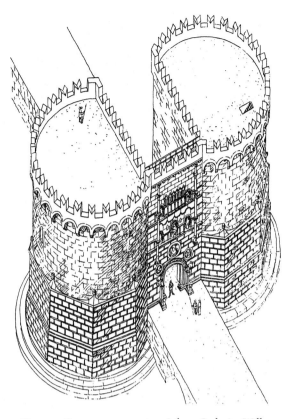

12. Capuan Gate, reconstruction [after Carl A. Willemsen, *Kaiser Friedrichs II. Triumphtor zu Capua*, Wiesbaden, 1953].

monies, and other court activities were also directed: the reestablishment of the imperial dignity and authority of the Holy Roman Empire on a scale rivaling that of ancient Rome. As Willibald Sauerländer has put it, we see here a choice of Roman models "in order to render Caesar's program in Caesar's language."[11] Despite the self-conscious imitation of antique models, however, the stylistic language, for example, of drapery folds and hair patterns, is thoroughly linear, often tending toward the schematic, and to this extent conforms rather with the Romanesque tradition. Thus, there is a contradiction here between stylistic means and ideological ends. Although this antiquarian mode originated in a secular setting and for secular purposes, it appears later in an ecclesiastical milieu unconnected to Frederick's court, which essentially collapsed with his death in 1250. An example is the impressive classicizing sculpture of the pulpit in the cathedral of Ravello (Fig. 16) signed, to be sure, by an Apulian sculptor, Nicola, son of Bartolomeo of Foggia, in 1272.

If the Capuan Gate represents official imperial propaganda in the language of ancient Rome and thus – more

13. Female Allegory, from Capuan Gate, before 1250. Capua, Museo Campano [Naples, Soprintendenza per I Beni Artistici e Storici].

14. "Zeus," from Capuan Gate, before 1250. Capua, Museo Campano [Naples, Soprintendenza per I Beni Artistici e Storici].

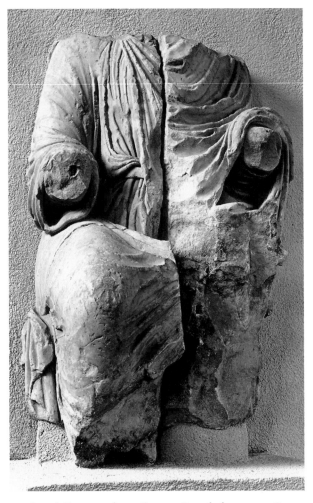

15. Seated Emperor, from Capuan Gate, before 1250. Capua, Museo Campano [Foto Marburg/Art Resource, New York].

than other contemporary sculptures – is literally "Roman-esque," the architectural sculpture of Castel del Monte (c. 1240–50), a private residence of Frederick II (perhaps a hunting lodge), can hardly be characterized as such. Unlike that of the Capuan Gate, the program of Castel del Monte seems to be primarily decorative, and the style is not the "pseudo-classical" style (Sauerländer's words) of the imperial gateway. In this octagonal, eight-towered structure with a central courtyard surrounded by two stories of rib-vaulted chambers, the surviving sculpture is all connected to some of its most Gothic architectural features: the keystones, rib-vaults, and consoles supporting the ribs. Here we see heads between ribs and on the consoles, as well as atlantes supporting the ribs (Figs. 17 and 18), all elements that are not seen earlier in Italy but are widespread in the north and thus clearly reveal French inspiration.

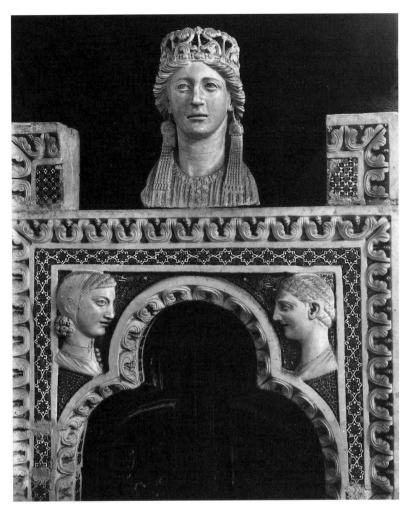

16. Nicola da Foggia: Pulpit, detail, 1272. Ravello cathedral [Alinari/Art Resource, New York].

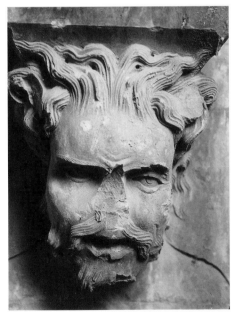

17. Console head, before 1250. Castel del Monte [Istituto Centrale per il Catalogo e la Documentazione].

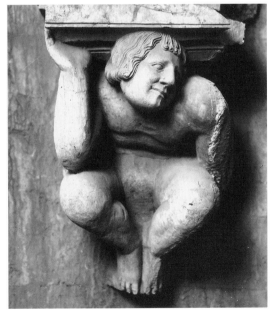

18. Console figure, before 1250. Castel del Monte [Istituto Centrale per il Catalogo e la Documentazione].

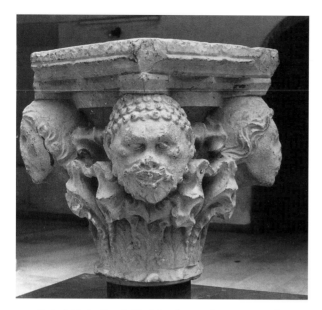

19. Capital, Troia, first half of the thirteenth century [Valentino Pace].

Nevertheless, despite attempts to relate these features to Chartres, Reims, and Paris, the style of the sculptures at Castel del Monte (as well as such related sculptures as the capitals from nearby Troia [Fig. 19]) eludes convincing comparisons to French examples, and the precise mode of transmission of northern influence is open to discussion. Nor do the muscular atlantes, with their unabashed pagan nudity, energetic poses, and expressive faces (Fig. 18), resemble anything on the Capuan Gate. This witty, robust naturalism, this response to *one* of the many possible aspects of pagan sculpture available for emulation, must have been encouraged for *this* setting (Castel del Monte) and not *that* one (Capuan Gate) by the emperor, an admirer and collector of antiquities. A highly selective and indeed variable attitude toward classical sculpture, then, may be said to characterize the productions for Frederick II, and it is this in part that has made them so difficult for art historians to categorize (see pp. 21f).[12]

The Classical and French Connections

The antique past on the Italian peninsula, more than in other areas of Roman conquest, remained a pervasive physical presence throughout the Middle Ages. Patrons and their stone-carvers found many uses for such *spolia*. For example, ancient columns were employed for the naves of Early Christian basilicas, both for reasons of economy – in saving the expense and labor of quarrying

and carving *ex novo* – and for ideological ends, as expressive of the New Church built on the ruins of the Old. For the very same reasons Roman sarcophagi were re-employed for Christian burial, first for the tombs of saints, a practice that began in the eighth century with the large-scale translation of the relics of martyrs from the outlying catacombs to Roman basilicas; and then, beginning in the twelfth century, as the choice of some popes for their future burial, preferably in a sarcophagus of porphyry or one embellished with symbols and themes of triumph.[13] Inherent in this papal choice was a double allusion: By this means the popes appropriated to themselves the aura of sainthood while also effecting an *imitatio imperii*. During our period, in the communes of Central Italy and in the courts of the north, no less than in the ducal oligarchy of Venice, the topos of direct lineage to ancient Rome served as a device for establishing civic identity or seignorial legitimacy and was a significant factor in the reuse or the imitation of antique sculpture – this despite the fact that many such claims (with the exception of Rome itself), and in particular those of Venice, required a strong dose of mythology.[14]

The Italian stone-carver's bias, from Romanesque times on (and especially in the work of Antelami as indicated earlier), toward a sculptural solidity that both asserts the plane of the original block and implies an existence within space, was a legacy of antiquity more pervasive here than anywhere else in Europe. When in the late thirteenth century such masters as Nicola Pisano and Arnolfo di Cambio sought in addition to create more lifelike figures, they found models in ancient reliefs and statues. Since drawing the nude from life was not practiced until the fifteenth century, earlier artists turned to Roman examples to develop a sense of human anatomy, naturalistic poses, and the relationship of drapery to body. But Roman art offered an aesthetic ideal as well. To the extent that some Trecento masters, such as Andrea Pisano, achieved formal balances between solids and voids, verticals and horizontals, the sense of movement and stability, and "the representation of the specific and the generic . . . [making] . . . the viewer acutely conscious of both" (in J. J. Pollitt's definition of the term "classicism"),[15] the paradigms were found in ancient examples.

As has already been indicated with regard to the sculptures at Castel del Monte, the extent, importance, and means of transmission of northern influence on Italian art is an issue that has not yet been fully resolved. But many factors encouraged the reception of

northern Gothic style, including the existence of ateliers of northern-trained stone-carvers in Italy already during the Romanesque period; the cosmopolitan nature of the court of Frederick II in the early thirteenth century; the presence of a French court in Naples during the Angevin rule of the late thirteenth and fourteenth centuries; the international character of Tuscan commercial and banking interests; the establishment of Cistercian abbeys with churches built along the principles of French structure and design and whose members served as *operai* for such projects as the cathedral of Siena; French patronage, particularly that of members of the curia both in Avignon and Italy; and the northern political and cultural connections of the seignorial courts in Milan and Verona.

By 1300, for example, a veritable network of Italian commercial and financial interests extended throughout western Europe, to North Africa, and even to the far reaches of Asia.[16] Tuscan bankers found important positions in the courts of France, and with the establishment of the papacy in Avignon in 1309, a magnetic attraction to that city was felt by many Tuscan tradesmen. The interests of Guelf Florence, moreover, were intimately connected with those of the French rulers in Naples, who brought with them architects and artisans from north of the Alps. There is documentary evidence not only of northern artists working in Naples and Genoa but also of Italian artists working in the north; furthermore, a number of Italian inventories list French-made objects, some still found in cathedral treasuries.[17] Given the extraordinary development of French architecture and sculpture during the twelfth and thirteenth centuries and continuing into the fourteenth – much of it reflected in small portable objects – and the commercial and political crosscurrents between the two areas, it is not surprising that a powerful artistic current from the north should reach the centers of artistic production in Italy.

Northern influence was both stylistic and programmatic. To the Italian observer, the linear stylizations, mannered gestures, and play of ornament and fold forms seen in French Gothic sculpture were visually appealing. At the same time, the implications of movement suggested by these devices and the exploration of facial signs that convey a sense of the interior life encouraged a psychological engagement quite in contrast with the effect produced by the stolid, heavy forms and formulaic expressive quality of much of Italian Romanesque art. To employ similar elements was to breathe life into the

stony forms. But such northern Gothic elements had to be adapted to and integrated with the fundamental classicism of the Italian tradition, or rather traditions, for the local or regional factor was never absent; thus, northern Gothic experience was interpreted in the different regions in different ways, depending on the tenacity of the local traditions, as well as other factors.

Of equal importance as the stylistic is the programmatic impact of northern art, which is especially relevant in funerary monuments, liturgical furnishings, and facade design. For instance, the appearance of the tomb effigy on Italian soil (it had been employed earlier in France) can be directly related to French patronage and in many cases to the very fact that the deceased was a Frenchman high in the ecclesiastical hierarchy whose associates, including executors, were also French. The earliest extant example is the monument of Pope Clement IV (Guy Foulcquois) in Viterbo (Fig. 59), soon to be followed by the tombs of Cardinal Guillaume de Bray (Fig. 56) and Cardinal Ancher de Troyes, buried in Orvieto and Rome, respectively. Elements of the northern repertory to be adopted in Italy included the *lit de parade* on which the effigy lies (as seen on the de Bray monument), the accurate portrayal of the dress and paraphernalia in and with which the deceased was buried (as seen on the tomb of Honorius IV), the theme of clerics participating in the funerary rite (as in the tomb of the pontifical notary Riccardo Annibaldi, d. 1289 [Fig. 60]), and the Gothic canopy (the first example being the Clement IV tomb, Fig. 59). Yet the particular form and combination may not have a discernable northern source, and the emphasis on surface by way of mosaic and intarsia shared by all of these tombs is decidedly Italian and specifically Roman.[18]

Both the reception of northern influence and the independence of Italian masters and their patrons is nowhere more evident than in the design of cathedral facades (see pp. 294ff.). The cathedrals that were rising in France during the course of the thirteenth century were, in the words of Emile Mâle, the "visible counterparts" of the "intellectual edifices" that were being developed by the Scholastic theologians.[19] The French cathedral program attempted to encompass the sum total of human knowledge, moral ideals, and God's cosmic plan for the universe. According to the Scholastic theologians, that plan is not only comprehensive, it is harmonious: Every moment in history, every detail of nature, every act of man has its place and its relationship to all other elements. The French Gothic cathedral,

with its vast program of pictorial and sculptural decoration and its tendency toward hierarchical ordering, symmetry, and vertical and horizontal linkages, parallels not only the intellectual scope but also the structure of such compendia as the Speculum Majus of the Dominican theologian Vincent of Beauvais (d. 1264) with its organization into four books – the Mirror of Nature, the Mirror of Instruction, the Mirror of Morals, and the Mirror of History – whose contents are theologically linked.[20] Italy, more restrained in its embrace of that vision, was hardly immune from its appeal.

Among the earliest manifestations of the spread of the Scholastic impulse are the pulpits of Nicola and Giovanni Pisano, where biblical history is augmented by representations of Virtues and Vices, Liberal Arts, and pagan prophetesses of antiquity. The encyclopedic urge expresses itself even more fully on a secular and civic monument, the Fontana Maggiore in Perugia, on which, in addition to scenes from Genesis and an array of prophets and saints, there are several contemporary secular personages, the Labors of the Months, the Liberal Arts, and various fables and allegorical figures. While Italian designers generally rejected the two-towered facade of France, they incorporated aspects of the latter's complex iconography. The facade of Orvieto cathedral, following after the more strictly Marian programs at Siena and Florence, has a more comprehensive iconographical program than its predecessors: In addition to a Genesis cycle, a Tree of Jesse, a New Testament cycle, and the Last Judgment there are representations of the Liberal Arts. Not to be outdone programmatically, the Florentines soon augmented their own Marian program by adding reliefs to the Campanile, including Genesis scenes and the Labors of Mankind, ancient heros, the Sacraments, the Liberal Arts, and the Planets.[21]

The transformation in Italy of transalpine stylistic and iconographic features has been characterized as an "editing" of French Gothic,[22] a term that could be applied equally to the adaptation of classical art. Virtually unedited, however, as the late thirteenth century gave way to the fourteenth, was the impact of contemporary painting in Tuscany and Rome, with its passion for spatial exploration and vivid narrative. The varying but often related concerns of Pietro Cavallini in Rome and Naples, the master of the San Francesco cycle in Assisi, and Giotto, Simone Martini, and the Lorenzetti brothers often guide, as will become evident, developments in sculpture, especially in Central Italy. At the same time, and this is true throughout Italy, sculpture shares with painting an insistence on rethinking subject and theme, frequently reformulating sacred iconography in the most human, even vernacular terms. This will become evident in the works of the first three masters to be discussed, Nicola Pisano, Arnolfo di Cambio, and Giovanni Pisano.

2

Central Italy c. 1250–c. 1310

NICOLA PISANO

One could legitimately ask whether, rather than the pulpits of Nicola Pisano, it is the sculpture from Castel del Monte and the related capitals from Troia (Figs. 17–19) that ought to be considered the first examples of "Italian Gothic" sculpture. They were of course produced in Italy during the era generally designated as Gothic, but their authorship, French or Italian, locally or foreign-trained, remains controversial. Although they can hardly be considered Romanesque, they are also not unambiguously French Gothic; yet in their relationship to the architecture they embellish, these sculptures conform to widespread French motifs of the Gothic era. For better or worse, the exigencies and conventions of art historical discourse tend to discourage focus on productions that do not reveal an evolution while also forming a stylistic whole; that are only fragmentary (like individual capitals) and not part of a reconstructable, programatically rich architectural-sculptural ensemble; whose style does not clearly reverberate in later works influenced by it; or that cannot be connected with a known artistic personality.[1] It should be admitted at the outset that the "key"

21

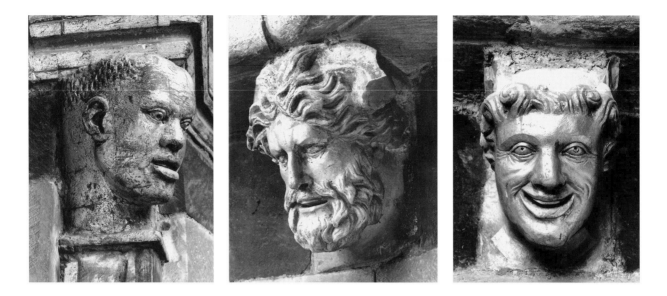

20. Nicola Pisano(?): Console figure, c. 1250. Siena cathedral [Siena, Soprintendente per I Beni Artistici e Storici].
21. Nicola Pisano(?): Console figure, c. 1250. Siena cathedral [Siena, Soprintendente per I Beni Artistici e Storici].
22. Nicola Pisano(?): Console figure, c. 1250. Siena cathedral [Siena, Soprintendente per I Beni Artistici e Storici].

monuments selected for art historical surveys, even rather narrow ones, almost always tend to be those that involve a wealthy or powerful patron, one and preferably more than one complex and grandiose, extant monument (or at least fragments that can be related to one whose stylistic characteristics can be articulated), and artists whose names are known from documents. If the Hohenstaufen sculptures are lacking in one or more of these conditions, the artistic output of Nicola Pisano of Apulia definitely fulfills these requirements.

The revival of an art more truly approaching the standards and ideals of classical antiquity than was seen earlier in either Italy or France during the thirteenth century was achieved in Tuscany upon Nicola's arrival from southern Italy. Abandoning what must have appeared to be the static formulas of Italian Romanesque sculpture, with its puppetlike figures, stylized drapery patterns, and stilted movements (Fig. 367) (as well as the abstractions and decorative effects of contemporary Italo-Byzantine painting), Nicola revitalized sculpture by combining monumental forms and compositions derived from Roman antiquity with the expression of human emotions that were first convincingly portrayed in northern Gothic art.

Nicola's presumed origins in Apulia within or near the cultural milieu of the court of Frederick II may explain in part his intimate acquaintance with and attraction to antique monumental forms; yet he avoided totally the sense of imitative antiquarianism seen in the classicizing sculptures at Capua.[2] Nicola's earliest signed and dated work is the hexagonal pulpit in the Baptistry of Pisa (Fig. 25). By the date of the completion of the pulpit in 1260, however, Nicola must have been resident in Tuscany for some time, perhaps a decade or more. It has been suggested, in fact, that he was active in Siena in the cathedral workshop from about 1245 when the cupola was under construction and when he may have carved a series of heads and animals on consoles beneath the cupola and on some of the capitals of the north triforium (Figs. 20–24).[3] There is no documentary evidence for this attribution, although the quality and liveliness of these sculptures indicate one or more remarkable talents whose roots, indeed, would seem to lie precisely in the dichotomous modes – classical and Gothic – of the court of Frederick II and its milieu (cf. Figs. 16–17, 20–22; see pp. 15ff.). The Siena figures, visually inaccessible for centuries until revealed to modern eyes through the use of scaffolding and photography, must have been essentially private experiments, although they are indicative of the new enthusiasm for empirical observation already inherent in the Scholastic tradition and the scientific investigations promoted by Frederick II.[4] Included are types identifiable as African, Nordic, and Asian, with in some cases individualized, in others idealized, classicizing faces and headdress, and with expressions ranging from intense concentration, solemnity, and contentment to a grimace

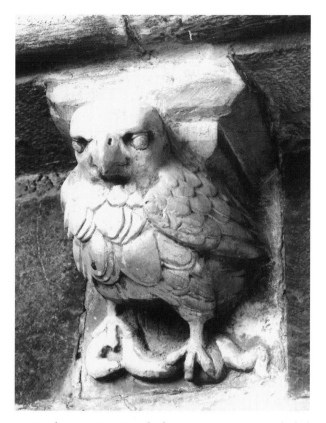

23. Nicola Pisano(?): Console figure, c. 1250. Siena cathedral [Siena, Soprintendente per I Beni Artistici e Storici].

to them in sermons ringing out from pulpits. These sermons nourished the hunger for the new spirituality promoted by the mendicant friars. Preachers and teachers, the friars – in particular the Franciscans but also the Dominicans – emphasized the humanity of Christ and encouraged meditation on and identification with his sufferings. Sermons could act as stimuli to the senses and emotions; and a preacher could even hope to motivate behavior, such as pious acts, prayer, penitence, or other of the numerous devotional options that had developed over the course of the previous centuries.[7] Many of the pulpits of the late thirteenth and early fourteenth centuries, including the four Pisano pulpits – two by Nicola and two by his son Giovanni – would seem to have answered to the intersecting interests of priest and worshiper – the one to effectively expound, the other to experience and absorb the literary, theological, and didactic messages heard from and illustrated on the pulpit. In fact, by the late thirteenth century the importance of sermons, augmenting or complementing the dramatic and moving illustrations of sacred history on the pulpits, went well beyond the liturgical and

24. Nicola Pisano(?): Console figure, c. 1250. Siena cathedral [Siena, Soprintendente per I Beni Artistici e Storici].

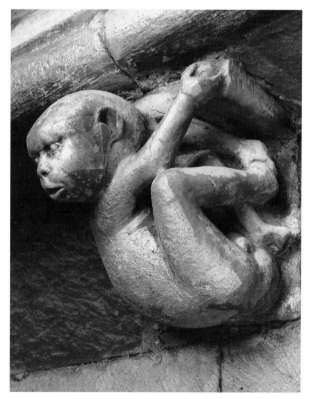

(Figs. 20–22). The sculptor's powers of observation and imagination reveal themselves no less in the portrayal of animals, as evident in the small but assertive bird (Fig. 23), the anthropomorphically expressive bear and lion, and the baby monkey (Fig. 24), clinging to its perch but peering with intense curiosity across the vast space.[5] These early essays, then, whether or not they are by Nicola Pisano – and there is no proof that they are – show an astonishing mastery of plastic form and expression.

The Pisa Baptistry Pulpit

It has been said with some justification that "the religious culture of the later Middle Ages was in large measure a preached culture."[6] With the growth of literacy, many people to be sure could read the proliferating devotional literature – the *Meditations on the Life of Christ*, the apocryphal lives of the saints, the treatises on virtues and vices, and so on – newly addressed to the laity and written in vernacular languages; but countless more heard the contents of such expositions preached

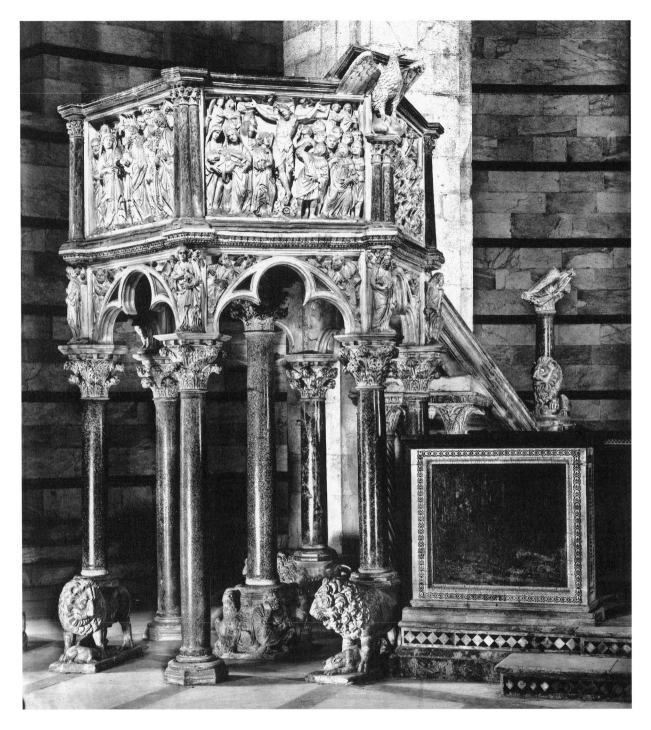

25. Nicola Pisano: Pulpit, completed 1260. Baptistry of Pisa [Alinari/Art Resource, New York].

solemnly didactic to become at times a kind of "edifying diversion."

Nicola is referred to in two documents, the earliest one dated 1258, as Nicola "de Pisis" or "Pisanus," indicating Pisan citizenship. By 1258 he must, then, have worked in Pisa long enough to have won the esteem of its citizens and government.[8] If he was, in fact, architect and/or sculptor of Siena from 1245, it may be that the conferral of citizenship was both an honor and an enticement, for the Pisans successfully recruited the master, who established himself and his workshop in this important port city. Here, he was given a most challenging commission: to create a pulpit not for a tra-

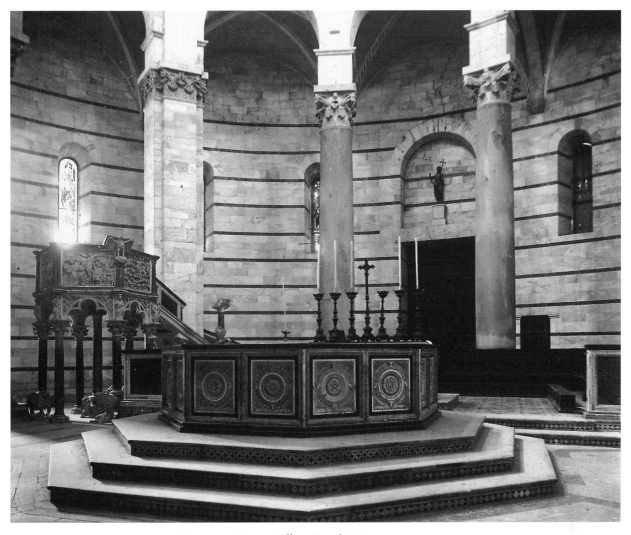

26. Pisa Baptistry, interior [Vatican, Monumenti Musei e Gallerie Pontificie].

ditional site, a basilican church, but for the centrally planned Romanesque Baptistry of Pisa. The monument, which Nicola signed and dated 1260, met the challenge with an unprecedented design (Fig. 25).[9] In contrast to the traditional Tuscan rectangular format (see Figs. 366–68), Nicola conceived instead a polygonal structure, a shape happily suited to the centralized plan of the Baptistry and echoing Guido da Como's octagonal font occupying the center of the interior space (Fig. 26).[10] Unlike most earlier pulpits, this one is freestanding, with the casket sustained by seven columns: one in the center whose base is surrounded by crouching figures and animals, and a ring of six outer columns alternately resting on lions and on the ground. The columns support an archivolt with trilobed arches between which are placed representations of Virtues and John the Bap-

tist. Above this section rises the balustrade with its historiated relief fields separated by triple colonettes. The pulpit is richly colored: Not only are the creamy marble reliefs framed by reddish colonettes and moldings, but the supporting columns are speckled and patterned red and green marble. Furthermore, the backgrounds of the reliefs were originally filled with colored glazed tesserae (some of which remain) while parts of the figures were originally painted. The coloristic effect is not entirely absent even today when most of the polychromy is lost.

The inclusion of narrative reliefs is virtually the only element that conforms with the Tuscan pulpit tradition (see pp. 286ff.). The reliefs cover five of the six sides (the sixth is the entrance to the pulpit platform) with scenes from the life of Christ: In a continuous narrative,

the first panel shows the *Annunciation, Nativity, Bathing of the Christ Child* (an apocryphal incident), and *Annunciation to the Shepherds* (Fig. 27). This is followed by panels illustrating the *Adoration of the Magi* (Fig. 29), the *Presentation in the Temple* (Figs. 30, 31), the *Crucifixion* (Fig. 32), and the *Last Judgment*. As in several earlier Tuscan pulpits (cf. Fig. 366), the narratives are dominated by verticals and horizontals that lend stability to the compositions and at the same time serve to relate the reliefs to the architectural forms surrounding and supporting them.

It is, however, Nicola's achievement as a storyteller employing powerfully plastic and expressive forms that has most impressed viewers throughout the intervening centuries. Rejecting the highly stylized reliefs created by his predecessors and even his contemporaries (cf.

Guido da Como's pulpit of 1250, Fig. 366), Nicola turned to ancient sculpture and to northern Gothic art as sources of inspiration for a new style, one that combined majesty with a deeply felt sense of human experience. This new mode was the visual counterpart of the by now widely diffused apocryphal literature, in which the sparse accounts of the lives of the sacred persons as told in the Gospels were enriched with homely incident, making them convincingly human. The popularity of these embellishments was to have a profound effect on the art of the fourteenth century, but Nicola, already, was not content merely to present symbolic narratives of transcendental events. His goal was, rather, to tell a human story in a credible and empathetic manner. Not only was the biblical story enriched by the inclusion of naturalistic details (such as the hairy goats on the lower

27. Nicola Pisano: *Annunciation, Nativity*. Pulpit. Pisa Baptistry [Ralph Lieberman].

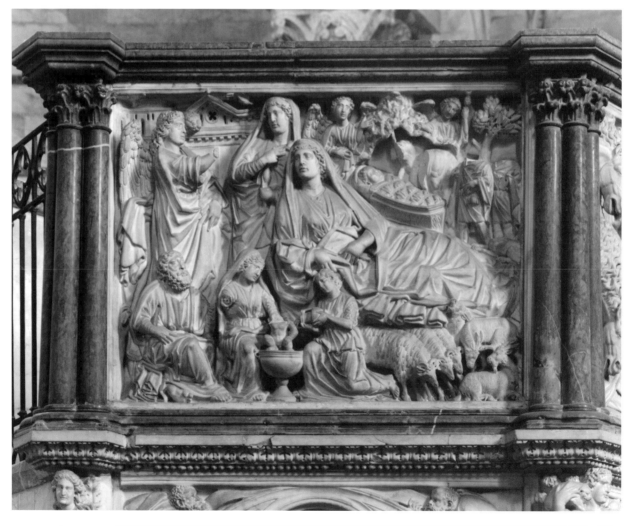

28. Sarcophagus of Hyppolytus and Phaedra. Pisa, Camposanto
[Alinari/Art Resource, New York].

29. Nicola Pisano: *Adoration of the Magi*. Pulpit. Pisa Baptistry
[Ralph Lieberman].

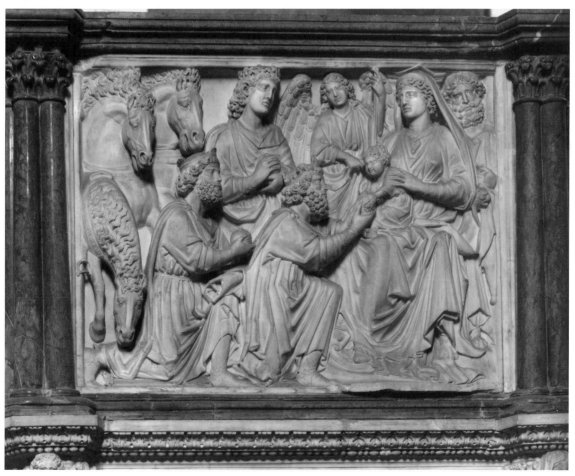

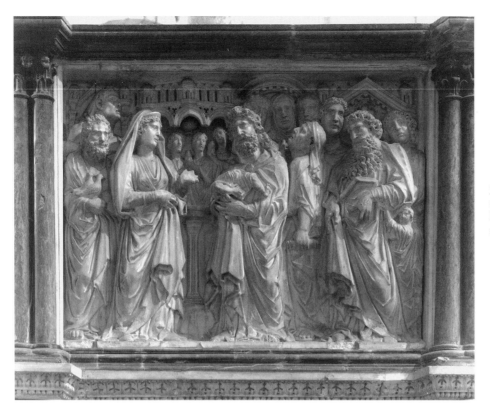

30. Nicola Pisano: *Presentation in the Temple.* Pulpit. Pisa Baptistry [Ralph Lieberman].

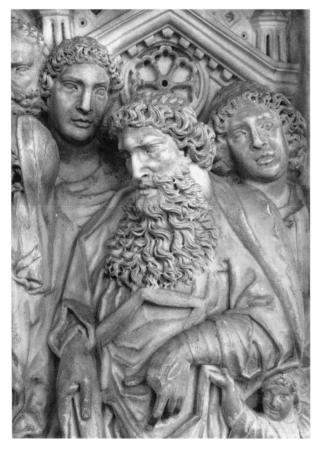

31. Nicola Pisano: *Presentation in the Temple,* detail Pulpit. Pisa Baptistry [Istituto Centrale per il Catalogo e la Documentazione].

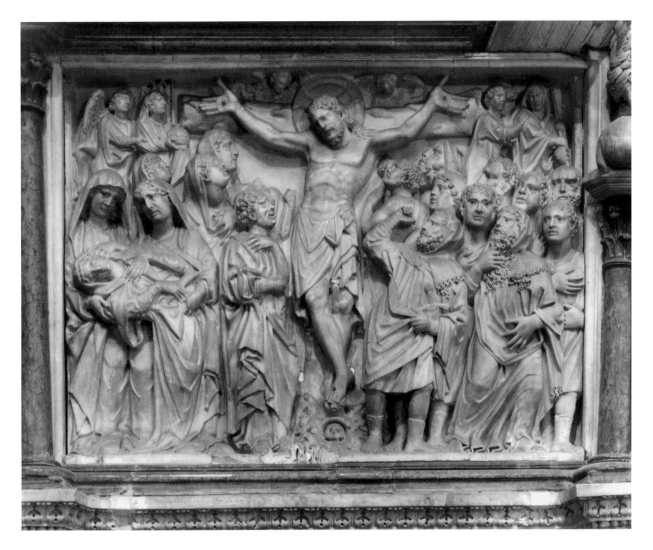

right of the first relief, one scratching an ear and the second curious to see what is behind him), but all the figures have bulk and a sense of weight and are rendered with a convincing naturalism of gesture and movement.

In the *Annunciation to Mary* we witness the Virgin's strong reaction to Gabriel's message, conveyed by her gesture and the impulsive retreat of her body (Fig. 27). Similarly, in the second relief, the *Adoration of the Magi* (Fig. 29), the Christ Child is not a stiff icon but a pudgy infant leaning forward eagerly to touch the gifts. The *Crucifixion* (Fig. 32), with the swooning Virgin and gesticulating figures surrounding Christ, is an especially poignant scene. Compared to earlier representations, the figure of Christ has a wholly new sense of physical presence and a restrained yet eloquent emotional power. If the latter characteristic suggests Nicola's awareness of developments north of the Alps,

32. Nicola Pisano: *Crucifixion*. Pulpit. Pisa Baptistry [Ralph Lieberman].

his close study of antique forms is also demonstrated, particularly in the articulation of the torso and limbs and in the modeling of the flesh conceived as a soft covering over a skeletal frame. During an age when the concept and techniques of copying forms directly from life were long forgotten, antique Roman sculpture offered Nicola models of plastic form that appeared to imitate the physical forms of nature. Several extant Roman monuments have been identified as the sources for motifs on the Pisa pulpit. The stately Virgin in the *Adoration of the Magi*, for example, is a direct quotation from the second-century sarcophagus of Hyppolytus and Phaedra (Fig. 28), which stood outside the cathedral during Nicola's lifetime and is now in the Camposanto.[11] Even where specific prototypes have not

33. Nicola Pisano: *Fortitude*. Pulpit. Pisa Baptistry [Ralph Lieberman].

the spiritual attributes of Fortitude by means of symbolic accoutrements, as was traditional, here Nicola chose to convey those attributes by means of the figure's physical characteristics, selecting an antique Hercules for his model.[12] The rich, dense relief patterns, the tendency to use the full height of the relief field for the figures, and the extensive use of the drill also recall characteristics of Roman sculpture, particularly of sarcophagi.

Conceived as a freestanding architectonic complex – almost a *tempietto*, self-sufficient yet responsive to the surrounding centrally planned space and polygonal font (Fig. 26) – the structure of the pulpit, as well as the sequence of the narratives, invited and indeed determined the movement of the observer. It should be noted that originally, when the worshiper entered the Baptistry from the eastern portal opposite the cathedral facade, the pulpit stood toward the right, not the left, of the baptismal font that dominates the center of the circular space. In this position (and with greater logic than the present disposition, in which, from the entrance of the building, one faces the Crucifixion), the viewer approaching from the portal would have seen the two reliefs that open the narrative of Christ's childhood and Passion: the *Nativity* panel (whose Washing of the Christ Child would have immediately resonated with the function of the Baptistry) and the *Adoration of the Magi*, the relief with the fewest number of protagonists, whose scale is larger than that in any other relief. Walking toward the pulpit, then, the observer would have focused on the Epiphany and veneration for the infant Lord (again echoed in the rite of Baptism). The figures in these opening reliefs, with easily readable gestures and movements, are large in relation to the field and thus readily legible from a distance.

been found, Nicola's adaptation of the antique is apparent, as in his rendering of the powerfully muscular, nude figure of Fortitude (the nudity itself heretofore unknown outside the contexts of Genesis and Last Judgment scenes), which stands in a contrapposto pose above one of the capitals (Fig. 33). Instead of suggesting

But perhaps even prior to embarking on the narrative itinerary, the entering viewer might have noticed the syncopated rhythm of the supports of the pulpit casket produced by the alternating taller and shorter columns set on column bases and on the backs of lions. Further prohibiting any sense of strict regularity or symmetry are the different colors of the marble columns as well as the change in direction of the movement of the lions: Two follow the direction of the narrative, whereas the third faces in the opposite direction, thus halting and indeed terminating the flow at the very point, the viewer by now becomes aware, when the narrative itself has reached its climax in the *Last Judgment*. For if the first two narratives show a relatively small number of protagonists, the three final scenes show a progressive increase in the number of figures and a decrease in their scale.[13] All this must have been motivated primarily by a desire to accommodate the shifting position of the observer, whose first, distant, diagonal view led, as he or she approached the pulpit moving toward the right to follow the course of the narrative, to the central scene, the *Presentation* (Fig. 30) – viewed from a slight diagonal but from fairly close up – to the frontal but more confining *da sotto in sù* viewpoint beneath the final two scenes, a viewpoint constricted by the nearby monumental column supporting the interior arcade of the Baptistry.[14] In effect, then, the pulpit encouraged the informed and sensitive observer to engage physically in the left-right impulse of the narrative and formal program. But the viewer also responded (and can do so still) to the increasing programmatic and sculptural density of the three levels: The eye moves from the lowest, most open region with its columns and lions, to the spritely trefoil arches flanked by figural reliefs, to rest finally on the packed narratives above. The kinetic effect can only be described as a spiral, for as one moves around the pulpit one's glance simultaneously moves both horizontally and vertically.[15]

Nicola Pisano's Pisa Baptistry pulpit is a truly revolutionary monument – in its architectonic form that intimately integrates the structural and sculptural components, in its highly meditated relationship to its environment and to the worshiper, in the range and breadth of its iconographic program, and finally, in the sculptural richness and monumentality in which a fresh and vivid interpretation of the sacred stories is imbued with the dignity and naturalism of antique sculpture – all of this executed with the highest standards of technical control over the material (Fig. 31).

At the same time, the Baptistry pulpit is surely the result of a partnership between an artist of the highest intellectual and artistic capacity and visionary patrons, presumably the cathedral canons and the Archbishop Federico Visconti, all of whom resided in and contributed to a particularly stimulating and receptive environment. At midcentury, Pisa was experiencing the initial stages of what would become "phenomenal urban growth," with an expanding population, increased communication, and a vigorous economy based on productivity in urban crafts and industries, such as the textile, leather, and building trades.[16] If Pisa's trade in the Levant was diminishing in the mid–thirteenth century, it was dominant in Sardinia and Africa, while the port of Pisa continued to flourish and control foreign traders' access to Tuscany.[17] Furthermore, in 1256, to the joy of traditionally antipapal and pro-imperial Ghibelline Pisa, a papal interdict invoked in 1241 – punishment for the city's active support of Frederick II – was lifted, orchestrated in part by the archbishop. The pulpit, prominent and engaging both visually and didactically, stood in a building that had long served not only religious but also civic purposes. The archbishop's civico-pastoral mission may well be considered a determinant factor in aspects of the pulpit's form and contents.[18]

It is worth reiterating, finally, that the growing impact of mendicant preaching and spirituality helped create a demand for vivid biblical imagery, which while engaging the spectator in its narrative sweep, encouraged contemplation and acceptance of Christian doctrine.[19] Thus, the *Crucifixion* and *Last Judgment*, themes not traditionally represented on pulpits, serve both to illustrate the ineluctable consequences of the childhood events represented in the earlier panels and to dramatize (and thus impose on the worshiper the need to reflect on) the very raison d'être of the building within which the pulpit is housed. Baptism, then, already foretold in the *Bathing of the Christ Child* in the first narrative, is placed within the broadest possible context of biblical history.

The Arca di San Domenico

Shortly after completion of the Baptistry pulpit, the Arca di San Domenico was erected in Bologna. Though not verified by documents, Nicola Pisano's name has been associated with the tomb since Vasari, and scholars universally agree that it was executed in his workshop,

31

most likely in Pisa; in fact, an early source reports that Nicola's Pisan assistant Fra Guglielmo was present in Bologna at the translation of Dominic's remains to the new tomb in 1267.[20] Dominic, who died in 1221, had founded a unique religious order whose members were clergy and who, while living communally, abjured the isolation that had characterized medieval monasticism; instead they chose to live in the growing urban centers of Europe, devoting themselves to the activities of teaching and preaching. Like his contemporary St. Francis of Assisi, St. Dominic promoted a new spirituality, imbued with apostolic fervor and free from the heretical doctrines that had been tainting Christianity. Upon his death Dominic was buried in a simple coffin underground, but about a decade later his body was translated to a more dignified stone sarcophagus placed aboveground. Following his canonization in 1233 and the growing popularity of his cult, it was decided around 1264 to erect a new, more grandiose tomb.

Whereas in the Pisa Baptistry pulpit Nicola's personal intervention in the reliefs fully overshadows that of his assistants – and there must have been several – on the Arca di San Domenico the hands of at least three sculptors are evident, including that of his major assistant, Arnolfo di Cambio.[21] The many attempts to distinguish passages by Nicola himself and those of his collaborators have often obscured the master's real achievement in this tomb, however, namely its total form, which was no less original than the design of the Pisa Baptistry pulpit; indeed, it became the prototype for an entire class of tombs through the fourteenth century and beyond.

When first erected (there have been many changes and additions; see pp. 322f. and Fig. 395), the tomb was conceived as a monumental, free-standing historiated sarcophagus resting atop a series of telamones, a form and structure that is without precedent in the history of sepulchral art (Figs. 34–40).[22] The sarcophagus is embellished on all four sides with an extensive cycle of biographical reliefs (Figs. 37–40) rather than the traditional biblical or symbolic themes. Unknown on earlier tombs are the eight figural supports: Representing friars, archangels, and Virtues, these supports include groups of three figures about a central column, reminiscent of ancient trifigural caryatids. The marble sarcophagus, the only part of the original monument still to be seen in San Domenico (Figs. 37 and 395), is capped by a cornice embellished with a lush acanthus frieze with birds pecking at the leaves, motifs reminiscent of

antique architectural and sepulchral decoration. There are two relief fields on each long side and one on each short side. The background of the reliefs is composed of a variety of patterns in red and gold *verre églomisé* (much of it restored).[23] The narrative fields are separated by full-length figures projecting in high relief, including the *Madonna and Child* and the *Redeemer*, respectively, on the long sides, and the four Church Fathers, Augustine, Ambrose, Jerome, and Gregory, at the corners of the sarcophagus. The corner figures, both on and supporting the sarcophagus, are not set parallel to the relief planes but project out diagonally, serving thus to encourage the observer's movement around the ensemble.

The sources for the tomb are incredibly varied: In addition to the classicizing frieze, the idea of supporting the sarcophagus by telamones may have been suggested by antique examples of sarcophagi resting on atlantes. The three-figured telamon, which goes back to ancient representations of the triple goddess Hekate, was revived in Romanesque times in the form of addorsed figures around a column, employed for ecclesiastical furnishings such as holy water stoups or lectern supports. The full-length figures that frame the narrative reliefs also have antique precedents, as does the diagonal orientation of those at the corners. But these and the diagonally placed supports immediately below are also seen in the Pistoia pulpit by Guido da Como (Fig. 366), dated c. 1250.[24] The more immediate source, however, is surely the angle figures of Nicola's own pulpit in the Baptistry of Pisa (Fig. 25) completed a few years earlier. Finally, the fact that the tomb is raised rather than set on the ground accords with a tradition for saints' shrines, but in addition it may have been motivated by a desire on the part of the Dominican patrons, the Order of Preachers, to evoke in the tomb of their founder something of the look of a preaching pulpit.[25]

This bold design, then, whose elements have sources as disparate as pulpits, bishops' thrones, holy water fonts, and ancient sarcophagi,[26] can only be explained by once again assuming a creative partnership between the sculptor and his patrons, this time the Dominican community. Like Dominican preaching, the Arca was conceived to appeal to the common worshiper; but at the same time its program and formal structure satisfied the demands of the Dominican hierarchy at large. This double purpose becomes clear when one considers the tomb's original site on the south side near the *tramezzo* (choir screen), separating the friars' space

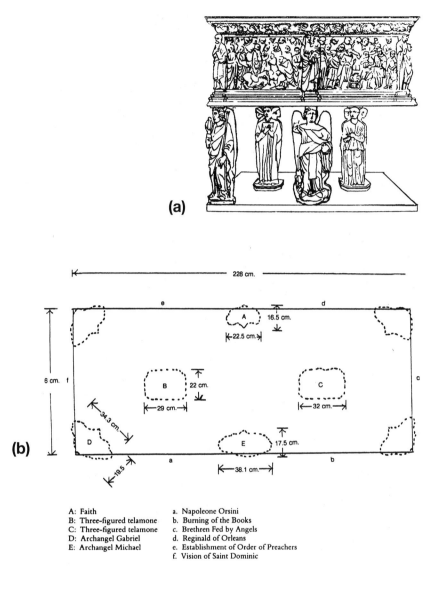

34. (a) Nicola Pisano: Arca di San Domenico, completed 1267. Bologna, San Domenico [after Pope-Hennessy]; (b.) Plan [author].

A: Faith
B: Three-figured telamone
C: Three-figured telamone
D: Archangel Gabriel
E: Archangel Michael

a. Napoleone Orsini
b. Burning of the Books
c. Brethren Fed by Angels
d. Reginald of Orleans
e. Establishment of Order of Preachers
f. Vision of Saint Dominic

from that of the lay congregation. Raised on supports, it was visible and accessible from both locations. The most spectacular and public of the miracles on the sarcophagus appear on the side with the Madonna (Figs. 37, 38), which probably faced the lay congregation: Not only are the compositions here less complex and more easily read from a distance – we have already seen Nicola's concern with legibility in the Pisa pulpit – but this is the side whose subject matter serves to promote the cult. The first episode, *The Raising of Napoleone Orsini*, concerning the resuscitation of a dead youth (Fig. 37, left), verifies the saint's powers as a healer, of great importance to the thaumaturgical function of a saint's shrine, while the second miracle, the *Burning of the Heretical Books* (Figs. 37, right, 38), asserts the cor-

rectness and divine sanction of Dominic's theology against that of heretics. Heresy remained a recurrent problem for the church. Thus, the *Burning of the Books*, addressed to the lay congregation visiting the shrine, reminded them of Dominic's past glories while also warning them of present dangers.

In contrast to the scenes facing the lay worshiper, those on the opposite side would seem to be addressed to the clergy: Here appear episodes concerning the founding and expansion of the Order.[27] Finally, the reliefs on the short sides are cunningly conceived so that they are directed to both audiences, lay and clerical. Thus, *Saint Dominic and his Brethren Fed by Angels* (Fig. 39) asserts divine support for the spiritual mission of the friars, but it also assures the lay wor-

35. Nicola Pisano: Arca di San Domenico, telamon. Boston Museum of Fine Arts [Boston, Museum of Fine Arts. Grace M. Edwards Fund].

36. Nicola Pisano: Arca di San Domenico, telamon. London, Victoria and Albert Museum [London, Victoria and Albert Museum].

37. Nicola Pisano: Arca di San Domenico, detail, completed 1267 [Ralph Lieberman].

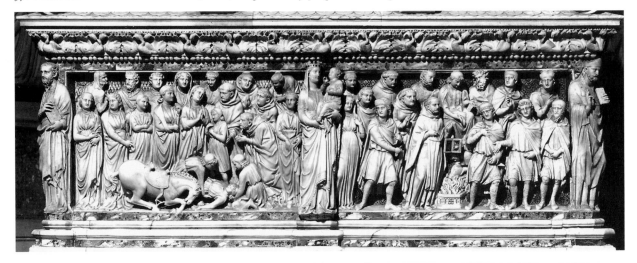

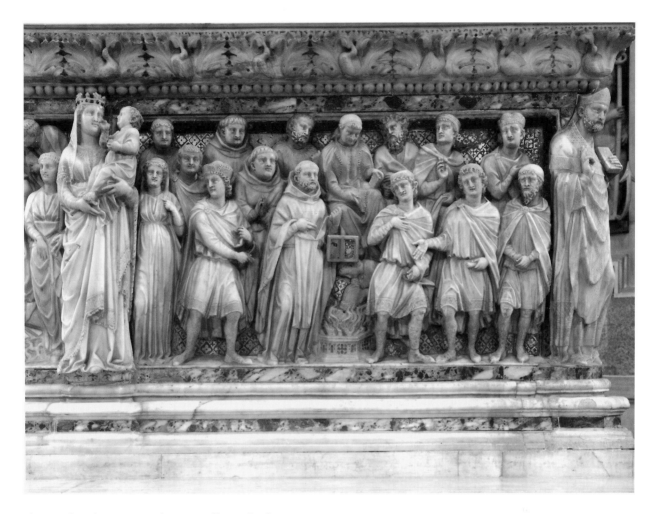

38. Nicola Pisano: Arca di San Domenico, detail, *Burning of the Heretical Books* [Ralph Lieberman].

shipers that divine nourishment will satisfy *their* spiritual hunger. Similarly, the relief with Saints Peter and Paul (Fig. 40) on the opposite short side transfers the divine authority given to Dominic to the individual friars; these, in turn, become the mendicants who preach to the lay congregation and to the world at large. In the Arca di San Domenico, then, Nicola offered an extremely inventive design whose purposeful iconography served not only the ecclesiastics who were its patrons but the ordinary people who gathered to pray and to be healed near the holy relics of St. Dominic.

The Siena Pulpit

While yet residing in Pisa, on 29 September 1265 Nicola contracted to create a second pulpit, this time for the cathedral of Siena (Figs. 41–47).[28] Several assistants, including Arnolfo di Cambio and Nicola's young son Giovanni, are named. Placed within the enormous space of the Duomo, the Siena pulpit (Fig. 41), larger and more complex than that made for the Pisa Baptistry, was com-

pleted in 1268. It too has been moved from its original site beneath the cupola and between the first two piers on the right, the Evangelist or south side.[29] Other alterations include the addition of a base, for originally the lions and columns rested directly on the ground and thus the narratives were closer to the viewer.[30] Finally, the narrative program embraced not only the relief fields but the stairway bridge leading to the pulpit casket, for corresponding to the figure of Mary of the Annunciation seen at the left edge of the first relief there must have been an Annunciatory Angel on the far end of the platform balustrade; a fragment now in Berlin has been identified as this angel.[31]

As at Pisa there are three tiers – supporting columns, arcade, and parapet. Surprisingly, the central support includes figural reliefs representing the Liberal Arts.[32] Instead of the hexagon of its predecessor, the Siena pulpit is octagonal in shape, allowing for the inclusion of

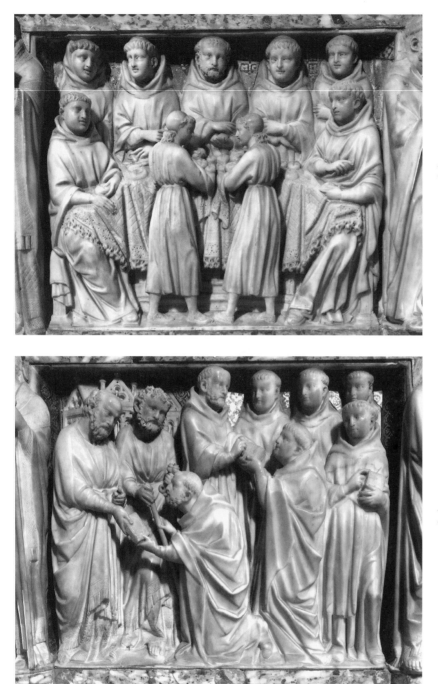

39. Nicola Pisano: Arca di San Domenico, detail, *St. Dominic and his Brethren Served by Angels* [Ralph Lieberman].

40. Nicola Pisano: Arca di San Domenico, detail, *Mission of Sts. Peter and Paul* [Ralph Lieberman].

the emotionally wrenching *Massacre of the Innocents* (Fig. 45) and a *Last Judgment* that now spreads over two fields, with Christ the Judge a full-length figure between the reliefs. Furthermore, instead of the column clusters that frame the narratives of the Pisa pulpit, here corner figures assume that role (cf. Figs. 25 and 41). As a result, the viewer's eye is led in a continuous movement from relief to corner figure to relief, resulting in a nar-

rative flow analogous to, and indeed more persuasive than, that of the Arca di San Domenico. The relatively plain moldings of the Pisa pulpit are replaced by extremely rich, classicizing cornices between which the tapestry of the reliefs and corner figures seem to revolve as though stretched around an octagonal frame. As to figure style, the heavier, more classicizing forms of the earlier pulpit are replaced by more elegantly pro-

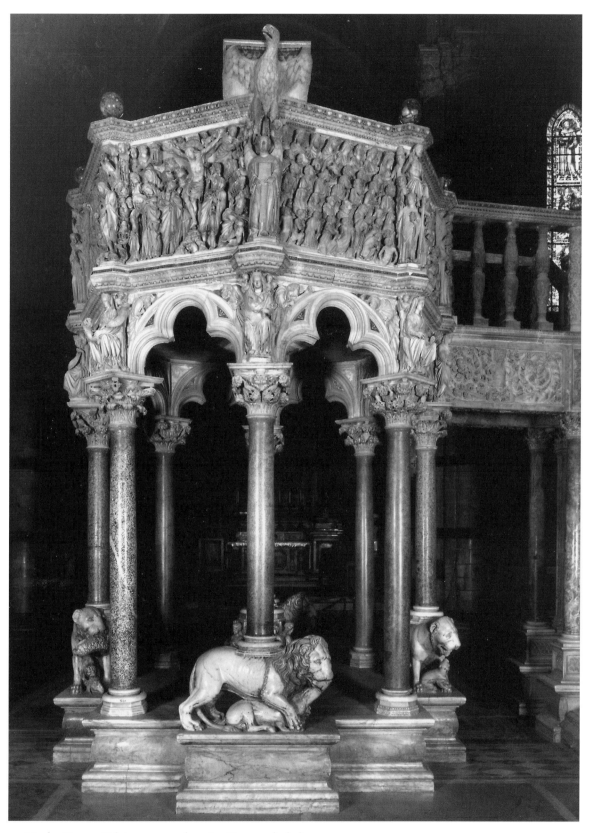

41. Nicola Pisano: Pulpit, contracted 1265. Siena cathedral
[Ralph Lieberman].

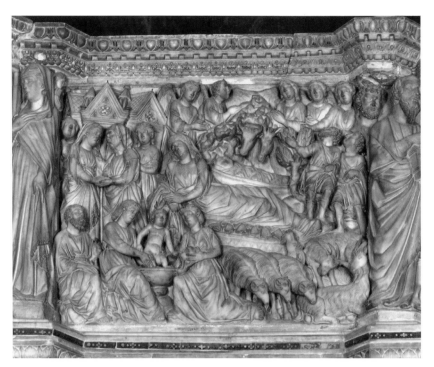

42. Nicola Pisano: *Nativity*. Siena cathedral pulpit [Ralph Lieberman].

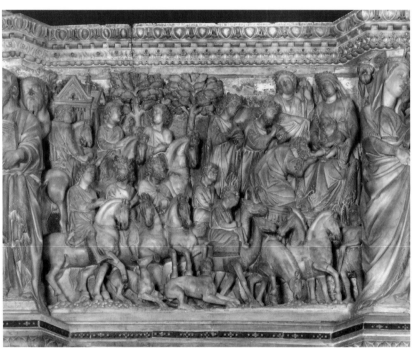

43. Nicola Pisano: *Adoration of the Magi*. Siena cathedral pulpit [Ralph Lieberman].

portioned figures with softer draperies and more refined features – an ideal influenced by French Gothic art. In the narratives the figures are smaller in relation to the relief field, more densely packed yet more deeply undercut, and the compositions are organized to suggest movement into depth, offering scope for an increase in narrative realism.

The Siena *Nativity* and *Adoration* (Figs. 42, 43) repeat and expand upon the basic iconography seen in Pisa, with the addition of many more motifs seemingly studied directly from nature. In the *Adoration*, for example, Nicola includes a representation of a black among the cortege following the Magi. His models could well have been the black slaves not only at the

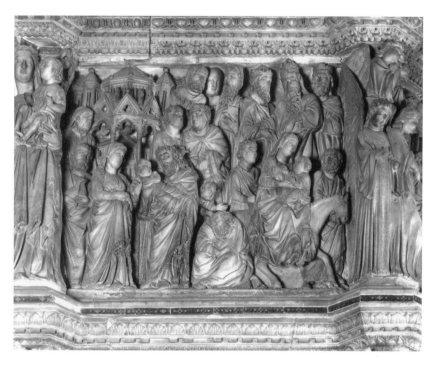

44. Nicola Pisano: *Presentation.* Siena cathedral pulpit [Ralph Lieberman].

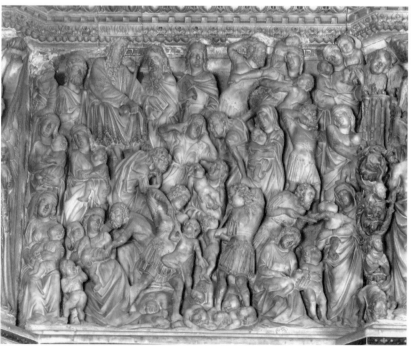

45. Nicola Pisano: *Massacre of the Innocents.* Siena cathedral pulpit [Ralph Lieberman].

court of Frederick II but also in many Tuscan households. The naturalistic representation of camels (mentioned in the Golden Legend) may have been based on those that often accompanied Frederick II on his various travels, including one of 1247 to Siena.[33]

Despite the larger number, smaller scale, and increased density of the figures, the sense of distinct horizontal layerings implying spatial setbacks is greater in the Siena pulpit than in the one in Pisa. It is nothing less than astonishing, indeed, to observe Nicola's developing spatial consciousness as he moves from his first to his second pulpit. On the Pisa Baptistry pulpit, the episodes in the opening relief, the *Nativity* (Fig. 27), are distributed without regard to a logical relationship of space or

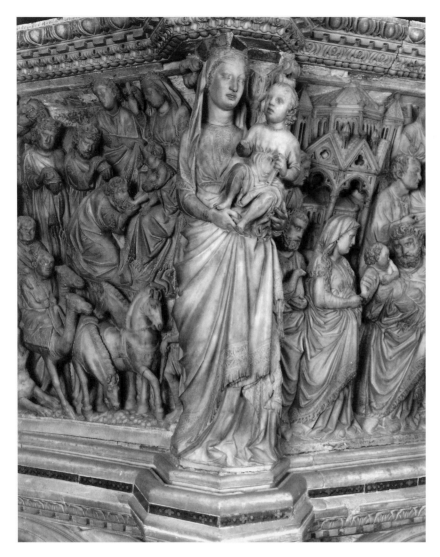

46. Nicola Pisano: *Virgin and Child*. Siena cathedral pulpit [Ralph Lieberman].

In the Siena *Nativity* (Fig. 42), there are three spatial setbacks: A receding foreground plane includes Joseph, the Bathing scene, and the sheep (compare, especially, the triplet of sheep to the right); a backward sloping middle ground contains the *Visitation*, Virgin of the *Nativity*, and the Infant with the ox and ass emerging from the penumbra of a hollow cave; finally the most distant plane consists of the building on the left and the angels hovering over the cave and addressing the shepherds. Admittedly, there is not yet the coherency that will appear in the following reliefs (which suggests that the reliefs were designed in the chronological order of the narratives).

These still tentative and inconsistent spatial experiments come to fruition in the *Adoration of the Magi* (Fig. 43). Space, to be sure, continues to incline upward. But the awkwardly foreshortened horses of the Pisa Baptistry *Adoration* are gone; instead, the Magus astride a steed seen in strict profile defines the foreground plane against which or toward which the two adjacent horses move from a deeper space, halted in their forward movement by the frisky dog in the center of the relief. The procession continues with the camels, two deep, and horses led by a groom who, facing in the opposite direction implies a sharp (but actually hidden) turn of the file back to the left. A second turn, clearly signified by the horseman on a steed whose rump faces the observer, brings the troupe to a second spatial platform on which the Madonna and Child sit greeting the visitors. Architecture and landscape elements form the rear ground for this highly cogitated experiment. More than any earlier representation of the subject, the *Adoration of the Magi* in Siena, with its horses seen from a variety of viewpoints, its gesticulating figures engaging each other with strongly directed glances, and its varied and lively fauna, conveys a sense of the tumultuous movement of a free-wheeling procession. At the same time,

consistent scale of figures, but the three central reliefs – the *Adoration, Presentation* (Figs. 29, 30) and *Crucifixion* (Fig. 32) – all contain a single narrative and all have a single, if only implied, ground plane. Although there is some overlapping and diminution in the size of the background figures in the Pisa pulpit, it is the unified scale and consistency of high relief figures on an implied ground that accounts for their satisfying spatial and narrative unity. (The iconography of the *Last Judgment*, however, required tiers of figures surrounding Christ and left little room for compositional or spatial exploration; what it did allow was an investigation of the human body based on antique examples.)

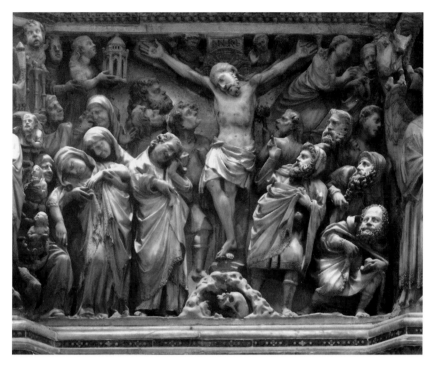

47. Nicola Pisano: *Crucifixion*. Siena cathedral pulpit [Ralph Lieberman].

the soft modeling of the flesh, the palpitating half-open mouths (Fig. 46), and the sensitive hands with fingers that seem to quiver slightly, seen in many figures on the Siena pulpit, contribute a new emotional resonance that departs from the more formal and solemn images on the Pisa pulpit.

In general, Nicola has enlarged his emotional repertory: Consider, for instance, the Madonna who now inclines her head toward the kneeling Magus tenderly kissing the Child's foot (Fig. 43). But the sculptor also encourages a deepened meditation on the meaning of the symbolic and narrative content. One could compare, for example, the *Crucifixions* in Pisa and Siena (cf. Figs. 32 and 47). If the Pisa Christ, with its pronounced swing of the body and the jagged forms of the drapery folds, still reveals sources in contemporary and earlier Italian painting (which in turn had its roots in the Byzantine tradition), in the cognate figure in Siena virtually all Byzantine vestiges disappear: Christ hangs with arms stretched into two great diagonals, shoulders dislocated, and abdomen no longer curving gracefully but sunken by the weight of the upper torso. The jagged drapery folds of the earlier example are replaced by softer, more naturalistic forms, and all linearism is gone from the modeling of the torso. The

head of Christ sinks into his chest, increasing the silent pathos of the dead figure. The death of the Savior has become a human tragedy, which for the Christian worshiper intensifies the meaning of Christ's transcendent sacrifice.

The Fontana Maggiore

A number of additional monuments have been attributed to Nicola and his workshop: These include the much damaged albeit moving *Deposition* on the tympanum, and the *Annunciation, Nativity,* and *Adoration of the Magi* on the architrave of Lucca cathedral, whose dating and attribution remain problematic. Between 1269 and 1279, he, and at some point possibly also Giovanni, executed a group of monumental heads, busts, and full figures for the exterior of the Pisa Baptistry. (Many are still in situ but several are in the Museo dell'Opera del Duomo and the Museo Nazionale in Pisa.)[34] The last major work securely tied to his name, however, is the monumental, polygonal, sculpturally embellished fountain in Perugia's main civic and religious square (Figs. 48–49).

The project originated not as an architectural or sculptural one but rather as an engineering and hydraulic problem with the goal of bringing an adequate water supply to the citizens of Perugia, a hillside town rather poor in freshwater springs. Documents record about eighty years of government deliberations regarding the feasibility of transporting water from a plentiful source on a nearby hill about three miles from Perugia to the piazza at the town's apex, a focal point of the town's civic life for centuries. The piazza was not only the site of the Duomo and bishop's palace, and the fulcrum of the newly built roads leading from each of the five ancient city gates, but was soon to see the construction of the town hall as part of the city's greatly expanding demographic, economic, and urban development.[35] The decision to erect a fountain here followed the intensive program, beginning in the 1260s, to increase the water supply to other parts of the city by building five new fountains in each district and repairing existing ones.[36] After many false starts, an underground aqueduct was

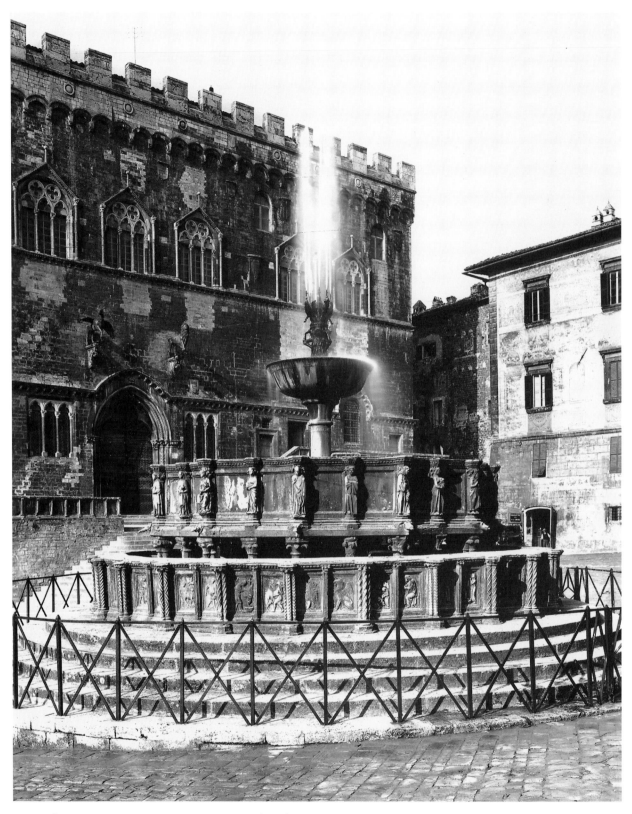

48. Nicola Pisano: Fontana Maggiore, 1278. Perugia [Alinari/Art
Resource, New York].

49. Nicola Pisano: Fontana Maggiore, detail Perugia [Alinari/ Art Resource, New York].

built but subsequently damaged; this was eventually replaced by an aboveground aqueduct (following the Roman method). Not until the year 1277 was the aqueduct sufficiently advanced so that discussion began on the fountain itself and its location on the piazza. Little more than a year later the fountain was essentially complete, and an inscription carved on the second basin informs us of the date and includes the names of the pope (Nicholas III), the emperor (Rudolph I of Hapsburg), members of the civic government, and the engineers and sculptors responsible for the pulpit's design: Fra Bevignate, who directed the entire undertaking, Nicola Pisano and his son Giovanni, and finally Boninsegna as the hydraulic engineer. A second inscription on the bronze basin holding the caryatids records the name of the bronze-caster.[37]

The Fontana Maggiore (Fig. 48) is one of the most remarkable secular and civic monuments of the Italian Gothic age, again as original in its form and conception in the history of fountains as are Nicola Pisano's pulpits and the tomb of St. Dominic in relation to the preceding pulpit and tomb traditions. Two- and three-basined baptismal and cloister fonts had existed earlier and, indeed, to the medieval user such a multistoried vessel and source for water as the Fontana Maggiore was rich with

associations with a wide range of liturgical furnishings and theological concepts, such as the *fons vitae* (the fountain of life), baptism as rebirth, copies of the Holy Tomb, and even pulpits and altar ciboria.[38] Elements of its formal structure find precedents in several of these liturgical furnishings as well as in earlier civic fountains, many of which have a broad lower basin within which a central column supports an upper container with spouts or a smaller upper basin.[39] But there is no close prototype for the scale, the complexity of the design, and the richness of the iconographic program of this indispensably functional, urban monument. Whereas assistants, including his son Giovanni, were responsible for some of the sculptures, and the officials of the commune of Perugia must have played an important role in determining its program, the basic conception and design of the fountain itself must be attributed to Nicola alone.

In his two pulpits Nicola and his respective patrons chose to expand the iconographic content of the Tuscan pulpit tradition by adding new scenes and by augmenting biblical history with representations of Virtues and Vices, and in the case of the Siena pulpit, the Liberal Arts. In the pulpits but even more so in the fountain one witnesses that same impulse that informs the encyclopedic content of French Gothic cathedral decoration. The Fontana Maggiore is unique in its sculptural expansiveness, which includes scenes from Genesis, an array of prophets and saints, the Labors of the Months, the Liberal Arts, various fables and allegorical figures, and even contemporary civic personalities.

Like the pulpits, the fountain is polygonal in shape and is enlivened by color contrasts – this time an alternation of local red marble and white Carrara marble. A ring of steps serves as a base from which rises a twenty-five-sided basin embellished by low reliefs and articulated by colonettes. Above this rises a second basin of twelve plain concave sides with figures at the angles and at the center of each face. From here a thick bronze column emerges supporting a third, smaller basin, also of bronze, which in turn contains three graceful bronze female caryatids; these may originally

43

have supported yet a fourth basin, now lost (the griffins that appear in our illustration are later additions). In addition to the contrasts of color and material, there are juxtapositions of highly plastic with flatter forms: Projecting architectural members and sculptured figures make for dark pockets of shadow and dazzling highlights in the bright sunshine; these, in turn, play against the flat surfaces or low reliefs in which the light-dark contrasts are minimal. Compared to the narratives of the Pisa and Siena pulpits, the compositions of the fountain's low reliefs are rather simple, and the handling of figures is freer, with many motifs taken from life (Fig. 49). Reminiscent of the pulpits, however, the radial symmetry is enlivened by syncopation: The columns and figures articulating the superimposed lower basins do not line up, resulting in a subtle offbeat rhythm that impels one's movement about the structure.[40] Simultaneously, the vertical elements, together with the diminishing sizes of the basins and the increasing plasticity of the sculpture, draw the eye upward. The effect, once again, is of a spiral movement – reminiscent of and yet more fluid than that seen on the Pisa Baptistry pulpit – that culminates in and is resolved by the caryatid group.

The Fontana Maggiore, no less than Nicola's earlier monuments, reveals a concern with the movement and viewpoint of the spectator, now quite unrestricted in the open space of the piazza. Indeed, in the late thirteenth century the fountain, surrounded as it was by buildings less imposing than those of today, with the Palazzo del Popolo (now the Palazzo dei Priori, planned in the 1270s and completed in 1292) narrower, less massive, and flanked by the small church of San Severo, took on even greater prominence as the focus of the five roads leading to the piazza. But the fountain was probably designed not only for a viewpoint from the ground. There is good evidence that the fountain and communal palace near it were conceived together as part of a total program for the urban reconfiguration of the piazza.[41] The original palace had a single steep set of frontal stairs (later replaced by a double set similar to that seen today) leading up to the entrance and to a balcony with a balustrade to the right and left of the stairs. From there, announcements to the piazza below were made and the Capitano del Popolo, as well as other government officials and the *popoli* themselves, entered into the audience hall within. As any visitor to Perugia can see today while standing on the present platform looking down toward the fountain, the view

from above (though more expansive and possibly from a slightly higher point than was the case in the late Duecento) has its own special effect, with the play of descending water contrasting to the ascending concentric superimposed basins.

Viewing the secure monuments of Nicola Pisano as a whole, one sees a style that evolved from the monumental, if stark, grandeur of his early Pisan reliefs to the rich pictorial images at Siena; it mellowed finally into a more fluid, accessible mode on the Fontana Maggiore in Perugia. Nicola's sculpture provided the source and impetus for the development of his two major assistants. His son, Giovanni, was to develop the emotional current of Nicola's style, in part by transforming the decorative vocabulary of northern art into a very personal and highly charged idiom. Arnolfo di Cambio's temperament, reinforced by his Roman experience early on, led him in the opposite direction, toward a starkly monumental and classicizing mode. It is certainly fair to say that Nicola Pisano's art profoundly influenced not only his immediate successors but also the painting of Giotto and, indeed, the entire naturalistic and classicizing tradition of the art of the following centuries.

ARNOLFO DI CAMBIO

Arnolfo di Cambio, the older of Nicola Pisano's two major assistants on the Siena pulpit, was of course thoroughly trained in the technical and stylistic mode of his master; yet his art moved in a direction that could hardly have been anticipated by the latter. As is true of the pulpits, Arnolfo's commissions necessitated the integration of sculpture and architectonic structure. As we shall see, however, the ensembles designed by Arnolfo are distinguished by their "dramatic" character – dramatic in the sense both of realizing vivid, compelling narratives by way of a restricted number of figures employing telling gestures and expressions, and in the more technical sense of placing actors on and within clearly discernable spaces, often enframed as in a proscenium, and into which the viewer, theoretically or imaginatively, can enter. This characteristic, which reaches a high point in his Roman and late Florentine periods, reveals an artistic mind-set engaged in issues similar to those of painters working in Assisi and Rome, including the Isaac Master and Pietro Cavallini. At least that is the impression given by the few extant monuments and the numerous fragments whose reconstruction and original disposition continue to engage scholarly attention – with considerable debate

concerning not so much the general approach of Arnolfo as the details of the placement and relationship of individual figures.[1]

Trained, then, in Nicola Pisano's workshop and responsible for considerable portions of the Arca di San Domenico and the Siena pulpit,[2] Arnolfo is documented in Rome in the late 1270s, apparently in the employ of Charles of Anjou, King of Naples and Sicily and Senator of Rome. Datable to the 1280s are the figures for a second fountain in Perugia (documented), a seated portrait of Charles of Anjou in the Capitoline Museum in Rome,[3] the signed Monument of Cardinal de Bray (d. 1282) in San Domenico, Orvieto, and the signed ciborium over the high altar of San Paolo fuori le mura. His last datable work of this decade is the now fragmentary tomb of 1289 of Riccardo Annibaldi in San Giovanni in Laterano. Sometime between c. 1285 and 1292 Arnolfo executed an Adoration of the Magi, noted by Vasari, for a chapel in Sta. Maria Maggiore, and in 1293 he signed the ciborium in Sta. Cecilia, Rome. Shortly thereafter he designed Boniface VIII's tomb. Finally, in 1294 he was called upon to rebuild Sta. Reparata, the cathedral of Florence, which was later rededicated as Sta. Maria del Fiore. Arnolfo died sometime before 1310, and possibly as early as 1302.[4]

Perugia's Second Fountain

In 1277 the city of Perugia, having embarked on a major campaign to bring an adequate supply of water to its citizens, and having already commissioned Nicola Pisano to design the Fontana Maggiore (completed in 1278), requested from Charles of Anjou permission for Arnolfo to come to Perugia to work on a fountain, presumably the Fontana Maggiore. Permission was promptly granted by way of a letter from the king (the autograph letter is extant), in which Arnolfo was further allowed to transport marbles from the Roman forum.[5] For whatever reason, Arnolfo seems not to have participated in work on the Fontana Maggiore since his name is not included among the sculptors, engineers, or project directors noted in the fountain inscription, nor is there stylistic evidence of his hand in the sculptures themselves. However, several years later, in 1281, he is paid for work on a second monumental, decorative fountain to complement the one recently completed by Nicola and Giovanni Pisano. Whereas the Fontana Maggiore, surrounded by civic and religious structures, including the already planned and soon to

be built communal palace, crowned the ancient and most important piazza of Perugia at the topographical apex of the city, this second fountain was to be placed southward at a lower piazza that functioned as its commercial pole. Not surprisingly, then, whereas the program of the Fontana Maggiore, with its civic, religious, and allegorical themes, emphasized the place of the commune and its governing bodies within a universal scheme, the "minor" fountain embodied a more down-to-earth program directed – from what can be gathered from the extant pieces – toward the urban community, *il popolo*, enjoining them in effect to recognize and celebrate the benefits brought by the *comune* and by those officials directly responsible for bringing the precious liquid to the heart of the district. Subsumed under the themes of both fountains, however, is an allusion to another kind of human need, the satisfaction of spiritual thirst.[6]

The extant pieces are five in number: three figures generally designated as "Assetati" or "Thirsty Ones" – clearly, members of the lower social strata – and two seated, so-called Scribes (Figs. 50–54). These figures, while perhaps the earliest extant sculptures carved by Arnolfo as master of his own workshop, declare his independence from Nicola in unequivocal terms. The insistent emphasis on cubic planes that characterize the entire group, in which the original form of the stone block is decisively felt, is only moderately mitigated by the transitional surfaces. More than a touch of Byzantine linearism, however, is felt in the drapery folds whose patterns, while remaining predominantly on the surfaces, are modeled after Roman fold forms. Awkward passages, such as the extended arms of the kneeling woman, which are unarticulated and too short – most likely due to the hand of an assistant working after a design by Arnolfo – combine with an intense emotional quality, seen in this same figure, whose simplicity of form and expressive body language anticipate similar characteristics in Giotto's Arena Chapel frescoes executed more than two decades later.[7] The other two "Thirsty Ones" – a woman resting her elbow on an empty vase and a crippled male leaning on a hand crutch and lifting his garment to reveal his damaged limb – show a sure mastery of anatomy and careful observation from life. Whereas the kneeling woman is based on Early Christian models representing, among other themes, Mary Magdalene in a scene of Noli Me Tangere, the two reclining figures are clearly modeled, in their poses, as well as in their confronted juxtaposition, on

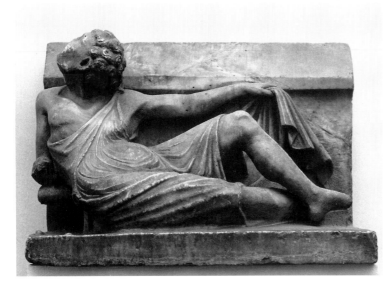

50. Arnolfo di Cambio: "Thirsty One," 1280s. Perugia, Galleria Nazionale dell'Umbria [Carlo Fiorucci].

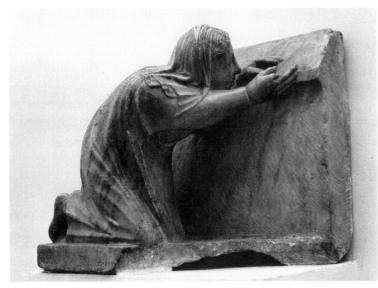

51. Arnolfo di Cambio: "Thirsty One," 1280s. Perugia, Galleria Nazionale dell'Umbria [Carlo Fiorucci].

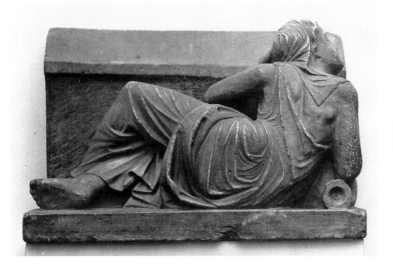

52. Arnolfo di Cambio: "Thirsty One," 1280s. Perugia, Galleria Nazionale dell'Umbria [Carlo Fiorucci].

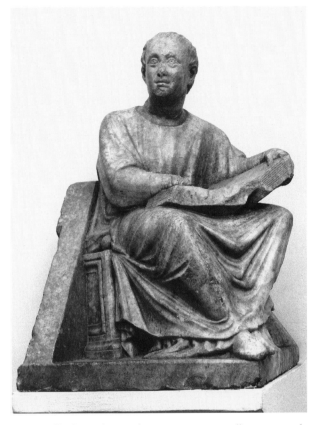

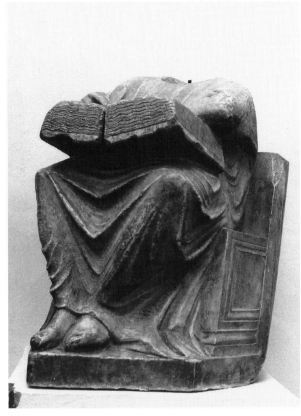

53. Arnolfo di Cambio: Scribe, 1280s. Perugia, Galleria Nazionale dell'Umbria [Carlo Fiorucci].

54. Arnolfo di Cambio: Scribe, 1280s. Perugia, Galleria Nazionale dell'Umbria [Carlo Fiorucci].

55. Reconstruction of Fountain [after Cuccini].

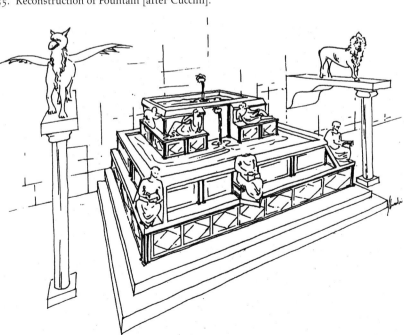

Roman examples, of which Arnolfo must have had first-hand knowledge during his Roman sojourn.[8] The compact solidity and the disposition of the drapery of the two seated Scribes are also powerfully evocative of Roman sculpture. These figures are shown writing or pointing to passages (records of expenditures for the fountain; city statutes concerning its appropriate use and

56. Arnolfo di Cambio: Guillaume de Bray monument (d. 1282). Orvieto, San Domenico [Alinari/Art Resource, New York].

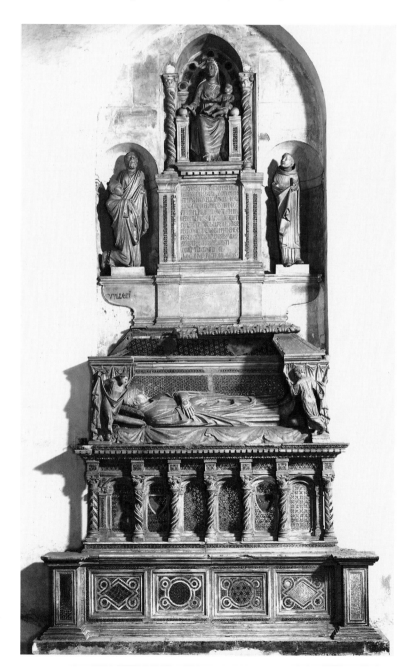

maintenance?) in the enormous volumes poised on their laps. One of the figures is headless, but in the second one we recognize that combination of stereometric design and palpitating inner life that will characterize the best of Arnolfo's sculptures throughout his career.

There is virtually no evidence for the original form of this second fountain, which, sadly, was destroyed by the first decade of the fourteenth century.[9] Given the classical sources for Arnolfo's figures – including examples of reclining figures facing each other with one seen from the front and the other from the back – as well as his tendency to create forms that emphasize perpendicular planes, it is likely that the fountain followed Roman models and was rectangular in form (see Fig. 55).[10] In shape and detail, as well as program, the two fountains could hardly have been more different: The earlier one, with its syncopated rhythms, generated by flattened narrative or emblematic reliefs and projecting, shadow-producing architectural and figural elements, allowed the figures only limited freedom of movement; in contrast, the second fountain included figures carved fully or almost fully in the round, and so they must have had a presence more imposing than any on Nicola's fountain. One senses, whatever the original form of Arnolfo's fountain, that the local resident or merchant seeking water was confronted with a series of human actions taking place in his or her space, not the idealized and purely notional world conveyed by the reliefs on the Fontana Maggiore.

The Guillaume de Bray Monument and the Tomb of Ricardo Annibaldi

After centuries of relative restraint in the form and embellishment of tomb monuments, the Arca di San Domenico was the first monumental, sculptured, and even freestanding tomb of late medieval Italy, and it initiated a breakdown of earlier barriers to the erection of elaborate sculptured tomb monuments. Despite legislation to the contrary, mendicant authorities eventually welcomed the revenues that accompanied the building of tombs within their

convents.[11] During the late thirteenth century, some members of the higher clergy (who benefited economically from the growth in demand for ecclesiastic services) were desirous of impressive tombs; they and their heirs became increasingly willing to pay sculptors of note to create monuments that first of all presented evidence of the deceased's appropriate adherence to the *ars moriendi* (the art of dying), a subject addressed in contemporary treatises. But the tombs also served to commemorate the deceased and to promote prayer for his soul, whose entrance into heaven was hoped for but certainly not assured. Indeed, the growing belief that Purgatory is a variable and controllable state of existence in the afterlife made suffrage for the deceased more than desirable; it became essential. Two of the earliest tombs expressing these themes were created by Arnolfo di Cambio.

Arnolfo's earliest known signed work is the sepulchral monument of the French cardinal Guilliame de Bray (d. 1282), erected in San Domenico, Orvieto, and later dismantled and poorly recomposed in a fragmentary arrangement (Figs. 56, 58).[12] Recently again dismantled, the work has undergone new analysis in the laboratory of the Cooperativo Beni Culturali in Rome, and at the time of this writing, the pieces are awaiting reconstruction in Orvieto. During the course of examining the extant parts, a stunning, unanticipated discovery was made about the figure of the Virgin and Child, namely, that Arnolfo had employed and adapted an ancient Roman statue for the seated figure on whose lap a newly carved Christ Child was placed.[13] The Roman statue, originally carved in the round, had been narrowed in depth and hollowed out in the back, and square and circular holes were excavated to receive the dowels with which Arnolfo's Christ Child was attached.[14]

Hypothetical reconstructions of the tomb, based on the extant sculptures and fragments from San Domenico and in the Museo dell'Opera del Duomo, Orvieto, as well as the evidence of later tomb monuments that appear to be based on Arnolfo's design, generally agree that the de Bray monument was set against the wall with the funeral chamber and effigy enframed by an overarching baldacchino (Fig. 57). Many of the architectural surfaces are embellished with gold and colored mosaic, as well as larger geometric marble intarsia (known as Cosmati work and named after a family of Roman marble workers renowned for their colorful geometric designs, particularly on church floors and furnishings). Above the funeral chamber, but probably considerably closer to it than in its post-sixteenth-century disposition, a Gothic

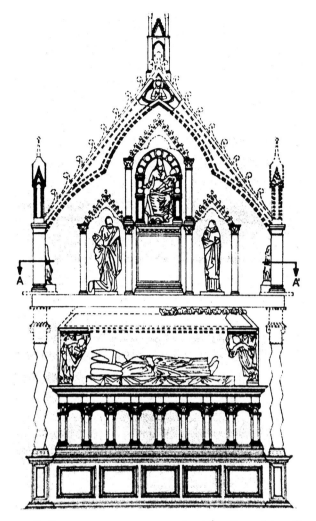

57. De Bray monument, reconstruction [after Romanini, 1968, 1980].

tabernacle held the Madonna and Child, with St. Dominic on the right, and on the left St. Mark presenting the Cardinal to the Virgin. Unlike the elderly reclining effigy, the kneeling figure is plump-cheeked and alive. From the evidence of the upward glances and the Madonna's gesture, the flanking groups were on a level only slightly lower than that of the enthroned figure.[15] The Virgin originally sat, not in a niche but on a throne whose back was actually the rear wall with its patterned Cosmati inlay, the circle of which (later placed too low) served as her halo and was clearly visible to the viewer standing at ground level.[16]

The funeral chamber with effigy, the intercessory motif, and the (presumed) enframing tabernacle are seen in earlier sepulchral monuments, such as the tomb of Pope Clement IV (d. 1268), the first secure example

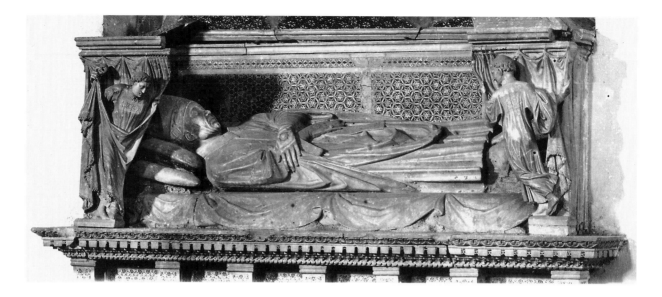

58. Arnolfo di Cambio: Guillaume de Bray monument, detail. Orvieto, San Domenico [Vatican, Monumenti Musei e Gallerie Pontificie].

in Italy to include a salient effigy (Fig. 59).[17] In notable contrast to French examples from which the idea of a sculptured effigy derives and in which the figures are shown youthful and alive, Clement IV, as later Cardinal de Bray, is portrayed as elderly and deceased. Thus, the reality of physical death, as expressed in the effigy, is mitigated by the hope of eternal life. Arnolfo, moreover, has transformed the relatively static image of the papal tomb (Fig. 59) into a dramatic presentation – discernable even in the fragmentary state in which it has come down to us: Two sculptured acolytes are "caught" in the midst of lively action, that is, in the act of opening the curtain to display the figure of the deceased to the worshiper standing before the tomb (Fig. 58).[18] Thus, the viewer is presented with a sequence that begins with the funeral chamber enclosing the deceased, replicating, it should be noted, a real funerary event that was probably of recent memory to some Duecento viewers.[19] This is followed above by an allusion to the hope of salvation through the intercession of saints, the *commendatio anima*.[20] Finally, the crowning element of the composition shows the maternal and merciful Mary. Thus the worshiper, whose suffrage for the deceased is thereby enjoined, is witness to the dualism between, and the dramatic contrast of, the mundane reality of death and the hoped for reward in the afterlife, between corruptible body and eternal soul.

Fragments from a later tomb, the monument for the papal notary Riccardo Annibaldi (d. 1289) in San Giovanni in Laterano, include an effigy of the deceased, a frieze of clerics holding liturgical instruments (Fig. 60), and an inscription.[21] The tomb is the first known example of an effigial monument for a papal notary – he is dressed as a subdeacon – an important and influential person but relatively low in the ecclesiastical hierarchy. The frieze of clerics refers not only to the exequies performed on the occasion of his death but also to the daily masses to be performed continuously, as called for by the inscription.[22] Although a convincing reconstruction of the tomb has proved elusive, the sculptured obsequies became extremely influential and appear later on Lombard, Tuscan, and Neapolitan tombs; none, however, display the sensitivity to spacing and the classical rhythmic alternation of solid and void as seen on the Annibaldi frieze.

The Ciboria

During the last third of the thirteenth century, Rome underwent a vigorous artistic renewal under papal patronage, complemented by initiatives made by cardinals, the Benedictine and Franciscan orders, and even Charles of Anjou. It was under Nicholas III Orsini (1277–80) that restorations of the early Christian nave frescoes of San Paolo fuori le mura were commissioned from Pietro Cavallini. The initiative for the ciborium over the high altar of San Paolo seems to have come from the abbot of the Benedictine basilica. Shortly thereafter, Nicholas IV, pope from 1288 to 1292 and the first Franciscan elected to that office, personally took the lead in major restorations at San Giovanni Laterano, Sta.

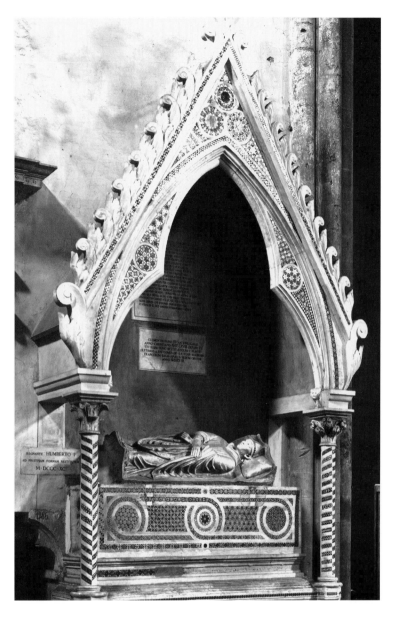

59. Tomb of Clement IV (d. 1268). Viterbo, San Francesco [Alinari/Art Resource, New York].

60. Arnolfo di Cambio: Annibaldi monument, frieze of clerics (d. 1289). Rome, San Giovanni in Laterano [Alinari/Art Resource, New York].

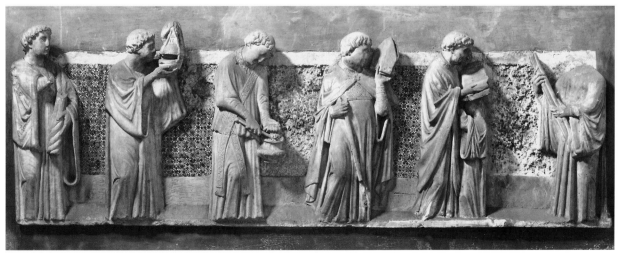

61. Francesco Barbazza, engraver, after drawing by Francesco Pannini: View toward apse of San Paolo fuori le mura, 1797. Rome, Lanciani collection, Palazzo Venezia [Rome, Biblioteca di Archeologia e Storia dell'Arte].

Maria Maggiore, and perhaps also Sta. Maria in Trastevere, commissioning artists of the caliber of Jacopo Torriti and Pietro Cavallini to restore or create anew paintings for these churches. The Franciscan pope, naturally, felt a special reverence for the relics of the Praesepe (Latin for manger) in Sta. Maria Maggiore, and so he probably should also be associated with the decision to erect a new chapel dedicated to them, commissioned from Arnolfo di Cambio. It was once again the Benedictines who promoted the restorations at Sta. Cecilia, a convent of the Order, in which Cavallini and Arnolfo di Cambio may have worked almost side by side.[23]

Bartolomeo, abbot of San Paolo fuori le mura between 1282 and 1287, commissioned Arnolfo to design a ciborium for the basilica, mother church of the Benedictines in Rome. Set over the high altar containing the relics of St. Paul, the ciborium (Fig. 62) was completed in 1284 according to an inscription on the west tympanum, which also names the abbot, shown offering a model to St. Paul. To the left and right are inscribed the words HOC OPUS FECIT ARNOLFUS – CUM SUO

SOCIO PETRO ("Arnolfo made this work, with his associate Pietro") and in the center the date 1285. Associated with Arnolfo's workshop, then, was a major assistant worthy of being named on the monument.[24]

The first impression of the ciborium conveyed upon entering the enormously spacious church is that of a profusion of spiky, gothic pinnacles, crockets, and a slender tabernacle with pointed trefoil arches and niches, set off by the enframing triumphal arch of the basilica and silhouetted against the apse with its glittering mosaics. This impression was considerably stronger before renovation of the church after a fire in the early nineteenth century, as is evident from engravings made prior to the disaster (Fig. 61; see pp. 318ff.). The striking contrast between the regular rhythm of columns, arches, and horizontal rows of frescoes and the elegant, almost delicate structure strongly reminiscent of French Rayonnant style could hardly have been unmeditated. Yet the rectilinear envelope of the basilica is by no means contradicted by the square plan, cubic elevation, and emphasis on planes enhanced by the Cosmatesque surface decoration (Fig. 62). Even the niches cut out of the corners on the level of the trefoil arches do not belie the four-square planarity, for the implied planes behind which the niches have been excavated emphatically

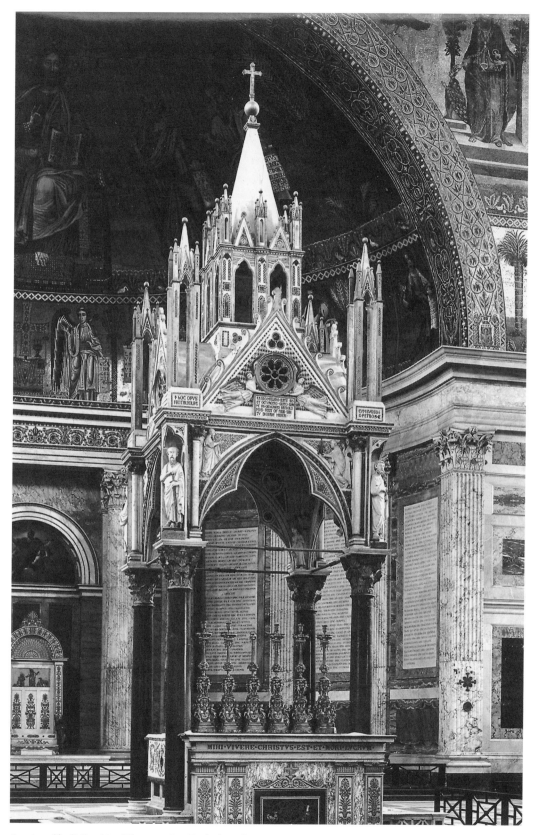

62. Arnolfo di Cambio: Ciborium, San Paolo fuori le mura, 1284
[Istituto Centrale per il Catalogo e la Documentazione].

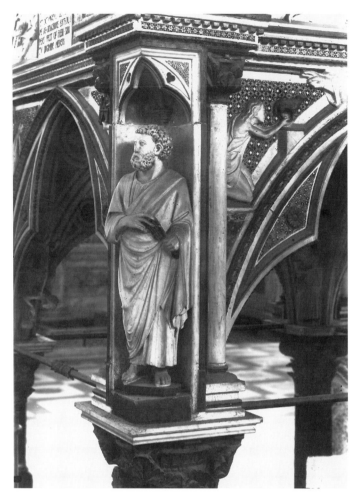

63. Arnolfo di Cambio: Ciborium, San Paolo fuori le mura, detail [Istituto Centrale per il Catalogo e la Documentazione].

64. (below left) Arnolfo di Cambio: Ciborium, San Paolo fuori le mura (Eve) [Istituto Centrale per il Catalogo e la Documentazione].

65. (below) Arnolfo di Cambio: Ciborium, San Paolo fuori le mura (Adam) [Istituto Centrale per il Catalogo e la Documentazione].

restrain any potential projections of the enclosed figures (Fig. 63). At the same time these corner niches, which interrupt, even disrupt, the vertical thrust from column to corner pinnacle, reveal Arnolfo's response to the visionary and, dare one say, even playful, aspects of French Gothic architecture with its illusion of structural impossibilities: For where we expect solid supports beneath the superstructure, we see dangerous (or mock) lacunae. Only when one perceives, with relief, that the figures are of sufficient presence and classicizing weight to withstand the pressures from above (Fig. 63) is one's sense of security fully restored.[25] (As we shall see, an alternative but equally playful solution is found in his second ciborium.)[26] The niche figures, of course, perform another role: With the exception of the porphyry columns, these are the only elements that mitigate the insistent planarity and rectilinearity of the structure, since they are turned to the diagonal with respect to the dominant planes. This device, it will be recalled, had been employed earlier by Nicola Pisano on several monuments to encourage the spectator's movement from one narrative to the next.

The program of the ciborium served to underline the closeness of the Benedictine order to the apostolic tradition: Saints Peter and Paul are represented in the corner niches framing the spandrels, where the abbot Bartolomeo presents the ciborium to Saint Paul. The other two niches show Paul's disciple Timothy and either a second figure of the abbot or more likely Saint Benedict himself.[27] Humankind's first sin (Figs. 64, 65) and the subsequent guilt of Cain on two of the other spandrel pairs pertain to the salvific function of the Eucharistic rite performed on the altar below.

The San Paolo ciborium is a striking departure from medieval tradition. Earlier ciboria tended to be relatively simple structures with four columns supporting architraves or arches and a flat, sloped, or pyramidal roof sometimes over an open *loggetta* and occasionally crowned with a lantern.[28] Sculptural embellishment was rare, and when it appeared it was very restrained. Arnolfo radically altered this traditional scheme of four-square, solidly implanted enframements for the altar by the introduction, as we have seen, of pinnacles, crockets, pointed trefoil arches and niches, and a slender tabernacle, all forms derived from French Gothic architecture and goldsmithwork. Furthermore, as in northern Gothic architecture – already adapted to a different scale and function in Nicola's pulpits – Arnolfo introduced an abundance of sculpture by way of classicizing

66. Arnolfo di Cambio: Censing Angel. Ciborium, San Paolo fuori le mura [Istituto Centrale per il Catalogo e la Documentazione].

statuettes within niches and reliefs in the lunettes and pediments. The vault, too, is enriched with sculpture, both at the keystone (a French-derived device already employed at Castel del Monte) and at the interior springing of the ribs, where angels hold a candle, crown, and censers. Two of the latter are shown flying downward toward the high altar, their backs to the viewer, a charmingly bold and not soon to be repeated motif (Fig. 66). Finally, one of the capitals atop the supporting porphyry columns is embellished with sculpured heads (Fig. 67). The ciborium in San Paolo, then, represents a fusion of the linear dynamics of French Gothic, the Cosmatesque polychrome intarsia traditional in Rome, and a classical articulation of structure that separates support from load and insistently balances the vertical with the horizontal, the whole enlivened by classicizing

67. Arnolfo di Cambio: Capital with heads. Ciborium, San Paolo fuori le mura [Istituto Centrale per il Catalogo e la Documentazione].

sculpture. These last classicizing aspects derive in part from the pulpits of Arnolfo's master, Nicola Pisano.

In 1293, less than a decade after completion of the ciborium of San Paolo fuori le mura, Arnolfo signed and dated a second ciborium, this one in the Benedictine convent church of Sta. Cecilia (Figs. 68–70).[29] The church had been built in the ninth century when the relics of the martyred saint were first discovered; then, after having been lost for centuries, in the Duecento the saint's remains were again discovered, probably by the titular cardinal of the church, Simon di Brion, who eventually was elected pope and took the name Martin IV in 1281. Devoted as he was to the cult and relics of saints, and in particular to those of Sta. Cecilia, it was probably Martin IV who promoted the extensive decorative program that involved not only the erection of the ciborium but also the mural decoration of Pietro Cavallini.[30] It is probably not mere coincidence that the same artists, Arnolfo and Cavallini, were commissioned for the refurbishing or restoration of both San Paolo, mother church of the Benedictines in Rome, and the Benedictine convent church of Sta. Cecilia, for the order saw itself as a major instrument in the renovation and glorification of Christian Rome.[31]

The building (extensively altered during the Baroque period) is much smaller in scale than the Constantinian basilica of San Paolo, and here Arnolfo rejected the dynamic upwardly surging Gothic forms of his earlier tabernacle.[32] Instead, there is a stronger emphasis on the horizontal, and compared to the earlier monument, the pointed and trefoil arches as well as the tympana are

squatter. But a new dynamism is achieved by alternative means. In place of the insistent rectilinearity of the earlier structure, here there is a modulated assertion of diagonal elements: The abaci above the impost blocks serve as base while the strongly projecting cornice above the arches serves as a roof or canopy for the figures, which are no longer actually contained within niches. The cornice produces, on that level, if not an undulating effect at least a movement in, out, and around the internal body of the structure. This effect is echoed in the pinnacles above, which are likewise placed on a diagonal axis. Most strikingly, they appear to be supported not by the niches as at San Paolo but by the empty space – thus creating a diaphanous structure – beneath the cornice.

Niches are visible but they are vestigial, serving as background framing and offering an implied depth from which the figures emerge. Here Arnolfo has employed on a small scale the device seen on Giovanni Pisano's facade of Siena cathedral where figures seem to have emerged from shallow or shadowy niches (Figs. 85, 86). Whereas in the earlier ciborium the figures, with only slight turns of the head or torso, were essentially frontal (when seen from the diagonal view, that is, standing in front of and looking toward the corners), now the figures take on freer movements in space – and in this respect they differ from French canopied statue columns and again seem influenced by Giovanni's facade. Not only are the types and poses more varied than in Arnolfo's earlier ciborium, but the drapery folds are softer, less linear, and more reflective of body and pose. Especially striking is the depiction of St. Valeriano, the husband of St. Cecilia (Fig. 69), clearly modeled – note in particular the gesture of the rider and the raised leg of the horse – on the equestrian Marcus Areleus in Rome.[33] But unlike the Roman example, where horse and rider move and glance in parallel directions, Arnolfo presents an opposition between the spritely rightward turn of the steed's head and the leftward glance and gesture of the saint, thus emphasizing the transitional role of the corner group.

As noteworthy is the new utilization of the field and framing of the spandrels flanking the arches. In the earlier ciborium Arnolfo simply filled in this inconvenient curved triangular shape with his figural motifs, placed frontally or in profile, and ignored the lessons of his master Nicola, who – tentatively in the Pisa pulpit and more assertively in the Siena pulpit – had employed the arch framing the trefoils as functional elements upon

68. Arnolfo di Cambio: Ciborium, Rome, Sta. Cecilia, 1293 [Istituto Centrale per il Catalogo e la Documentazione].

69. Arnolfo di Cambio: St. Valeriano. Ciborium, Rome, Sta. Cecilia [Alinari/Art Resource, New York].

which the figures could lean and over which the drapery could fall (Figs. 25 and 41). While Arnolfo does not go as far as Nicola in this respect, preferring a stricter separation of sculpture and architectural framing, in the ciborium of Sta. Cecilia he does permit the arch to serve as functional support for the figures whose poses must respond to the physical presence of the arch (Fig. 70).

At Sta. Cecilia the program would seem to glorify the choice of virginity as a way of life (in keeping with the patron saint's vows) as well as saintly martyrdom, Christian values confirmed by biblical and apostolic testimony: The corner figures represent the martyred saint to whom the church is dedicated, her husband Valeriano, and the latter's brother Tiburzio, as well as Pope Urban, who converted them to Christianity. In the spandrels are represented the four evangelists, two prophets, and two wise virgins.[34]

The ciboria in San Paolo fuori le mura and Sta. Cecilia are examples of Arnolfo's characteristic and successful integration of Gothic architectural elements, the decorative vocabulary of medieval Rome, and the revived tradition of antique Roman sculpture. The play of white and

colored marble combined with polychrome intarsia reveals, as well, Arnolfo's roots in the Tuscan workshops of Nicola Pisano. But the Roman monuments also show Arnolfo's turning away from his master's architectural-sculptural vision. Whereas on the pulpits sculpture increasingly took on the role of architectural members, to form the very fabric of the ensemble, on the ciboria sculpture has greater autonomy, as it inhabits a conceptually preexisting tectonic frame and shelter. Furthermore, Arnolfo exhibits a decisive playfulness in the relationship of figure and frame: Where we would expect inert architectural members or wall surfaces to define the limits of the trefoil section of the ciborium in San Paolo, these areas are hollowed out to provide niches for the human figure. Inverting the relationship, in the later ciborium the projecting abaci and diagonal cornice unexpectedly serve as platform and canopy to provide a stage-like space for independent, virtually freestanding statuettes seemingly carved in the round.

As is true of their medieval prototypes, Arnolfo's two ciboria serve as shelter and frame for altar and celebrant. More elaborate in their form, polychromy, sculptural embellishment, and program than most earlier examples, however, they drew (and magnetically still draw) the eyes of the worshiper toward the altar and the Eucharistic rite enacted on it. This Arnolfian concept of architecture as providing a stage – whether for sculpture or human beings – becomes explicit in his next two known commissions, the *Praesepe* in Sta. Maria Maggiore and the tomb of Boniface VIII in St. Peter's.

The Praesepe

Arnolfo's flair for the dramatic reveals itself in the *Adoration of the Magi*, or *Praesepe*, in Sta. Maria Maggiore, Rome, datable between 1285/87 and 1291. Moved to the crypt in the sixteenth-century renovation of the basilica, the ensemble originally stood in a chapel (Vasari mentions a "cappella di marmo") entered from the north aisle of the church and visible from the nave.[35] Only a few pieces are extant: two fragmentary spandrels of an arch with prophets holding scrolls carved in relief against a mosaic background; a kneeling Magus; a slab with two standing Magi carved in high relief; a block with the heads of a donkey and ox; and the standing figure of Joseph (Figs. 71–73). The Virgin of the Adoration is lost, however (the seated Virgin and Child seen today is of the sixteenth century); furthermore, the present disposition of the pieces has little to

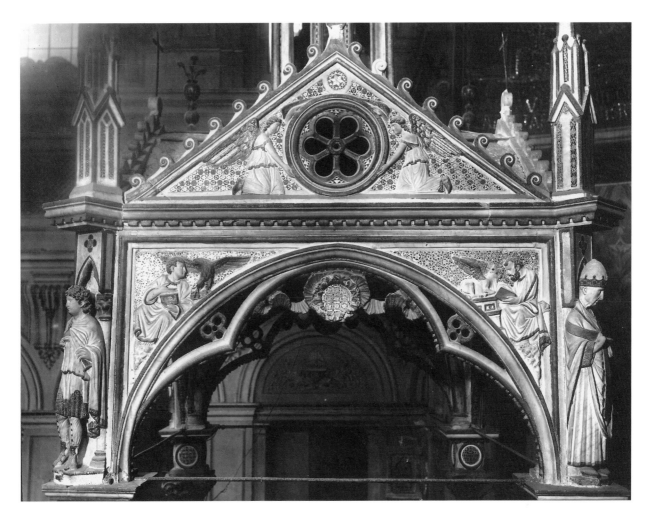

70. Arnolfo di Cambio: Ciborium, Rome, Sta. Cecilia, detail [Alinari/Art Resource, New York].

do with the original conception. Examination of the individual blocks suggests from what viewpoint they were to be seen, and the most elementary interpretation of the gestures and poses indicates the relationship of the figures and the emotional tone of the original.[36]

The chapel was built to house a relic of the *mangiatoia*, the trough of the donkey and ox that were present at the Nativity. Thus, instead of a seated Virgin and Child, it is likely that the group included a reclining Virgin similar to that carved for the Florentine Duomo facade a decade later (see Fig. 82). The direction of the glance of the kneeling Magus indeed implies that the focus of his attention was closer to the ground.

A precise reconstruction of the original disposition of this "tableau vivant" is difficult, but close examination of the sculptures, which are left rough in the parts not intended to be seen, permits some conclusions. Since

Joseph (Fig. 72) looks forward and toward the (spectator's) right while the kneeling Magus inclines toward the left, the Nativity scene must have been near the center of the composition. A recent reconstruction (Fig. 74) suggests that Joseph as well as the two standing Magi were situated against walls outside the immediate vicinity of the Virgin, while the full carving of the rear view of the kneeling Magus indicates that the figure's back was turned three-quarters to the spectator as he leans toward the Nativity. Joseph and the kneeling Magus, then, provide two emotional extremes – meek, perhaps uncomprehending acceptance and quiet affection on the one hand, and fervent, highly focused adoration on the other.[37] The volumes and contours, as the emotions, are reciprocal and opposing. Somewhere to the right of the kneeling Magus stood the younger kings, in mutual discourse, not yet caught up fully in the epiphany, not yet fully imbued with the sense of awe at the revelation of the incarnate God. And between the Madonna and Joseph the heads of the ani-

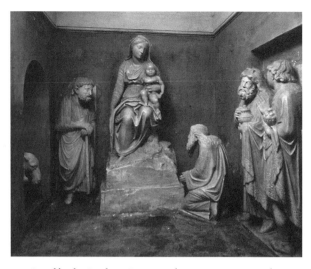

71. Arnolfo di Cambio: *Praesepe*, between c. 1285 and 1291, with sixteenth-century Madonna and Child. Rome, Sta. Maria Maggiore [Istituto Centrale per il Catalogo e la Documentazione].

72. Arnolfo di Cambio: St. Joseph, *Praesepe*. Rome, Sta. Maria Maggiore [Istituto Centrale per il Catalogo e la Documentazione].

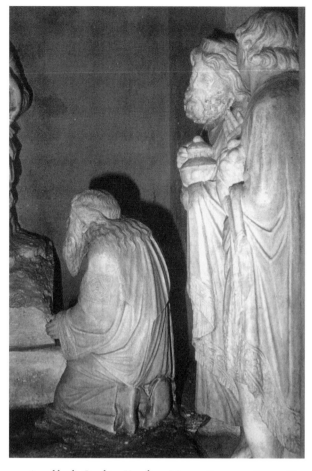

73. Arnolfo di Cambio: Kneeling Magus, *Praesepe*. Rome, Sta. Maria Maggiore [Valentino Pace].

mals would have been visible behind the trough. Joseph and the standing Magi, then, served as the outer limits or framing elements of the composition, while the kneeling Magus was balanced by the ox and donkey closer to the main protagonists. The forms strongly suggest not only a bilateral flow from and toward the center but a movement and emotional reciprocity in and out of space. One must imagine this "sacra rappresentazione" in stone enframed by its architectural components with the spectator witnessing the event closer to eye level and invited to identify with the range of emotions depicted. Here, perhaps more than in any other work by Arnolfo, the dual meaning of "dramatic" as expressed in the opening paragraph of this section is fully realized.

What are the precedents for this striking conception? There is no evidence that a mise-en-scène of this type

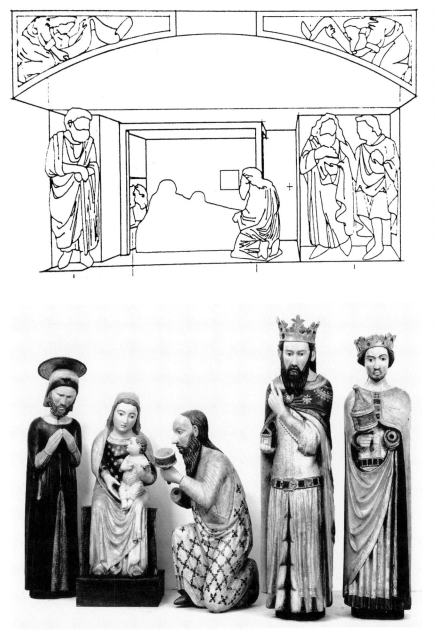

74. (top) Reconstruction of *Praesepe* (after Pomarici).
75. (above) *Adoration of the Magi,* wood, late fourteenth century. Bologna, Sto. Stefano [Bologna, Museo Civico].

lunette space and was thus relatively remote from the spectator.[39] To my knowledge there remain no examples prior to Arnolfo's *Adoration* of figures arranged within a stagelike space into which the spectator can imaginatively enter. The intimacy of the ensemble and the sense of identification with the holy figures that it evokes is surely connected to the shift in religion from the search for the transcendental to the desire for empathetic experience.[40] The intense sacrality of the event as represented by Arnolfo was not soon to be repeated. A polychromed wood *Adoration of the Magi* (Fig. 75) in Bologna of the late fourteenth century, for example, emphasizes rather the courtly aspects that would become so congenial to the fifteenth century in its interpretation of the theme of the Adoration.[41]

The Tomb Chapel of Boniface VIII

Less intimate, but no less involving the spectator, is the tomb chapel of Boniface VIII. Early in his papacy, the Caetani pope commissioned his own tomb ensemble to be erected within the Constantinian basilica of St. Peter's, Rome. The tomb chapel, which bore a (lost) inscription identifying Arnolfo as its author,[42] was dismantled during the sixteenth-century rebuilding of St. Peter's but was originally set against the inner facade wall. In this, the most elaborate of Arnolfo's tomb monuments, and, indeed, unprecedented in this regard for a papal tomb, sculpture, architecture, and painting were conceived to create an integrated whole that dramatically involved the spectator. Fragments and a number of drawings (Fig. 76) offer indications of the original disposition of Boniface's tomb and chapel.[43] The sarcophagus and effigy (Fig. 77) were set within a shallow rectangular niche; at head and foot of

existed earlier despite the long tradition of liturgical (and extraliturgical) plays of the Magi story.[38] Carved representations of the Adoration of the Magi are seen earlier in pulpit and lunette reliefs, but rarely as figures physically free from a background. An exception is a group in Venice, which, however, originally also belonged to a

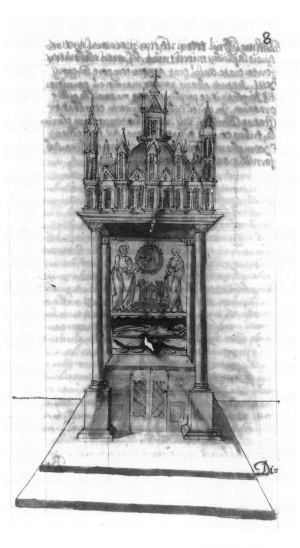

the effigy stood two angels (now at the entrance of the Confessio of Nicholas V) holding or drawing curtains, a device seen first on the de Bray monument and soon to become a standard motif on Italian tombs.[44] On the rear wall above the niche an "intercession" scene appeared in a mosaic by Jacopo Torriti representing the kneeling pope, between Sts. Peter and Paul, praying to the Madonna and Child seen in a roundel. In front of the sarcophagus with its effigy stood an altar dedicated to a saintly predecessor, the seventh-century pope Boniface IV. This entire ensemble was within an architectural canopy projecting from the wall.

The motivation for the unusual step of commissioning the tomb monument during his own lifetime, and including a portrait effigy (bearing the features that must have been known to the sculptor), were strongly, even flagrantly political: Having been elected pope after the resignation of the pious but incompetent Celestine V, Boniface VIII found his papacy's legitimacy being questioned by his enemies, primarily members of the Colonna family and their supporters. After an appeal by the latter for a convocation to depose the pope, Boniface responded by preaching a crusade against the family. It was during the initial phases of this growing conflict, which conditioned several aspects of his papacy, that the

76. (left) Grimaldi drawing of Boniface VIII tomb chapel, 1605 (chapel probably completed 1296). Vaticano Codice Latino 2733 Barberini mss. [Biblioteca Apostolica Vaticana].

77. Arnolfo di Cambio: Tomb of Boniface VIII, detail. Rome [Alinari/Art Resource, New York].

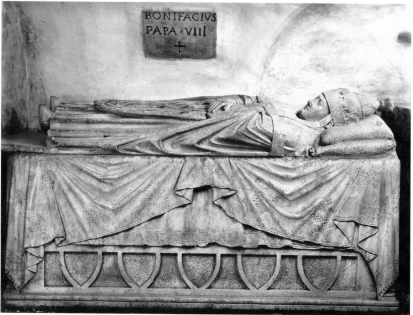

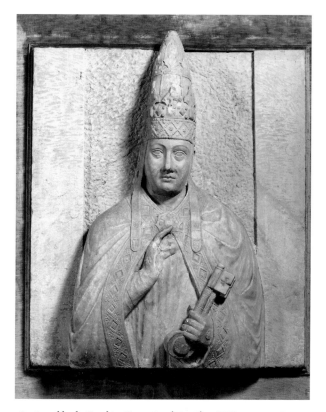

78. Arnolfo di Cambio: Portrait of Boniface VIII, c. 1300. Rome, San Pietro in Vaticano, grottoes [Istituto Centrale per il Catalogo e la Documentazione].

commission for the tomb chapel was given. Here, Boniface would be seen dressed in papal vestments at the very entrance of the basilica and "surrounded" in nave and apse by "portraits" of earlier popes. Furthermore, if the half-length image of the pontiff (Fig. 78) in the Vatican also belonged to the tomb chapel (this is not certain but is assumed by many scholars), then in addition to his tomb effigy visitors to the basilica would see the pope holding the keys of St. Peter in one hand and blessing with the other, in short, in the very exercise of his office.[45]

The canopy, as mentioned, enclosed a space that encompassed tomb and altar; but it also, significantly, encompassed the priestly celebrant. In other words, while on the Annibaldi monument the liturgical celebration remains strictly a part of the fictive world of sculpture, here the human celebrant becomes a protagonist within Arnolfo's created ensemble.[46] The germ of this idea is already seen in the Praesepe, where the spectator could identify with St. Joseph or, since he faced in the same direction as the kneeling Magus,

could feel his own sense of reverence echoed in the latter. For the tomb of Boniface VIII, the sculptor-architect has carried this idea one step further: human celebrant within, surrounded by pious visitors – an audience, so to speak – outside the chapel, performed in what has aptly been called "art as theater."[47]

The Facade of Florence Cathedral

The chapel for the tomb of Boniface VIII was probably the most architectural of Arnolfo's tomb monuments. Several works of architecture proper have been attributed to him, including the Franciscan church of Sta. Croce, rebuilt beginning 1294, the Badia, and the Palazzo Vecchio, all in Florence, all undocumented but mentioned by Vasari.[48] The Duomo of Florence, however, is Arnolfo's last documented work.[49]

From the middle of the thirteenth century on, Florence like several other Italian cities witnessed an unprecedented growth in its population and wealth mainly due to its grain production, wool manufacturing, and banking activities. Florentine bankers managed the monetary affairs of the most important European rulers as well as the papacy, and the city's trading interests extended to most of the known Christian and a large part of the Islamic world. Concomitant with the explosive economic growth was the development of a new political hierarchy in which power was vested in the merchant classes at the expense of the old feudal nobility, still dominant elsewhere in Europe. This situation culminated in the famous Ordinances of Justice of January 1293, a series of constitutional provisions that strictly limited the power of the nobles, or "magnates," as they were called.[50] The growth in population and in the economy during these decades encouraged building activity on an unparalleled scale. Early on, the Palazzo del Podestà (the governor's palace, now called the Bargello), Sta. Trinita, Santa Maria Novella, and other structures rose, and in the 1290s the Palazzo dei Priori and Sta. Croce were begun.[51] By that date the scale of the Carolingian cathedral dedicated to an otherwise obscure local saint, Sta. Reparata, was dwarfed not only by the surrounding urban expansion and by the new large and spacious mendicant churches of Sta. Croce and Sta. Maria Novella but also by the cathedrals of Pisa and Siena whose economic prosperity was being overshadowed by that of Florence. And so it was decided to build a new, much larger cathedral, which was erected as a shell around the older church (later demolished). The new

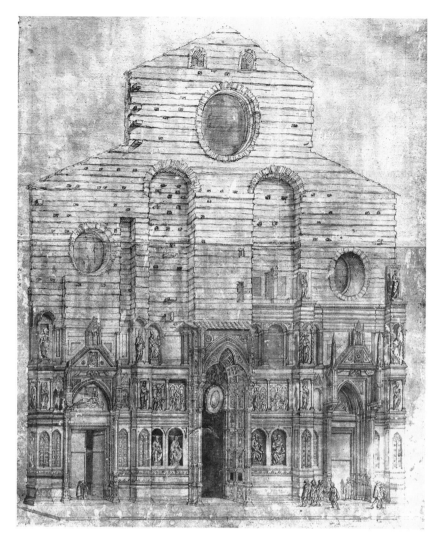

79. Attributed to B. Poccetti: Florence Duomo, facade, 1587. Florence, Museo dell'Opera del Duomo [Alinari/Art Resource, New York].

cathedral was to be rededicated to the Virgin Mary, evidence of the flourishing cult of the Virgin that had swept much of Europe in the thirteenth century and became especially intense in Florence and Siena.[52]

Arnolfo's facade, only partially completed, was destroyed in 1587; some elements of its design, however, are indicated in a drawing made immediately prior to its destruction (Fig. 79).[53] Whether this drawing reflects the facade of Arnolfo's time, or whether major changes were made during the fourteenth century has been a matter of debate; it certainly shows the fifteenth-century niches added to accommodate the seated Apostle figures by Donatello and others of the early fifteenth century. Although a convincing reconstruction of details of the

original facade has remained elusive,[54] it is probable that the design was much purer and simpler than that seen in the drawing, with its late Gothic accretion of sculptures difficult to imagine as forming a coherent iconographic or aesthetic whole. That color played an unusually important role in the total effect of the facade is already suggested by the extant geometric intarsia that formed the background for the statue of the Madonna and Child in the central lunette. Evidence from recent excavations under the duomo, showing star- and lozenge-shaped patterns in red, gold, and dark bluish-green, confirms the important role of polychromy and suggests that the lowest story, immediately above the socle zone, was composed not of deep Renaissance niches but of a blind arcade (as seen in the drawing to left and right of the niches) embellished with Cosmati work of intense chromatism.[55] Above this arcade was a trabeated gallery punctuated by tabernacles, all containing statues or reliefs. Projecting buttresses and the three portals, the lateral ones surmounted by truncated gables and tabernacles and the central taller one composed of a Gothic trefoil arch, articulated the surface, interrupting the horizontality of the moldings, blind niches, and galleries sweeping across the facade. The sculptures, many of which are almost fully three-dimensional, would have effectively contrasted with the mural surfaces of polychromed marble.

Indeed, the prominence given to sculpture on the facade represented a decisive break with Florentine tradition, which preferred flat geometric marble intarsia of restrained polychromy (dark green and white), as seen on the facades of the Baptistry and San Miniato al Monte. The sculptural program, concentrated on the three facade portals, was clearly a response both to the facade then under construction in Siena, designed by Giovanni Pisano, and to developments north of the Alps. Already for about a century the major French cathedral

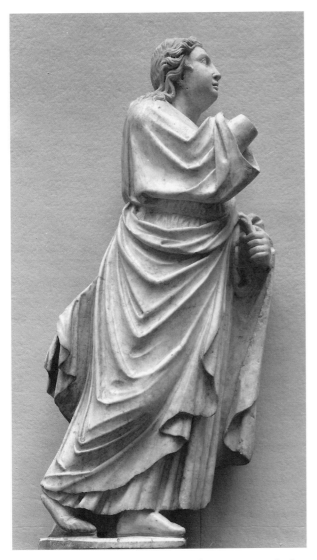

80. Arnofo di Cambio: *Censing Angel*, c. 1300. Cambridge, Mass., Fogg Museum [Courtesy of the Fogg Art Museum, Harvard Universty Art Museum. Gift of Mrs. Arthur Kingsley Porter in memory of her husband].

ing angels, while within the left and right tympana were the *Nativity of Christ* and the *Death of the Virgin*, again revealed through curtains (Figs. 82, 83).[56]

One of the censing angels that flanked the *Madonna* is now in the Fogg Museum, Cambridge, Massachusetts, and can be studied rather closely (Fig. 80).[57] The figure is characterized by a compact massing of form enlivened by the play of light and shadow and a sure sense of structure in the differentiation of drapery layers from each other

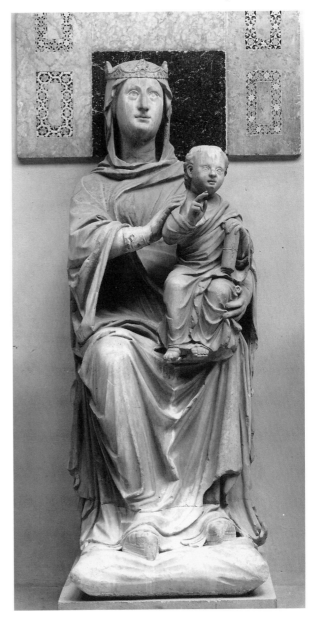

81. Arnolfo di Cambio: *Madonna and Child*, c. 1300. Florence, Museo dell'Opera del Duomo [Florence, Soprintendenza per I Beni Artistici e Storici di Firenze Pistoia e Prato].

programs had been both encyclopedic in content and multimedia in scope, employing as they did both stained glass and sculpture in relief and in the round. Though usually dedicated to the Virgin, the French cathedral programs encompassed the whole of human faith and knowledge instead of focusing on the life of the patron saint, and no French cathedral had images of Mary on all three facade tympana as was true of Florence (and its immediate predecessor, Siena). Here, in the central tympanum was a seated Madonna and Child flanked by censing angels (Figs. 80, 81), two local saints (Sta. Reparata and San Zenobius), and possibly a group of curtain-hold-

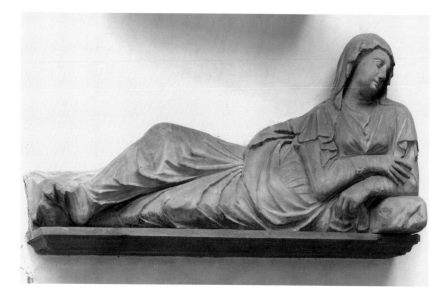

82. Arnolfo di Cambio: *Nativity*, c. 1300. Florence, Museo dell'-Opera del Duomo [Ralph Lieberman].

and from the underlying forms. The jagged, crystallized folds of the mantle are composed of smooth planes articulated by dark, linear accents; these are contrasted with the fluted folds of the robe. The figure combines emotional intensity, conveyed through the movement of the body and the ardent gaze, with formal restraint evident in the disciplined stylizations and compactness of form. This same combination of Gothic emotion and classical restraint is seen in the seated *Madonna and Child* (Fig. 81) in the Museo dell'Opera del Duomo in Florence,

83. Arnolfo di Cambio: *Dormition*, plaster cast, c. 1300. Florence, Museo dell'Opera del Duomo [Alinari/Art Resource, New York].

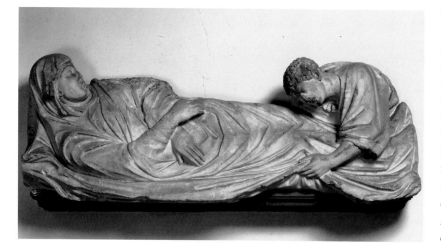

unanimously accepted by modern critics as a masterpiece of Arnolfo di Cambio. Of regal bearing and classicizing composure, the enthroned Madonna – despite an almost hieratic frontality that recalls the Romanesque tradition of the Sedes Sapiente[58] – is imbued with the sparkle of life and with maternal tenderness, the first by way of the vitreous eyes (an almost unique occurrence for marble statues of the Middle Ages),[59] and the second by means of the firm yet gentle support which her lap, left arm, and both hands provide for the Christ Child. Unlike some other figures that also come from the facade but were probably executed by assistants (e.g., St. Zenobius in the Florentine museum), the Fogg Angel and the seated *Madonna* are carved with absolute assurance in every detail and must be attributed to Arnolfo himself.

On the facade of Florence cathedral then, there would seem to have been a concentrated and dramatic emphasis on the three portals, with the highly plastic sculptural narratives and the Madonna in Majesty offering a strong and attractive – indeed, attracting – contrast to the flat rectangular and arched bands stretching across the facade. Such sculptural restraint, and the pointed contrasts between sculpture and mural decoration, was fully in keeping with Arnolfo's aesthetic as seen on the ciboria in Rome.

Unlike that of Nicola (and, as we shall see, Giovanni) Pisano, Arnolfo's sculpture does not present a clearly discernable stylistic development. The early fountain figures in Perugia (Figs. 50–54) (with the exception of the Thirsty kneeling woman, probably by an assistant) show a comparable maturity of technical means and anatomical competence as do the facade sculptures, in particular the autograph Fogg Angel and the *Madonna and Child*. The differences between the two ciboria (Figs. 62 and 68) are attributable more to the exigencies of their respective sites than to stylistic development. The very fact that the Annibaldi monument (Fig. 60), long considered datable to 1276 based on

the mistaken assumption that the figure represents the Cardinal Riccardo who died in that year, has been redated to 1289, based on the convincing arguments that the effigy represents instead the papal notary of the same name who died in the latter year,[60] reveals the hazards of assuming a linear stylistic development for Arnolfo. Spanning little more than two decades, and defying chronological analyses, Arnolfo's sculptural-architectural projects invoked creative problem solving directed toward the specific task. But they also reveal a consistency of conception in the relationship of architecture to sculpture and, in the best of the individual pieces, a mastery of execution in which we can observe a balance between the classical restraint inherited from Nicola Pisano and encouraged by the newly appreciated indigenous antique remains, and the infusion of human emotion inspired by northern Gothic art. Although the work of each of the sculptors we have studied thus far (but including also Giovanni Pisano) embodies a variable mix of Gothic and classical elements, Arnolfo's monuments perhaps more than the work of any contemporary may be said to offer a "classic" balance between the real and the ideal, the specific and the generic, and the humanly expressive and abstract.[61]

GIOVANNI PISANO

It is hard to believe that both Giovanni Pisano and Arnolfo di Cambio were trained by the same master, so radically different are their approaches to sculptural form and the relationship of sculpture to architecture. The two younger sculptors, as well as Nicola, have in common a willingness to intermingle quite unpredictably Gothic and classical elements. For instance, among their various ensembles one finds Gothicizing capitals surmounted on classicizing columns; a classical cornice set above Gothic bundled columns; and arches designed with Gothic cusps but profiles rounded and sensual in the classical sense. A similar admixture, with varying emphases, is striking in their figural sculpture.

Giovanni in Nicola Pisano's Workshop

From his signatures on the pulpits in Pistoia and the Pisa Duomo, we may assume that Giovanni Pisano, the son of Nicola, was a Pisan by birth.[1] The earliest documentary reference to him is in the contract of 1265 for the Siena cathedral pulpit in which three assistants of Nicola are mentioned: Arnolfo di Cambio, Lapo, and Giovanni, on whose behalf the father is to receive payment. This

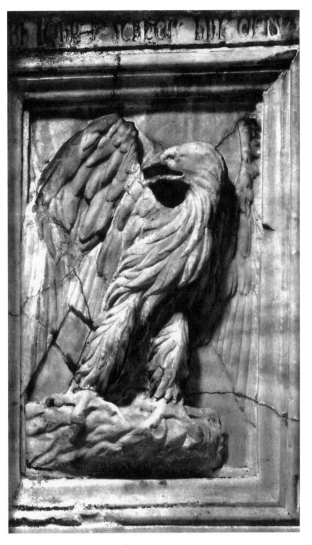

84. Giovanni Pisano: Eagle on Fontana Maggiore, 1278, Perugia [Pisa, Azienda di Promozione Turistico].

strongly suggests that Giovanni was still a minor when the Siena pulpit was begun. Documents record periodic payments to him extending to October 1268 when the pulpit was complete.[2] Stylistic variations in the pulpit are evident, although it also seems clear, as was indicated earlier, that the controlling mind and hand was that of Nicola, whose style and technique his co-workers did their best to emulate. Our limited knowledge of workshop practices and the distribution of labor during the thirteenth century has hindered the making of convincing attributions of specific passages to any of Nicola's assistants (although numerous, contradictory attempts have been made).

Nothing secure is known of Giovanni's activities between 1268 when the Siena pulpit was completed and 1278 when his name appears on the rhymed inscription

on the middle basin of the Fontana Maggiore in Perugia, recording the date of completion and the names of the individuals responsible for the project.[3] As with the Siena pulpit, the attribution of individual figures to Nicola or Giovanni remains controversial. In general, those figures or passages that convey a greater degree of "spiritual tension" compel an attribution to Giovanni while those characterized by greater emotional restraint suggest the hand of Nicola. One image, by consensus, is almost certainly by the younger artist: the pair of panels on the lower basin, each with an eagle that seems a prelude to the griffin of the central support of the Pistoia pulpit (cf. Figs. 84 and 93). Instead of the emphasis on contours and shapes against a flat background seen in the other reliefs, here we see forms carved in higher relief with strong surface patterns and a torsion of bodies that project from a less definable space. The movement seems more than physical: Each bird clutches his support with enormous claws and twists in space, powerful breast jutting forward in one direction and head turned abruptly in the other; each seems ready to burst out of the confines of the panel and frames. Giovanni's name appears on the upper frame of one of these panels – redundant in a sense, since he is named on the rhymed inscription running around the framing of the basin above; yet in this one representation (not coincidentally, perhaps, an image of the symbol of St. John, Giovanni's namesake) he seems to take pride in a more personal visual language distinguishable from that of his father.[4]

The Siena Cathedral Facade

Nicola died sometime before 13 March 1284, when he is referred to in a document as the "late master." Giovanni is then recorded in Siena for about a decade, from c. 1285 to c. 1297, presumably called there to work on the facade of the cathedral. Following the example of Pisa with respect to Nicola, Sienese citizenship was conferred now on Giovanni, as well as exemption from taxes and military service. The first mention of him as Capomaestro dates from as late as 1290, although it seems likely that he functioned in this capacity earlier on.[5] There is considerable controversy as to whether the present facade (Fig. 85), of which the portal section alone was completed before Giovanni's departure from Siena c. 1297, reflects his original plan (as held by Antje Middeldorf Kosegarten) or whether the upper section, with its huge square and rose window surmounted by a gable and flanked by turrets that do not align vertically with the

portal divisions, is a much later design of c. 1370 (a view argued by Harald Keller and accepted by Enzo Carli and John White).[6] Be that as it may, the Marian and typological iconography, as we shall see, has a coherency that strongly suggests its planning at an early stage.

It is noteworthy that Giovanni's patrons, in contrast to the civic authorities in Perugia for their fountain, did not take up the challenge posed by the "encyclopedic content" of French Gothic cathedrals. Sienese history, and in particular the crucial outcome of the Battle of Montaperti on 4 September 1260, a battle that pitted then-Ghibelline Siena against Guelf Florence and resulted in a glorious victory for the Sienese, lies behind the decision to make of the Duomo a "canticle of glory" to the heavenly advocate of the city; for on the eve of the battle the Madonna herself was elected by the commune to be patron and protectress of Siena.[7] From several early visual representations of the facade and from a sixteenth-century description prior to its drastic renovation in the seventeenth century, the original program can be generally if only partially reconstructed. A (lost) Madonna and Child, as fulcrum of the program, stood in the lunette of the central portal. To her right appeared an angel presenting a representative of the commune, the Sienese knight Bonaguida Lucari, to the Virgin, who as queen of heaven, accepts his oath of allegiance on behalf of Siena. To her left, also presented by an angel, was a personification of Siena holding up a model of the cathedral. Scenes from the lives of Joachim and Anna and the childhood of Mary embellished the central lintel beneath the Madonna, while the side lunettes and the gable fields contained mosaics representing further events from Mary's life.[8] On platforms projecting from the towers and between the lunettes of the lower facade were placed prophets and kings of the Old Testament and sibyls and pagan philosophers, those who in remote times had prophesied or foreseen the miraculous birth of Christ and savior of humankind. Spread out along the upper facade, most likely also part of the original program but whose execution postdates Giovanni's presence in Siena, appeared Evangelists and Apostles whose teachings are confirmed by the prophets; the latter, thus, stand like foundations for the New Testament figures above. Around the rose window appeared a seated Madonna and Child flanked by half figures representing the genealogy of Christ, while scenes from the life of David, ancestor of Christ, appeared on one of the tendril columns that originally flanked the portals.

To the Sienese citizens of the late thirteenth and four-

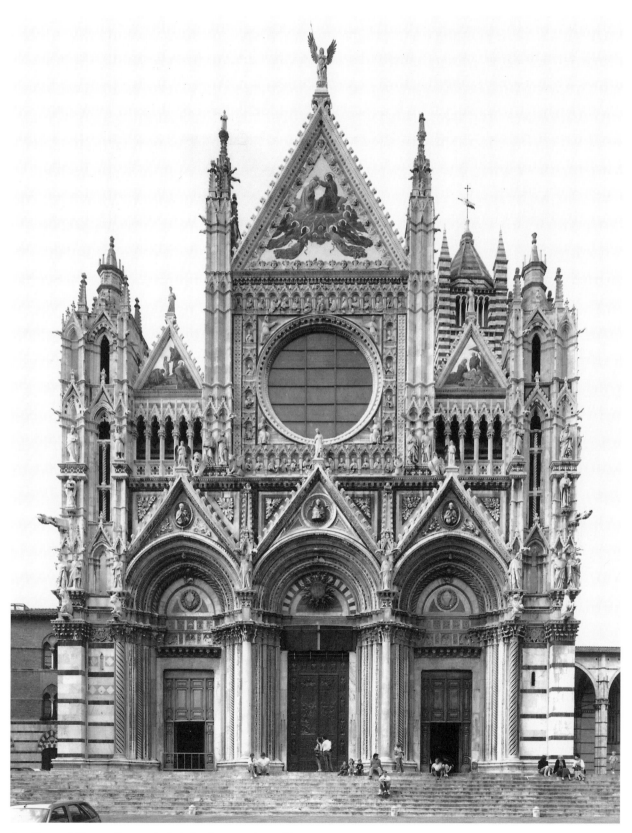

85. Giovanni Pisano: Siena cathedral, facade, c. 1286–90s [Foto
Lensini, Siena].

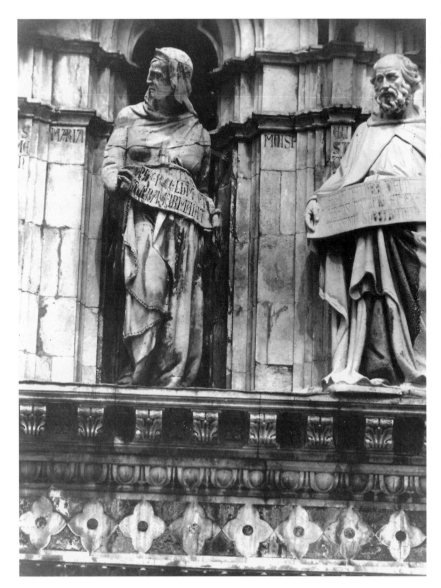

86. Giovanni Pisano: Siena cathedral, facade detail [Foto Siena, Lensini].

teenth century, then, the pictorial program of the facade revealed the place of Siena within the total redemptive plan of Christian theology: The Virgin Mary, mother of Christ whose birth was predicted by prophets and intimated even by ancient pagans and whose message was communicated by the evangelists and apostles, appears on the facade as Queen of Siena, accepting the fealty of the commune at the defining moment of its history, in 1260, when it defeated its powerful and traditional enemy at the Battle of Montaperti.[9]

The Siena facade derives its initial visual impact from the interplay of its various chromatic, plastic, and struc-

tural effects: the contrasts of color, light, and shadow created by the deep jambs, gables, and gallery; the rich tactile plasticity and rhythmic flow of concave-convex movements across the lower horizontal band of portals and lunettes; and the stepping back of the upper facade behind the gables, all of which point to an acquaintance with the facade of Reims cathedral, although there is no secure evidence that Giovanni visited France.[10] Whereas at Reims, however, as is characteristic of French facades generally, the sculpture is completely integrated with the architecture so that the jamb figures, for instance, play the role of surrogate architectural elements, at Siena there is a clear separation in which architecture to a large extent serves as backdrop and support for the sculpture. Only the most sculptural architectural elements – the two remaining classicizing foliate columns that until their recent removal flanked the central portal, and the sculptured lintel – perform as architectonic-decorative features whose texture offers effective contrasts to the chromatic and geometric patterning of the stepped back colonettes they front and connect, respectively.

The major sculptural components are raised above the cornice level, beginning with six half figures of horses, lions, a griffin, and a bull. Above these, standing on platforms in front of shallow niches between the gables and continuing around the corner piers are the single figures, quite unlike the *series* that form a figural band at the portal level of French cathedrals, since here they are given an independent, virtually self-sufficient existence like actors on a stage.[11] These figures, fourteen in all, represent, as we have seen, Old Testament prophets and kings, pagan seers (sibyls), and philosophers (Plato and Aristotle). Dynamic, plastic forms, they reach out and across space, and in gesture and movement embody the excitement of their special enlightenment, foreknowledge of the Incarnation of Christ in the womb of the Vir-

87. Giovanni Pisano: *King Solomon*, between c. 1286 and 1297. Siena, Museo dell'Opera del Duomo [Ralph Lieberman].

88. Giovanni Pisano: *Miriam*, between c. 1286 and 1297. Siena, Museo dell'Opera del Duomo [Foto Siena, Soprintendenza per I Beni Artistici e Storici].

gin Mother.[12] Here, in contrast to Arnolfo's ensembles, the architecture is not a pre-existing stage into which the actors are placed but rather is itself determined by its function as setting for the dramatic action. Thus, the niches (unlike, for instance, that of Antelami's niche for the Old Testament Patriarchs in Fidenza, Fig. 10) are too shallow to contain the figures; instead, they suggest and frame the spatial ambient from which the figures move forward to proclaim their messages (Fig. 86). The niches on the north and south corner piers originally opened

89. Giovanni Pisano: *Simeon*, between c. 1286 and 1297. Siena, Museo dell'Opera del Duomo [Foto Siena, Lensini].

90. Giovanni Pisano: *Simeon*, detail. Siena, Museo dell'Opera del Duomo [Foto Siena, Lensini].

onto the dark interior of the towers, so that Miriam, sister of Moses, open-mouthed and leaning toward her right, and Isaiah, stretching forward in response, seemed to emerge from the deep shadows behind. The resulting dramatic effect has no medieval or antique precedent.[13]

The statuary for the facade ranges from the more

blocklike forms with relatively closed contours and restrained facial expressions, as in the Kings (Fig. 87), to more open and expressive gestures and movements, with deeper undercutting, as in the drapery folds seen in Miriam and Simeon (Figs. 88–90). The low-set knees and the exaggerated thrust of the neck and head of several of these figures reveal the sculptor's concern with the visual effects of monumental statuary seen from a distance and from below. This concern with the spectator, seen earlier in the forward-thrusting reliefs of Nicola's Pisa and Siena pulpits, continues to be felt in Giovanni Pisano's later works at Pistoia and the Pisa Duomo.[14] Such is the power of Giovanni's forms – broadly modeled and deeply excavated but resting on a solid structural armature – that even the extreme weathering over many centuries of exposure has hardly diminished their effect.

It is often stated that Nicola Pisano was a classicizing sculptor and Giovanni was a Gothic one, but this characterization fails to take into account the intermingling of classical and Gothic elements in the work of *both* masters. The facade abounds in classicizing motifs such as

72

bead and reel patterns, dentils, masks and acanthus foliage, a classicizing cornice, and *all' antica* "peopled columns" that originally flanked the main portal.[15] The Siena facade, in short, combines a classicizing tactility and stability with a Gothic undermining of solid surface in favor of perforated, if not truly diaphanous, mass. Indeed, the facade is a creative synthesis of local tradition and northern Gothic influences. The alternation of dark and light marble revetment characterizes Tuscan Romanesque architecture; the historiated vine-scroll columns derive from the antique; and numerous architectural motifs such as the traceried mullioned windows and arcades and some aspects of the figure style, for instance, the fold forms of the full-length figures, are strongly influenced by French precedents. Northern (including German) inspiration, however, was reinterpreted on Giovanni's own terms. His statues bring to mind those on the south transept portal of Strasbourg cathedral, where Ecclesia remonstrates across space to Synagogue, and the Judgment Pillar, where there are expressive turning figures.[16] It is possible that Giovanni Pisano knew these examples, at least indirectly, but he has transformed the relationship of figure to architecture as well as the type and degree of animation of the figures. At Strasbourg the space in which each figure resides is strictly circumscribed by console and canopy, whereas at Siena the figures move freely in front of the architectural backdrop. Moreover, whereas the figures on the Strasbourg Judgment Pillar are characterized by gentle and rhythmic turns, and gestures and expressions that reveal the messages in hushed and breathless tones, the Sienese figures are aggressive and declamatory. Thus, the basic conception of the facade as stage and background for a population of active, indeed, interactive figures addressing not only one another across wide spaces but the observer in the piazza below, is absolutely novel and is Giovanni's invention.[17]

Perhaps while still engaged in Siena,[18] but more probably after his departure, Giovanni continued work on the exterior sculpture for the Baptistry of Pisa (Fig. 91). Although the sculptures are badly damaged by weathering, it is again astonishing to contemplate how powerless time and weather have been, leaving undiminished the effect of these swelling, twisting fragments bursting with inner energy.[19] The "freestanding" figures from the Siena facade and Pisa Baptistry reveal, indeed, that "principle of axiality" that characterizes Gothic (as opposed to Romanesque) sculpture,[20] but here the coiled tension of the body about a central axis – even when the implied release suggests a gentle, swaying lyricism) –

91. Giovanni Pisano: Figure from Pisa Baptistry, 1290s [Aurelio Amendola].

has more energy than that in French sculpture, be they jamb statues or Madonna statuettes.

Giovanni Pisano's sojourn in Siena was evidently not always serene. At first he appears to have had conflicts with another sculptor, Ramo di Paganello, who was eventually removed from the project. Then in 1290 Giovanni found himself, for reasons not recorded, in legal difficulties; he was sentenced to punishment, possibly even imprisonment, which the government of Siena later waived in favor of a fine. This clemency was most likely due to the fact that his services were very

much needed for the Duomo project.[21] Finally, in 1297 a scandal erupted that was evidently long in the making: Although Giovanni is not mentioned by name, an investigation was begun that revealed serious negligence in financial and artistic matters, including waste of money and materials and loss and abandonment of stones already carved; all those involved in the Duomo project were to be held "in chains" until the matter was resolved. Whether the Capomaestro was actually imprisoned is not known, but he left or fled Siena in c. 1297 leaving the Duomo facade incomplete.[22]

The Pulpit in Sant'Andrea, Pistoia

Nicola's pulpits had been executed for cathedral patrons in two of the most important medieval Tuscan communes of the second half of the thirteenth century. Around 1297, when Giovanni must have been almost fifty years old, he finally received a pulpit commission, but it was for a small parish church in Pistoia.[23] If relatively insignificant in modern times, during the late Middle Ages this Tuscan commune had considerable importance as the hub of six major roads linking cities north, south, and east, and in particular it served as a gateway to the university city of Bologna, to Lombardy, and to France. The city was also a pilgrimage site that drew visitors from Tuscany and beyond, since it preserved a relic of San Jacopo that its saintly bishop Atto (d. 1156) had obtained from Compostela.[24] Pistoia's richest mercantile families serviced and profited from an international community. Its economic wealth – as well as the ferocious violence of its internecine conflicts – reached its apex in the late Duecento and early Trecento; indeed, David Herlihy comments that "[b]y most measures, the decades before the Black Death, and particularly the years from about 1290–1340, would have to be reckoned an age of brilliant prosperity."[25]

For reasons that have yet to be explored, Pistoia was unusually rich in monumental sculptured pulpits. The cathedral had a pulpit by Guido da Como (dismantled in the sixteenth century),[26] and both the church of San Bartolomeo in Pantano and San Giovanni Fuorcivitas possessed impressive pulpits with historiated panels also by Guido (1250) (see Fig. 366) and the Dominican sculptor Fra Guglielmo (1270) (see Fig. 370), respectively. In 1298 it was proposed that a pulpit be made for Sant'Andrea that would not be inferior to that made in San Giovanni Fuorcivitas by Guglielmo, student of Nicola Pisano,[27] so there was clearly a sense of rivalry between these parish churches.

A carved inscription on the Pistoia pulpit gives its date of completion, 1301, as well as the names of the donor and financial supervisor.[28] The inscription continues: "Giovanni carved it who performed no empty works. Born of Nicola, but blessed with higher skill, Pisa gave him birth, endowed with mastery greater than any seen before."[29] The pulpit (Figs. 92–99) originally stood in full view in front of the choir toward the right side of the nave and not, as today, between the nave and left aisle half hidden from the entering worshiper by the nave arcade. Altered too is the sequence of figures and narratives as well as the supporting elements, for originally the *Massacre of Innocents* (Figs. 97, 98) and the *Crucifixion* (Figs. 92, 99), between which stood the Mystical Christ, were visible from the nave.[30] The impact of this richly carved, coloristic, and elegant structure, its parapet poised upon Gothic trefoil arches on slender columns with alternating animal or figural supports, must have been particularly strong when seen from the entrance of the Romanesque church of Sant'Andrea with its simple round-arched arcade, flat nave walls, and timber roof. The elegance of its total form as apprehended from the distance belies the raw, unpolished surfaces of the carvings of the narratives. In this, his first pulpit, Giovanni reveals both his debt to Nicola's two earlier works and his complete independence technically, compositionally, and expressively. Like the Pisa Baptistry pulpit (Fig. 25), that in Sant'Andrea is hexagonal in plan and has great structural clarity: The angles of the hexagon are clearly articulated, while the cornice and moldings of columns and balustrade project strongly to sharply define each separate story. But instead of the triple colonettes framing the reliefs at Pisa, here, adopting his father's invention in the Siena pulpit, the narrative reliefs are flanked by figures; the contrast of scale between the corner figures and the actors in the narratives, however, is much greater. In place of the round-headed trefoil arcades of the earlier pulpits, here there are elegant pointed Gothic arches; instead of the relatively compact capitals, blocky lions, and static central supports seen earlier, here the acanthus leaves and volutes are more open and seem almost to burst out into space, the lions are more naturalistic and energetic, and the central support with lion, griffin, and eagle (Fig. 93) are revolving and opposing forces about the column hub. Similarly, the angle figures offer strong, if sometimes ambivalent, directives linking the narratives: With sharply turning axes, the sibyls and saints pull the viewer to left and right. The observer, caught up in the emotional intensity of each panel, is

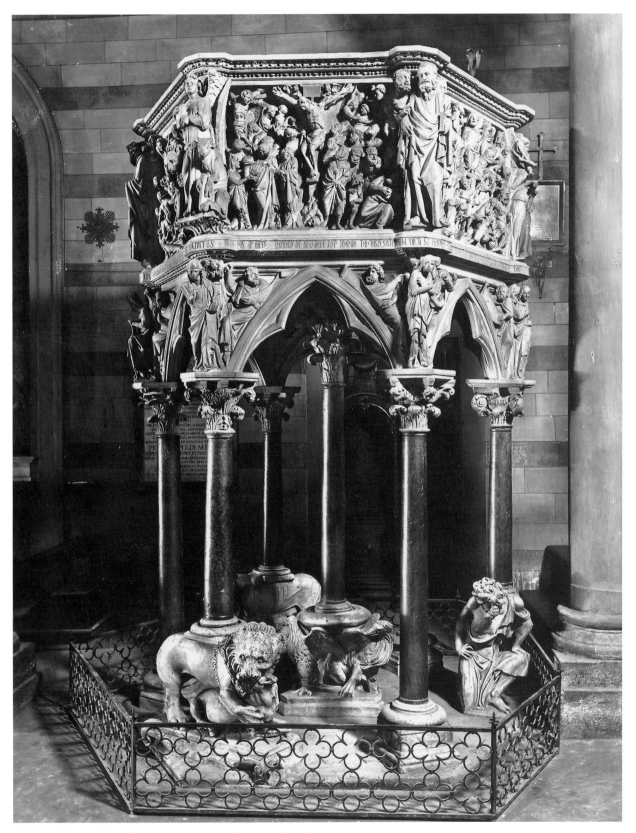

92. Giovanni Pisano: Pulpit. Pistoia, Sant'Andrea, completed
1301 [Alinari/Art Resource, New York].

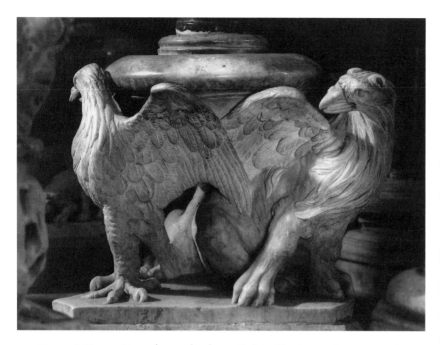

93. Giovanni Pisano: Base of central column. Pulpit. Pistoia, Sant'Andrea [Aurelio Amendola].

first locked into a frontal view, then enticed to continue to move around the structure in either direction by means of the compelling peripheral views and the directions of body and glance of the angle figures between the narratives and atop the columns (Fig. 94). In contrast to the more static spandrel figures of the earlier pulpits (Figs. 25, 41), here the prophets look toward and communicate with each other across the space of the arcade (Fig. 92). These spandrel figures, especially in the upper half of the bodies, are virtually detached from their backgrounds and thus are active presences that do not take second place to the angle or column figures (as they tend to do on the earlier pulpits). In short, Giovanni has translated his experience of the monumental figures on the Siena Duomo facade, detached from columns or niches and in active communication, onto the diminutive scale of the high relief sculptures on the Pistoia pulpit.

But it is the heightened emotional content of the narrative reliefs that is for many the most stunning feature of the Pistoia pulpit. In comparison to Nicola's Siena pulpit the number of figures in the first narrative (Fig. 95) is reduced, so that as in the Pisa Baptistry pulpit, each figure is larger in relation to the field and has greater individual presence. In fact, however, the *Nativity* (Figs. 95, 96) is filled not so much by individual figures as by units comprised of two or more actors, groupings such as that in the Annunciation, in which the awesome message

both thrusts the Virgin away from Gabriel and magnetically draws the figures together. These groups cohere no less by virtue of the contours (the parentheses formed by the backs and heads of Gabriel and Mary), the rhythmic relationships (such as the zigzag movement connecting Gabriel's and Mary's right arms), or the various related or interconnecting rhythms of drapery folds than by virtue of the poses, gestures, and glances – interpretations as they are of universal human experience. Joseph, a closed, physically isolated and psychologically inward turning form, nevertheless looks toward the bathing scene where once again two confronting and reciprocal forms and movements coalesce. The naturalism of the pouring and testing of the water is noteworthy; even more so is the infant held by the midwife. The Christ Child is not the formulaic miniature

94. Giovanni Pisano: Sibyl, Pulpit. Pistoia, Sant'Andrea [Alinari/Art Resource, New York].

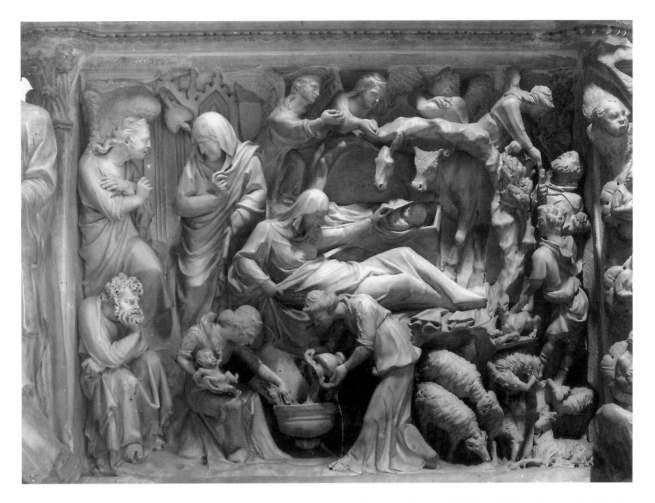

95. Giovanni Pisano: *Nativity*, Pulpit. Pistoia, Sant'Andrea [Aurelio Amendola].

96. Giovanni Pisano: *Nativity*, detail. Pulpit. Pistoia, Sant'Andrea [Aurelio Amendola].

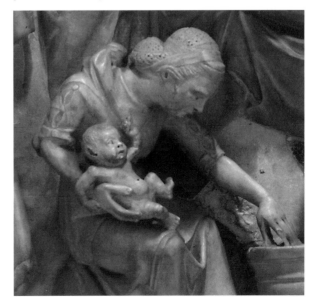

adult of medieval tradition or the small Herculean child rendered by Nicola but is arguably the first realistic, almost newborn infant in the history of art, whose large head and tiny body, puffy cheeks, swollen belly, clinging arm, and flailing legs are clearly drawn from life. Not even a sculptor in antiquity, as far as I have been able to determine, reproduced with such fidelity the proportions and actions of an infant.[31]

In the Siena pulpit Nicola had abandoned the medieval practice of placing virtually all figures close to and parallel to the picture plane in favor of a more illusionistic layering of several – usually three – sloping planes, but the density of the surface texture, so reminiscent of pagan battle sarcophagi, tends to limit the spatial illusion. Giovanni, in contrast, reduces the number of figures in most reliefs, allows more of the background to show through, and creates larger but more self-contained spatial vignettes. Thus, while the composition of the *Nativity* (Fig. 95) may be read as a whorl at the edges of the field that culminates in the central Madonna and the cave behind her, the vertical and horizontal

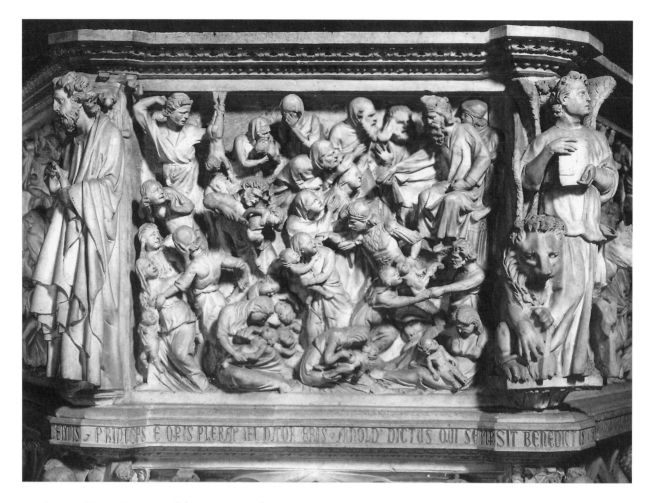

97. Giovanni Pisano: *Massacre of the Innocents.* Pulpit. Pistoia, Sant'Andrea [Alinari/Art Resource, New York].

98. Giovanni Pisano: *Massacre of the Innocents,* detail. Pulpit. Pistoia, Sant'Andrea [Aurelio Amendola].

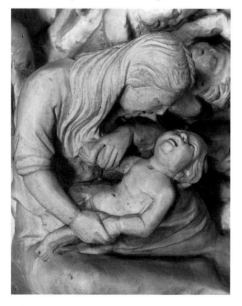

armature creates a distinct if sloping foreground (Joseph, Bathing scene, sheep and goats), a middle ground (Annunciation, Nativity) and a distant area including the building and the space from which the angels emerge. Indeed, analysis of each of the panels reveals that the groupings coalesce narratively and compositionally, while yet adhering to a stabilizing armature.

Giovanni's compositional and expressive powers are nowhere more evident than in the *Massacre of the Innocents* (Figs. 97, 98). At first glance and from a distance the composition appears chaotic. Closer examination reveals that the violent movements, deep pockets of shadow, and flashing highlights cohere as a series of zigzag, vertical, and horizontal rhythms generated by the forward motion of King Herod's upper body and right arm. In an almost cinematic sequence, every stage in the brutal event and every moment of response is portrayed: At the upper right, two advisers seem to discourage the king in his monstrous directive, while a third individual may be urging him on; moving diagonally to the left, three women plead before its fulfill-

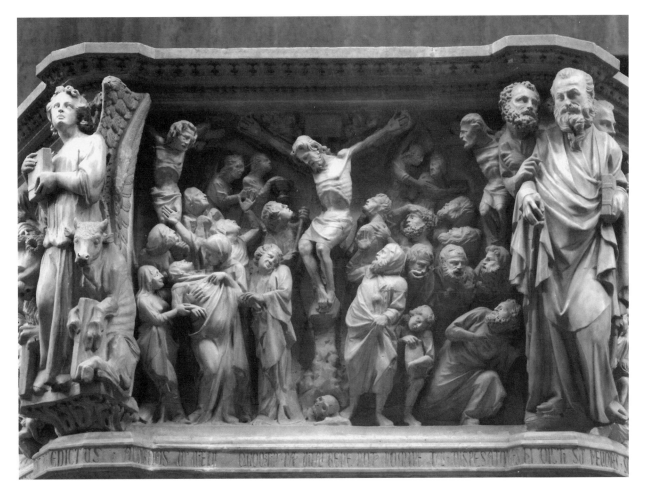

99. Giovanni Pisano: *Crucifixion*. Pulpit. Pistoia, Sant'Andrea [Aurelio Amendola].

ment; immediately below and at the lower left several mothers clutch their infants in terror, shielding them with their own bodies. The base of the composition is formed by three grieving mothers bent over their dead children (Fig. 98), while above them, bringing the eye upward toward Herod again, mother and murderer – like an angel and devil fighting for a soul in the Last Judgment – battle over the body of a screaming infant who has already received the death blow.

Concerning the carving technique, one must go back to late antiquity to seek a precedent for the handling of the chisel, which almost hacks away at the stone, leaving roughly hewn surfaces conceived as co-relative to the brutality and tragedy of the scene. The effect of the technique is further heightened by its contrast to the smoother draperies and the more highly finished surfaces of the flanking Tetramorph and apostle Andrew. In this and other reliefs on the pulpit the projection from the background and undercutting of the surfaces is just about as daring as is possible in relief sculpture: Some forms stand out as much as two inches forward of the

frame and are carved six inches deep into the block. In several reliefs there is, furthermore, a tendency for the figures in the upper registers to project more strongly than those below to create better legibility.[32] Again, the most effective view is that from the ground, not the head-on views seen in most photographs.

Although only hemlines and drapery linings were gilt or colored, significant traces of the original glazed colored background hint of the effect produced by the strongly projecting creamy, marble figures against the deeply undercut background, whose tesserae flickered or were absorbed in shadow depending on the light that penetrated the relatively dimly lit church. But as in all architectural spaces, the light of the interior changed with the time of day and season, and the visual effect of the light on the monument consequently was continuously changing. It is important to realize that the contemporary user, clergy and worshipers alike, did not

100. Giovanni Pisano: *Madonna and Child* from Pisa cathedral, mid-1270s [Aurelio Amendola].

101. Giovanni Pisano: *Madonna and Child* from Pisa Baptistry, c. 1295. Pisa, Museo dell'Opera del Duomo [Ralph Lieberman].

experience the pulpit (and the same may be said for all the works under discussion) for five or ten minutes under artificial lighting conditions, as does the tourist and student of today. Worshipers and pilgrims all saw the pulpit for longer and shorter periods – often experiencing the visual together with the auditory while listening to Scripture or sermons – within a continuum of changing environmental circumstances. As John White has written, "In the normal half-light of the Romanesque church . . . [the background] glazes would have showed as black, intensifying both the projection of the figures and the dark, suggestive quality of the depths behind them. In the candlelight or in reflected sunlight the strengthening cast shadows would have been accompanied by fitful gleams and flashes of rich color, and only in the short time when the light was strong upon the panels facing the nave would space be flattened out, as in a manuscript illumination, by a clearly visible, patterned backdrop."[33] It is fair to assume that the sculptor was as attuned to the changing conditions of light as he was of the spectator's spatial relationship to the monument.

Madonnas and Crucifixes

A quieter, more intimate side of Giovanni Pisano's artistic personality is revealed in a series of Madonna and Child figures executed throughout his career. In a development parallel to but later than one that took place in France, the Madonna and Child in Tuscany evolved from an austere iconic image toward one

increasingly infused with a sense of humanity and intimacy. Nicola's *Madonna and Child* on the Arca di San Domenico (c. 1265) (Fig. 38), for instance, shows a frontal, rigid, and columnar Madonna with closed contours, prismatic drapery folds, and compact forms. Mary looks straight ahead and the Child's glance is perpendicular to hers. On Nicola's Siena Duomo pulpit (1265–68), although the Virgin and Child (Fig. 46) still direct their glances across each other's, the drapery folds are less angular and the Christ Child is not as stiff as in the Arca. It is in the hands of Giovanni Pisano, however, that the image of the Madonna and Child undergoes a fundamental change, which is first seen in the half-length Madonna from a tympanum of the Pisa Duomo (Fig. 100) of unknown date but stylistically datable to the mid-1270s.[34] Here for the first time the intimacy of mother and child is expressed by the reciprocal glances, and the connectedness is enhanced by the curve of Mary's veil, which is continued in the line of Christ's arm and mantle. The most influential of Giovanni's Madonnas was undoubtedly the signed standing figure (Fig. 101) originally in the tympanum of the Baptistry of Pisa, plausibly dated c. 1295.[35] Although the Christ Child is disfigured by clumsy restorations of its entire upper torso, his head is lost, and there is considerable damage on the surface of the Madonna's apron, given that Mary turns her head sharply to her left (the viewer's right), it is likely that here, too, the Child's head was turned toward his mother,[36] as seen in the Madonna and Child (Fig. 102) in the Arena Chapel, Padua (c. 1305). In the latter the Child has lost all rigidity, leans toward his mother, and rests his arm on her shoulder. Finally, in the Prato Madonna (Fig. 103), universally attributed to Giovanni and probably dated c. 1312, the pitch of the relationship intensifies. Christ touches Mary's crown as she leans her head downward to direct her smiling gaze at her son. No longer a Roman matron with regular and planar features as in his Pisa Duomo tympanum figure (Fig. 100), the Prato Madonna is characterized by refined features with delicate transitions in the soft planes and contours. Characteristic of Giovanni's interpretation of the theme in all these groups is the projection of a "radiant gravity,"[37] so difficult to emulate, however much his followers adopted the pose and attitude of his Madonnas (cf. Figs. 103 and 104).

Giovanni's mastery extended beyond stone carving to wood and ivory, including a ravishing ivory Madonna and Child (Fig. 105) that belonged originally to a wood

102. Giovanni Pisano: *Madonna and Child*, c. 1305. Padua, Arena Chapel [Musei Civici di Padova. Museo d'Arte Medievale e Moderna].

and gilded tabernacle and was flanked by two ivory angels, these last all lost. The ensemble was made for the high altar of Pisa cathedral.[38] In addition, a series of wood and ivory crucifixes – none documented or dated – are so compellingly close to his images on the pulpits that they appear to have been executed by Giovanni or by the most gifted members of his workshop.[39] While

103. Giovanni Pisano: *Madonna and Child*, c. 1312. Prato cathedral [Alinari/Art Resource, New York].

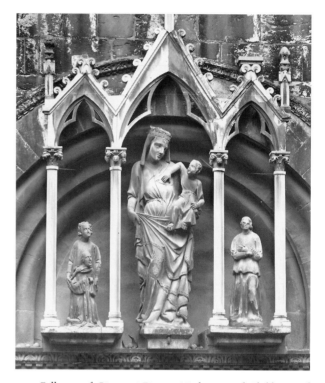

104. Follower of Giovanni Pisano: *Madonna and Child*, second decade of the fourteenth century? Pisa, S. Michele in Borgo. Pisa, Museo Nazionale di San Matteo [Alinari/Art Resource, New York].

distinctly informed by the examples of his father, these carvings, and the Pistoia pulpit Crucifixion – like the Madonna images just discussed – mark a turning point in the history of the theme in Italy. The relative quietude of Nicola's representations (Figs. 32, 47) is replaced on the Pistoia pulpit (Fig. 99) by an aching pathos that, while reminiscent of some northern Gothic representa-

tions of the Crucified, never succumbs to the depiction of excruciating suffering seen in many transalpine examples.[40] Here Christ is turned sharply to a three-quarter view with the body disposed in a series of opposing diagonal axes. The head, no longer resting on the chest, is thrust forward; the muscles are stretched into tense, linear accents; and the shoulder, rib, and hip bones press against the thin, emaciated flesh. No complex drapery flourishes or subtle internal modeling, no virtuoso display of high finish are allowed to distract the viewer from the essential message. Everything, from the seemingly impetuous carving to the poignant confrontation between the still living Christ and the centurion with rod and sponge, is calculated to effect an intensely empathetic physical and emotional response on the part of the viewer. A similar conception is seen in a wooden Crucifix in Massa Marittima (Fig. 106), which not only was displayed on the cathedral's high altar as it is today but probably was occasionally removed to be carried in processions. The secure modeling of the form in three dimensions, with every view effective and affecting, must have astonished Giovanni's contemporaries accus-

erected in Sant' Andrea – Giovanni was commissioned to execute a second pulpit. This last of the four Pisano pulpits was to be erected in the grand, Tuscan Romanesque cathedral of Pisa, beneath the cupola, at the entrance to the choir and near the south (right-hand) transept. Due to its location within the vast space of the Duomo, it naturally had to be much larger than the Pistoia pulpit.[42] Like the pulpit in Siena, it is octagonal, not hexagonal in plan.

The Pisa cathedral pulpit (Figs. 107–14) has suffered from both critical disapprobation and physical damage, the latter a dire consequence of the former. There are two inscriptions on the pulpit, one of which might allude to a less than completely favorable reception of the monument already in Giovanni's day. The following words suggest this: "The more I have achieved the more hostile injuries have I experienced." Further along, there is a reference to the "envy" of others and the "sorrow" of the sculptor who lacks adequate "recognition."[43] Vasari, in his 1550 edition of the *Vita*, wrote, "E' un peccato veramente che tanta spesa, tanta diligenza e tanta fatica non fusse accompagnata da buon disegno, e non havesse la sua perfezzione né invenzione né grazia né maniera che buona fusse . . ." (It is a pity, truly, that so great cost, so great diligence, and so great labor should not have been accompanied by good design, and should be wanting in perfection and in excellence of invention, grace and manner . . .).[44] With such disapproval and considering the much altered taste of the times, it is not surprising that when an excuse presented itself, the monument was dismantled: Shortly after a disastrous fire on 25 October 1595, which ruined much of the cathedral but left the cupola under which the pulpit stood, and thus the pulpit itself, intact, the authorities decided to dismantle the pulpit, store most of its parts, and use some fragments in a new pulpit or elsewhere in the church.[45] Although a serious but apparently misguided proposal to reconstruct the pulpit was made in the late nineteenth century, it was only in 1926, after much debate, that a proposal received approval and was brought to realization in the present construction by Peleò Bacci.[46] Response to the pulpit continues to be mixed, a reaction due to a number of factors. For one thing, in contrast to the Pistoia pulpit in which virtually every passage is autograph, at Pisa the sheer size of the monument, the increased complexity of its iconography – which must have been demanded by the Duomo theologians – and the concomitant increase in the number of figural and narrative elements meant that the extensive participa-

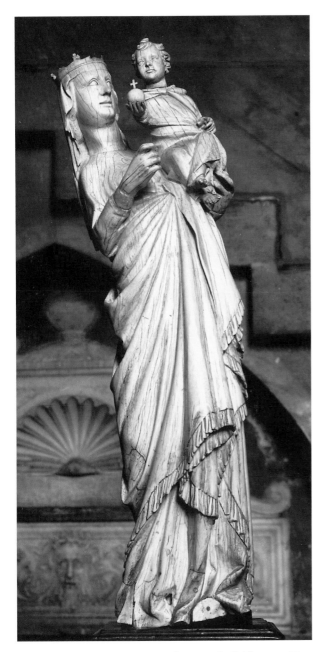

105. Giovanni Pisano: Ivory *Madonna and Child*, 1290s. Pisa, Museo dell'Opera del Duomo [Aurelio Amendola].

tomed to the frontal and rigid processional Crucifixes heretofore known.[41]

The Pisa Duomo Pulpit

In 1302, almost immediately upon completion of the Pistoia pulpit – keeping in mind that the actual carvings of the latter, including the inscription of 1301, had to be transported from the workshop in Pisa to Pistoia and

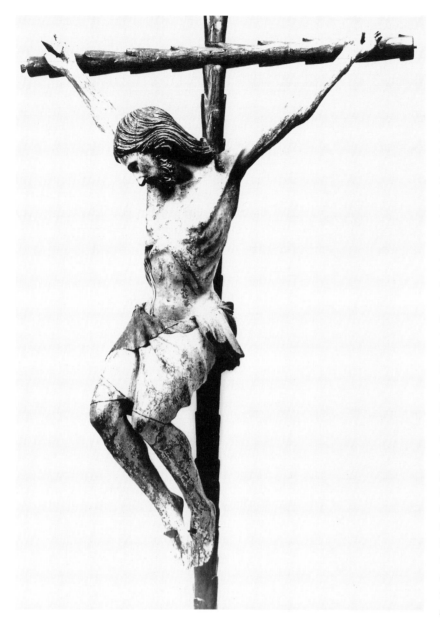

106. Giovanni Pisano: Crucifix, wood. Massa Marittima cathedral [Florence, Kunsthistorisches Institute].

his creative powers reached in Siena. In terms of sheer inventiveness of form, the Pistoia pulpit, in fact, is relatively conservative: Only the Gothic arcade separates it fundamentally from Nicola's earlier structures. If anything, it is perhaps the superabundance of inventiveness, combined with the necessity to parcel out so much of the execution to lesser talents, that has resulted in the Pisa pulpit's critical misfortunes.

Both artist and patron must have felt the challenge of the three earlier pulpits, seeking to surpass them in size, iconographic and sculptural complexity, and decorative richness. Indeed, the Pisa Duomo pulpit (Fig. 107) appears to be a recapitulation, a synthesis, and an amplification not only of the pulpits but of the major innovations and solutions of almost *all* the previous monuments of Giovanni and his father. Its iconographic amplification is immediately evident not only in the enlarged number of narratives – each parapet of the bridge leading from stairway to balustrade contains a narrative, for an unprecedented total of nine – but also in the supporting elements that, in addition to the lions (and in the case of Pistoia, an atlante) surmounted by columns of the earlier pulpits, now include unusually complex figural supports as well: in the center, the three Theological Virtues (Fig. 108), supported by personifications of the eight Liberal Arts; Ecclesia supported by the Cardinal Virtues (Fortitude, Prudence [Figs. 109, 110], Justice, and Temperance); a statue column of St. Michael, and another of Hercules (or Samson); and finally, a statue column of Christ supported by the Evangelists. Embedded in the supports there are also two individuals in contemporary garb, possibly Giovanni himself, kneeling before his namesake St. John the Evangelist, and Burgundio, the Operaio.

In an amplification of an invention of Nicola Pisano in

tion of workshop assistants became a necessity. Furthermore, coming so shortly after the completion of his Pistoia pulpit, the need to produce a second monument repeating many of the themes of the earlier one must have greatly taxed the artist's powers of invention.[47]

If, however, we expand the concept of "powers of invention" beyond that of the carving of individual reliefs to include the conception of the monument as a whole, we shall find Giovanni still at the high plateau of

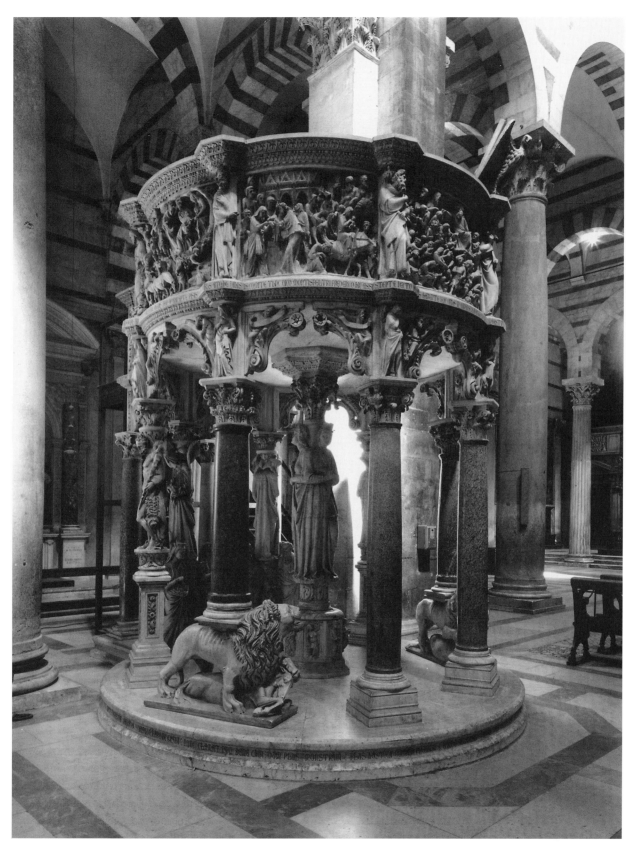

107. Giovanni Pisano: Pulpit. Pisa cathedral [Aurelio Amendola].

the Arca di San Domenico, the central support is a grouping of the antique three-figured type (Fig. 108). Descendants almost of the caryatids on the Porch of Maidens of the Erectheum, standing as they do with serene expressions, fluted drapery, and bent knee, the life-size Theological Virtues (Faith, Hope, and Charity) form the physical as well as spiritual center of the monument, for they radiate, as one observer has commented, a quiet luminosity that is more than physical.[48] The group is set upon a columnar pedestal and octagonal base; this figurated drum derives from yet another of his father's motifs, the bases of the central columns with crouching or seated figures seen on the Pisa and Siena pulpits. As on the Arca and in the case of the crowning "nymphs" on the Fontana Maggiore, the figural triad (and polygonal base) invites movement around the monument. In addition to this central trifigural support, Giovanni introduces single-figure supports as on the Arca di San Domenico. But in contrast to the latter, here the

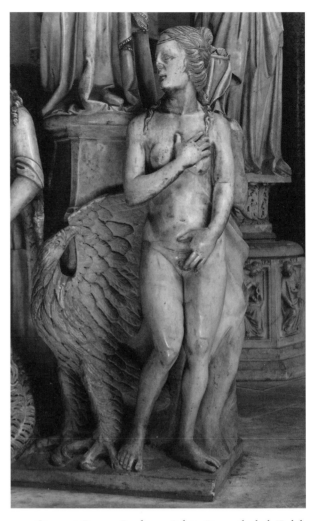

109. Giovanni Pisano: *Prudence*. Pulpit. Pisa cathedral [Ralph Lieberman].

108. Giovanni Pisano: Three Theological Virtues. Pulpit. Pisa cathedral [Pisa, Azienda di Promozione Turistica].

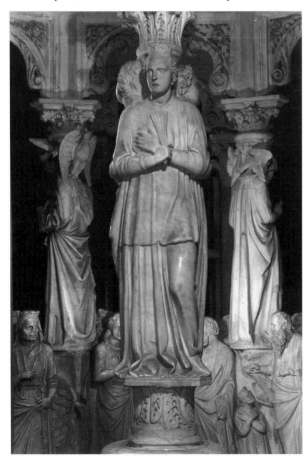

Hercules-Samson, Michael, Mystical Christ, and Ecclesia are modeled completely in the round – virtually unprecedented for supporting figures since the caryatids of antiquity. The Savior, earnest and communicative – his scroll reads, "Come to Me" – bends his head toward the faithful who must, on occasions, have stood very close to the monument to receive this address. Two of the freestanding figures – the Savior and Ecclesia – in turn, stand on cubic bases around which are represented the four Evangelists and the Cardinal Virtues, respectively. Thus, the actual (or imaginary) movement of the observer revolves around the individual supports no less than about the monument as a whole (analogous to and – dare one say? – a fascinating, unconscious anticipation of the concept of the rotation of earth and other planets as they revolve around the sun).

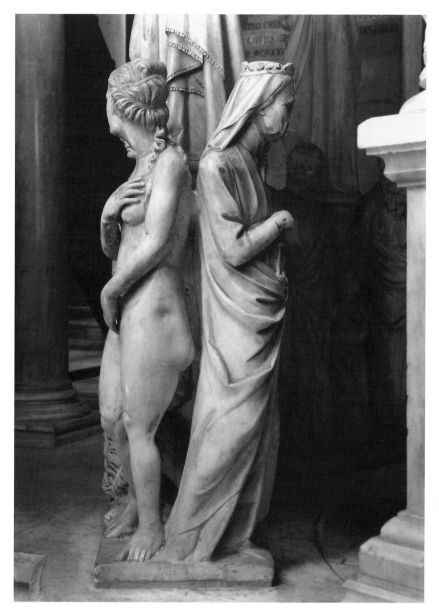

110. Giovanni Pisano: *Prudence*. Pulpit. Pisa cathedral [Ralph Lieberman].

almost from the rear (Fig. 110), as she and three other Virtues (all modestly garbed) encircle the pedestal forming the base of a single-figure support representing Ecclesia.

These groups carry the arcade and balustrade of the upper section. The first and last reliefs of the narrative sequence, enclosing the bridge leading to the pulpit platform, are on flat rather than curved panels. All the others are on curved panels, as though the unadorned concave surfaces of the Perugia fountain's middle basin have been turned inside out, so to speak, to become the convex narrative panels of strong chiaroscuro effects and undulating rhythms – convexity and concavity both always striking in their defiance of visual expectations. In the Pisa Duomo pulpit, Giovanni carries further the tendency in the previous two pulpits to replace architectural elements with sculptural ones and, as we have seen, introduces far more complex figural supports than had appeared on any earlier pulpit. In addition, where earlier one saw round-headed or pointed trefoil arcades, now classical volutes of a Baroque exuberance, impossible to enclose within the regular geometric contours of architectural norms, support the spandrel reliefs. As with the concave reliefs above, Giovanni must have relished this radical departure from the expected, although, judging from the ill will of others alluded to in the inscription on the base, this and other aspects of the pulpit may not have been universally appreciated.

Indeed, the qualitative level of the carving of individual passages is not uniform as it is, for the most part, on the Pistoia pulpit. Documents record the names of dozens of individuals engaged on the pulpit in Pisa. Given the titanic power of Giovanni's artistic temperament, promising talents must have had little room for development. At the same time, Giovanni's perhaps undisciplined nature must have made it difficult to

Nicola had introduced on the Baptistry pulpit the earliest male nude of a truly classicizing stamp, seen in the contrapposto pose and powerful muscularity of the figure of Fortitude (Fig. 33). Now, on the Pisa Duomo pulpit, in addition to the nude Hercules Giovanni introduces a female nude, standing in the Venus Pudica pose, as a personification of Prudence (Figs. 109, 110). No longer a high relief between spandrels as was the male nude on the Baptistry pulpit, thus absorbed into the fabric of the whole, the Prudence on the Duomo pulpit is virtually freestanding, her puckered flesh visible

87

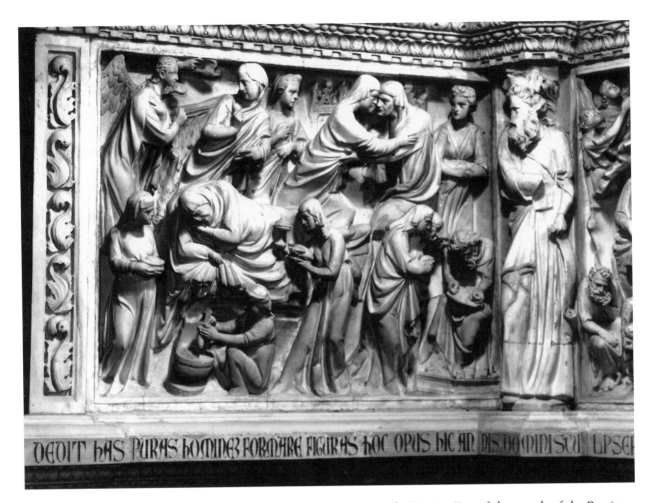

OEOIT bAS PURAS bOMINES FORMARE FIGURAS bOC OPUS bIC AN MIS OOMINI SCU LPSE

111. Giovanni Pisano: *Nativity of the Baptist*. Pulpit. Pisa cathedral [Pisa, Opera della Primaziale Pisana. Settore Patrimonio Artistico].

maintain control over all the details of the pulpit's execution. Nevertheless, not only are there passages of unsurpassed emotional power and inventiveness, such as the angel dragging a resurrected soul toward the Savior (Fig. 114) – like an Italian mamma demanding justice for a beloved scion – but many of the reliefs reveal the continuing engagement with issues of spatial illusionism and naturalism in the treatment of figures and landscape.

The narrative sequence begins with scenes from the life of Mary and of the Precursor of Christ, John the Baptist (Fig. 111). The inclusion of the Baptist's life was not determined by the need to find subjects for an expanded number of relief panels; rather, the expanded number of panels to nine was welcomed as it permitted the inclusion of key scenes of the Baptist story. Nicola's Baptistry pulpit, devoted to the life of Christ, omits ref-

erence to the Baptist. Two of the portals of the Baptistry itself, however, contain scenes from his life, dating from the early thirteenth century: the *Annunciation to Zacharias* on the north portal; the *Baptist Preaching*, the *Ecce Agnus Dei*, the banquet and dance of Salome, and the beheading and funeral of the Baptist on the east portal.[49] Missing is the *Visitation* and the *Nativity of John*. Yet the late thirteenth and early fourteenth century was a period, as already mentioned, when apocryphal literature concerning the lives of Mary, Christ, and John the Baptist flourished, and often these writings highlighted the childhood of the sacred persons. Moreover, the parallels and intersections between the life of Christ and that of the precursor are frequently emphasized. Those connections – what one scholar has called a "beautifully wrought double-helix"[50] – are made eloquently clear by representing in a single panel of the Duomo pulpit the *Annunciation to Mary*, the *Visitation*, and the *Nativity of John the Baptist*, and by the fact that more readily than the reliefs on all the other pulpits, here the first and second narratives, the *Nativity of the Baptist* and the

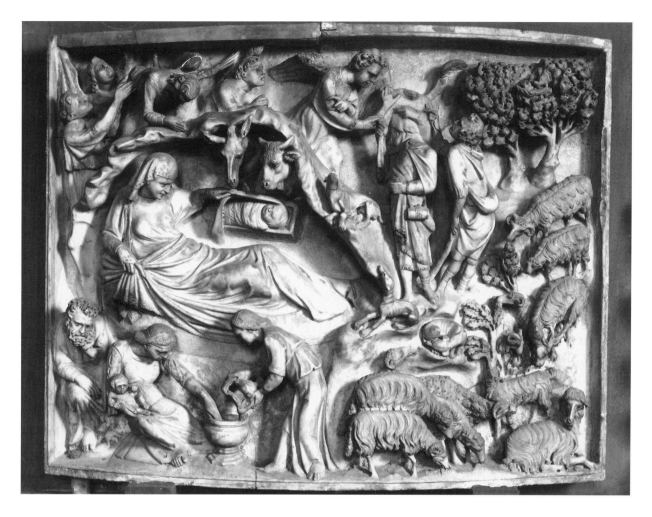

Nativity of Christ (Figs. 111, 112), can be viewed simultaneously in their totality. By filling in the iconographic lacunae of the Baptistry itself, the expanded iconography of the cathedral pulpit enhances the connections of Baptistry and cathedral.[51] The necessity of creating two Nativity scenes on a single pulpit must have been vexing, but Giovanni highlights the Baptist by showing the passionate solicitude of Mother for son as Elizabeth directly confronts the bathing scene with her gaze and hunched-over shoulders.

As on several panels of the Pistoia pulpit, three separate planes of action are suggested in the Baptist relief. In the next panel, with the *Nativity of Christ* (Fig. 112), the sense of continuity between foreground and background, already the subject of experimentation on the part of Nicola in the Siena *Adoration,* is greater and more fluid. Superimposition and overlapping and sloping ground are effective devices used by Giovanni to indicate spatial depth, likewise achieved in the *Journey and Adoration of the Magi.*[52] Here, the layering of fig-

112. Giovanni Pisano: *Nativity of Christ.* Pulpit. Pisa cathedral [Alinari/Art Resource, New York].

ures suggests a continuous if sloping ground from the horses, camels, and sleeping Magi of the foreground to the Magi on horseback and the Adoration in the background. As his father had done before him, on the upper left of the scene a horseman is seen from the back with the animal's rump facing the viewer. But in all these reliefs there is more "breathing space" between and around figures.

The *Presentation* (Fig. 107) includes one of the most complete architectural structures seen on the Pisano pulpits: a circular building with triangular gables enclosing rose windows, an attic story, and an arcade with trefoil openings from which hang lamps, all strongly reminiscent of the Baptistry. The building is clearly convex, like the curvature of the panel itself. The surging crowds of the scene bulge forward toward the *Presentation,* thus echoing the convexity of the building; only the Vir-

113. Giovanni Pisano: *Kiss of Judas and Flagellation*. Pulpit. Pisa cathedral [Ralph Lieberman].

gin and her entourage on the lower right do not participate in this ballooning of human forms as they exit and lead one's eye toward the next panel: the *Massacre of the Innocents*. Scenes from the Passion of Christ follow next, and include poignant motifs, such as Christ's direct gaze at Judas in the *Kiss* and the dejected body of the seated Christ in the *Flagellation* (Fig. 113). The *Crucifixion* panel shows the emaciated and tortured body of Christ depicted with unflinching candor. Finally, the *Last Judgment* (Fig. 114) is divided, as it had been by Nicola in Siena, between two panels separated by Christ the Judge. In contrast to the earlier depiction, here, as in the first two narratives, one can view the Elect and the Damned simultaneously since the curved surface of the

casket proper and the flat slab of the entrance bridge are juxtaposed and angled with respect to each other. The contrast between the orderly rows of the saved and the chaotic turmoil of the damned is particularly effective here. The more closely one examines the narratives, the more one becomes cognizant of the range of emotions and the effective gestures used to express them. To be sure, the theological correspondences that would give much of the pulpit's iconography meaning are lost to us due to loss of figures and possibly an incorrect disposition of some parts.[53] Nevertheless, the Pisa pulpit represents an intellectual and artistic achievement of tremendous proportions.

The Tomb of Margaret of Luxemburg

The last major work by Giovanni is the tomb of Margaret of Luxemburg (Figs. 115, 116), wife of the emperor

Henry VII. After her death from the plague in 1310 and her initial burial in a lead sarcophagus, a cult grew up around her remains, promoted both by the imperial circle and by the Franciscans of Genoa in whose church of San Francesco di Castelletto a new tomb was to be placed. Reports of miracles led to a beatification process that was concluded in 1313, the probable date for the initiation of the new tomb.[54] Much of the original complex is lost, but a major element, the exceptionally fine carving of the empress being raised heavenward by two angels, and several other fragments, including a figure of Justice, are extant. Although some scholars have argued that the tomb was a wall monument, it is more than probable that, like Nicola Pisano's Arca di San Domenico, which served as prototype for many later saints' tombs, the tomb for the beatified Margaret was freestanding.[55] The most original aspect of the tomb – the elevation of the deceased – is also open to dispute. Does it represent the *elevatio animae,* the soul elevated to heaven, fervently wished for in the prayers for the dead and assured for the saintly? Or does the patently corporeal figure of Margaret suggest not the elevation of a weightless soul

114. Giovanni Pisano: *Last Judgment.* Pulpit. Pisa cathedral [Pisa, Opera della Primaziale Pisana. Settore Patrimonio Artistico].

but rather bodily resurrection that should occur only at the Last Judgment? The visual evidence certainly suggests the latter since Margaret is sufficiently weighty to require the *physical* exertion of the two angels.

The creation of a grandiose tomb for a holy individual, with an appropriate iconographic message, sometimes served as a sort of public relations device to promote the cult and enhance the possibility of canonization. Several motifs on the tomb suggest that it was intended to function in this way. The empress wears two items of clothing that, far from deriving from actual imperial dress, have important symbolic significance: Her headgear is similar to that of the figure of Justice that supported the sarcophagus, and the criss-cross stola is garb reserved for images of the Virgin Mary, the emperor at coronation ceremonies, and priests performing the Eucharistic service. The crossed stola, thus, has liturgical associations; indeed, at daily mass the bishop recited the phrase,

91

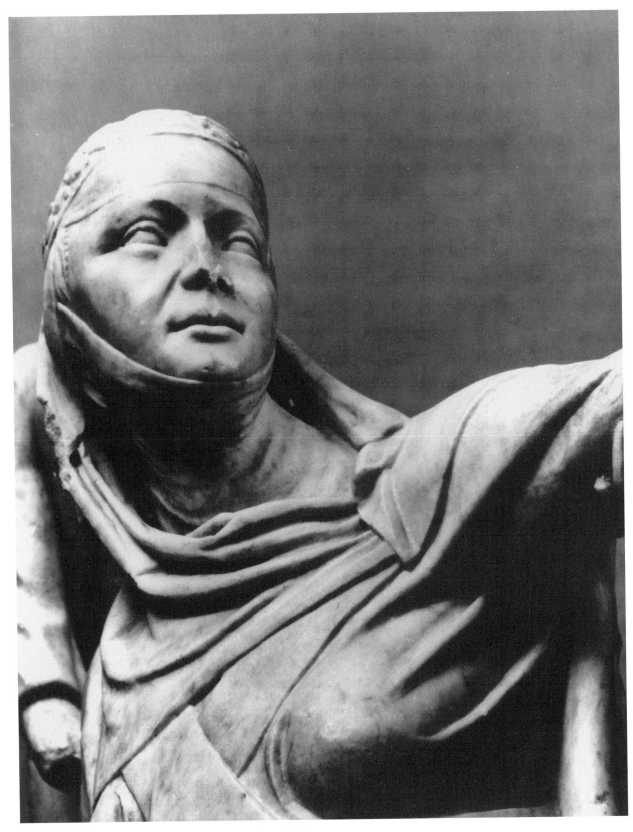

115. Giovanni Pisano: Tomb of Margaret of Luxemburg, detail.
Genoa, Museo di Sant'Agostino [after Seidel, 1987].

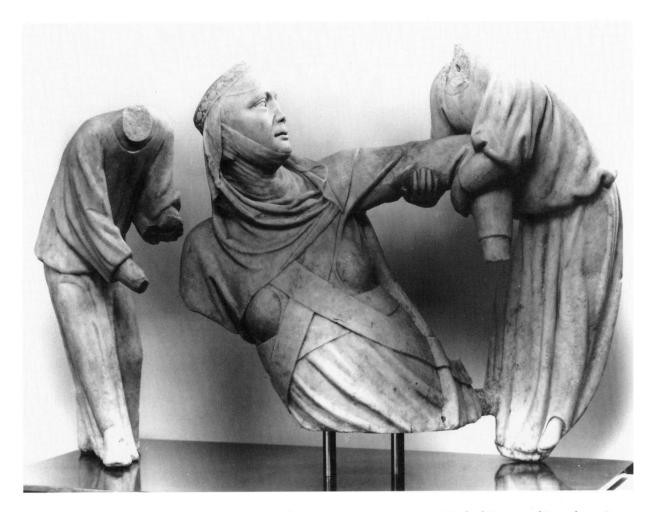

"Redde mihi, Domine, obsecro, stolam immortalitatis
. . ." (I implore of you, O Lord, the stola of immortal-
ity).[56] This combination of traditional and unusual
iconographic associations – the very physical *elevatio
animae* (with the implication that the earthly remains of
Margaret will be, or more radically, are being, accepted
into heaven like the body of the Virgin Mary at the
Assumption), the priestly stola with its associations of
eternal beatitude, and the headgear of Justice – all assure
the observer of Margaret's saintliness. Doubtless, this
furthered her cult, whose followers could hope that
eventually she would be fully inserted via papal author-
ity into the calendar of saints.

116. Giovanni Pisano: Tomb of Margaret of Luxemburg. Genoa,
Museo di Sant'Agostino [after Seidel, 1987].

The tomb for Margaret of Luxemburg is the last
known monument created by Giovanni Pisano. His name
is recorded in Siena in 1314, but in 1319 he is referred to
as deceased. Despite his disappearance from the scene,
any sculptor working in or near Pisa or Siena during the
early fourteenth century had to confront the challenge of
Giovanni Pisano's achievements. How did the former
members of his workshop, or other, independently
minded masters, deal with this formidable influence?

3

Pisan and Sienese Sculpture to 1330

Tuscan sculptors of the early fourteenth century, many of whom were trained in Giovanni Pisano's Sienese or Pisan workshops, could hardly avoid the impact of his forceful style. The evidence suggests that during his tenure at Siena cathedral from around 1285 to 1297, and while at work on the Pisan Duomo pulpit between 1302 and 1310, he was quite disinclined to tolerate opposition or independence, making it difficult for any sculptor of talent to take a path that diverged from that of the master.[1] Indeed, it requires a finely tuned eye to distinguish, for instance, work that may plausibly be attributed to the young Tino di Camaino, such as the lintel with scenes from the life of Mary on the Siena cathedral and some passages on the Pistoia and Pisa Duomo pulpits, from Giovanni's output. Not surprisingly, attempts to do so have not received scholarly consensus.[2]

In Pisa, too, although the cathedral pulpit had been completed by the end of 1310, its influence continued to dominate sculpture well into the second and third decades of the century. The pulpit reliefs from San Michele in Borgo (Fig. 117), dated after 1310, represent a naive, if appealing, vernacular

94

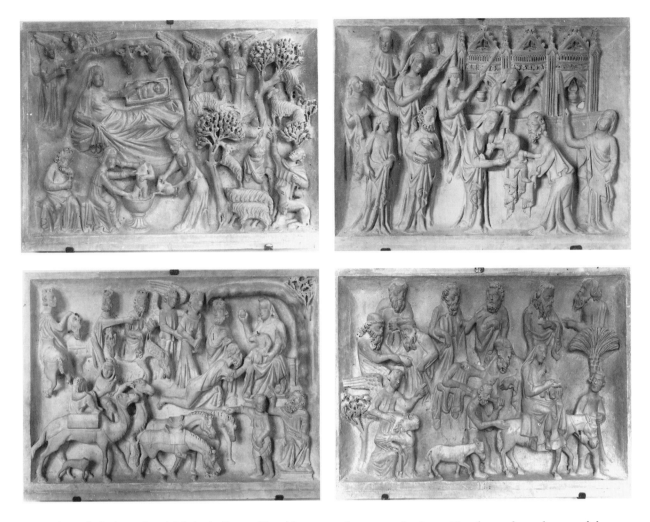

117. Pulpit reliefs from San Michele in Borgo. Pisa, Museo Nazionale di San Matteo [Istituto Centrale per il Catalogo e la Documentazione].

interpretation of Giovanni's style.[3] The *Madonna and Child* from the exterior of San Michele in Borgo (Fig. 104) and the tabernacle on the exterior of the Camposanto are examples of the transformation of Giovanni's expressive mode into what has been termed a post-Giovannesque mannerism.[4] The Oratory of Sta. Maria della Spina in Pisa, rebuilt in 1322, is embellished with sculptures by former members of Giovanni's workshop attempting with greater or lesser success to emulate his figure style.[5]

But even while Giovanni was still active, there remained an artistic undercurrent that tended to conserve the ideals of Nicola's art with its calmer, more stable compositions and greater emotional restraint. An example of this preference is the so-called Sacra Cintola formerly in the treasury of Pisa cathedral: Originally a long cloth "belt" embellished with small gilt silver and enamel relief

plaquettes, the Sacra Cintola was brought out of the sacristy of the cathedral during Easter and, according to records going back to the early fourteenth century, was wrapped around the entire cathedral ("circuncingit totam ecclesiam") on special occasions; no wonder the weight of the Cintola required two porters to carry it! Only five of the reliefs – of an extensive series representing scenes from the lives of Christ and of Saints Peter and Paul, as well as the four Evangelists with their symbols – are extant. Attributed to a follower of Nicola of the late Duecento or early Trecento, the reliefs show simplified compositions and a rhythmical spacing of the figures that highlight the gestures and relationships (Fig. 118).[6]

A rejection of the style and emotional tenor of Giovanni Pisano is seen also in a series of reliefs on the Silver Altar in the Duomo of Pistoia (Figs. 119, 120). Begun in 1287 as a simple *tabula argentea* with representations of the apostles, and made to be placed on the marble altar of the Capella di San Jacopo, it was enlarged several times to eventually become an ensemble that

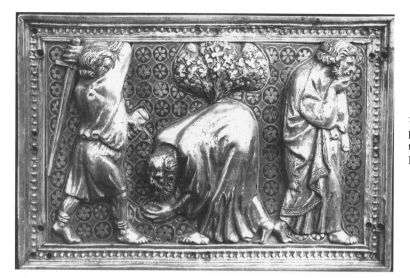

118. Follower of Nicola Pisano: Sacra Cintola plaquette, late thirteenth/early fourteenth century. Pisa, Museo dell'Opera del Duomo [Pisa, Ministero per i Beni e le Attività Culturali].

included an altar table and above it a large *pala,* replete with numerous statuettes and narrative reliefs. The earliest portions are by followers of Nicola Pisano, possibly including the one who executed the Sacra Cintola. Several goldsmiths are recorded as contributing to the altar, among them Andrea di Jacopo d'Ognabene, who signed its front in 1316.[7] Although the *Nativity,* probably his earliest relief, is modeled directly on that of the Pisa Duomo pulpit with its figures distributed throughout the picture field and little attempt to render space naturalistically, many of the remaining scenes show greater independence, for here we see figures standing on a horizontal ground in front of or within architectural or landscape settings that allow them ample room to breathe (Fig. 120). Compared to Giovanni's pulpit narratives, the emotional content is muted and the energy of the compositional rhythms is very much dampened.

Among the most gifted of the stone-carvers engaged at Sta. Maria della Spina was Giovanni di Balduccio, earlier employed in the Pisan Duomo workshop in 1317–18 when Lupo di Francesco is recorded as Capomaestro. His *Madonna and Child* (Fig. 121) on the Spina (1320s) already shows an independence from Giovanni Pisano's influence and that tendency, as we shall see, increases in his later work. Due most likely to the waning economic growth and decline of patronage in the aftermath of the death of Henry VII and the embattled political situation of Ghibelline Pisa, Balduccio seems to have worked for the most part outside his native city.[8] Very shortly, in fact, Pisa would lose its artistic prominence as major commissions attracted skilled masters to other parts of Tuscany and other regions on the peninsula.

In Siena, even after the departure of Giovanni Pisano, when work continued on the Duomo facade under the leadership of Camaino di Crescentino (the father of Tino di Camaino), the sculptures produced by Camaino's team are, on the whole, fine if somewhat less embattled versions of the language of Giovanni.[9] At the same time, what appears to be a reaction against the turbulent, aggressive art of Giovanni is seen in some of the later sculptures for the Siena Duomo facade, whose execution, if not its design, dates from after c. 1300 (see p. 68). In contrast to the powerful figures dynamically relating to each other through gesture and expression across vast architectural spaces that Giovanni had created for the lower facade in the 1280s and 1290s, the *Madonna and Child* (Fig. 122) above the rose window is imbued with a classical restraint that recalls the sculpture of Arnolfo, as a comparison with his statue from the Florentine Duomo (Fig. 81) makes clear. Several of the figures behind the balustrades on either side of the Madonna (Fig. 123) bring to mind the kneeling Magus in Arnolfo's Praesepe in Santa Maria Maggiore in Rome (cf. Fig. 73), especially with regard to the relationship of head to body and the sense of bulk beneath the simplified drapery.[10]

Also around the turn of the century, there is evidence of an acute awareness of the space-creating painting of Rome and Assisi.[11] A decade or so later a number of masters, again in contrast to the style of Giovanni and his immediate followers, worked in a more lyrical mode, translating into sculpture the formal values and engaging humanity of the frescoes and panels by Simone Martini and the Lorenzetti brothers. In the area of tomb sculpture

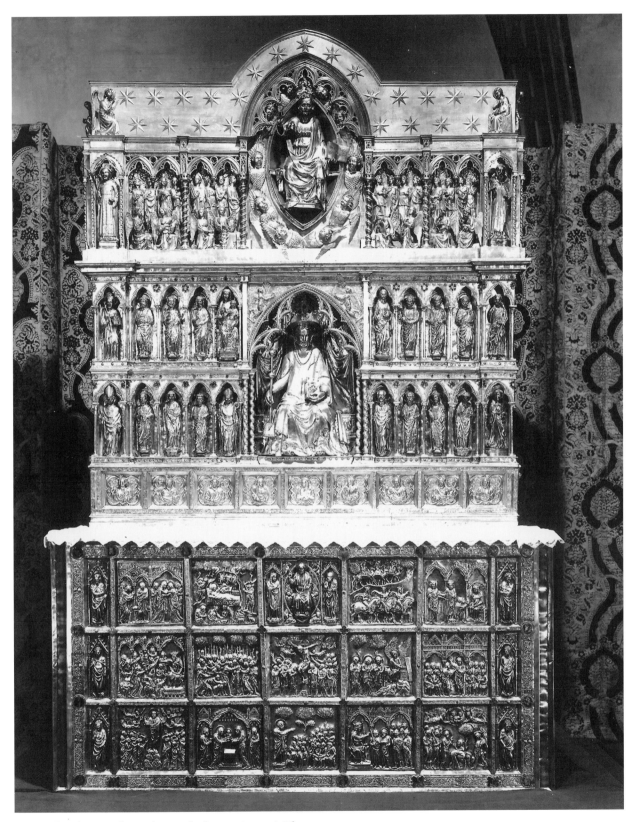

119. Andrea di Jacopo d'Ognabene and others, 1287–1316. Silver Altar, Pistoia cathedral [Florence, Soprintendenza per I Beni Artistici e Storici di Firenze, Pistoia e Prato].

97

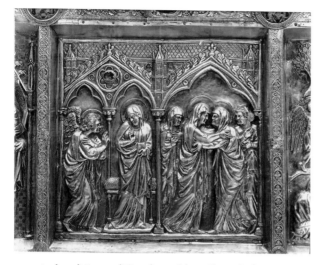

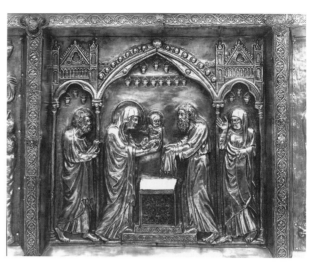

120. Andrea di Jacopo d'Ognabene. Silver Altar reliefs, 1316. Pistoia cathedral [Florence, Soprintendenza per I Beni Artistici e Storici di Firenze, Pistoia e Prato].

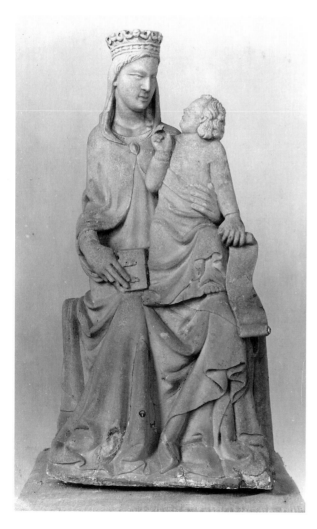

121. (left) Giovanni di Balduccio: *Madonna and Child,* 1320s. Pisa, from Sta. Maria della Spina (currently in restoration) [Istituto Centrale per il Catalogo e la Documentazione].

122. (below) *Madonna and Child* from rose window, Siena cathedral, early fourteenth century. Siena, Museo dell'Opera del Duomo [Siena, Foto Lensini].

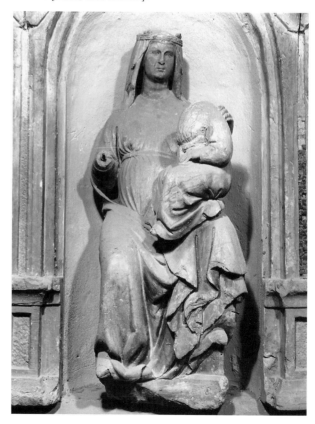

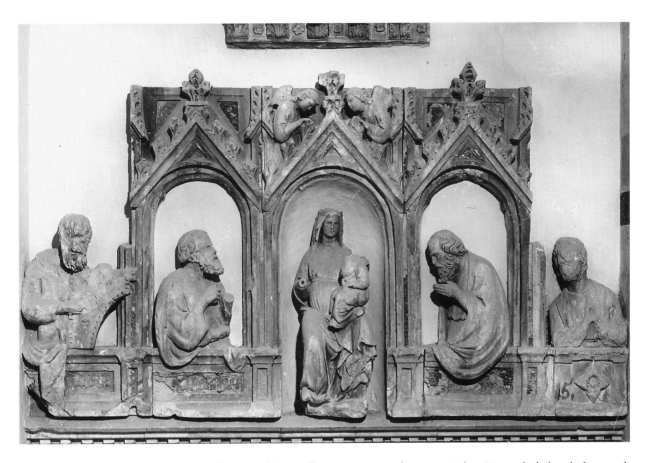

123. Figures from rose window, Siena cathedral, early fourteenth century. Siena, Museo dell'Opera del Duomo [Siena, Foto Lensini].

a significant innovation was the introduction of the wall tomb on consoles, to which we shall turn first.

The Sienese sculptor Gano di Fazio (d. 1317) executed the signed monument of Tommaso d'Andrea (Figs. 124, 125) in the Collegiata of Casole d'Elsa, his only secure work. Tommaso was born in Casole and was elected bishop of Pistoia in 1285; he died on 13 July 1303. The epigraph beneath the monument informs us that his brothers Iacopo and Sozzo had the tomb made, and so it was probably executed c. 1303–4.[12] The tomb, the earliest extant Sienese tomb with Gothic features, rests against a wall and is supported on six consoles; the narrow sarcophagus is divided into five compartments embellished with a floral motif, and on this rests the effigy of the deceased attended by five angels or deacons that hold the drapery on which he is lying. A wide trilobed arch with an Agnus Dei in the central lobe and a Blessing Christ in the gable embraces the sarcophagus and figures. The sarcophagus on consoles, which had the advantage of leaving the floor space relatively unencumbered, and the recumbent effigy are two features that would be appropriated and given new impetus by Tino di Camaino in the Petroni tomb in Siena (see Fig. 137); but the portraitlike individ-

uality of the facial features in this, and in the tomb of Beltramo del Porrina, lord of Casole, in the same collegiate church, is unsurpassed at this period and rare in Italy until the fifteenth century.[13]

The Porrina monument (Figs. 126, 127), set on the wall opposite that of Tommaso d'Andrea, was formerly attributed to Gano di Fazio but is now considered by some scholars to be a work of Marco Romano.[14] The monument shows a standing effigy that appears to be an even more penetrating portrait of the deceased than seen on the wall opposite. Previously believed to represent the Ghibelline lord of Casole, Ranieri del Porrina (the Porrina coat of arms hangs between the two arches; he died in 1315), a document discovered recently recording a lost inscription informs us that the person represented is actually Ranieri's father, Beltramo degli Arighieri, called "il Porrino," also lord of Casole, who was dead by 1313.[15] The architectural elements appear to be put together haphazardly and the tomb, originally located elsewhere in Casole,

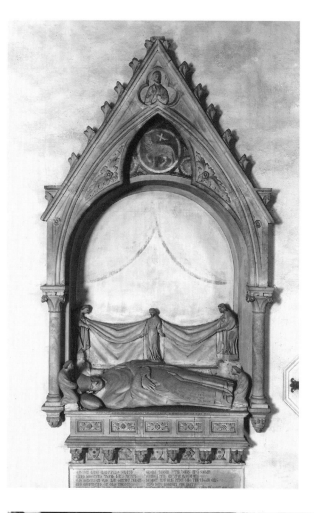

may be a pastiche of fourteenth-century and more modern pieces.[16] The inclusion of a standing figure in a tomb or cenotaph is rare if not unprecedented at this date, and in fact it is not known if the figure does originate in such a context. In any case, it would seem to be the first celebration of a layman, who is neither king nor emperor, on a monumental scale.[17] Here we see a portly figure, wearing a cloak and hat, with a sword hanging from his belt. He carries a book, almost certain proof that the figure represents the elder Porrina, who was a Doctor of Law. It is above all the unidealized naturalism of the facial features – round-faced and fleshy, with pug nose, wrinkled brow, and double chin – that impresses and intrigues the observer who wonders about its original context. Hardly an imposing authoritarian figure, it is pensive and dignified, and is to be considered a real milestone in the development of portraiture.

But it is in the area of narrative relief sculpture that Sienese carvers, after the departure of Giovanni Pisano in 1297, were most experimental and willing to be independent. Nowhere is this more evident than in a relief in San

124. (left) Gano di Fazio: Tomb of Bishop Tommaso d'Andrea, 1303–4. Casole d'Elsa, Collegiata [Alinari/Art Resource, New York].

125. (below) Gano di Fazio: Tomb of Bishop Tommaso d'Andrea. Casole d'Elsa, Collegiata [Servizio Fotografico Elemond].

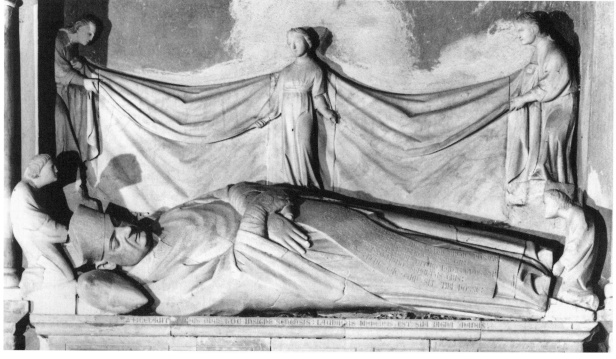

Francesco, Siena, that represents, according to an inscription beneath the figures, the participants in a consecration ceremony for the convent's cemetery that occurred on 11 April 1298 (Fig. 128).[18] Four high ecclesiastics are mentioned in the inscription, including the former General of the Order and current papal legate, Cardinal Matteo d'Acquasparta, friend and adviser to Boniface VIII, and three other bishops, all of whom appear on the relief; also shown are three Franciscan friars. The relief is perhaps one of the first sculptural representations since antiquity of a specific historical event and may have served a quasi-legal function, to support the Franciscan Convent's claim to the land destined for their cemetery.[19] In place of the complex compositions and strong chiaroscuro effects of Giovanni's reliefs, here we see a compositional economy and a quiet rhythmic movement eschewing entirely any sense of *horror vacui*. Quite the contrary, for since the figures are carved in very low relief, set against an unadorned neutral background and placed on a unified ground line with a simple, carved rectangular frame allowing plenty of headroom, they appear to be surrounded by space. The volume of the figures, further-

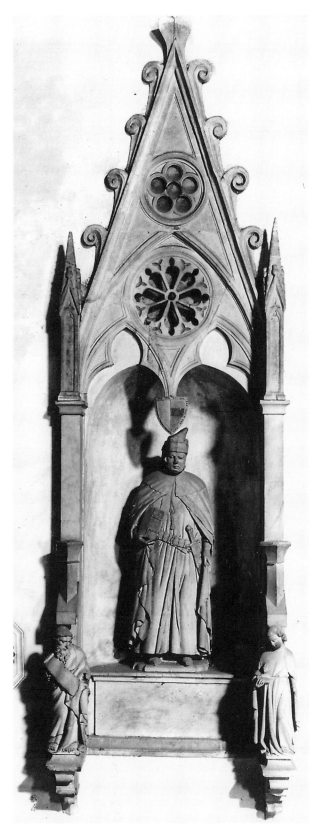

126. Marco Romano(?): Tomb of Beltramo del Porrina, c. 1313. Casole d'Elsa, Collegiata [Servizio Fotografico Elemond].

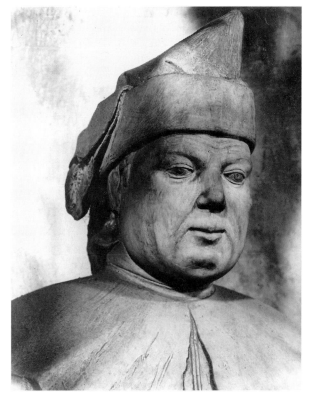

127. Marco Romano(?): Tomb of Beltramo del Porrina, detail, c. 1313. Casole d'Elsa, Collegiata [Servizio Fotografico Elemond].

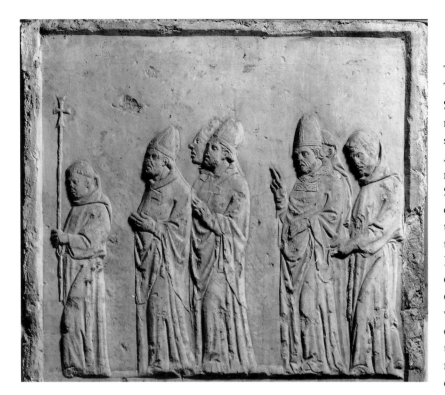

128. Consecration relief, c. 1300. Siena, S. Francesco [Siena, Foto Lensini].

TINO DI CAMAINO IN TUSCANY

Tino di Camaino introduced into Tuscan sculpture the lyrical ideals of Sienese Trecento painting. His mature works renounce both the stoicism that was Nicola's legacy to Arnolfo and the emotional vehemence of Giovanni. The son of the Sienese architect-sculptor, Camaino di Crescentino, Tino was likely trained first in his father's shop and then (possibly) in that of Giovanni Pisano in Pisa. Upon Giovanni's departure from Siena c. 1298, the elder Camaino, though not recorded with the title of Capomaestro, took on an increasingly prominent role in the architectural affairs of the commune and the Duomo.[1] The team of carvers working on the facade sculptures under his direction were for the most part unable to emulate the plastic and emotional intensity of Giovanni's figures, producing dampened versions of the former Capomaestro's style. Other sculptors in Siena would soon work in the more serene, lyrical style seen in Sienese Trecento painting. Tino's training in Siena, as well as his close study of the sculpture of Giovanni Pisano, there and elsewhere, is evident early on in a certain ambivalence between the two tendencies.[2]

more, is conveyed not by projecting the forms from the background but through illusionistic means – including a foreshortening of the shoulders – so that the effect of three-dimensionality depends entirely on the nuanced shadows created as light passes over the relief's surface. All these features, and in particular the rhythmic flow from right to left, seem calculated to convey a strong sense of the sacred and solemn nature of the ceremony. We do not know who was the author of this precocious relief. Although his style and especially *schiacciato* technique do not become prevalent in Sienese sculpture, his legacy, as we shall see, was not negligible, for many later Sienese carvers likewise rejected the crowded relief mode of Nicola and Giovanni and a few experimented with similar illusionistic means.

One of the two major Sienese sculptors who emerged as a distinctive and independent talent early in the Trecento was Tino di Camaino (the second was the master of the Orvieto cathedral sculptures, possibly Lorenzo Maitani). Tino worked in Siena, Pisa, and Florence before departing for Naples in 1323 and introducing the new ideals to Campania; it is to his Tuscan period that we first turn.

Pisa 1301–1315

The earliest work attributed to Tino, on sure stylistic and historical grounds (Vasari mentions a "Lino" of Siena – evidently a misreading of his source – who ornamented the entire Chapel of San Ranieri in the Duomo), is the tomb of Pisa's patron Saint Ranierus, executed sometime between 1301 and 1306 (Figs. 129, 130).[3] The tomb was part of a complex that apparently included an altar below the sarcophagus and a baptismal font nearby. The physical relationship between sepulcher and altar – two distinct components not usually connected – was probably like that seen in two of the reliefs on the sarcophagus, whose front forms what can only be considered a predella to the sculptured dossal above. The dossal, whose original form with crockets and pinnacles may be sur-

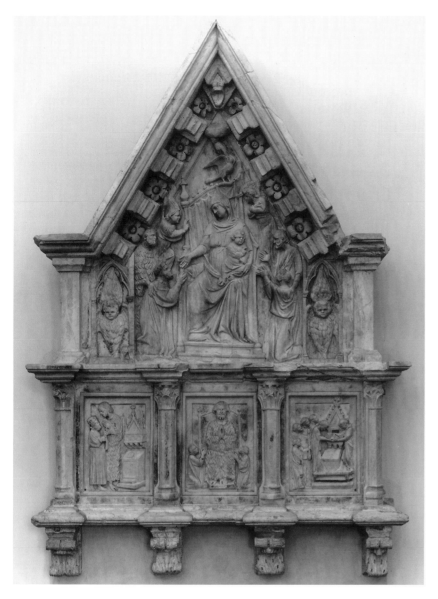

129. Tino di Camaino: Altar of San Ranierus, between 1301 and 1306. Pisa, Museo dell'Opera del Duomo [Ralph Lieberman].

mised from its representation on the tomb, shows the enthroned Madonna and Child flanked by saints and angels, as well as two kneeling figures – probably Marco Sicchi, who donated land in 1291 to pay for the tomb, and Burgundio Tadi, Operaio of the cathedral, who also contributed to the tomb's expenses and commissioned the project.[4] In the main relief the donors are presented to the Virgin by two saints, one of whom is Saint Ranierus wearing a hairy pelt indicating his ascetic life. At the apex of the gable the hand of God and a dove are

seen, probably a reference to a vision recorded in the saint's Vita. The three predella scenes show, on the left, one donor offering to the saint the tomb, complete with ancona and predella surmounted on consoles above the altar; in the center the two patrons kneel before a frontal image of the enthroned saint; and on the right, the saint's burial is represented, again showing the tomb-altar combination.

The San Ranieri altarpiece represents a freewheeling and imaginative combination of traditional and innovative elements, surprising in the work of a youthful sculptor. If the gable shape of the dossal, at least in its general outlines, is conventional for painted altar retables (although its proportions are not canonical),[5] the division into a main section and a compartmentalized predella – a good two years before the earliest preserved painted predella was begun, that of Duccio's Maestà of 1308–11 – is to my knowledge unprecedented both in painted and in carved altarpieces.[6] The upper framing, consisting of consoles projecting out strongly and alternating with sculptured rosettes, derives directly from the cornice above the Siena facade architrave, the reliefs of which have been attributed to Tino himself.[7] The awkward tilt of the Madonna's throne, the quarter circle of friars belting out chant around the burial, as well as the attempted foreshortening of the represented altar and the corpse – head thrust toward the viewer, body lost from view as it is being shoved into its tomb (Fig. 130) – reveals, in this early phase of activity, a strong desire to experiment with and translate into the medium of stone the perspective achievements seen in contemporary Sienese, Roman, and Florentine painting. This interest in spatial illusionism, combined with a figure style of simple masses and contours against a flat background, as seen in the predella reliefs, shows Tino aligning himself with the alternative current of Sienese sculpture and painting. But the unconventional form and

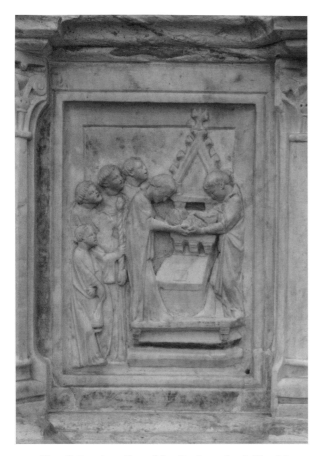

130. Tino di Camaino: Altar of San Ranierus, detail. Pisa, Museo dell'Opera del Duomo [Ralph Lieberman].

tion in Italy during his march to Rome to acquire, at the hands of the Supreme Pontiff, the imperial crown, emblem of a renewed Holy Roman Empire.[9] The republics of Central Italy, for the most part, were Guelf and thus opposed to a strengthened imperial presence, but Pisa, both for political and ideological reasons (the latter shared by such Florentine exiles as Dante Alighieri, who believed that only a strong imperial authority could restore peace to the peninsula), supported the reestablishment of the empire, essentially moribund since the death of Frederick II in 1250. But the imperial coronation proved to be very hard-won, and the hoped-for return to peace remained elusive. In August 1313, one year after his coronation, the embattled emperor took ill and died unexpectedly in Buonconvento, south of Siena. His remains were brought to Pisa for a solemn funeral that took place in the Duomo on 12

131. Tino di Camaino: Fragment from Baptismal Font, c. 1310. Pisa, Museo dell'Opera del Duomo [Florence, Kunsthistorisches Institut].

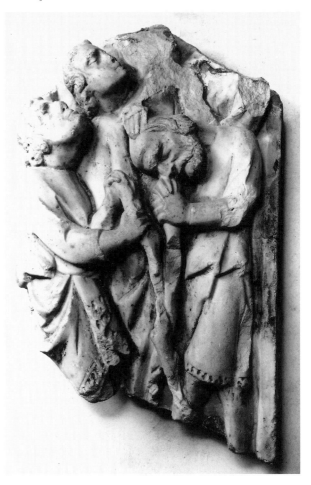

structure of the monument and the combining of motifs from disparate sources shows an inventiveness that is characteristic throughout his career.

For that same chapel Tino was called upon to make a baptismal font showing scenes from the life of the Baptist. Completed by 1312 but later dismantled, only a few fragments are extant.[8] These indicate a relief mode quite different from that of the San Ranieri altarpiece, more densely packed and without the smooth background passages seen on the earlier carving. The resultant deep shadows as well as the extreme poses of some of the figures (Fig. 131) recall the narrative and expressive mode of Giovanni Pisano. The two opposing tendencies, then, were seen side by side in the same chapel.

The Tomb of Henry VII Sometime prior to February 1315 Tino, called Capomaestro for the first time, signed a contract for the tomb of Emperor Henry VII. Henry, count of Luxemburg, had been chosen to be German king in 1308 and won the support of the Ghibelline fac-

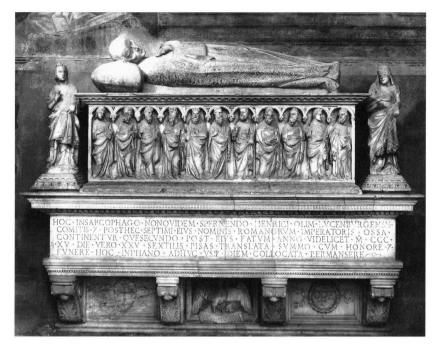

132. Tino di Camaino: Sarcophagus and effigy of Emperor Henry VII, c. 1314. Pisa, Museo dell'Opera del Duomo [Alinari/Art Resource, New York].

September.[10] Several months later Tino was given the commission for a grandiose tomb, to be set up behind the high altar against the apse wall of the cathedral. But in July 1315, before final payments were received, Tino unexpectedly left Pisa to return to his native Guelf city and the monument apparently remained incomplete.[11]

The tomb underwent several dispersions beginning in the late fifteenth century.[12] The extant parts include a sarcophagus with an apostle series on its front and a reclining effigy of the deceased (Fig. 132). The impressive seated figure of a ruler wearing the imperial crown and four almost life-size councillors that flank the monarch (Figs. 133, 134) are generally accepted as also belonging to the original composition (although at least one scholar has questioned the identity of the ruler). There is no documentary evidence that these figures were intended for a tomb, and thus some have suggested that they were designed for the city gate through which Henry entered in March 1313, returning to Pisa after his coronation in June 1312.[13] As the potentially most important emperor since Frederick II, it is entirely possible that, in an adaptation of the Porta Capua with its statue of the seated monarch and accompanying court (see Figs. 12–15), Henry with *his* court was conceived – whether or not the figures were actually installed – for a similar context. Upon his sudden

death, with the need for a monumental tomb, the figures may have found a new function and context. The inclusion of a life-size seated image of the deceased on the tomb, then, incorporates a traditional commemorative figure – with references not just to the seated emperor Frederick II (Fig. 15) from Capua but also to Arnolfo's seated portrait of Charles d'Anjou in Rome[14] – into a sepulchral context. The influence of this innovation was to be widespread (see pp. 186f., 190ff., and 309f.).

The head of a fifth councillor has been identified, leading to the conclusion that for reasons of symmetry, there must also have been a sixth figure; and, in fact, a candidate has recently been discovered.[15] The attribution of the standing figures to Tino di Camaino, however, has been questioned, for their style clearly differs from other sculptures associated with the tomb, including the seated emperor himself, the sarcophagus, and the effigy. In contrast to the enthroned monarch, the councillors are composed of massive blocklike forms with sharp edges and almost no internal modeling; the folds are flat and abstract; figure and drapery seem to belong to a single homogeneous mass; and the heads, tending toward the square-boned and broad-cheeked, while conforming to a distinctive type not seen in the work of any other sculptor, project amiable engaging personalities but display among themselves relatively little individuality. It is, however, the awkwardness of the poses – feet splayed out, or parallel, or in one case with only a single leg rather than a pair – and the lack of organic relationship of legs to torso and resultant sense of instability that are the most puzzling features, for no other statues attributed to Tino display comparable inconsistencies.[16] In contrast to the severity of these blocky, closed forms, the seated emperor's drapery is more variegated and complex, with diagonal folds and cascading hemlines; his posture has organic credibility and he gestures in space toward the viewer (the arms are broken); finally, the high-cheeked, small-boned, and sensitive head indicates an attempt at realistic "portraiture." These notable differences between the central and the flanking figures have been explained by the desire to create an expressive contrast between the hieratic yet noble emperor and his down-to-earth,

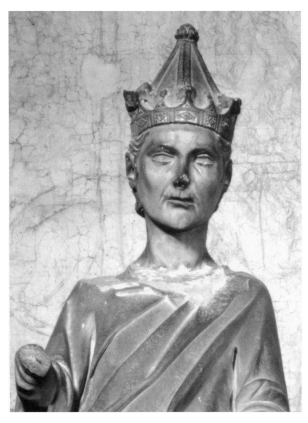

slightly whimsical (at least to modern eyes) yet dignified councillors. It has also been proposed that the more summary carving of the latter is due to the desire to make the forms, placed high on the tomb (or city gate), read effectively from a distance. The only really plausible explanation, in my opinion, is that Tino carved the figure of the emperor himself but only designed and/or partially blocked out the forms of the councillors, perhaps carving their heads, and that the figures accompanying the emperor were completed after the master's departure from Pisa by less adept assistants on the basis of misunderstood sketches by Tino.

As mentioned earlier, the association of these figures with the tomb of Henry VII has been generally upheld, but that is as far as agreement goes. There have been at least seven widely differing reconstructions of the monument.[17] The two most recent hypotheses concerning the original form of the tomb, and incorporating various

133. (left) Tino di Camaino: Emperor Henry VII, c. 1314 [Scala/Art Resource, New York].
134. (below) Tino di Camaino: Councillors and Emperor Henry VII (from Tomb?), c. 1314 [Alinari/Art Resource, New York].

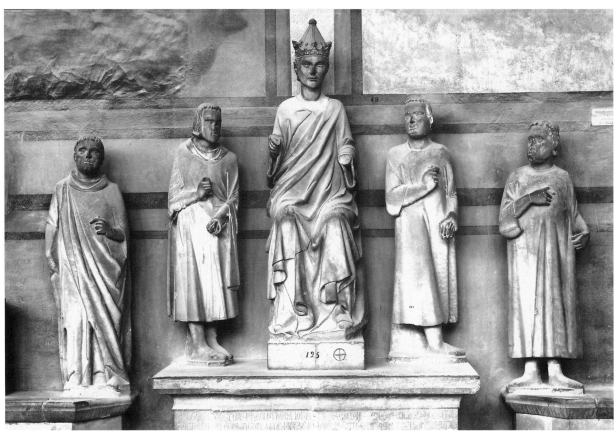

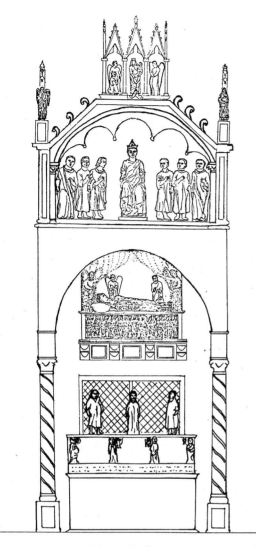

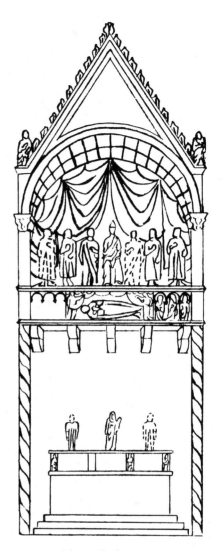

135. Reconstruction of the tomb of Emperor Henry VII [after N. Dan, *La Tomba di Arrigo VII di Tino di Camaino e il Rinascimento,* Florence, 1982].

136. Reconstruction of the tomb of Emperor Henry VII [after G. Kreytenberg, "Das Grabmal von Kaiser Heinrich VII in Pisa," *Mitteilungen des Kunsthistorischen Institutes in Florenz,* XXVIII, 1984].

other extant figures, are those of Naoki Dan and Gert Kreytenberg; and under the premise that the enthroned monarch and accompanying figures represent Henry VII and his councillors and belong to the tomb, these hypotheses offer plausible alternatives (Figs. 135, 136).[18] Both reconstructions assume a monumental baldacchino of two stories, the upper one with a platform for the large statues of Henry and his associates. Both proposals incorporate the altar of St. Bartholomew (it was on that saint's feast day that Henry died), known from a description of the late fifteenth century to have been on the ground beneath the tomb.[19] Dan offers the more conventional reconstruction (Fig. 135), which incorporates

motifs from earlier and later tombs, places the sarcophagus with effigy on consoles, and includes curtain-drawing angels against the wall beneath the round arch of the lower section and, above this, the emperor and his councillors; finally, there is a tripartite tabernacle enclosing the Madonna and Child, flanked by angels, one of whom recommends to her the kneeling emperor. The more provocative and in many ways compelling hypothesis is that of Kreytenberg, who connects the design of the Tarlati monument in Arezzo, built for the Ghibelline tyrant and militant Archbishop Guido Tarlati (d. 1327), with that of Henry VII's tomb. The Tarlati tomb (Fig. 148), the most singular monument signed by the Sienese sculp-

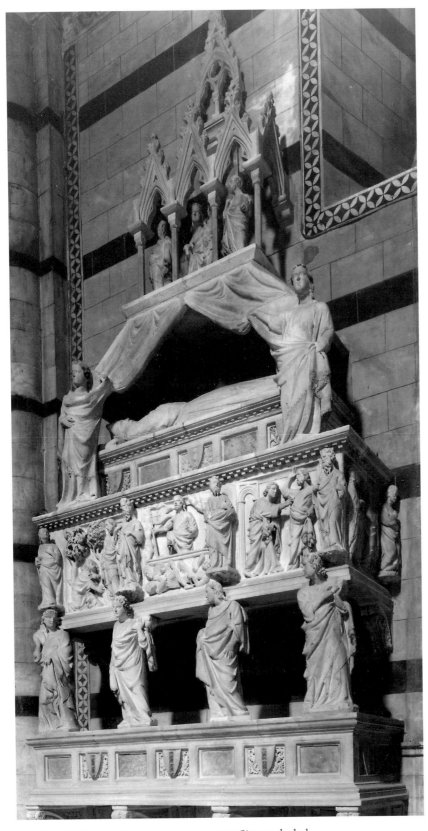

137. Tino di Camaino: Petroni monument, 1317. Siena cathedral
[Ralph Lieberman].

tors Agostino di Giovanni and Agnolo Ventura (see pp. 117ff.), has puzzled scholars because of its lack of a prototype. Not only is it one of the largest preserved medieval sculptured sepulchers, but the triumphal arch motif with its coffered vault and curtains has no medieval precedent, and it is inconceivable that the invention belongs to the modest sculptors of the tomb in Arezzo. Kreytenberg points out the likelihood that Tarlati's heirs, who commissioned the tomb, based the project on some well-known example, whose imperial symbolism was considered appropriate to the over-reaching ambitions of the Aretine bishop. Within the huge, gaping space in front of the curtains below the arch there must have been planned a sculptural group of some sort. Working backward, then, from the Tarlati monument (Fig. 148), Kreytenberg proposes that the imperial tomb in Pisa included the triumphal arch and curtain motif capped by a gable, and a platform on which were set the seated emperor and his six councillors (Fig. 136). The effigy (Fig. 132) is tipped forward, indicating that the face (the figure originally wore a metal crown, which explains the rough carving of the cranium) and the elaborately carved insignia of the emperor's garment were conceived to be effective visually. The placement of the monument within the apse and above the altar of the cathedral was unprecedented even for the tombs of saints (altars, to be sure, could be placed *over* a saint's tomb in the crypt below), and was a mark of the veneration the Pisans felt for their divinely ordained emperor. Indeed, the tomb, in which color and gold played an important role (no fewer than seven painters

were paid for work on the monument),[20] was on axis with the apse mosaic showing the Pantocrator, further emphasizing the divine origin of the imperial office.[21]

Tino di Camaino, together with his Ghibelline patrons, the commune of Pisa, conceived a monument decidedly unlike the imperial tombs of Henry's Hohenstaufen predecessors and their Norman antecedents, tombs composed of simple if grand baldacchinos enclosing massive unembellished sarcophagi.[22] With the new impulse toward sculptured monuments, in a cultural milieu that newly apprehended and valued the vestiges of its Roman past, physically present in the abundant antique remains still to be seen in Pisa, the tomb for Henry VII (if this reconstruction is accepted), with its triumphal and imperial associations, sepulchral motifs, and grandiose scale, was a worthy monument for the emperor whom Dante had described as "the solace of the world and the glory of your people, the most clement Henry, Divine and Augustus and Caesar."[23]

Siena 1315–1318

The Henry VII tomb was a Ghibelline monument, but Tino was born in Guelf Siena, and when war broke out he abruptly departed for his native city to join forces with his compatriots, taking part in the battle of Montecatini on 29 August 1315. The Guelfs, led by the Sienese, lost the battle against Ghibelline Pisa, but it was a temporary setback, for the wave of the future in Tuscan politics lay with the Guelf party. Moreover, during the next two decades Siena was to experience a remarkable flowering of artistic culture while Pisa continued to experience a political and cultural decline.[24] Tino's return to Siena, indeed, opened the way to commissions not only in his native city but in Guelf Florence and Angevin Naples as well.

The Petroni Monument Tino's first important commission in Siena, ascribed to him on stylistic grounds, was the tomb for the Sienese Cardinal Riccardo Petroni, papal legate to Genoa, where he died on 26 February 1313. His remains were carried to Siena for a solemn funeral only in March 1317, when his tomb (Fig. 137) was presumably complete.[25] Although several documents of 1318 refer to payments to Camaino di Crescentino as well as to Tino, there are no specific references to the tomb; nevertheless, Tino's authorship of the Petroni monument has been universally accepted and, indeed, with the hindsight of his later work it is hard to think of any other sculptor who

might have designed and executed this harmonious and impressive monument. The most ambitious ecclesiastical wall monument to date, the Petroni tomb derives in part from Arnolfo's de Bray monument with its curtain-holding figures revealing the effigy on its bier within the funeral chamber. Beneath this is the sarcophagus supported by four caryatids, the inclusion of which goes back to Giovanni Pisano's Margaret of Luxemburg tomb (which Petroni and/or his executors surely had seen in Genoa) (Fig. 116) and beyond that to Nicola's Arca di San Domenico (Fig. 34). Their meaning here, however, is difficult to establish since the caryatids bear no attributes; it is possible that they are angels, although they, like the curtain-holding figures above, have no wings. The sarcophagus is embellished with narrative reliefs separated, as on the Pisano pulpits in Siena, Pistoia, and Pisa cathedral, by full-length figures. Here, the *Resurrection* and its after events appear for the first time in Italian sepulchral art, asserting more vividly than ever before the belief in and hope for salvation of the soul. Christ's Resurrection is placed prominently in the center while the flanking panels, interpretations in a more vigorous language of scenes on Duccio's Maestà, show the *Noli Me Tangere* and *Doubting Thomas*.[26] As on the tomb of Henry VII, color played an important role: Traces of polychromy indicate that some garments were painted; in addition, the coats of arms were colored, and reddish marble slabs fill the fields between the coats of arms above the consoles.[27]

If Tino's work in Pisa reveals a certain tension between the pull of his native Sienese tradition and the influence of Giovanni Pisano, the Petroni monument shows Tino distancing himself decisively from the latter: In place of Giovanni's rich, pictorial mode with its crowded figures, deep undercutting that creates strong contrasts of dark and light, and contours that abruptly change direction, Tino restricts his actors to two or three figures with a few props against a flat plane (Fig. 137). Here, in contrast to both Nicola and Giovanni, and in common with the master of the Consecration panel (Fig. 128), Tino rejects all sense of *horror vacui*. The reliefs nevertheless display an inherent spatial contradiction: Strongly projecting figures extend to the limits of the picture field, and the plane against which they are set appears impenetrable, without spatial implication. The effect, as one might expect, is very different from the Consecration relief, whose function is the representation of a solemn event of recent memory. Tino's reliefs, instead, present static images outside of time and space.

As we shall see further on, it is not his relief style, as

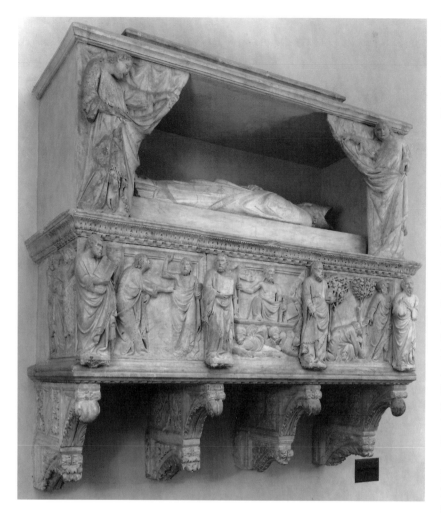

138. Tino di Camaino: Della Torre monument (d. 1318). Florence, Sta. Croce [Ralph Lieberman].

modest memorials, the fact remains that it is outside of Siena that sculptors trained in Sienese workshops, including Tino himself, found important sepulchral commissions.[28]

Florence 1321?–1323

In 1320 Tino is documented as Capomaestro of Siena cathedral, but by around 1321 he seems to have transferred to Florence.[29] Prior to this relocation, however, while still residing in Siena, he was apparently called upon by the executors of the Will of Gastone della Torre, a Florentine by birth who had become archbishop of Milan and then patriarch of Aquileia, to execute a tomb similar to the Petroni monument for Gastone, who died in August of 1318.[30] The tomb was installed in Sta. Croce, Florence.

The Della Torre Monument

Though no documents connect the tomb with Tino, it has generally been ascribed to him and his assistants.[31] The della Torre tomb (Fig. 138), which remains in a fragmentary state and thus has been the subject of various reconstructions, was clearly modeled on that of Petroni.[32] Like the latter, this was a wall tomb supported by consoles, with the sarcophagus resting on four caryatids, one of which may be that in Frankfurt (Fig. 139).[33] In this example we see a remarkable transformation, already hinted at in the varied poses and turns of the supports on the Petroni monument, of the traditional static caryatid form into a wonderfully lively figure in a dancing pose.[34]

The same subjects seen in the Petroni monument appear here on the sarcophagus front, but the relief style has changed into a dryer, less fluid one, suggesting the intervention of an assistant. The fundamental contradiction between frame and pictorial space – the figures are large in relation to the field and here even overlap the upper frame – remains the same: Tino (unlike, later, Andrea Pisano) seems unwilling to take up the challenge of his contemporary in Florence, Giotto di Bondone, who

such, but his invention and development of tomb types that is Tino's major contribution to Italian Gothic art. The narrative economy seen here, however, will be adopted by Tino's Sienese followers, Agostino di Giovanni and Giovanni d'Agostino, as well as by Andrea Pisano in Florence. Furthermore, the sculpturally rich conception and many-leveled construction of the tomb – consoles supporting a slab with caryatids, on which rest the sarcophagus and tomb chamber, the whole capped by a tripartite tabernacle containing the Madonna and saints supporting yet a smaller crowning element – will prove to be very influential in subsequent tomb designs. Curiously, however, following the erection of the Petroni monument, Siena produced few large-scale tombs within the city itself. Whether the result of tradition, of laws restricting the degree of pomp in burial ceremonies, or of social pressure for

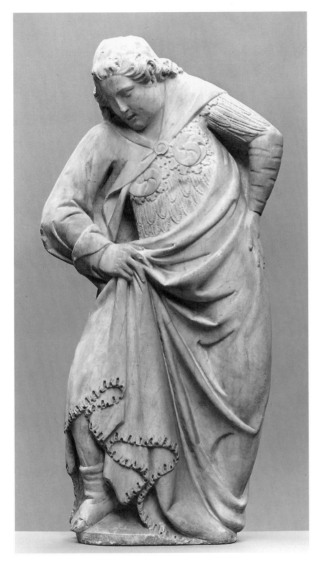

139. Tino di Camaino: Caryatid from Della Torre monument? c. 1318. Frankfurt am Main, Liebieghaus [Museum].

Madonna (Fig. 80), is belied by the gentle turn of Mary's head and the lively movement of the Child. Although the Madonna wears a veil and crown like Arnolfo's figure for the facade of Florence cathedral, and the contours are closed with few projections, the figures are not at all hieratic, but rather project an engaging warmth that characterizes many of Tino's later sculptures.

The Tomb of Bishop Orso Tino's second major contribution to Florentine sculture is the Tomb of Antonio Orso, bishop of Florence, who died in 1320 and was interred in his monument on 18 July 1321, by which date Tino seems

140. Tino di Camaino: *Madonna and Child*, c. 1318. Florence, Bargello [Scala/Art Resource, New York].

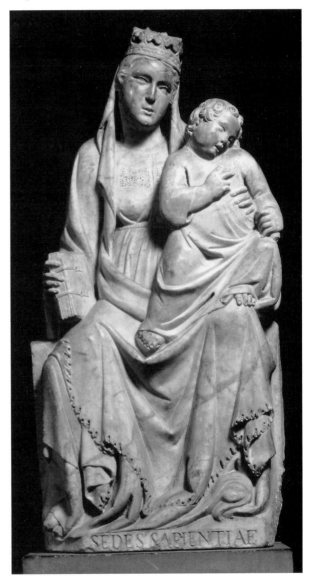

had transformed the framing elements into windows onto a new reality.

Above the sarcophagus is the funeral chamber with effigy revealed by curtain-drawing angels, and above the roof of this chamber there most likely was found an enthroned Virgin and Child flanked by two angels, one of which, shown with the kneeling deceased, may be that in the Liebieghaus.[35] Also possibly belonging to this monument is the stupendous *Madonna and Child* now in the Bargello and bearing a later inscription "Sedes Sapientiae" (Throne of Wisdom) (Fig. 140).[36] The derivation from the Romanesque type to which this designation refers, more apt with respect to Arnolfo's Florentine

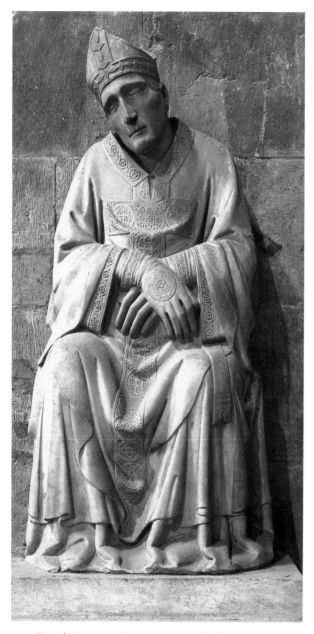

141. Tino di Camaino: Orso monument, detail. c. 1321. Florence cathedral [Alinari/Art Resource, New York].

to have moved his workshop to that city. The tomb bears the famous signature in which the sculptor – in marked contrast to the hubris of the inscription on Giovanni Pisano's Pisa pulpit – states his unwillingness to be called Maestro while his father is still alive. Once again, the monument has come down to us only in fragments (Figs. 141, 142), including an image of the seated bishop and a sarcophagus with effigy. For this tomb, too, numerous reconstructions have been proposed.[37] Without entering into the debate, we may agree that what remains suggests

a highly unusual and inventive composition with few precedents. Instead of resting on simple consoles, the sarcophagus rests on two round-headed arches, which in turn are supported by three consoles carved on all surfaces (Fig. 142).[38] The spandrels are embellished in a very unconventional manner: Rather than one or two figures as seen in Arnolfo's ciboria and the Pisano pulpits, they are densely covered with an allegorical scene whose elusive iconography is unique on tomb sculpture, although it may be based on a miniature in Francesco da Barberino's "Documenti d'Amore":[39] In the center a frontal figure, presumably representing Death, stands on a dragon and holds bow and arrows in his outstretched arms. He points toward the six figures on each spandrel, which include a pope, bishop, physician, emperor, woman, and jurist on the left and skeletons, a nobleman, a monk, and a townsman on the right. All these figures, awake, asleep, or dead, were originally pierced by bronze arrows, the remains of which are evident in the small holes filled with metal.[40] The unusual iconography seems motivated neither by any event in the contemporary political situation nor by any event in the bishop's biography; rather, the theme seems to be that Death comes to all regardless of age, rank, or gender. But the hope for *personal* salvation is seen above on the sarcophagus, where unlike the tripartite Petroni and della Torre sarcophagi, there is a continuous frieze as in an antique tomb, showing the bishop kneeling in front of Christ to whom he is recommended by the Madonna in the company of saints and angels.

The most striking feature is the statue of the bishop, *seated* instead of reclining as a traditional effigy, though like the latter the figure is represented with eyes closed and hands crossed (Fig. 141). Did the Florentine executors seek a composition that might recall that of the Pisan Henry VII monument with its large, frontal seated figure of the emperor? In that monument, and in several later tombs of secular rulers, the figures are shown alive and well, following antique precedent; here, however, the Bishop sits in an utterly indolent pose – ambiguously suggestive of sleep and death – quite in contrast to the tense demeanor of the emperor Henry VII on his tomb.[41] The bishop's pose may also allude to images of Christ in a Resurrection-Pietà, introducing in this unusual way the resurrection theme.[42] Two angels in the Victoria and Albert Museum, fragments of an *elevatio animae*, may well have been the crowning element of the composition,[43] suggestive thus of the impressive image on Giovanni Pisano's Margaret of Luxemburg tomb (Fig. 116). The general program of the monument, then, whatever

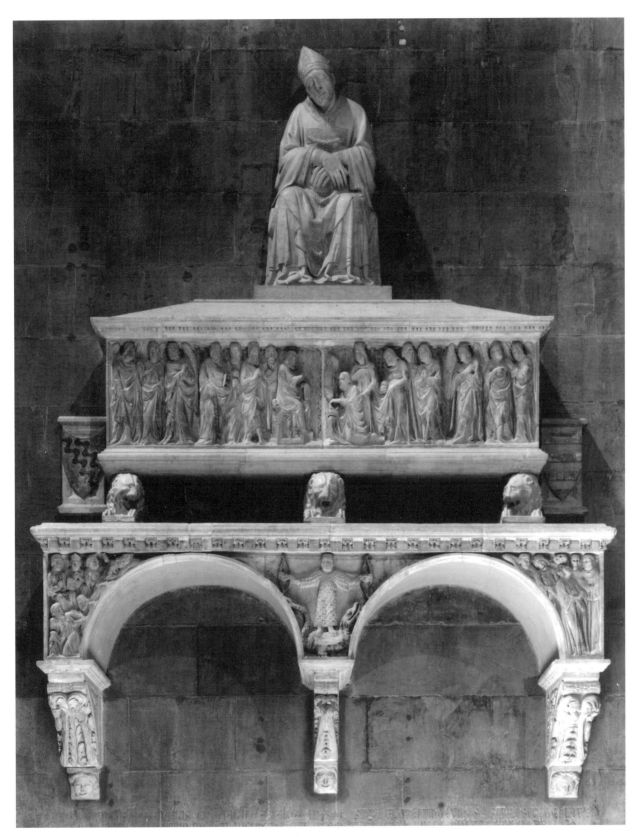

142. Tino di Camaino: Orso monument, detail. Florence cathedral [Ralph Lieberman].

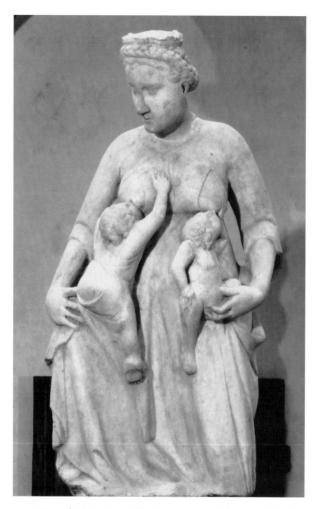

143. Tino di Camaino: *Charity,* c. 1320. Florence, Bardini Museum [Scala, Art Resource, New York].

the specifics of its reconstruction, concerned the death, judgment, and resurrection of the soul of the bishop Orso. The Orso tomb clearly reveals the willingness of Tino and his patron to adopt and manipulate iconographic elements from a variety of sources.[44]

Figure Sculptures Several other noteworthy sculptures were executed by Tino during his Florentine sojourn. In 1321 he was entrusted by the Arte di Calimala (the Guild of importers and exporters of cloth, which was in charge of the Baptistry), to execute a Baptism of Christ over the south portal and, around the same time, three Virtues over the east portal of the Baptistry of San Giovanni.[45] In addition, it must have been at this time that he – or a workshop collaborator following Tino's design, since some details of the carving bespeak another hand – made the engaging, voluptuous Charity, of unknown prove-

nance, now in the Bardini Museum, Florence (Fig. 143).[46] Closely related stylistically to the seated Orso (Fig. 141), the image is no less intriguing iconographically: One putto with back toward the observer scrambles up the mother's lap, clinging precariously to a surface that fails to provide a secure platform, and nurses voraciously. The second infant, with body facing observer but head twisted toward the breast, is supported less by his mother's lap than by her hand, which serves as a sort of seat and between whose fingers emerges a tiny penis.

Tino's Tuscan periods, then, reveal the artist to be an extremely independent personality who, together with his patrons, conceived a series of innovative tombs both in terms of structure and iconography. Although his debt to Giovanni Pisano and Arnolfo di Cambio is discernable, his sculptures are less severe and abstract than Arnolfo's, less dynamic and dramatic than Giovanni's, and more accessible than either in terms of the human warmth with which they are infused. These qualities of his figure style are equally evident during his final period in Naples when he was called upon to execute a series of tombs, remarkable for their variety and inventiveness, commissioned by the Angevin rulers of southern Italy (see pp. 180ff.).

SIENESE SCULPTURE AFTER TINO

Tino's departure from Tuscany left the field open to other talented masters, many of them probably trained in his botteghe. A number of interesting tombs originated in Sienese workshops, but the major contribution of Sienese carvers remained in the realm of narrative relief. The problem faced by the sculptor seeking a credible illusion of figures in space is how to avoid on the one hand the superimposed rows of figures illogically disposed along the entire field, as was true of most of the Pisano pulpit reliefs, while on the other providing enough visual information to create an informative narrative. The Consecration relief (Fig. 128) in San Francesco, with its two or three rows of figures in procession barely projecting from the background, did not seem to offer a solution for a narrative that required figures in action and pertinent stage paraphernalia. Sienese sculptors developed several alternative modes in their search for vivid narration. Some, such as Goro di Gregorio, created narratives with lively figures interacting in boxlike spaces carved within the block of stone (Figs. 144, 145). In Enzo Carli's apt phrase, these sculptors produced a distinct "predella style," characterized by an inclination to storytelling and lively description, an absence of drama, a loving attention to

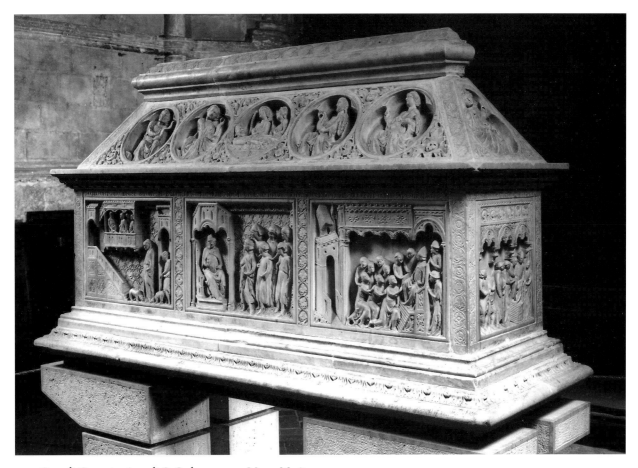

144. Goro di Gregorio: Arca di S. Cerbone, 1324. Massa Marittima [Siena, Foto Lensini].

145. Goro di Gregorio: Arca di San Cerbone, detail. 1324. Massa Marittima [Siena, Soprintendenza per I Beni Artistici e Storici].

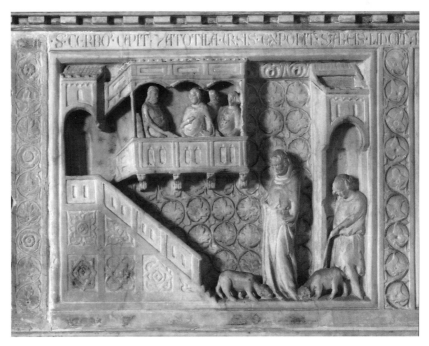

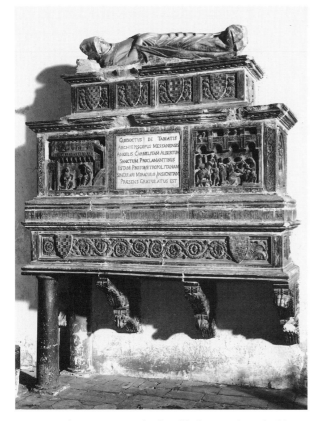

146. Goro di Gregorio: Tomb of Archbishop Guidotto d'Abbiate, 1333. Messina, [Alinari/Art Resource, New York].

detail, and a taste for flowing contours.[1] Others compromised between the low relief of the Consecration panel and the higher relief mode of Tino and Goro di Gregorio, to produce semi-illusionistic narratives.

Goro di Gregorio

Little is known about Goro di Gregorio except that his father was a Florentine sculptor who became a Sienese citizen engaged in the Duomo workshop. Goro is the author of two signed monuments – the Arca di San Cerbone (Figs. 144, 145) of 1324 in the Duomo of Massa Marittima and the tomb of Archbishop Guidotto d'Abbiate (formerly cited as de' Tabiati) (Fig. 146) of 1333 in the Duomo of Messina; many other sculptures, including a captivating Madonna and Child (Fig. 147), have been attributed to him.[2] The Arca di San Cerbone (Fig. 144) is composed of a rectangular chest of white marble surmounted by a cover with four sloping sides. The cover is embellished with twelve carved medallions with images of saints and prophets as well as the Madonna and Child,

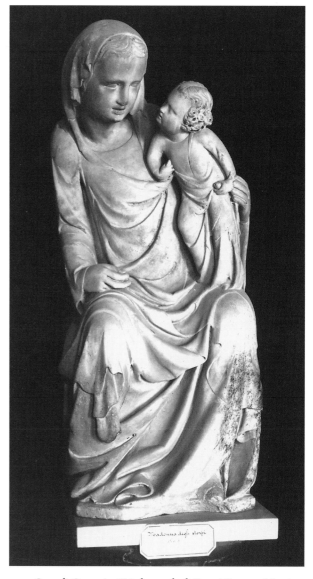

147. Goro di Gregorio: "Madonna degli Storpi," 1330s. Messina, Museo Nazionale [Alinari/Art Resource, New York].

while the sarcophagus illustrates on its four sides episodes from the life of San Cerbone, a fifth-century saint who was born in Africa but died in the Maremma. Latin inscriptions on the upper border explain the meaning of the episodes. The figures in the narratives are conceived as almost fully three-dimensional volumes with gently swaying poses and curvilinear drapery folds reminiscent of Tino's figures in Siena and Florence. They are placed into a space carved within the block of stone; yet frequently figures and architecture are applied against a highly patterned, wallpaper-like ornamental background that limits the sense of depth. The architecture is given

realistic details and occasionally, like those on Andrea Pisano's bronze doors in Florence (see pp. 134ff.), is placed at an angle to the front plane to enhance the sense of depth. Often the figures are disposed in two groups about a central caesura as though engaged in a dramatic dialogue. Until recently and for a long time, the tomb was placed under the altar of the Duomo and the reliefs were not easy to view. Although some scholars believe that this was its original site, given the liveliness of the narratives, clearly directed to the *popolo*, it seems more likely that the sarcophagus was placed in an accessible location, perhaps raised on columnar supports so that the faithful could scrutinize each individual episode with the care and enjoyment the reliefs demand.

On the basis of its similarity to the Madonna and Child in relief on the cover of the Arca di San Cerbone, a sculpture in the round, the so-called Madonna degli Storpi (Fig. 147), formerly in the Duomo (it is not known if it was part of the d'Abbaite monument), now in the Museo Nazionale di Messina, is universally accepted as the work of Goro. An exquisite reinterpretation of the French Gothic *déhanchement*, the work communicates an intimacy between mother and child – hardly surpassed even by the paintings of Simone Martini and Ambrogio Lorenzetti – that is conveyed both by the physical relationship of the two figures and the reciprocal and echoing curves that bind them together.

The Tarlati Monument

The most impressive Sienese tomb of the fourteenth century is the monument for Bishop Guido Tarlati, *signore* of Arezzo (Fig. 148), signed

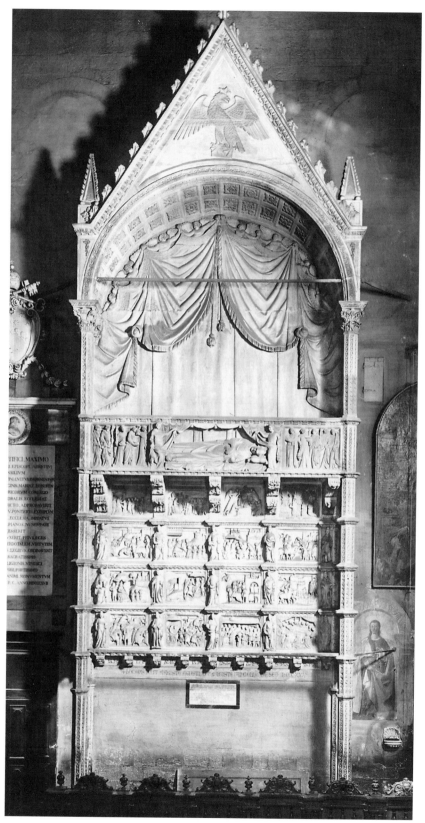

148. Agostino di Giovanni and Agnolo Ventura: Tarlati monument, 1330. Arezzo cathedral [Alinari/Art Resource, New York].

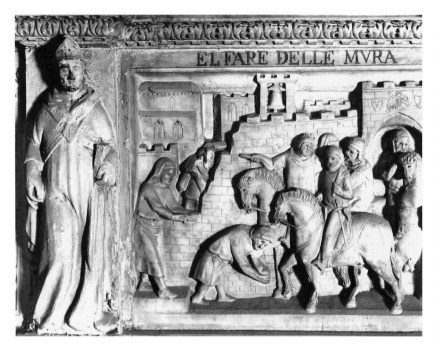

149. Agostino di Giovanni and Agnolo Ventura: Tarlati monument, relief. Arezzo cathedral [Alinari/Art Resource, New York].

and dated 1330 by two masters: MAGISTER AUGUSTINUS ET MAGISTER ANGELUS DE SENIS.[3] The two authors are presumed to be the sculptors Agostino di Giovanni and Agnolo di Ventura, cited by Vasari in connection with the monument.[4] Guido Tarlati became bishop of Arezzo in 1315 and was elected *signore* in 1323. His importance was such that he became leader of the Ghibelline party and on 13 May 1327 it was he who crowned Ludwig of Bavaria with the emperor's iron crown in the basilica of Sant' Ambrogio, Milan. He died at Montenero dell'Amiata 21 October 1327 not yet fifty years old. The monument was commissioned by his brother, Pier Saccone. Many of the heads on the monument were destroyed in 1341 when the brother and other members of his family were expelled from Arezzo; these heads were replaced in the eighteenth century when the complex was moved to its present site.

The monument, which reaches to a height of 12.90 meters and is 4.50 meters wide,[5] rests on four slender octagonal pilasters, but its bulk is also supported by a series of consoles above an inscription slab. The central section is composed of four registers of reliefs depicting an unprecedented sixteen scenes from the bishop's life, with the largest number devoted to military feats (Fig. 149). On the lower three registers the reliefs are separated by standing figures, representing Tarlati (or perhaps Tarlati and his ecclesiastic predecessors).[6] Above the biographical reliefs, and supported by consoles aligned with the standing figures of the three lowest rows, is a slab with the reclining effigy, tilted upward for greater visibility; a procession of mourning figures is seen to the left and right of the pair of curtain-holding angels (Fig. 150). Atop this section is a coffered, barrel-vaulted chamber surmounted by a broad gable and pyramidal pinnacles; the gable is embellished with the imperial eagle.[7] Extraordinary for its height, the

150. Agostino di Giovanni and Agnolo Ventura: Tarlati monument, relief. Arezzo cathedral [Alinari/Art Resource, New York].

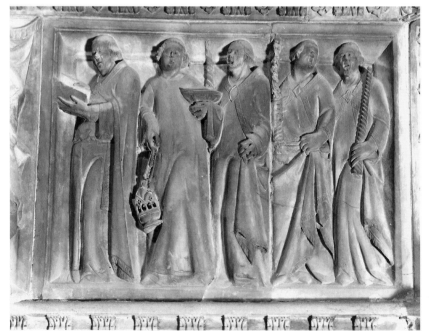

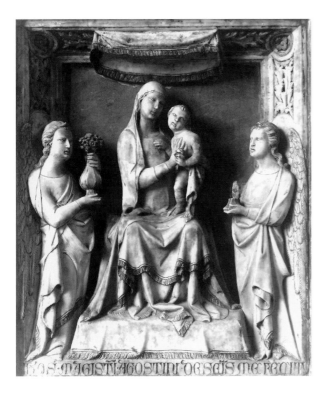

151. Giovanni di Agostino: Tabernacle. Siena, Oratory of San Bernardino, 1330s [Alinari/Art Resource, New York].

stagelike, coffered, barrel-vaulted niche recalling a triumphal arch, but which may have appeared (as noted earlier) on the monument for Henry VII; and the probable inclusion of a standing or seated image of the Aretine bishop within that niche.[10] It is significant, too, because it foreshadows future developments in which the biographical relief, the effigy, and the triumphal arch with or without a standing figure become major features of fifteenth-century tomb monuments, rarely on the scale, however, of the Tarlati monument.

The sixteen reliefs, rather than celebrating a pastoral, religious activism, relate political events and military feats in the life of Tarlati. Figures, landscape elements, and especially architecture are rendered with an eye to characteristic detail: One sees crenelated castle walls, the crocketed gable of a church portal, a trilobed window, the machinery of war, and tools of destruction, and the numerous figures play their roles with easily legible gestures (Figs. 149, 150).

Giovanni di Agostino and Sienese Pictorial Relief

The lyrical tendencies seen in the work of Goro reappear in that of his contemporary Giovanni di Agostino, son of the previously mentioned Agostino di Giovanni. A relief

monument has been called an impressive, if "uncomfortable concoction," less valuable artistically than as a social document revealing the climate of ideas and exigencies necessary for survival in a medieval commune.[8] The potency of its political message was well understood by those who defaced the monument following the expulsion of the Tarlati from Arezzo in 1341.

Yet the monument does have importance artistically, first in its eclectic adaptation of earlier works from a variety of contexts – the serialization of narratives separated by full-length figures seen in Duccio's Maestà (and earlier on the Pisano pulpits);[9] the traditional ecclesiastic effigy; the sculptured "vita" appropriating a feature of the tombs of saints; the now empty classicizing

152. Giovanni di Agostino(?): Baptismal font relief, early 1330s. Arezzo, Sta. Maria della Pieve [Alinari/Art Resource, New York].

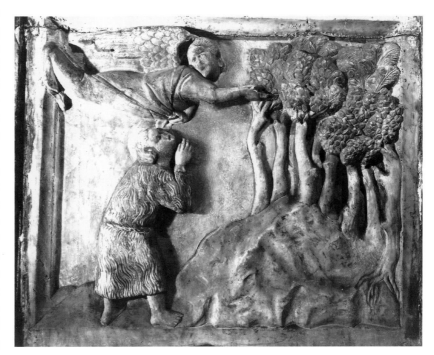

(Fig. 151) in the Oratory of San Bernadino, Siena, is his only signed work and thus a touchstone for attributions such as another tabernacle of relatively small dimensions in the Cleveland Museum of Art.[11] Both reliefs show an artist experimenting with establishing a spatial milieu for the figures by employing devices seen on well-known earlier monuments: The canopy hovering above the Siena Madonna recalls the canopy on Simone Martini's Maestà, whereas the tripartite Gothic arcade with cusped gables, pinnacles, and crockets, in Cleveland, may derive from Simone's *Annunciation* panel of 1333 for Siena cathedral.

The new pictorial illusionism but not the *schiacciato* modeling of the Consecration panel (Fig. 128) is seen in a series of reliefs on the baptismal font in the Pieve of Sta. Maria, Arezzo, datable to c. 1330–32 and generally attributed to Giovanni d'Agostino.[12] The sculptor combined a high and a flattened relief mode with figures set against a relatively unencumbered background. In the *Preaching in the Desert* there are three separate planes of depth and even a gradation of relief projection depending on the figures' positions in space. Surrounding Christ is a clearly discernable circle of figures, one of whom has his back to the viewer.[13] In another relief, the *Young Baptist Led to the Wilderness* (Fig. 152), the Baptist is placed close to the foreground and there is a bold attempt to foreshorten the left foot seen from the back; furthermore, a series of tree trunks move up toward and behind the peak of the hill that represents the wilderness.

The new pictorial language is seen in a much damaged yet still impressive relief in the parish church of Chiusdino by an anonymous sculptor.[14] The relief (Fig. 153) represents Saint Galganus being led to Monte Siepe by the Archangel Michael while a friar awaits his arrival in a wooded area. The economy of the representation, with few figures and landscape motifs against a flat neutral background, make for a highly legible narrative, while the liveliness of the poses and fluttering drapery convey a sense of exuberant movement from left to right, balanced compositionally and halted by the verticality of the trees and awaiting friar. The suggestion of a spatial milieu inhabited by corporeal forms and landscape elements, despite the illogicality of the frame molding in relation to the figures, is quite convincing.

Several other Sienese reliefs (receiving varying attributions but close in style to Giovanni di Agostino)[15] also reveal the attempt to grapple with these problems. One of the most successful is the *Funeral of Saint Ottaviano* (Fig. 154) in the Museo d'Arte Sacra, Volterra, where again there are three distinct rows of figures and corresponding degrees of relief projection seen in the foreground monks, the deceased, and the tonsured heads, carved in very low relief and visible just above the saint's body. But the relationship of figures to frame and to setting remains awkward; the translation into sculpture of Giotto's "window" behind which one views an inhabitable world has not been fully realized.

ORVIETO AND "LORENZO MAITANI"

Perched on a broad high mass of volcanic rock difficult of ascent, the town of Orvieto so dominates its surroundings that throughout its history it has severely discouraged assault. Orvieto is located about half way between Rome and Florence, and although it was an independent republic (though surrounded by the papal territories), it was of strategic importance in the struggles between the papacy and its enemies. Indeed, in times of trouble popes chose Orvieto as curial residence, and their advocates the Angevins also made extended appearances: Urban IV fled to Orvieto in 1264 to escape the threat of Frederick II's son Manfred; Clement IV arrived in 1266; Charles of Anjou in 1268; Gregory X in 1272 and 1273; and Martin IV lived in Orvieto almost without interruption from spring 1281 to the summer of 1284; finally, between 1290 and 1291 Orvieto became the seat of the Curia under Nicholas IV (1288–92). Nicholas was even elected Podestà and Capitano del Popolo of Orvieto, offices held by popes in several cities within the Papal States but never before in Orvieto. Given the consequent panoply of clerics, guards, and servants, this papal and Angevin presence provided considerable economic benefits to an already flourishing artisanal and agricultural community,[1] and it was during this period of economic growth that plans were initiated c. 1285 for building a new cathedral. The enterprise was encouraged by Nicholas IV, who laid the foundation stone in 1290.[2]

Orvieto Cathedral

The interior of Orvieto cathedral, with its round but tall columns, rich classicizing capitals, round-headed arcade arches, and open timber roof, looks at first glance more like a grand Romanesque than a Gothic structure, until one notices that the upper interior walls with large windows come to rest on points supported by the projecting shelves of the capitals, so that the actual massiveness of the walls is seemingly denied. This tension between substance and the denial of substance, between the grandeur

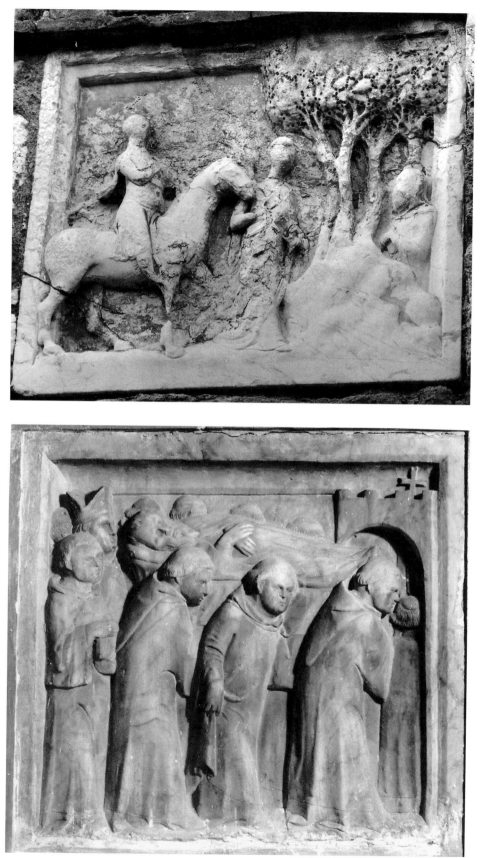

153. San Galgano relief, 1330s. Chiusdino, parish church [Roberto Bartalini].

154. *Funeral of Saint Otta-viano,* 1330s. Volterra, Museo d'Arte Sacra [Pisa. Opera della Primaziale Pisana. Settore Patrimonio Artistico].

and dignity of the forms and the immense spatiality that helps to dematerialize the solids and surfaces, makes this building unique and difficult to categorize. One scholar has suggested the term "papal Gothic" for the building,[3] as a partial acknowledgment of its connection with the early Christian structures contemporaneously being restored by the popes, such as Sta. Maria Maggiore under Nicholas IV, who as we have seen was also a patron of Orvieto cathedral. The papal connection is suggested, as well, by the projecting semicircular chapels on the exterior north and south flanks, derived from the council hall of the Lateran palace,[4] and by the decision, propelled by a renewed interest in the extensive narrative cycles in fresco and mosaic of early Christian basilicas, to incorporate a vast narrative cycle on the facade. Local tradition also would seem to have played a role in this decision: The Romanesque facade of San Piero in nearby Spoleto (Fig.

155. San Pietro, Spoleto [Alinari/Art Resource, New York].

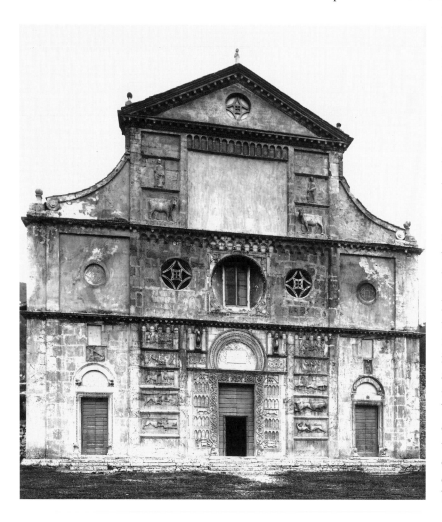

155), showing a series of reliefs extending to the first cornice, may have suggested the employment of *facade* reliefs. Furthermore, Umbria was a center of Franciscanism, and the planners of the Orvieto facade program were surely acquainted with the extensive narrative fresco cycles of the upper church of San Francesco recently completed in Assisi. The new impulse toward affective spirituality, toward an empathetic relationship with Mary and Christ that could be induced, for example, by reading and contemplating the events depicted in the *Meditations on the Life of Christ,* could hardly be satisfied on Tuscan cathedral walls, given the tradition of striped incrustation and limited openings for stained glass. The desire to more closely connect to the sacred stories and their protagonists partially explains the sudden appearance of extensive narratives on pulpits, on the back of Duccio's Maestà, and on the facade of Orvieto cathedral.[5]

The combination of arches, gables, mosaic, textured or perforated surfaces, and the delicate soaring pilasters and pinnacles make the facade of Orvieto cathedral (Fig. 156) look like a huge reliquary, much more so than the facades of Siena and Florence, which were a source of inspiration and a challenge to the Orvieto planners. The visual interest of, and tension between, the immaterial – the great variety of surfaces, textures, colors, and forms – and the actual structural solidity of the building with its huge base upon which the four-square geometric design of the upper facade is anchored, at once keeps the observer at a distance in order to take in the whole and invites him or her to come closer to examine the details. From a distance the effect of the lower facade is of an undulating, textured, and colorful band of fabric stretching across the underlying masonry support.[6] As one approaches, one becomes aware of the delicate balance achieved between the narrower, more densely carved central piers with their manuscript-like circular medallions evolving from acanthus-like leaves enframing the reliefs, and the broader, less compacted lateral relief

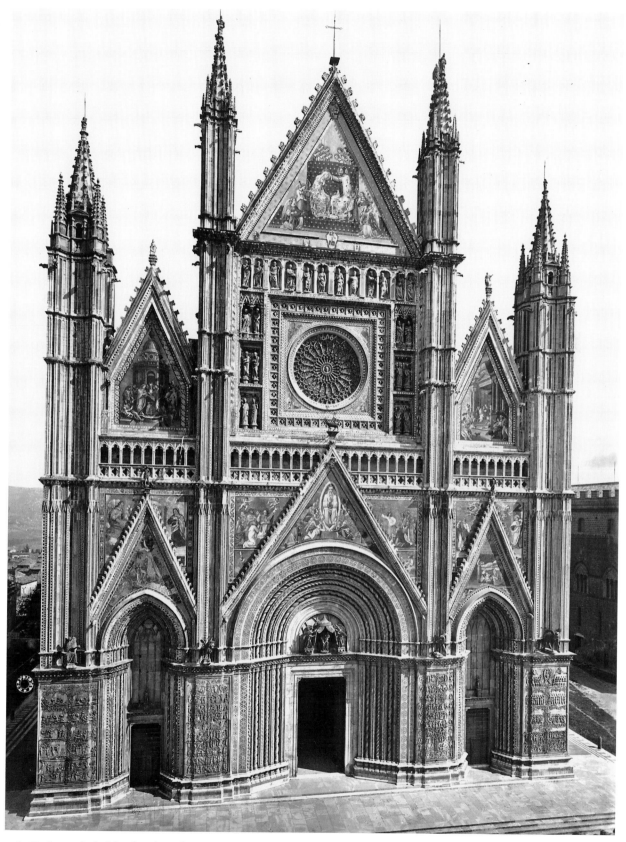

156. Orvieto cathedral facade [Alinari/Art Resource, New York].

157. Lorenzo Maitani(?): *The Creation of Adam,* c. 1310–30. Orvieto cathedral facade [Istituto Centrale per il Catalogo e la Documentazione].

bands separated by slender vines that spread out from their central, intertwined stems. Finally, only upon moving very close to these surfaces is the transformation from relief texture to relief narrative perceived, at which point the observer is invited to scrutinize the individual vignettes and follow the course of the story told on a grand scale (Figs. 157–60).

Like the cathedrals of Florence and Siena, that of Orvieto is dedicated to the Virgin Mary. Whereas at Siena, because of the Virgin's intervention against the Florentines in the Battle of Montaperti of 1260, the program is a civic-oriented one, at Orvieto the Marian theme is, for the first time, placed within a universal context.[7] The Orvieto facade includes not only sculptures of Mary enthroned with angels (Fig. 161), and scenes from her life, but a Genesis cycle, a pier devoted to the Tree of Jesse and

the Old Testament prophesies of Redemption, a New Testament cycle, and the Last Judgment (Figs. 157–60). On the Genesis pier, in addition, we find representations of the Liberal Arts. Thus, the viewer stands before a sweeping exposition of the Creator's universal plan, moving from left to right, with the beginning and end of time bracketing the precursors or prophesies of the Old, and the fulfillment in the New Law.

The decision to expand the scope of the illustrative material provoked a highly original solution to the problem of sculptural embellishment: Instead of the niche and pinnacle figures and the lintel or lunette reliefs that abound at Florence and Siena (Figs. 79–83, 85–90), here all the sculpture (with a few notable exceptions, e.g., the marble Madonna with bronze angels, in the lunette of the main portal [Fig. 161], and the bronze symbols of the Evangelists) is concentrated on the four piers of the lower facade. The use of foliage as enframements for figures ultimately goes back to the antique, but was employed by Giovanni Pisano on the half columns that

framed the central portal of the Siena Duomo facade.[8] Here, however, it is as though Giovanni's "peopled scrolls" were unfolded and spread across the facade.

None of the documents refer to Lorenzo Maitani as a sculptor (although he was the son of a Sienese stone- and wood-carver, which makes it not unlikely that he followed in his father's profession). Lorenzo's name first appears in Orvieto in 1310 when he is called "universalis caput magister" of the cathedral works and given Orvietan citizenship as well as immunity from municipal taxes. From the same document we learn that he had been called on earlier to repair the fabric of the building, which was in precarious condition. He retained his position until his death in June 1330. The only reference to a work of sculpture associated with his name is in a document of 1330 concerning the casting of an eagle, symbol of John the Evangelist, presumably for the facade, but this does not prove that he designed the bronze. However, in 1310 he was authorized to take on whatever "discipulos" he wanted "ad designandum, figurandum ed faciendum lapides pro pariete supradicta," that is, to design, to image/conceive, and to make the stones for the walls of the cathedral. From this we must assume that he oversaw the entire project including the sculpture, a task that itself must have required an experienced sculptor, especially given the vastness and complexity of both the design and installation of the reliefs.[9]

Artistic rival of Siena and Florence, and latecomer as well in initiating a new cathedral project, Orvieto gave expressive scope to one of the most singular masters of the early Trecento. Although the reliefs show some variation in style, and there have been many attempts to distinguish the hands and identify the names of the stone-carvers involved, a large portion of the outer piers with Genesis and the Last Judgment as well as several of the inner pier reliefs reveal the hand of a distinctive

158. Lorenzo Maitani(?): *Angels at the Creation*, c. 1310–30. Orvieto cathedral facade [Istituto Centrale per il Catalogo e la Documentazione].

artistic personality that Carli, for one, has labeled "the probable Lorenzo Maitani."[10] The Sienese roots of this master are clearly discernable in the quiet lyricism with which the events from Genesis are depicted and the intense interest in landscape, abundantly inhabited by flora and fauna.[11] Characteristic of this master are figures conceived as volumes that occupy and displace three-dimensional space, achieved in part by a gradation of relief height carried out with unequaled subtlety: The angels in the Creation scenes (Fig. 158) emerge diagonally out of space, a result achieved by the difference in the projection between the upper and lower parts of

159. (above) Lorenzo Maitani(?): *Visitation*, c. 1310–30. Orvieto cathedral facade [Istituto Centrale per il Catalogo e la Documentazione].

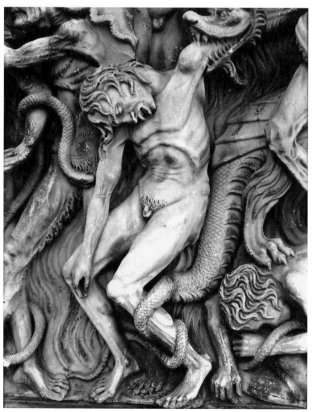

160. Lorenzo Maitani(?): *Last Judgment*, detail, c. 1310–30. Orvieto cathedral facade [Istituto Centrale per il Catalogo e la Documentazione].

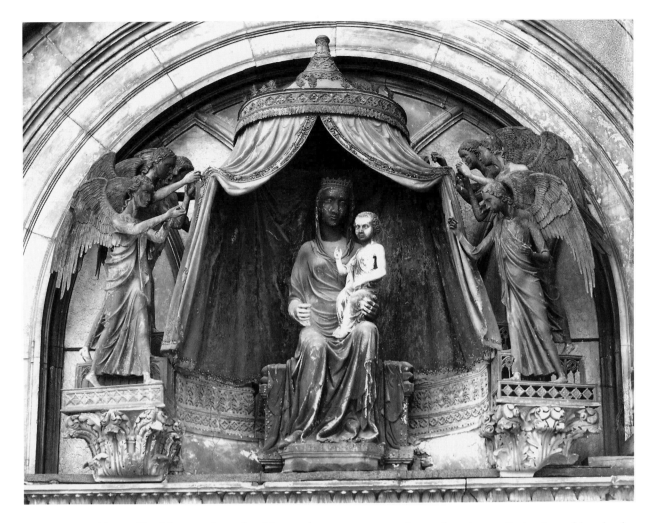

161. Lorenzo Maitani(?): Mary enthroned with angels, c. 1310–30. Orvieto cathedral [Alinari/Art Resource, New York].

their bodies. This master's figures tend toward a particular physiognomic type with long straight noses, short upper lips, and small chins; the hair undulates in deeply undercut strands; and the drapery is drawn tightly in transparent folds that cling about the limbs. Despite the poetic elegance of the figures in Genesis, the master was also capable of conveying suffering of unparalleled intensity through contortions of pose and expression made more effective by the realism of the anatomical details (Fig. 160). A second sculptor may have been responsible for the design of the more robust, less elongated figures within a deeper inhabitable space, such as the representations of the *Annunciation, Visitation* (Fig. 159), and *Nativity*.

To date, the most compelling assessment and analysis of the Orvietan sculptures and the documents associated with them is a brilliant article by John White of 1959.[12]

He argues that rather than a distinction of hands, the apparent stylistic differences on the facade reliefs result primarily from varying states of finish in the individual slabs that were roughed out and partially carved on the ground, and then completed in situ. White claims that following the initial blocking out and rough finishing of the blocks, there was a division of labor in which groups of craftsmen were assigned specific executing tasks, moving from one block to another to work, for instance, on hair, or trees, or bodies and drapery. The individual slabs – totaling 162 separate pieces! – were then installed jigsaw puzzle–like with adjustments to the shapes made as necessary. Only after this stage was the final polishing done, and in fact, many of the reliefs never reached that stage of completion. Thus, in this view, the rougher carvings – for example, the Crucifixion – are not the result of a cruder hand but of the particular state of finish.

While a veritable "army of masons" may have executed the reliefs, the carvings, which date from c. 1310 to 1330,

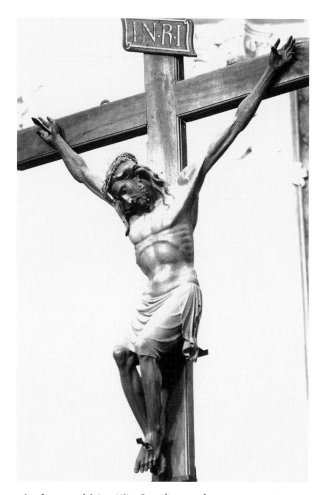

162. Lorenzo Maitani(?): *Crucifix*, wood, c. 1310–30. Orvieto, San Francesco [author].

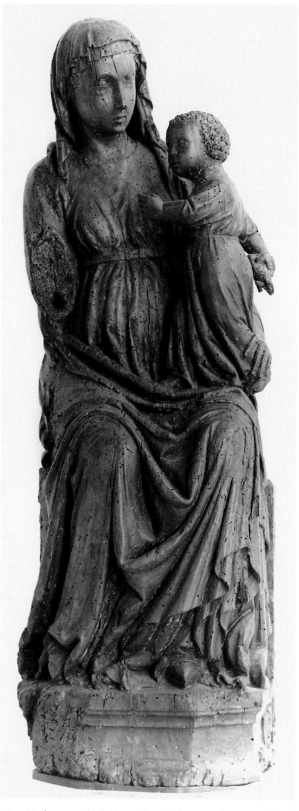

163. *Madonna and Child*, wood, early fourteenth century. Orvieto, Museo dell'Opera del Duomo [Courtesy of the Opera del Duomo of Orvieto].

must have been supervised by one, or possibly two masters under the immediate direction of the Capomaestro, Lorenzo Maitani, who may himself have been identical with one of these. A large number of the facade sculptures, and the works associated with them, are of a very personal style without compelling affiliations to any of the major masters of Siena: Whereas iconographic connections are clear in the many cognate scenes on the pulpits, there is no direct stylistic line from Nicola or Giovanni to "Maitani" or from Tino and Sienese sculpture to "Maitani" and Orvieto.[13] For the time being we must be content to recognize in the facade as a whole a masterpiece of design whose reliefs count among the most beautiful and powerful of the Trecento.

Like the facades of Siena and Florence – perhaps even more so – that of Orvieto cathedral had no close precedent and certainly no successors. Only the figure style of "Lorenzo Maitani" shows up elsewhere than the facade,

notably in a number of wood cruci-
fixes and Madonna groups. Three
stupendous wood crucifixes, in the
Duomo and in San Francesco (Fig.
162), reveal a rejection of the
almost bitter dramatic power of
Giovanni Pisano in favor of a clas-
sicizing emotional restraint.[14] In
these works, while the lower torso
and legs turn to the left, the upper
torso is frontal and thus accommo-
dates itself to the axis of the cross.
There is, moreover, a tendency to
reduce the sharp angle of the head
in relation to the body. Notable,
too, are the gently swinging curves
of the drapery, which add a lyrical
accent to the composition and serve
to heighten the dominance of the
vertical axis. The effect of these
variations is to decrease even fur-
ther the sense of physical pain. In
the elegance of the linear rhythms,
and the noble poignancy of the
expressions, we have here an inten-
sity of a different sort from that of
Giovanni Pisano (cf. Fig. 106), one
that is no less emotionally com-
pelling and empathetic in its effect.

A family resemblance to the
lunette Madonna (Fig. 161), if not an
identity of hand, can be seen in the
features of a wooden Madonna in
the Museo dell'Opera del Duomo,
Orvieto (Fig. 163), although the
thick drapery differs from that of the
clinging folds of the marble. The
motif of the standing Child is of
French origin (and was employed by
Simone Martini in the Maestà in the
Palazzo Pubblico in Siena), but here
it exhibits an impetuous liveliness
not seen elsewhere.[15] A master from
Orvieto almost certainly executed
the monument of Pope Benedict XI
(d. 1304) in Perugia (Fig. 164).
Although it is conventionally dated
shortly after the pope's death, on
stylistic grounds it is more likely

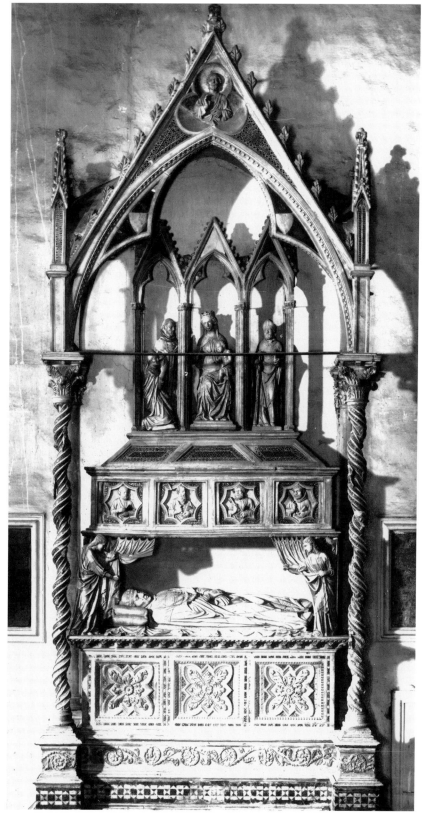

164. Monument of Pope Benedict XI (d. 1304). Perugia, San
Domenico [Alinari/Art Resource, New York].

that it was executed about a decade later.[16] To be sure, the design is based on that of Arnolfo's de Bray monument (Figs. 56–58) in nearby Orvieto (Arnolfo had also designed the tomb of Benedict's predecessor, Boniface VIII). Like the de Bray monument, there is an effigy above the sarcophagus in a tomb chamber that is revealed by acolytes holding curtains, and in the upper register the deceased kneels before the Madonna and Child. As was probably the case in the earlier tomb at Orvieto, the whole is enclosed within a Gothic canopy supported by columns. Here, the inlaid spiral colonettes include the novel feature, based on antique precedents, of putti clambering up the surfaces.[17] The physiognomy and drapery of the acolytes bear strong resemblance to figures in the Genesis scenes at Orvieto, whereas the Madonna and Child recalls the wood figure (Fig. 163) also associated with Maitani. The influence of "Maitani" has been discerned, as well, in the figures on the portal of the Palazzo dei Priori in Perugia.[18]

We have observed during the first third of the Trecento the varied reflections, interpretations, and rejections of the styles of the founding masters of Italian Gothic sculpture, Nicola and Giovanni Pisano and Arnolfo di Cambio. The classicizing gravity of Arnolfo remained an undercurrent in Pisa, where Giovanni was still active during the first decade or so of the fourteenth century, but it found a more receptive milieu in Siena as work proceeded on the upper facade of the cathedral after the departure of the Capomaestro. Indeed, Siena seems to have encouraged a variety of artistic modes: While some Sienese masters worked in a more lyrical, some in a more expressive style, still others created works reflective of the ideals seen in Arnolfo's sculpture and Giottesque painting, the roots of which go back to the art of Nicola Pisano. Many of the sculptors strove to translate into the medium of stone some of the achievements in painting of Duccio, Giotto, and the St. Francis Master in Assisi, all of whom created credible stage sets for the action of their figures. Indeed, the attempt is often made to avoid (not always successfully) the inherent spatial contradictions of Tino's relief style that result from the juxtaposition of figures in high relief extending to the limits of the picture field and a flat, impregnable background plane. It is in the area of this new "pictorial relief"[19] that the most striking, varied, and characteristic achievements in Sienese sculpture lie. Participating in these experiments is the master of the facade of Orvieto cathedral, whose impact, together with other Sienese masters, will be discernable shortly in Florence, as well. Whether we call him "Lorenzo Maitani" or not, the directing master proved capable of orchestrating a complex and grandiose architectural-sculptural enterprise in which, notwithstanding the varieties of individual expression on the part of the major stone-carvers and the division of labor in the execution of the vast number of reliefs, the final result was a decorative and programmatic unity of unsurpassed quality.

4

Trecento Florence and Pisa

ANDREA PISANO

Perhaps more than any other early Trecento sculptor, Andrea Pisano assimilated into his art the elegant and precious style that originated in Paris in the 1220s, reached full flower around the middle of the century, and infiltrated Italy by way of goldsmithwork, ivories, and other portable objects. Indeed, some of his most impressive achievements are difficult to explain on the basis of Italian tradition alone. But his native classical bias and his pictorial restraint as a disciple of Giotto made him receptive also to the "classical" tendencies of French art that developed simultaneously in some mid-thirteenth-century workshops in Paris and Bourges.[1]

As his name indicates, Andrea was not a Florentine by birth (nor is he related to the earlier Pisano family) but was born in Pontedera near Pisa, where he probably received his apprenticeship.[2] But the decline of Pisa and ascending fortunes of Florence must have attracted him to that city. During the late thirteenth and early fourteenth centuries Florence, participating in a pan-European phenomenon that had begun earlier, experienced an unprecedented and rapid urban and cultural growth that transformed a

131

modest town smaller than Pisa into one of Europe's great cities. Its population increased four- to sixfold, reaching in the early Trecento a figure close to 90,000. Physically Florence expanded well beyond the confines of its twelfth-century walls; a new wall was built between 1284 and 1333 that incorporated five times the area of the earlier one, among the largest ever built to that date by any European city.[3]

Earlier it was pointed out that economic prosperity, based on grain production, the banking industry, and the manufacture and export of wool, and a rise in the urban population led to a demand for building in the private, civic, and ecclesiastic sectors.[4] And so a program of building and decoration was initiated that saw, among other activities, the transformation of the modest cathedral into one of the grandest churches of Europe (begun 1296),[5] the embellishment of the Baptistry with a new set of monumental bronze doors (executed between 1330 and 1336), the rise of the Campanile (begun 1334), and the erection of the Palazzo dei Priori (under way in 1299, and later called the Palazzo Vecchio). Finally, midway between the civic and ecclesiastic centers of the Palazzo dei Priori and the Duomo, and linking them along the present Via dei Calzaiuoli, the old grain market of the city was given a monumental structure, the open loggia and storage facilities of Orsanmichele (begun in 1337).[6]

Arnolfo di Cambio had died leaving unfinished the Florence cathedral facade, which was the first element of the new structure to rise. After his death attention seems to have turned to the flanks, which rose surrounding the old cathedral of Sta. Reparata, and to the foundation for the new eastern end. In the early 1320s the Arte di Calimala (the Guild of importers and exporters of cloth), which was in charge of the Baptistry, decided to embellish that building's exterior, devoid till then of sculpture, with a series of sculptured groups over the portals, and to cover the existing wooden doors with metal plates, but in November of 1329 the officials of the guild altered the plan. Instead of the traditional wooden doors covered in metal, the Baptistry doors were to be made entirely of metal. Furthermore, the goldsmith Piero di Jacopo was to be sent to Pisa to sketch the bronze doors there and then to find a bronze-caster in Venice, where the technique was still a living craft. Andrea Pisano is first documented, and in fact mentioned as "maestro delle porte," in early 1330, although he must have been involved in its design prior to that date.

That Andrea was trained as a goldsmith is indicated not only by the several documentary references to him as *orefice* but also by the evidence of a goldsmith's mental-

ity in the pristine decorative and miniaturist details seen in his architectural designs and monumental sculpture. In Florence he executed his masterpiece, the bronze doors for the Baptistry, which he signed in 1330 and which were installed in 1336.[7] Contemporary records indicate that he was given the role of Capomaestro of the cathedral after the death in 1337 of Giotto, who had held that office from 1334. During Giotto's tenure attention had turned from the cathedral itself to the erection of the Campanile; Giotto designed but did not live to execute more than the lowest relief story of the structure. Controversy surrounds the precise contribution of Andrea to the architectural design of the Campanile,[8] but there is general agreement regarding most of the reliefs that are attributed to him on the lowest relief zone. Andrea seems to have left Florence c. 1343, during a period of social and economic decline, moving his workshop to Pisa where he remained until 1347 and executed, among other projects (none documented), the Saltarelli tomb in Sta. Caterina.[9] He is documented in Orvieto in 1347 and 1348 as Capomaestro, but either died or was inactive by late 1349 when his son Nino is named in that office.[10]

The Annunziata and the Baptistry Doors

Although the scale and workmanship of the bronze reliefs would seem to confirm Andrea's training as a goldsmith, the demands of small-scale execution and the type of commissions Andrea would have received in such a workshop do not seem sufficient preparation for the execution of those figures on the doors whose monumentality belie their size (e.g., Fig. 171). These figures presuppose larger works in wood or stone, whose impact as three-dimensional presences Andrea was able to reduce to the tiny scale required on the doors. One work, whose attribution has been vigorously disputed, but which so closely anticipates his figure style on the door reliefs and later statues that this writer firmly maintains the earlier ascription to Andrea, would seem to offer an example of the sculptor's style prior to his appearance in Florence. The polychromed wood life-size Annunciate Virgin (Figs. 165, 166) in the Museo di San Matteo, Pisa, bears the date of 1322 on its octagonal base, as well as the signatures of two individuals, Agostino di Giovanni and Stefano Accolti of Siena. For that reason most scholars have concluded that the first name is that of the Sienese sculptor of the Tarlati monument (Figs. 148–50) of c. 1330, while the second is an otherwise unknown painter who did the polychromy.[11] But the wood Virgin, whose

gravity and sense of balance recall nothing so much as Giotto's figure style (a major influence on the doors, as well), has little to do with the swaying poses lacking in anatomical conviction of the Sienese sculptor (cf. Fig. 150, left); nor can one point to any work by him with a comparable expression of alertness and psychological warmth (Fig. 166).[12] Here, rather, the weight of the body and the forces of gravity on it, expressed by the long, unyielding, and predominantly vertical folds that break only slightly near the plane of the ground, result in a columnar form, enlivened, however, by the "entasis" of its contours. The figure is given further potential for movement by the hint of distinction between the engaged and free leg, and by the slight rotation of the body, its spiral movement culminating in the turn of the head. It is perhaps the quality and expression of the head – infused as it is with a palpitating vitality – that more than any other aspect distinguishes this Annunziata from contemporary carvings (and which is comparable only to the finest of Giotto's heads), to be seen again in the Sibyls of the Campanile and the Madonna della Rosa (Figs. 180, 181, 184).[13]

If Andrea was trained and working in Pisa in the 1320s, where the influence of Giovanni Pisano could still be felt, almost nothing in Andrea's sculpture suggests that he was receptive to this current; rather, it is the alternative mode that conserved the ideals of Nicola's art with its calmer, more stable compositions and greater emotional restraint that seems to have been important in the formation of Andrea. But Pisa, culturally on the decline (see pp. 96, 109), was not favorable to his development; employment opportunities must have been extremely limited, as there were no major sculptural projects under way. Siena, in contrast, had productive workshops and moreover provided an environment that, as we have seen, permitted the development of independent and personal modes, including those that appear at Orvieto, which must have attracted many sculptors to its active *équipes*. The Baptistry and Campanile reliefs in Florence show that Andrea had carefully studied the sculpture of his Tuscan predecessors, not only Nicola Pisano and Arnolfo di Cambio but also Tino di Camaino and Lorenzo Maitani, as well as the painting of Giotto.[14]

Despite Arnolfo's presence in Florence at the turn of the century, after his death the city on the Arno could hardly boast a vital school of sculpture. Florentine patrons had to turn to the Sienese Tino di Camaino when important public and private commissions had to be fulfilled. If interest and money were not lacking for such new projects as the making of a set of bronze doors for

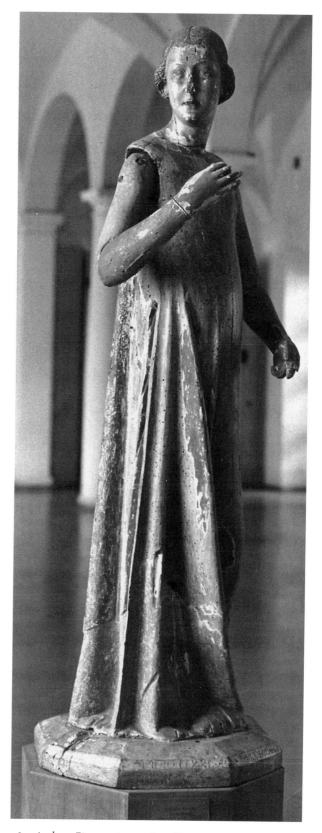

165. Andrea Pisano: Annunciate Virgin, 1322. Pisa, Museo Nazionale di San Matteo [author].

133

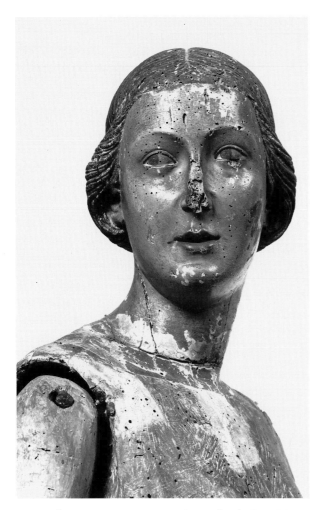

166. Andrea Pisano: Annunciate Virgin, detail. Pisa, Museo Nazionale di San Matteo [Aurelio Amendola].

the Baptistry during the years when the Florentine economy was approaching its peak, a sculptor equal to the task was not to be found within the city walls. So once again the Florentine authorities turned to a "foreign" master, offering the portal commission to Andrea Pisano.

The upper frame of the Baptistry doors (Fig. 167) bears the inscription ANDREAS: UGOLINO: NINI: DI: PISIS: ME: FECIT: A:D: MCCC:XXX. The doors were cast by means of the ancient *cire perdu* method – a technique largely lost during the Middle Ages[15] – with the figures, details of setting, and decorative motifs fire-gilt. The installation, itself a difficult and laborious project, was complete in time for the June Festa di San Giovanni in 1336.

Each door valve consists of fourteen rectangular fields enclosing a quatrefoil frame with figural reliefs. Twenty quatrefoils illustrate the life of John the Baptist and, on the lowest two rows, eight contain seated Virtues. The

design, based on the general configuration of Bonanus's doors on the Duomo of Pisa, represents a total transformation of the Romanesque model into the language of Gothic,[16] and unlike any earlier example impresses the viewer as the creation not just of a sculptor but, paradoxically, of an architect as well as a goldsmith. Brilliantly calculated to achieve maximum overall decorative unity, the design presents a series of varied geometric shapes that encourage the transition from monumental door to small narrative reliefs. The relief compositions, in turn, continually refer back to the shapes and directions of the framing elements, both that of the quatrefoils pierced by rhomboids, and the surrounding rectangular moldings; indeed, the action of the narratives rarely extends beyond the limits of an implied inner rectangle whose boundary is defined by the intruding points of the angles and lobes. As the observer approaches the doors, the perception of the larger abstract pattern (the door and its framing elements) gives way to an awareness of the pierced quatrefoils with their figural reliefs, ending finally with a focus on the naturalistic organic forms and the content and meaning of the narratives.[17]

The doors illustrate the life of John the Baptist, patron saint both of the building, as one would expect (scenes from his life are included in the apocalyptic vision of the universe in the mosaic vault inside the building), and of the city of Florence itself. The spiritual foundation and ideals of his Vita are signified in the lowest row of reliefs containing personifications of Virtues. The Baptist's story is narrated with utmost concentration and focus by means of few figures and the sparing use of props (Figs. 168–71).[18] The compositions of most reliefs tend to adhere closely to the demands not of the curves and angles of the pierced quatrefoil frame but of an inner, "invisible" rectangle determined by their intruding points and echoing the outer dentilated rectangular moldings. Within this implied framework, verticals and horizontals predominate as the main compositional vectors, lending a Giottesque stability to the narrative action. The austerity of the images, in which strongly projecting forms are set against the broad flat ground, is mitigated, however, by the flowing drapery rhythms that enliven the surface of each quatrefoil. Poignant and expressive gestures are often isolated against the flat ground so that the stance of a body, the movement of arms and hands, or the tilt of a head is saturated with significance – as in a pantomime production on a stage. The emotional range of facial expression is limited, as though in reaction to the dramatically expressive figures of Giovanni Pisano and in favor of the restrained expressive con-

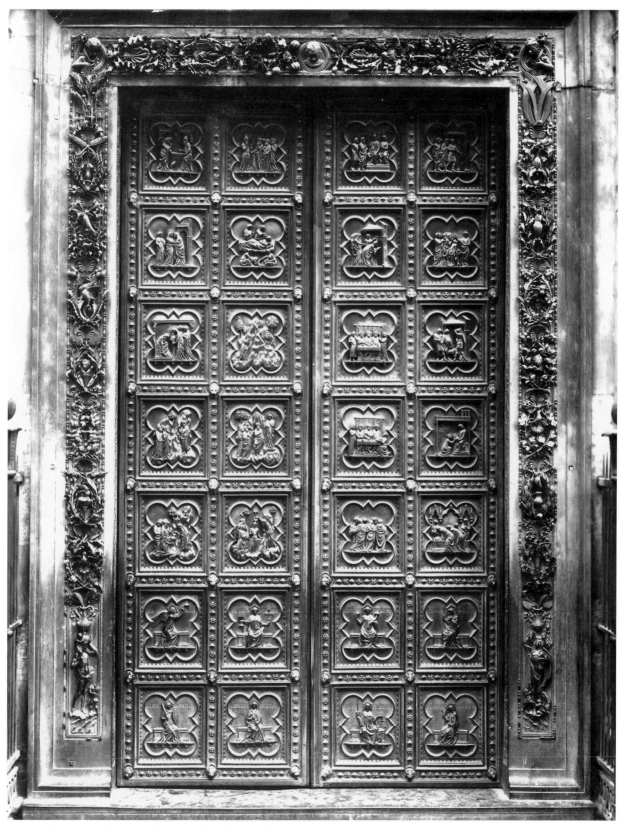

167. Andrea Pisano: Baptistry doors, completed 1336. Florence,
Baptistry [Alinari/Art Resource, New York].

168. Andrea Pisano: *Annunciation to Zacharias*. Florence, Baptistry [Soprintendenza per I Beni Artistici e Storici di Firenze, Pistoia e Prato].

169. Andrea Pisano: *Visitation*. Florence, Baptistry [Soprintendenza per I Beni Artistici e Storici di Firenze, Pistoia e Prato].

170. Andrea Pisano: Baptistry doors, *Young John in the Wilderness*. Florence, Baptistry [Soprintendenza per I Beni Artistici e Storici di Firenze, Pistoia e Prato].

171. Andrea Pisano: *Visit of the Disciples*. Florence, Baptistry [Alinari/Art Resource, New York].

tent of Giotto's paintings. Yet upon close examination – and unlike most architectural sculpture these reliefs demand very close scrutiny – the viewer is invited to respond to the consternation of Zacharias's companions (Fig. 168), the joyful anticipation of the infirm upon meeting Christ, and the anguish of the disciples at the burial of the Baptist.[19] Within these concentrated worlds the figures achieve a monumentality heretofore seen only in large-scale sculpture (Fig. 171). Indeed, although the architectural motifs – fragmentary and sometimes placed obliquely, as in the Arena Chapel frescoes – contribute to the illusion of spatial depth, the impression that there exists a cogent space derives primarily, again as in Giotto's paintings, from the plasticity of the figures themselves, which have a weight and presence that both demand and create spatial scope (Fig. 169).

Italian tradition alone, as suggested earlier, cannot explain many of Andrea's most characteristic forms; they presuppose an acquaintance with and deep receptivity to developments in architecture and sculpture north of the Alps. From among the various stylistic threads that make up the rich fabric of transalpine art, Andrea, particularly in his early bronze reliefs, adopted elements of the decorative vocabulary and figure style seen in the courtly and mannered art originating in Paris and spreading elsewhere during the second half of the thirteenth century. Increasingly, however, in his later bronze and marble reliefs, he turned toward a more "classicizing" current of French sculpture that dates from the middle of the thirteenth century.[20]

There is, in fact, a noticeable stylistic development from the left- to the right-hand door valves, suggesting that the former were designed before the latter, more or less in the chronological order of the narratives. The earlier reliefs (e.g., Fig. 168) show a stronger emphasis on linear and decorative elements, more closely tied to con-

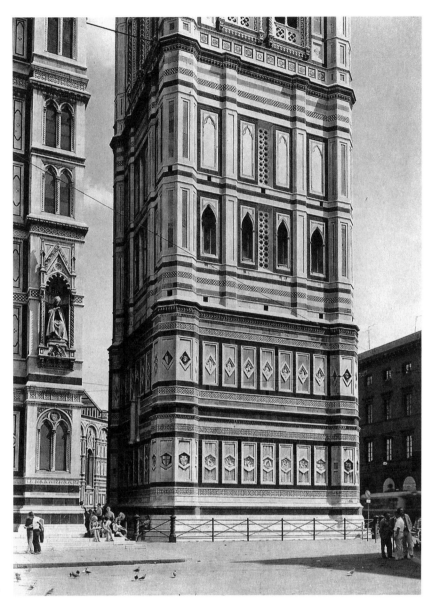

172. Campanile of Florence cathedral, lower section [Marvin Trachtenberg].

temporary French art, whereas the later narratives (e.g., Fig. 171) tend toward a more plastic and monumental conception of figures and composition, a tendency that is fully developed in the Campanile reliefs of 1334–37.[21]

The Campanile Hexagons and Niche Figures

Even before the bronze doors were installed on the Baptistry in 1336, and while Giotto was Capomaestro, Andrea was at work on the hexagonal reliefs for the Campanile of Florence cathedral (Fig. 172). It is not clear

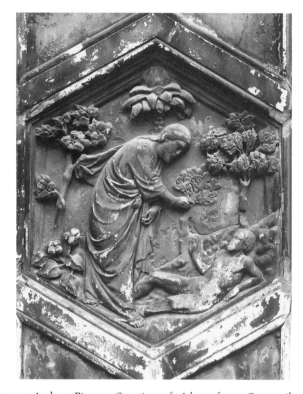

173. Andrea Pisano: *Creation of Adam*, from Campanile, 1334–37. Florence, Museo dell'Opera del Duomo [Alinari/Art Resource, New York].

174. Andrea Pisano: *Jabal*, from Campanile, 1334–37. Florence, Museo dell'Opera del Duomo [Alinari/Art Resource, New York].

175. Andrea Pisano: *Noah*, from Campanile, 1334–37. Florence, Museo dell'Opera del Duomo [Alinari/Art Resource, New York].

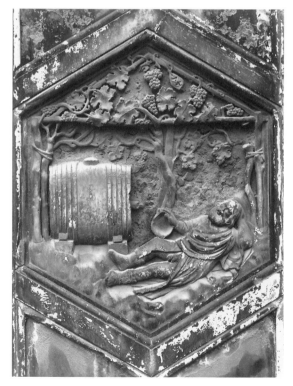

whether Giotto's original conception for the bell tower included a program of relief sculptures, although fairly early on a Genesis cycle was executed on the west facade. Indeed, careful analysis of the reliefs indicates that there are rather abrupt changes of style, suggesting three periods of execution and even a change of directing hand.[22] Conceptually and stylistically closest to the Baptistry doors are the reliefs on the west face, executed while Giotto was Capomaestro and installed prior to his death in 1337 (Figs. 173–75).[23] A second group of reliefs was executed between 1337 and 1343, the year in which Andrea seems to have left Florence for Pisa. Much more monumental, with many reliefs conceived *all' antica*, this second group has less complex compositions with few figures against a flat, neutral background (Figs. 176, 178, 179).[24] Upon completion of these reliefs, and as the Campanile continued to rise, Andrea executed a series of statues of Sibyls and Prophets for the niche zone (Figs. 180, 181). Finally, a third group of reliefs (e.g., Figs. 194–196), most likely executed after he left Florence for Pisa, betrays an imagination utterly at variance with that of Andrea's as we have come to know it from the doors and the first two Campanile groups. *Construction* and *Law*

(Figs. 194, 195) are characterized by symmetrical, hieratic compositions; *Geometry* and *Astronomy* (Fig. 196) contain figures placed in strict profile, and the furniture is rendered in "foreshortened frontal perspective," archaic for this period.[25] The drapery folds are composed of regular geometric curves and the hair patterns are mechanically incised. This group must be the product of members of Andrea's workshop who remained in Florence after his departure.

Unlike the bronze reliefs, which may be scrutinized and enjoyed in every pristine detail, the marble hexagons must be read from a considerable distance, thus precluding a design based on geometric subdivisions and subtle internal references to the frame as seen on the doors. Instead, most scenes on the Campanile employ the full expanse of the available field. Unlike the doors, with their pervasive contrasts between gilded figure and dark bronze background, here, especially in the landscape scenes, one perceives a continuity between foreground and background. Interior scenes, such as *Sculpture* and *Medicine* (Figs. 176, 177), are given credibility by means of the oblique placement of furniture and figures, an implied ground plane – not projecting forward as on the doors but rather inward, behind the hexagonal frame – and rear wall, the material existence of which is demonstrated by the shelves or tools hung on it. Movements and gestures are used, not to express emotional or spiritual content but to convey an activity, human or divine, in a naturalistic way, and this they do with great accomplishment. As in the Baptistry, however, one notes the predisposition to narrative economy rather than iconographic richness: Two or three figures, in general, suffice to convey the content, and these are clothed in fluid, curvilinear draperies that both envelop the figures and suggest the presence of the solid and functional body beneath. Primarily, however, what links the Campanile reliefs to those on the Baptistry is the elevated conception of humanity conveyed through naturalistic yet idealized forms, a restrained emotional content, and a concentrated, focused imagery.

At first the Campanile program seems to have included only the series for the western facade: the Creation of Adam and Eve, their first labors (plowing and spinning), and the inventions of their descendants, Jabal, Jubal, Tubalcain, and Noah (the first shepherd, musician, smith, and vintner, respectively) (Figs. 173–75) (see p. 138). Probably after Andrea became Capomaestro in 1337, the program was expanded to include the Labors of Mankind distributed across the other three sides of the bell tower. There are representations of the seven

Artes Mechanicae (Figs. 178, 179), as well as various contributors to civilization; even pagan figures find a place: Hercules, who by conquering Cacus cleansed the earth of the monsters of prehistory, thus preparing the way for civilization; Gionitus, the inventor of astronomy; Phoroneus (Fig. 195), the founder of law and order; and Daedalus, the inventor of the arts. In addition, a painter and a sculptor (Fig. 176) are represented. A geometer with compass appears as well (possibly representing Architecture). In the row above, seven on each side, are seen the Planets, Virtues, Liberal Arts, and Sacraments (most likely executed by former members of Andrea's workshop after c. 1343).[26] A lunette above the portal entrance from a bridge leading to the cathedral has a half-length image of the Madonna and Child, while niches above the relief zones contain Prophets, Sibyls, and Kings who prefigured and heralded the Coming of Christ (Figs. 180, 181).[27]

This elaborate program and its sculptural realization is unprecedented on a bell tower. Its appearance is rooted in several separate but related cultural phenomena. First, the Campanile program shares in the Scholastic attitude that had swept Europe during the thirteenth century and that is manifested in the encyclopedic content of French cathedrals and then reflected in Italy in the Fontana Maggiore in Perugia (see pp. 19f. and 143). Indeed, to a generation that had fully assimilated the encyclopedic thinking of the medieval Scholastics and was cognizant of the richly endowed sculpture programs of French Gothic cathedrals, the Campanile program answered to what must have appeared a notable poverty of iconographic content on the Duomo facade itself, limited as it was to a Marian program. The solution to the problem must have struck the planners of the Campanile project with a force and clarity equaled only by the brilliance of the actual execution of the plan, first under Giotto and then under Andrea Pisano. The scholastic enrichment of the cathedral program required the expansion of the iconographic content beyond the Duomo to encompass the Campanile. The Old and New Testaments of the Baptistry mosaics, begun in the late Duecento, had been augmented by the Marian facade of c. 1300; indeed, the Last Judgment within the Baptistry faced (or would face, since the mosaics may not have been completed until the early fourteenth century) the incarnation themes on the cathedral facade outside, including Arnolfo's Madonna of c. 1300.[28] She, in turn, would eventually address the Baptist who predicted salvation, as shown on the Baptistry doors of 1330–36. In

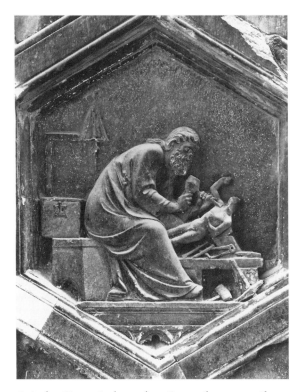

176. Andrea Pisano: *Sculpture,* from Campanile, 1337–43. Florence, Museo dell'Opera del Duomo [Alinari/Art Resource, New York].

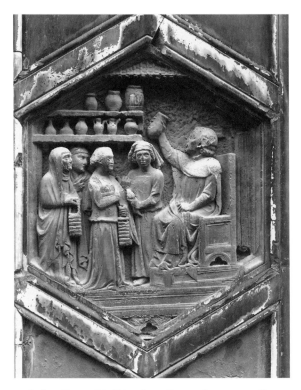

177. Andrea Pisano: *Medicine,* from Campanile, 1337–43. Florence, Museo dell'Opera del Duomo [Alinari/Art Resource, New York].

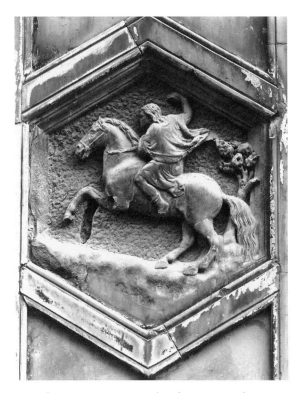

178. Andrea Pisano: *Horsemanship,* from Campanile, 1337–43. Florence, Museo dell'Opera del Duomo [Alinari/Art Resource, New York].

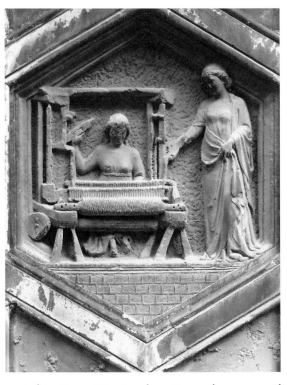

179. Andrea Pisano: *Weaving,* from Campanile, 1337–43. Florence, Museo dell'Opera del Duomo [Alinari/Art Resource, New York].

the meantime, Giotto had introduced the novel idea of including Genesis reliefs on the Campanile's western face; and shortly thereafter the band of hexagons was continued around the other sides with the Labors of Mankind. With the addition of a second relief zone, God's cosmological plan was further augmented, for here appear the Planets that influence the course of human life, the Virtues and Liberal Arts that make human beings worthy of God's grace, and the Seven Sacraments required to achieve that grace. Finally, in the niches of the next zone those who foretold and heralded Christ address the observer below who awaits His second coming. The cathedral group of Florence – Baptistry, Duomo, Campanile – then, reveals a historically complex, organic development in which iconographic schemes of one epoch are richly interwoven with those of later campaigns.

But subsumed within their universal context, the Campanile reliefs also belong to very specific moments in Florentine history, reflecting in both style and content the changing political, cultural, and economic climate in Florence during the 1330s and 1340s. The series introduces a peculiarly contemporary and Florentine twist into the conventional Genesis program by devoting a full five of the seven reliefs to artisanal, musical, and agricultural activities (Figs. 174–75). Even after 1337 when the subsequent reliefs were designed, the program continues its strong emphasis on the creative and productive side of life. Included are not only those *artes mechanicae*, which are essential for a thriving commercial republic – Trade, Agriculture, and Navigation – but also the arts of Architecture, Painting, and Sculpture (Fig. 176).[29] The prominence and thus distinction accorded those labors, while finding support in the Scholastic tradition, goes beyond anything sanctioned by that tradition and is unprecedented in the visual arts; it bespeaks more than a merely nascent perception of the dignity of the arts.[30] The program may well reflect the interests of the early humanists cognizant of the ancient scholarly curriculum, now studied in the works of the best classical authors.[31] These reliefs, as stated earlier, belong to a group that is stylistically the most classicizing of the series. Begun during a peak in the civic, economic, and cultural life of the city of Florence, the lowest zone on the Campanile is characterized by a celebrative spirit keenly appreciative of humankind's creative faculties.[32]

The second zone, however, suggests a different mood and may well have been planned only in the mid-1340s; indeed, Andrea's hand is not seen in this group, which

would then have been executed by former members of his workshop after his departure for Pisa in 1343. The themes here, which include the Planets and Sacraments, remind human beings of their limitations and ultimate dependence upon the grace of God. This group will be discussed later, in the context of mid-Trecento Tuscan sculpture.[33]

Pisa and Orvieto

We do not know why Andrea left his lucrative position in Florence to establish a workshop in Pisa.[34] Documents together with several sculptures that can be connected with them indicate that he returned to the region of his birth c. 1343 where he employed, among others, his son Nino.[35] The Saltarelli monument (Fig. 182) in Santa Caterina, Pisa, appears to be a product of this Pisano shop designed shortly after Andrea's arrival in Pisa. Simone Saltarelli, prior of the Dominican convent of Sta. Maria Novella in Florence, was appointed archbishop of Pisa in 1323. He played an important role in the conflict between Pope John XXII and Ludwig of Bavaria, ambitious for the crown of Italy and the Holy Roman Empire. So vigorously did Saltarelli engage in Guelf politics – and this within a Ghibelline city – that the emperor condemned him to death and he had to flee Pisa. However, in 1329 the Pisans relented of their support of the emperor and a papal interdict against the city was lifted. In 1330 Saltarelli returned to Pisa and remained archbishop until his death at the age of eighty in 1342.[36] It was surely his status as former prior of the Dominican convent in Florence and as archbishop of Pisa, as well as his role in international affairs, that merited for him a monument whose original size and complexity rivals that of popes.

The monument, moved several times, was described in the seventeenth century as a grandiose wall tomb suspended about four *braccia* above the ground.[37] Despite the fragmentary nature of the tomb in its current state, and even allowing that some intermediary elements such as consoles are lacking, enough remains to suggest the original relationship of the parts, which combine into a masterpiece of integration and harmony. The physical, visual, and metaphorical base for the composition as a whole is provided by the sarcophagus with its three horizontal, rectangular reliefs depicting important events in the political life of the archbishop. The inclusion of a Vita is an appropriation of a feature heretofore restricted primarily to the tombs of saints. Though never canonized, Saltarelli was called Beato and his heirs may have hoped

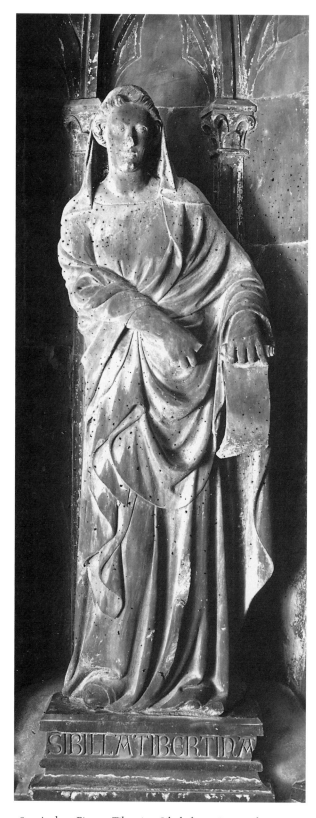

180. Andrea Pisano: Tiburtine Sibyl, from Campanile, c. 1340. Florence, Museo dell'Opera del Duomo [Alinari/Art Resource, New York].

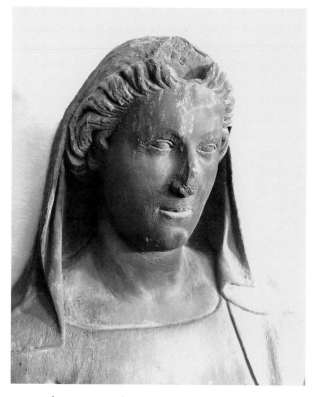

181. Andrea Pisano: Tiburtine Sibyl, detail, from Campanile. Florence, Museo dell'Opera del Duomo [Alinari/Art Resource, New York].

to have him eventually incorporated into the calendar of saints. The reliefs may also be a response to the narratives on the Ghibelline Bishop Tarlati's tomb (Fig. 148) in Arezzo. The celebration and exhaustive display of Tarlati's political and military triumphs, as well as his support of Ludwig of Bavaria, are countered by the wise and generous civic and ecclesiastic activities – opposition to usury, the gift of a chalice to his former convent, and the homage of Pisan citizens[38] – of Saltarelli, staunch opponent of "the accursed Bavarian" as the pope called him.

Above the sarcophagus, within a funeral chamber screened by twisted columns, lies the effigy on a *lit de parade*. Recalling the conceit of the de Bray monument, the intermediate stage in the journey of the soul toward heaven is dramatized by the curtain-drawing angels, as the archbishop, dead and still earthbound, is both revealed and obscured by the screen of columns. If the angels lack a totally convincing distribution of weight in their contrapposto stance, they nevertheless function supremely well as part of the rhythm that links them – almost as though by way of a festoon – with the curtains and trefoil arches flowing across the composition. On the cover

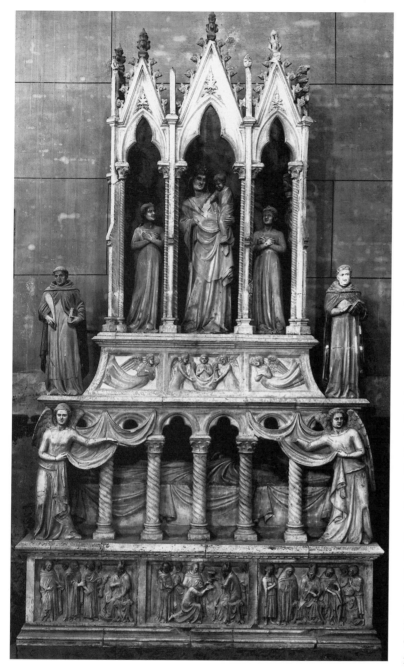

182. Andrea Pisano: Saltarelli monument, 1343–c. 1348. Pisa, Sta. Caterina [Alinari/Art Resource, New York].

position, the Madonna, is the goal and culmination of the impulses – as we are made aware – that determined the course of the life of Simone Saltarelli.

Despite Saltarelli's status as a Blessed, neither fellow Preachers nor the heirs of the deceased archbishop could be certain that he might not spend some time in Purgatory. Combined hope and anxiety finds powerful expression in the organization and visual impact of the tomb: The eschatological components are not simply juxtaposed but are organized to introduce the element of time. If the monument on one hand demands response by way of prayer for the deceased, it also reveals a rapid journey to salvation, as the eye moves from life (the biographical reliefs) to death (the effigy) to the ascent of the soul, and finally to heaven. Despite some losses and changes of location, the extant components of the Saltarelli tomb clearly suggest the logic that determined the original organization, which combined elements from the tradition of Tuscan sepulchral monuments in a new and meaningful sequence offering a visual and theological demonstration of the journey that culminates in heavenly salvation.

Several additional sculptures executed in Pisa are very likely by Andrea, among them a statuette in Orvieto (Fig. 183), which has been convincingly associated (together with angel fragments) with documents of 1348 concerning a Maestà partially completed in Pisa and then sent to Orvieto.[39] Small in scale but monumental in conception, the Orvieto Madonna exhibits an articulate contrapposto stance and a naturalistic relationship of drapery to body. Notwithstanding their veiled definition, the facial features are strongly reminiscent in other respects of the Sibyls; compare, in particular, the narrow eyelids, the subtly drawn contours of the broad, smooth faces, and the reserved, evocative smiles (Figs. 180, 181). The Madonna's warm serenity is identical in mood not only to the Sibyls but to the lunette Madonna as well, and the extraordinary delicacy of her gesture is seen again in the Spina Madonna (Fig. 184). The Orvieto Madonna, then,

of the sarcophagus, directly below and on axis with the Virgin above, two angels bear the soul of Saltarelli heavenward. Nearby, two Dominican saints, the founder of the Order and Peter Martyr, are present as intercessors. The sequence culminates in the Madonna who gazes lovingly at the Christ Child and who is flanked by ecstatic angels. As the pinnacle of the upwardly ascending com-

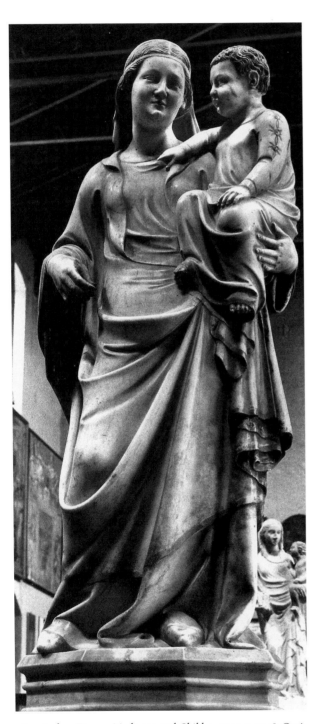

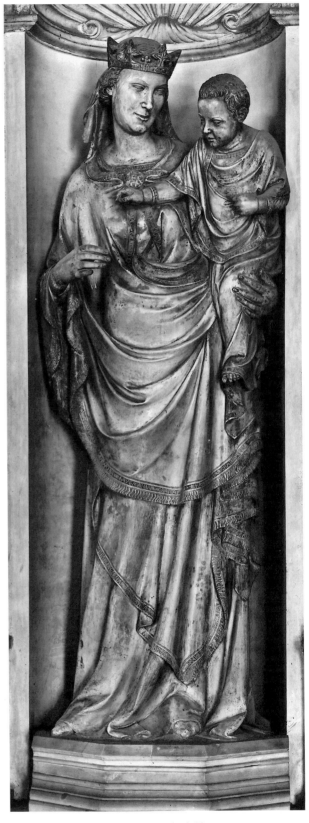

183. Andrea Pisano: *Madonna and Child,* c. 1343–c. 1348. Orvieto, Museo dell'Opera del Duomo [author].

184. Andrea Pisano: *Madonna and Child,* c. 1343–c. 1348. Pisa, Sta. Maria della Spina [Alinari/Art Resource, New York].

would seem to represent the translation onto a larger scale and more monumental mode of ideals achieved earlier in the Campanile reliefs.

Subsequent to the Orvieto Madonna, however, Andrea strove increasingly to integrate classical composure and stability with Gothic decorative rhythms.[40] The last works attributable to him in Pisa are the *Madonna and Child* (sometimes referred to as the *Madonna della Rosa*) in Santa Maria della Spina and the *Madonna del Latte* (Figs. 184, 185). In the full-length figure, Andrea achieves an unparalleled integration of diverse stylistic sources: classical composure and stability, Gothic poise and decorative rhythms, and a profound yet exalted sense of realism. If a new level of sophistication is achieved in the harmonious balance of seemingly opposing elements, the expressive content nevertheless remains unchanged. Close in style and probably in date to the *Madonna della Rosa* is the half-length *Madonna del Latte* (Fig. 185). As in the standing figure, the intimacy between mother and child is conveyed not only by the obvious means of pose, glance, and physical relationship but also by way of the curves and countercurves that flow from one to the other, binding the figures into a close unity. The half-length of the figure is rare if not unique for sculptures of the period and is clearly a translation into stone of a format that had become very popular for panel paintings.[41] The iconography and composition of the *Madonna del Latte* are based, however, on a type invented by Simone Martini in his lost *Madonna of Humility*.[42] In a copy of that work by Bartolomeo da Camogli in Palermo, dated 1346, the relationship of the Madonna to her son, especially the position of her hands and incline of her head, are so close to that of the marble group as to speak for a common prototype. The delightfully naturalistic motif of the infant's crossed feet seen in the marble group also appears in the painted example and became almost formulaic for nursing Madonnas of Humility throughout the remainder of the Trecento.

Some of the statues here regarded as autograph Andrea Pisano (Figs. 165, 180, 183–85) have received alternative attributions; yet each figure projects a characteristic mood of balance between gravity and a quiet inner warmth, utterly lacking in the slightest affectations of late Gothic style and thus seem to be conceived by a single imagination and executed by a single hand. Within this group the *Madonna del Latte* and the *Madonna della Rosa* represent the culmination of Andrea's experiments with sculpture in the round.

More than any other sculptor – or even painter – of

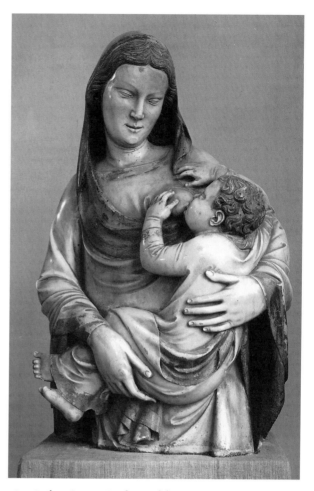

185. Andrea Pisano: *Madonna del Latte*, c. 1343–c. 1348. Pisa, Museo di San Matteo [Istituto Centrale per il Catalogo e la Documentazione].

the period, Andrea was a true disciple of Giotto; indeed, he was the only fourteenth-century master capable of translating the narrative power of Giotto's paintings into the language of sculpture. His receptivity to northern Gothic influence, however, and his strong response to classical sculpture resulted, in his most mature works, in an unsurpassed synthesis of the two ideals.

GIOVANNI DI BALDUCCIO IN TUSCANY

Giovanni di Balduccio Albonetto is one of the most appealing of those followers of Giovanni Pisano who tended to temper the dramatic expressiveness of the master and, largely under the influence of Sienese painting and the sculpture of Tino di Camaino, reinterpreted his formal language in a gentler, more calligraphic style. Balduccio's forte, however, was not so

much relief sculpture as mastery in the orchestration – at least during his mature period in Milan – of complex ensembles such as the Arca di San Pietro Martire. In addition, he designed and executed individual or groups of figures – Annunciations, Madonna and Child images, and saints, many of these for lost ensembles – that have a distinctive and congenial presence, with recognizable physiognomic traits analogous to, yet of a different genetic constitution from, the family resemblances seen in many of Tino's sculptures.

After the death of Giovanni Pisano, probably in 1314, and the sudden departure of Tino di Camaino for Siena in July 1315 with the tomb of Henry VII not yet completed, little sculpture of note was produced in Pisa during the immediately following years.[1] It was during the second decade of the fourteenth century, however, that Giovanni di Balduccio, recorded as receiving a modest salary in the Pisan Duomo workshop in 1317–18, was obtaining his technical training prior to his emergence as an independent artistic personality. He belonged to a team of former members of Giovanni's Siena and Pisan workshops who executed the statues embellishing the Oratory of Sta. Maria della Spina, rebuilt beginning 1322. Without doubt he is the author of the charming Madonna and Child for an exterior tabernacle on that building (Fig. 121).[2] After his work on the Spina, however, he appears to have been employed mainly by patrons outside of Pisa itself, such as the mendicant orders of Bologna and Florence, the Lucchese lord Castruccio Castracani, and possibly even unknown patrons in Genoa, where he would have become acquainted with the last work of Giovanni Pisano.[3]

The first of three works bearing Balduccio's signature is the surprisingly elaborate yet poignant tomb of a small boy in San Francesco, Sarzana (Figs. 186, 187). The effigy represents Guarnerio degli Antelminelli, youngest son of the upstart conqueror and tyrant of Lucca, Castruccio Castracani. Children's tombs are a rare enough phenomenon (see pp. 311ff.), given the high child mortality rate of the period, but Castruccio's dynastic ambitions – soon to be dashed, however – far more than any great interest in art or artistic patronage, motivated the decision to erect a canopied tomb with an effigy of the little boy.[4] The tomb probably dates sometime between late 1327 and Castruccio's death on 3 September 1328, for an inscription on the monument refers to titles that he received at the coronation of Emperor Ludwig of Bavaria in January 1327 and others dating from November of that year.[5] It appropriates elements of such major ecclesiastic monuments as

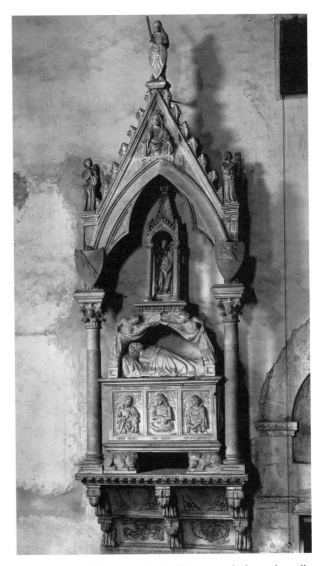

186. Giovanni di Balduccio: Tomb of Guarnerio degli Antelminelli. Sarzana, San Francesco [Alinari/Art Resource, New York].

that of Benedict XI in Perugia (Fig. 164) and perhaps also of Cardinal Petronius (Fig. 137) in its original form in Siena cathedral, with their curtain-drawing angels revealing the effigy and architectural framings (now missing on the Petronius tomb). The curly headed, puffy-cheeked child, in its compact solidity and finely carved garment, seems the recipient of the grief not only of the mournful lions supporting the sarcophagus but also of the Madonna and St. John the Evangelist, as well as the dead Christ between them on the sarcophagus. Despite its effective evocation of pathos, the work must be among Balduccio's earliest independent creations, for the archi-

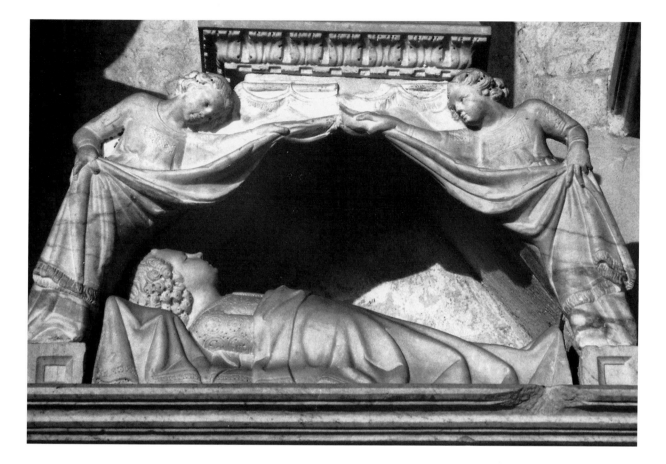

tectural structure and design of the whole reveal certain insecurities: One notes, in particular, the precarious position of the curtain-holding angels in their eager attempt to view the deceased child, and the fact that they had to be placed on blocks to be at the appropriate height.

On stylistic grounds most scholars agree that Balduccio's major commission in Florence was the Baroncelli monument (Figs. 188, 189) and an Annunciation group (Figs. 190, 191) at the entrance to that family's chapel in Sta. Croce.[6] The Baroncelli, an entrepreneurial clan with close connections to the important banking houses of the Peruzzi and Acciaiuoli, began planning a burial chapel at the end of the south transept in Sta. Croce in 1328, and the chapel with its monument must have been completed in the early 1330s; the chapel's frescoes were painted, possibly after completion of the tomb, by Taddeo Gaddi.[7] This tomb, in an unusual emplacement, was inserted into the narrow wall to the right of the chapel's entrance arch. Like the wall itself, the tomb, which is pierced by an openwork *cancello* (screen), is double-sided; without the screen, the monument would have appeared more like an avello-type wall tomb and the

187. Giovanni di Balduccio: Tomb of Guarnerio degli Antelminelli, 1327–28. Sarzana, San Francesco [author].

observer would not guess the existence of a space and a second tomb facade on the other side of the entrance wall. Each side shows the sarcophagus framed and surmounted by spiral columns supporting a Gothic arch and gable (the gables must originally have had crockets). The gables are embellished with angels in relief holding the family coat of arms and are flanked by freestanding figures of praying angels. While all other carvings, including the sarcophagus reliefs, are by assistants, the two pairs of praying angels, and especially the beautiful figures of Gabriel and Mary (Figs. 190, 191) at the entrance to the chapel are almost certainly autograph. Despite their small scale in relation to the vast space they face, their gestures are clearly legible, and the drill-work, the physiognomic details, and the lyrical drapery forms reappear in the master's later creations.

Vasari informs us of a marble altar for the choir of San Domenico, Bologna, which he incorrectly attributes to Giovanni Pisano (probably under the assumption that a

147

188. Giovanni di Balduccio: Baroncelli monument, early 1330s. Florence, Sta. Croce [Alinari/Art Resource, New York].

189. Giovanni di Balduccio: Baroncelli monument, early 1330s. Florence, Sta. Croce [Alinari/Art Resource, New York].

Giovanni of Pisa, which might have appeared as a signature on the altar, referred to the earlier master).[8] A number of statuettes clearly attributable to Balduccio in Bologna and elsewhere, a Nativity panel, and a fragment of a cusp have been plausibly identified as parts of such an altar (Fig. 192) and dated c. 1332–33.[9] Also ascribed to

him in Florence is a series of small framed reliefs representing half figures of apostles encased in the exterior walls of Orsanmichele but evidently belonging, together with other fragments, to an altar or tabernacle.[10]

Given the phlegmatic relief sculpture on the Guarnerio and Baroncelli monuments (Figs. 186, 188, 189) (probably

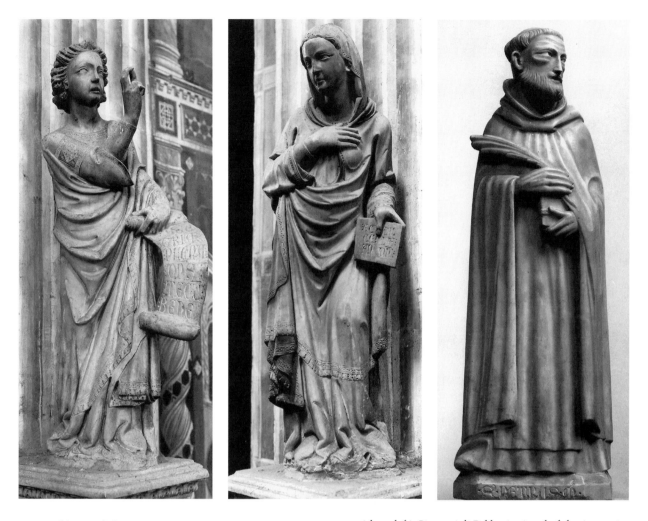

executed by workshop assistants), it comes as a surprise to note the exquisite composition and carving technique of the signed but otherwise undocumented pulpit reliefs (Fig. 193) in the Misericordia, formerly the Dominican church of Sta. Maria del Prato, in San Casciano Val di Pesa near Florence. With one exception, scholars have insisted – incorrectly, in my opinion – on dating the pulpit reliefs between the Guarnerio tomb and the Baroncelli monument, although several have noted that the qualitative leap between the former and the San Casciano reliefs is striking. As constituted at present, the pulpit is composed of two square panels of Gabriel and Mary forming a sort of diptych of the Annunciation on the front, with the figures of Sts. Dominic and Peter Martyr embellishing the sides. The pulpit is supported by two consoles, one a finely carved marble, and the other apparently a later stone copy of the original marble. The lectern that likely once formed part of the pulpit is missing and the present encasement of the reliefs in a green marble casket and white marble cornice with dentils perhaps dates from a later period.[11] What

190. (above left) Giovanni di Balduccio: Angel of the Annunciation, early 1330s. Florence, Sta. Croce [Alinari/Art Resource, New York].
191. (above middle) Giovanni di Balduccio: Mary of the Annunciation, early 1330s. Florence, Sta. Croce [Alinari/Art Resource, New York].
192. (above right) Giovanni di Balducccio: San Pietro Martire, 1332–33. Bologna, Museo Civico [Bologna, Museo Civico].

is evident and striking is the fact that Balduccio and his patrons decidedly rejected the polygonal pulpit format developed by his predecessors at Pisa, Siena, and Pistoia in favor of a return to the rectangular, box-shaped pulpit of the earlier Tuscan tradition.[12] Although citizens and clergy of the village of San Casciano may have preferred a more traditional type of church furnishing, it is even more likely that the shape and size were determined by the intimate single-aisled space of the church, apparent even today. Clearly, a complex, spatially engaging polygonal format would have been incongruous here.

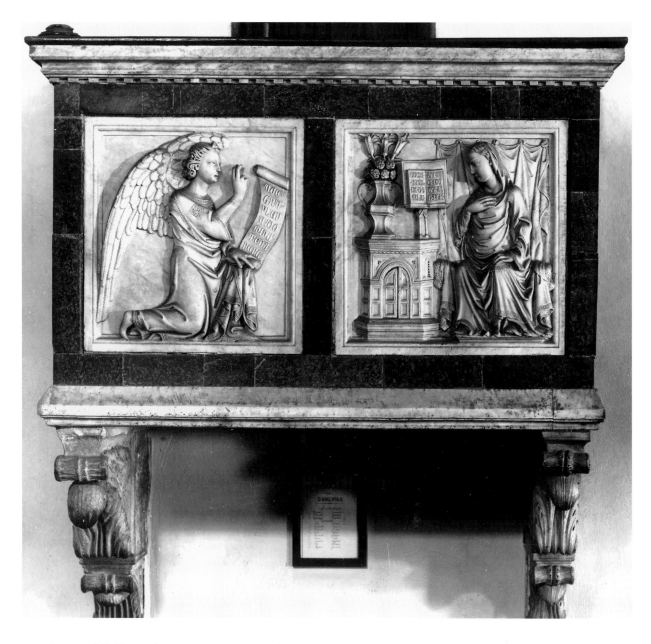

193. Giovanni di Balduccio: *Annunciation*, c. 1334. San Casciano Val di Pesa, Sta. Maria del Prato [Alinari/Art Resource, New York].

The Annunciation reliefs – unlike the Baroncelli Annunciation still under the sway of Tino – show that Giovanni di Balduccio had by now liberated himself from both Giovanni Pisano and Tino di Camaino and was creating in his own formal and expressive language. The motif of the kneeling angel is rare during this period, but it had two prestigious prototypes: Giotto's Arena Chapel Annunciation and Simone Martini's altarpiece for the Duomo of Siena.[13] Unlike Giotto's convincing spatial

milieu, and in this regard closer to Tino's reliefs, the compact figures and realistically rendered objects – curtain, vase of flowers (unprecedented in sculpture but also reminiscent of Simone's painting), reading desk, and lectern – are placed against the smooth background and fill up the entire field within the squarish frames. The figures, whose gestures communicate across the panels, project an intimacy with which the viewer, encouraged to inspect the rich modeling and delicate precision of carving in the homely details, cannot help but empathize. This same precision and delicacy is matched only by some of the Virtues of the Arca di San Pietro Martire in Milan (cf. Figs. 193 and 263). The San Casciano pulpit, then, belongs to a fully

mature phase of Giovanni di Balduccio's career and most likely immediately precedes his departure from Tuscany. Indeed, the Baroncelli chapel statues and the pulpit in San Casciano may well have provided Giovanni di Balduccio with the credentials for his call to Milan in 1334 or 1335.

THE SECOND HALF OF THE TRECENTO

From the enormous number of sculptural and decorative projects of the late Duecento and early Trecento, requiring the carving or modeling of countless individual figures and reliefs, we have focused on a relatively small selection. Although the facades, fountains, and liturgical furnishings chosen to discuss here represent highlights in a vast arena of creativity and productivity from c. 1250 through the 1330s, the high level of technical skill and the search for imaginative iconography and expressiveness extend well beyond the examples discussed and illustrated in the preceding sections. By the middle of the Trecento, however, the "creative temperature" of Tuscan sculpture was waning in comparison to the achievements of the earlier Italian Gothic masters. Many of the projects of midcentury indicate a lessened energy in the pursuit of innovative solutions to pictorial as well as formal problems: Gone is the creative eclecticism that resulted in the successful orchestration of so many complex projects, including the pulpits, facades, ciboria, and tombs we have examined. Instead, we find a tendency to conceive – in the case of liturgical furnishings – ambiguously articulated structures and overelaborate surfaces, and with regard to figures and reliefs, there is a lack of subtlety both in the plastic forms and expressive content. Often for want of the direction of a master with decisive and self-conscious stylistic goals, large projects lacked consistency of mood or detail.

Whether or not this situation can be attributed to the Black Death of 1348 and its aftermath, or more generally to the social and economic conditions and the developing mood in Tuscany and elsewhere that preceded it, remains controversial. Other possible factors include the simple exhaustion of talent and resources following the realization or near realization of so many ambitious earlier projects. The fact remains that no new main facade designs, for example, were initiated after that of Orvieto.[1] Clearly, in Florence the economic and political climate had begun to deteriorate by the early 1340s. One after another, the great banking houses collapsed. An increased urban population and inadequate crops led to undernourishment, which prepared the way for a series of epidemics of which

the Black Death of 1348 was only the most catastrophic.[2] On the political front, the ouster of the tyrannous Duke of Athens in 1343 was followed by a short period of popular demand for reform; this movement was superseded, however, by a strong oligarchic reaction.[3] Whatever effect these events had on patronage and creativity in Florence and Tuscany, other disasters in other periods and places appear not to be so neatly and conveniently reflected in artistic production, thus calling into question the entire methodological approach that finds cause and effect relationships between economic and political factors and style or iconographic content.[4]

In Pisa and Siena, it must be acknowledged, little of note was forthcoming during the middle decades of the Trecento, which may well mean that no large, challenging sculptural projects were proposed by church or state.[5] In Florence, however, a number of important sculptural commissions were undertaken. During the forties and fifties Florence saw the completion of the lower zone and expansion of the program to the upper relief zone of the Campanile, the erection of Orcagna's Tabernacle in Orsanmichele, and the execution of Alberto Arnoldi's sculpture for the Bigallo. The services of Nino Pisano and his followers, which responded to an increasing demand for elegance and intimacy in the depiction of the Madonna and Child, were called upon in Pisa, Orvieto, Florence, and Venice. Elsewhere during the early fifties, under the influence of Giovanni di Balduccio's work in Milan, a Lombard master designed the Arca di Sant'Agostino in Pavia (which will be discussed in the context of Lombard sculpture), while in the sixties a Florentine together with a local collaborator worked on the huge Arca di San Donato in Arezzo. If many of the sculptures during these decades represent formulaic repetitions of earlier style and iconography, the significance of others, such as the saints' tombs in Arezzo and Pavia, and the tabernacle in Orsanmichele, lies at the very least in their evidence for a decisive change of taste that favored elaboration and richness over classical restraint. The most remarkable construction in mid-Trecento Tuscany, furthermore, Orcagna's tabernacle, shows an inventiveness in response to demanding requirements of site, function, and iconography that rivals many of the earlier productions of the century.

The Later Campanile Workshops and Alberto Arnoldi

Reference has already been made to a transformation of style and iconographic emphasis among the Campanile

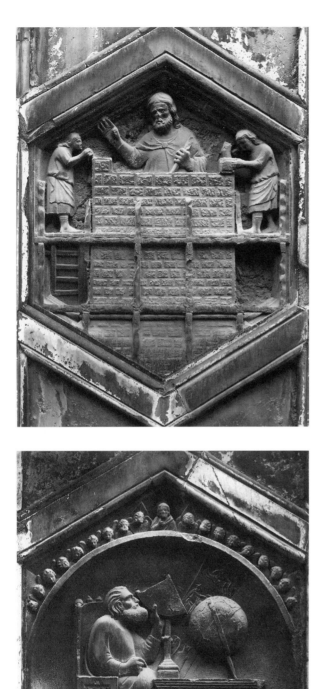

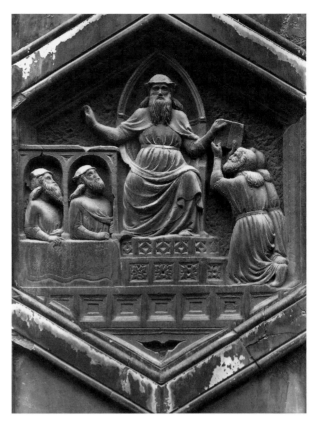

194. (above left) *Builder*, after 1343, from Campanile. Florence, Museo dell'Opera del Duomo [Alinari/Art Resource, New York].
195. (above) *Law*, after 1343, from Campanile. Florence, Museo dell'Opera del Duomo [Alinari/Art Resource, New York].
196. (left) *Astronomy*, after 1343, from Campanile. Florence, Museo dell'Opera del Duomo [Alinari/Art Resource, New York].

hexagons after Andrea Pisano's departure from Florence. The hexagons of this group are characterized either by symmetrical hieratic compositions with a dominating frontal figure or by figures placed in strict profile with the furnishings rendered in an archaic form of perspective.[6] The drapery folds tend toward regular geometric curves and the hair patterns are mechanically incised. In contrast to Andrea's reliefs showing a painter and a sculptor (Fig. 176), celebrated as individual creators, the *Builder* (Fig. 194) is depicted as an emblem of dictatorial authority – frontal, centrally placed, and considerably larger in scale than his underlings. The judge in *Law* (Fig. 195) is seated on a high throne shaped like a mandorla, arms extended as though he were Christ offering the keys to Peter, while the defendants kneel in supplication before him and the jurors humbly attend his words. *Astronomy* (Fig. 196) departs still further from the natu-

ralism of the earlier reliefs, for the figure, while seated at a desk with globe and sextant, is placed not in a naturalistic space but rather a symbolic one, a heavenly halfsphere. This new phase in the development of Tuscan Trecento sculpture rejects the monumental and classicizing conception apparent in Andrea's reliefs.

In the second row of reliefs on the Campanile one senses a rejection of the celebration of human creativity that informed Andrea's hexagons. This new series, introduced perhaps to balance the celebrative and even prideful spirit of the hexagons and further reflecting the deepening mood of crisis in Florence that preceded and culminated in the Black Death, reminds us of our limitations and ultimate dependence on the grace of God.[7] In addition to allegories of the Liberal Arts and Virtues and representations of the Sacraments through which human beings may free themselves from sin (Figs. 198–201), there is a series showing the Planets (see Fig. 197), placed most prominently on the Campanile's main facade, and thus emphasizing the external factors that determine one's fate.

The Planets, Virtues, and Liberal Arts of the upper relief zone were executed by anonymous former workshop assistants and followers of Andrea Pisano and may well date from immediately after his departure for Pisa; indeed, although workshop productions, many of the reliefs are qualitatively superior to those belonging to the third group of hexagons (Fig. 194–96), which we have also dated after 1343. Despite the shift in iconographic emphasis, the lozenges on the west, south, and east faces, though executed by a number of hands, essentially continue the monumental, classicizing forms of Andrea Pisano, suggesting that several independent workshops contemporaneously executed the reliefs, both for the remaining lower socle series and for the lozenges above. It is also possible that dissatisfaction with the rigid hieratic mode of *Law* and *Construction* led to dismissal of one group of former workshop members and the selection of another, more capable of continuing the former Capomaestro's sculptural ideals. In any case, it is clear that no pervasive and ongoing change of style accompanied the alteration in iconographic emphasis on the third group of hexagons and upper relief zone of the Campanile.

Only the Seven Sacraments (Figs. 198–201) on the north face of the bell tower reveal a distinctive independent hand, one that further calls into question any putative Black Death style. Largely on the basis of a comparison between a documented relief of the

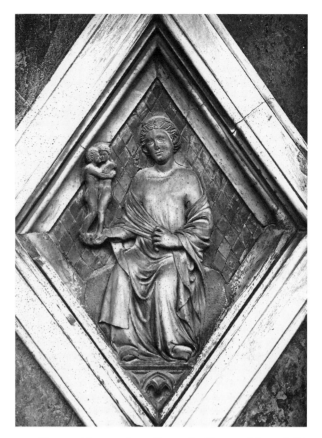

197. *Venus*, mid-1340s, from Campanile. Florence, Museo dell'Opera del Duomo [Alinari/Art Resource, New York].

Madonna (Fig. 202) on the exterior of the Bigallo and the mother and child in the lozenge representing *Consecration* (Fig. 199) on the Campanile, this group had long been attributed to Alberto Arnoldi, an attribution later rejected in favor of Maso di Banco, known primarily as a painter.[8] But since, on the one hand, comparisons with paintings are difficult to sustain and no secure work of sculpture by Maso is known, and on the other hand, there are a number of morphological details that connect one or two of the Sacrament reliefs to Arnoldi's documented works, the new attribution remains problematic.

Nothing is known of the origins or training of Alberto Arnoldi (in the 1350s he was employed in the cathedral workshop), and the usual attributional games have been played resulting in assignments and rejections of a large number of works to his name.[9] As is true of his contemporary Orcagna, he was strongly influenced and perhaps even trained by Andrea Pisano, as seems evident from the statues and reliefs for which commissions or payments are recorded: In 1359 he is asked to execute a

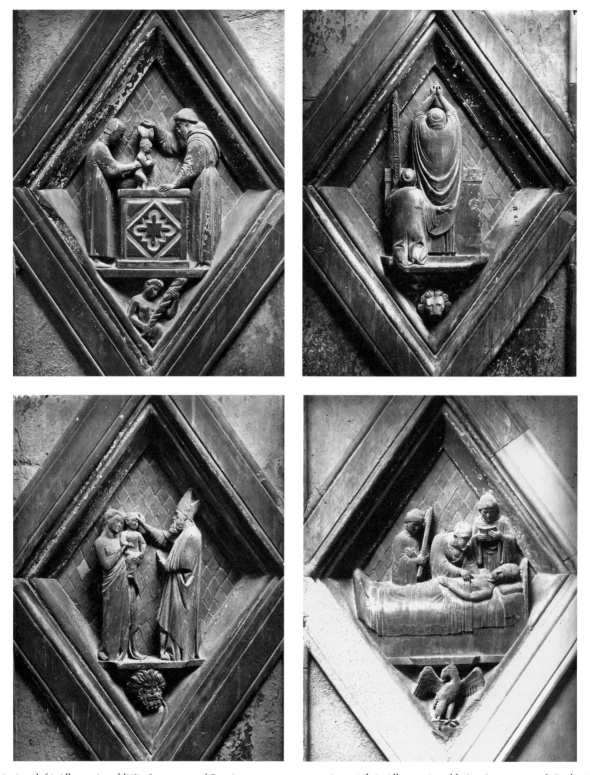

198. (top left) Alberto Arnoldi(?): *Sacrament of Baptism*, 1350s, from Campanile. Florence, Museo dell'Opera del Duomo [Alinari/Art Resource, New York].

199. (bottom left) Alberto Arnoldi(?): *Sacrament of Consecration*, 1350s, from Campanile. Florence, Museo dell'Opera del Duomo [Alinari/Art Resource, New York].

200. (top right) Alberto Arnoldi(?): *Sacrament of Eucharist*, 1350s, from Campanile. Florence, Museo dell'Opera del Duomo [Alinari/Art Resource, New York].

201. (bottom right) Alberto Arnoldi(?): *Sacrament of Last Unction*, 1350s, from Campanile. Florence, Museo dell'Opera del Duomo [Alinari/Art Resource, New York].

There is little reason to suppose that a sculptor might not be capable of one stylistic tendency for smaller-scale narratives (to be viewed at close hand by clergy entering the Campanile chamber from the bridge connecting tower to cathedral)[12] or for a welcoming Madonna image above the confraternity's portal, and another for a major and imposing sculptured altarpiece.

Adopting Andrea's device of a platform to provide a stage for the figures and props, and restricting himself to only the essential participants, the author of the Sacrament reliefs employs simple Giottesque volumes, limiting the modeling to that sufficient to suggest the underlying bodies or to convey movements both ritualistic and intimate. Gestures and glances are direct and express intense feeling as the humble but dignified participants engage in the awesome mysteries of the holy sacraments. Not since Giovanni Pisano's Pistoia pulpit *Nativity* (Fig. 95) at the turn of the century have the proportions of a real infant (this time not quite as young) been rendered as naturalistically as that in the lozenge depicting Baptism (Fig. 198); not since Giotto's *Death of St. Francis* (probably datable to the late 1320s or early 1330s) in Sta. Croce has such intense solicitude in the face of death been conveyed as in the representation of *Last Unction* (Fig. 201). In the *Eucharist* (Fig. 200), employing a brilliant compositional device seen only rarely in earlier reliefs – a figure with back to viewer (cf. Nicola Pisano's *Saint Dominic and His Brethren Served by Angels* on the Bolognese Arca [Fig. 39] and Andrea Pisano's *Funeral of the Baptist* on the doors)[13] – the sculptor naturalistically conveys a sight familiar to every contemporary Christian: that sacred moment of the Mass after the priest has pronounced the words of consecration and with his back to the congregation elevates the transubstantiated host. Whoever the author of these enchanting and poetic representations, his style vanishes from view as abruptly as it had appeared.

The lunette relief (Fig. 202) on the exterior of the Bigallo clearly derives from Andrea Pisano's lunette Madonna on the north face of the Campanile, in which the playful, if somewhat ambiguous relationship of mother and child[14] is reinterpreted as the straightforward desire of the Child for his mother's breast. Mary seems ready to offer physical nourishment to the Child but also, as her direct look toward the piazza makes clear, spiritual nourishment to the observer. If this tender act of misericordia is appropriate to the confraternity's function, the carving style is nevertheless somewhat metalic, with sharp concentric folds and smooth surfaces. The full-length Madonna (Fig. 203) within the

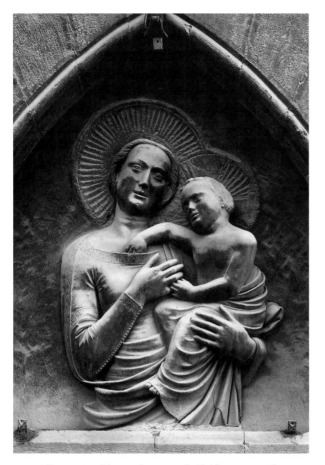

202. Alberto Arnoldi: *Madonna and Child,* c. 1360. Florence, Bigallo [Alinari/Art Resource, New York].

Madonna and Child ("of the same quality and mastery as the figure of Our Lady in Pisa," possibly referring to Andrea Pisano's Madonna in Santa Maria della Spina [Fig. 184])[10] flanked by candelabra-bearing angels (Fig. 203). Made for an altar in the Bigallo, the administrative building of the Compagnia Maggiore di Sta. Maria del Bigallo, a lay confraternity that operated hospitals and hospices, they were paid for in 1364. For the half-length Madonna relief in a lunette on the exterior of the building (Fig. 202) he received payment in 1361.[11]

Concerning the Campanile Sacrament reliefs (Figs. 198–201), it is true that these have an intimacy and disarming appeal lacking in the full-length Bigallo altar figures (Fig. 203) in which the Madonna displays such a rigorous frontality. But the Bigallo lunette relief (Fig. 202), in contrast, is extremely close to the Consecration lozenge, both in the intimacy of the gestures and in such morphological elements as the broad round faces and the long right arms that bend sharply at the elbows.

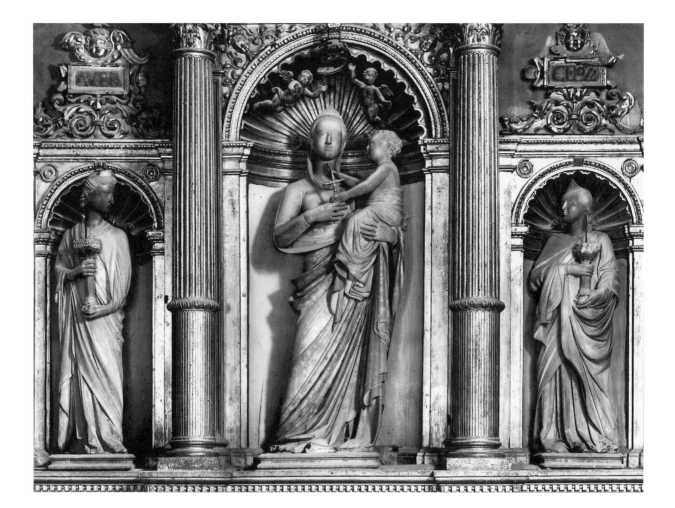

203. Alberto Arnoldi: *Madonna and Child, and Angels,* 1359. Florence, Bigallo [Alinari/Art Resource, New York].

building, too, is an adaptation of a figure by Andrea, the Erythrean Sibyl[15] on the Campanile, with echos of Giovanni Pisano's Pisan lunette Madonna (Fig. 101), among others. The sharp folds of drapery projecting from the column of the torso recalls Giovanni Pisano's Prato Madonna (Fig. 103), but the intimacy of the latter is completely gone, as the glances of the two figures remain rigidly perpendicular to each other. The work has been criticized for being carved primarily in relief, but this effect is due to the iconic impression of frontal Madonna and profile Child rather than a close examination of the sculptural qualities. The excavation of the marble folds do, in fact, swirl about the figures, indicating the high technical capabilities of the sculptor. The finely (if a bit mechanically) carved hair spiraling down along the sides of the smooth-skinned, high-cheeked, long-necked left-hand angel results in a rather unex-

pected elegance new to Florence, although the figure is anatomically flawed, in particular in the depiction of the left arm. The drapery of the right-hand angel, heavier with more robust features than its pendant, is closer to Andrea's Tiburtine sibyl (Fig. 180). The combination of elegance and iconic frontality, of plasticity and an emphasis on line is perhaps the sculptural counterpart of similar qualities seen in some paintings of the period and may be compared to Orcagna's Strozzi altarpiece.

Nino Pisano

Andrea's sons Nino and Tommaso Pisano represent, respectively, a progressive shift away from, and a weak dilution of, the synthesis of classicizing ideals and French Gothic rhythms that characterize the work of their father. Tommaso was a stone-carver undoubtedly riding on the coattails of his father's renown. Competent enough technically, he lacked an imaginative faculty equal to the grandness of his most important commis-

sion, the large marble altarpiece in San Francesco, Pisa, datable to the 1370s.[16] Nino is more problematic: It is not clear whether he was limited by the scope of the commissions offered to him or by an artistic vision of diminished intensity. Despite the appeal of the many Madonna and Child and Annunciation groups associated with his name, few of his extant works reach the elevated naturalism of his father's output, nor does the evidence suggest a capacity to orchestrate monumental ensembles such as the Saltarelli monument, whose design is attributed to Andrea.[17] From the many copies and adaptations of his cult images of the Madonna, it is clear, however, that a particular stylistic current and affective ideal associated with his name captured the imagination of subsequent artists and patrons.

Nino is documented between 1349 and 1368, although he may well have been active in his father's workshop in Pisa from c. 1343.[18] He is mentioned in Orvieto in October and November of 1349 as Capomaestro of the cathedral, a position he may have retained until 1350.[19] His name comes up next in 1358 in connection with a (lost) silver altarpiece for the Opera del Duomo of Pisa. After the death of the Pisan archbishop Giovanni Scherlatti in February 1362, the cleric's executors contracted Nino, who is called *aurifex et magister et sculptor lapidum*, to make his tomb monument. A *terminus ante quem* for Nino's death is given by a document of 8 December 1368 when his son, named after his renowned grandfather Andrea, received funds from the Pisan government owed to Nino for the tomb of Giovanni dell'Agnello, a wealthy and powerful merchant of Pisa who had assumed the title of doge; no longer extant, the tomb had been built on the facade of San Francesco, Pisa.[20]

Nino's signature appears on three statues, none dated: a *Bishop Saint* (Fig. 204) in San Francesco, Oristano; the *Madonna and Child* (Fig. 205) on the Cornaro monument in SS. Giovanni e Paolo in Venice; and another *Madonna and Child* (Figs. 206, 207) in Sta. Maria Novella in Florence. Given the tradition of family workshops and apprenticeship, Nino's father must have exerted a powerful influence on the development of his son, at least during its earlier stages. There is good reason to believe that the earliest signed sculpture, closest stylistically to Andrea's figure style, is the *Bishop Saint* in Oristano. If one assumes that Nino evolved from a style close to that of his father toward one that increasingly absorbed foreign or other influences, then the Cornaro monument would be his second, and the Sta. Maria Novella Madonna his third signed work.[21]

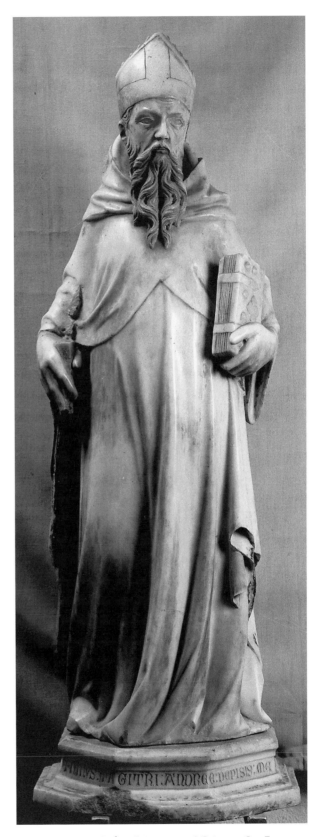

204. Nino Pisano: Bishop Saint, c. 1345? Oristano, San Francesco [Aurelio Amendola].

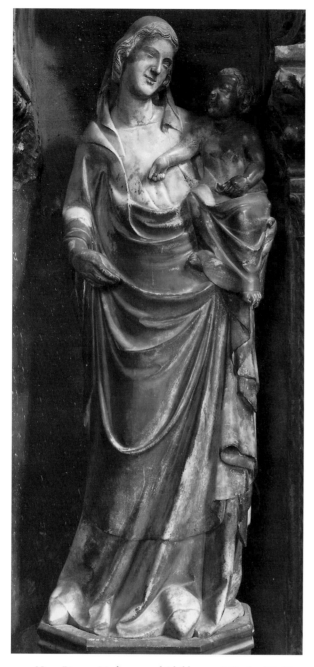

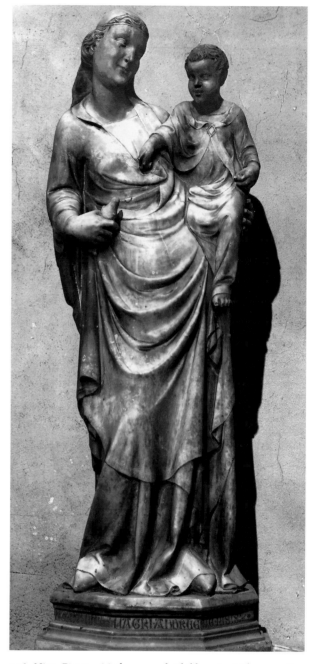

205. Nino Pisano: *Madonna and Child,* 1350s? Venice, SS. Giovanni e Paolo [Oswaldo Boehm].

206. Nino Pisano: *Madonna and Child,* 1360s? Florence, Sta. Maria Novella [Alinari/Art Resource, New York].

The *Madonna* (Fig. 205) and the flanking saints on the Cornaro monument in Venice were not necessarily made for the doge's tomb to which they now belong. There is no evidence of Nino's physical presence in Venice, and it seems likely that the sculptures were executed in Pisa and sent to Venice only at the time of the doge's death in 1368.[22] Recent technical examination reveals that the manner of applying polychromy on the marble statues conforms to that used in Pisa, in particular on the Scherlatti and Moricotti tombs (the former a documented work by Nino),[23] whereas that on the Istrian stone parts of the Cornaro monument (the effigy and architectural framework) conform to Venetian practice. This fact, as well as stylistic considerations, free the statues from the tomb's chronology.[24] Indeed, the span between January when the doge died and December of

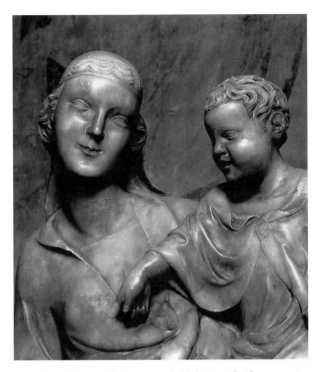

207. Nino Pisano: *Madonna and Child*, detail. Florence, Sta. Maria Novella [Aurelio Amendola].

facture of the marble surfaces deserve Vasari's praise of Nino's craftsmanship: "si può dire che Nino cominciasse veramente a cavare la durezza de sassi e ridurgli alla vivezza delle carni" [it may be said that Nino was beginning to rob the stone of its hardness and to reduce it to the softness of flesh].[26] Similar characteristics appear in the exquisite *Madonna and Child* in the Detroit Institute of Arts (Fig. 208).[27]

An Annunciation group (Figs. 209, 210) in Sta. Caterina, Pisa, according to Vasari, bore Nino's signature and the date February 1370 (Nino, however, was dead by December 1368). Stylistic analysis indicates that it is,

208. Nino Pisano (attrib.): *Madonna and Child,* 1360s? Detroit, Institute of Arts [Photograph © The Detroit Institute of Arts. Gift of Mr. and Mrs. Edsel B. Ford].

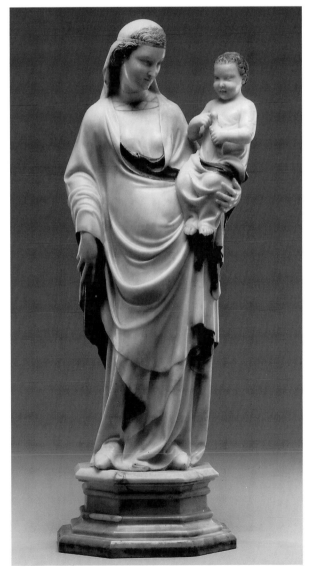

1368, the *terminus ante quem* of Nino's death date, seems hardly enough time for the design, execution, and shipment from Pisa to Venice of a complex tomb monument with five large figures. In short, given the closeness of the Madonna's characteristics to statues by Andrea, such as the Madonna at the apex of the Saltarelli monument, it is very possible and even probable that the Venetian figure was executed for some earlier uncompleted commission and recycled for use on the Cornaro monument.

Compared to the Venetian Madonna (Fig. 205) the one in Florence (Figs. 206, 207) presents more elongated proportions, the pose has more swing, and the impression of equilibrium in the structure and stance is diminished; the slender-hipped Child too has more attenuated proportions.[25] Furthermore, the honeyed expression of the Florentine Madonna contrasts with the affectionate yet restrained gaze of the Venetian Madonna. The classical balance and naturalism that inform the Bishop (Fig. 204) are almost completely abandoned in this work. The Florentine Madonna slinks, relatively weightlessly, her drapery patterns motivated more by decorative considerations than by posture and gravity. Her head seems made of a malleable and sensuous substance, with little underlying structure. The softness of drapery and the

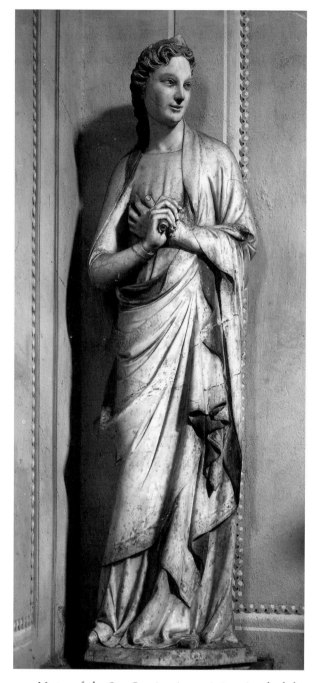

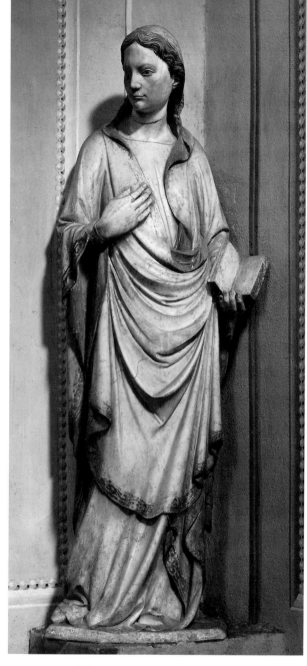

209. Master of the Sta. Caterina Annunciation: Angel of the Annunciation, late 1360s? Pisa, Sta. Caterina [Alinari/Art Resource, New York].

210. Master of the Sta. Caterina Annunciation: Virgin of the Annunciation, late 1360s? Pisa, Sta. Caterina [Alinari/Art Resource, New York].

rather, by an anonymous master who absorbed influences from Andrea, from Nino, and from Alberto Arnoldi. To this same carver may be attributed the splendid *Madonna and Child* in Trapani (Fig. 211), a cult image so popular and efficacious that it was copied endless times for centuries to come.[28] The association of the

Sta. Caterina group with Nino may well derive from a (hypothetical lost) model for this and numerous other monumental Annunciation pairs, whose impressive immediacy was achieved by means of lifelike polychromy, expressive gestures, and communicative glances that project well across a wide space.

swinging drapery rhythms played against vertically cascading hemlines. In these sculptures he incorporates and reinterprets some of the mannerisms found in early-fourteenth-century French sculpture, particularly the exaggerated Gothic stance, the idiosyncratic turn of the wrists, the winsome smiles, and the melodious drapery patterns. Nino's Madonnas were to inspire dozens of lithe, svelte, smiling Marys gazing lovingly at Christ with an unprecedented intimacy of expression.[29]

Andrea Orcagna at Orsanmichele

Andrea di Cione, known as Orcagna, was enrolled in 1344 in the Arte dei Medici e Speziali, the guild to which painters belonged, and in 1352 in the guild of stonemasons. Several documented and two signed paintings, including the large altarpiece in Sta. Maria Novella, Florence, are by his hand, this last commissioned in 1354 for the Strozzi family chapel in Sta. Maria Novella.[30] Following upon the influential thesis of Millard Meiss, this altarpiece had become an icon of a post–Black Death style. Recent reappraisals of its stylistic character, as well as that of the Tabernacle in Orsanmichele (Fig. 214), prompt a more balanced view of Orcagna's style and his position in the history of Trecento art.[31]

Before turning our attention to the Orsanmichele Tabernacle, we should glance at the only other extant work of sculpture that can be attributed to Orcagna on the basis of compelling stylistic arguments, the wood Crucifix (Figs. 212, 213) in San Carlo dei Lombardi, which was probably originally made for the interior of the Loggia of Orsanmichele.[32] As was indicated in our discussion of Andrea Pisano, a sculptor trained as a goldsmith or – in this case – as a painter who hoped to gain major sculptural commissions might prove his mettle with a large work in wood.[33] Recent restoration of the wood Crucifix (Figs. 212, 213), which has revealed the beautiful original polychromy long hidden under brownish overpaint, has also led to the realization that this is the work of a young sculptor still mastering his technical means: Certain flaws in the construction of the Crucifix have been revealed, for example, insufficient excavation of the back to eliminate unequal drying of the log, causing radial fissures throughout the torso.[34] Thus it is reasonable to date the work just around the time that Orcagna entered the guild of woodworkers and stonecutters in 1352.

If technical defects indicate inexperience in carving, the intensely stoic humanity of the figure reveals a master in

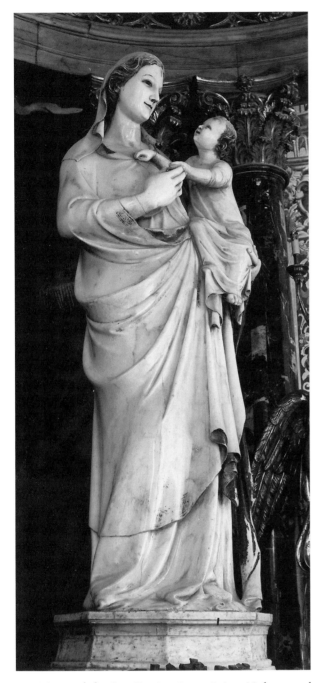

211. Master of the Sta. Caterina Annunciation: *Madonna and Child*, c. 1370? Trapani, Santissima Annunziata [Aurelio Amendola].

These statues, too, provide compelling evidence to refute any theory concerning a prevalent "post–Black Death" style in sculpture. The mood, especially of Nino's late Madonnas, is tender and joyful; the drapery fluid; the poses anything but frontal and hieratic. There is, in addition, a continuing shift toward more elongated proportions, a stronger Gothic contrapposto stance, and

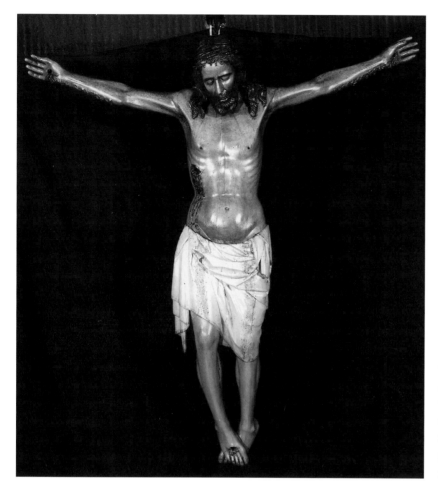

212. Orcagna (attrib.): Crucifix, wood, c. 1362. Florence, San Carlo dei Lombardi [Florence, Opificio delle Pietre Dure].

Coppo di Marcovaldo but also the highly emotional, if naturalistic, interpretation of the event on the Pistoia pulpit (Fig. 99) by Giovanni Pisano. In the Arena Chapel (consecrated 1305), the body of Christ and the cross upon which it hangs remain in planes that are parallel to each other; the torso is robust, the eyes closed, and the face expresses not suffering but the serenity of death. It is this image that seems to have been favored by the Florentines and that is seen in several other examples within the Florentine milieu.[35]

Orsanmichele, which rises like a massive palace and takes up an entire block, is an unusual building of seemingly contradictory functions: It served as both a religious and a commercial site, housing a shrine and a marketplace for grain on its originally completely open first-floor loggia, and a municipal granary on the second and third floors.

An earlier building on the site, which sheltered a miracle-performing image of the Madonna and Child, was replaced in 1337 when the present grand, three-story structure was begun. In 1347, well before the building was complete and for reasons not clear (perhaps the destruction of the miraculous painting), Bernardo Daddi was called upon to paint a new image of the Madonna, and it was for this painting that Orcagna's tabernacle was designed.[36]

Financing for a new tabernacle was begun immediately after completion of Bernardo Daddi's panel in 1347, thus prior to the Black Death; but after the disaster of 1348 donations and bequests to the Compagnia di Orsanmichele, the confraternity dedicated to the veneration of the miraculous image, increased.[37] The tabernacle was completed in 1359 as indicated by an inscription on the lower edge of the Virgin's sarcophagus in the large relief on the back of the structure, which also gives the author's name, Andrea di Cione. The commission may reach back to shortly after Orcagna's enrollment in the stonemasons' guild.

The tabernacle that Orcagna was called upon to design

complete control of his expressive means. The Crucifix clearly represents a departure from the canon established by Giovanni Pisano (cf. Figs. 99, 106). Although the head is turned slightly to the viewer's right, the body remains frontal and almost completely aligned with the axis of the cross. The proportions are stocky and the flesh full-bodied, not emaciated as in Giovanni's crucifixions. The face betrays no sign of suffering; nor is the torso wrenched in pain. Although released from the agony of his martyrdom, Christ is portrayed rather at the moment before he has taken his last breath. Despite its symmetry, then, the figure conveys a powerful yet eminently human and poignant sense of dignity.

The serenity of expression and the composition clearly go back to painted examples by Giotto: In his depiction of the theme, Giotto rejected not only the exaggerated swing of the body seen in examples by Cimabue and

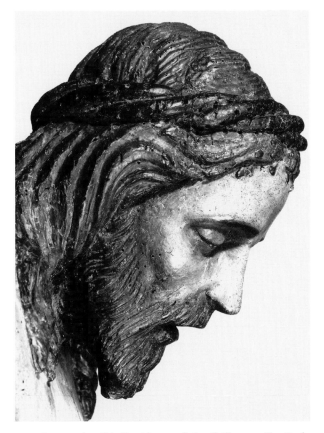

213. Orcagna (attrib.): Crucifix, wood, detail. Florence, San Carlo dei Lombardi [Florence, Opificio delle Pietre Dure].

had to fulfill several, somewhat contradictory, functions. First, it was to house and protect a sacred image fully unveiled only on special occasions, but when on view it had to be visible to the large crowds filling the loggia. The tabernacle had to be wide and broad enough so that worshipers, including the large numbers of pilgrims visiting the site, could gather around it to light candles and venerate the holy image, which thus had to be high off the ground for reasons both of security and visibility. An enclosed space in front of the image was required where confraternity officials could stand to receive offerings and important visitors, who were occasionally given special viewings. Locked storage in which offerings and other objects could be secure was required. An internal space was needed, both for access by way of a narrow staircase to the platform of the dome and for laud singers to perform hidden from view. Since perpetual oil lamps and thousands of lit candles each day surrounded the tabernacle (not to speak of potentially explosive grain or flour dust), the structure had to be made of durable, noncombustible materials. Finally, it had to be a

splendid object, attracting the eye from the surrounding urban area (which had not yet been built up), through the broad arches of the then open loggia.[38]

Set in the southeastern bay of the vaulted ground floor of Orsanmichele, the Tabernacle (Fig. 214) received ample natural light, enhanced by the glow of candles. The iron grille that today connects the four exterior piers of the Tabernacle was added in 1389, but originally the reliefs of the balustrade were fully visible. Thus, if from afar the architectural structure imposed itself on one's line of sight, as one approached the building the surfaces of colored and gold mosaics and inlaid marble patterns predominated, framing the large relief of the Dormition and Assumption of the Virgin (if one approached the building from the direction of the Bargello to the east) and the panel of the Virgin and Child surrounded by saints (visible from various perspectives on the other three sides). Finally, from up close the reliefs representing the Life of the Virgin, and the accompanying figures, invited intimate viewing and contemplation. This multivalent experience is no longer possible in the dark, masonry-enclosed interior.[39]

The Tabernacle (Fig. 214) belongs generally to the genre of structures that hallow and enclose holy objects, like altar ciboria or large-scale reliquary shrines (cf. Figs. 62, 68).[40] Square in plan, it is composed of three main – if ambiguously articulated – stories. A massive socle bearing narrative and allegorical reliefs supports polygonal piers, framed by spiral columns and linked by round-headed arches that echo the original openings of the Loggia of Orsanmichele itself. Above this vaulted, baldacchino-like story rise crocketed gables and pinnacles that frame a high octagonal drum on which rests a tall, ogival ribbed cupola. Reliefs and statuettes abound, culminating in the statue of the Archangel Michael, whose head reaches to the keystone – serving as a huge halo – of the bay's rib-vault. The structure, with its patterned triangular gable, diagonally placed figures atop the main pillars, and soaring superstructure, owes a clear debt to Arnolfo's ciboria in Rome (Figs. 62, 68), although Orcagna moves decisively away from the open airiness and spindly forms that reveal in the work of his predecessor the influence of French Gothic architecture.

Although it relates to earlier ciborium-like structures, Orcagna's Tabernacle is visually more complex than most earlier church furnishings: At first glance, with its gables and crockets, its pinnacles and polychrome inlays, it looks like an enormous piece of opulent goldsmith-work, but one soon realizes that the structure is solid

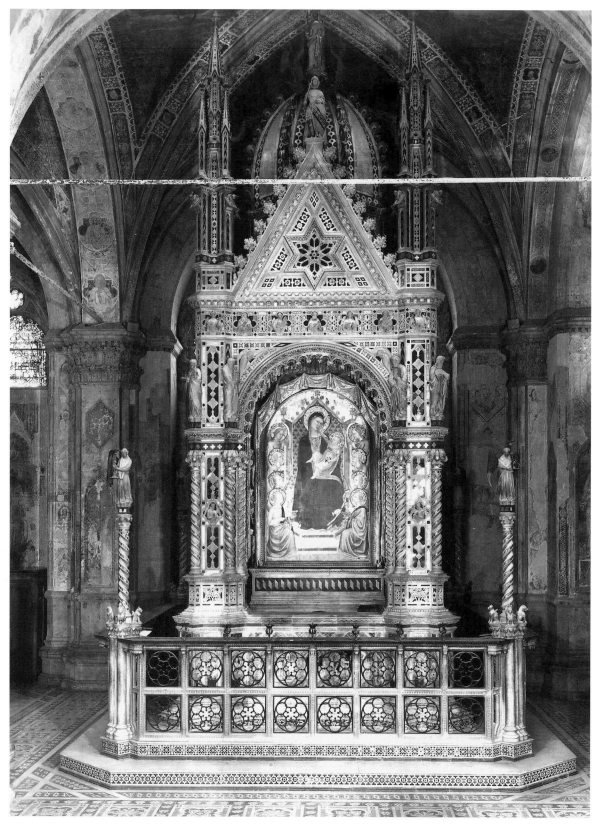

214. Orcagna: Tabernacle, completed 1359. Florence, Orsan-
michele [Alinari/Art Resource, New York].

and massive, actually enclosing space and thus more like a miniaturized building than an enlarged shrine. There is an inherent contradiction, however, between the architecture as such and the decorative quality of the surfaces, between the massive, broad proportions and the linearity and weightlessness of the surface effects, so that at moments – at least within its present restricted environment – it presents the oxymoronic effect of an architectural structure composed of lace. This is in strong contrast both to the Pisano pulpits, in which all the elements – socles, columns, capitals, parapet with base, and cornice – are distinct, and to Arnolfo's ciboria, for example that in San Paolo fuori le mura (Fig. 62), in which the moldings that cap the arcade and niche story are clearly distinguishable from the bases of the corner pinnacles that rise above and frame the triangular gables. In these earlier examples, as in classical architecture, each separate element is distinct and one perceives and comprehends the components that make up the whole complex. In contrast, on Orcagna's Tabernacle the various levels are not clearly defined: Is it a three-part or a four-part elevation? Are the projecting polygonal moldings to be considered cornices above the columns or are they platform bases for the statuettes? Is the band above the arches a frieze and cornice capping the middle story or the base for the gables and pinnacles? Compared to the earlier structures, Orcagna's tabernacle can be considered anything but rationally classical; indeed, it decisively rejects that tradition in favor of a profusion of pattern and texture that dematerializes the solid forms. Although it impresses and even overwhelms by way of its visionary effect, it also does not adhere closely to the principles of northern Gothic architectural design, in which *all* the elements tend to contribute to the visionary diaphanous quality, presenting thus a unified conception of structure and component elements. Here, reliefs, statuettes, and ornament compete for the viewer's attention, diffusing the sense of unity and offering, except for those moments of focus on the narratives of the balustrade, little rest for the eye.

The pictorial program of the tabernacle is directed toward the life of the Virgin, which appears in nine reliefs, eight on the socle and a large Death and Assumption on the rear side.[41] Alternating with the socle narratives are figures of Virtues to suggest the foundation of Mary's life. Finally, biblical figures – mainly prophets and patriarchs – and candle-bearing angels are set atop the corner piers and the spiral columns of the surrounding balustrade. Angels that hold a curtain and sing and play musical instruments form a frame about Daddi's panel.

The extensive Marian cycle includes more scenes from her life than appeared even on the Florentine and Sienese Duomo facades: On the north are the *Nativity of the Virgin* and the *Presentation* (Figs. 215, 216); on the west, the *Marriage* and *Annunciation*; on the south, the *Nativity of Christ* and *Adoration of the Magi* (Figs. 217, 218); and on the east, the *Presentation of Christ in the Temple* and the *Annunciation of the Death of the Virgin* (Fig. 219). Above these last two appear the large *Dormition and Assumption of the Virgin* (Fig. 220). Despite the distracting richness and complexity of the tabernacle's structure and surfaces, the reliefs themselves invite close examination. Some, such as the *Presentation in the Temple* (Fig. 216), with its centralized composition, frontal main figure, and diminutive figures out of scale with the main one, is compositionally reminiscent of *Builder* and *Law* (Figs. 194, 195) belonging to the third group of Campanile reliefs; only the small handmaidens who peer out to welcome the new member soften the effect. Others offer many touching scenes of human interaction and contact. For example, in the *Nativity of Christ* (Fig. 217) Mary lavishes attention more directly on the Infant – whose tiny hand emerges from the covering blanket being solicitously pulled over his bed – than is seen in earlier Nativity scenes (cf. Figs. 27, 42, 82). Many episodes, such as the *Birth of the Virgin* (Fig. 215), include homely domestic furnishings within a unified space, which encourages the viewer's imaginative entrance into the setting as well as his or her empathy with the event; here, too, the mother reaches toward and looks at her child with tender satisfaction that the swaddled infant is in competent hands, and this same tactile physicality of human contact pervades many of the scenes.[42] Finally, in the *Annunciation of the Death of the Virgin* (Fig. 219) we witness a not too elderly Mary, seated before a *cassone*, the touch of a smile illuminating her face as she gestures in total acceptance of her fate. What comfort this must have offered to those who had survived and witnessed even younger members of their families succumb to the terrible epidemic.

Orcagna's sculptural style, particularly his depiction of space in the socle reliefs, derives directly from that of Andrea Pisano, but the figures are stiffer and the carving, with few exceptions, less refined, tending at times to the mechanical. One might point to the differing ways the hair is carved: Andrea employs a varied and often subtle pattern of striations of differing depths and thick-

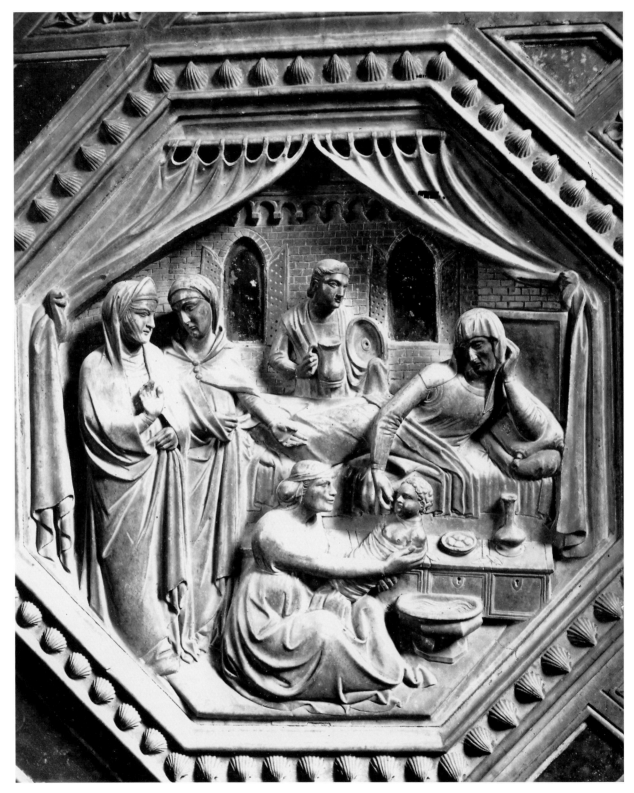

215. Orcagna: *Nativity of the Virgin.* Tabernacle, Florence,
Orsanmichele [Alinari/Art Resource, New York].

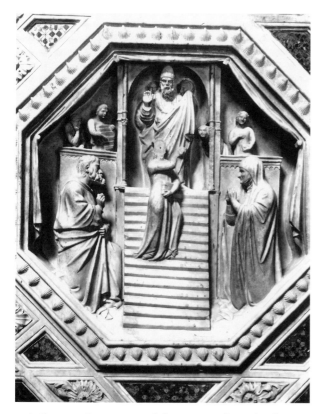

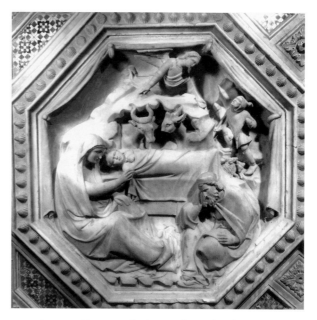

217. Orcagna: *Nativity of Christ.* Tabernacle, Florence, Orsanmichele [David Finn].

216. Orcagna: *Presentation of the Virgin.* Tabernacle, Florence, Orsanmichele [Alinari/Art Resource, New York].

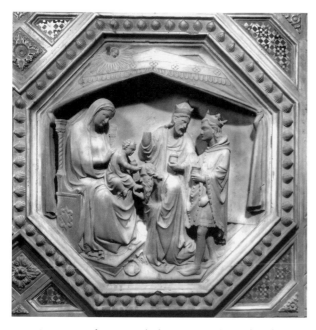

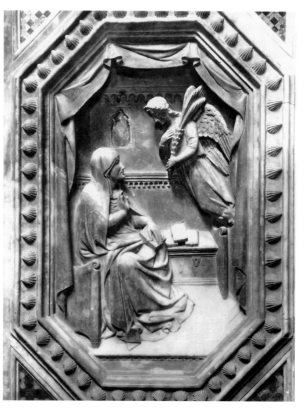

218. Orcagna: *Adoration of the Magi.* Tabernacle. Florence, Orsanmichele [David Finn].

219. Orcagna: *Annunciation of the Death of the Virgin.* Tabernacle, Florence, Orsanmichele [Alinari/Art Resource, New York].

167

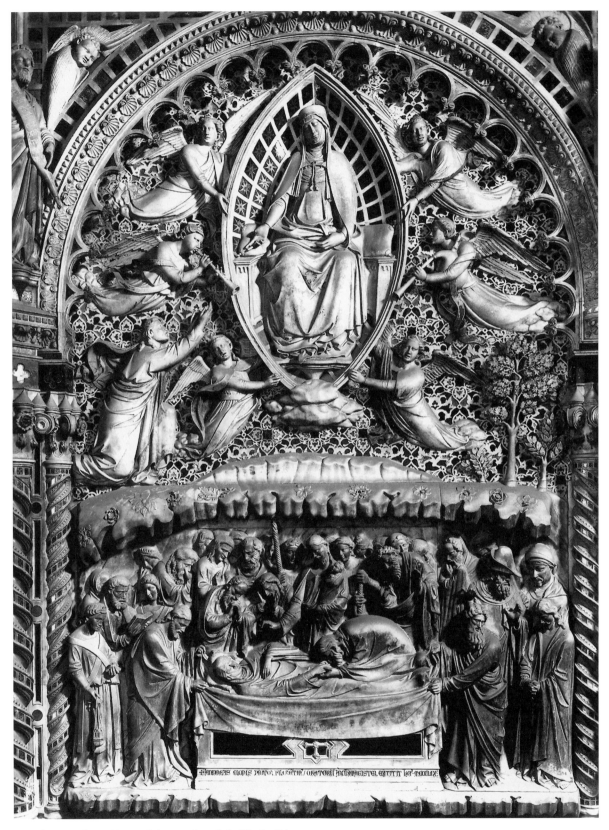

220. Orcagna: *Dormition and Assumption of the Virgin*. Tabernacle, Florence, Orsanmichele [Alinari/Art Resource, New York].

ness; Orcagna, instead, tends toward uniform patterns of parallel striations. The concept of turning the frame into a sort of proscenium, with open tent or curtain, derives from Andrea's *Jabal* and *Jubal* (cf. Figs. 174 and 218), and the rendering of the background plane as a real wall into which windows open and from which objects are hung also recalls the early Campanile reliefs (cf. Figs. 177 and 215). But if the domestic details are engaging, the spatial illusion is often less convincing, for in most of the reliefs the ground tilts upward and objects are placed in an exaggerated perspective: Here, symmetries of composition and the distribution of forms over the surfaces take precedence over illusionism.

A large workshop offering a multiplicity of carving and decorative skills was required to produce the Tabernacle of Orsanmichele. Although various hands are evident in the sculptures, and it is perhaps not surprising that inconsistencies exist in the style and expressive content of the socle reliefs, with some compositions based on Andrea's hexagonal reliefs and others closer to the later Campanile reliefs (cf. Figs. 215 and 216, respectively), Orcagna maintained a remarkable degree of control over style and quality,.

Most of the reliefs on the socle essentially adopt Andrea Pisano's stagelike illusionism, but the huge, ambitious relief on the back, the *Dormition and Assumption of the Virgin* (Fig. 220), involves quite different pictorial principles on the upper and lower sections. As in Arnolfo's Duomo facade sculpture, the Virgin of the *Dormition* lies on a bier cloth and an apostle bends over her in mourning and grasps an edge of the cloth. Christ appears and holds the Virgin's soul in the form of a small childlike form. In place of Arnolfo's restrained scene made poignant by the inclusion of and concentration on only a few figures against a flat background,[43] Orcagna's composition portrays a host of mourners, one row behind the other so that only the tops of heads are seen in the rear, all crowding around the deceased Virgin in a broad semicircle. Despite the device of overlapping figures, the dense linear patterns of drapery, gestures, and hair, together with the lack of any architectural indications, all undermine the sense of movement into depth so that the figures seem pressed rather close to the foreground plane; nevertheless, compared to the Assumption above, this scene clearly takes place within a tangible earthly realm. Among the host of generalized mourners appear two figures larger than the rest and dressed in contemporary garb. The figure on the extreme right, with fleshy face and naturalistic characterization, could well be, as

Ghiberti informs us, a self-portrait of Orcagna.[44] The Dormition is separated from the event above by a platform of stylized earth and flowers. The Assumption itself takes place against a background of gilded and colored marble inlay like a richly embroidered cloth, which if intended to seduce the eye of the approaching visitor from the east, also further reduces the sense of solidity and depth. Four angels support the Mandorla, two others play bagpipe and horn, while the doubting Thomas reaches up to grasp the Virgin's belt (probably originally of metal or leather, now lost), proof of her assumption to heaven. As is true of the figures on the Strozzi altarpiece, taken individually the Madonna and Thomas by no means lack weight and solidity: Mary sits enthroned, her lap convincingly foreshortened while the drapery moves around, not just on the surface of, her body. Once again, however, volumetric forms compete with surface patterns. The final effect of visionary dematerialization must have been even more overwhelming when the relief was illuminated only by the natural light of the open loggia and/or by candles, and when the feast for the eye was enhanced, as we shall see, by the *laude* of the confraternity's musicians.

The tabernacle was designed so as to afford security for the venerated image while permitting its occasional display to the pilgrims that flocked to Orsanmichele. For this purpose, a system was devised by which iron grilles on the three open sides from which the painting could be viewed could be raised or lowered for storage in the basement area by sliding them along grooves in the framework; when raised they obscured but did not completely hide the venerated image. It required at least two workers to operate the mechanism for the grilles. In addition, a curtain of cloth or leather may have been used to hide the image itself, not only from daily viewing but also from the dust and debris of the active grain market.[45] A space below the cupola reached by a small set of stairs permitted a man to untie the curtain. Furthermore, it would seem that the space within the shrine on its lowest story was used by singers and musicians of the confraternity to sing the praises of the Madonna while they themselves were hidden from view, thus enhancing the spectacle in which music seemed to emanate not from earthbound musicians but from the angelic choir, carved in stone, hovering around the Madonna.[46] Architecture, sculpture, painting, and music – multimedia performance art at its most effective – combined to stimulate awe, empathy, and pious intimacy in the worshipers' relationship to Mary and Christ.

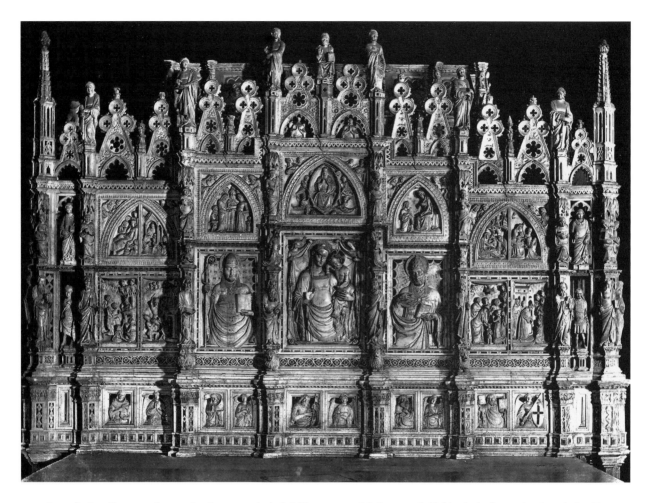

221. Arca di San Donato, after 1362. Arezzo cathedral [Alinari/Art Resource, New York].

222. Madonna and Child relief, after 1362. Arca di San Donato. Arezzo cathedral [Alinari/Art Resource, New York].

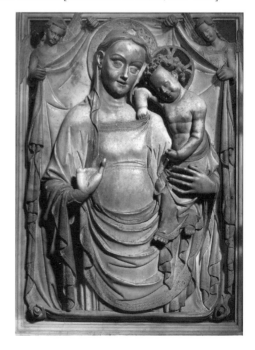

The Arca di San Donato in Arezzo

Shortly after the completion of Orcagna's tabernacle, another elaborate shrine (Figs. 221–23), showing a similar combination of massive architectonic structure and ornate surface effects, was begun by the Florentine Betto di Francesco and an Aretine associate Giovanni di Francesco for the Duomo of Arezzo; at least these are the two masters whose names, mentioned in documents of 1369 and 1375, have come down in connection with the shrine. The monument was initiated after relics of Donatus, second bishop of Arezzo, were discovered in 1362 and he was declared patron of the city. Possession of the saint's remains was disputed between the clerics of the Pieve and the cathedral canons, and the erection of a grandiose shrine in the cathedral to offer the saint's body a home worthy of devotion may well have been the definitive end of such disputes.[47] The Arca serves

170

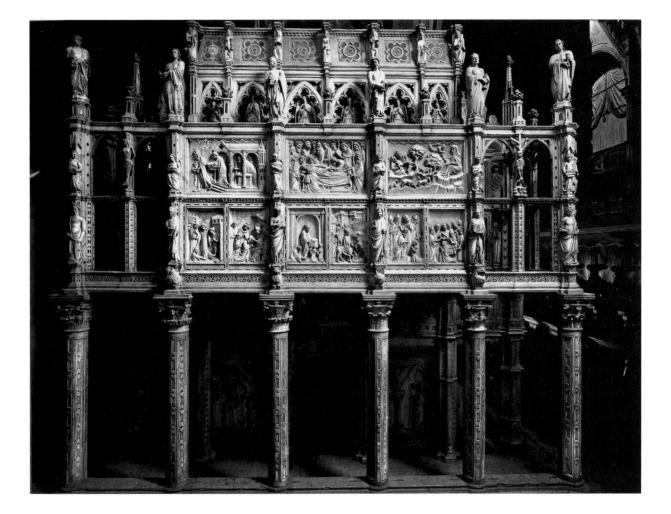

223. Arca di San Donato, after 1362. Arezzo cathedral [Alinari/Art Resource, New York].

both as an altar and a tomb, but it pays no debt to that earlier tomb-altar combination, the compact, integrated monument of San Ranieri (Fig. 129) by Tino di Camaino. Here, a thirteenth-century altar table covers the stone casket that originally contained the relics; above this *mensa* there rises a huge *ancona*, in effect a giant stone polyptych even including a predella. Behind this, resting on a series of polygonal columns, there is a two-storied sarcophagus-like ensemble, flanked by open arcades with narrative reliefs separated by polygonal pilasters, fronted and capped by statuettes (Fig. 223). This loosely connected monument, then – a freestanding structure, supported in the rear by columns, pierced by Gothic openwork, filled with colored intarsia, and showing an extensive saint's Vita (as well as scenes from the lives of Mary and Christ) and numerous statuettes of saints and music-making angels – appropriates some-

what infelicitously elements from a conglomeration of sources. The reliefs (Figs. 221, 223) – perhaps inspired by the extensive Tarlati narratives in the same building – at their best are engaging vernacular adaptations of Tuscan models and were executed by various hands. The influence of Orcagna is unmistakable in many of the narratives, while the central Madonna and Child relief (Fig. 222) takes up the motif of the Child seeking his mother's breast seen on Arnoldi's Bigallo lunette relief. The curtain-holding angels, however, recall this motif in the work of Giovanni di Balduccio. Tender emotion combines here with a love of minute pattern superimposed on formulaic drapery. Nevertheless, with its original, now lost, gilding and patterned polychromy the effect must have been quite splendid and clearly answered to the taste for ornate design that was so prevalent during the middle decades of the Trecento.

Tuscan sculpture from the late forties to the early seventies, then, exhibits both a continuation of earlier stylistic modes – sometimes, however, of lower technical and

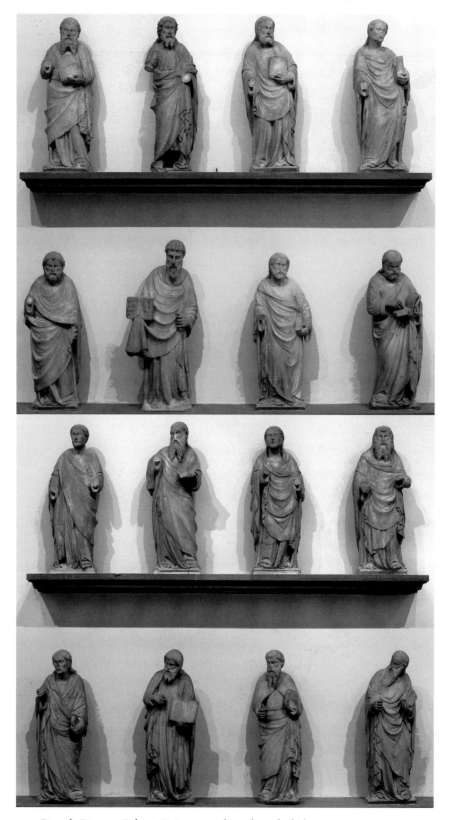

224. Piero di Giovanni Tedesco(?): Statuettes from the cathedral
facade, late fourteenth century. Florence, Museo dell'Opera del
Duomo [Nicolò Orsi Battaglini].

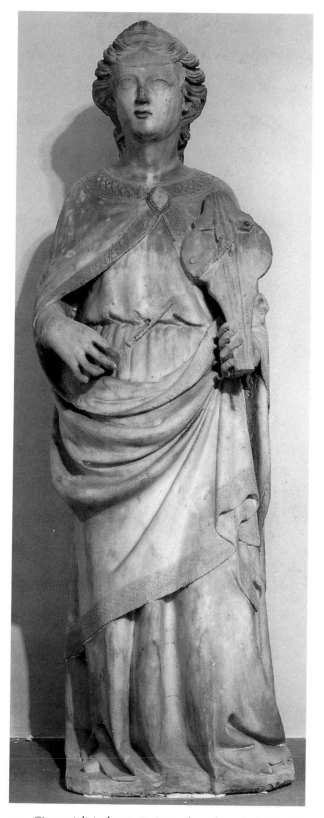

225. Giovanni di Ambrogio(?): Statue from the cathedral facade, late fourteenth century. Florence, Museo dell'Opera del Duomo [Nicolò Orsi Battaglini].

expressive quality – and a rejection of them in favor of diverse and even dichotomous ideals. Lyrical rhythms, exquisite craftsmanship, polyphonies of color and pattern, narratives emphasizing the quotidian, tenderness of emotional content – all these and others are the ingredients mixed in varying quantities in the productions of the period. To the extent that contradictions and dichotomies exist, they may be, in fact, emblematic of the tensions of the period.

Florentine Sculpture of the Late Trecento

In late 1362 attention turned from the virtually completed Campanile back to the cathedral facade, and groups of sculptors were commissioned to fill in the missing gaps in the portal zone. Although the next few decades produced many individual statues skillfully carved, on the whole the project, often involving series of figures commissioned from groups of artists working together, resulted in formulas that repeated and refined those based primarily on Andrea Pisano, as well as on Orcagna and Arnoldi.[48] For the group of statuettes of saints in the Museo dell'Opera del Duomo attributed to Piero di Giovanni Tedesco (evidently an artist coming from across the Alps), documented between 1386 and 1402, variations of pose and physiognomy manage to save these from monotonous repetition, but their derivation from Andrea's statues is evident (Fig. 224).[49] Specialists have argued over attributions of the many carvers mentioned in the documents during this period, but it has proved very difficult to tie the documents to specific sculptures. The overall impression, however, with a few exceptions, is of committee patronage and uninspired committee execution. The exceptions include the almost academically classical music-making angel (Fig. 225) attributed to Giovanni di Ambrogio, who, together with Jacopo di Piero Guidi, executed several of the Virtues (Fig. 226) on the Loggia della Signoria (later called the Loggia dei Lanzi).[50] The Loggia, a structure begun in early 1374 to serve civic ceremonial functions, such as the welcoming of foreign dignitaries or the transfer and acceptance of state offices, received embellishment and made its civic statement by means of personifications of Virtues: The four Cardinal Virtues find their place on the long side facing the piazza, and the three Theological Virtues are on the short side facing the civic palace. Over the central arch, where government officials exiting the Palazzo della Signoria were likely to enter ceremonially, was placed the figure of Charity.

The Virtues were designed not by the sculptors who

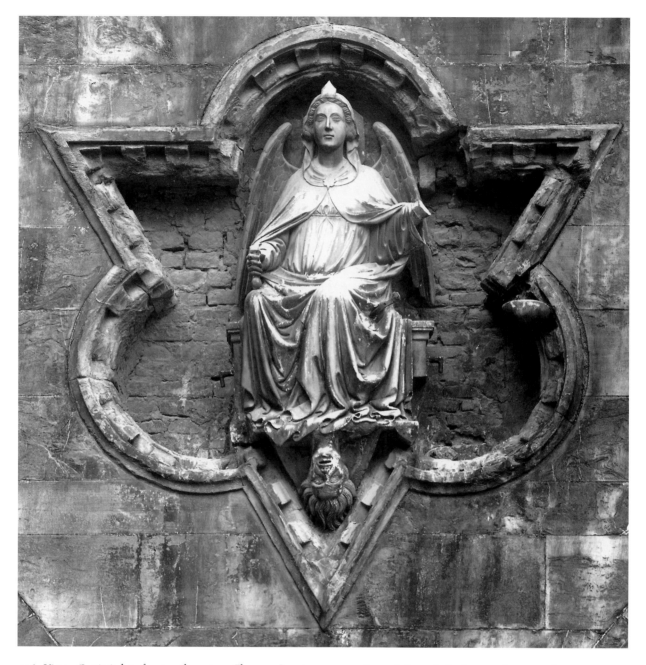

226. Virtue (Justice), late fourteenth century. Florence, Loggia dei Lanzi [Alinari/Art Resource, New York].

executed them between 1383 and 1391 – Jacopo di Piero Guidi, Giovanni di Ambrogio, and Giovanni di Francesco Fetti are named in the documents – but by the painter Agnolo Gaddi, whose father had been trained by Giotto. Painted, gilded, and originally all set against backgrounds of colored glass inlay, these marble relief figures are composed of broad forms amply but convincingly swathed in belted tunic and veil. Notwithstanding a certain monu-

mentality of the whole figure, the smooth inexpressive faces and linear hair treatment give the impression of an almost mechanical translation from the two- to three-dimensional realm. Although at least three carvers were involved, the fact that a single painter provided designs must have assured a unity of effect. But it is emblematic of the age – witness Milan cathedral, where painters, as we shall see, also provided designs for sculptors – that toward the end of the century design skills had apparently become so weak among stone-carvers that an alternative system had to be employed.

From Center to Periphery:
The Diffusion of Tuscan Ideals

In regions outside of Tuscany, Rome, and Naples not favored by powerful patrons of church, state, and the mercantile classes, the infusion of impulses of varying intensity from the centers to the periphery occasionally produced works of surprising quality in which local, *popolaresco* traditions were newly invigorated while still retaining their relevance. In the Abruzzi region, stone and marble, not in plentiful supply, had been employed exclusively for architecture and its embellishment, not for cult objects, which were most often made of wood. Indeed, by the mid–thirteenth century the area had developed a peculiarly strong tradition of carving in wood, of which there was both an abundant and varied supply: Countless stiff, iconic images of the seated Madonna and Child, carved from a single trunk of chestnut, oak, or walnut, and always polychromed, are found in the hillside oratories and parish churches of the region, objects of intense and continuous veneration whose unchanging forms were hallowed by tradition.[51]

Its geographic location in the center of the peninsula enabled the Abruzzi region, when other factors favored it, to receive stylistic currents from the north, that is, Umbria and southern Tuscany, and probably also from the south, from Naples where the French culture of the Angevin court gave way in the field of sculpture and painting to Tuscan dominance by the third decade of the fourteenth century. The crowned *Madonna* (Fig. 227) from San Silvestro in L'Aquila (now in the National Museum of that city) retains the closed contours and adherence to the slightly curved columnar form of the material from which she was carved, remaining thus loyal to the older tradition; but rather than being rigidly frontal, with stiff unnaturalistic drapery, the Madonna as well as her son are enlivened by shifting axes, and the face of the Madonna, illuminated by the hint of a smile, is in notable and comforting contrast to the serious intentions visible on that of the blessing Christ Child. A mixture of Orvietan and Neapolitan influences (cf. the seated Madonna in the Orvieto Museo dell'Opera del Duomo [Fig. 163] and the Tinesque *Madonna and Child* in San Bartolommeo, Anghiari,[52] respectively) has gently energized the otherwise conservative tendencies in this and in several other Abbruzzian examples. The deep piety that such figures evoked, and undoubtedly the efficacy of their response to worshipers' prayers, induced their imitation.[53] Many such figures were originally placed within a wooden housing

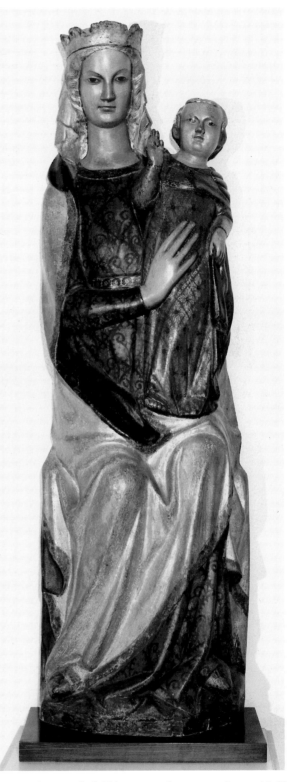

227. *Madonna and Child* from San Silvestro, wood, second half of the fourteenth century. L'Aquila, Museo Nazionale [Soprintendenza per I Beni Ambientali Architettoici Artistici e Storici per l'Abruzzo l'Aquila].

when the figures were carved life-size (the standing magi in Fabriano are approximately 170 cm high), the telling gestures, lifelike polychromy, and spatial disposition resulted in such vivid evocations of the sacred event that the line between mimesis and reality, between observation and experience, shifts and fades as in few other artistic genres. Often a carved group of local renown would be copied, either in the bottega of the original master as a precise replica or by another workshop.[56]

Another subject, which may well have been more popular among women than the number of preserved

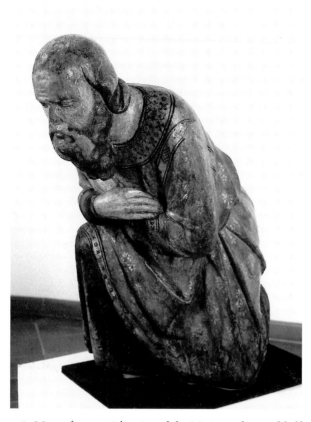

228. Magus from an Adoration of the Magi, wood, second half of the fourteenth century. Fabriano, Archivescovaldo [Comune di Fabriano Pinacoteca Civica e Museo degli Arazzi "Bruno Molajoli"].

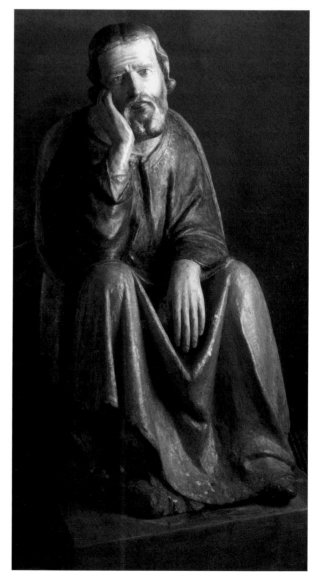

229. Joseph from an Adoration of the Magi, wood, second half of the fourteenth century. Fabriano, Archivescovaldo [Comune di Fabriano Pinacoteca Civica e Museo degli Arazzi "Bruno Molajoli"].

with wings like those of a triptych capable of opening and closing upon the image. When open, the wings might reveal painted scenes from the life of the saint to whom the altar on which the image stood was dedicated. The *Madonna* in Sta. Maria Assunta, a weaker simulacrum of the San Silvestro *Madonna*, is a well-preserved example of this type (its paintings date from the fifteenth century) in which the three-dimensional figure of the *Madonna* sits on an illusionistically painted throne.[54]

The example of Arnolfo's marble *Praesepe* in St. Maria Maggiore, Rome (Figs. 71–73), stimulated the creation of other sculptured groupings of this and other subjects: Mention has already been made of the *Adoration of the Magi* in Bologna (Fig. 75), unique in that all five brightly colored and gilded wood figures are preserved. The Epiphany theme seems to have been especially favored in the Marches region. Most often just one, but perhaps even three or four figures from a yet larger group are preserved, for example, the Joseph and Kings from an Adoration in Fabriano (Figs. 228, 229).[55] Particularly

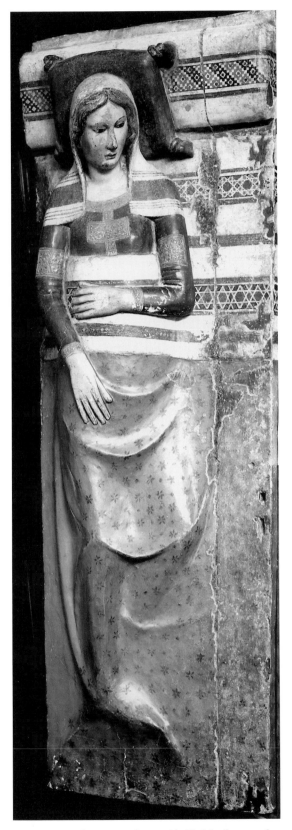

230. Nativity Madonna, wood, second half of the fourteenth century. Naples, Museo di San Martino [Luciano Pedicini].

examples indicate, is the Nativity showing a reclining Virgin, either lying on her back after the exhaustion of childbirth, as in the example from Sta. Chiara, Naples (Fig. 230, now in the Museo di San Martino), or resting on one arm and directing her attention toward the infant in front of her while Joseph sits nearby, as in the *Madonna* in San Niccolo di Tolentino (Fig. 231); this, too, may have been part of an ensemble, possibly even an extensive one that included kings, the animals, the shepherds, and the midwives.[57]

Finally, from the hillside church of San Michele in the Mugello town of Casanuova comes an unexpectedly theatrical ensemble carved in wood, of which four figures are extant (Figs. 232, 233): These formed part of a Lamentation over the Dead Christ.[58] The expressive gesticulation of some of Giovanni Pisano's narratives is carried now to the intensity level of a German Andachtsbild; like such scorching images made for other times and places that seem to respond to an agonized desire for empathy and catharsis, this group may truly represent a response to plague (in addition to the Black Death of 1348, a major epidemic hit Italy in 1362–63) and would thus be datable to the second half of the fourteenth century.

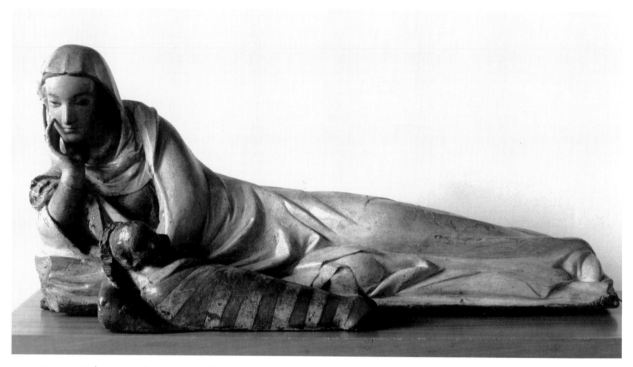

231. Nativity Madonna, wood, second half of the fourteenth century. Tolentino, Museo di San Nicola [author].

232. Figures from a Pietà, wood, second half of the fourteenth century. Florence, Museo di Santo Stefano al Ponte [Ralph Lieberman].

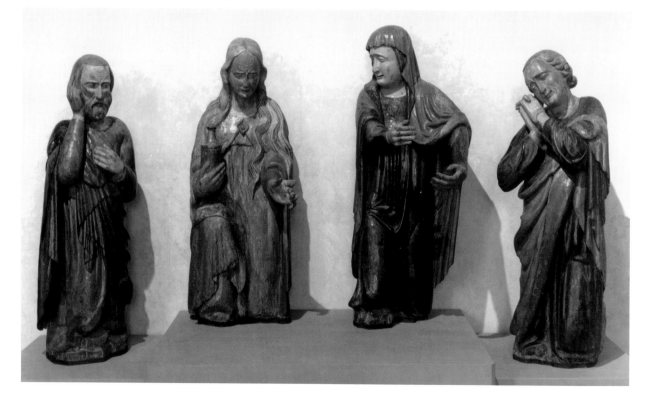

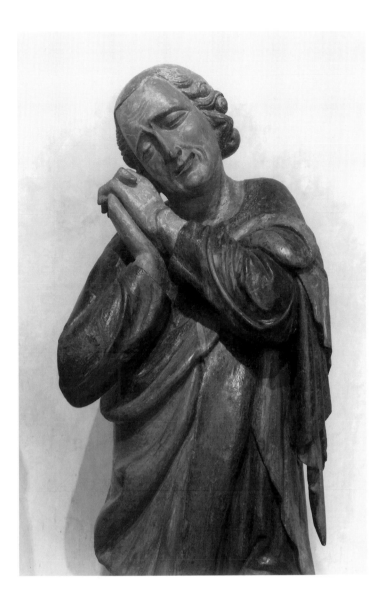

233. Figure from a Pietà, wood, second half of the fourteenth century. Florence, Museo di Santo Stefano al Ponte [Ralph Lieberman].

5

Angevin Patronage in Naples and Southern Italy

TINO DI CAMAINO IN NAPLES

Tino di Camaino had reached artistic maturity in Tuscany, but it was in the courtly environment of Naples that his full potential was realized and his inventiveness given scope. In or around 1323 he was called to Naples, probably by King Robert the Wise of Anjou after the death of his son's wife, Catherine of Austria, in January of that year.[1] The Hapsburg princess had previously been engaged to the emperor Henry VII after the death of his first wife, Margaret of Brabant, but by August 1313, before the marriage could take place, Henry had died. The union of Charles of Calabria and Catherine was a political one, made to strengthen King Robert's position in Italy by eliminating threats from Germany (her brother was Frederick the Fair, contestor of the imperial crown against Ludwig of Bavaria).[2] The choice of Tino as the major sculptor of the tomb (see following discussion) may well have been motivated by the fact that not only was he an established master of tomb designs in Tuscany but also early in his career (as seems likely) he had been a member of the workshop of Giovanni Pisano, the very master who had designed the Margaret of Luxemburg tomb in

Genoa; furthermore, it was Tino who had received the commission for the monument to Henry VII in Pisa. This political and artistic networking is reflected, as we shall see, in several design choices for the tomb of the Austrian princess.

Naples was home to a medley of artistic traditions – local Romanesque, French Gothic, and contemporary Tuscan and Roman, among others – that coexisted and intermingled. The city itself, as was true of much of southern Italy, had already been open to a wide variety of cultural influences under the Hohenstaufen. In addition to Byzantine, Muslim, and northern European influxes, the region had experienced, as we have seen, a strong classical revival in the middle of the thirteenth century, promoted by Frederick II.[3] The Cosmati tradition traveled to Naples either directly or by way of the influence of Arnolfo.[4] Beginning with the arrival of Charles I after his forces killed the last of the Hohenstaufen line at the battle of Benevento on 26 April 1266, and continuing into the fourteenth century, the city of Naples, now the seat of the royal court, developed into a truly cosmopolitan center attracting painters, sculptors, architects, and goldsmiths from other parts of Italy, from France, and from Germany.[5] Under Charles (king from 1266 to 1285), extensive building activity was begun employing French architectural style, whose prestige and elegance could be exploited to further the monarch's political and propagandistic aims, the solidification of French rule in his new realm. Later, under Charles II (who ruled from 1285 to 1309) and his successor Robert the Wise (d. 1343), a less aggressively French style of architecture appears, which melded northern Gothic elements with indigenous traditions.[6]

On the one hand, imported masters continued to be active: The names of many French goldsmiths, for example, are noted in the documents, including those who executed the beautiful reliquary bust of San Gennaro in 1304.[7] With its strong modeling of the features and forceful characterization of the saint, the work challenges in monumentality any carving in stone. Side by side with French artists there were local masters of French training, such as Gagliardo Primario, putative designer of the Provence-influenced Church of Sta. Chiara (begun 1310).[8]

By the early fourteenth century Naples had also become a magnet for Tuscan artists and intellectuals: Cino da Pistoia, the noted jurist and lecturer (see Fig. 381), arrived in 1330, the same year that saw the appearance of Boccaccio; a few years later Petrarch

arrived. A follower of Duccio, Montano da Arezzo, is mentioned in the registers between 1305 and 1315. Pietro Cavallini worked in Naples in 1308, Simone Martini was employed by the court from 1317 to 1320, and Giotto headed a workshop there from 1329 to 1333.[9] Although there are documentary references to several Tuscan sculptors, only three have left known bodies of work. A certain Ramulus de Senis was sent in 1314 to Orvieto to procure marble and workers to be brought to Naples, but whether this is the same Ramo di Paganello who had supposedly been to France and who was active in Siena with Giovanni Pisano and in Orvieto in 1293 has not been ascertained.[10] Lando di Pietro, who had made the crown for Emperor Henry VII's coronation in Milan, came to Naples around the same time as Tino; he left in 1339 for Siena, called there to work on the Duomo Nuovo.[11] The Angevin court's interest in Tuscan sculptors, in fact, goes back at least to the time when Arnolfo, working in Rome, executed the statue of Charles I of Anjou dressed as a Roman senator. Thus Naples was already rich in Tuscan influences prior to Tino's arrival, and judging, for example, by the extant frescoes by Cavallini and his workshop, the Neapolitan atmosphere proved conducive to the creation of monumental works fully in the avant-garde. Tino, then, coming from an environment of cultural ferment in Central Italy, with its sequence of forceful artistic personalities, now entered into a relatively relaxed and variegated artistic milieu, where no single style or master dominated. This very fact, however, may well have encouraged the free development of the sculptor's poetic and lyrical side. Finding his major patrons in an ambitious royal house with temporal concerns as strong as religious ones, Tino was, furthermore, challenged to develop a sequence of inventive tomb constructions and programs to satisfy their demands.[12]

Tino's major commissions in Naples were a series of tombs for members of the Angevin dynasty.[13] In these works, beginning with the tomb of Catherine of Austria, he instituted a fundamental change of tomb structure with respect to his earlier commissions. All his extant Tuscan tombs are wall monuments supported by consoles. They offer a great variety of types, but in each one sculpture plays a dominant role while architectural elements serve to support, to frame, or, as in the Petroni monument, to crown the sculptural components. In this respect they adhere to the pattern set by Arnolfo, who himself following in the footsteps of his master Nicola Pisano, had greatly increased the amount, prominence,

and scale of sculpture on tomb monuments. Unlike their Tuscan predecessors, Tino's Neapolitan tombs are not supported by consoles but are set directly on the ground, and the relationship between sculpture and architecture has been altered.[14]

The Tomb of Catherine of Austria

Tino is not documented as the author of the tomb of Catherine of Austria (Figs. 234–36), but modern scholarship unanimously accepts the sculptures as by his hand; regarding the design of the tomb as a whole, opinions vary.[15] The chosen site of the tomb presented an unusual challenge, however, for it was not to be set against a wall but rather placed between two pairs of columns forming part of the ambulatory of San Lorenzo, rebuilt as a French-style structure during the reign of Charles II d'Anjou in the late thirteenth century.[16] The tomb, thus, whose design must have resulted from close collaboration of patron, master, and perhaps a local consultant, is double-sided: The observer can walk both around and through it, for the sarcophagus forms a high bridge between the freestanding columns. The tomb's design draws upon a variety of traditions: Freestanding tombs meant to be seen on all sides are characteristic of saints' shrines, but the double-sided aspect of Catherine's tomb also belongs to a transalpine tradition and was probably a deliberate choice on the part of the Angevin.[17] The architectural aspects, however, also suggest a return to an older scheme represented, for example, by the tomb of Clement IV in Viterbo of 1271–74 (Fig. 59); it is equally reminiscent of those late-thirteenth-century freestanding tombs of professors of jurisprudence in Bologna (Figs. 378, 379), in which columns support a tabernacle, and the sarcophagus, sometimes with an effigy, forms a bridge between the columns. The baldacchino-like structure and the extensive use of mosaic in the twisted columns and relief backgrounds derive from the Roman Cosmati tradition continued by Arnolfo in his tombs and ciboria and suggest that Tino passed through Rome – not to do so seems hardly conceivable – on his way to Naples. The diminutive standing saints at the head and feet of the effigy imply sources in northern Italy,[18] whereas the Virtue caryatids beneath the sarcophagus have been seen both on the Arca di San Domenico and on the tomb of Margaret of Luxemburg, the latter, in fact, known to Robert of Anjou from several sojourns in Genoa.[19] The tomb of Margaret's husband (and adver-

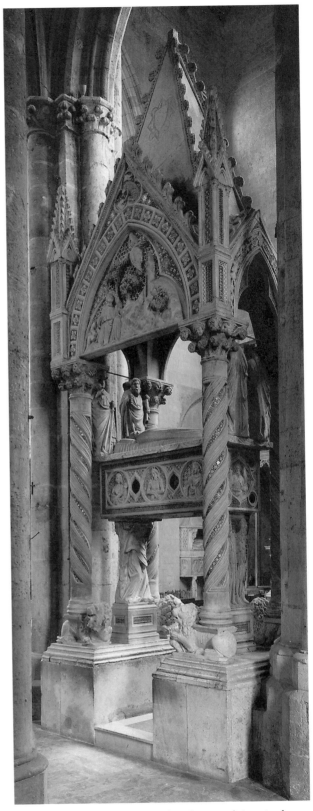

234. Tino di Camaino: Tomb of Catherine of Austria, begun c. 1323. Naples, San Lorenzo [The Conway Library, Courtauld Institute of Art].

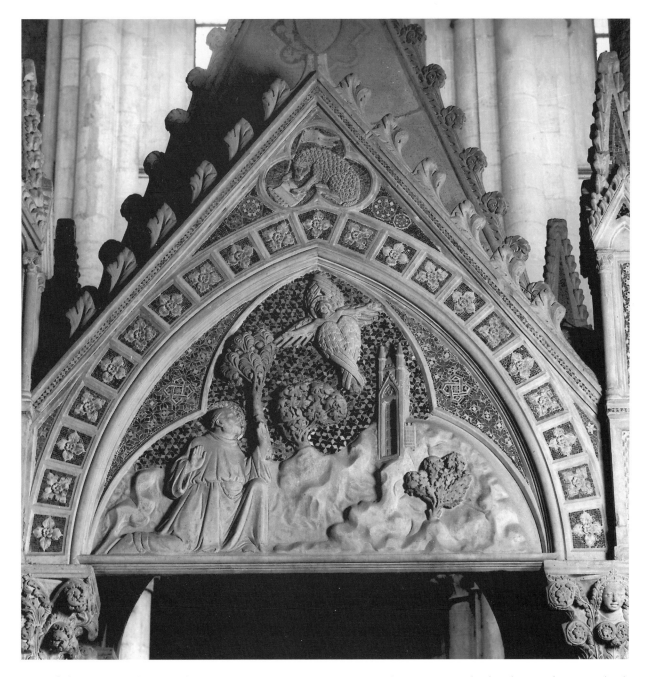

235. Tino di Camaino: Tomb of Catherine of Austria, detail. Naples, San Lorenzo [The Conway Library, Courtauld Institute of Art].

sary of the Angevin house), the emperor Henry VII, had of course been designed by Tino, who now was challenged to create an equally impressive monument for the emperor's former fiancée.

In order to support the heavy sarcophagus and effigy, Tino ingeniously altered the traditional caryatid, embedding the figures in thick fronds of leafy and blooming trees. The figure holding a bouquet of flowers represents Hope and the one with two clinging children represents Charity (Fig. 236), a theme that Tino had explored in at least one earlier work in Florence (Fig. 143). These fig-

ures are characterized by a new melting softness with full, rounded forms, in strong contrast to the more angular caryatid in Frankfurt (Fig. 139). Nevertheless, the peasant ideal – a robust Mother Earth type with stocky proportions – and the expression of quiet joyfulness is the same as that seen in Tino's Florentine female figures and, indeed, throughout his career.

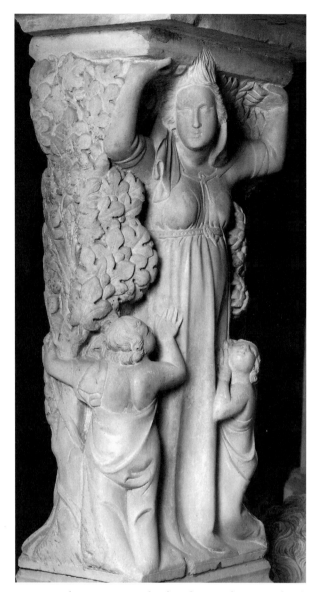

236. Tino di Camaino: Tomb of Catherine of Austria, detail. Naples, San Lorenzo [The Conway Library, Courtauld Institute of Art].

ures along a single front plane against a flat ground, with little to suggest movement into depth. By contrast, in the *Stigmatization*, the figure, landscape elements, and architecture are distributed in such a way as to suggest their existence in several planes. The kneeling saint hugs the foreground plane and is carved from a viewpoint *da sotto in sù*; he is considerably larger in scale than the chapel in the background, toward which the soft clumps of earth and the stairs seemingly carved out of the living rock appear to extend. The remarkable sense of continuity when observed in situ has no counterpart in contemporary sculpture but anticipates in this regard the Campanile landscape reliefs (Fig. 173) and some Sienese reliefs of the 1330s (Figs. 152, 153).[20]

The tomb's iconography is centered on dynastic and Franciscan ties and on the expression of the princess's virtues, which ensure her reward in heaven: Royal saints related to the Angevins (Elizabeth of Hungary and Louis of Toulouse) are included among those standing at the head and foot of the effigy; three Franciscan saints (Anthony, Francis, and Clare) appear on one side of the sarcophagus while the relief of the *Stigmatization* is carved on the outer tympanum above the effigy. The sarcophagus itself is supported by the Theological Virtues of Hope and Charity; the third virtue, Faith, is implied by the appearance of the Pietà on the other side of the sarcophagus. Finally, the inner tympanum (facing the altar) shows a relief of Catherine recommended by an angel to the enthroned Savior.

The Tomb of Mary of Hungary

Only two months after the death of the monarch's daughter-in-law, Robert's mother, Mary of Hungary, died in March of 1323. She had been the granddaughter of St. Elizabeth of Hungary and the mother of another saint, Louis of Toulouse, canonized in 1317. In her Will, the queen mother named Tino di Camaino and the Neapolitan architect and mason Gagliardo Primario as the creators of her tomb, to be erected in Sta. Maria Donna Regina.[21]

The tomb (Fig. 237), completed in 1326, takes up a concept seen earlier in the monument of Benedict XI (Fig. 164) in San Domenico Perugia (d. 1304), which Tino could have seen on his way to Rome and Naples, and perhaps on other lost structures: Here, there are two independent, self-contained yet related forms, namely, a baldacchino-like enframement that in turn houses an entire wall tomb of a type similar to the Petroni monu-

A decisive change in relief mode is seen in the lunette over the funeral chamber representing the *Stigmatization of St. Francis* (Fig. 235). Although the iconography may depend on a composition by Giotto, and the mosaic background – given that this is a spatially conceived narrative – may be considered an archaism and thus probably a concession to local taste, nevertheless, the representation is extremely pictorial with a greater emphasis on landscape than is seen in Tino's earlier reliefs. Tino's Tuscan reliefs, as we have seen, are characterized by a tendency to dispose the fig-

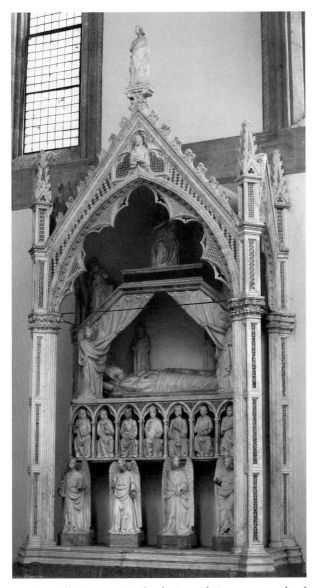

237. Tino di Camaino: Tomb of Mary of Hungary, completed 1326. Naples, Sta. Maria Donna Regina [The Getty Research Institute].

Tino's earlier tombs. The caryatids no longer express the act of supporting, although this is visually compensated for by their closed form enframed vertically by wings, and their relatively static poses, all in the service of their architectonic function. The sarcophagus embellished with arcades derives from a French tradition seen, for example, on the tomb of Louis de France (d. 1260) in St. Denis.[22] Instead of the mourners usual on French tombs, however, the Neapolitan monument shows enthroned members of the royal family, the seven sons of Mary on the front (with the central position given to St. Louis of Toulouse), and four attendants along the sides, thus highlighting a distinguished and flourishing dynasty.[23] In a delightful adaptation of a southern and Roman leitmotif, seen for example on Arnolfo di Cambio's ciborium capital in San Paolo fuori le mura and introduced, in turn, by Tino on a capital of the tomb of Catherine of Austria, there are included a number of whimsical heads among the leafy capitals of the baldacchino (Fig. 238).

As to the figures' style, given that the queen expressly chose Tino to execute her tomb, one is not surprised that upon close examination there is little evidence of workshop intervention: Each figure and each relief is conceived and carved with mastery; nowhere else in his oeuvre is Tino's serene spirituality more in evidence. Compared to his earlier sculpture one notes an elaboration of forms, for example in the deep drilling of the luxuriant curls of the angels (Figs. 239, 240) and the richer flow of the drapery forms. The Sienese facial type with narrow elongated eyes, long nose, and broad cheeks remains characteristic. Whereas in his earlier figures, body and drapery tend to be undifferentiated masses, here there is a greater distinction between the two. The royal effigy, compact and graceful, is an image of sweetness and serenity, as if death were free from drama or terror. In the Madonna above the funeral chamber, any reminiscences of Giovanni Pisano, still evident in the Florentine Sedes Sapientae (Fig. 140), are gone. If the pose is more static, there also is a new humanity: The Madonna gently touches the Christ Child, confidently balanced on one leg, while turning with a tender glance toward the kneeling Mary of Hungary, whose upturned eyes and crossed hands express deep devotion and earnest pleading for salvation.

The relationship of the sculptured tomb elements with the architecture of the outer canopy is finely cogitated, and in this respect suggests a critique of the Benedict XI tomb (Fig. 164), in which there are few visual correspondences between the outer framework

ment, except that both tomb and baldacchino stand directly on the floor. Much more elaborate than the tomb of Catherine of Austria (Fig. 234), it is also lighter and more graceful, and the relationship of the different architectural parts to each other shows a more sophisticated handling than is seen on the earlier monument. Instead of almost overwhelming the sculpture, there is now a balance between architecture and sculpture. The repetition of motifs, however – the series of arched niches containing seated figures on the sarcophagus, and the four angel caryatids – results in the figures taking on less individual importance than do the figural parts of

238. Tino di Camaino: Tomb of Mary of Hungary, detail. Naples, Sta. Maria Donna Regina [author].

239. Tino di Camaino: Tomb of Mary of Hungary (angel caryatid). Naples, Sta. Maria Donna Regina [Marburg/Art Resource, New York].

and the composition contained within. One notes the tripartite division of the external architecture aligned with the heads of the caryatids, the top of the sarcophagus, and the ends of the sloping roof of the death chamber, respectively, and the cusped polylobes related to the platform for the Madonna, as well. The poses of the caryatids balance each other pairwise and about the central axis of the monument. In the upper region along that axis are seen the Madonna (flanked on one side by the kneeling queen mother and on the other by an angel presenting a model of the church), the blessing Savior in the gable, and the Archangel Michael atop its peak. Thus, both dynastic and resurrection themes are embodied in the tomb's program.

The Tombs of Charles of Calabria and Mary of Valois

If the tomb of Mary of Hungary (Fig. 237) can be considered almost completely autograph Tino, in all later tombs there is considerably more workshop intervention, some of very high quality. The tombs of Charles of Calabria (son of King Robert the Wise) of 1332–33 (Figs. 241, 242) and Mary of Valois (Charles's second wife who died in 1331)[24] (Figs. 243–45) repeat the two-part scheme introduced in the monument of Mary of Hungary (Fig. 237). In Charles's tomb the supporting figures are not freestanding caryatids but are attached to short massive columns in a most unusual interpretation of the Gothic statue column, although one that recalls the triad of column figures supporting the Arca di San Domenico (Fig. 35). Furthermore, instead of representing on the sarcophagus only members of the family, the enthroned Charles, who had been heir to the throne but died in 1328 at age 31, is seen isolated and hieratic, surrounded by two rows of ecclesiastical and secular advisers recalling motifs seen on the tombs of law professors in Bologna. In place of the mosaic backgrounds of the seated figures in the tomb of Mary of Hungary, the figures here are set against a unifying slab of red marble (meant to suggest porphyry with its imperial connota-

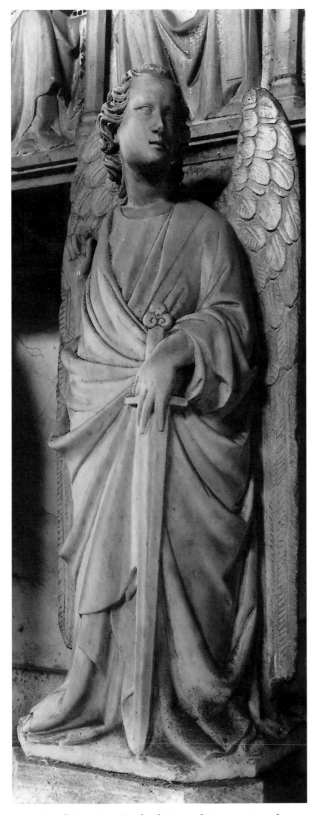

240. Tino di Camaino: Tomb of Mary of Hungary (angel caryatid). Naples, Sta. Maria Donna Regina [Marburg/Art Resource, New York].

tions?). A third innovation is the appearance of mourners behind the effigy instead of clergy performing the exequies, as seen on Arnolfo's Annibaldi monument (Fig. 60); these mourners are certainly one of the most notable examples of a French-derived motif. But in contrast to French precedents, here the mourners are placed in close proximity to the effigy, reflecting perhaps the profound sorrow felt by king Robert of Anjou, whose political hopes for the succession of his only son were dashed by the duke's untimely death. The solemnity of the funeral and the suggestion of an endless retinue – clerics on the left and friars on the right – is conveyed by the rather dark chamber into whose shadows the line of figures seems to extend in both directions. Traces of color indicate a subdued color scheme that originally enhanced the effect.

The tomb of Mary of Valois (Figs. 243–45), dated between 1335 and the sculptor's death in 1337, includes Virtue caryatids that have reached such a high point of elegance and refinement, notwithstanding a certain metallic quality in the surfaces, that it is difficult at first to accept them as coming from the same chisel as that of the Hungarian queen's tomb (Figs. 239, 240), although the designs of both bear Tino's imprint. No longer robust, earthy peasant types, these are graceful princesses of more elongated proportions who wear drapery that is hollowed out by sharp, elegant curvilinear folds (Fig. 244). These figures indeed come closer to contemporary French sculpture than do any others in Tino's oeuvre, a development occurring contemporaneously in Tuscany, witness Simone Martini's Uffizi Annunciation for the Siena cathedral, Andrea Pisano's Baptistry doors, and Giovanni di Balduccio's Virgin Annunciate in Sta. Croce, all of the 1330s. A similar metallic quality in the carving and a schematic way of rendering the hair is seen in the angels drawing the curtains of the funeral chamber, and these same characteristics are found in several of the caryatids of the later tomb of Robert of Anjou, also in Sta. Chiara (Fig. 249), by the Florentine Bertini brothers. One wonders whether the latter, documented authors of Robert's tomb were not engaged in Tino's shop at this point (we do not know when they appeared in Naples) and carved some of the figures closely following Tino's design. Be that as it may, the caryatids on the tomb of Mary of Valois, with their linear elegance and elongated proportions, but also with their strong sense of weight and balance, suggest that in his designs Tino has arrived at a true synthesis of Gothic and classicizing forms.

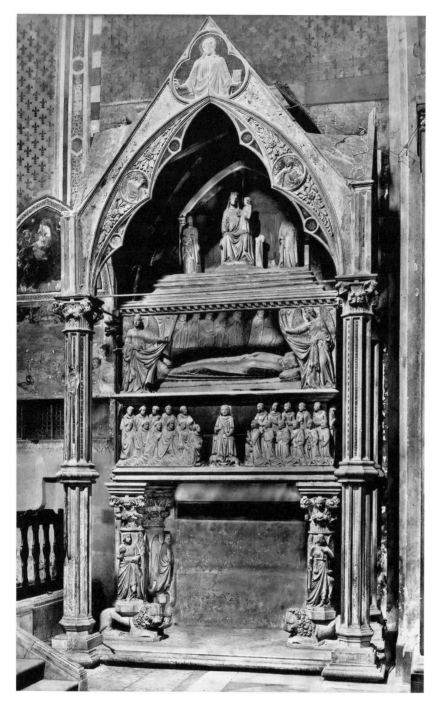

241. Tino di Camaino: Tomb of Charles of Calabria, 1332–33. Naples, Sta. Chiara [Alinari/Art Resource, New York].

The Votive Relief of Queen Sancia

In Naples Tino also executed at least one altarpiece and other smaller-scale objects.[25] The undocumented, undated votive panel of Queen Sancia, second wife of Robert the Wise, in the National Gallery of Art in Wash-

ington, D.C. (Fig. 246), is certainly by Tino. Made for private devotion to be viewed from close proximity, the surfaces have an alabaster-like translucency, while the figures' gestures and expressions communicate a deeply felt religious mood. Although the queen joined the Order of St. Claire only toward the end of her life in 1343, earlier on she often wore the habit of the nuns of Sta. Chiara, the convent that she had founded with papal permission in 1311 and to which she devoted considerable energy and resources;[26] and it is in the garb of the Clarissans that she is shown kneeling modestly and on a diminutive scale before the Madonna while directing her fervent glance toward St. Francis. Her nun's garb does not, however, completely conceal her regal status, for her crown is worn like a bracelet about her right arm and a glimpse of her elaborate coiffure is seen under her veil.

Tino di Camaino has been the subject of widely varying evaluations. Some perceive his work as marred by careless and too rapid execution and as a superficial adaptation of Giovanni Pisano's style; others view Tino as a sculptor whose formal inventions not only are taken up by the great masters of the Renaissance but even anticipate the development of abstraction and Cubism of the twentieth century.[27] The fact that many of his projects have come down to us in an incomplete state, and that the extant statues and fragments do in fact show considerable variations of style and/or quality, has contributed to ambivalent assessments of his achievements. During the earlier part of this century the masters of our period were appraised primarily in terms of the technical and aesthetic qualities of individual sculptures and reliefs divorced from their con-

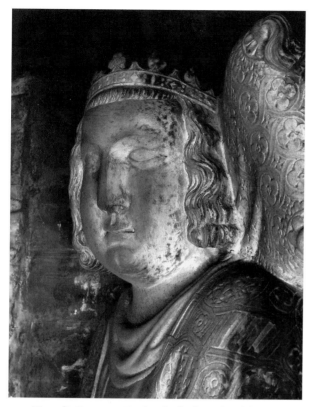

242. Tino di Camaino: Tomb of Charles of Calabria, detail. Naples, Sta. Chiara [Alinari/Art Resource, New York].

niously altered the traditional caryatid, embedding the figures within their floral matrix in order to provide adequate support for the unusual placement of the sarcophagus, to the elaborate two-part sepulcher of Mary of Hungary (Figs. 237–40) with its baldacchino superstructure housing an entire wall tomb, including a sarcophagus with images of the queen's sons and council-

243. Tino di Camaino: Tomb of Mary of Valois, 1335–37. Naples, Sta. Chiara [Alinari/Art Resource, New York].

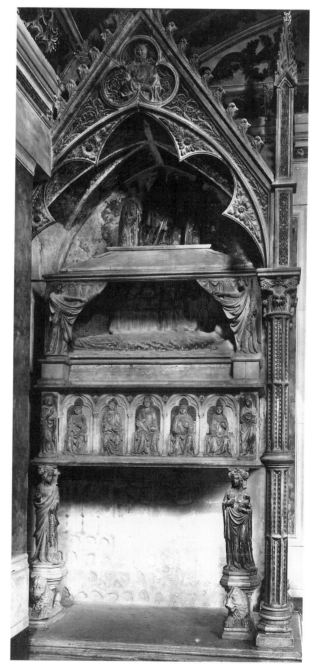

texts. Tino lacked, it has been felt, the tragic temperament, so that his figural sculptures suffered from comparisons with those of Giovanni Pisano. It is only during the last third of the twentieth century that the conception of a monument as a whole – now understood as the product of both patron and sculptor within a given historical context – has gained importance in the assessment of a master's place within the history of the media and the typology of the monument itself. As an inventor of tomb forms Tino is unique in the fourteenth century. With perhaps the sole exception of the Della Torre tomb, whose patron clearly wished for a repetition of the Petroni monument, there is no tomb by Tino that is without iconographic, structural, or stylistic novelty as he continuously explored means to express the spiritual, political, or dynastic aims of his patrons and their heirs. Particularly in Naples under the patronage of the feudal monarchy and drawing upon a variety of traditions, Tino created a remarkable series of sepulchral monuments that range from the double-sided tomb of Catherine of Austria (Figs. 234–36), in which he inge-

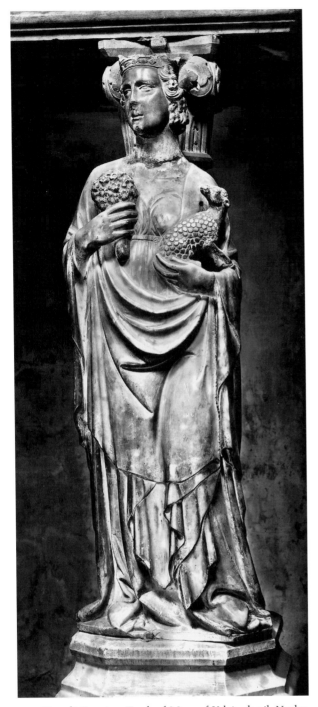

244. Tino di Camaino: Tomb of Mary of Valois, detail. Naples, Sta. Chiara [Alinari/Art Resource, New York].

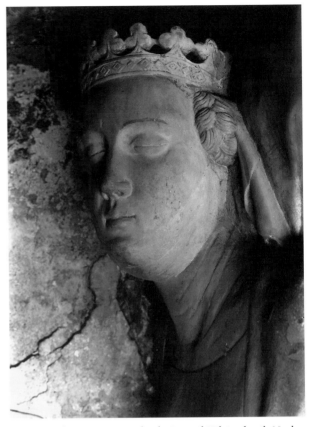

245. Tino di Camaino: Tomb of Mary of Valois, detail. Naples, Sta. Chiara [Marburg/Art Resource, New York].

the two-part scheme of the monument of Mary of Hungary, further elaborated the concept of dynastic continuity: In Charles's tomb, the prince himself is enthroned, isolated and hieratic but surrounded by two rows of ecclesiastical and secular advisers, while on the princess's sarcophagus the deceased with her children (some of them, in fact, themselves no longer living) are represented sitting side by side. A new elegance and balance between classical and Gothic ideals characterize the caryatids of this last tomb (Fig. 244), for which Tino was still owed money when he died in 1337.[28]

GIOVANNI AND PACIO BERTINI DA FIRENZE

Robert of Anjou, who died in 1343, had been a person of wide-ranging interests in the intellectual, artistic, and theological realms. Known as an erudite and cultured individual, he was bold enough even to contradict tenets firmly held by the pope with respect to the controversial doctrine of the Beatific Vision.[1] Under his reign poets, artists (including Tino), and scholars flocked to

lors (instead of the traditional theological themes), and caryatids of unsurpassed beauty and serene spirituality. Finally, in the tombs of Robert's son Charles of Calabria (Figs. 241, 242), and Charles's wife, Mary of Valois (Figs. 243–45), the sculptor, while repeating

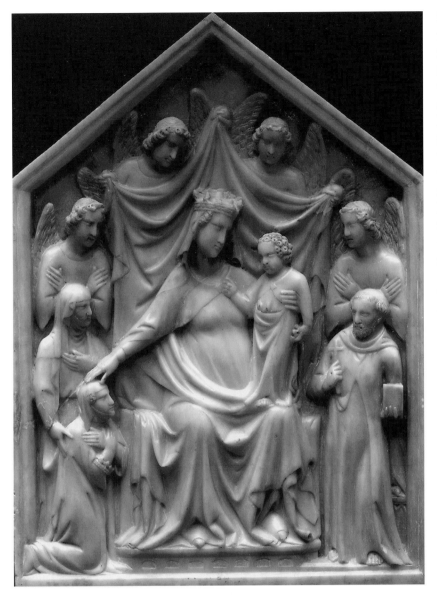

246. Tino di Camaino: Votive panel of Queen Sancia, 1330s?. Washington, D.C., National Gallery of Art [Samuel H. Kress Collection. Board of Trustees, National Gallery of Art, Washington, D.C.].

in 1345 there are indications that the ambitious complex was still incomplete.[2] Almost fifteen meters in height, with a base six meters wide, this was to be the largest sepulchral monument of the first half of the century.[3] The monument was severely damaged during the Second World War and partially reconstructed from extant fragments. Its original design, known from old photographs and illustrations, was a prodigious elaboration of sepulchral themes and motifs seen in the creations of Tino di Camaino (Fig. 247). Like most of Tino's Neapolitan tombs, it is composed of two independent structures, a huge enclosing baldacchino and the tomb proper consisting of caryatids (representing Virtues and thus alluding to the political and religious ideals of the king) supporting a sarcophagus on which the enthroned monarch and his royal family are represented in relief. Above the sarcophagus lies an effigy of the deceased, behind which stand allegories of the Liberal Arts – the first known use of such figures serving as mourners at the funerary mass – all revealed by curtain-holding angels. Above this – in contrast to the reticent relief image of Charles of Calabria by Tino in that same church, and very possibly inspired by the original form of the Henry VII monument[4] – in a huge chamber with drawn curtains, the king appears a third time, again hieratically frontal, alive, and enthroned holding globe and scepter but now (seemingly) carved in the round, while flanking him are his subjects, in fresco, kneeling toward him with awe and respect. Finally, atop the chamber in which the king is seated he appears a fourth time but on a more discreet scale, presented to the Madonna and Child by Saints Frances and Clara (Sta. Chiara) surrounded by frescoed angels.

No less modest is the architectural encasement, especially the piers, which are no longer solid masses or twisted gilded columns; rather, they are composed of

Naples enriching the cultural atmosphere of the city and its environs. Upon the monarch's death his niece Giovanna I commissioned two Florentines, Giovanni and Pacio Bertini, to create his tomb, and it is evident that the monarch's religious, political, and cultural accomplishments and aspirations were decisive factors in the design, as well as the scale, of the monument.

The two masters are named in several documents of 1343 in connection with the tomb, one of which states that it must be completed in one year. Not surprisingly,

five tiers excavated by canopied niches containing a host of statuettes (prophets, sibyls, and Franciscan as well as other saints). At the apex of the composition, within the highly peaked gable enclosing a traceried Gothic arch, there is carved in relief an image of Christ in a mandorla held by angels, displaying his wounds. The interior of the ribbed vault of the baldacchino was painted in fresco with angels, glittering with red and gold nimbi against an ultramarine ground; behind the sculptured Virgin and Child there was painted a choir of angels, perhaps here asserting the doctrine of the Beatific Vision, so vigorously defended by King Robert against the opposing views of Pope John XXII.[5] The monument, which united architecture, sculpture, fresco, and much polychromy in the patterned decorative embellishments, was meant to impress and overwhelm the beholder; even today, with so much of the upper section lost and despite the intrusion of a baroque altar, it succeeds in doing just that.

Robert of Anjou's tomb monument was clearly executed by a large number of stonemasons, and when one examines the individual figures and reliefs one finds that the stylistic variations are vast with little that can be considered a uniform, "autograph" style of any single, dominant sculptor.[6] It is likely, however, that the best of the carvings are by the masters, while the vast majority, ranging widely in quality, are probably by local artisans. The highest level of artistry is achieved in the Virtue caryatids supporting the sarcophagus, the curtain-drawing angels of the funeral chamber, and a select few of the niche figures of the baldacchino. The curtain-holding angels (largely destroyed but known from old photographs) (Fig. 248) are characterized by robust, even classicizing faces and garments that seem

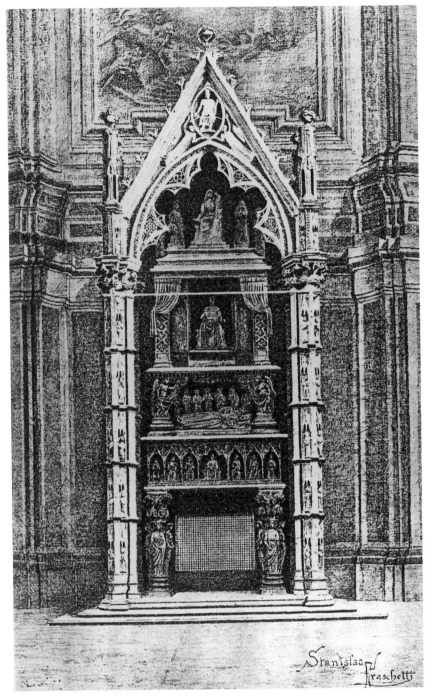

247. Giovanni and Pacio Bertini: Tomb of Robert of Anjou [engraving, Stanislao Fraschetti, *Rivista d'Italia*, III, October 1900, 247–78].

separate from the bodies beneath, although their physical balance is not completely secure. The classicizing restraint of the master who carved these figures prohibited zigzag or arabesque hemlines and extraneous

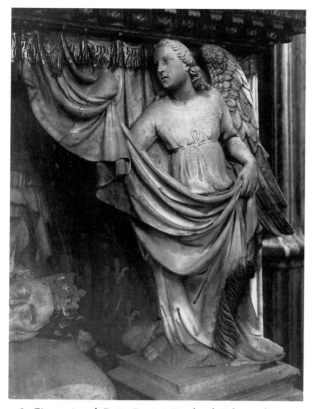

248. Giovanni and Pacio Bertini: Tomb of Robert of Anjou, begun 1343, detail [Naples. Soprintendenza per I Beni Artistici e Storici].

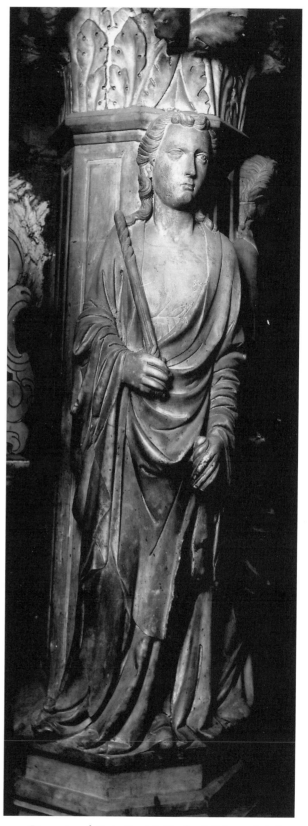

249. Giovanni and Pacio Bertini: Tomb of Robert of Anjou, detail [Vatican, Monumenti Musei e Gallerie Pontificie].

drapery enveloping the bodies. The figures also reveal a certain hardness of carving technique that departs from Tino's softer, more malleable forms. In contrast to the curtain-holding angels above, the Virtue caryatids (Fig. 249) are far more Gothic, with the fold patterns of the drapery more lyrically fluid; they recall, as suggested earlier, the caryatids of the tomb of Mary of Valois (Fig. 244). Thus, even among the finest of the figures on the tomb, no single, characteristic hand seems dominant, making any specific attribution to Giovanni or Pacio Bertini hazardous.

Although a number of sculptures other than those on the tomb have been attributed to the Bertini brothers, there are no signed works, and no monuments other than the Angevin tomb documented as by them. The most important attribution is the series of reliefs representing the Life of Saint Catherine of Alexandria (Figs. 250, 251), formerly embedded in the tribune screen of the church of Sta. Chiara.[7] The Sta. Caterina reliefs (also almost completely destroyed during World War II, and now to be seen in fragments in the Sta.

193

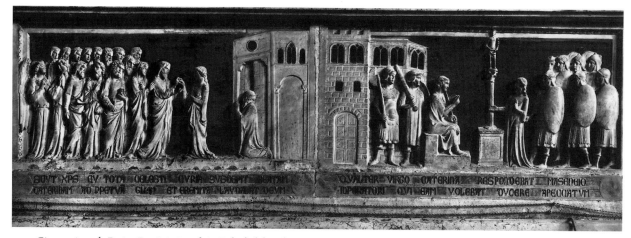

250. Giovanni and Pacio Bertini (attrib.): Relief, life of St. Catherine of Alexandria, 1340s? [Alinari/Art Resource, New York].

251. Giovanni and Pacio Bertini (attrib.): Relief, life of St. Catherine of Alexandria, 1340s? [Alinari/Art Resource, New York].

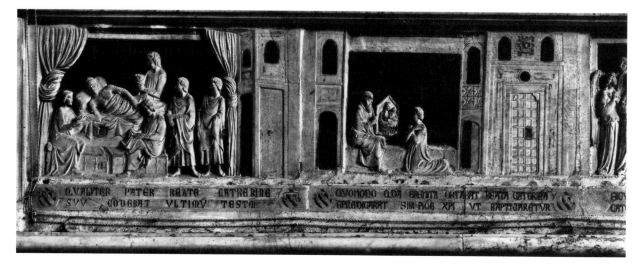

Chiara museum with a useful series of large photographs to scale showing their prewar state)[8] were carved in white marble and set against a very dark green marble ground, a contrast and procedure that recalls the bronze door reliefs of the Baptistry of Florence in which the figures are modeled and cast separately and then attached to the flat background. As in the bronze reliefs, the fictive space available for the figures is precisely that between the frame and the background plane, this distance sometimes emphasized by the oblique placement of an architectural structure.[9] The graceful figures are composed with a sense of rhythm and lyrical elegance reminiscent of Andrea's

figures, but the drapery forms tend to be simpler, without the complications of folds and hems seen on many figures on the doors. The harmonious compositions and economy of narrative mode also recall Andrea's reliefs.

In contrast to Andrea's reliefs, however, which show slow, measured movements suggestive almost of a ritual enactment, these marble reliefs tell a lively narrative, enhanced by gestures and realistic background details. Each episode is identified by an inscription. In *St. Catherine Disputes with the Emperor* (Fig. 250, right) the saint energetically emphasizes her arguments with her fingers, and the palace with rusticated masonry,

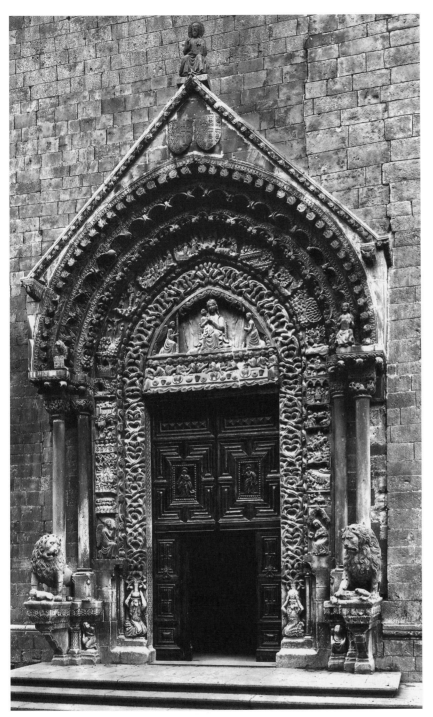

252. Portal. Altamura cathedral, 1340s/1350s? [Alinari/Art Resource, New York].

torture. Thus, the narrative tone of these reliefs is closer to that of Goro di Gregorio and his Sienese compatriots than to Andrea Pisano. In the San Cerbone narratives (see Figs. 144 and 145), figures and architecture are given a three-dimensional concreteness and set against a flat – in some cases decoratively incised and once richly colored – background, while the architectural elements are sometimes placed at an angle to the front plane to suggest depth. The figures are often distributed about a central caesura to enhance the sense of dramatic dialogue, a device also found in the Neapolitan reliefs. This narrative impulse, using a few selected but vivid details and telling gestures, enhanced by their isolation against a neutral or patterned but flat background, is characteristic of Goro di Gregorio's d'Abbiate sarcophagus (Fig. 146) and Agostino di Giovanni and Agnolo di Ventura's Tarlati monument in Arezzo dated 1330 (Figs. 148–50). These relationships to Florentine and Sienese sculpture of the 1330s suggest both the filiations of the St. Catherine reliefs and the problematics of attempting attributions.

THE SECOND HALF OF THE TRECENTO AND BEYOND

South of Naples the Romanesque style remained a living idiom well into the fourteenth century. An isolated but direct response to the new currents filtering south from Tuscany and Naples is seen in the main portal of the cathedral of Altamura in Apulia (Figs. 252–54). The church was built by Frederick II in the early Duecento but was severely damaged, perhaps by an earthquake, and restored in 1316 (as indicated by an inscription on the right flank of the building). At that time control of southern Italy was in the hands of the Angevins, and it was under Robert of

crenelation, and *bifore* windows recalls a real structure, the Palazzo Signoria in Florence. In the *Flagellation of Catherine* the emperor earnestly leans forward, imploring the saint to worship an idol rather than submit to

195

Anjou (two stemmi of the House of Anjou are carved within the gable of the facade portal) that the church was rebuilt. The inscription informs us that the facade was executed by masters from Bitonto; evidently, it was thought that Bitonto could provide artisans more au courant of recent artistic developments, although there

253. Portal, detail. Altamura cathedral [Alinari/Art Resource, New York].

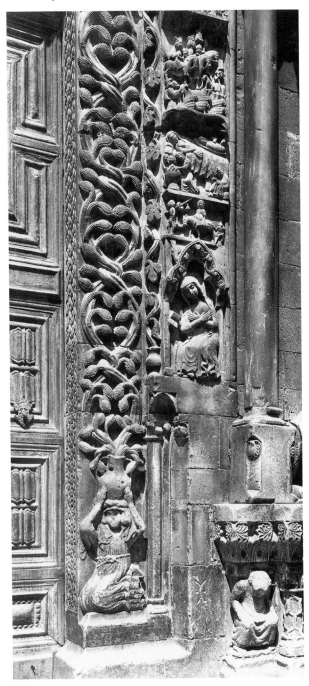

is little stylistic connection – excepting the densely foliated archivolts and jambs seen on the facade of Bitonto cathedral – between contemporary production there and this portal at Altamura.

The main portal, which follows a Pugliese tradition of portal design, was rebuilt now in Gothic form. It has been dated as early as 1316 (which seems too early) and as late as between 1356 and 1374.[1] The entranceway is framed by a series of concentric pointed arches crowned by a shallow gable. The outermost archivolts surmount columns, two of which rest on the backs of lions on consoles;[2] a second pair of columns rests atop kneeling atlantes. The columns originally supported symbols of the four Evangelists; only Mark and Matthew are extant. Above the gable there appears a figure of the enthroned Christ. The innermost arch shows two women supporting on their heads amphora from which emerges a magnificent frieze of intertwining floral forms serving to frame the doors and the tympanum (Fig. 253). The architrave presents the Last Supper along a well-appointed table, and in the lunette above

254. Portal, detail. Altamura cathedral [Alinari/Art Resource, New York].

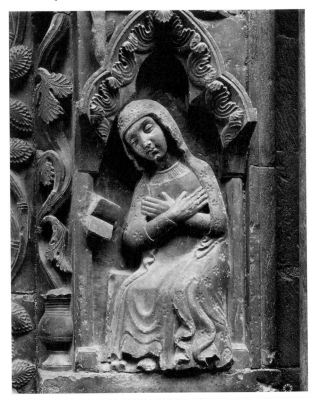

this is a Madonna and Child flanked by two kneeling angels.

Large figures of the Angel of the Annunciation on one side and the Annunziata (Figs. 252, 254) on the side opposite serve as base for a series of loquacious narrative reliefs. Twenty-two panels – perhaps the most extensive cycle of narratives after Orvieto, and certainly including many more episodes than seen on the Pisano pulpits – illustrate the Life of Christ in a vivacious, *popolaresco* mode, full of realistic details and credible movements that belie the usual reference of these reliefs to the Romanesque style. Composed of broad, simple forms, the Virgin of the Annunciation (Fig. 254) projects an expression of sweet humility and acceptance of her mission as she crosses her arms over her breasts and lowers not only her head but her eyelids, now turned away from the open book she has just been reading. The narrative opens above Mary and moves continuously up to the apex of the archivolt and down again on the side opposite.[3]

At least two hands are at work: the master who executed the Madonna and the Annunciation figures, and the assistant(s) who carved the other narrative reliefs. Although the bold enframing ornamentation, ultimately of Byzantine origin, projects out more vigorously than was conventional in the Pugliese tradition, providing strongly patterned chiaroscuro effects, the narratives, of a muscular plasticity combined with a new sense of humanity, clearly manage to hold their own within the eye-catching ornamentation. This most impressive portal of the period in Apulia is virtually a unicum of fourteenth-century sculpture in this region and deserves fuller study.

In Naples itself, it was not too long after the death of Tino di Camaino that formulaic repetitions of his sepulchral schemes proliferated. These, in combination with elements derived from the tomb of Robert of Anjou, were employed by sculptors who had contributed to the latter and who answered to the great demand for sepulchral monuments. Tombs for royalty, aristocrats, and clergymen filled the churches of Naples with undistinguished effigies on sarcophagi or tomb slabs, supported by columns or caryatids, with or without architectural framings. Similar tombs, executed in Neapolitan workshops, were sent elsewhere, for example, to Calabria where a number of important feudal Angevin families resided; these, in turn, influenced local craftsmen.[4] Only one Gothic monument postdating the tomb of King Robert presents a new conception of the royal sepulchral monument, going beyond anything heretofore done in Naples. Retardataire in its component parts and fully Renaissance in several of its individual figures, the marble monument of King Ladislao (d. 1414) (Fig. 255) in San Giovanni a Carbonara, dated well past the turn of the century, combines motifs and inventions not only from Naples but also from Lombardy and the Veneto. It clearly reveals the attempt to outdo the grandiose tomb of his great uncle Robert the Wise in Sta. Chiara (Fig. 247) while also, in its overt references to the latter, unequivocally suggesting dynastic continuity.

Like Robert's tomb, this monument is about fifteen meters tall, reaching almost to the vault of the church and it is even wider, measuring about eight meters at its base. But instead of repeating the two-part scheme of Tino and his successors, here the entire monument reaches out from the rear wall to embrace the side walls of the choir chapel in which it is situated. The effect is of an architectural ensemble ambiguously suggestive both of an exterior facade and of enclosing interior walls. Four huge caryatids (among the few elements that can be considered Renaissance in style) on high bases sustain the sumptuous mass that rises above in three further tiers: On the lower level, cavernous niches contain, in the larger central opening, enthroned figures of the king and his sister Giovanna II (who assumed power upon his death), and these are flanked by four Virtues. Above this, rising in the central bay and flanked by crocketed gables and pinnacles that turn the two corners, is the funeral chamber with effigy revealed by curtain-drawing angels. Above the funeral chamber, on the truncated gable framed by tabernacles and capping the entire monument, rises an armored equestrian figure of the king reminiscent of the Scaligeri tombs in Verona (see Chapter 7). Apparently oblivious to the declining fortunes of the house of Anjou, shortly to be overwhelmed by the Aragonese, the king raises his arm and sword triumphantly.

We do not know who designed this regal monument.[5] Whoever its author, given its late date, the resistance of Neapolitan patrons and sculptors to full acceptance of the Renaissance is stunningly evident: The broad round arch of the central chamber, the classicizing drapery worn by the caryatids, and the severe trabiation do little to modernize an ensemble that so strongly proclaims its traditional roots. Proudly, even obstinately, flaunting its "heady Gothic decor," as one observer has commented, the monument represents in Naples "the last great affirmation of medieval thought and Gothic art."[6]

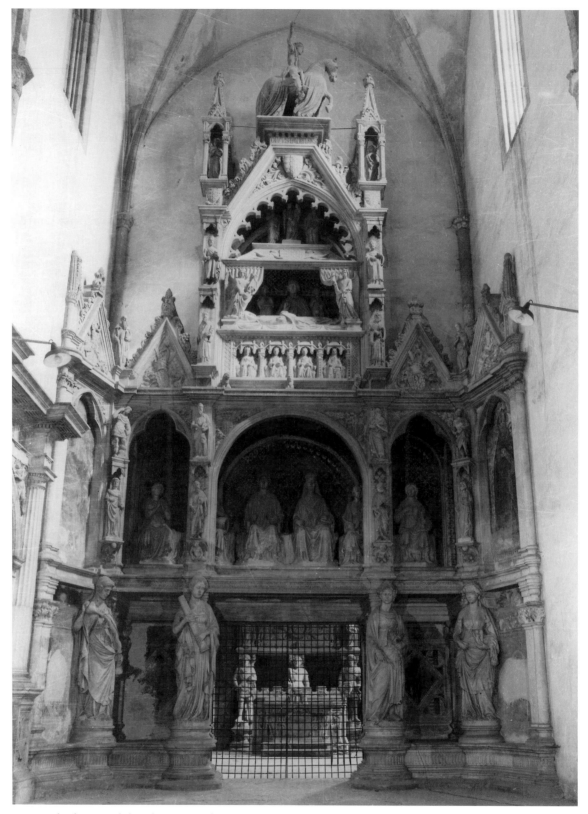

255. Tomb of King Ladislao (d. 1414). Naples, San Giovanni in
Carbonara [Naples. Soprintendenza per I Beni Artistici e
Storici].

6

Lombardy

LOMBARD SCULPTURE BEFORE 1334

In contrast to our discussion of sculpture in Tuscany, Rome, and Naples,
which focused largely on individual artists and their oeuvre, the themes to
be dealt with when confronting sculpture in Lombardy, with some notable
exceptions, revolve around artistic or stylistic circles (rather than individ-
ual, identifiable artists) and patterns of patronage. To begin with, unlike
Tuscany where Gothic style suddenly replaced the Romanesque, in Lom-
bardy a strong and vital Romanesque tradition persisted and sometimes
blended with, sometimes rivaled or even clashed with, the new current.
This northern region was renowned from the second half of the twelfth
through the fourteenth century for its family workshops of sculptors,
stone carvers and architects originally from the Campione region, from
Lugano, and from the Lombard lakes. Among the most prominent of these
groups is the one whose members came to be known as the "maestri Cam-
pionesi." These masters shared not so much a unified style as a particular
stone-carving tradition. Indeed, they worked almost exclusively in stone,
and their sculptural productions, at least until the late Trecento, are charac-

perceives hints of the new Gothic realism and sense of humanity.

Guglielmo Longhi died in Avignon in 1319 but, in accord with his testamentary wishes, was buried in his native territory. The tomb was erected in San Francesco, Bergamo, and moved to Sta. Maria Maggiore in the nineteenth century, where, with some alterations, it remains today. The anonymous designer of the tomb, very likely responding to the cosmopolitan social milieu of Guiglielmo's circle, reveals his awareness of sepulchral elements known in Central Italy. The angels behind the effigy had appeared on Tino's Petroni monument (Fig. 137) (Guglielmo had been named one of the executors of Petroni's Will). The clerics performing the funerary exequies – originally, in addition to the two carved figures at

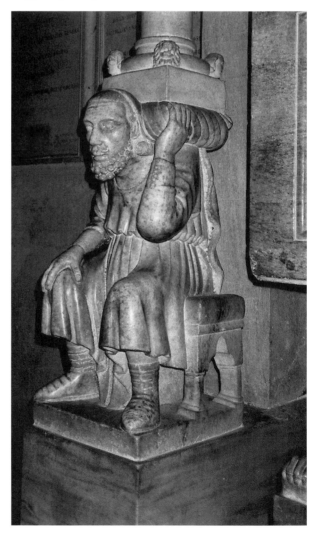

257. Guglielmo Longhi monument, detail. Bergamo, Sta. Maria Maggiore [author].

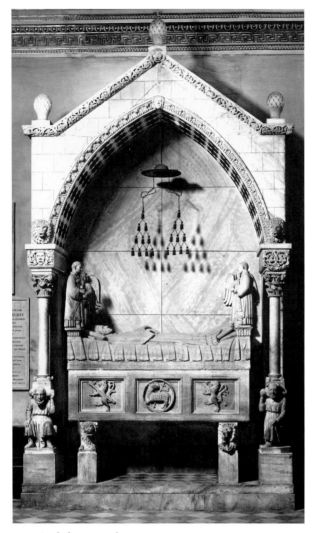

256. Guglielmo Longhi monument, c. 1320. Bergamo, Sta. Maria Maggiore [Alinari/Art Resource, New York].

terized by a solid compactness and simplicity of form (thus, the continuing connection to Romanesque style). In many works, a directness of expression is combined with a narrative richness of *popolaresco* appeal.[1]

Apparently during the first thirty years or so of the fourteenth century, both the ecclesiastical and lay patrons who commissioned these stone-carvers to embellish their churches, tombs, and other liturgical furnishings found satisfaction in their stylistic conservatism. Looking, for example, at the tomb of Cardinal Guglielmo Longhi of about 1320 in Bergamo (Figs. 256, 257) by a Campionese master, one would hardly suspect that the monumental works of Nicola and Giovanni Pisano and Arnolfo di Cambio were already events of the past. Yet here and elsewhere, if rarely, one

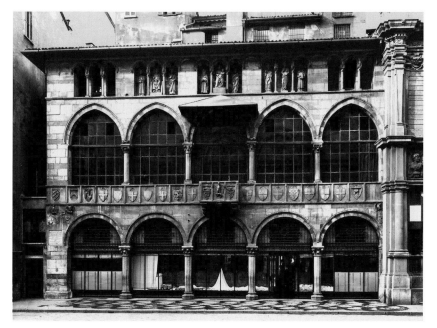

258. Campionese master: Milan, Loggia degli Osii, 1316 [Alinari/Art Resource, New York].

embellished with nine statues, including four saints on each side of the Virgin, all within niches. Two hands have been distinguished among this group: One reveals an unusually expressive force in the agitated draperies and realistic excavations of the faces (Fig. 260). Here, one senses influences from across the Alps, helping to animate, furrow, and decompose the block. The other (Fig. 259) is closer to, and perhaps by the same carver as, the figures on the Longhi tomb in Bergamo (Fig. 256).[4]

A final example of this stylistic current may be seen in a Madonna and Child (Fig. 261) in the Art Institute of Chicago. This group is characterized by a compact frontality in which the broad, planar forms of the body and drapery are enlivened by occasional touches of minute and delicate decorative elements seen on the neck and sleeve borders of the garments and on Mary's crown. The anonymous carver has combined a Romanesque assertion of mass with a new awareness of the relationship of drapery to body: The folds follow the underlying forms, curving gently around their projections and descending into the hollows. The emphasis on symmetry and frontality on the one hand results in a hieratic austerity reminiscent of Arnolfo's Florentine Duomo Madonna (Fig. 81); yet the simplified masses, focused glance, and affable expression recall Tino di Camaino's analogous Madonna in the Bargello (Fig. 140). The Lombard carver thus reveals himself not immune to Tuscan influence, yet he retains allegiance to his native traditions and succeeds in creating an image of great plastic vigor that combines the suggestion of gentle warmth with majesty.[5]

the head and foot of the bier, there was a frescoed frieze of clerics against the chamber's rear wall – is a motif that Arnolfo had introduced in the Annibaldi monument (Fig. 60). The figures themselves remain compact and massive, and the hair and beard stylized, yet a closer look at some of the elements, such as the left-hand telamone (Fig. 257), reveals a new attitude toward the human figure. Although the eyes bulge following the Romanesque formula, the three-dimensional corporeality of the torso, the logic of the drapery whose simple vertical folds reflect the bends of that torso, and the fleshy features with a touch of a sensuous smile reveal a sculptor capable of infusing into the stolid form a sense of a living presence, a human personality who bears his burden with resignation yet equanimity.[2]

A similar inclination to soften the blockiness and impassive stability of figures strongly informed by the older Campionese tradition is seen in the Loggia degli Osii figures (Figs. 258–60) in Milan. The Loggia, which already reveals a predilection for Tuscan mural design in its architecture of alternating dark and light marble revetment (instead of the brickwork common in Lombardy) and an airy quality derived from its two superimposed, (originally) open arcades, was erected for public pronouncements of sentences and edicts in 1316 during the period of Matteo Visconti's rule.[3] At a slightly later date it was

AZZONE VISCONTI AND GIOVANNI DI BALDUCCIO IN MILAN

Just as Tino's talents were nourished by the royal court at Naples, those of Giovanni di Balduccio were profoundly appreciated in the signorial environment of Milan, where opportunities abounded in commissions for architecture, tomb ensembles, and civic sculpture. Northern Italy except for Genoa and Venice, as mentioned earlier, was controlled by several rivalrous families, the most prominent and powerful being the Vis-

altered the urban physiognomy of Milan by constructing bridges, paving old and building new streets, erecting covered markets, and rebuilding the city walls.

The *signore's* patronage of public works and architectural and artistic projects of great magnificence was very likely motivated by the desire to promote himself as the benevolent ruler whose resources are expended for the public well-being in both the secular and religious fields,

260. Lombard Master: Saint, after 1316. Milan. From Loggia degli Osii. Private Collection. [Studio Fotografico Perotti, Milan].

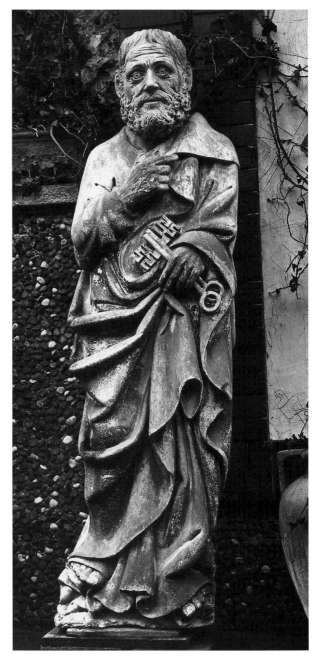

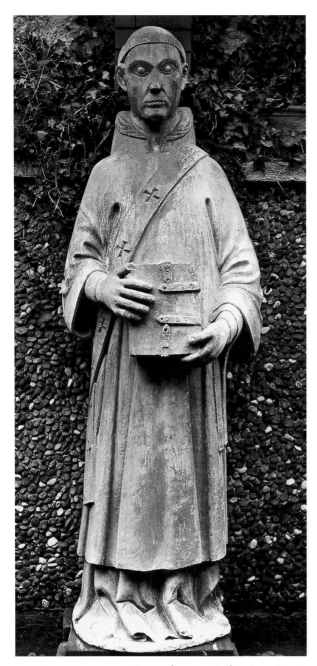

259. Campionese master: Saint, after 1316. Milan. From Loggia degli Osii. Private Collection. [Studio Fotografico Perotti, Milan].

conti of Milan. Although earlier members of the ruling Visconti dynasty took relatively little initiative in developing Milan's artistic culture, beginning very noticeably with Azzone (ruler from 1329 until his death in 1339) the Visconti became active promoters, patrons, and collectors of art who invested considerable resources in commissioning architecture, sculpture, frescoes, and miniatures.[1] Azzone himself effectively

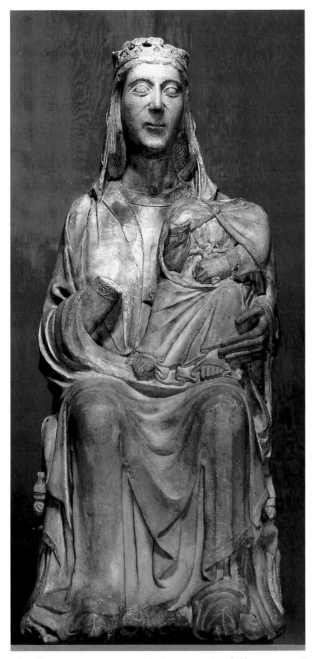

261. Campionese master: *Madonna and Child*, c. 1320s? Chicago, Art Institute [The Art Institute of Chicago. Lucy Maud Buckingham Collection].

a policy calculated to help forge, out of the disparate territorial dominions newly under his control, a cohesive state with a sense of collective identity. Through conspicuous public and ecclesiastical patronage (including the promotion of splendid festivals), Azzone hoped to replace previous local and factional allegiances with loyalty to himself as the *signore* lavishly serving the common good.[2]

It is generally agreed, though there is no proof, that Giovanni di Balduccio was called to Milan c. 1334 by Azzone Visconti, who had both political and familial connections to Pisa, and who shortly later would also invite Giotto, as well as other foreign artists, to the northern court.[3] Between 1335 and 1336 Balduccio was given the task of designing a series of tabernacles to be placed over the portals of the city walls and enclosing statues of the Madonna and saints dear to the citizens of Milan, such as Sant' Ambrogio and Sant' Eustorgio, as well as the patron saints of the respective local neighborhoods, serving as protective presences. In 1339 the sculptor signed the Arca di San Pietro Martire, his most influential sculptural project, and in 1347 his design for the facade of Sta. Maria di Brera (lost, but known through several graphic representations and some fragments) was completed.[4] Only one of the tabernacles on the city gates, that of the Porta Nuova, retains its original sculptures; the rest are in the Castello Sforzesco in Milan.[5] These groups must have presented a striking contrast to the Madonna images executed prior to Balduccio's arrival in Milan (cf. Figs. 261 and 262). In place of the unmodulated surfaces, broad ovoid faces with bulging eyes, frontality, and imposing blockiness echoing the earlier Campionese tradition, the Porta Ticinese Madonna (Fig. 262), for example, like Balduccio's earlier group for Santa Maria della Spina in Pisa (Fig. 121), turns away from the frontal plane, inclines her head slightly, and tenderly supports the Christ Child; the relationship of mother and child is enhanced further by the veil that descends in curves from her crown and arm to connect visually to the baby.

The Arca di San Pietro Martire

Several tombs in Milan have been ascribed to Balduccio, but the only secure one, and arguably his most important commission, is the signed and dated Arca di San Pietro Martire (Figs. 263–65) in the Dominican church of Sant' Eustorgio, Milan; the inscription on the sarcophagus reads MAGISTER IOHANNES BALDVCII DE PISIS. SCULPSIT HANC ARCHAM.ANNO DOMINI MCCCXXXVIIII.[6] Much of the tomb's execution, in particular the lively reliefs, are the work of Lombard assistants. But the beautiful supporting Virtues, svelte and aristocratic, are by the hand of Balduccio. Carved with masterly delicacy, the technique recalls that of the reliefs on the pulpit in San Casciano (Fig. 193).

The tomb contains the remains of Peter of Verona, a

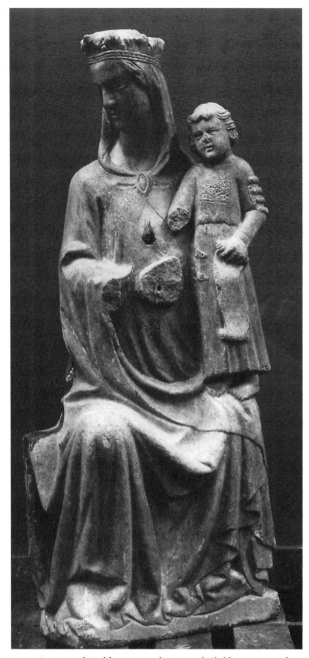

262. Giovanni di Balduccio: *Madonna and Child*, c. 1336. Milan, Museo Sforzesco, formerly Porta Ticinese [Milan. Ufficio Istituti Culturali, Castello Sforzesco].

Dominican preacher and, briefly, an Inquisitor, who was murdered by heretics on the road between Como and Milan on 6 April 1252. After his canonization on 25 March 1253, only eleven months after his death, his remains were transferred from the cemetery adjacent to the basilica of Sant'Eustorgio to a simple marble sarcophagus placed within the church. But by the third

decade of the fourteenth century this unadorned tomb must have appeared extremely modest. At first, the Dominicans proposed to erect a new monument for their martyr closely following the design of the founder's tomb ("in forma et materia simile per omnia sepulcro beati Dominici, patris nostri"). But the project soon expanded, with a sculptural and iconographic program far more elaborate than that of any other Italian tomb of the late thirteenth and early fourteenth century.

In addition to the Arca di San Domenico, several other monuments served as models, but also as points of departure for the design and iconography of the Arca di San Pietro Martire. Like its Bolognese predecessor, the Peter Martyr tomb has figural supports, but these do not include archangels, Dominican friars and acolytes; instead the supports – here actually caryatid-like figures standing against rectangular pillars – are restricted to personifications of Virtues. In this, Balduccio followed the example of Giovanni Pisano's tomb of Margaret of Luxemburg (c. 1313) in Genoa.[7] The general shape and structure of the Arca recalls Tino di Camaino's Cardinal Petroni monument (Fig. 137) in Siena, dated 1317; but the Petroni monument is a wall tomb while the Pietro Martire tomb, in accord with the tradition of saints' shrines, is freestanding. Both, however, include a historiated sarcophagus although the New Testament scenes of the Petroni monument are replaced by scenes from the saint's Vita, as on the Arca di San Domenico. Also recalling the Bolognese tomb, there are full-length standing holy figures embellishing all four corners and framing the narrative fields of the sarcophagus (in this case Doctors of the church and saints, including Ambrose, Eustorgius, and Thomas Acquinas). Atop the sarcophagus a sloped trapezoidal cover shows reliefs of saints in the central compartments and – most unusually – benefactors, including Azzone Visconti and the sovereigns of Cyprus.[8] Again as on the Petroni tomb, the monument is crowned with a tabernacle of three compartments containing the Madonna flanked by saints (in the Milanese tomb these represent Dominic and Peter Martyr). But the most unexpected element is the inclusion of a full angelic hierarchy (originally with wings and identified by carved inscriptions) and a freestanding figure of the Redeemer at the pinnacle of the tabernacle.

With its caryatids and biographical reliefs, the form and structure of the Arca develop the theme of a life based on virtue: Imbued with virtues that sustain him through life on earth and through his moment of ulti-

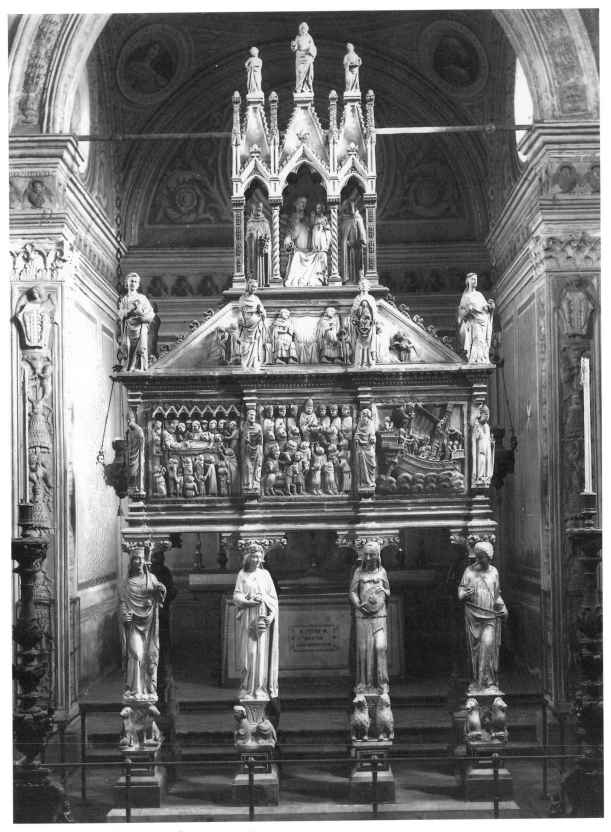

263. Giovanni di Balduccio: Arca di San Pietro Martire, 1339.
Milan, Sant'Eustorgio [Alinari/Art Resource, New York].

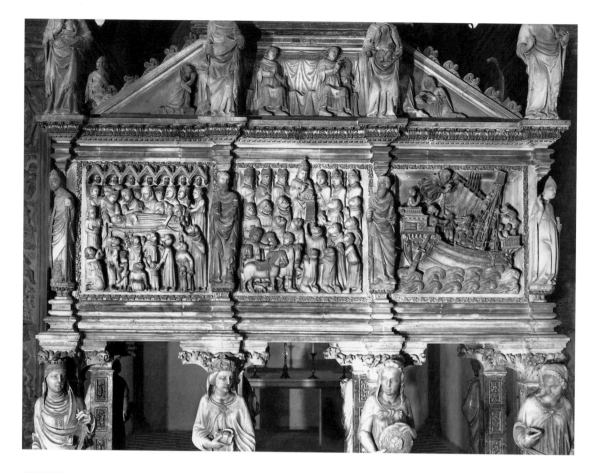

264. (Above) Giovanni di Balduccio: Arca di San Pietro Martire, detail. Milan, Sant'Eustorgio [Alinari/Art Resource, New York].

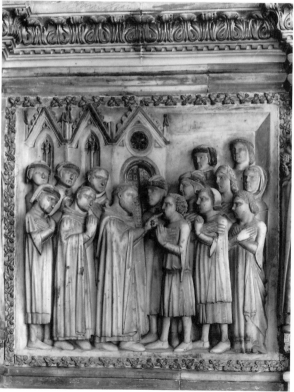

265. Giovanni di Balduccio: Arca di San Pietro Martire, detail. Milan, Sant'Eustorgio [Servizio Fotografico Elemond].

mate sacrifice, the soul of Peter Martyr (as seen in the relief of his death) is carried upward toward the angels, to reach its final goal, union with the Redeemer. The inclusion of the full angelic hierarchy and the Redeemer may well have been an assertion of the doctrine of the Beatific Vision, which in the 1330s had become a matter of intense debate. Until his retraction on his deathbed, Pope John XXII had held that purified souls must await the day of resurrection when body and soul are reunited before achieving a face-to-face vision of God. His successor Benedict XII issued a bull to the contrary: that purified souls need not await the Last Judgment but achieve the Beatific Vision from the moment of death. Virtually unknown on earlier tombs, the angelic choir and the Redeemer appear suddenly and prominently on the tomb of Peter Martyr at the very moment when the doctrine of the Beatific Vision was receiving definitive papal affirmation and when the Dominicans, in particular, were asserting papal support. Indeed, they could hardly be expected to concur with the idea that neither their founding saint, Dominic, nor their beloved martyr Pietro were even at this moment being denied the Beatific Vision.[9]

The fact that the Arca di San Pietro Martire is free-standing and includes a raised sarcophagus accords with its function as a focus of veneration for the saint. Before its transfer in the eighteenth century to the Portinari Chapel it stood in the fifth bay of the north aisle, where it could be seen from the nave.[10] Thus, as was true of the Arca di San Domenico, the siting of the tomb of Peter Martyr allowed clear access to the reliefs on all sides. Grandiose yet more accessible than in its present spacious Renaissance site, the Arca could first be viewed from a distance by the crowds of worshipers and suppli-cants visiting the shrine. They could then approach the tomb and walk around it, viewing all the reliefs and statues from close proximity. Visitors were allowed to touch the tomb in order to benefit from the saint's heal-ing powers. Three of the reliefs testify to those powers: The first scene in the narrative shows the saint touch-ing the mouth of a mute youth and restoring his speech (Fig. 265). Another scene illustrates Peter Martyr heal-ing two invalids in bed. Finally, in the *Funeral of the Saint*, sick and crippled persons display their ailments and pray before his bier, touching its undersurface and covering cloth as well as the saint's garment (Fig. 264, left relief). As the sick and crippled do in the relief, so, too, could the faithful touch the sarcophagus of the monument itself.[11]

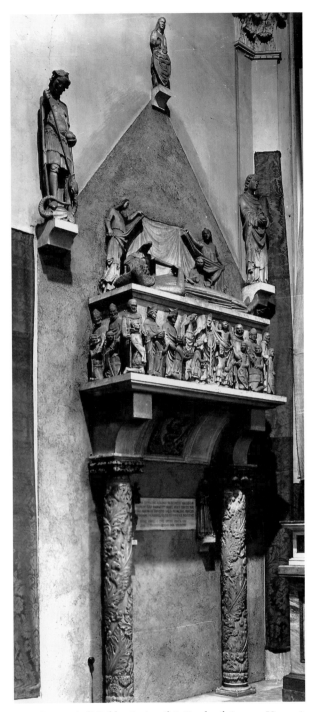

266. Giovanni di Balduccio (attrib.): Tomb of Azzone Visconti, 1342–46. Milan, San Gottardo [Studio Fotofrafico Perotti, Milan].

The Tomb of Azzone Visconti

Azzone, who had generously contributed funds for the tomb of Peter Martyr and whose image appeared on its cover, died in August of 1339. His own tomb (Figs. 266–68) in San Gottardo, Milan, almost unani-

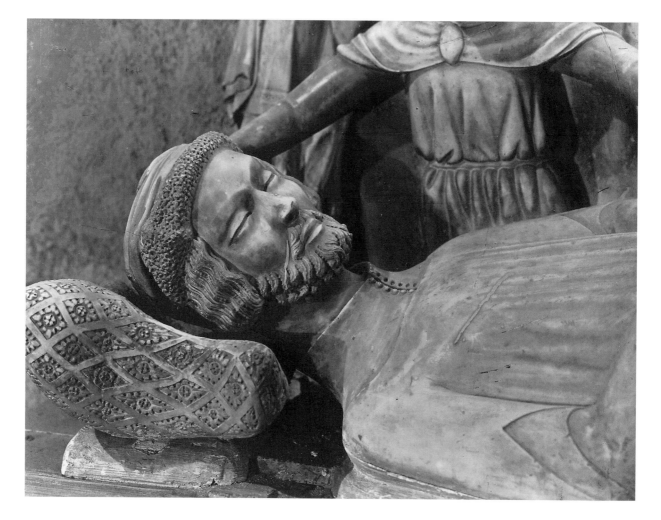

267. Giovanni di Balduccio (attrib.): Tomb of Azzone Visconti, detail Milan, San Gottardo [Milan. Ufficio Istituti Culturali, Castello Sforzesco].

mously attributed to Giovanni di Balduccio (with portions executed by assistants), and probably commissioned by his uncles and successors Luchino and Giovanni, was erected between 1342 and 1346.[12] Although only some portions of the tomb are extant, enough remains so that with the help of an eighteenth-century engraving, one can reconstruct much of the form and iconography of what was once an impressive ensemble.[13] A wall tomb on consoles, the monument of the *signore* was a grandiose version of the Antelminelli tomb in Sarzana (Fig. 186), executed early in Balduccio's career. Its core included the effigy (of great refinement and, judging from its similarity to Azzone on the Pietro Martire monument, very likely representing the *signore*'s features) reclining on a historiated sarcophagus, and a funeral chamber with curtain-drawing angels, surmounted by a tabernacle with the Madonna and Child. This core was surrounded by an overarching Gothic baldacchino, here

supported by vine-entwined columns; the gable of the baldacchino was flanked by figures of Gabriel and Michael. But the religious theme shares the stage with the secular: On the sarcophagus appear St. Ambrose and two enthroned figures flanked again by curtain-drawing angels; to the left and right are representations of ten cities (shown as kneeling personifications and standing civic patrons) that Azzone's successors had conquered between 1342 and 1346; these figures pay homage to the saint (Fig. 268) and the enthroned figures, the latter possibly personifications of Milan (giver of public welfare, suggested by the bag of money) and the Commune (as the city body politic, holding the globe of rulership). The prominent cen-

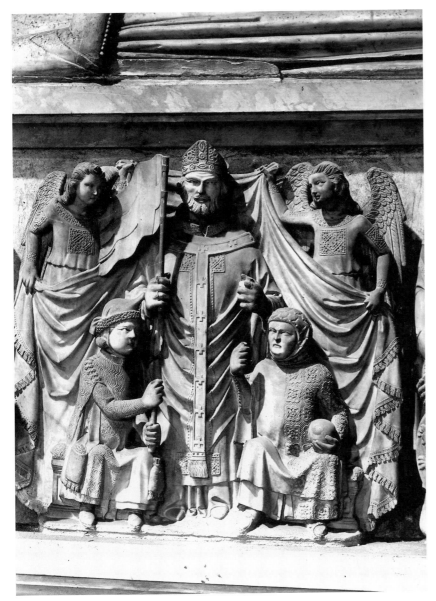

Martire, a number of tomb monuments in Lombardy took on the complexity of Tuscan tombs with their superimposed levels of figural supports, sarcophagus, bier, effigy, and architectural enframements, elaborating in a more modern style the elements first seen on the Longhi monument (Fig. 256) in Bergamo. Such modernizations or elaborations, however, did not necessarily extend to the figure style or reliefs within the monument, which, as in the Arca di Sant'Agostino (Figs. 269, 270) in San Pietro in Ciel d'Oro, Pavia, remained closely tied to the Campionese tradition. At Pavia, one witnesses a master cognizant of Central Italian monuments and responsible for the tomb's design nevertheless accommodating stonecarvers who maintained their adherence to local conventions.

The Arca di Sant'Agostino

The tomb of Saint Augustine is a work of eclectic iconography whose immediate point of departure is that of Peter Martyr (Fig. 263).[1] Some of the Lombard sculptors who participated in work on the earlier monument seem to have contributed to this one as

268. Giovanni di Balduccio (attrib.): Tomb of Azzone Visconti, detail. Milan, San Gottardo [Studio Fotografico Perotti, Milan].

tralized figure of St. Ambrose makes clear that Visconti rulership and conquest are sanctioned by the patron saint of Milan.

MASTERS OF THE MID-TRECENTO IN LOMBARDY

The influence of Giovanni di Balduccio and the Tuscan Gothic language he brought with him took several forms. After the completion of the Arca di San Pietro

well. The erection of the shrine – never a simple matter of veneration for the saint's remains – resulted from the convergence of two sets of conflicts only incidentally related. The first was that between the Augustinian friars and the Canons Regular of San Pietro in Ciel d'Oro: By order of Pope John XXII in 1327, the Canons' heretofore exclusive control of San Pietro had now to be shared with the friars. The friars and the Canons were philosophically, socially, and politically in opposite camps, and the requirement that they share the basilica and its revenues resulted in a good deal of acrimony.[2] To the Canons, the Augustinians were intruders attempting to control their space and revenues. For the

Hermits, however, the move to San Pietro in Ciel d'Oro was a coup: After centuries of separation from Augustine's relics, which had been buried in an unknown place beneath the basilica, they at last had a home in close proximity to the precious remains. This momentous event, from the point of view of the Augustinian Hermits, was the culmination of a long struggle to gain the prestige that had long been enjoyed by the Dominicans and the Franciscans. It is probable that the initiative for erecting the monumental tomb for Saint Augustine came not from the Canons Regular, nor even jointly from the two houses, but rather from the Augustinians alone, very possibly as part of a program to aggrandize Augustinian prerogatives, thus diminishing those of the Canons both in the church and in the city of Pavia itself. With a large visible monument for Saint Augustine, richly embellished with didactic yet lively sculptures and reliefs (a tomb type that had proven its efficacy over the past century in drawing pilgrims and the economic benefits therefrom), San Pietro in Ciel d'Oro could, and in fact did, become essentially an *Augustinian* church.

The second conflict took place within the larger arena of enmity between Pavia and Milan dating back centuries. Pavia, intent on preserving itself as an independent commune, had been constantly under the threat of subjugation by Milan. The Arca di Sant'Agostino carries a date of 1362 on the socle of the second story; however, the project was probably initiated some time earlier, perhaps in the mid-fifties. This was the decade when the larger political conflict was reaching crisis proportions. In January 1354 the Milanese set out to conquer their intractable neighbor, but an assault in March of 1356 by Galeazzo II Visconti against Pavia failed completely. The Milanese forces were destroyed or dispersed and the ecstatic Pavians returned to their city in triumph (a triumph, however, soon to be reversed). It seems likely

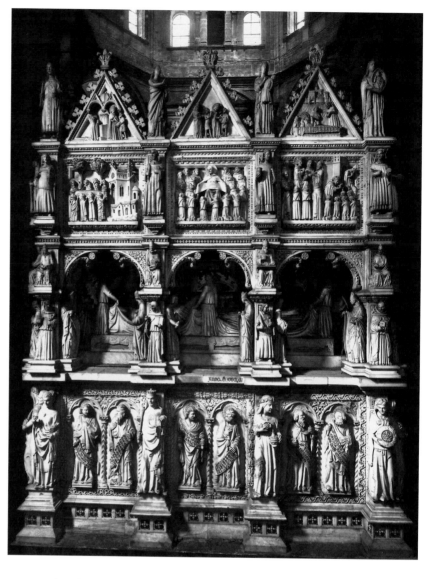

269. Arca di Sant'Agostino, begun early 1350s. Pavia, San Pietro in Ciel d'Oro [Alinari/Art Resource, New York].

that plans to construct a monument for St. Augustine were set in motion during this heady period of Pavian resistance in the early 1350s, which culminated in the victory of 1356.[3] To exacerbate matters further, the Milanese had always insisted on their own historical claim to the relics of St. Augustine, for the saint had been baptized in the city by none other than Bishop Ambrose, the patron saint of Milan. The Pavians held fast to their own claims, for the Lombard king Luitprand had brought the relics from Sardinia to Pavia as long ago as the eighth century. In any case, saints less universally revered than the venerable church father

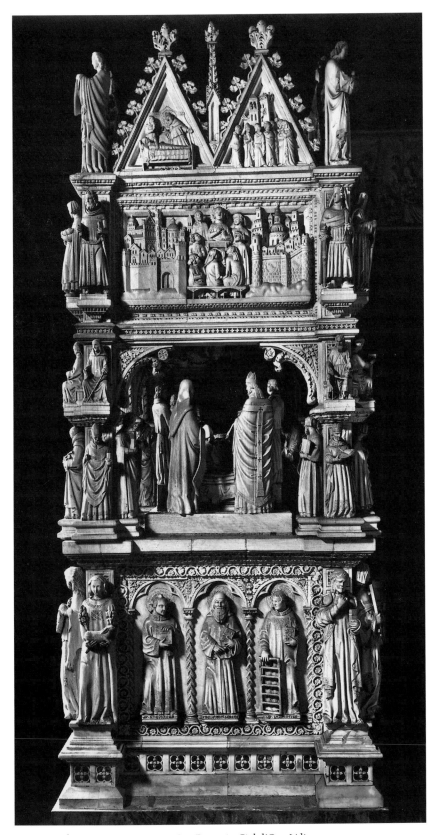

270. Arca di Sant'Agostino. Pavia, San Pietro in Ciel d'Oro [Alinari/Art Resource, New York].

had been honored elsewhere with elaborate, freestanding sculptured tombs, including that of Peter Martyr which stood in Sant' Eustorgio, a basilica that had become the sepulchral church of the hated Visconti.[4] Thus, while Milan could boast a large, freestanding, richly sculptured and iconographically complex tomb (lavishly patronized by the Visconti, who in return were given the rare honor of having their images carved on the shrine), San Pietro in Ciel d'Oro in Pavia, housing the venerated relics of Augustine, could boast no comparable monument; that discrepancy must have stung the citizens of Pavia keenly. If initially spurred by the conflicts between the Hermits and the Canons of Ciel d'Oro, the erection of the shrine, then, was also an instrument in Pavia's rivalry with Milan. It seems evident that the Pavians were determined to construct a monument that could compete in size, grandeur, and iconographic content with the famous tomb in Milan.[5]

The Arca di Sant'Agostino (Figs. 269, 270), a freestanding structure, is incomparably grandiose, and the massive block of its three stories, including a solid, richly sculptured sarcophagus-like base, presents a striking contrast to the elegant, Gothic form of the shrine of Peter Martyr (Fig. 263). Instead of freestanding figural supports beneath a sarcophagus, as had become traditional by now (cf. Tino's Petroni monument, Fig. 137), here there are pairs of saints in niches alternating with Virtues that project from buttresses. Above this, a tripartite funeral chamber formed by projecting figurated piers that support three arches shelter an effigy

of Augustine. Finally, the tomb is capped by a tall attic story with gables, enframing an extensive narrative cycle illustrating the saint's Vita.[6] The number of reliefs, nineteen narratives in all, is far greater than that of any earlier tomb (including the 12.90 m high Tarlati monument in Arezzo). The most striking departure from the earlier saints' shrines in Bologna and Milan is the funeral chamber with its effigy of Augustine dressed in bishop's attire and surrounded by figures, probably Augustinian Hermits, holding the funerary cloth. The inclusion of a sculptured effigy is characteristic, not of saints' tombs, but rather of the tombs of popes, cardinals, and bishops;[7] thus the effigy was an especially appropriate addition to the monument of the great Bishop of Hippo.

The iconography of the tomb as a whole, however, lacks the thematic logic of its predecessors. On the tombs of Dominic and Peter Martyr (Figs. 34, 263). Virtues support the sarcophagus and thus serve both as literal base and metaphorical basis of the Vita repre-

sented directly above. Moreover, on the tomb in Milan, the crowning elements of the Madonna and Child and the Redeemer show the saint's heavenly reward. The by now traditional upwardly moving sequence (Virtues supporting Vita; death followed by heavenly reward) is contravened on Augustine's arca. Instead of serving as supports for the Vita, here the Virtues sustain the funeral chamber while the Vita appears on the uppermost levels, with the effigy in between. An unexpected source for the tomb's architectonic structure could well be the Arch of Constantine in Rome: Like the tomb monument, the Arch is freestanding and includes a high base and tall attic story embellished with figural reliefs, an arched tripartite articulation of projecting pilasters or half columns, and a broken entablature, surmounted by projecting figures. Pavia claimed strong historic ties to Rome: Early in the city's history not one but four churches were built dedicated to St. Peter (tradition even had it that San Pietro in Ciel d'Oro had been founded by Constantine); further-

271. Ancona of the Magi, 1347. Milan, Sant'Eustorgio [Alinari/Art Resource, New York].

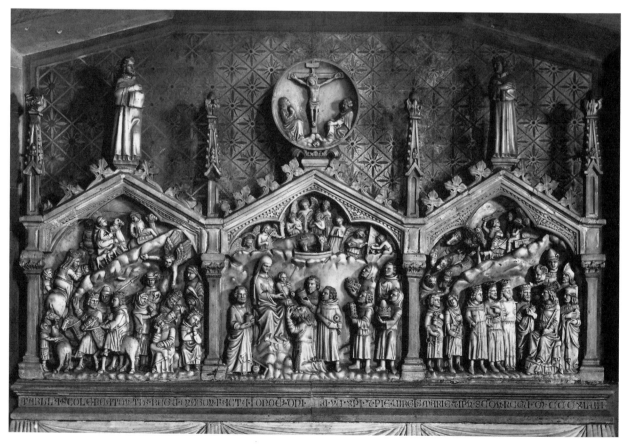

more, Augustine himself had taught in the Eternal City, a fact made explicit on one of the reliefs on the Arca where Rome is identified by the initials SPQR (see Fig. 270, upper section).[8]

Despite the richness of its form, to modern eyes both the artistic standard of the carvings on the Arca di Sant'Agostino and the control and logic of its iconography are weaker than those of its predecessors. If the allusion of its architectonic structure is to monumental architecture, the detailed and visually active sculptural and decorative emphasis suggests, rather, a work of minor art, a reliquary. This contrast, if not contradiction, is seen in several other mid- and late-fourteenth-century monuments, such as Orcagna's tabernacle (Fig. 214) in Orsanmichele of 1359 and the Arca di San Donato in Arezzo of 1362 (Figs. 221, 223). To the Pavians of the second half of the fourteenth century, however, the monument must have served its purpose to perfection. It combined and integrated allusions to three traditions: that of monumental, freestanding saints' arcas with their cycles of Virtues and bio-

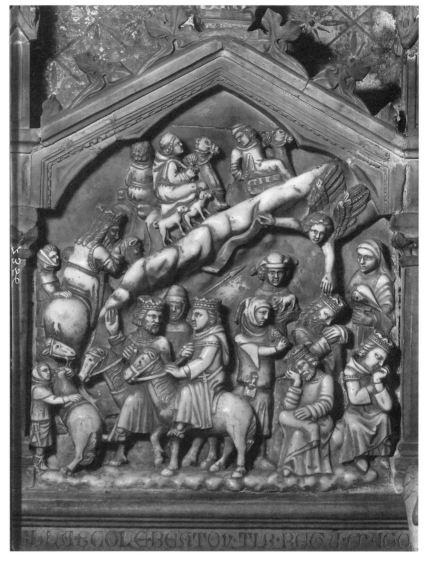

272. Ancona of the Magi, detail. Milan, Sant'Eustorgio [Studio Fotografico Perotti, Milan].

graphical narratives; the tradition of ecclesiastical tombs that highlight the individuality and station of the deceased by way of the effigy; and finally that ancient symbol of the triumph of Christianity over paganism, the Arch of Constantine. To its contemporary viewers, it must have appeared that by every standard of judgment, the Arca di Sant'Agostino outdid its models elsewhere.

The Ancona of the Three Magi

The Dominicans, as we know, were deeply concerned with correct doctrine and the elimination of heresy; they also strove to make their messages accessible and appealing to the ordinary worshiper. This may explain in part

the preference for an empathetic and vernacular narrative mode, in which multitudes of common folk are seen participating in the lives and miracles of the saintly protagonist. This mode is apparent in the reliefs on the Arca di San Pietro Martire (Figs. 263–65) and in the marble Ancona of the Three Magi (Figs. 271, 272), inscribed with the date 1347, also in the Dominican church of Sant'Eustorgio, Milan. Sant'Eustorgio had been the proud possessor of relics of the Magi (originally preserved in an extant Roman sarcophagus) until they were carried away to Cologne by the archbishop Rainaldo in 1164 (a portion was returned in 1903). Despite this loss,

the Milanese retained a lively cult of the Magi, including yearly processions during the feast of Epiphany, and it seems that a lay confraternity, the Scuola dei Magi in Milan, commissioned this altarpiece. The three scenes of the ancona, with their lively portrayal of colorfully costumed Magi and their retinue, including saddled and bridled horses, dogs, and camels, would seem to be an almost literal transcription of the Visconti chronicler Galvano Fiamma's description of the procession of the Magi that took place in 1336, climaxing within the church of Sant'Eustorgio, where the Madonna and a creche with Christ awaited the adoring kings.[9]

Giovanni da Campione

We have already witnessed native Lombard sculptors at work on the Longhi tomb (Fig. 256) of c. 1320 in Bergamo prior to the appearance of Giovanni di Balduccio. In that same city in 1340 a certain IOHANNES inscribed his name and the date on the octagonal Baptistery (on a slab today embedded in the base). Originally built within the south aisle of the basilica of Sta. Maria Maggiore, the structure was dismantled in 1660 and reconstructed only in 1898, this time outside the church (Fig. 273), possibly with significant alterations.[10] On its upper story, the building has a trabeated loggia of slender columns along the sides and long narrow niches excavated at the corners of the octagon; these contain figures of Virtues (Fig. 274) carved of reddish Veronese marble. Despite the signature on the building itself, there is no evidence for the authorship of the sculptural embellishment; furthermore, the figures may have been heavily restored in the nineteenth-century reconstruction, and thus it is hazardous to base a concept of the style of "Giovanni da Campione," named on a tabernacle on Sta. Maria

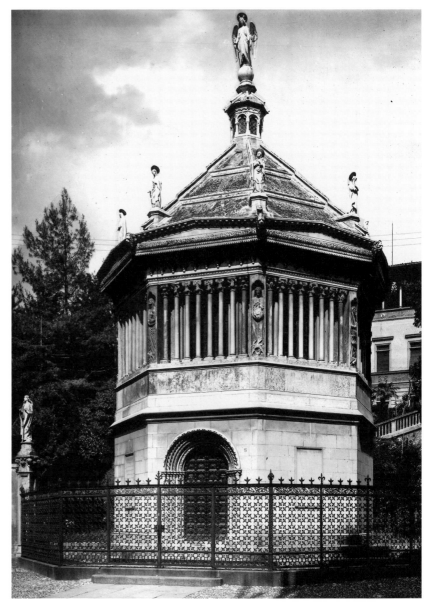

273. Giovanni di Campione: Baptistry, 1340. Bergamo [Alinari/Art Resource, New York].

Maggiore, on these Virtue reliefs. Although the caryatids of the Arca di San Pietro Martire (Fig. 263) by Balduccio have been suggested as prototypes, curiously several of the Baptistry Virtues are not shown as youthful females full of grace and even elegance, but rather as mature, even elderly women (Fig. 274). Their elongation and linearity, markedly flattened drapery folds, and calligraphic hemlines are very different from the elegant gravitas of the tomb figures in Milan yet

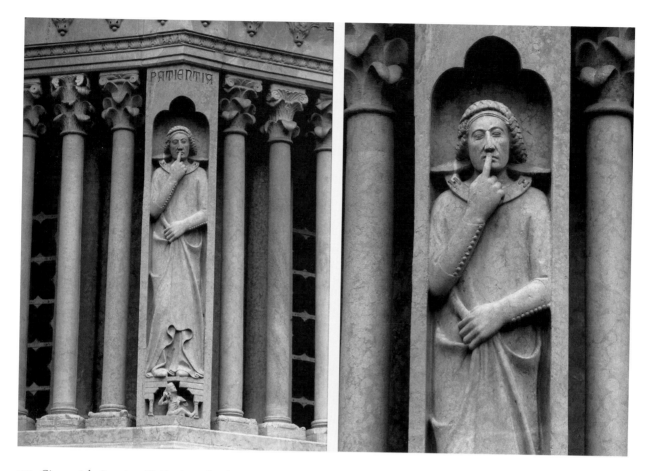

274. Giovanni da Campione(?): Baptistry, detail. Bergamo [Mauro Ranzani].

accord with their placement within the narrow confines of the niches and suggest a reception of French Gothic ideals.

The name Giovanni appears three times on the cathedral of Sta. Maria Maggiore: on the lower arch of the north portal with the date 1351; on the base of the tabernacle enclosing the rider statue of Sant'Alessandro placed over the north porch with the date 1353; and finally, on the south portal showing a date of 1360.[11] The second of these epigraphs states: "Magister Johanes filius magistri Ugi de Compleono fecit hoc opus MCCCLIII," thus identifying himself as the son of Ugo from Campione, information repeated in the third inscription.[12] Despite the many signatures – one on the Bapistry and three on Sta. Maria Maggiore – no unified artistic personality has yet emerged in discussions of this master. Indeed, the major sculptural complexes associated with Giovanni da Campione (the Virtue fig-

ures on the exterior and a series of New Testament reliefs on the interior of the Baptistry, the equestrian figure of Sant'Alessandro on the northern porch and various reliefs and figures on the southern side of Sta. Maria Maggiore) do not at all reveal an identity of hand or even workshop, although the question needs further study.[13] At any rate, it is clear that the master sculptor and/or the patrons allowed work in a wide range of styles.

Bergamo is a city, indeed, where several phases of the development of Lombard Gothic art may be observed. Moving away from the more conservative tomb of Guglielmo Longhi to the Tuscan-influenced Virtues on the Baptistry, the city then displays evidence of a striking change of taste in the tabernacle of the south facade of Sta. Maria Maggiore: Here there are traceried and crocketed gables, projecting gargoyles, and numerous inhabited niches (Fig. 275). The tabernacle is the work of the German sculptor Johannes von Fernach, who is also documented in the Duomo of Milan.[14] Within the main niche sits a rigid and thoroughly Campionese Blessing Christ that must be by a local master.

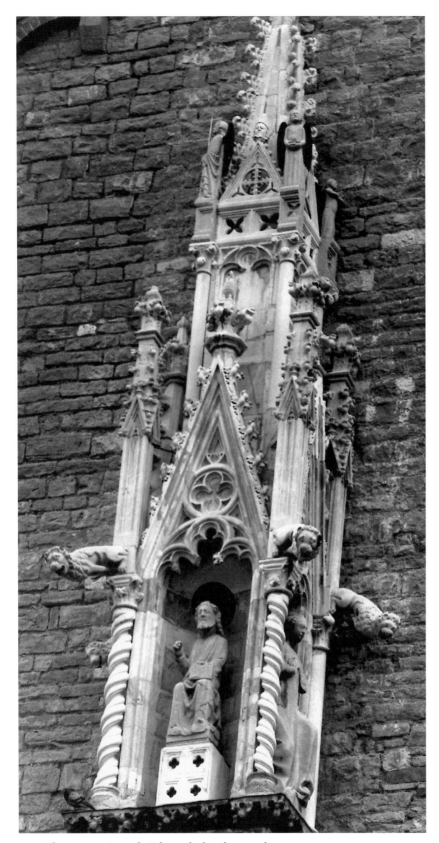

275. Johannes von Fernach: Tabernacle, late fourteenth century. Bergamo, Sta. Maria Maggiore [author].

Bonino da Campione

Only one member of the "maestri Campionesi" group possesses an identifiable artistic personality, but it is, curiously, based less on the two monuments that bear his signature than on a series of anonymous, idiosyncratic yet extremely appealing Lombard works. That master is Bonino da Campione, whose work presents one of the most intriguing challenges of Trecento connoisseurship. Bonino's name appears below the sarcophagus of Folchino degli Schizzi (Fig. 276) in Cremona (d. 1357) and on the tomb monument of Cansignorio della Scala (d. 1375) (the latter signed *Boninus de Campigliono mediolanensis diocesis*) in Verona (Figs. 363, 364). In 1388 Bonino is documented in Milan, where he was consulted regarding work on the Duomo, and he apparently died in March of 1397.[15] Around these few facts a large number of carvings and at least one other major sepulcher – the equestrian monument of Bernabò Visconti (d. 1385) – have been attributed to him or his workshop, with tortuous attempts to encompass vastly different stylistic characteristics within a single artistic personality: the harshly rigid figure of Bernabò Visconti (Figs. 280, 281) on one hand, and a series of serene, amiable, and tender Madonna and Child images (e.g., Fig. 277) on the other; the emphasis on simple masses seen in the latter on one hand, and the ostentatious richness of the signed Cansignorio monument (Figs. 363, 364) on the other.[16]

The Schizzi tomb (Fig. 276), somewhat difficult to see in situ and not well published,[17] is notably of lower quality than many of the analogous reliefs to which it can be compared; however, it does show

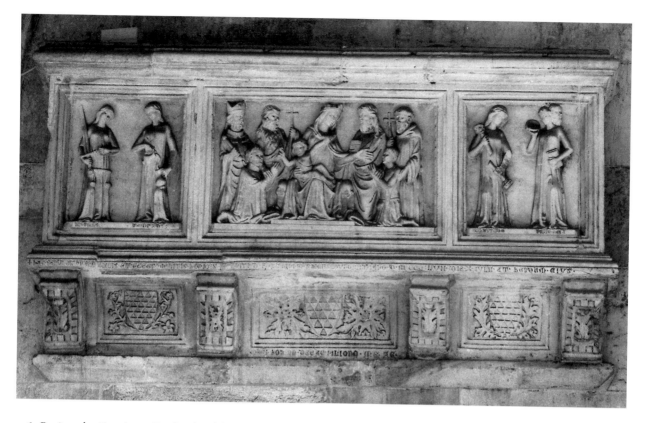

276. Bonino da Campione: Tomb of Folchino degli Schizzi (d. 1357). Cremona cathedral [author].

several motifs and characteristics that appear in a number of reliefs that have been connected to Bonino's name. In line with the Campionese tradition, the figures are carved in relatively high relief, are set against a flat background plane, and are placed within a shallow boxlike space formed by the frame. In the central panel – as also in another attributed work, the Stefano and Valentina Visconti monument in Sant'Eustorgio, Milan[18] – the Madonna sits in a contrapposto pose with lower body turned in one direction and upper body and head in the other. Heads are formed of broad ovals, and a genial smile illuminates the faces of mother and child. Among the masterpieces of the genre is a moving Crucifixion relief (Fig. 278), formerly in Sant'Antonio and now in San Nazaro. The effectiveness of the traditional mode of high relief figures set against a stark background is apparent, for the rear plane provides a foil for the new expressive language of gesture and emotion that distinguishes Bonino, or whoever executed this relief, from the earlier Campione carvers.

As a group, many of the Madonna and Child images attributed to Bonino, while they resist close comparisons to his signed works, do reveal a distinct artistic personality. Thus, the tombs of Valentina and Stefano Visconti in Milan,[19] the sarcophagus of Lambertino Balduino in Brescia (Fig. 279), another sarcophagus relief in Sant'Agostino, Cremona,[20] the Madonna and Child in Detroit (Fig. 277), and the beautiful and touching Crucifixion in San Nazaro (Fig. 278) have morphological consistencies that belong to a single master, and these are reminiscent of, if not stylistically identical with, the signed Schizzi tomb.[21]

The second work to bear the signature of Bonino is the tomb monument of Cansignorio della Scala (Figs. 363, 364) in Verona. Even discounting the vastly different typologies of the two signed monuments and examining only the relief and figure style, one cannot claim for them the slightest unity of style. The Cansignorio monument is the last major tomb – and by far the most elaborate – in a sequence of monumental tombs built in the cemetery churchyard of Sta. Maria Antica; it therefore more properly belongs in the context of the culture of Verona, a hybrid subchapter – for lack of a better phrase – of Lombardy and Venice. As we shall see in the following chapter, although some of the reliefs on the sarcophagus belong to the Campionese tradition of Bonino (even if not directly attributable to his hand), and the equestrian figure has a rigid frontality closer to that of the Bernabò group than to its predecessors in Verona, the

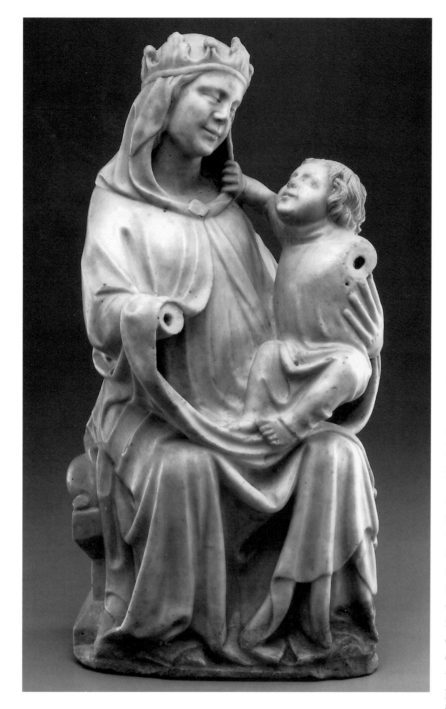

277. Bonino da Campione (attrib.): Madonna and Child. Detroit Institute of Arts [Detroit Institute of Arts. City of Detroit Purchase].

The Bernabò Visconti Tomb

The traditional ascription to Bonino of the Bernabò Visconti tomb (Figs. 280, 281), its equestrian figure completed by 1363 and the sarcophagus added after the ruler's death in 1385, has not been questioned, but neither has it been adequately argued.[22] Although the reasoning is somewhat circular, the fact that Cansignorio called Bonino to Verona having obviously been impressed with an enterprise of his, and the fact that the two equestrian figures have much in common, argue back to an association of the Milanese group with Bonino. But is he the sculptor of the equestrian figure? The contrast of the latter to the affectionate intimacy of the Madonna and Child figures and reliefs (Figs. 277, 279) and the unabashed poignancy of the Crucifixion relief in San Nazaro (Fig. 278) could hardly be greater. These divergences might be evidence that the sculptor was capable of answering to the specific needs of his respective patrons. The tombs and votive reliefs presumably made for patrons of lower social stature than the Visconti rulers, including parish churches, display an intimacy and accessibility that suggests a response to Tuscan currents, whereas the evident desire of his seignorial patron for the projection of intimidating power called for a quite different sculptural mode.

Bernabò clearly sought a master who could produce an unforgettable image of political power with its implications of military invincibility and of ruthlessness in the suppression of adversaries, but also of divine sanction. Both the steed and the life-size rider – his armor and chain mail meticulously detailed – are rigid and frontal without the slightest concession to an enlivening movement of head or limbs. Yet the figure is hardly

design of the reliquary-like monument of dissolved surfaces cannot securely be placed within the oeuvre of Bonino da Campione. Thus, even this signed monument is of little evidentiary value for attributions to Bonino.

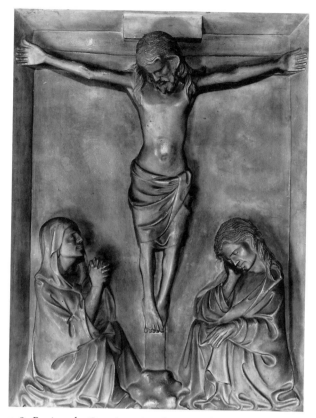

278. Bonino da Campione (attrib.): Crucifixion relief. Milan, San Nazaro [Comune di Milano. Settore Cultura e Spettacolo].

a Pantocrator: The tense lips and ever so slightly squinting eyes (Fig. 281) project an all too human expression of the will to power and the ability to implement it without scruple.

The carvings on the sarcophagus tend toward formulaic interpretations of those relief panels that form the group that has traditionally been associated with Bonino, such as the Stefano and Valentina Visconti sarcophagus and the aforementioned series of Madonna and Child reliefs and figures; indeed, the sarcophagus presents similar morphological types and communicative poses and gestures. But perhaps more significant than the authorship of individual figures and reliefs is the extraordinary conception of the monument. The entire complex, now in the Castello Sforzesco, originally stood behind the high altar in San Giovanni in Conca, Milan. Certainly the Bernabò monument is not the first to include an equestrian image of the deceased; it had appeared earlier in modest reliefs (Fig. 350) or else – as in the Cangrande and Mastino II tombs in Verona (Figs. 353, 356) – as the crowning element of an architectural complex. But although there may have been some other architectural components, here the equestrian statue must have been designed as the main

279. Bonino da Campione (attrib.): Lambertino Balduino. Brescia, Duomo Vecchio [Istituto Centrale per il Catalogo e la Documentazione].

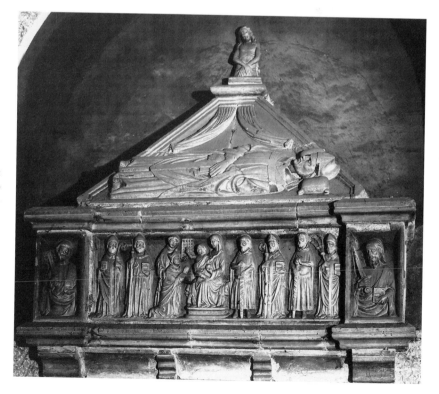

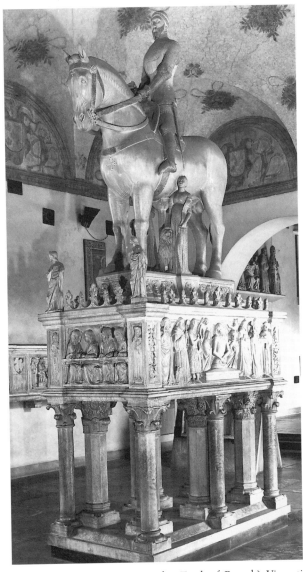

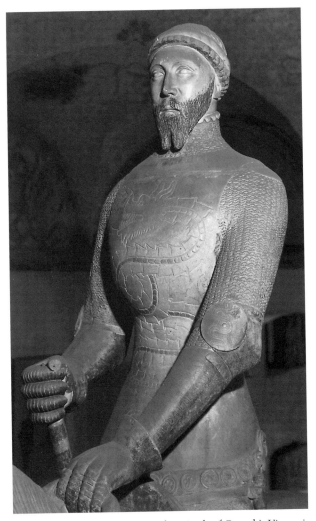

281. Bonino da Campione (attrib.): Tomb of Bernabò Visconti, detail. Milan, Castello Sforzesco [Milan. Ufficio Istituti Culturali, Castello Sforzesco].

280. Bonino da Campione (attrib.): Tomb of Bernabò Visconti (d. 1385). Equestrian figure completed 1363; sarcophagus after 1385. Milan, Castello Sforzesco [Milan. Ufficio Istituti Culturali, Castello Sforzesco].

element and focus of the entire composition, indeed of the church itself, looming above the altar and visible from the nave. In this it recalls not the typology but rather the intended location of both the Henry VII monument (Figs. 133, 134) in Pisa and the Robert of Anjou monument (Fig. 247) in Naples. However, while the emperor is presented as a noble and aristocratic figure, he is not entirely lacking in human fragility.[23] And the Angevin king, hieratic as his presentation is, is part of a more diffused composition that includes several

portraits, one of which – his effigy in Franciscan attire – is even closer to the viewer than the enthroned monarch. In contrast, neither human vulnerability nor pious humility mitigate the effect of the frightening austerity of the Milanese despot.

Bernabò's sarcophagus, on which one might have expected a reclining effigy, is unusually large and serves as the base, unique in this regard, for the equestrian statue. At the same time, raised as it is on a series of columns (decorated with lilylike flowers), it recalls the by now well-established tradition of raised saints' tombs that could also stand near altars. Flanking the horse are two smaller-scale allegories of the Virtues Fortitude and Justice, again recalling holy shrines; significantly lacking,

however, are the Theological Virtues of Faith, Hope, and Charity! When one considers that the entire monument was originally polychromed and gilded (some portions remain to suggest the effect) and loomed above the high altar of San Giovanni in Conca, Milan, one can readily imagine the degree to which it inspired both dread and awe; it is hardly surprising that foreign visitors were scandalized and accused Bernabò of promoting idolatry.

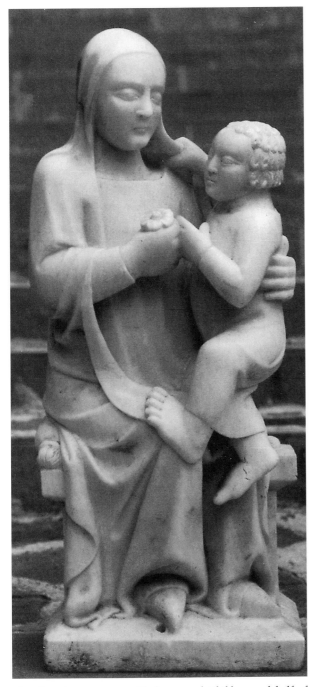

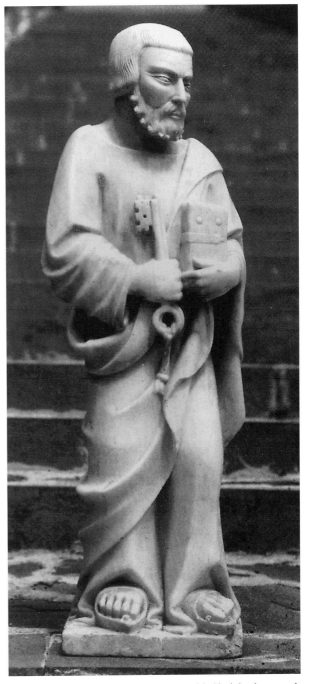

282. Campionese master: *Madonna and Child*, second half of the fourteenth century. Montedivalli, Sant'Andrea [after *Niveo de Marmore*, 1992].

283. Campionese master: *St. Peter*, second half of the fourteenth century. Montedivalli, Sant'Andrea [after *Niveo de Marmore*, 1992].

notable if unassertive modifications of the basic tendencies of the Campionese tradition. More provincial masters, responding even more reticently, also did not remain immune to the new language. Three sculptures of polished and translucent Carrara marble with traces of polychromy are examples, however, that indicate the diffusion and persistent appeal of the sense of solidity and robustness of the Campionese stone-carving tradition. A seated Madonna and Child, a standing St. Peter, and a Man of Sorrows (Figs. 282–84) from the church of Sant'Andrea in the hilltop village of Montedivalli (northeast of La Spezia) have been dated to the late 1360s or early 1370s.[1] The figures, whose original context is not known, display an almost Minoan simplicity of form and purity of surface, on the one hand enlivened by sharp linear accents in hair and beard, and on the other softened by the fluidity of the drapery (especially the Madonna group and St. Peter) and a quiet humanity that bespeaks – or rather whispers – of Tuscan influence. Whereas modern viewers are usually quite enamored with the novelty and humanity of Tuscan sculpture of this period, Lombard sculptors and their patrons were obviously less impressed by the elaborations of form inherent in the new synthesis of Gothic and classicizing values.

Slowly but surely the native tendencies of the Campionesi bent, however, to accept the language of softer,

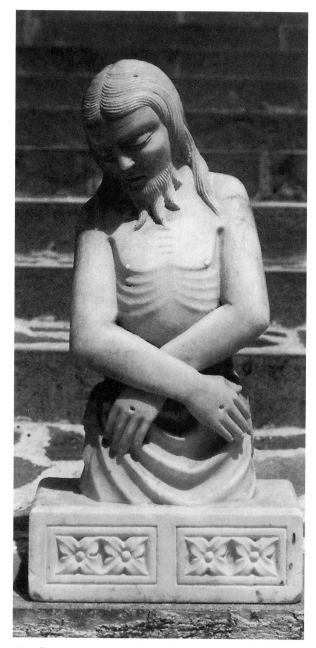

284. Campionese master: *Man of Sorrows*, second half of the fourteenth century. Montedivalli, Sant'Andrea [after *Niveo de Marmore*, 1992].

LOMBARD ASSIMILATION OF TUSCAN STYLE

Lombard sculptors and their patrons responded in various ways and with differing intensity to the classicizing idealization and Tuscan grace introduced by Giovanni di Balduccio after his arrival in Milan c. 1334. As we have seen, the sculptures associated with Bonino show some

285. Campionese master (Master of the Viboldone lunette): *Madonna and Child*, c. 1350. Viboldone, Abbey church [author].

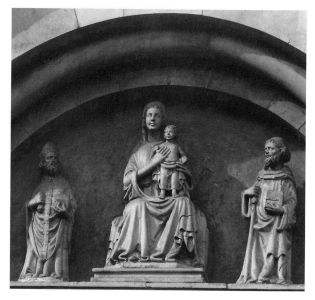

222

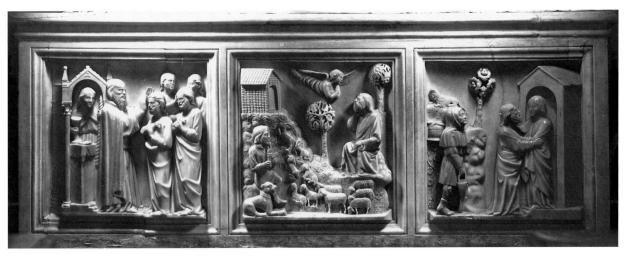

286. Campionese master: Reliefs from altar. Carpiano, Pieve
[Studio Fotografico Perotti, Milan].

287. Campionese master: Relief from altar. Carpiano, Pieve
[Studio Fotografico Perotti, Milan].

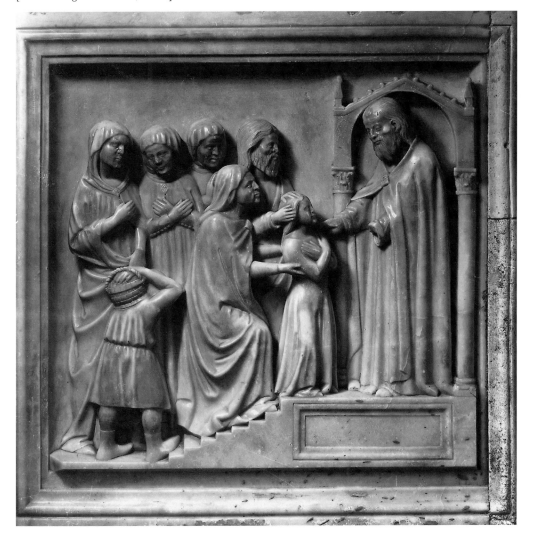

more fluid forms and empathetic humanity brought north by Giovanni di Balduccio. A generous infusion of Tuscan ideals is apparent in the work of the "Master of the Viboldone lunette." In the Madonna and Child with saints (Fig. 285) of c. 1350 placed in the lunette of the convent church of Viboldone near Milan,[2] the faces have a refinement of features that is quite alien to the art of Bonino, and the sculptor does not hesitate to excavate the draperies in complex, flowing, and cascading folds and hemlines. One could almost mistake this group, full of grace combined with a monumental "gravitas," as coming from Tuscany, and indeed the subtle contrapposto of the Madonna recalls Giotto's Ognissanti figure, while the earnest, standing Christ Child brings to mind Simone Martini's Maestà. The complexities of the drapery hemlines also depart noticeably from the Campionese tradition.

An acquaintance with Giotto's compositions is also suggested by the series of reliefs forming an altar in the parish church of Carpiano near Milan. One, or possibly two Lombard masters working around 1360 executed the reliefs, which represent scenes from the life of the Virgin on all four sides,[3] in itself an unusual feature that may derive from the tombs of saints (assuming that the present disposition is original, which is not certain). Some of the panels suggest an acquaintance with Andrea Pisano's bronze doors in Florence as well as with Giotto's Arena Chapel frescoes (Figs. 286, 287); for, unlike the Ancona of the Three Magi (Figs. 271, 272) and the reliefs on the tombs of San Pietro Martire and Sant' Agostino (Figs. 264, 265, 269, 270), a rather clear stage is provided, with only a few props and a focus on telling gestures: The tender urging of Anne as the young Virgin ascends the stairs to be received in the temple is directly based on the Paduan fresco by Giotto. An affable, down-to-earth naturalism characterizes these engaging reliefs, whose figure style owes more to Balduccio than to the conventions of Campionese sculpture.

GIAN GALEAZZO VISCONTI AND THE INTERNATIONAL GOTHIC CURRENT

Despite the fact that the art produced in the courts of Europe between c. 1380 and 1420 reveals little stylistic unity, the term "International Gothic" has become the conventional designation for much European painting and sculpture of that period, including that of Italy.

Regarding sculpture of the late Trecento in Milan, the term has the particular advantage of making reference to one important aspect: the abandonment of the provincialism that had for the most part ruled in Lombardy up to this point, with its illustrative "popolaresco-naturalismo,"[1] in favor of a new sophistication demanded by the duchy and its court. By now the Romanesque formulas of the provincial Lombard repertory were exhausted and all too obviously retardataire.

The catalyst for change was Gian Galeazzo Visconti (1351–1402), *signore* of Milan, whose international connections and diplomatic skills helped him achieve what he fervently sought, the title of duke, obtained from the Holy Roman Emperor Wenceslao in September 1395.[2] Continuing the expansionist course laid out by his predecessors, who had already laid claim to almost all of present-day Lombardy (Mantua and its immediate surroundings being the exception), most of Liguria, and a good part of western Piedmont and Emilia including Bologna, Gian Galeazzo gained control of much of the Veneto from Verona to Padua to Belluno, and finally parts of Central Italy, including Pisa and Siena. He died unexpectedly in 1402 as his armies were approaching Florence ready to attack.

Following in the footsteps of his predecessors, Gian Galeazzo continued his family's patronage of Sant' Eustorgio: He contributed to the commission for the marble Ancona of the Passion (Figs. 288–90), executed between 1395 and 1402 for the high altar.[3] Possibly inspired by the multilayered polyptych format of Duccio's Maestà, it shares with the latter both the double-scaled centralized Crucifixion and (in a simplified sequence) a narrative that begins at the lower left and concludes at the upper right.[4] Classicizing and florid Gothic motifs intermingle in the enframement. The panels, which reveal the hand of more than one carver, are densely populated and enriched with picturesque details of costume, coiffeur, and accoutrements; at the same time, there is an adherence to the Dominican preference for straightforward legible narrative.[5]

Embriachi Ivories

Gian Galeazzo turned to the Venetian workshop of Baldassare Embriachi for the monumental polyptych in the Certosa of Pavia (Figs. 291, 292).[6] Baldassare's origins lie, in fact, in Florence, where he is known to have built a chapel dedicated to the Magi – one of

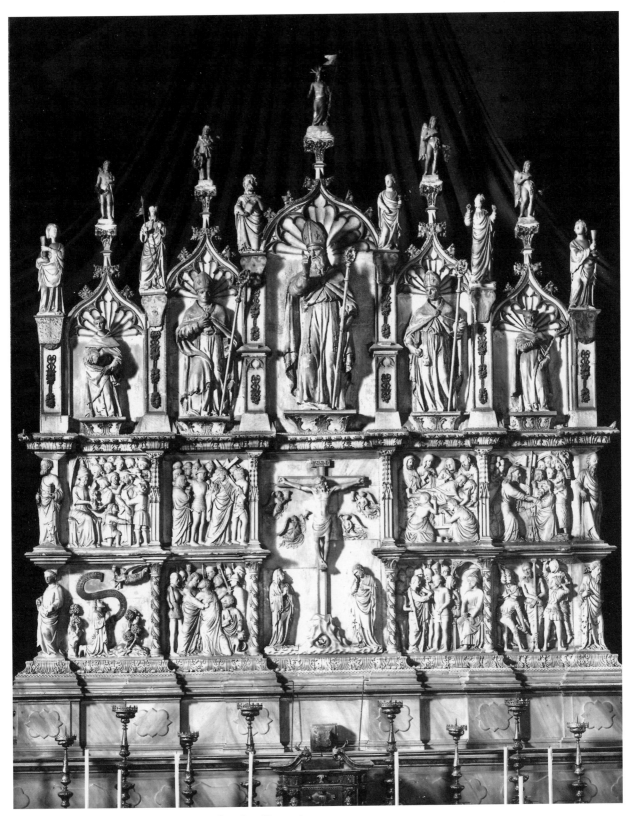

288. Ancona of the Passion, 1395–1402. Milan, Sant'Eustorgio
[Alinari/Art Resource, New York].

289. Ancona of the Passion, detail. Milan, Sant'Eustorgio [Milan. Civiche Raccolte d'Arte Applicata ed Incisioni, Castello Sforzesco].

290. Ancona of the Passion, detail. Milan, Sant'Eustorgio [Milan. Civiche Raccolte d'Arte Applicata ed Incisioni, Castello Sforzesco].

whom, as his name implies, was his patron saint – in the Dominican convent of Sta. Maria Novella. Although a branch of the family had been living in Venice for decades, he himself established his workshop there only in the 1390s, and he employed among others a certain Giovanni di Jacopo from Florence, named in his Will of 1395 as "maestro de' miei lavori dell' osso." Baldassare may have been a carver himself, but most of his energies seem to have been devoted to promoting his commercial interests (which went well beyond artistic production), as well as to political and diplomatic activities during a long and extraordinarily active life.[7]

The altarpiece, commissioned in 1395, is one of the most imposing objects of the late Gothic period in Italy. The three compartments are composed of pointed arches surmounted by gables and separated by spiral columns, all supported by a sturdy base and framed by projecting polygonal buttresses. Every surface is embellished with reliefs, niche figures, and geometric intarsia, which came to be known as "alla certosina," since it was commissioned for a *certosa* (chapter house). A great variety of materials is employed, including hippopotamus teeth, bone, mother-of-pearl, and different colored woods to form patterns of geometric, often illusionistically three-dimensional shapes, all tying the

carved portions together. There are a total of ninety-four small niches and sixty-two historiated panels. The work was highlighted with touches of gold in the reliefs and statuettes. Despite the variety of forms and patterns, the simple overall composition of the dossal, and the rhythm of rectangular relief panels and niches, lend this object of grand proportions (h. 2.54 m., w. 2.4 m.) and virtuoso richness an effect of stability.

It has been suggested that the choice of and emphasis on the Magi theme – in particular, the amplitude with which the story is told – is not only connected with the popular Milanese cult, as might be expected in the Visconti milieu, but is also to be understood as a commemoration of the ducal investment of 5 September 1395 when Gian Galeazzo Visconti became a duke and Milan became a duchy; it is significant that both the Visconti impresa and the imperial eagle appear on shields of soldiers. Indeed, the Magi cult at the end of the Middle Ages often had political significance, indicating the protection of the nobility and the legitimacy of princely authority.[8]

On a smaller scale and made for aristocratic patrons all over Europe are the many small triptychs for private devotion, objects for personal use such as combs and mirrors and marquetry boxes (generally illustrated with mythological or amorous scenes, the latter appar-

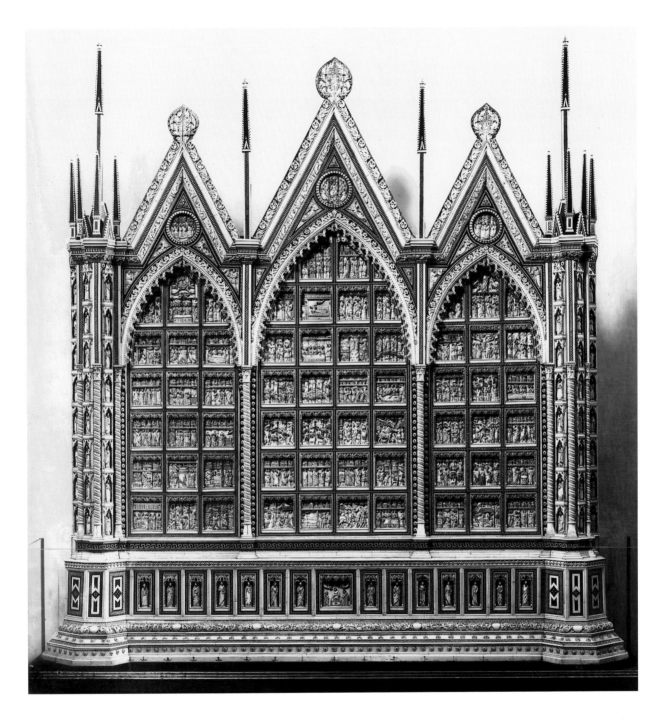

291. Embriachi Workshop: Altarpiece, ivory and other materials, c. 1395. Pavia, Certosa [Alinari/Art Resource, New York].

ently given as symbolic gifts to seal a marriage), and other secular objects in ivory and bone. During the fourteenth century there developed an increased demand for bone and wood boxes from Italian, often Venetian, workshops, despite the employment of a material more economical than ivory. The Embriachi workshop under the commercial leadership of Baldassare degli Embriachi engaged in the production of these objects on an almost industrial scale. Although the quality of execution could vary under these circumstances, a particularly fine example of an "Embriachi" container (*cofanetto* is the Italian term used) is the one

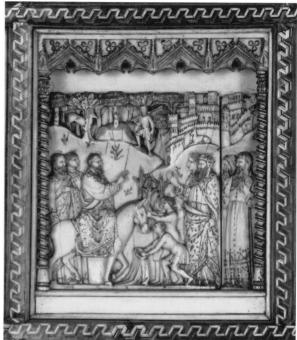

292a and b. Embriachi Workshop: Altarpiece, details. Pavia, Certosa [Franco Maria Ricci].

in the Museo Nazionale in Ravenna (Figs. 293, 294).[9] Of octagonal plan, the container has a cover in the form of an eight-sided truncated prism, surmounted by a crowning element that originally probably had a metal ring attached. The internal structure is made of wood, while the revetment is composed of a series of sculpted bone sections, three per face, inserted into a rich system of geometric intarsia in wood, bone, and horn "alla certosina." Each face of the container is embellished with scenes from the ancient legend of Helyas (known in the Middle Ages as the story of Queen Stella and Mattabruna) framed by a low trefoil arch with traceried spandrels supported by spiral colonettes. The story concerns the deceptive Mattabruna, who kidnaps the sextuplets born to the queen, replacing them with puppies and thus disgracing the queen. The infants are abandoned but discovered by a hermit who prays to God for help. Succor arrives in the form of a deer, who nurses the children. Raised and educated by the hermit, the wrong done to them and to the queen is eventually righted when they are miraculously returned home. One can readily imagine the delight that these charming illustrations gave, suggesting to the newlywed recipients of this precious gift that virtue would be rewarded by heavenly intervention – and numerous offspring!

The Duomo of Milan

The major ecclesiastical project toward the end of the century was the construction of the Duomo of Milan. The project began rather modestly. The basilica of Sta. Maria Maggiore, which served as cathedral, was one of the city's two major churches (the other was Santa Tecla), but it had suffered much damage, exacerbated by the collapse of the nearby campanile in 1353. The old crumbling facade was at first merely patched up with material recovered from the ruins. Further attempts at restoration were made, considerable amounts of money spent, and finally in 1386 the archbishop Antonio da Saluzzo, cousin of Gian Galeazzo Visconti, advised a reconstruction and enlargement of the basilica; for that project the traditional material of Lombard brick was to be employed. But in 1387 at the insistence of Gian Galeazzo the plan was changed: The *signore* of Milan – ambitious patron of the arts, and inspired perhaps by descriptions offered by Milanese merchants who had traveled widely – decided that his political ambitions could be served only by an edifice in marble, one that might rival the cathedrals of the most

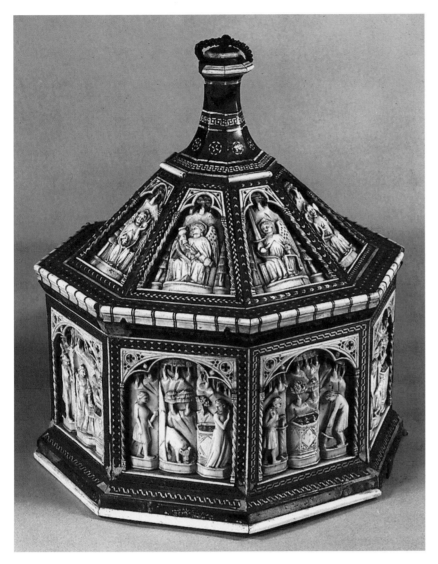

293. Embriachi Workshop: *Cofanetto*, late fourteenth century. Ravenna, Museo Nazionale.

being sent out to regions well beyond Lombardy. An indication of the sheer number of workmen involved in just one small part of the project is a reference to several masters in 1391, including one Laslo from Hungary, who was present at the Duomo with about a hundred of his own workmen. Virtually from the beginning of construction of the new Duomo not only were northern Italian architects present as advisers, but foreigners – above all French, Flemish, and German – actively participated in the execution of the sculptural decoration.

The first sculptor named in the documents, however, is Giacomo da Campione, who is also the last artistically identifiable member of the Campionese workshop tradition. He was the head of a team of stonecutters as early as 1387, and several times he participated in discussions concerning the architecture of the church. The strength of his connection to his native region is indicated by the fact that upon his death on 31 October 1398, probably following his wishes, his body was transported to his hometown for burial at the expense of the Duomo Fabbrica.[11]

The climate in which he and his associates worked, however, was very different from that of the earlier Campionesi. The Duomo Fabbrica included so many foreigners working side by side with native masters that the relative insulation of the carvers of the earlier period was no longer possible; instead we find a keen if often accommodating sense of competition. The tension between local and foreign traditions, which James Ackerman has so vividly described regarding problems of the Duomo's architectural design and engineering,[12] could also insinuate itself into sculpture: On 5 August 1393 a meeting took place in the archbishop's palace, presided over by that very ecclesiastic. Present were the sculptor Johannes di Fernach, designated as *teutonico*

important European states and Central Italian communes. He offered considerable financial support, including conceding to the Fabbrica – the governing body that had full responsibility for the design and execution of the Duomo – free excavation of marble from nearby Candoglia.[10]

Not only was the Duomo to be colossal in size and constructed of precious marble, but like northern Gothic cathedrals – and certainly outdoing those elsewhere in Italy – it was to be blanketed with sculpture. This required battalions of stone-carvers: The enormous demand for stone-cutting skills resulted in calls

294a and b. Embriachi Workshop: *Cofanetto*. Ravenna, Museo Nazionale [Ravenna. Ministero per i Beni Culturali e Ambientali].

and thus of German origin or training, Giacomo Campione, and Giovannino de Grassi. The German was asked, in no uncertain terms, to exercise more restraint in his work, simplifying the ornament. Probably this clipping of the German's wings was instigated by Giacomo and Giovannino, the two major Campionesi on the site.[13]

It is not difficult to imagine the response on the part of the Lombard masters to the south sacristy tabernacle by Fernach (Fig. 295),[14] with its florid decorative style that contrasts so strongly to the sober architrave of the portal on which it rests, possibly the work of Giacomo. Figural sculpture, architectural moldings, and minutely carved tabernacle enclosures, as well as floral motifs, compete for attention. Not only are there three main historiated reliefs – a northern-type Lamentation on the lower rectangular field, a Madonna and Child between two saints in the lunette above this, and a Madonna of Mercy in the space between the round-headed lunette and the ogival arch enframing the whole sequence – but the base of the tabernacle contains a band of Wise and Foolish virgins, and the crocketed frame itself provides a field for six little tabernacles

enclosing the *Annunciation, Visitation, Adoration, Presentation, Flight into Egypt,* and *Massacre of Innocents.* The ensemble culminates with an image of the Crucifixion that seems to blossom from the lush crockets of the ogival frame. If the general program celebrates the life of Mary, the composition of the portal and tabernacle lack unity – they may not have been conceived contemporaneously – and even within the upper section, presumably under the direction of Fernach, there is little relation between the divisions of the framing fields and those of the larger narratives. However, when one examines the individual elements – virtually impossible to do in situ – the sculptor's (or sculptors') skills become evident.

Fernach's south sacristy portal glorifies Mary, whereas that on the opposite side of the apse glorifies Christ. The tabernacle (Figs. 296, 297) over the door of the latter carries – a rare occurrence on the Duomo – the signature of Giacomo da Campione: IACOBVS FILIVS SER ZAMBONINI DE CAMPILLIONO FABRICAVIT HOC OPVS.[15] On 25 July 1395 Giovannino de Grassi was engaged to color the architectural and ornamental frames of both northern and southern sacristy portals;[16] thus, the sacristy sculptures were completed by that date.

As on the south portal, that on the north is composed of two distinct parts, not especially well integrated and suggesting the same additive approach to design. The

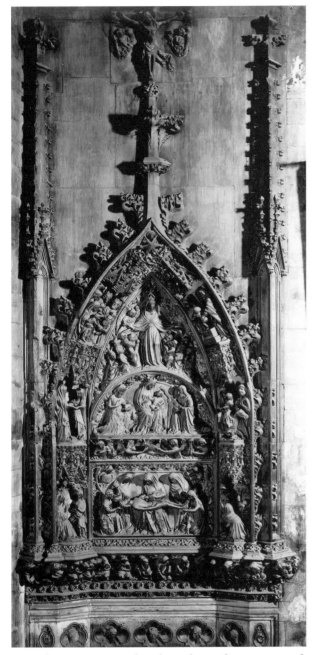

295. Johannes von Fernach: Tabernacle, south sacristy portal, completed by 1395. Milan cathedral [Alinari/Art Resource, New York].

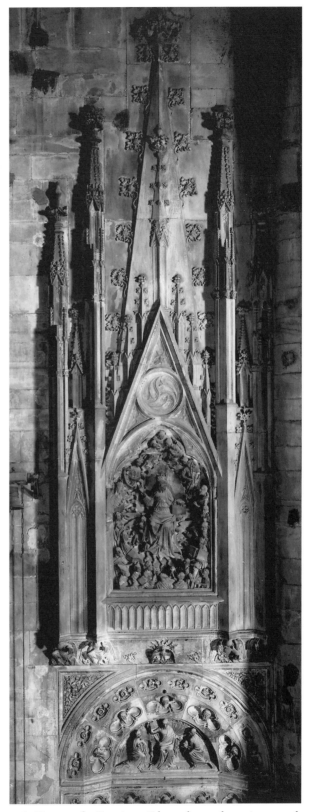

296. Giacomo da Campione: Tabernacle, north sacristy portal, completed by 1395. Milan cathedral [Alinari/Art Resource, New York].

portal proper carries an architrave with heads enframed by pierced quatrefoils, similar to that on the north, but here the architrave is capped by a round-headed lunette with a relief of the enthroned Christ adored by Mary and John the Baptist. It is the upper relief (Fig. 297) that commands the most attention. Here we see the Redeemer seated on a throne seemingly composed of

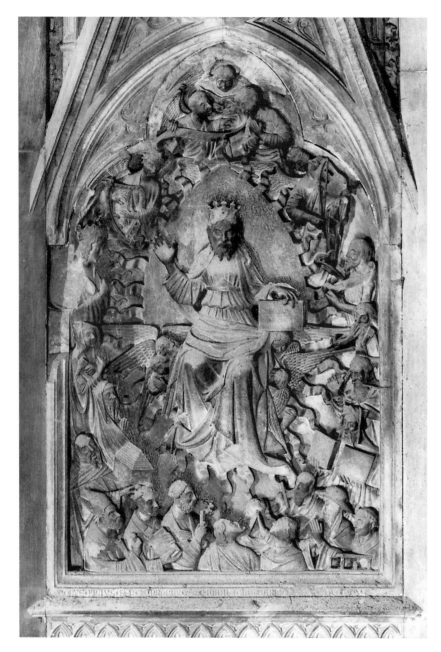

297. Giacomo da Campione: Tabernacle, north sacristy portal, detail. Milan cathedral [Alinari/Art Resource, New York].

the center at the bottom, three ecstatic figures look upward at this vision – one, a woman with head turned backward so far that we see only her chin and nostrils! One figure at the lower left offers what seems to be a model of a church; below him is a figure that probably represents the archbishop Antonio da Saluzzo, a zealous supporter of the new Duomo project during its early stages.[17]

The third name frequently cited in the early documents of the Duomo is that of Giovannino de Grassi, painter, sculptor, architect, and one of Gian Galeazzo's most esteemed illuminators.[18] Indeed, he is best known for his marvelously observant drawings of animals, as well as the fantasies of floral-architectural forms in the various manuscripts that have been attributed to him. He is documented in 1391 as having worked on a marble sculpture, very likely the relief of Christ and the Samaritan (Fig. 298) above the lavabo in the south sacristy, although as seems to have been common practice at the Duomo of Milan, design and execution might well belong to different hands. The relief was apparently painted and gilded by Giovannino in 1396.[19]

The subject is rare in Italian sculpture[20] and, as far as I know,

cherubs, within a mandorla surrounded with flaming rays. Christ raises his right hand in blessing and displays a panel that originally bore a painted inscription, now lost. He is flanked by the Virgin and John the Baptist at the head of a team of apostles, prophets, and saints echoing the lower half of the mandorla, while its upper half is surrounded by angels of the utmost charm who sing lustily and play musical instruments. Near

without precedent in a sacristy program. Here in Milan, however, it was an apt theme for its setting: The lavabo below the relief was used, of course, for the celebrant's ablution, but it also served for the washing of sacred objects and to pour the holy water used for baptism, as is known from the tradition of the Ambrosian liturgy codified in the *Beroldo*, a compilation of the Ambrosian rite.[21] (In fact, Giovannino and his workshop illuminated the copy commissioned by the Duomo Fabbrica in 1396 and preserved in the Biblioteca Trivulziana.)[22] In John 4:14, Jesus contrasts the water of the well, which quenches thirst only temporarily, with the living

298. Giovaninno de Grassi: *Christ and the Samaritan*, c. 1390.
Milan Duomo [author].

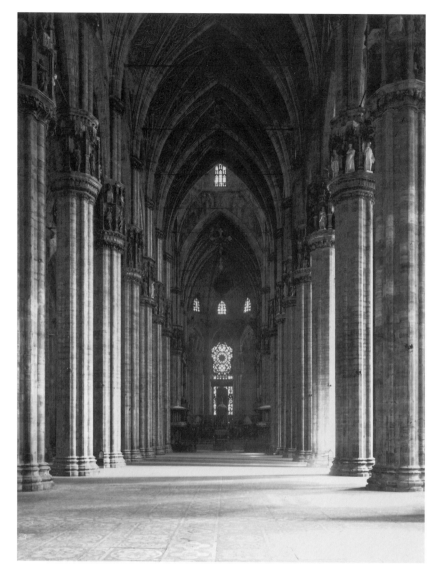

299. Milan cathedral, nave. [Alinari/Art Resource, New York].

encloses a pierced quatrefoil whose highly profiled moldings seem to grow like an exquisite flower from the leafy ornament below. The relief itself rests on a polygonal console seemingly supported on the crown and acanthus leaves held by two angels. Like a jewel within its setting, or an image within a decorative capital in a manuscript, the figures of Christ and the Samaritan Woman, the rocky slopes and trees, the scroll and even the pulley of the pail accommodate themselves to the contours and the geometry of the frame, although Christ's garment overlaps it on the lower left. The decorative instinct of the designer, seen as well in the calligraphic hemlines on Christ's garment, prevails until one notices the robust, even plebeian figure of the Samaritan and the less than refined features of Christ and the little angels. This melding of local and northern traditions is but the microcosmic counterpart of the tendencies of the Duomo's architecture itself.

The most original invention on the Duomo is without doubt the "capitals" – if they can truly be designated thus – of the nave, transept, and choir pillars, all based on a prototype that was designed by Giovannino de Grassi.[24] Throughout the Middle Ages Italian architects, living on Roman soil and steeped as they were in the classical tradition, accepted with only slight modifications the demand of classical structure and aesthetics that the capital provide a visually convincing support and transition from the vertical column to the horizontal lintel (or arcade). And even French Gothic architecture, with its attenuated columns and piers, on which the capitals are so reduced as to be almost vestigial, providing the briefest of pauses in the upward surge climaxing in the rib-vaults, retained a link, barely perceptible as it was, to this tradition. In Milan (Fig. 299) neither the classical nor the Gothic solution was adopted, and it is fascinating to follow the controversies between local members of the

water that he offers: "... whosoever drinketh of the water that I shall give him shall never thirst; but the water that I shall give him shall be in him a well of water springing up into everlasting life."

Only the upper frame of the lavabo containing the relief of Christ and the Samaritan (Fig. 298) belongs to the late Trecento; the lower section was redone in the late Cinquecento.[23] In Giovannino's relief we see a combination of rigorous architectonic enframement – a steep triangle bending at its base to develop into a broader rectangle pierced by an ogive – and richly decorative floral motifs from which, in the band above the ogive, emerge little nude angels. This outer frame

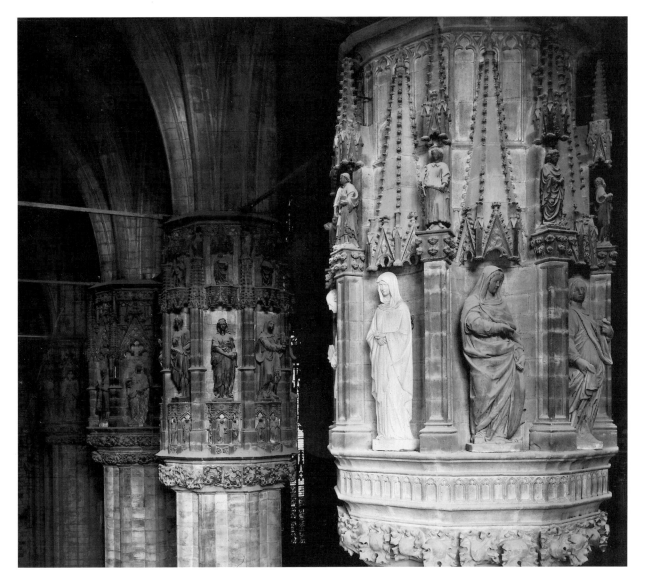

300. Giovaninno de Grassi: Capital, last decade of the fourteenth century. Milan Duomo [Alinari/Art Resource, New York].

Fabbrica and their northern consultants, who found the early capital designs (preceding that of Giovannino but likely as unconventional as his model) quite unacceptable.[25] Giovannino's capital (Fig. 300), six meters in height, rises above the clustered pier (whose core is of octagonal plan); it is composed of a circle of niches supported by an undulating cornice that follows in a general way the profile of the pier. The niches, of shell formation in their upper section, contain statues standing on polygonal consoles. Each niche is surmounted by a gable enclosing a teardrop-shaped motif, while leafy crockets, pinnacles, and flame-shaped protuberances add to the complexity. Thus, instead of a solid transition from vertical to horizontal as in classical architecture, or a continuous linear surge toward the vault, as in northern Gothic, here we have a huge section of the pier-vault connection excavated and busy with pattern, providing pockets for shadow and multifaceted surfaces for occasional splashes of light within the dimly lit forest of colossal piers (Fig. 299). All the other capitals are variations, some considerably more complex – occasionally with two stories of inhabited tabernacles – on the basic scheme of this first example, and together they not only disrupt the vertical thrust of the piers but insist upon lateral movement around each pier and forward movement along the axis of the great space.[26] Such an eclectic and picturesque combination of motifs and typology informs much of the late Gothic production in Lombardy and Milan.

Venice, the Veneto, and Verona

VENETIAN SCULPTURE, C. 1300–C. 1340

Throughout much of the Duecento Venice enjoyed a flourishing school of Veneto-Byzantine and Romanesque sculpture, prominently exposed on the facades of San Marco.[1] Its continuing vitality was favored by a distinctly conservative patronage that remained happy even longer with the still dominant Byzantine school of painting well into the fourteenth century. One might have expected Giovanni Pisano's *Madonna and Child* (Fig. 102) and its accompanying angels, as well as Giotto's stupendous fresco cycle in the Arena Chapel in nearby Padua, to have a resounding effect on the ecclesiastical and civic patrons of Venice and its environs. Yet with few exceptions, even potential patrons of the avant-garde, primarily the doges and church hierarchy, did not seek or commission works by masters trained in the artistic centers of Tuscany. As was true in Genoa following the erection of the Margaret of Luxemburg tomb (Fig. 116), the older styles continued to satisfy. In both Genoa and Padua, the fact that Giovanni Pisano was not physically present in the region, apparently sending his completed work north from Pisa instead of setting up shop and training

and employing local artisans, meant that indigenous stone-carvers were trained exclusively in local workshops.[2] In short, a conservative patronage, a limited number of innovative Tuscan models on view, the lack of opportunities for technical training in more advanced workshops, and most important a still vital Byzantine and Romanesque tradition of imagery and carving modes all combined to forestall the infusion of Central Italian ideals. Just as on the political front the belief in the value of the status quo was stronger in Venice than in Tuscany, so it was in the area of artistic patronage.

The productions of the first few decades of the Trecento, then, tended toward the extremely conservative: These included numerous relief icons that are essentially translations from the medium of painting, although they might combine painted kneeling donors with an iconic saint's figure carved in low relief.[3] A whisper of Gothic humanism appears in the unexpected intimacy of the so-called *Madonna dello Schioppo* (Fig. 301), whose Byzantine linearism combines with a new tenderness in the relation between mother and child.[4] As to sepulchral monuments, the tombs of wealthy or eminent Venetians tended toward massive sarcophagi surmounted by sloped roofs with corner *acroteri* in imitation of early Christian examples or, in Padua, in imitation of the tomb of the mythical founder of that city, Antenor of Troy.[5] In addition to such newly carved tombs, Venetian patrons might reuse Early Christian sarcophagi, adapting them to new use by the addition of an aedicula, some new carvings, and an inscription. This practice served Venice's self-image, which saw its roots reaching back not to inglorious escape from the Barbarian invasions that accompanied the collapse of the Roman Empire, but rather further back in antiquity, and thus suggests a conscious program of "renovatio imperii christiani."[6] A curious conglomeration of antique and newly made parts, emblematic of this attitude, is seen in the figure of San Teodoro, the first patron saint of Venice, which was prominently placed on a column in the piazzetta of the ducal palace in 1329; here, a Greek head, attached to a Roman torso encased in a cuirass of sophisticated imperial imagery, includes additions of medieval armor and limbs added in the early fourteenth century (Fig. 302).[7]

Early Trecento Tomb Monuments and Venetian Sculptured "Portraits"

Although conservative modes predominated, a few isolated works indicate a simmering pressure to introduce

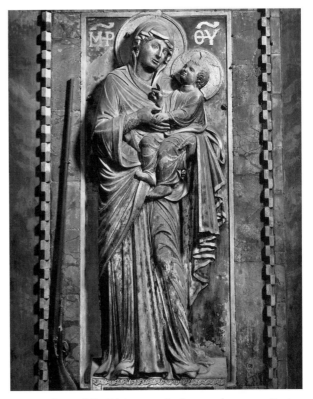

301. Madonna dello Schioppo, early fourteenth century. Venice, San Marco [Alinari/Art Resource, New York].

new sculptural ideas.[8] The tomb effigy of St. Simeon, in San Simeone Grande, Venice, possibly dating as early as 1317–18, as indicated by an inscription plaque belonging to the original tomb, includes one of the few sculptures in the Veneto attesting to the presence of a Central Italian master. Only the effigy, a sarcophagus, and two inscription plaques (a third inscription appears on the sarcophagus front) remain of what must have been a larger ensemble whose original form is unknown (Figs. 303, 304).[9] But the over-life-size reclining figure is extremely impressive, enveloped as it is by a series of overlapping folds ending in harmonious curving hemlines. Yet the garment only momentarily distracts one's eye from the marvelous head (Fig. 304), framed with its luxuriantly curling hair and long, flowing beard. The open mouth – teeth showing – and overhanging contracted brows, together with the utterly relaxed hands, with their still seemingly pulsing veins, create the impression that the passage to death has occurred just moments earlier. The work is signed by one Marco Romano, to whom no other sculpture is documented but who, as both the style and evidence of the use of the drill indicate, may have been trained by Giovanni

302. San Teodoro. Venice, Piazzetta San Marco [Alinari/Art Resource, New York].

Pisano or was a close follower (cf. Fig. 89).[10] One wonders what impelled the patrons, who included four bishops and the parish priest of San Simeone, to seek out a master capable of creating such an imposing presence, so much in contrast to the reticent icons of the Venetian tradition. Indeed, the appearance of an effigy carved in such high relief as to appear in the round is characteristic not of saints' tombs but rather the tombs of high clerics, especially cardinals.[11] It may be that the choice was motivated by a continuing and passionate controversy over the authenticity of the relics, fed by the political conflicts between Venice and the Dalmatian city of Zara, which also claimed to possess the saint's remains. A late duecento sarcophagus front in Zara, showing the reclining saint in relief, may have provoked inclusion of an even more salient effigy on the Venetian tomb, one of the earliest saint's tombs to include such a figure.[12]

That some northern patrons had awakened to Central Italian artistic achievements becomes evident in the person of Enrico Scrovegni, who commissioned Giotto to execute the frescoes in the Arena Chapel and Giovanni Pisano to carve the Madonna and Child accompanied by angels for that chapel's altar. The standing life-size statue of Enrico Scrovegni (d. 1336) (Figs. 305, 306) in the sacristy of the Arena Chapel is a work whose attribution to Giovanni had for long been accepted but is now generally refuted. Not only the authorship, but also the date and artistic milieu – central Italian or Venetian – have been open to discussion.[13] The solid plasticity of the figure relates it to Tuscan modes, as does the fact that a standing layperson is represented within a niche (cf. the figure of Beltramo del Porrina in Casole di Val d'Elsa [d. 1313], Figs. 126, 127).[14] In both cases nothing secure is known of the original context and whether the figures were intended for tombs or cenotaphs or were conceived as celebratory images of a living person. If, as Wolfgang Wolters argues, the figure dates between 1315 and 1320, that is, prior to Scrovegni's exile from Padua – then a Central Italian milieu for the Paduan portrait is suggested, especially given the patron's known esteem for Tuscan painting and sculpture. Although the facial features are somewhat generalized, they would seem to have been drawn from life, as comparisons with his images in the *Last Judgment* and in the tomb effigy in the choir suggest. As such, this figure initiated a noteworthy tradition of realistic sculptured portraiture in the Veneto.[15]

One scholar has argued that this standing figure now in the sacristy belonged to an earlier tomb of Enrico Scrovegni, of which the present monument with recumbent figure (Figs. 309, 310) is a replacement dating from the time the choir of the Arena Chapel was enlarged by the addition of a polygonal apse.[16] According to this thesis, the standing figure was originally placed in its niche (later somewhat altered) in front of the wall to the right of the choir entrance, significantly on the side of the Virtues along the base of the adjacent wall; that it faced

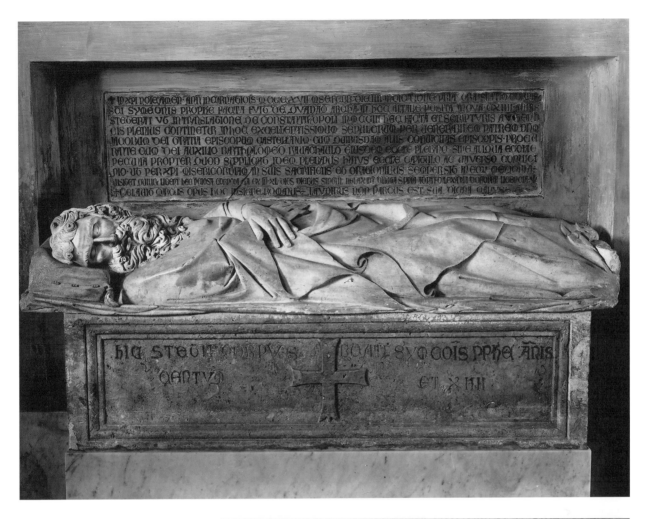

303. (above) Tomb of San Simeone, 1317–18? Venice, San Simione Grande [Osvaldo Boehm].

304. Tomb of San Simeone, detail. 1317–18? Venice, San Simeone Grande [Osvaldo Boehm].

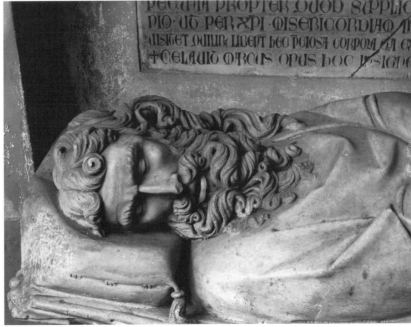

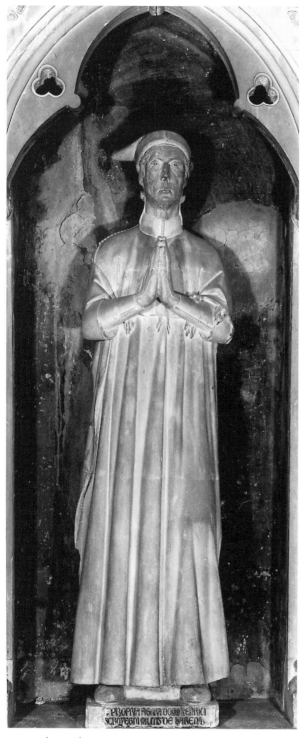

305. Niche with Enrico Scrovegni, 1315/20? Padua, Arena Chapel [Padua, Museo Civico, Gabinetto Fotografico].

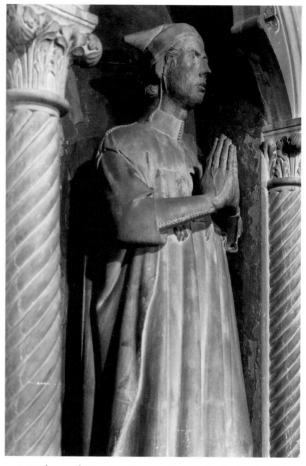

306. Niche with Enrico Scrovegni, 1315/20?, detail. Padua, Arena Chapel [Osvaldo Boehm].

the *Last Judgment* on the entrance wall and faced it from the side of the Blessed; and that its earnest, almost anxious expression, and its gesture (which derives from the tradition of reclining effigies in France with hands simi-

larly pressed together in prayer) are specifically directed toward the *Last Judgment* on the entrance wall. Full of fear and hope – not expectation or confidence, for that would have been lacking in Christian humility – the wide-eyed Scrovegni is offered a vision of the Day of Judgment in the huge, powerful image on the west wall of the chapel.[17] If this provocative hypothesis is accepted, then the *Last Judgment* fresco and the standing figure of Scrovegni belong to a unified conception, a conception surely worthy of Giotto himself.[18]

If the image of Scrovegni is an early example of a portrait drawn from life, the effigy on the tomb of Bishop Castellano Salomone (d. 1322) in the Duomo of Treviso, by an anonymous sculptor, is arguably the first true masterpiece of Trecento Venetian portraiture (Figs. 307, 308). Here the sculptor skillfully distinguishes between the tauter passages of skin over the bony portions of the skull and the more flaccid flesh under the eyes and around the mouth; and the incised lines that

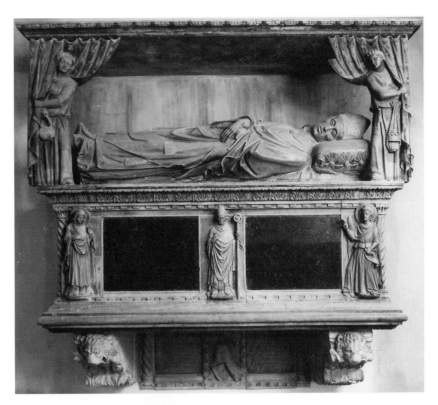

307. Tomb of Bishop Castellano Salomone (d. 1322). Treviso cathedral [Osvaldo Boehm].

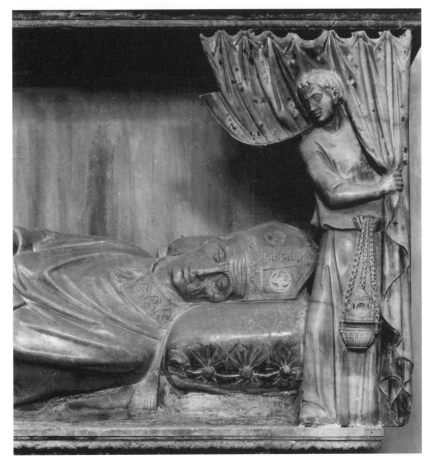

308. Tomb of Bishop Castellano Salomone, detail. Treviso cathedral [Osvaldo Boehm].

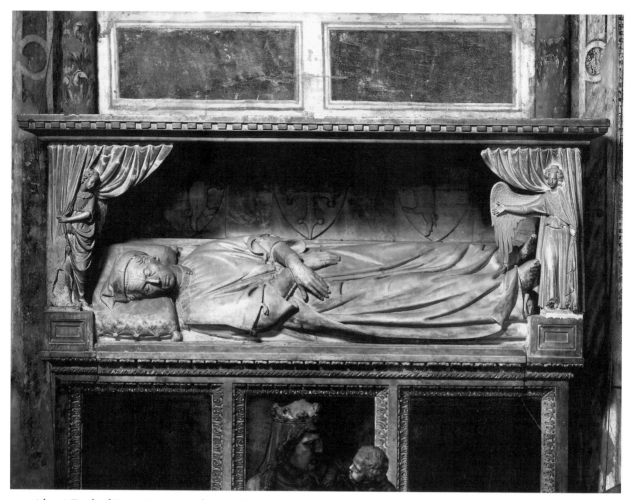

309. (above) Tomb of Enrico Scrovegni (d. 1336). Padua, Arena
Chapel [Alinari/ Art Resource, New York].

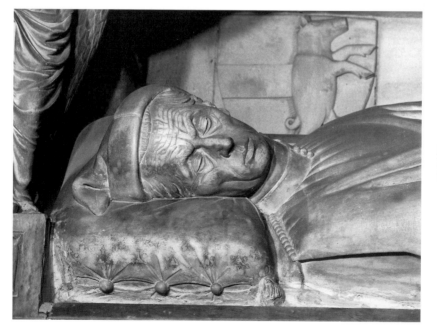

310. Tomb of Enrico Scrovegni, detail.
Padua, Arena Chapel [Università degli
Studi di Padova].

express tension in the mouth and forehead are distinguished from those under the eyes and descending from the nose that indicate age. The linear pattern of the garment's hems and the relaxed and veined crossed hands recall the effigy of San Simeone (Fig. 304), although the facial features of Salomone form a more integrated whole and are hardly by the author of the saint's effigy. The tomb itself combines Central Italian and Venetian elements: The effigy within a funerary chamber exposed to view by two curtain-holding deacons is seen in Arnolfo's de Bray monument (Figs. 56, 58), while the sarcophagus belongs to a type – three sculptured panels separated by colored marble slabs, with columns at the corners – that will become absolutely typical and indeed mass-produced throughout the Veneto during the remainder of the century. With the Castellano Salomone tomb, sculpture begins to replace painting as the leading art of the century.

The funerary chamber with curtain-holding angels appears again in the later tomb of Enrico Scrovegni in the Arena Chapel, Padua (Figs. 309, 310). The effigy shows Scrovegni considerably older than the standing figure in that same chapel (Figs. 305, 306), and was probably executed after his death in 1336. Certain characteristics of the portrait have suggested that the author is the same as that of the Castellano Salomone effigy, and indeed, the concern with physiognomic details, including the rendering of looser and more taut passages of flesh, as well as the psychological intensity – expressive perhaps of the gravity of Scrovegni's material losses and exile during the last decade and a half of his life – makes this a plausible attribution.[19]

That even minor masters who otherwise created conventional panels could be skilled portraitists is apparent in the relief showing John the Evangelist venerated by Bartolomeo Ravachaulo (Fig. 311), the very priest who together with several bishops commissioned the tomb of San Simeone, mentioned earlier. The panel, traditionally dated 1334, belongs to the genre of donor icons of Byzantine origin referred to earlier. But the face of the kneeling monk is far from conventional: The features of this slightly portly figure with heavy eyelids, round cheeks, and a sensual mouth clearly represent an individual.[20]

A distinctive "portrait" style is seen in the figure of Rizzardo VI di Camino on his tomb in Sta. Giustina, Vittorio Veneto (Figs. 312, 313). Rizzardo, a warrior, died in battle in 1335, but as his only heir was his wife, it was probably she who commissioned the tomb. Although the modern reconstruction is far from reliable and includes

311. John the Evangelist venerated by Bartolomeo Ravachaulo, detail, 1334? Venice, San Simeone Grande [Osvaldo Boehm].

fragments of diverse provenance, the supporting figures and the effigy clearly belong together. The sarcophagus (with some reliefs not originally pertaining to it) conforms to the conventional Venetian type, but the concept of a sarcophagus supported by standing figures (in this case, however, representing not allegories or clerics but probably warriors) derives from the tradition of saints' shrines.[21] Several sculptors collaborated, and their talents range from the heavy-handed carver of the crude torsos of the supporting figures – the heads are carved separately by another, superior sculptor – to the highly skilled master of the powerful head of Rizzardo. Less subtly modeled and sensitive than the effigies of Castellano Salomone or Enrico Scrovegni, Rizzardo's features

243

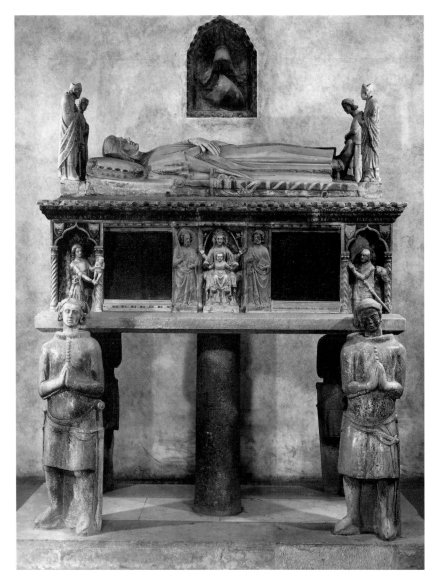

312. Tomb of Rizzardo VI di Camino (d. 1335). Vittorio Veneto, Sta. Giustina [Alinari/Art Resource, New York].

cleric, or layman. Such tombs usually consisted of a sarcophagus mounted against the wall on consoles (which might include lions), three reliefs showing Annunciation figures at the corners, and a Madonna and Child or enthroned Christ, sometimes flanked by interceding saints and the donor, in the center; the sarcophagus corners might be marked by spiral columns, and the whole was usually capped by a more or less classicizing cornice of acanthus leaves. Between the reliefs the sarcophagus front was often composed of veined, even richly colored marble; the reliefs were generally of marble while the cornice and console were of local stone. Some details were painted and/or gilded so the total effect was far more coloristic than generally appears today. The components of such tombs were often mass-produced to be employed and adapted on demand. Clearly, many patrons wanted a tomb that conformed to an established model.[23] The quality, however, could range from the finely worked figures of the Marsilio II da Carrara tomb (Fig. 315) (the drapery has been compared to that of Giovanni di Balduccio's San Casciano pulpit of c. 1334, Fig. 193) to the humdrum depictions scattered around churches in the Veneto and elsewhere.

Vere da Pozzo

A characteristic feature of the Venetian urban landscape is – or rather was, since only a fraction are extant and in situ – the appearance in the midst of a *campo* (the Venetian term for piazza) of wellheads, or *vere da pozzo*, by means of which Venice, interlaced by waterways but poor in the drinkable liquid, conserved precious rainwater. Wellheads functioned both as water storage tanks and as artificial wells.[24] Projecting above the underground tanks were the decorated wellheads. Specialized craftsmen, called *pozzieri*, were the exclu-

are carved in broad planes whose forms project strongly or are deeply excavated. Probably carved from memory or the imagination after the death of Rizzardo in 1335, it can hardly be called a portrait in the modern sense. But the intent of characterization is clear: The bushy brows, large broad nose, and square jaw convey both individuality and the sense of a powerful bellicose spirit (Fig. 313).[22]

The exquisite tomb of Marsilio II da Carrara (Figs. 314, 315) (d. 1339) in Carrara Sto. Stefano presents all the characteristics of what by now will have become the typical and most common type of Venetian Gothic funerary monument, which could be employed for doge,

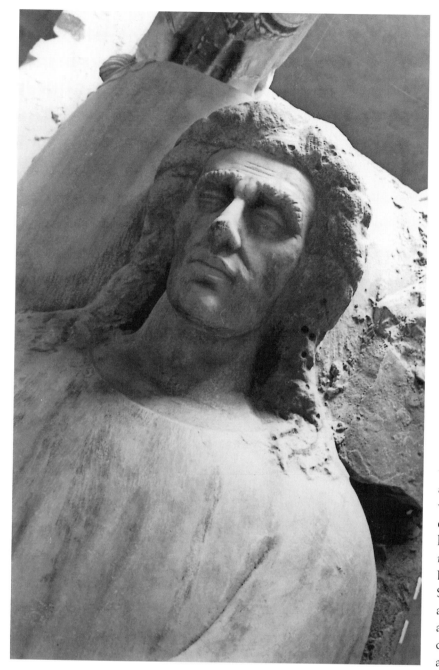

313. Tomb of Rizzardo VI di Camino, detail. Vittorio Veneto, Sta. Giustina [Università degli Studi di Padova].

teristic and authentic monuments in their own right. There are many types and styles, ranging from reworked blocks of marble of classical origin, such as column shafts or capitals, altars, and cinerary urns, to containers in a variety of shapes with finely modeled architectural, floral, animal, and figural motifs. During the fourteenth and fifteenth centuries, the more common "Veneto-Byzantine" type prevalent from the eleventh to the thirteenth century was replaced by allegorical (or other secular) figural reliefs. A rare and lovely example surviving from the fourteenth century is seen in the Museum of Fine Arts, Budapest (Fig. 316).[25] The wellhead is polygonal at its upper molding and cylindrical at its base. The surfaces are carved with a series of young men and women engaged in a delicate rondo dance while two youths play lute and tambourine. Such a dance form was a favorite of the nobility, and both the subject and style suggest that the sculptor was aware of Florentine and Sienese examples (one thinks of the roundelay in the *Effects of Good Government*, dated 1338–39, by Ambrogio Lorenzetti in the Palazzo Pubblico, Siena). Whether adapted from antique or medieval spoils, or carved anew, *vere da pozzo* were the visible concomitants of a relatively simple and elegant system by which, until modern times, Venice supplied its citizens with a clean and adequate supply of water.

Venice's most important achievements in sculpture during the first four decades of the Trecento, however, extend as we have seen to two main areas: the development of an extremely adaptable tomb type that could be employed with or without a funerary chamber and superstructure; and a propensity for "portraiture" that, whether or not based on life, captures the sense of an individual. The artistic personality of no single master of monumental sculpture stands out, however, until the

sive guardians of the elegant engineering techniques employed to collect and conserve water and to produce and maintain the *vere da pozzo*. Another group of specialists, the carvers of the decorated cisterns, were known by the humble term *tajapiera,* or stonecutter.

Ubiquitous as they were, and although most often of modest artistic value, Venetian wellheads became charac-

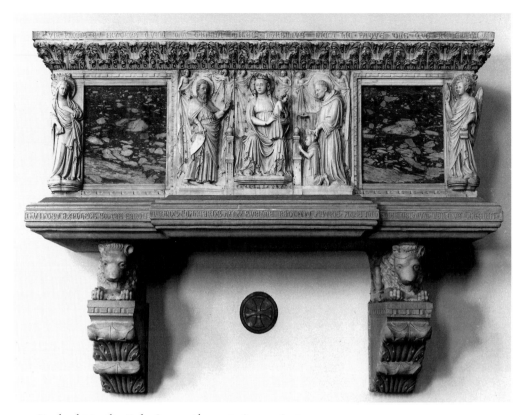

314. Tomb of Marsilio II da Carrara (d. 1339). Carrara Santo
Stefano, Sto. Stefano [Osvaldo Boehm].

315. Tomb of Marsilio II da Carrara, detail. Carrara Santo Ste-
fano, Sto. Stefano [Osvaldo Boehm].

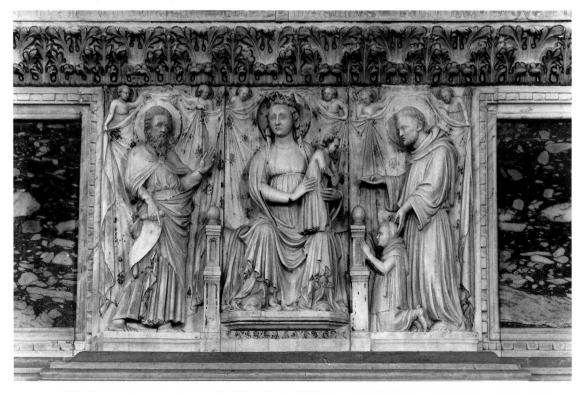

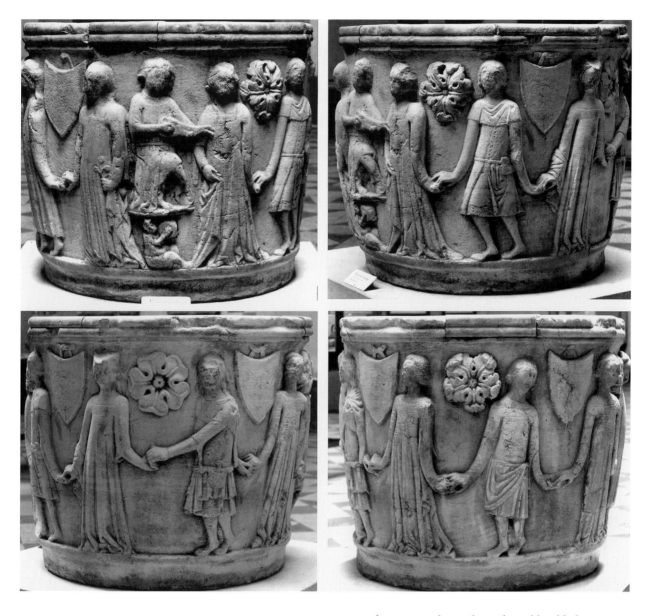

316. Wellhead, fourteenth century. Budapest, Museum of Fine Arts [Budapest, Museum of Fine Arts].

ANDRIOLO DE SANTI

Born near Padua, residing on and off in Venice, and signing his name as a Venetian, Andriolo's first documented works are two portals of San Lorenzo, Vicenza, a city under the rule of the della Scala lords of Verona.[1] Only the facade portal (Fig. 317) is extant, and documents attest that its construction was financed by the *cavalliere*

arrival on the scene of Andriolo de Santi, and then it is in Padua and elsewhere in the Veneto, not Venice, where he received the major part of his commissions.

Pietro da Marano, descendant of an old noble but inconsequential family of Vicenza, who gradually ascended the social hierarchy to become a trusted knight and adviser first of Cangrande della Scala and, after the latter's death, of Mastino II della Scala. As an esteemed member of the Scaliger court, he received many benefits, which enabled him to accumulate enormous wealth, some of which was lent at high interest rates even to members of his own family; he was creditor of the Scaligeri as well. In 1329, shortly after Cangrande della Scala was granted Venetian citizenship, Pietro too received that honor and in turn invested many funds in the Serenissima. In an early Will, having no direct heirs, he left his considerable wealth to the current *Signore* Mastino della Scala. But sometime between summer and autumn of 1340, possi-

bly on his deathbed and at the suggestion of his confessor, he repented of his practice of usury and chose instead to expiate his sins by giving donations to those he had harmed by his lending activities and offering charitable donations in Venice, Verona, and Vicenza. In his Testament he also left sums for the construction of the San Lorenzo portals "per anima mia."[2]

We do not know exactly when he died, although it has been assumed that it was shortly after he wrote his Will. An inscription on a pilaster of the portal gives his name and the date 1344, when presumably the work was completed. Pietro was a dwarf and, quite remarkably, is represented as such in the lunette of the portal, kneeling before the Madonna and Child (Figs. 318, 319).[3] At the periphery of the lunette stand two saints, probably St. Francis and St. Lawrence, patron of the church, the latter

gesturing as an intercessor. It must have been the high social rank Pietro had attained, combined with a generous donation of funds, that permitted the unusual inclusion of his portrait on the church portal. The image of humble penitence in the lunette, then, should be read as emblematic of his conversion from earthly material concerns to spiritual ones in the hope of saving his soul. The Venetian tradition of realistic "portraiture" continues here, for the artist made no attempt to idealize or mask the patron's physical traits. In this remarkable image, a theme from sepulchral art – the deceased presented to the Virgin by an intercessory saint – is placed on a church portal, the first appearance of a devotional image in such a context in Venetian art.[4] Furthermore, in a profoundly suggestive semiotic inversion, the diminutive patron, who presumably spent his life crooking his neck upward in every human encounter, went so far as to have himself represented not only on a scale larger than that of the saints flanking the Madonna, but on high, for now it is the viewer who must look upward to the lunette in order to see the donor in the presence of the holy persons.

Andriolo is referred to in the Vicenza document as *protomagister*, and a number of collaborators, including Venetians and Vicentines, are mentioned. It was probably Andriolo himself, however, who executed the masterful lunette figures, which are characterized by simple contours, legible movements, and expressive gestures. The sense of bulk, the fluted drapery folds with their emphasis on vertical rhythms (more subtle and varied than on the Scrovegni niche figure), and the earnest gravity of comportment – not previously seen in Venetian sculpture – all suggest that the study of Giotto's Arena Chapel frescoes had a decisive influence on Andriolo.

The portal design itself is related to two almost contemporary examples, that on the facade of Sta. Maria di Brera in Milan, designed by Giovanni di Balduccio and completed in 1347, and the main portal of the Palazzo dei Priori in Perugia,

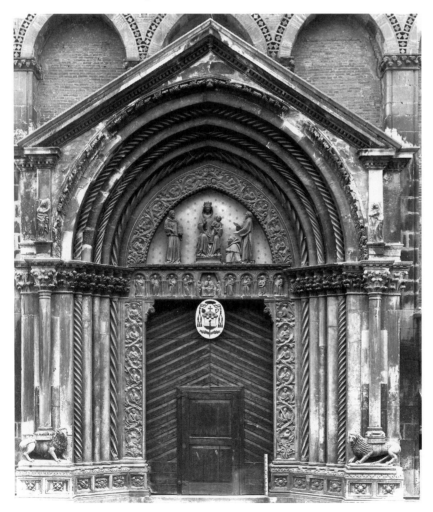

317. Andriolo de Santi: Portal, 1344. Vicenza, San Lorenzo [Alinari/Art Resource, New York].

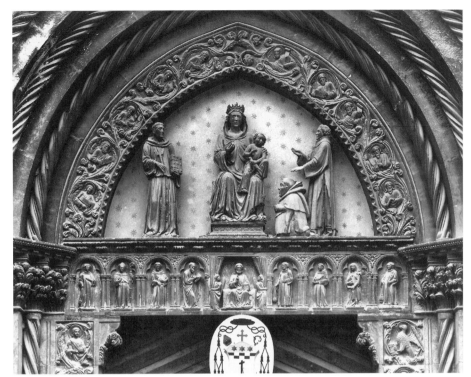

318. Andriolo de Santi: Portal, detail. Vicenza, San Lorenzo [Alinari/Art Resource, New York].

319. Andriolo de Santi: Portal, detail. Vicenza, San Lorenzo [author].

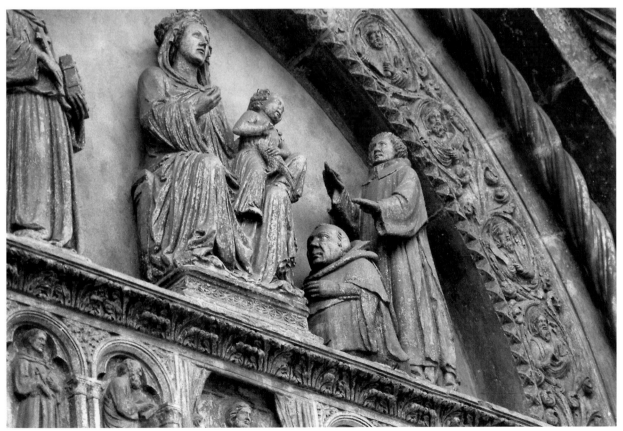

datable only to the early Trecento, though probably after 1317 when St. Louis of Toulouse, to whom the portal is dedicated, was canonized by Pope John XXII.[5] All three show a rational, unified design (Italian versions of the new harmonious relationships that had long ago characterized French Gothic portal design) in which every supporting element – pilaster, spiral columns, colonettes – corresponds to a member of the archivolt, while the capitals and bases form continuous horizontals; in each case the lunette area contains (or contained) sculpture, in the case of Vicenza and Perugia, sculpture in the round. Unlike the Milan portal but like that in Perugia, the jambs at Vicenza are embellished with reliefs. Here within foliate scrolls forming frames around the half figures are prophets, saints, and symbols of the Evangelists, and the series continues upward to form a frame around the lunette. Carefully calibrated is the relationship of lunette figures to those in the arcade and the architrave, with, for example, the Madonna and Child seated directly above and of the same width as the enthroned Christ flanked by curtain-drawing angels. These connections to Perugia and Milan indicate Andriolo's awareness of and receptivity to currents outside the Veneto.

A year after the completion of the San Lorenzo portal Andriolo is found working in Padua. An important university town as well as home of the shrine of Sant'Antonio, Padua was still politically independent of Venice during the fourteenth century, first as a commune until 1328 and then under the control of the Carrara dynasty.[6] The fact that a major fresco cycle was executed by Giotto in the Arena Chapel and Giovanni Pisano had executed his Madonna and Child and angels (see Fig. 102) for that same chapel shows that well before a similar occurrence in Venice, at least one Paduan patron, Enrico Scrovegni, favored the avant-garde art of Tuscany.

On the basis of a contract signed by Andriolo and two collaborators

in Venice on 26 February 1351 for the tomb of the Paduan *signore* Jacopo da Carrara (d. 1350) (Fig. 320), the very similar but earlier tomb of his kinsman, the Paduan *signore* Ubertino da Carrara (d. 1345), has been attributed to Andriolo. The later monument was clearly designed as pendant to the earlier and is similar in its structure and details. Both are seen today in the Eremitani, Padua, although originally they were located opposite one another in the presbytery of Sant'Agostino (destroyed in the early nineteenth century), which for a time became a sort of funeral chapel for the da Carrara family. Jacopo da Carrara's tomb (and probably that of Ubertino) once included a fresco in the lunette of the wall behind the baldacchino; the lunette showed a Coro-

320. Andriolo de Santi: Tomb of Jacopo da Carrara (d. 1350). Padua, Eremitani [Alinari/Art Resource, New York].

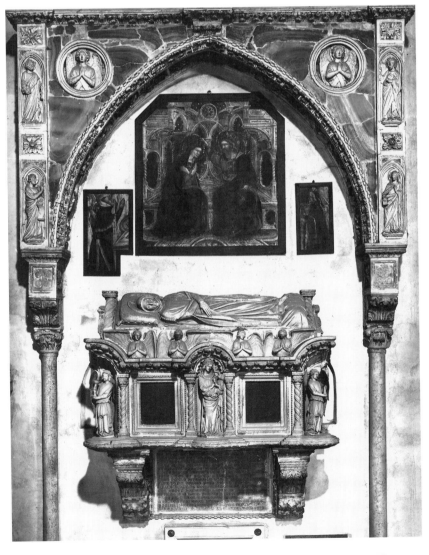

nation of the Virgin and two kneeling figures, most likely the deceased and another member of the family (perhaps a spouse).[7] Although several hands are evident, including a sculptor very close to Bonino da Campione for the figure of the Madonna in the Jacopo da Carrara tomb, the finely modeled effigy should probably be attributed to Andriolo himself. The Venetian concern with portraiture remains evident, although the features are not as strongly characterized as were those of Castellone Salomone or Enrico Scrovegni. A striking novelty on these tombs is the design of the sarcophagi: Instead of the common horizontal cornice, the sculptor has introduced a frontal niche in the center and diagonally excavated niches at the corners that "force" the cornice to project upward, recalling, at least at the extremities, the conventional *acroteri* of many Venetian and northern Italian tombs, including that of Antenor, referred to earlier. Whereas the patron may have been attracted to this association, the sculptor's motivation may well have been to provide a more ample, inhabitable space for his figures than was conventional for corner figures.[8] In addition, the diagonal placement of the candelabra-bearing angels at the corners breaks the dominant frontality of earlier sarcophagi so that the observer is encouraged to consider the sides of the monument as well.

Various other works have been attributed to Andriolo on the basis of the San Lorenzo portal and the da Carrara tombs, but the only other documented work is the chapel originally dedicated to San Giacomo Maggiore and rededicated in the early sixteenth century to San Felice in Sant'Antonio, Padua (Figs. 321–24). The chapel was commissioned from Andriolo on 22 Feburary 1372 by Bonifacio Lupi, whose patron saint was St. James (San Giacomo), and completed after Bonifacio's death in c. 1375. The contract stipulates – and this was most unusual for Venetian contracts – that the master will not only design and direct the construction but execute the sculptures with his own hand. Of the five apostles on the chapel's facade, however, only one or two can be attributed, albeit with reservations, to Andriolo himself.

Consideration of the Chapel of San Giacomo, an ensemble in which architecture, sculpture, and painting are coordinated to create a true *Gesamtkunstwerk*,[9] brings to the foreground the limitations of a study devoted to a single art, since very often during the medieval and Renaissance periods, and most conspicuously in this chapel, the three sister arts were intimately connnected. According to the contract, Andriolo had to follow the form "come fu mostrato nella deta capella

dipincta" (i.e., the chapel of the Santo, painted by Stefano da Ferrara; the paintings were destroyed in the sixteenth-century rebuilding of the chapel), and the vaults had to follow the example of that same chapel.[10] Thus we do not know how free Andriolo's hand was in the design of the space, although the requirement to "copy" an earlier work was generally interpreted in a very loose manner during the Middle Ages. The likelihood is that a chapel was required that was somewhat similar to that of the opposite transept dedicated to St. Anthony – most likely a screened space, thus separate from yet easily accessible and visible from the main space – in order to create a degree of harmonious symmetry and to make reference to the chapel of the patron saint of Padua.[11]

Still, the Chapel of San Giacomo must have been entirely different visually from anything seen in Padua up to that time. Both its architectonic structure and its chromatic as well as plastic effects were new and reveal Andriolo to have been an architect of considerable imagination.[12] Set within the right (southern) transept in the relatively austere, domed basilica (based in part on San Marco in Venice but without its mosaic richness and chromatism), with its regular spaces and brick surfaces (calling out for frescoes), the chapel forms a small, virtually self-contained Gothic edifice. From the main space of the basilica one sees (and sees through) the facade composed of a sequence of pointed arches resting on slender columns and surmounted by a wall whose crowning gables peak at the interstices of the arcade below, forming a rhythmic counterpoint of arches below and zigzag gables above. Between the gables there are aediculas framed by colonettes and pinnacles, forming trefoil niches whose tympana project even higher than those of the patterned wall surfaces between them; each niche contains a statue standing on a console that projects directly over the peak of the pointed arch of the arcade below.[13] This facade screen is reflected in the blind arcade that articulates the rear wall of the chapel and is echoed in the crocketed gables over the side wall stalls, so that the transept chapel becomes a sort of laterally developed Gothic "cage." Through this facade screen was visible the altar table with its group of five figures (including a sturdy, massive Madonna and Child and four saints, now in the Museo di Sant'Antonio) by a French sculptor evidently trained in Lombardy, Rainaldino di Francia, who received payment for the figures in 1379.[14] Behind the altar, which probably stood beneath the central vault of the chapel, rose the magnificent Crucifixion that covers three of the rear bays with its focus on the

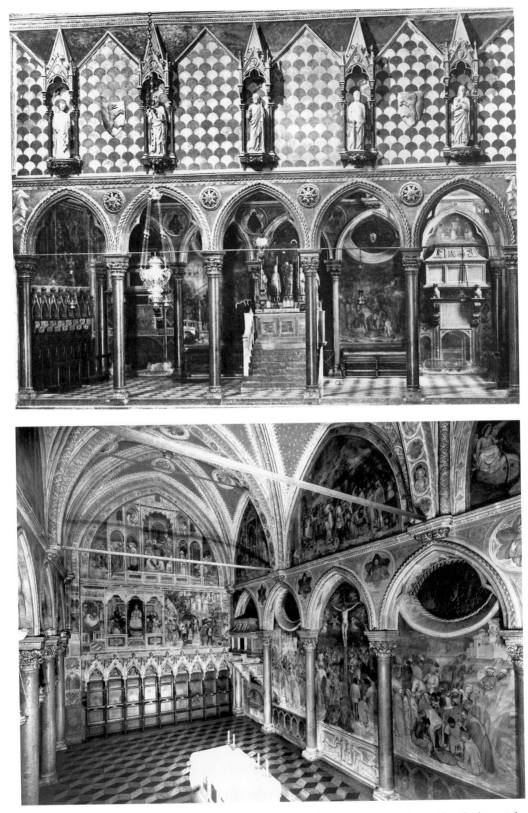

321. (top) Andriolo de Santi: Chapel of San Felice (formerly San Giacomo), 1372–c. 1375. Padua, Sant'Antonio [Comune di Padova, Settore Musei e Biblioteche].

322. (above) Andriolo de Santi: Chapel of San Felice (formerly San Giacomo). Padua, Sant'Antonio [Comune di Padova, Settore Musei e Biblioteche].

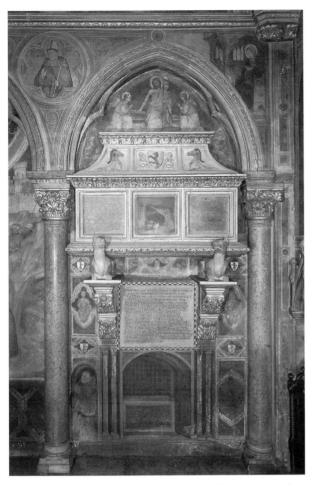

323. Andriolo de Santi: Chapel of San Felice, detail. Padua, Sant'Antonio [Padua. Veneranda Arca di S. Antonio].

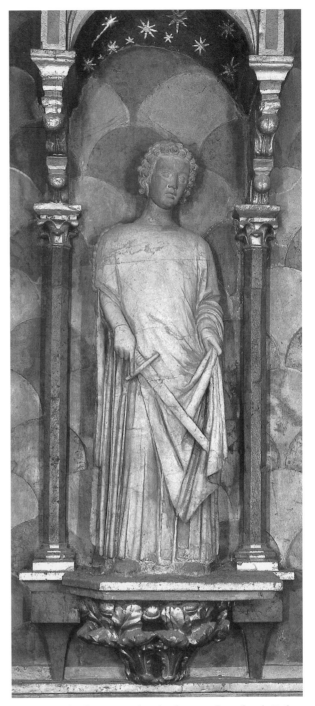

324. Andriolo de Santi: Chapel of San Felice, detail. Padua, Sant'Antonio [Comune di Padova].

centralized crucified Christ, part of a fresco cycle embellishing the entire interior of the chapel and painted in large part by Altichiero. The Crucifixion fresco acts almost like a giant triptych behind the altar.[15]

If the chapel's Gothic structural features are reminiscent of northern European form filtered through Central Italy with its emphasis on mural surfaces, the chromatic qualities suggest Andriolo's native Venice: Here we see a play, not only of solid and voids (so common on the facades of Venetian palazzi) and of alternating broader and steeper tympana, but also of surfaces covered with colored incrustations of red and white marble in a fish-scale pattern, played against the red marble columns with gilded capitals and the white marble niche tabernacles with their statues. The stalls, too, were partially gilded, as were the oval window embrasures and star-filled oculi of the spandrels of the facade. Originally, the chromatic play was completed by the pave-

ment, which, according to the contract, was to be composed of red and white marble.

Altichiero's large Crucifixion encompasses the three central bays of the blind arcade on the rear wall. The outer bays are filled with two unadorned wall tombs resting on raised consoles, with trompe l'oeil niches

below and painted images above.[16] Seemingly being lowered into the left-hand tomb, in which are buried four of Bonifacio's kinsmen who had died between 1339 and 1345, is the figure of Christ in a Deposition scene; seemingly rising from Bonifacio's tomb on the right is an image of Christ in the Resurrection (Fig. 323). Although it is possible that Altichiero had had no contact with Andriolo when he began work on the frescoes in c. 1377 after the chapel's completion and after the death of Andriolo, so perfectly coordinated are the paintings with the architecture that it is difficult to believe the two artists did not consult and even collaborate.[17]

Even taking into account the gap of almost thirty years between the San Lorenzo portal (Figs. 317–19) in Vicenza and the San Giacomo Chapel (Figs. 321–24) in the Santo of Padua, it is not easy to reconcile the style of the figures in the chapel facade niches with those on the earlier portal. The figures have in common the tendency toward broad volumes that are broken up into a series of smaller linear elements. But the easy gait and sense of full, rounded form – in short, the Giottesque quality – of the figures on the portal have been replaced by forms less plastic and more linear in effect in the Santo figures. Although the head of San Martino (Fig. 324) has morphological features in common with the Madonna in Vicenza (Fig. 319), the upper torsos of several of the San Giacomo facade figures – especially the San Martino – are flat and quite lacking in articulation. Given that Andriolo lived to work on the Chapel for only three years and had to supervise the complex architectural construction, which consisted not only of the facade and rear walls but probably also the wood seats and the groin-vaulted ceiling, and given the retreat from the more solid, less linear treatment seen in his earlier figures in Vicenza, it is probable that Andriolo provided only the designs and did not carve any of the figures with his own hand.[18] Nevertheless, the Chapel of

San Giacomo is a memorable example of a successful coordination of architecture, sculpture, and painting to create a functional and aesthetic whole.

THE SCULPTURE OF THE PALAZZO DUCALE

While Andriolo de Santi was employed outside of Venice, the major architect-sculptor working within the city was Filippo Calendario, who is named, in chronicles dating back to the early fifteenth century, both as the creator of the "new" Palazzo Ducale, begun c. 1340, and as "tajapiera," thus as stonemason/sculptor.[1] There is no proof, however, that he designed or carved the capitals

325. Venice, Palazzo Ducale, southwest corner [Alinari/Art Resource, New York].

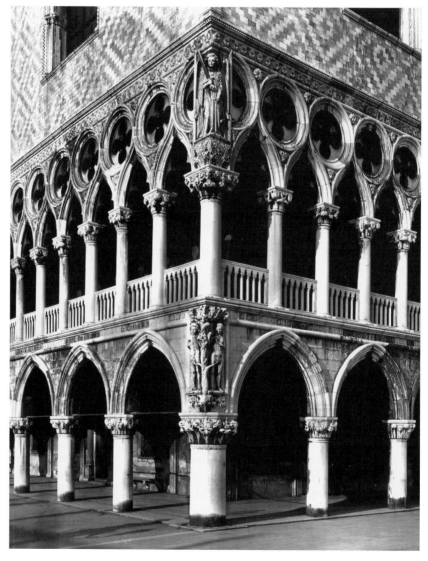

and reliefs on the exterior of the palazzo, and opinions have differed widely regarding the authorship, artistic sources, dating, and interpretation of the sculptural program. Wolfgang Wolters, for one, has argued forcefully for accepting the word of the early Venetian chroniclers who praised Calendario for his masterful work; in his view the lower-story capitals of the Trecento palace, the corner sculptures illustrating *Adam and Eve* and the *Drunkenness of Noah*, and the archangels above these narratives were done by or in the workshop of a single individual who must therefore be Filippo Calendario (Fig. 325).[2] In contrast to other observers, he holds that Filippo was Venetian, rather than a Lombard or northern master, and that he reveals acquaintance with Tuscan, Lombard, and French art. Ultimately, however, without the discovery of new documents the question of authorship of the sculptures is irresolvable and their date of execution insecure; opinions have ranged from the 1340s to late in the century and even beyond.[3] The capitals, for structural reasons, must have been executed shortly after the project to enlarge the palace was begun in the early 1340s. In my view, however, the visual evidence does not compel an identification of the master of the capitals with the one responsible for the corner narratives and archangels.

The arcade on the ground story of the Palazzo Ducale (Fig. 325) is composed of sturdy low columns supporting figured octagonal capitals that present a seemingly infinite variety of subjects and themes.[4] The master of the capitals clearly was offered a program allowing for a wide range of descriptive and inventive designs, and he was capable of giving scope to the many hands at work. Although numerous details have defied interpretation, the program as a whole clearly reflects that same encyclopedic impulse we have seen at work on the Fontana Maggiore in Perugia and the Cathedral-Campanile program in Florence. But the exalted classicism of the Cam-

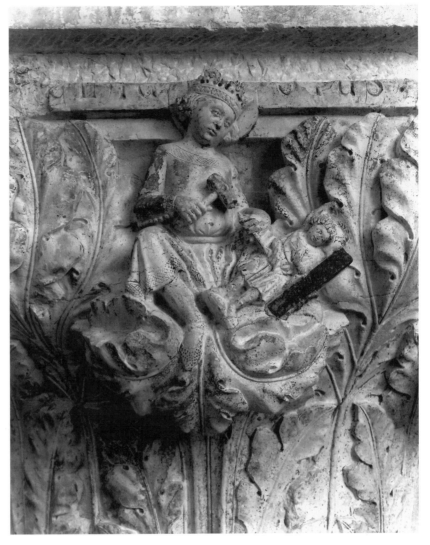

326. Venice, Palazzo Ducale, capital with stone-carver, San Claudio [Lieberman].

panile reliefs (Figs. 176, 178, 179) is replaced here by an endearing naturalism, closer in this regard to the Perugia fountain's Labors of the Months (Fig. 49), rendered with an eye for the naturalistic detail that will best convey the activity in question. Generally speaking, the capitals form three main subject groups: busts, including those of biblical and pagan sages and human races and nationalities; different species of birds and animals, both naturalistic and fantastic, as well as fruits of the earth; and small scenes that include allegories and biblical and genre subjects, all forming small vignettes within the full-bodied foliage (Figs. 326–30). Among the most captivating are the scenes of courtship, matrimony, and parenthood (Figs. 328, 329), which end poignantly with the

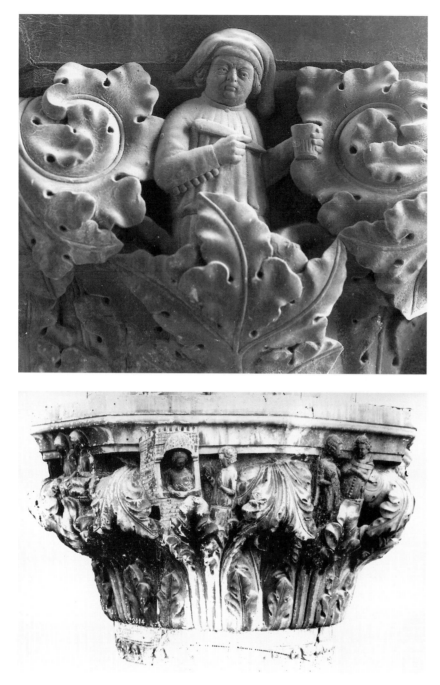

repeated, such as Virtues and Vices, the specific personifications are not identical. Restricting ourselves to the Trecento phase of construction (the facade on the Molo, the waterfront side, and moving around to the seventh column on the piazzetta side, which, being of larger diameter, marks the corner of the Trecento facade) we find that one capital (the ninth moving left from the Ponte della Paglia) illustrates the Theological and Cardinal Virtues and Humility (the same as represented on Andrea Pisano's bronze doors of the Baptistry), and the following capital (the tenth) shows canonical vices. The images on the next capital to the left illustrate secondary virtues and vices, including Stupidity, Injustice, and Abstinence.[5] It does not seem, however, that a strictly defined program based on a specific literary text determined the contents of the individual capitals but that general directives were given to the carvers who must have executed the reliefs on the basis of drawings provided by the master, since the group as a whole seems informed by a single artistic personality. With these carvings on the Palazzo Ducale, Venice had finally extricated itself from its Romanesque and Byzantine traditions, in notable contrast to contemporary painting, which retained allegiance to older compositions and iconographic modes.

327. (top) Venice, Palazzo Ducale, capital with Scribe, 1340s? [Osvaldo Boehm].

328. (above) Venice, Palazzo Ducale, capital: *Courtship*, 1340s? [Osvaldo Boehm].

death of a child. Revealing the sculptor's sharp powers of observation, the various races are distinguished and the Labors of Man (seen earlier on the Campanile of Florence) are depicted with the apposite tools of the trade (Fig. 327). Although some general subjects are

The enhancement of capitals with didactic reliefs was an old tradition that flourished during the Romanesque period in church interiors and cloisters, but the embellishment of the exterior walls of a civic palace with an extensive sculptural cycle was all but unprecedented.[6] The palace itself is unlike any other public edifice, and it is not surprising in light of this that the enhancement with sculpture required a comparably unconventional solution. One of the most unusual features of the palace is the appearance of narrative sculpture at the three exposed

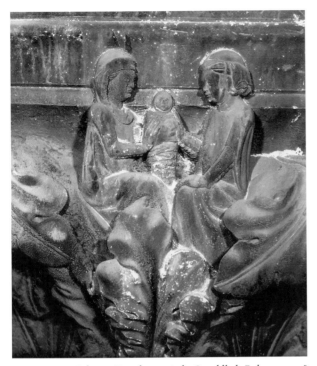

329. Venice, Palazzo Ducale, capital: *Swaddled Baby,* 1340s? [Osvaldo Boehm].

330. Venice, Palazzo Ducale, capital: *Vanity,* 1340s? [Venice. Civici Musei D'Arte].

corners of the lower arcade, above which stand archangels (Fig. 325). The classical principle that demands solidity at the corners of an edifice – compare the lengths to which Greek designers went to terminate a frieze with triglyphs rather than metopes – is here inverted by the large, deeply undercut reliefs that perforate the corners. The choice of this location for applied narratives has, to my knowledge, no antecedents, although corner niches and figures are seen earlier on ecclesiastical furnishings such as tombs and ciboria, and on the Baptistry of Bergamo (Figs. 273, 274). But the piercing of the two lower stories with arcades and oculi, and the luminous chromatic quality of the pink and white marble mural surfaces, no less than the absence of solid corner termini, all contribute to the visionary and diaphanous structure of this profoundly *Italian* Gothic building.

Although the capitals of the lower arcade must for tectonic reasons belong to the earliest phase of the Trecento building project, the corner figures might well have been incorporated while the fabric of the superstructure was being built in the 1340s; thus a dating beyond the middle of the century is quite possible and even likely. With these scenes the Palazzo program moves from the general to the specific: Whereas the capitals offer an encyclopedic enumeration of cosmology (the zodiac), nature, and

human activity, as well as the creation of Adam, the corner narratives concern subsequent biblical events that are key moments within the larger overview. At the same time, they make explicit an important aspect of Venetian political ideology, namely, the role of government in carrying out divine justice.[7] Since it is the weakness of human nature that necessitates the creation of governmental structure and a system of justice, two of the corners, forming part of the Trecento facades, bear arresting reliefs of human weakness taken from Genesis: the *Fall of Mankind* and the *Drunkenness of Noah.*

The *Fall* (Fig. 331) is seen on the southwest corner joining the piazzetta to the Molo; the corner itself is loosely marked by the tree and the serpent winding about it, and the sides are filled with the almost life-size figures of Adam and Eve, so that one must move around the building to take in the whole scene (Fig. 325). Below this scene, the capital contains a representation of the *Creation of Adam* while an inscription refers to the creation of Eve. Above the corner pair, and facing out diagonally, stands the archangel Michael with sword in hand; it was he who expelled Adam and Eve from Paradise, thus acting as executor of God's will in the enforcement of justice. But Michael is not just the angel of judgment and conqueror of Satan; he is also a

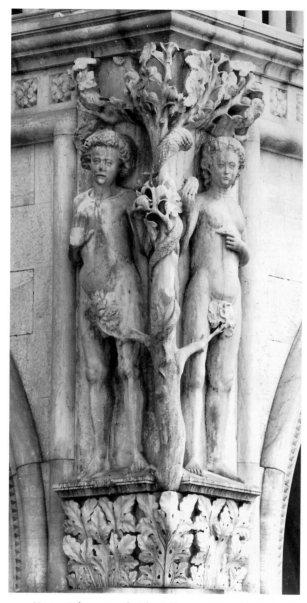

331. Venice, Palazzo Ducale, *The Fall*, 1350s? [Osvaldo Boehm].

misogynous tradition of associating female sexuality with evil), yet he gestures his reluctance (or is it a warning to the observer to avoid female seduction?) while Eve refuses responsibility as she points to the serpent.

Traversing the entire Molo side of the Palazzo, on the southeast corner near the Ponte della Paglia the viewer is faced with an even greater psychological tension in the representation of the *Drunkenness of Noah*

332. Venice, Palazzo Ducale, *Drunkenness of Noah*, 1350s? [Osvaldo Boehm].

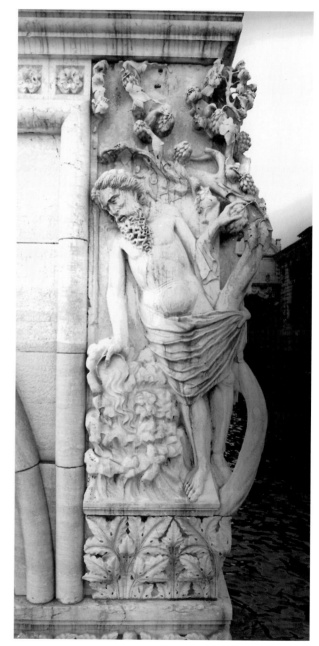

protector of sinful man who guides souls toward Paradise. Medieval theology, as well as Venetian political ideology, conceived of the state's function analogously, as a vehicle for leading men to eternal paradise.

By the standards of Tuscan sculpture – for example, the Creation scenes on the Campanile of Florence by Andrea Pisano (Fig. 173) – the Venetian figures are awkward, lacking in convincing ponderation and utterly unclassical in their form and proportions. But no Tuscan sculptor explored with such subtlety the human and psychological potential of the event. Here we see Adam conflicted as he plucks the fruit (not an apple but a fig, indicating the

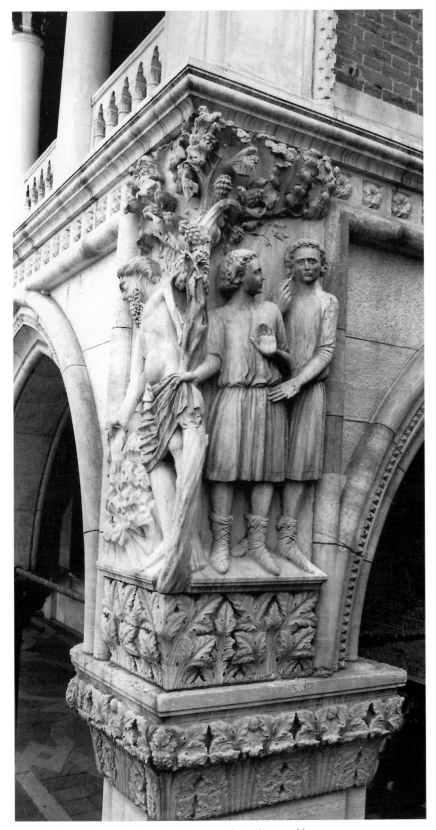

333. Venice, Palazzo Ducale, *Drunkenness of Noah* [Osvaldo Boehm].

(Figs. 332–36). Again a tree, this time entwined by grapevines, loosely marks the architectural terminus, with Noah to the left and two of his sons around the corner to the right. The second of these is probably Ham, suggested by the disapproving expression on his face and the gestures, one hand pointing to his eyes, the other toward his father: Ham has seen his father's sorry state and indicates it to his brother, Shem. The latter, full of pity and respect, covers the old man's nakedness, gestures and turns his head, refusing to witness directly the sad occurrence. The observer's eye is then led by a broad arch spanning the depth of the loggia to the next column on the eastern side of the building where Noah's third son appears (Figs. 335, 336). Employing a similar gesture of refusal as the first, he probably represents Japhet.[8]

The *Drunkenness of Noah* was replete with associations during the Middle Ages: Not only was Noah the inventor of wine (as such he appears among the exponents of the first human creative endeavors on the Campanile of Florence), but he was also the first seaman (having built the ark) and a progenitor of all nations, meaningful associations for Venice's cosmopolitan and seafaring culture. Furthermore, his association with wine made him an Old Testament type for Christ. The flowing beard bespeaks the venerable Old Testament hero, who is revealed, however, like a fallen Shakespearean protagonist, in all his weakness, tipsy and about to tumble to the ground (Figs. 332, 333). But the differing responses of the sons of Noah, as expressed in Genesis and in the sculptures, convey a contrast between worthiness

334. Venice, Palazzo Ducale, *Drunkenness of Noah,* detail [Venice. Civici Musei d'Arte].

early fifteenth century but may well have belonged to the original program;[10] it hardly requires interpretation given its context on the Palazzo Ducale. As the wise and just king who could settle disputes peacefully, Solomon was a most apt personification for the Venetian state. Above him is the figure of Gabriel, messenger of the New Law that replaced the law represented by Solomon below.

The three biblical narratives on the building's corners, then, together with the archangels, allude to the function of the Ducal Palace as a seat of government whose mission is to administer law and justice in accordance not with man-made but with divinely ordained concepts of an orderly and peaceful society.[11] Thus, just as the Florentine cathedral program encompassed the whole of divine cosmology and human activity, the Palazzo Ducale program alludes to the Venetian body politic and its constituents, revealing these as part of the larger natural and cosmological entity created by God.

JACOBELLO AND PIERPAOLO DALLE MASEGNA

The last decade of the fourteenth and the first of the fifteenth century in the Veneto were dominated by two brothers, Pierpaolo and Jacobello dalle Masegna, architects and sculptors who were given major commissions for San Marco and the Palazzo Ducale; but their fame in Venice was preceded by work in Bologna (which must have put them in fairly close, even direct contact with Tuscan sculpture) as well as Modena, and was followed by the commission for the facade of the Duomo of Mantua (demolished in the eighteenth century) and for the tomb of Margaret Gonzaga (d. 1399).[1] The figures carved by the dalle Masegna more than those of any of their predecessors, are constructed along principles found in Central Italian sculpture. But sculpted figures form only one aspect of style, and in the totality of their sculptural output – which, like the work of Andriolo de Santi, involved architectonic constructions – the influences are varied and difficult to define.

Although the execution of some monuments may have been largely the work of one or the other of the brothers, they accepted commissions and signed work jointly. Some scholars hold that the ancona of San Francesco, Bologna, though commissioned from both, is largely the work of Pierpaolo – whose Last Will and Testament refers to the *ancona* made by *him* – whereas

and unworthiness: The son who *looked* at his father's nakedness received his curse (Gen. 9:22–27). This, in turn, implies the need for judgment and a societal structure in which, according to Venetian political thought, the worthy lead and the unworthy follow. Above Noah stands the archangel Raphael, traditionally the leader and guide of virtuous men – as exemplified by the poignant story of the child Tobias seen at his side – leading them toward the divinely ordained goal of society.[9]

The third relief, that closest to San Marco and representing the *Judgment of Solomon,* was created in the

335. Venice, Palazzo Ducale, *Drunkenness of Noah* [Ralph Lieberman].

the worshiper and invite contemplation of and identification with the emotional responses to the central Crucifixion. Thus, our purposes will not be served by entering into the attributional fray.

The earliest secure work of the dalle Masegna is the tomb of an eminent jurist, Giovanni da Legnano, d. 1383 (formerly in S. Domenico, now in the Museo Civico Medioevale in Bologna) (Fig. 337), of which only fragments are extant. These include, in addition to consoles preserved at Riola di Vergato, a carved inscription flanked by two stemma of the Legnano family (with a painted, almost illegible signature below), a third stemma framed by an elaborate decorative molding developed from a quatrefoil, and a relief representing students attending a lecture, these last in the Museo Civico, Bologna (Fig. 337). Most of the students direct their attention (not all of them are attentive!) toward the observer's right, so the relief was probably the left panel of a three-part sarcophagus front, with an image of the jurist "in cattedra" in the center, flanked on the right by another group of students. The relief, then, formed part of a common Bolognese tomb type for professors of law.[3] The lecture scene would have formed the front of the sarcophagus while the elaborately framed insignia would most likely have embellished one of the sides. The inscription, as is common on Venetian tombs, would have been imbedded in the wall below the sarcophagus, which was originally raised on consoles.[4]

The tomb reveals the extremely high technical skill of the author (or authors): The carved inscription, coats of arms, floral passages, and especially the elaborate frame of curved, spiky moldings suggest the mentality of a goldsmith, although there is no evidence that the brothers were trained in this art, which in Venice was quite distinct from the training of a stonecarver.[5] The figural relief is more naturalistic and subtle than that of most other professor's tombs, which tend toward formulaic poses and expressions, although

the iconostasis of San Marco, Venice, is generally given to Jacobello; but attempts to distinguish the individual hands remain pure hypothesis.[2] Given the cosmopolitan environment of Venice, with its input of artistic currents from Central Italy and northern Europe, the figure styles of the Bologna altarpiece and the San Marco iconostasis, at least regarding its central section facing the nave, are not so divergent as to compel different attributions. Also to be taken into account are the differing functions and scale of the figures within each ensemble: an altarpiece whose dazzling effects were to be read by the worshipers from a distance but whose details were addressed more directly to the clergy and friars in closer proximity, in contrast to a choir screen on which large, freestanding apostles face

336. Venice, Palazzo Ducale, *Drunkenness of Noah*, detail [Venice. Civici Musei d'Arte].

there was a tradition of suggesting, as we see here, the varying modes of behavior of the individual students. The drapery is of an unusual fluidity and reveals the clear intention to suggest the form and position of the limbs that press through and determine the fall of the folds.[6]

The High Altar in San Francesco, Bologna

In 1388 the friars of San Francesco in Bologna commissioned the dalle Masegna brothers to execute a monumental marble ancona for the high altar.[7] Although sculptured stone altarpieces are the exception in Italy, both San Domenico in Bologna and the Dominican church of Sant'Eustorgio in Milan possessed marble altarpieces that included figures in niches and/or on gables, as well as narrative reliefs.[8] It is quite conceivable that the project for San Francesco in Bologna was motivated in part by a desire to supercede in magnificence the altarpieces by Giovanni di Balduccio or by local masters made for the Franciscan's Dominican rivals in Bologna and Milan (Figs. 192, 272).[9]

The form and structure of the San Francesco marble altarpiece (Fig. 338) is more closely related to the tradition of Venetian Gothic painted altarpieces than to these stone precedents. The large polyptych by Lorenzo Veneziano in the Accademia, Venice, commissioned in 1357, exemplifies the type: It is two-storied and rests on a predella that, like the upper sections, is articulated by polygonal buttresses. The lower story contains full-length standing figures, four per side, while the upper one has the same number of half figures. The central fields with the Annunciation and God the Father are wider than the frames for the saints. Finally, although altered in the nineteenth century, the central section of the painted polyptych may have been capped by a projecting baldacchino (a traditional feature of Venetian Gothic altarpieces), while the upper sections were capped originally by tall pinnacles.[10] The basic elements of the San Francesco altarpiece are the same, except that only the end buttresses are polygonal.

337. Dalle Masegna: Relief from tomb of Giovanni da Legnano (d. 1383). Bologna, Museo Civico [Alinari/Art Resource, New York].

The San Francesco altarpiece (Figs. 338–42), which was designed also to serve the function of an earlier sacrament tabernacle,[11] was conceived as a structure of visionary effect, both massive and delicate, solid and perforated, almost like an overblown multisectioned carving in ivory. Composed of Carrara marble with some details polychromed, the altarpiece rises in two main horizontal stories resting on a predella, bounded by massive octagonal piers to the left and right, and capped by tabernacles and pinnacles. The superimposed central baldacchino niches are considerably wider than the flanking niches and, with their projecting canopies,

provide deep recesses for the figures contained within: a Coronation of the Virgin (Fig. 340) below and God the Father above. The central section, thus, reads like a somewhat wider – but now hollowed out – pier echoing in inverse fashion the solidity of the outer piers. The tabernacles that cap the framing piers and central projecting baldacchino niches contain the Annunciation and the Virgin and Child (a nineteenth-century replacement), respectively.[12] Finally, the tall central finial supports a Crucifixion (also of the nineteenth century)[13] with Mary and John the Evangelist, and those on the flanks support trumpet-blowing angels.

Not only is the altarpiece conceived as a play of solids and voids within a strictly organized, bilaterally symmetrical composition, but there is also a secondary organizing principle of decreasing figure totality and

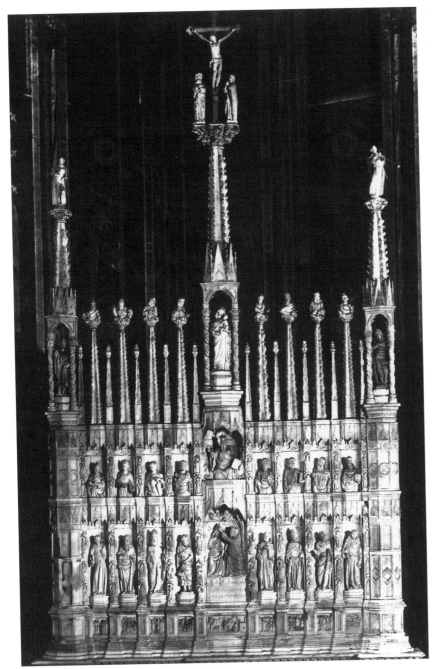

contain niches providing less illusionistic, more real or actual space first for full-length standing figures and then for three-quarter-length figures. Completing the sequence are the half-length busts that cap the spires above these niches, busts that remain entirely free of any architectural surrounding. Also standing free in space are the trumpet-blowing angels who direct their musical blasts toward the congregation, even facing outward, rather than inward toward the center of the composition.[14]

Although most writers have concentrated on the style of the individual figures and reliefs, few have commented on the effectiveness of the composition and structure within the nave of the Gothic basilica itself. Here, the linear, spiky, elegant forms and perforated structure echo the verticality and linearity of the choir and the perforations of the arcade of the ambulatory. If ever a monument was site-specific, this one is.[15] From the nave the altarpiece, with its apparently delicate structure, seems intended to produce amazement in the observer, who, like one standing within a French Gothic cathedral, wonders how the whole thing stands up, failing to comprehend (to be sure, with a "willing suspension" of disbelief) the structural supports for a seemingly dissolved mural structure. The reference to ivory, fanciful as it is, may also explain the unusual back of the altarpiece with its undulating convex sections apparently reflecting the niche hollows of the front side, as though each figure and niche were carved out of a section of tusk (Fig. 339). Even the predella, which has no niches, undulates in similar fashion on the rear side. The additional labor involved in creating these convexities, in contrast to a simple planar rear surface, must have been considerable.

338. Dalle Masegna: Marble altarpiece, 1388–96. Bologna, San Francesco [Alinari/Art Resource, New York].

increasing spatial freedom: The predella, formed of solid blocks of stone to provide both a physically necessary and aesthetically satisfying support for the superstructure, is embellished with narrative reliefs; these show figures within illusionistic environments, including a distant landscape (see Fig. 342). The next two stories

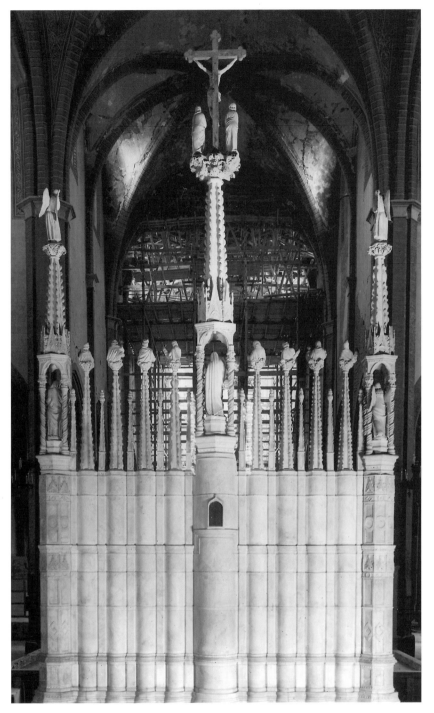

339. Dalle Masegna: Marble altarpiece, rear view. Bologna, San Francesco [Alinari/Art Resource, New York].

The figure style, as many have observed, suggests the influence of Nino Pisano and through him of his father Andrea, although a direct acquaintance with Andrea by way of a sojourn in Tuscany cannot be excluded. Sculp-

tures by Nino had been shipped from Pisa to Venice for the Cornaro monument (Fig. 205) of 1368 in Santi Giovanni e Paolo. The figures of Mary in the Coronation (Fig. 340) and the Annunciation (Fig. 341) seem especially close to the Virgin and Child on the Venetian tomb (Fig. 205), and the trumpet-blowing angels owe a debt to the angels flanking the Madonna and saints on that same monument. The aristocratic Christ with high cheekbones, softly waving hair, and short beard is based on the Tuscan prototype, which in turn goes back to French Gothic sources.[16]

The nine predella reliefs are of uneven quality. Eight of them share the "box space" that Andrea Pisano and others had inherited from French cathedral sculpture, so that here, too, the figures stand on a palpable stagelike ground.[17] The iconography derives from Giotto's fresco cycle in Sta. Croce. The central relief, representing the Stigmatization of Francis (Fig. 342), is conceived in an illusionistic mode reminiscent of Sienese early Trecento relief sculpture. Although the figures and some of the landscape elements are fully plastic, the ground and mountain are modeled in a *schiacciato* relief mode, suggesting atmosphere and a sense of recession.

The sources for this unique monument, then, are varied, ranging from goldsmithwork, ivory carving, Venetian (and perhaps Tuscan) painted retables, and – in this early appearance in Italy of the baldacchino niche – French monumental cathedral architecture.[18] The concentration on the question of attribution, focusing on the individual figures, has distracted scholars from a full appreciation of the inventiveness of the altarpiece's design, conceived to be effective from

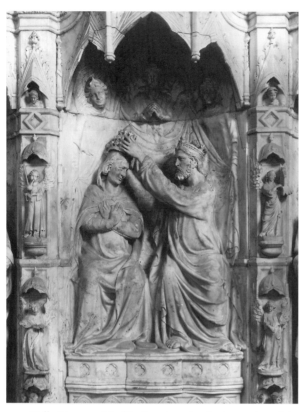

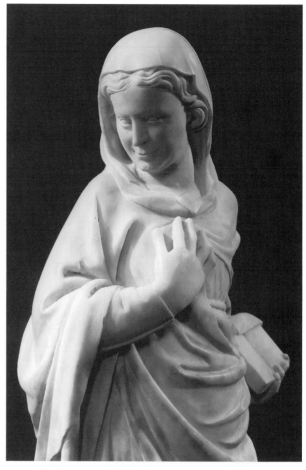

340. Dalle Masegna: Marble altarpiece, detail. *Coronation of the Virgin*. Bologna, San Francesco [Alinari/Art Resource, New York].

341. Dalle Masegna: Marble altarpiece, *Virgin of the Annunciation*. Bologna, San Francesco [Alinari/Art Resource, New York].

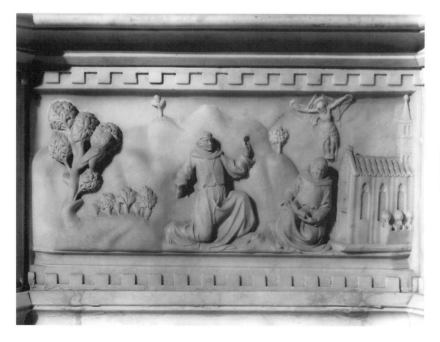

342. Dalle Masegna: Marble altarpiece, *Stigmatization of St. Francis*. Bologna, San Francesco [Alinari/Art Resource, New York].

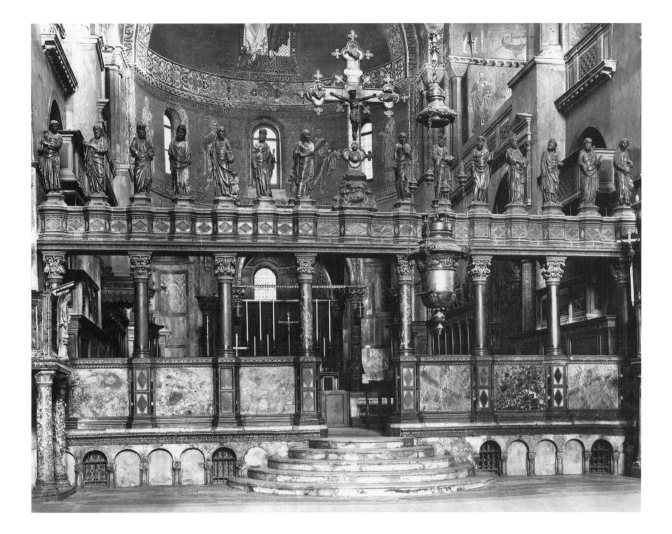

343. Dalle Masegna: Choir screen, completed 1394. Venice, San Marco [Osvaldo Boehm].

near and far and to respond in the play of its forms to the buildings within which it is housed.

The Iconostasis in San Marco, Venice

In 1394 the two brothers signed the iconostasis in San Marco (Figs. 343–46), which thus must have been begun several years earlier, prior even to the completion of the Bologna altarpiece. This choir screen replaced a previous one of the early thirteenth century, which seems to have included relief panels of Christ and the evangelists, several of which are extant and set elsewhere in San Marco.[19] The general form, like the later iconostasis, included a solid balustrade below surmounted by columns. Apparently, the desire to update San Marco,

manifested on the exterior by work begun in 1384 on the "Coronomento Gotico,"[20] led to the decision to erect a new choir screen in accord with Gothic taste. With the completion of this commission (Fig. 343), suddenly there was introduced into San Marco – resplendent with Byzantine mosaics in the domes and vaults, colorful intarsia floors, and rich marble walls and columns embellished in various places with Byzantinizing reliefs – a stage supporting a series of naturalistic, dynamic figures projecting emotions that are both subtle and intense, restrained yet sufficiently legible to invite and stimulate interpretation on the part of the observer (Figs. 344–46). The figures are enveloped in garments that, although more linear and brittle than those seen on the Bologna altarpiece, nevertheless have gracefully curving folds that suggest the underlying bodily forms. A successful synthesis is thus obtained between linear abstraction – fully in keeping with the linearity of the predominantly Byzantine images within San Marco – and the

new effects of physical and emotional gravity and naturalism. The twelve apostles, Saint Mark, Mary, and Christ of the Crucifixion that faced worshipers from the nave, as well as the female saints facing the side aisles, were presences to encounter across space in a way that none of the earlier icons or reliefs remotely suggested.

The San Marco iconostasis, excepting the discoloration of the originally white marble and partially polychromed figures, remains essentially in its original state and site. It is composed of three (discontinuous) sections, one separating the presbytery from the nave, and the other two stepped back and closing off two flanking lateral chapels, that of San Pietro on the north and of San Clemente on the south. The central section bears an inscription recording the consecration of 1394 and the signature of the two brothers, while the San Clemente screen repeats in abbreviated form the first inscription, without the signature and with a consecration date of 1397. The basic structure of all three screens is the same: a balustrade of unembellished marble slabs articulated or separated by projecting buttresses upon which rest the columns that support an architrave. Echoing the alternating flat and projecting sections below, projecting socles atop and between the capitals form a regular rhythm along the surface of the architrave; each of these socles then supports a figure, including the central crucifix.[21]

Because the statues of the central section – the twelve apostles and St. Mark flanking the lamenting Mary and John the Evangelist[22] and the Crucified Christ – face the nave while the figures on the lateral screens face the side aisles, it is the public worshiper rather than the clergy who is invited to contemplate the holy figures. Neither the apostles nor the Madonna of the central screen facing the nave look directly forward or toward the cross. Their expressions and closed contours tend to isolate each figure physically and psychologically; yet several also form pairs whose individuals are in silent communication with each other. The style of most of the figures surmounting the side screens, in my view, does not support an attribution to the dalle Masegna themselves, although clearly the three screens were conceived as an ensemble; it is likely that these figures were executed by collaborators and may even postdate the consecration of 1397.[23]

The identifiable masters of monumental sculpture who dominated Venice and the Veneto during the Trecento –

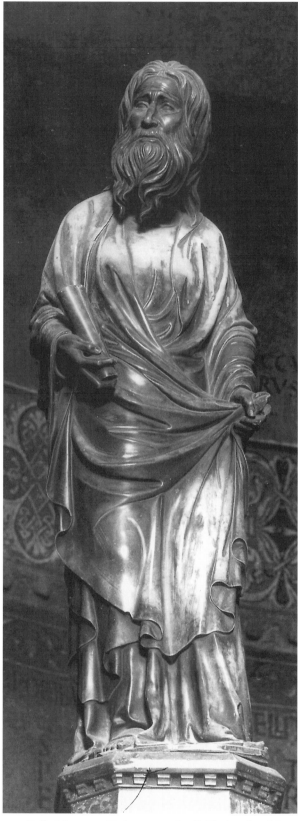

344. Dalle Masegna: Choir screen, detail. Venice, San Marco [Osvaldo Boehm].

268

345. Dalle Masegna: Choir screen, detail. Venice, San Marco [Osvaldo Boehm].

Venetian Trecento style remained current well into the fifteenth century. Wolters has pointed out the curious phenomenon that although a number of Tuscan sculptors were welcomed to Venice during the early Quattrocento and given commissions, native masters resisted their influence, preferring, as did many of their patrons, the older styles or their reinterpretation as International Gothic.[24] The early-fifteenth-century decoration of the upper facades of San Marco include apostles with slightly swaying poses, swinging drapery curves and arabesque hemlines, and reflective and often introspective psychological expressions reminiscent of their counterparts on the dalle Masegna choir screen. The curved gables are lush with leafy decor from which "grow" half-length figures like those atop the pinnacles of the San Francesco altarpiece. And in 1422, when the Maggior Consiglio decided to enlarge the Palazzo Ducale, the Trecento palace was not overlaid with Renaissance motifs but was imitated so precisely that hardly a seam separates the earlier from the later fabric. The fifteenth-century capitals of the lower arcade are close imitations of their predecessors, although the Latin inscriptions are more erudite.[25] And even the *Judgment of Solomon* relief remains so close to the idiom of the earlier corner narratives that occasionally all have been assigned to a single master.

Andriolo de Santi, the master of the capitals and the master of the corner reliefs on the Palazzo Ducale, and Pierpaolo and Jacobello dalle Masegna – hardly qualify as a "school." While they and their patrons all rejected the still functional conservative traditions preferred by others, there is no clear-cut influence of one upon the other, nor can a development of tomb typology, figure style, or tendencies in architectural design be demonstrated. Thus, Venetian sculpture of the Trecento, like the sculptured cathedral facade in Central Italy (see pp. 294ff.), does not offer a convenient narratological development. Unlike the latter, however, whose influence on later facades was virtually nonexistent, elements of

VERONA

In contrast to the republican oligarchy of Venice, whose doge was elected by a ruling council, in most of northern Italy during the late thirteenth and fourteenth centuries political life was characterized by the rise of hereditary lordships, which replaced the earlier communal government. The pattern of such rise to power was often as follows: A major officer of the government, duly elected or appointed by the commune, was allotted special powers

346. Dalle Masegna: Choir screen, detail. Venice, San Marco [Osvaldo Boehm].

during times of crisis. In response to alleged continuing or new crises additional powers might be allocated, and the term of office extended, sometimes for life. At some point hereditary powers were claimed and the title of *signore* taken; the office then passed on to one or more members of the family. Imperial or papal recognition was fervently sought, however, although the ruler might have to content himself with establishing, by way of various legal subterfuges, that the transfer of power had been legitimate and approved by the commune. As one writer has commented, "Arguably, the more illegitimate a regime, the more ostentatious its claims to constitutional right...."[1]

Class conflicts and conflicts between Guelf and Ghibelline, internecine violence, and the political as well as economic benefits of territorial expansion – since wealth and power in these northern areas depended to a large extent on agricultural rather than industrial productivity – resulted in constant warfare and the concomitant rise and fall of individual *signori*. Having achieved lordship, each *signore* to a man remained politically and territorially ambitious and ruthless against enemies at home and abroad. A few *signori*, however, notably Azzone Visconti of Milan and Cangrande della Scala of Verona, tended to identify their own interests with that of the well-being of their cities; and Milan and Verona in particular flourished economically and culturally during their rules.

Verona, about 130 miles from Milan and about 110 from Venice, had a culture distinct from and only peripherally related to that of its far more populous and powerful neighbors. Its artistic productions, moreover, have an identity so striking that a short section devoted to Veronese sculpture is well justified. More conspicuously than other cities, Verona reveals two distinct patterns of artistic patronage, and these, in turn, inform the language of its sculpture. The della Scala and other nobility gave commissions to some of the great foreign workshops, importing artists from Milan and Venice, whereas the convents and churches remained faithful to local tradition, commissioning works from local sculptors who answered to a *popolaresco* taste.[2] Indeed, early-fourteenth-century Veronese sculpture belonging to this second group has a special cast quite distinct not only from Tuscany, as one would expect, but also from Venice and from the Campionese sculpture of Milan and its surroundings. Like the latter, with which it shared a strong Romanesque tradition, this sculpture

retains an emphasis on solid mass so that the figures are broad, even stocky, and the forms tend to adhere to the planes of the stone blocks from which they are carved. A favored material, however, in addition to the red marble of Verona, especially for figure sculpture, was tufa, invariably polychromed. But in contrast to numerous examples of Campionese sculpture, the major works produced during the first three decades of the Trecento in Verona generally lack the narrative impulse, with its invitation to dwell on colorful detail and homely incidentals,[3] and are imbued, rather, with a deeply felt if unsubtle emotional intensity that suggests contact with German Gothic sculpture.

A number of works coming from various city churches have such close stylistic and morphological connections that a single authorship or at least workshop has been proposed; the sculptor is commonly referred to as the Master of Sant'Anastasia.[4] Unsigned and largely undocumented, this unified group "in search of an author" finds a parallel in, but has no direct stylistic connection to, the Chicago Madonna and Child and the related sculptures from the Loggia degli Osii in Milan (Figs. 259–61); the common thread is the *volgare* or local dialect that remains superficially faithful to the Romanesque and is only minimally responsive to stylistic influences from the Tuscan diaspora or French Gothic sculpture.[5]

A characteristic example is the *St. Ann and Virgin* (Fig. 347) in Sant'Anastasia. The broad, massive forms are insistently symmetrical in the lower half; but then the rather rigidly fluted folds converge and compress around St. Ann's abdomen and lead the eye upward toward a finale of utter and unexpected intimacy: The child Mary looks directly and inquiringly at her elderly mother and the glance is returned with an infinite sadness of expression. Not elegant or pretty but large-boned, of peasant stock but with a rustic dignity, St. Ann supports the child standing on her lap with both hands, whose protective embrace belies the presentiment expressed by her face. Were it not that Verona itself offered precedents for such intimacy in the relationship of mother and child – in Duecento images representing, however, the nursing Madonna – one would feel required to make reference to Giovanni Pisano (Figs. 100–103). But the local tradition exists and so such allusions are unnecessary.[6]

Both the stocky corporeality and intensely expressive content are seen again in an extraordinary Crucifixion

347. *St. Ann and the Virgin,* first third of the fourteenth century? Verona Sant'Anastasia [Umberto Tomba, Verona].

group (Figs. 348, 349) in polychromed tufa, originally in San Giacomo di Tomba and now in the Museo del Castelvecchio, Verona. This group seems almost outside the context of Italian sculpture, recalling instead – more in emotional tenor than in style – some of the great German crucifixion groups such as that on the choir screen in Naumberg.[7] Although the dramatic effect is reduced in the present arrangement (both mourners were probably turned more in the direction of Christ), there is a slow crescendo of intensity from the stoic resignation of the Evangelist, who nevertheless looks toward and appeals to the viewer, to the silent desperation of the Virgin focusing on her Son, the climax, where Christ, still fleshy and even muscular, having the moment before emitted a shriek of pain, gasps his last breath. The extravagant pathos of the human torso – flesh torn and creased over the nails, veins and tendons distended – is mitigated only by the stylized folds of drapery and the quietude of the accompanying figures.[8] Although the *Virgin and St. Ann* have been dated c. 1300, and the Cru-

271

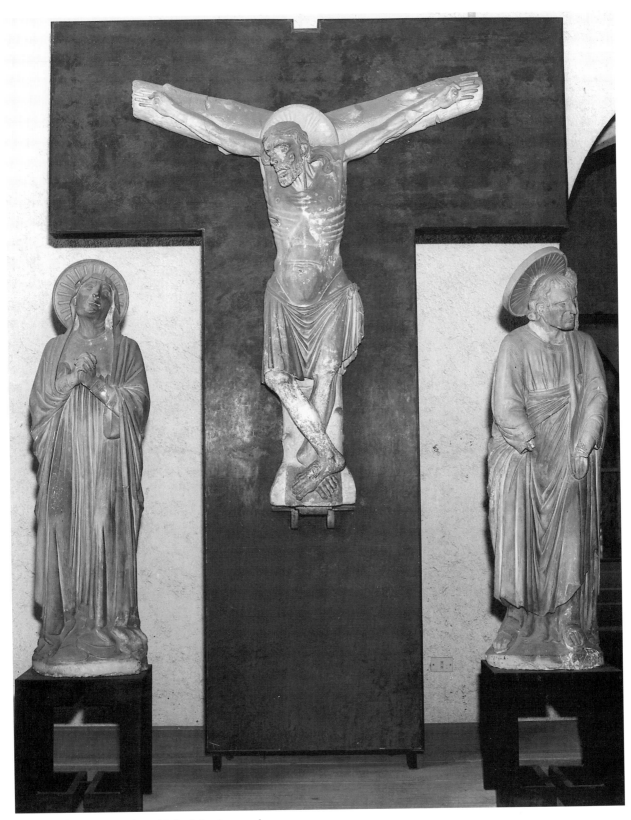

348. Crucifixion group, first third of the fourteenth century.
Verona, Castelvecchio Museum [Verona, Direzione Civici Musei
e Gallerie d'Arte].

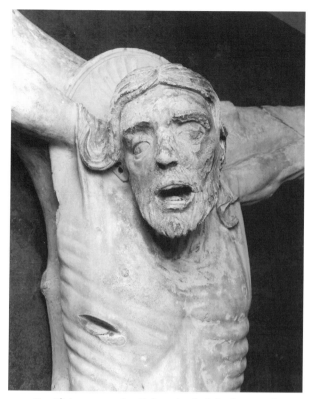

349. Crucifixion group, detail, first third of the fourteenth century. Verona, Castelvecchio Museum [Verona, Direzione Civici Musei e Gallerie d'Arte].

350. Tomb of Alberto della Scala (d. 1301). Verona, Sta. Maria Antica [Alinari/Art Resource, New York].

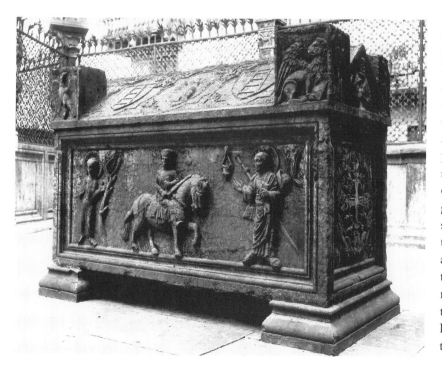

cifixion group to the second decade of the century,[9] there is little evidence to suggest more than a general dating, perhaps the first third of the century.

The Scaligeri Tombs

The second major patronage pattern is that of the nobility, which brings us to a study of the development of funerary architecture and sculpture in Verona. In that city, perhaps uniquely and almost as though conceived for the convenience of the art historian (who tends to be most comfortable with a linear, unswervingly evolutionary sequence of stylistic or typological events), one can follow the progressive elaboration of tomb type from simple to highly complex, and of sculptural style from planar and massive to soft and nuanced, both materially and psychologically.

Several aspects of this development are rooted in the city's earlier history. Verona possesses a remarkable sculptured sarcophagus with an inscribed date of 1179, that of Saints Sergius and Bacchus (now in the Museo del Castelvecchio),[10] which provided the basic sarcophagus form of massive rectangular block, with antefixes at the corners of the sloped roof and narratives along the sides. And what narratives these are! An image that will become a favorite theme, that of the equestrian rider, is seen here (twice), with the horses remarkably realistic and lively. Almost this same horse will appear on the tomb of Alberto della Scala (Fig. 350), Captain of Verona, who died in 1301 and whose sarcophagus was placed in front of the little Romanesque church of Sta. Maria Antica, thus initiating the practice continued by his descendants of choosing this site for their tombs. Alberto's sarcophagus is uncompromisingly rectilinear and massive, has a sloped lid and antefixes carved with symbols of the Evangelists and representations of saints and an Annunciation, and the casket's surfaces combine local and Byzantine motifs.[11] An equestrian image is also seen in a more restrained manner on the lid of the undated (probably very late Duecento) sarcophagus of Bartolomeo Dussaini.[12] But here,

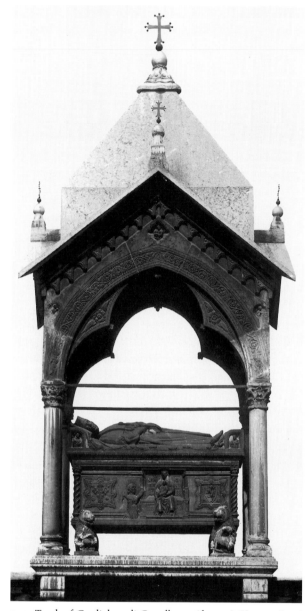

351. Tomb of Guglielmo di Castelbarco (d. 1320). Verona, Sant' Anastasia [Alinari/Art Resource, New York].

352. Drawing of Castelbarco tomb, by R. P. Bonington, Landsdowne Collection, Begwood, England; after R. Chiarelli, "Una citta per it pittori," *Antichità viva*, II, 5, 1963.

instead of resting on the ground, the sarcophagus is supported on consoles on the exterior apsidal wall of San Pietro Martire, Verona, and is framed by a large aedicula with columns supporting the trefoil arch and sloped roof.

Incorporating much the same architectural scheme of aedicula with pointed trefoil arch and sloped roof as on the Dussaini tomb – however, this time with four decorated gables forming the canopy – the tomb of Count Guglielmo di Castelbarco (Figs. 351, 352), who died in

1320, departs radically from the simple wall tombs that preceded it.[13] Not surprisingly, it is in the Dominican convent of Sant'Anastasia that we find this first among a series of freestanding tombs in Verona. The development of monumental, sculptured, and freestanding tomb monuments was especially nurtured on Dominican territory, having already found a receptive milieu in San Domenico, Bologna, home of the Arca di San Domenico and several freestanding Glossator tombs (Figs. 378, 379).[14] On the Castelbarco monument the canopy itself is surmounted by an additional element, a severely simple pyramid atop a cubic base, and thus projects higher toward the heavens than the earlier tombs. The Castelbarco monument is also the first to include, instead of the traditional sloped sarcophagus lid, a reclining effigy for which the corner antefixes now help support the pillow and bedding at the head and feet of the deceased. The face of Castelbarco, with its bushy eyebrows and marked dou-

ble chin, is hardly an idealized image. Unlike contemporary effigies in Venice, Padua, or Tuscany, with their serious and care-ridden expressions, Guglielmo di Castelbarco wears a slight smile that hints at the satisfaction of a life well lived, anticipating the expressions on the effigy and equestrian figure of Cangrande della Scala.[15] But despite these innovations, the sarcophagus reliefs, like that on the Dussaini tomb, adhere to Romanesque and Byzantine models.

The most remarkable aspect of the tomb is its placement more than seven meters high atop the cloister wall and entrance (now altered, but seen closer to its original state in a nineteenth-century drawing, Fig. 352), so that the monument can be seen both from the piazza and from within the cloister. The most important viewpoint, in fact, is that facing the city plaza, for the effigy is slightly tilted to afford a better view, and the important scene of Guglielmo kneeling in prayer before the Virgin appears on that side of the sarcophagus (while the side facing onto the cloister shows heraldic and ornamental images). As Ingo Herklotz has pointed out, the chosen site surpassed in optical effectiveness the more conventional location of church facade, for here the tomb not only served as backdrop to the piazza but more specifically impinged on the field of vision of all who entered or left the cloisters. No visitor could escape reference to this most important benefactor of the order and its convent.[16]

The effectiveness of this choice was not lost on the patron of the next in this sequence of ever more imposing monuments, that of Cangrande della Scala (d. 1329). Mastino II, who would succeed Cangrande, had the task of preparing the latter's monument; thus the tomb was probably executed c. 1330–35.[17] Cangrande, upon whom the emperor Henry VII had conferred the title of imperial vicar (together with his brother Alboino), was the most noted and admired of the Scaligeri *signori* and

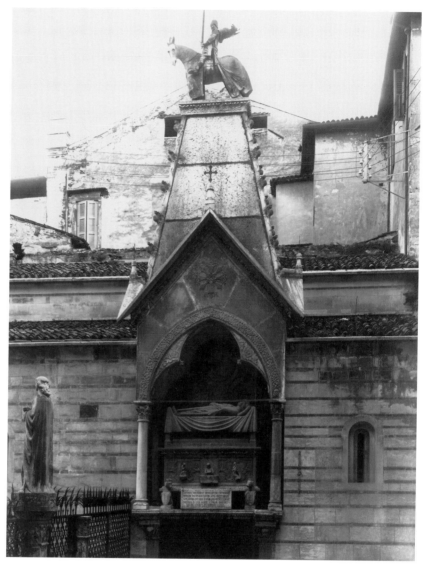

353. Monument of Cangrande della Scala, c. 1330–35. Verona, Sta. Maria Antica [Alinari/Art Resource, New York].

the founder of a courtly culture and civilization in Verona.[18]

The tomb (Figs. 353–355) repeats in its lower section the basic form and many of the elements of the Castelbarco tomb (including the figurated sarcophagus, the recumbent effigy, and the baldacchino) now elongated vertically. Although not raised on a freestanding wall, it nevertheless offered two viewpoints. As originally arranged, the sarcophagus, incorporated within the thickness of the wall over the side entrance of the church, was visible from inside the church, while the entire monument could be grasped from outside the

275

entrance in the cemetary space.[19] Above the aedicula with its sarcophagus is the truncated pyramid that rises into the open space and serves as base for the crowning feature: a completely free equestrian statue.

The sarcophagus is supported by crowned dogs (a punning emblem of the *signore*'s name – literally "big dog") holding the family arms; in the center is a Man of Sorrows; to the left and right, projecting from a background framed by quatrefoils, are figures of Mary Annunciate and Gabriel; the remaining spaces of the sarcophagus front are devoted to small narratives illustrating the feats of Cangrande, thus imposing a political program on the traditional sacred iconography.[20]

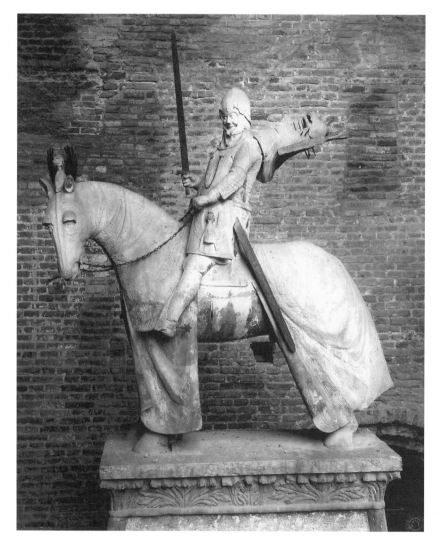

354. Monument of Cangrande della Scala, detail (Equestrian figure, now in Museo del Castelvecchio). Verona, Sta. Maria Antica [Alinari/Art Resource, New York].

Whether this is a development parallel to or influenced by the monument of Lord-Bishop Tarlati in Arezzo (Figs. 148–50) is difficult to determine. It is clear, however, that the inclusion of historical events glorifying a ruling dynasty or despot has become by now a mark of Ghibelline patronage.[21] The power and prestige of the imperial vicariate is unmistakably evoked not only by the small narratives on the sarcophagus but, above all, by the crowning equestrian image, and the latter especially would be widely imitated in Verona and elsewhere.

One's eyes indeed become riveted on the incredible figure at the apex of the tomb (the original is in the Museo del Castelvecchio) (Figs. 353–55). No longer the heraldic image suggested by its predecessors in relief sculpture, yet not lacking in the sense of pomp and solemnity, horse and rider have a physical and psychological presence of unprecedented effect. The movement of the diagonal leg with feet pointing through the stirrup continues through the backward-leaning body as though the war horse had a moment before been reined in; this movement culminates in the crested helm swung back behind his shoulders, leaving his skullcapped face exposed. The sense of spontaneous yet controlled movement is felt in the steed as well, which turns its head in the same direction as the glance of Cangrande. Silhouetted against the sky and smiling, the figure projects a sense of ecstatic vitality that is echoed formally in the contrasting curves, verticals, and diagonals, making for a truly visionary impression of the *cavalliere* par excellence.[22]

Having arranged for the creation of the tomb of his predecessor, Mastino II began to think of his own. A contemporary chronicler informs us that his tomb was erected prior to his death in 1350. The urge toward an increasing imposition of a monumental architectural presence within an urban

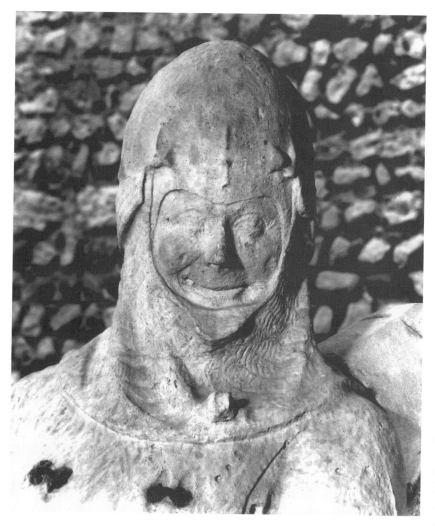

355. Monument of Cangrande della Scala, detail (Equestrian figure, now in Museo del Castelvecchio). Verona, Sta. Maria Antica [Verona, Civici Musei e Gallerie d'Arte, Umberto Tomba, Verona].

Was the architect familiar with Arnolfo di Cambio's ciborium in San Paolo fuori le mura (Fig. 62)? Like the latter, the Mastino II monument has a square plan and a canopy with steep gables and trefoil arches supported by four slender columns; these gables, crocketed and embellished with sculptures in high relief, are flanked by tabernacles at each of the four corners. The inclusion of Genesis scenes, unusual (and perhaps even unprecedented) on both ciboria and tomb, further provides a suggestive link.

Like that of Cangrande, Mastino's monument is capped by a truncated pyramid upon which stands the equestrian monument (Fig. 360), oriented as mentioned earlier in a direction opposite to that of Cangrande, thus outward toward the urban space. However, instead of the expansive, communicative body language of Cangrande and his steed (Fig. 354), and despite the fluttering drapery of the horse's saddle cloth, here the upright physical posture with stiffly held shield and sword, as though in tense expectation of imminent battle, and the solid armor covering every inch of the body including the head and face, forms an invincible barrier to the lord's humanity. The monument is rich with a variety of materials, all contributing to its courtly and heraldic splendor: Various colored stones are employed, including red Veronese marble, white marble of Candoglia, and metal for the wings both on the helmet of the rider and the angels watching over the effigy. Adding to its splendor is the overlay of carved decorative patterns on the armor, saddle cloth, and sarcophagus, and the gold and polychromy, only portions of which are extant.

One can only speculate concerning the division of labor in the execution of this ensemble with its variety of techniques and materials. A goldsmith's mentality prevails in the web of surface decoration on the sarcophagus and military accoutrements; in particular, the patterned low-relief background against which the figures are set in

and ecclesiastical space is realized here as nowhere else up to this point. The tomb (Figs. 356–60) both rivals and respects that of its predecessor. No longer connected to a building, this is the first completely freestanding tomb monument in Verona. Set as it is at the southeast corner of the cemetery (Fig. 361), it aligns with but is not on the same axis as the Cangrande monument, whose height it exceeds; furthermore, horse and rider face in a direction opposite to that of Cangrande (see Fig. 362). The monument, with its tabernacle sheltering the sarcophagus, not only alludes to the tradition of tomb monuments but also recalls Gothic reliquaries and ciboria.[23] Such associations were hardly fortuitous and reflect the increasingly public celebration – one might say cult – of imperial power.[24]

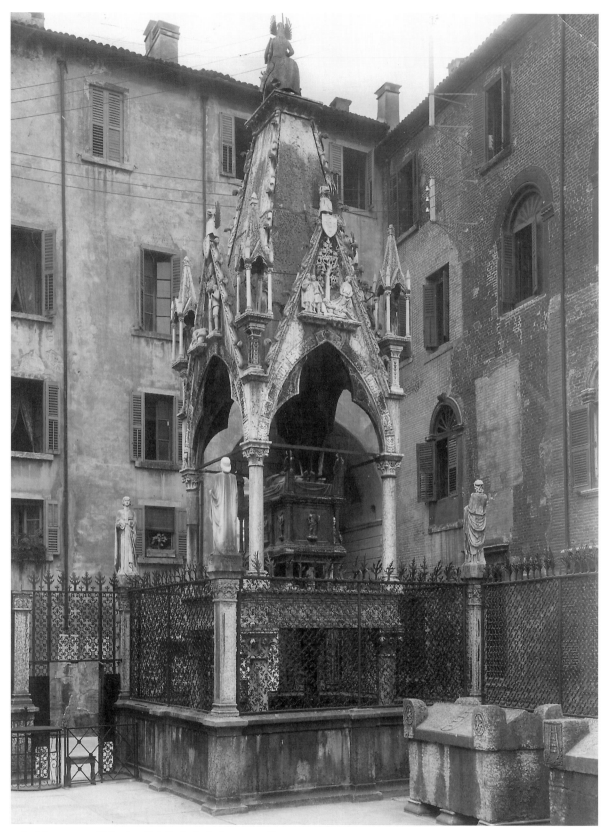

356. Monument of Mastino II della Scala, before 1350. Verona,
Sta. Maria Antica [Alinari/Art Resource, New York].

357. Monument of Mastino II della Scala, detail *(The Fall)*. Verona, Sta. Maria Antica [Soprintendenza per i beni artistici e storici del Veneto].

358. Monument of Mastino II della scala, detail *(Labors of Adam and Eve)*. Verona, Sta. Maria Antica [author].

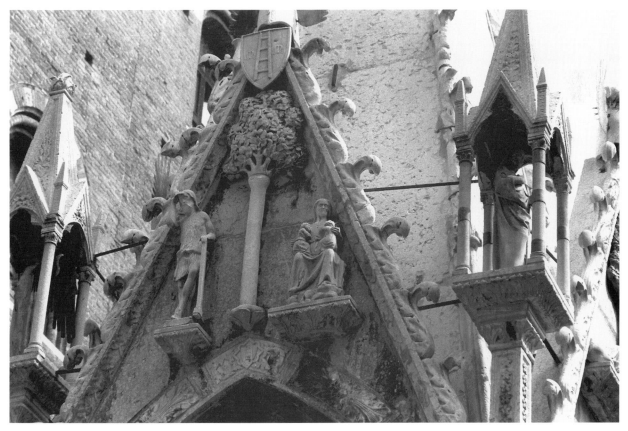

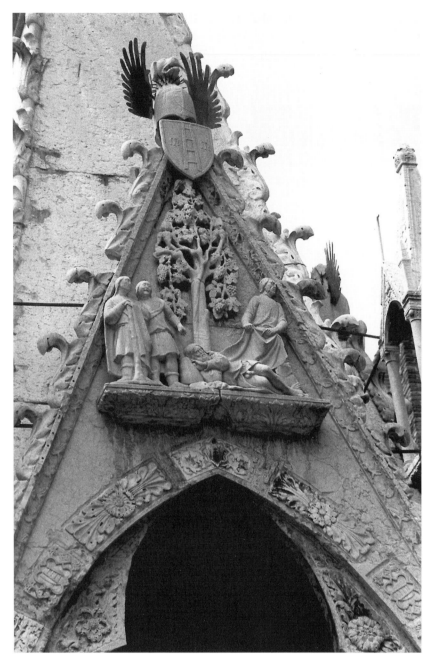

359. Monument of Mastino II della scala, detail *(Noah).* Verona, Sta. Maria Antica [author].

dented themes, to my knowledge, for sepulchral monuments but suggesting here that Mastino's reign belongs to God's universal plan. Seemingly fully detached, each figure stands on its own projecting platform rather than on a unified ground (a characteristic of Veronese reliefs). The reliefs are extremely expressive and full of subtle psychological interpretations. In the *Fall* (Fig. 357), we see Adam clutching his throat as though choked by the fruit of sin;[25] in the *Labors of Adam and Eve* (Fig. 358), Adam pauses, leaning wearily on his spade and wiping the sweat from his brow (cf. Genesis: By the sweat of thy brow . . .), while Eve seems aged beyond her years, having suffered the pains of labor during the birth of the sons she now nurses. As in the corner relief of the *Drunkenness of Noah* on the Palazzo Ducale in Venice (Figs. 332–36), Shem turns away in the *Noah* relief to avoid seeing his father's nakedness (Fig. 359); however, in contrast to the Venetian depiction, here his action is more impetuous, and since he has not yet succeeded in covering his slumbering father, the latter's genitals are daringly fully exposed. In the Genesis scenes the central axis of each gable is marked by the strong vertical of a tree. Thick, deeply undercut leaves and figures carved like statuettes against the background create

effects of chiaroscuro in strong contrast to the sarcophagus figures projecting against their patterned backgrounds. Stylistically, the Genesis scenes have been difficult to place, witness their having been linked to Lombard masters, to Andrea Pisano, and to Venetian sculpture. Indeed, the emphasis on subtle psychological response and the unidealized naturalism of such figures as Adam and Eve in the *Fall* anticipates (or recalls, depending on the respective dates) the Venetian masters at work on the Palazzo Ducale during midcentury.[26]

high relief on the sarcophagus panels recalls chased or repoussé metalwork. Painters were employed to color the damask of the bier drapery and starry field beneath the slab supporting the sarcophagus. Among the most impressive and original aspects of the monument are the Genesis scenes in the gables (Figs. 357–59), unprece-

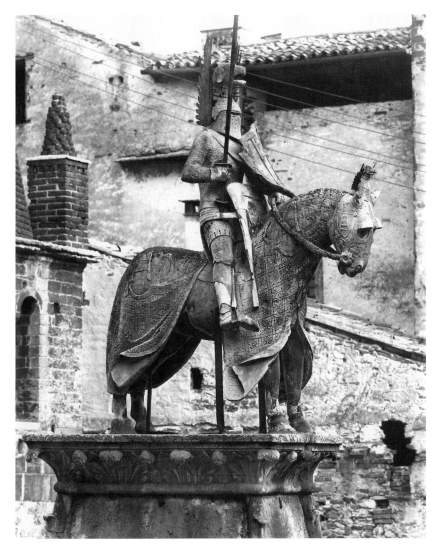

360. Monument of Mastino II della Scala, detail. Verona, Sta. Maria Antica [Alinari/Art Resource, New York].

The cycle of mausoleums in Sta. Maria Antica concludes with the monument of Cansignorio della Scala (Figs. 363, 364), who was also the last significant local power in Verona, taken over by the Visconti of Milan in 1387. Cansignorio died prematurely in 1375, barely thirty-six years of age, after fifteen years of rulership as successor to his older brother Cangrande II, whom he assassinated in 1359. From a contemporary chronicle we know that following in the footsteps of Mastino II, he arranged for the erection of his own tomb during his final illness and the work was completed in 1376. Rather than depending solely on a local sculptor to oversee the enterprise, he called upon "gli più eccellenti maestri scul-

tori ed architetti che in Italia in quel tempo si trovano."[27] Although two names appear in inscriptions, Bonino da Campione and a certain Gaspare (a Veronese name), the form and details of the monument leave no doubt that several masters participated in its execution, and it is virtually impossible to determine who designed the monument as a whole. Bonino had been active in Milan, and based in part on his signature on the Cansignorio tomb, the equestrian statue for the tomb of the latter's brother-in-law Bernabò Visconti, dated 1363 (Figs. 280, 281), has been attributed to Bonino.[28] If Bonino, indeed, designed Bernabò's monument (not completed, however, until after the latter's death in 1385), then Cansignorio must have felt that only this master could meet the demanding challenge of such an extensive and complex monument, which was intended, in the words of a contemporary, "non tanto pareggiare, ma soverchiare e vincere quella del padre suo Mastino già fatta."[29] The designer of Cansignorio's tomb found himself confronted, of course, with a cemetery already physically defined by the previous monuments. He had to create a monument that both complemented and outflanked its predecessors.[30]

Although the choice of Bonino may imply that Cansignorio wanted a tomb similar to that of the Visconti ruler, the outcome could hardly have been more different. For whereas the earlier figure, as far as is known, was to form the focus of the entire monument, here there is a return to the by now traditional architectural complex with the equestrian image perched at its apex. The two monuments are connected primarily by the similarly rigid and frontal rider, fully encased in armor and chain mail, sitting squarely on a warhorse whose upright rigidity and frontality echoes that of the *signore*. However, whereas the figure of Bernabò conveys in demeanor and facial expression a strong sense of the

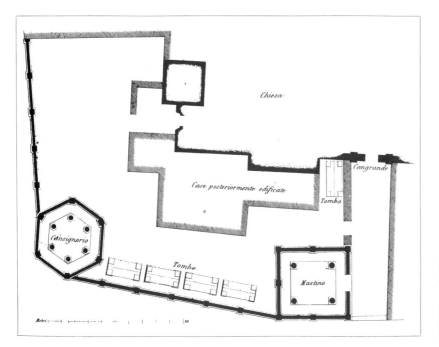

361. Plan of cemetery of Sta. Maria Antica (after Litta, 1824).

362. (below) Cemetery. Verona, Sta. Maria Antica [Alinari/Art Resource, New York].

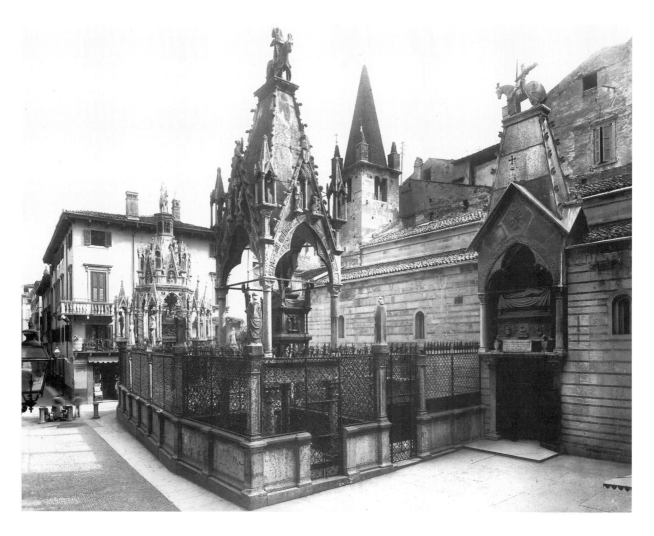

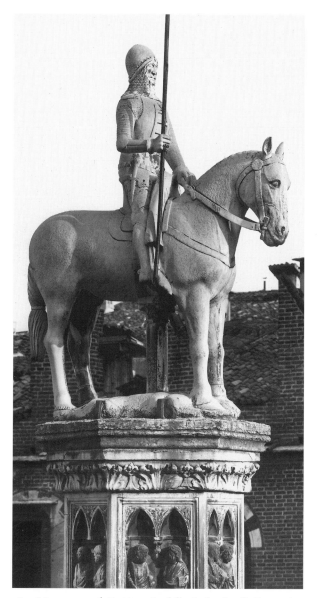

363. Monument of Cansignorio della Scala, detail (Equestrian figure). Verona, Sta. Maria Antica [Alinari/Art Resource, New York].

character of this particular despot, simultaneously evoking fear and awe, Cansignorio remains wooden, a mannequin without the vibration of life.

Despite any possible relationship between the two equestrian types, the details of the architectural complex of the Cansignorio monument are anything but traditional and represent a radical turn toward the rayonnant of a century earlier in France. If the Mastino II tomb recalls a ciborium, that of Consignorio suggests the more fragile form of an ostentorium or other delicate work of the goldsmith (cf. Figs. 3 and 364). The

structure, employing a great variety of materials, is completely transparent.[31] The monument is composed of a hexagonal *tempietto* carried by six richly embellished spiral columns and surmounted by pierced gables; these provide fields for relief sculpture and are flanked by tabernacles containing standing figures. The roof is formed by a truncated pyramid on whose lanternlike peak stands the equestrian group, rider as immobile as his stocky horse but necessarily less imposing than Bernabò (and arguably also than Cangrande and Mastino II) due to their relative scale and height and the distraction of the visually rich architectural components, fragile and fantastic, in strong contrast to the elevated yet heavy portrait above. The spiral columns and the polylobed arches – replacing the trefoil arches now commonly found in Verona – are Lombard elements seen, for instance, in the tomb of Stefano and Valentina Visconti in Sant'Eustorgio, Milan.[32] Sheltered by the *tempietto* is the sarcophagus embellished with religious and votive imagery, on which lies the effigy watched over by four candle-holding angels. The sarcophagus is supported by putti caryatids *all'antica*, a unique interpretation of Tuscan and Neapolitan tomb supports.[33]

The monument goes beyond all previous bounds in complexity and richness of decoration. The choice of a hexagonal plan itself invited enrichment and complications with ornamentation and numerous pinnacles. There is a noteworthy increase, too, in sculptural embellishment compared to the Mastino II tomb. Nothing is left empty: Everywhere statues, medallions, insignia, individual figures in the round and in relief fill the surfaces, niches, and tabernacles.

Bonino's signature appears twice on the monument, and both times he is designated specifically as the sculptor.[34] Certainly many of the individual sculptures, especially the sarcophagus reliefs, adhere to the Campionese tradition of figures in high relief projecting from an unembellished flat background plane, and some architectural details, such as the polylobed arches and spiral columns, are seen earlier in Lombardy. Yet there is little in the Lombard works attributable to Bonino and his workshop – the signed Schizzi tomb (Fig. 276), the sarcophagus of the Bernabò Visconti monument (Fig. 280), or the Stefano and Valentina Visconti tomb in Sant'-Eustorgio – that can be used as stylistic or typological comparison with the architecture of the Cansignorio monument, so strongly characterized by the almost total dissolution of surface. The effect is in sharp contrast to the traditional Lombard emphasis on the plane

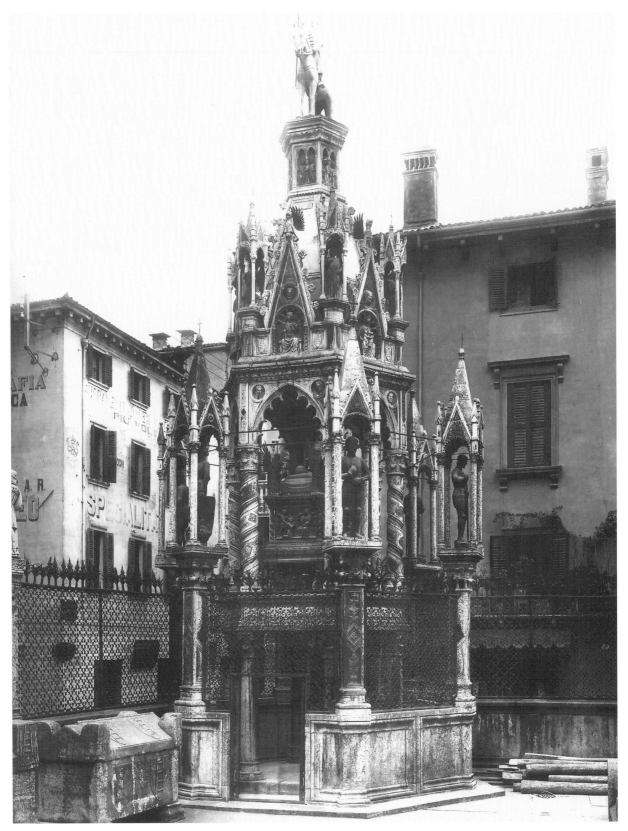

364. Monument of Cansignorio della Scala, completed 1376.
Verona, Sta. Maria Antica [Alinari/Art Resource, New York].

and on solid form. One feels compelled to seek an alternative author for the design of the monument. Although it is tempting to offer as this alternative the second name that appears on the monument, Gaspare (referred to as *recultor,* ambiguous in meaning but possibly referring to the architectural builder), the name could equally refer to the supervisor or engineer carrying out the design of another, or the impresario who brought together the team of the "best master sculptors and architects to be found in Italy at that time."[35]

The whole tabernacle and substructure is encircled by a balustrade above which rise pillars serving as supports for the iron gate stretched between them and as the base for small tabernacles above. The gate screens the lowest part but is integral to the conception of the whole, further dissolving any sense of solid mural structure. Probably shortly after the completion of the monument, a magnificent cast-iron gate connected the tombs of Mastino II and Cansignorio and continued around the entire cemetery, forming thus a "hortus conclusus,"[36] which also closed this remarkable chapter of Veronese sculpture.

8

Characteristic Forms: Tradition and Innovation

The earliest extant, full-blown expression of Italian Gothic sculpture, integrating classical, northern European, and local traditions, is Nicola Pisano's Pisa Baptistry pulpit. We have seen how the form and content of the pulpit, designed for preaching as well as for the Gospel readings, promoted the kinetic and auditory experience of its viewers. In this regard Nicola both acknowledged and departed from tradition.

From Early Christian times the ambo, or rather the two ambos that until the twelfth century were employed for the readings of the Gospel and the Epistles, was an essential element of ecclesiastical furnishing, prominent both visually and liturgically.[1] The earliest were of wood and were movable, but despite the fact that wooden reading or preaching platforms continued in use well into the Renaissance,[2] – the ambo soon became a fixed element of the church interior. Initially tied to the *schuola cantorum* (an enclosed area reserved for the clergy) as still seen in San Clemente, Rome, the ambo during late Romanesque times became connected to the *pontile*, or rood screen, as seen in San Miniato al Monte (1207), Florence, and alluded to in

286

Giotto's *Expulsion of Joachim* in Padua and in the Greccio scene at Assisi (Fig. 365). By the mid–thirteenth century, as the sermon became less a component of the mass and more an independent element, the pulpit – now a single structure, sometimes with two lecterns – was freed from its restricted placement in the presbytery and placed against a pier or wall, or even set up standing free in space near the eastern end of the nave.[3] This development is connected in part with the flourishing of the mendicant orders, whose members abjured monastic isolation and built their convents and churches in towns and cities. Given special papal privileges and encouragement, the Franciscans and Dominicans, for example, saw their mission as one of doctrinal reform and the encouragement of a more empathetic spirituality. For this they replaced the scholastic Latin sermons and biblical readings, distant and incomprehensible to much of the populace, with the living language of the *volgare*, and they required a platform adapted to teaching and preaching.[4] Physically closer to the worshiper within the nave, the new pulpit type frequently was embellished with narrative reliefs that supplemented and enhanced the spoken word.

The pulpit by Guido Bigarelli (also known as Guido da Como) dated 1250 in San Bartolommeo in Pantano (Fig. 366), Pistoia, has columns resting on the backs of lions and a crouching human, and two tiers of reliefs on its parapet. The pulpit would seem to be modeled in these respects on the type created by Master Guglielmo as early as between 1159 and 1162 for the cathedral of Pisa (Fig. 367). Prior to its transfer to Cagliari, and subsequent separation into two parts, Guglielmo's pulpit was a rectangular structure, very likely freestanding, with columns resting on the backs of lions.[5] It proved to be extremely influential both in its classicizing sculptural style (it has been called the "*fons origens* of Romanesque sculpture in western Tuscany)[6] and its general configura-

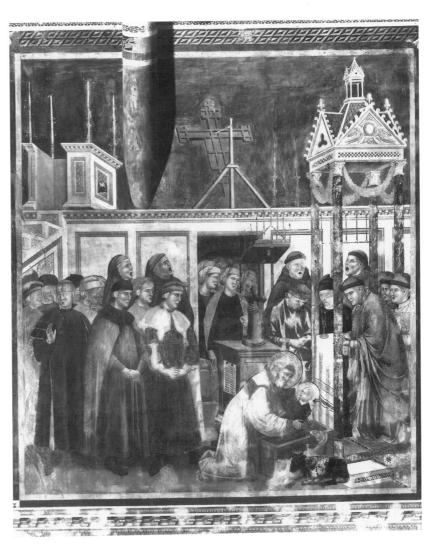

365. St. Francis Master: Greccio scene. Assisi, San Francesco [Alinari/Art Resource, New York].

tion but not, until Nicola's Pisa Baptistry pulpit, its freestanding placement.[7]

When Nicola Pisano began work on his pulpit for the Baptistry, Guglielmo's Pisa Cathedral pulpit (Fig. 367) must have been very much in mind – indeed, in full view – and it served as one of several challenging models. But instead of continuing in the common tradition of employing a rectangular plan, such as Guido da Como's pulpit of a decade earlier, Nicola opted for a hexagonal pulpit for the Pisa Baptistry (Fig. 25) (see pp. 23ff.). Attempts have been made, none fully convincing, to locate the sources for Nicola's polygonal pulpit form in southern Italy (which would provide further evidence for his origins in Apulia), or in Tuscany and northern Italy. It

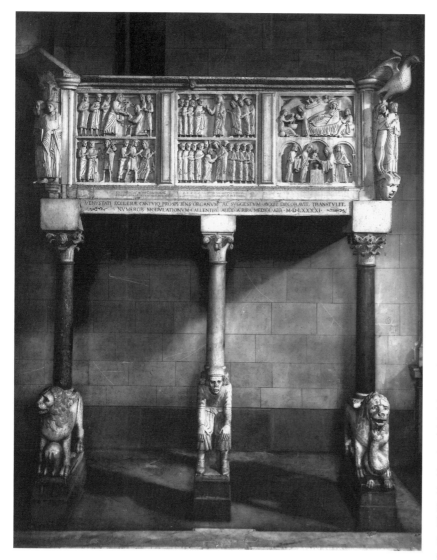

366. Guido Bigarelli da Como: Pulpit, 1250. Pistoia, San Bartolommeo in Pantano [Alinari/Art Resource, New York].

But Nicola's choice of a polygonal structure was most likely determined primarily by the pulpit's unusual site, not a basilican church but the round-walled Baptistry with its interior dodecagonal colonnade, in the center of which stood Guido Bigarelli's octagonal font of c. 1246 (Fig. 26).[11] Nicola must have felt not only that a rectangular format would harmonize less well with the surrounding centralized space but that it would inhibit the narrative flow with which, as we have seen, he was much concerned.

In addition to its hexagonal plan, the pulpit is distinguished by the fact that it is freestanding, that the columns, three of which rest on the backs of lions, support trefoil archivolts (rather than an architrave), and that the spandrels contain prophets holding scrolls, while the parapet surfaces are embellished with narrative reliefs separated by triple colonettes. The pulpit, in fact, is composed of elements deriving from diverse types of ecclesiastical furnishings, not only earlier pulpits but also bishop's thrones, baptismal fonts, and pascal candlesticks. The trefoil arcade and the clustered colonettes are clearly of French origin, such features having already been transposed onto Italian soil both by the Cistercians and by the architects working under Frederick II.[12] Columns resting on lions and figures are common on Italian Romanesque pulpits (as well as facade portals), and crouching atlantes also appear on tombs and bishop's thrones.[13] The spandrel figures holding long scrolls are anticipated on one of the pulpits in the cathedral of Salerno, as are the standing corner figures between them.

In contrast to the geometric or floral intarsia inlay that was the most common form of embellishment elsewhere (seen also in Tuscany, as at San Miniato al Monte, Florence), large narrative reliefs on the parapet belong to a tradition peculiar to Tuscany, as at Barga (second half of the twelfth century) (Fig. 368) with its series of nar-

seems, however, that despite not being common, round or polygonal pulpits were to be seen throughout Italy and also in artistically dependent Dalmatia.[8] Furthermore, polygonal or round baptismal fonts, many with biblical reliefs on their surfaces (examples include those in San Giovanni in Fonte in Verona and San Frediano in Lucca), may have suggested the advantages of such a form for continuous narratives.[9] John Pope-Hennessy was probably correct in stating that "the design [of the Pisa Baptistry pulpit] is apparently a synthesis of South Italian and Tuscan elements strongly colored by French Gothic forms."[10]

367. Guglielmo: Pulpit, detail. Cagliari cathedral, 1159–62 [Alinari/Art Resource, New York].

tended to be iconographically unrelated to the *specific* function of the ambo, restricting itself to decorative, symbolic, or even figural motifs that readily appeared in completely different contexts.[15]

Guglielmo's pulpit contained double relief fields, reminiscent of late classical–Early Christian sarcophagi. Nine reliefs in all, these wrapped around the four sides with a gap for the staircase in the rear.[16] To view all the narratives one had to walk around the entire structure. The casket rested on columns with leafy capitals that in turn were supported by lions. In contrast to earlier and contemporary examples, it contained an entire Christological cycle and thus had a program that related specifically to the Gospel messages read from the lecterns. The idea of relating program to function also informs the early-thirteenth-century transformation of the *pontile* of Modena cathedral: Here a circular ambo (Fig. 369) raised on two columns resting on crouching males was added to the preexisting rood screen. The ambo is composed of fields separated by slender colonettes and showing Doctors of the Church – Jerome, Ambrose, Augustine, and Gregory – and symbols of the Evangelists, as well as Christ enthroned with a book in his hand. A sixth scene, Christ at Gethsemene, introduces the Passion narratives that follow on the *pontile*,

ratives showing the *Annunciation, Nativity, Baptism,* and *Adoration of the Magi.* Reliefs also appear on the pulpits in Groppoli, Pistoia (Fig. 366), and most pertinently on Guglielmo's Pisa Duomo pulpit (Fig. 367).[14] Prior to Guglielmo's pulpit, when sculpture did appear it but all the others can be said to relate specifically to the function of the pulpit as a stage for the reading of the Gospels; the appearance of its interpreters and commentators (the Church doctors) suggests its use as a preaching platform as well.[17] But it was Guglielmo's twelfth-century pulpit that provided the immediate precedent for the inclusion on the Pisa Baptistry pulpit of an extensive narrative program directly related to the messages to be heard from the pulpit.[18] Nicola, however, enriched the icono-

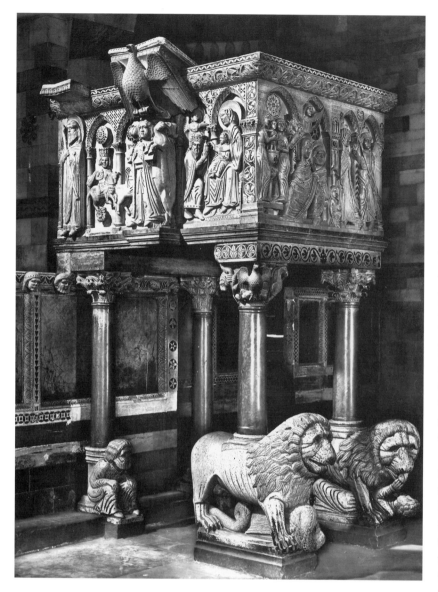

enhanced meaning: The uniquely extensive Christological cycle executed in an *all'antica* style, and thus reminiscent of ancient biographical sarcophagi, alludes to tomb sculpture, so that the pulpit becomes a "sepulchral symbol." The pulpit in effect "represents" the tomb of Christ, for the Baptistry that houses it, a centrally planned building, alludes, as Richard Krautheimer has argued, to the Rotunda of the Anastasis of the Holy Sepulchre in Jerusalem.[21] The association with Christ's tomb is further reinforced by the number symbolism of its hexagonal shape, particularly when viewed in relation to the octagonal baptismal font in the center of the building: The number six, among other allusions, symbolizes the sixth day of the week, Friday, when Christ was crucified and died, whereas the number eight symbolizes the day when Christ rose from the tomb.[22]

As we have seen, a wide repertory of structural, iconographic, and decorative precedents have been selected and brought together to produce a stunningly organic and revolutionary monument whose form and contents express the function and meaning of the pulpit within the context of the edi-

368. Pulpit. Barga cathedral, second half of the twelfth century [Alinari/Art Resource, New York].

graphic program by including, for the first time on a Tuscan pulpit, scenes of the Crucifixion and Last Judgment.[19]

Baptistries do not normally contain pulpits, which belong rather to the liturgical functions of a church. In Pisa, however, the baptistry and cathedral served expanded functions, both religious and civic. Sermons were given in the Baptistry, and by the early fourteenth century, when Tino di Camaino built a font in the cathedral, baptism took place there (see p. 104).[20] Furthermore, with its narrative program more extensive than on any earlier pulpit, the baptistry pulpit itself took on an

fice that contains it. Standing free and unencumbered, the pulpit offers a compelling vision: an exalted yet moving narrative carved in relief and supported by an impressive architectural enframement that to this day dominates the space in which it stands.

With the baptistry pulpit the advantages of a polygonal plan to the development of narrative sweep had become incontestable, so when Nicola was offered the commission for the Siena cathedral pulpit he and the cathedral authorities again selected this form. But it must also have become clear that the huge space of Siena cathedral with its soaring octagonal cupola, so much in contrast to the relative intimacy of the Pisa Baptistry, demanded an even more grandiose pulpit design. For this reason, Nicola chose an octagonal plan (Fig. 41), and the narrative pro-

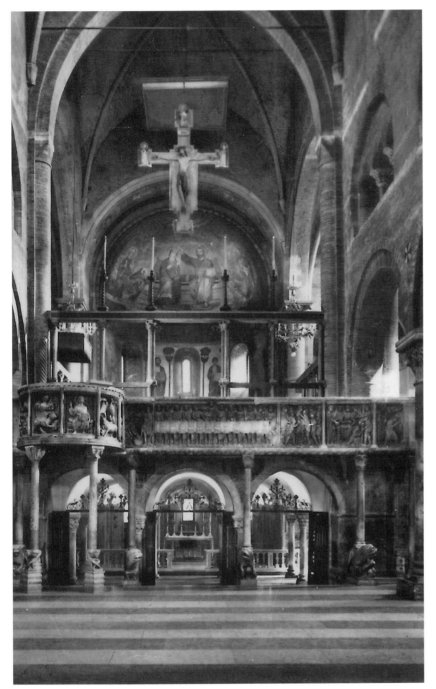

369. Ambo and choir screen, twelfth and early thirteenth century. Modena cathedral [Florence, Kunsthistorisches Institut].

remains attached to the opening relief (see Fig. 42), and a figure in Berlin has been identified as the Gabriel of this group.)[23] Included now is the emotionally wrenching *Massacre of the Innocents* (Fig. 45) and a *Last Judgment* spread over two fields, with Christ the Judge a full-length figure between the reliefs. A further change from the earlier pulpit is the substitution of corner figures for column clusters to frame the narratives. The effect is of a continuous tapestry wound about a skeletal structure suggested by the projecting cornice and base moldings of the casket.

Giovanni Pisano, in erecting a pulpit for the small parish church of Sant'Andrea in Pistoia, chose an appropriate scale and returned to the hexagonal plan of his father's baptistry pulpit. In addition to the new narrative power, expressive carving technique, and rejection of the earlier frontality of the angle figures, the major formal innovation on this pulpit was the introduction of a Gothic trefoil arcade between slender columns, giving a new elegance that contrasts with the seemingly impetuous carving technique of the narrative panels (Fig. 92). More startling in its structural novelty is his Pisa Duomo pulpit, which recapitulates and expands on the earlier solutions (Fig. 107).

In surveying all four pulpits, one notes a tendency to replace architectural elements with sculptural ones: Three of the six columns supporting the Pisa Baptistry pulpit are purely structural with no figural elements (lions or figurated base), and clustered columns separate the reliefs. On the Siena pulpit the latter are replaced by standing figures and the narrative elements extend across the entrance bridge with the Annunciation group. The framing figures between the reliefs on the Pistoia pulpit are more dynamic than those at Siena, but the innovations at Pistoia are of a different sort, primar-

gram was expanded not only with the reliefs of the parapet (seven instead of the five on the baptistry pulpit) but by the addition of a (lost) bridge from the stairs with an Annunciation preceding and leading to the Christological cycle of the casket itself. (The full-length figure of Mary

ily the new elegant structure that employs devices borrowed from northern Gothic architecture. In the Pisa Duomo pulpit, however, Giovanni introduces figural supports that are much more complex than had been seen earlier: There are both single standing figures carved in the round – virtually unprecedented since the caryatids of antiquity – and, in the three Theological Virtues about a central column, a grouping of the antique Hekate type, which encourages the tendency to move around the monument. Two of the figure groups – Christ and Ecclesia – are set on bases around which are represented the four Evangelists and Four Cardinal Virtues, respectively. Furthermore, to support the spandrel reliefs, Giovanni replaced the traditional round-headed or pointed trefoil arcades with exuberant classical volutes that refuse to conform to expectations of geometric architectural contours. As with the concave reliefs above, this breathtaking departure from expected norms lends a new dynamism to the composition of the pulpit, never to be surpassed by subsequent examples.

Much as each of the Pisano pulpits presents its own characteristics, they share, in addition to their polygonal shapes, the storytelling impulse announced in the first of the group. Why did narrative suddenly become such a prominent feature of pulpit embellishment? It may well be that the restricted space for narratives on Italian cathedral interiors led to the inclusion of such cycles on pulpits.[24] Unlike mendicant churches, such as San Francesco at Assisi, neither Pisa nor Siena cathedral, with their striped marble revetment, offered mural surfaces for didactic visual programs. The increasing desire for visually engaging narratives, counterparts to the engrossing stories told in the Golden Legend and other apocryphal texts, explains in part the expansion of narrative content onto one of the most prominent elements of liturgical

furnishing. Indeed, the Siena pulpit contained the Duomo's first iconographically significant visual program, a program that expanded only later with the facade sculpture, Duccio's *Maestà*, and the stained-glass window oculus.

Despite the impressiveness of the spatially assertive polygonal structures introduced by Nicola Pisano, this type was not necessarily taken up in later pulpits. The pulpit by the Dominican converse Fra Guglielmo (not to be confused with the earlier Guglielmo) for San Giovanni Fuorcivitas, Pistoia (Fig. 370), dated 1270, though heavily

370. Fra Guglielmo: Pulpit, 1270. Pisa, San Giovanni Fuorcivitas [Alinari/Art Resource, New York].

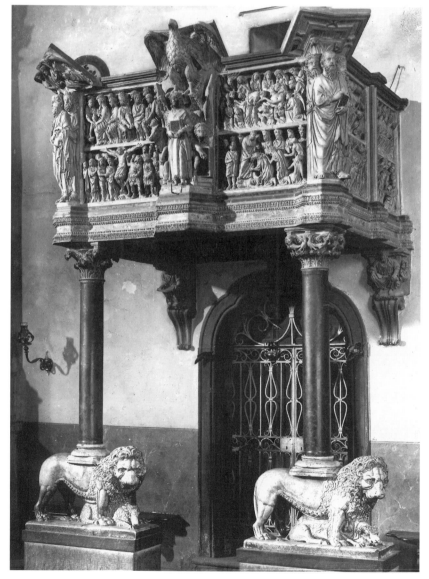

dependent on the style and iconography of Nicola's Siena pulpit, returns to the more traditional rectangular format of earlier Tuscan examples (see Figs. 366–68). The same holds true for the pulpit by Giovanni di Balduccio (Fig. 193) in San Casciano datable to c. 1334 just prior to his departure for Milan.[25] This last eschews the expansive narrative cycle employed in all the earlier Italian Gothic pulpits, illustrating instead, with large beautiful figures in two panels, only the Annunciation.[26]

Even after the completion of the Pisa Duomo pulpit only a few other pulpit designs, it would seem, took up the polygonal form. The first is the work of the relatively undistinguished Master of the San Michele in Borgo pulpit. It was erected in the early Trecento and dismantled in the seventeenth century, but several architectural members, two supporting lions, and five narrative panels are among the fragments extant in the Museo di San Matteo in Pisa. From these, it has been hypothetically reconstructed as a hexagonal pulpit supported by columns (some on the backs of lions) and a central support on a hexagonal base (Fig. 371); the parapet had five reliefs (all extant) of the life of Christ up to the Flight into Egypt (Fig. 117).[27]

The most spectacular pulpit design after those of Nicola and Giovanni was that for Orvieto cathedral, never realized but known from fragments of a drawing preserved in Orvieto, London, and Berlin (Fig. 372). It, too, was to be polygonal in plan and has been hypothetically reconstructed as a pentagonal structure with stairs entered through an arch and flanked by solid walls, the stairway projecting to a trapezoidal ground plan.[28] In the drawings, reliefs embellish the parapet, the entrance arch (if that is, indeed, the function of the Berlin fragment), and the upper sections of the side walls. The reconstruction offers, however, a rather unlikely design for there is neither precedent, to my knowledge, nor discernable motivation for a freestanding *pentagonal* plan.[29] Admittedly, it is not easy to come up with an alternative that makes iconographic and structural sense given the sequence of subjects in the drawings (the Lives of Mary and Christ). Were there additional, now lost sections of the original drawing allowing for a hexagonal or octagonal plan with a bridge from the stairs to the platform, as in Giovanni's Pisa Duomo pulpit? That seems unlikely, since the ratio of intercolumniation to height of arcade is unusually large compared to all of the Pisano pulpits.[30] Indeed, even if one employs only the extant reliefs for a hypothetical reconstruction of the whole, the proportions result in an excessively large pul-

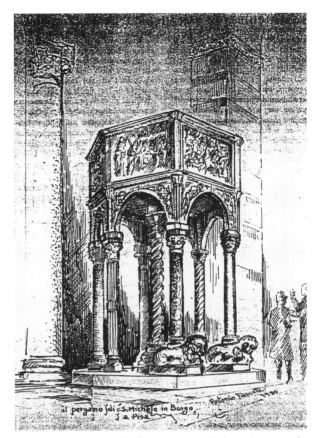

371. Reconstruction of pulpit in San Michele in Borgo, early fourteenth century. Pisa (after Fascetti, 1978).

pit, explainable only by a desire to outdo its predecessors in Pisa and Siena, paralleling and continuing the facade rivalry of the previous decades. It may well be that levelheaded Operai eventually rejected this peculiar and overambitious scheme, although other factors, such as the restraining effect of the Black Death, may also have hindered its realization.[31]

The figural style of the drawings has been correctly associated with Sienese sculpture.[32] The crowded fields, lack of interest in space, and incoherent architecture (as in the *Marriage of the Virgin* in the Orvieto fragment, Fig. 372) suggest a dating no earlier than the 1340s. Indeed, the inclusion of the celestial hierarchy, with angels and archangels in the tondos, cherubs in the spandrels, and angel heads in the decorative bands with leaves may be related to the appearance of such an angelic choir on Giovanni di Balduccio's Arca di San Pietro Martire, dated 1339. However, the elaborate design and specificity of detail in the architectural and ornamental parts – intarsia and mosaic decoration, vine reliefs, and so on – indicate that the original drawing was by a painter rather than a

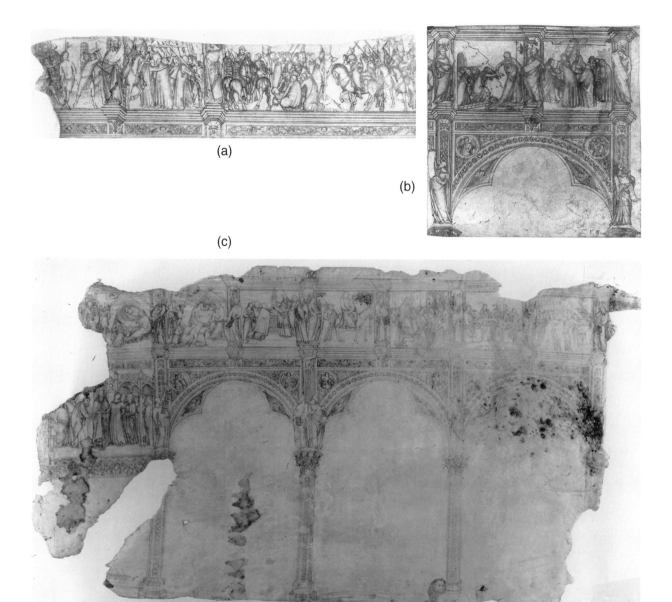

(a)

(b)

(c)

372. Fragments of drawing for pulpit design, 1340(?). (a) London, British Museum. (b) Berlin, Kupferstichkabinett, Staatliche Museen zu Berlin – Preussischer Kulturbesitz [Bildarchiv Preussischer Kulturbesitz, Berlin]. (c) Orvieto, Museo dell'Opera del Duomo [courtesy of the Opera del Duomo, Orvieto].

sculptor-architect. It is only toward the end of the century that there is evidence of painters providing drawings for sculptors, and thus although the Orvieto design is more likely a presentation piece than a working drawing, it may date from later in the century.

Be that as it may, the Orvieto design was never carried out, as progress on completion of the cathedral itself dragged on. The freestanding polygonal pulpit with extensive narratives, in any case, seems to have lost its appeal by the second half of the century, and by the fifteenth century the rectangular or, more often, the round or polygonal pulpit against a pier became the norm, and as in the Trecento examples, many include narratives on the walls of the caskets.[33]

THE SCULPTURED CATHEDRAL FACADE

In discussing Michelangelo's design for the facade of San Lorenzo, James Ackerman commented, "Nothing troubled medieval and Renaissance architects as much as facades. . . . [T]he finest churches of Florence hide behind

294

anonymous walls of stone or the brittle veneers of nineteenth-century antiquarians."[1] It is true that in contrast to ancient Greek and Roman buildings, and notwithstanding the strong classical tradition in Italy, medieval Italian facades, even when complete, form frontispieces – screens – appended to and unrelated to the shape of the structures behind them. The architect's problem, on a practical level, was how to design a unified system to front the high nave and low aisles. At the same time, during the High Middle Ages both in France and Italy the facade had to fulfill multiple functions of a didactic, spiritual, and even civic nature. Beyond the Alps a continuing tradition from Carolingian times on permitted the successful integration of facade and interior structure: The northern solution was the two-tower facade with broad central bay, reflecting on the outside the internal division into nave and aisles, whose contrasting heights were masked with imposing volumes and buttresses. Complementing or reinforcing the structural fabric of the architecture, sculpture (as well as other figural arts) responded to the increasing demand for didactic exposition spurred by (or paralleled by) Scholastic philosophy and theology, to become an ever more conspicuous presence in Gothic buildings.

Although individual facades have been the subject of study, it remains a desideratum of scholarship to provide a full investigation of "the Italian Gothic facade," on the one hand integrating the group into the history of medieval architecture and sculpture in general and, on the other, viewing each of these monumental frontispieces within the context of its city's local and regional traditions going back to Romanesque and earlier times. We will find that the Italian facade, uniquely independent and providing virtually no evolutionary (or as Marvin Trachtenberg has termed it, narratological[2]) development, as does its French counterpart, can be regarded as a creative reassembling of French Gothic elements applied to a structure fundamentally informed by indigenous tradition; and this assessment holds true for both architecture and sculpture. The local roots and regional independence can be seen in the three major Gothic cathedral facades built around the turn of the fourteenth century, those of Siena, Florence, and Orvieto – notwithstanding our imprecise knowledge about the original designs of the first two.

We have already referred to the putative relation between Scholastic theology and the design and iconography of French cathedrals. As Paul Frankl has noted, "Gothic sculpture continued in the tradition of Romanesque sculpture, but it changed in its iconography . . . tending toward a didactic representation of the most important persons and scenes in the Holy Scripture, of angels and saints, of nature in pictures of the months and of the signs of the zodiac, and of the *artes liberales*. The tendency began in the Romanesque period, but, in the Gothic age, it was channeled into comprehensive, calculated, and coherent intellectual programmes which sought to embrace the whole of the Christian religion, and within which the meaning of each piece of sculpture was to have its own intellectual function and to form part of the greater whole."[3] Italy, as we have seen and will expand on, responded in a very idiosyncratic way to this encyclopedic and Scholastic impulse.[4] But another aspect of French Gothic architecture required response. Evolving from the less integrated relationship of sculpture to architectural membering during the Romanesque period, Gothic facade sculpture in France became intimately connected to and reflective of the formal arrangement of the facade architecture, even taking on the architectonic role of column and arch; and when it eventually freed itself from its original architectonic restrictions during the High Gothic period, French facade sculpture nevertheless retained its integrated and harmonious relationship to the vertical and horizontal, structural and decorative components of the architectural members and surfaces.

Italian designers responded to some aspects of northern European solutions but on the whole rejected the two-tower facade and the articulation of architecture by means of sculpture. This was partially determined by tradition: Sculptured portals had not been widely adopted in Italy, and campanili had, from Early Christian times on, been separate structures standing apart from the church. Furthermore, the legacy of the earliest churches, with their splendidly decorated interior walls and simple unadorned exteriors, perhaps disposed the late medieval architect in Italy to virtually ignore the facade. The Italian medieval facade tended to be little more than a sort of protective or at best decorative screen (as in Lucca) having little organic relationship to the rest of the building.

Yet the sheer energy, the "intense visual complexity" of northern Gothic forms must have been profoundly appealing to Italian architects. Indeed, a fundamental characteristic of Italian Gothic, as suggested earlier, is a wide-ranging eclecticism that rejected little that could serve the immediate, local purpose. Gothic had become

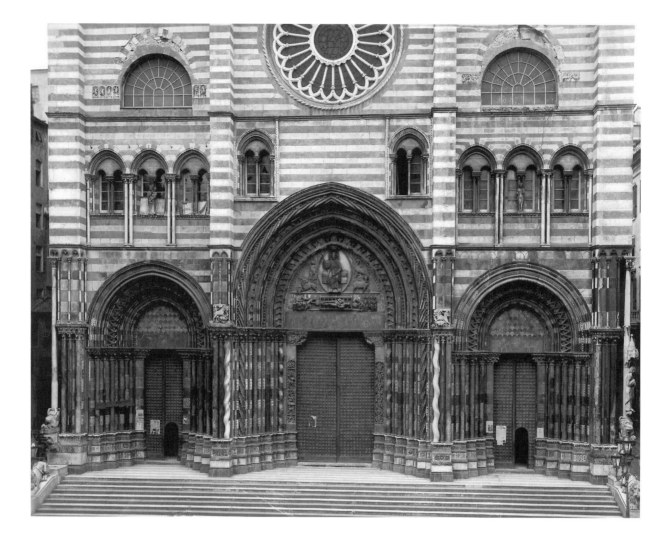

373. Genoa cathedral facade, c. 1220 [Alinari/Art Resource, New York].

"the prestige architecture of the rest of Europe, emblematic of *haute mode* modernity so that tracery windows, gables, and pinnacles, the very marks of modernity, were applied to buildings that were otherwise and in numerous aspects, quite traditional but now sparkled with a 'modernist *frisson*.'"[5] Italian masters, in rejecting, however, the soaring, linear skeletal structures of French Gothic in favor of the more classicizing and humanly scaled buildings of their own tradition, must have seen their designs as combining the best of both worlds. The Italian Gothic facade was conceived not as an imitation of, but rather in competition with French Gothic.

It is interesting to note that the earliest Gothic cathedral facade on Italian soil is one of the least studied in the context of Gothic, perhaps because its sculptural embellishment remains in essential ways stylistically

Romanesque, or at best transitional: Genoa Duomo was reconstructed in Gothic form c. 1220 by a foreign *maestranza* directed by an architect-sculptor of French training or origin. Unlike the later cathedrals of Siena and Florence, whose rebuilding and enlargement was in part a response to the enormous population growth of the thirteenth century, the Genovese conversion did not essentially alter the dimensions of the earlier structure and was conceived, it would seem, primarily for ideological and propagandistic purposes.[6] Competition with the port city of Pisa and commercial rivalry with Venice, two cities that had recently built or embellished major ecclesiastical structures, may have stimulated cultural rivalry on the part of the Genovese authorities, provoking the desire to erect their own splendid cathedral in an even more modern style. There can be no doubt that the design of the lower part of the facade (Fig. 373), composed of two towers and three wide portals with slightly pointed arches, is based on the facades that developed in

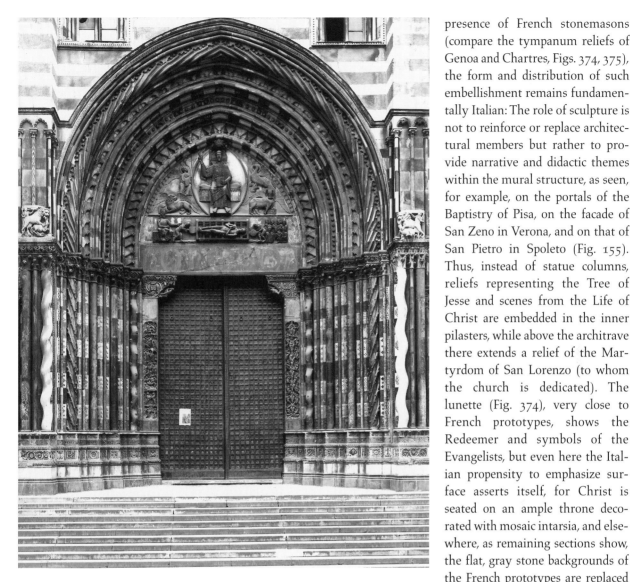

374. Genoa cathedral facade, detail, lunette [Alinari/Art Resource, New York].

presence of French stonemasons (compare the tympanum reliefs of Genoa and Chartres, Figs. 374, 375), the form and distribution of such embellishment remains fundamentally Italian: The role of sculpture is not to reinforce or replace architectural members but rather to provide narrative and didactic themes within the mural structure, as seen, for example, on the portals of the Baptistry of Pisa, on the facade of San Zeno in Verona, and on that of San Pietro in Spoleto (Fig. 155). Thus, instead of statue columns, reliefs representing the Tree of Jesse and scenes from the Life of Christ are embedded in the inner pilasters, while above the architrave there extends a relief of the Martyrdom of San Lorenzo (to whom the church is dedicated). The lunette (Fig. 374), very close to French prototypes, shows the Redeemer and symbols of the Evangelists, but even here the Italian propensity to emphasize surface asserts itself, for Christ is seated on an ample throne decorated with mosaic intarsia, and elsewhere, as remaining sections show, the flat, gray stone backgrounds of the French prototypes are replaced by brightly colored mosaic. Here, as Willibald Sauerländer has commented, is a marvelous eclecticism worthy of a commercial city open to all horizons.[8]

Compared to more or less contemporary facades, such as San Martino in Lucca and San Marco in Venice, the Genoa facade is precocious in its reception of the *opus francigenum*, and one might have expected to see it become the first of many new facades responding closely to the French mode.[9] In fact, the French-based Genovese formula was rejected when the new facades of Siena, Florence, and Orvieto were being designed.[10] Although numerous decorative elements – tabernacles and gables with pointed arches, pinnacles, and crockets – derive from France, the influence of France was, on a deeper level, intellectual rather than formal, and even in this regard it did not immediately affect facade design. The

the Île-de-France and in particular that of the Royal Portal of Chartres (cf. Figs. 374 and 375).[7] Also deriving from France is the rational articulation in which each stepped socle, column, and archivolt forms a continuous arch and the horizontal divisions are composed of uniform bands, in contrast with the relatively haphazard placement of divisions seen elsewhere in Italy. Nevertheless, here there are neither statue columns flanking the doors nor reliefs in the archivolts, and the rich marble polychromy familiar from Tuscan Romanesque architecture asserts the independence of the Genovese patrons and designers. If the style and aspects of the iconography of the sculptural embellishment reveal the

encyclopedic impulse that determined the themes embellishing French cathedrals at first found expression, as we have seen in Chapter 2, on the Pisano pulpits, where biblical history is accompanied by representations of Virtues and Vices, Liberal Arts, and pagan prophetesses of antiquity. The encyclopedic urge also informed the program of the Fontana Maggiore in Perugia, completed in 1278, where, in addition to scenes from Genesis and an array of prophets and saints, there are contemporary secular individuals, the Labors of the Months, personifications of the Liberal Arts (thus a reference to the mode by which human beings assist themselves toward an understanding of God's plan and make themselves worthy of salvation), and various fables and allegorical figures.

It comes as somewhat of a surprise, then, to realize that two of the great Tuscan facades that were rising at the turn of the fourteenth century reveal little of this tendency toward an expansion of iconographic content; rather, at Siena and Florence the cathedrals, both dedicated to the Virgin Mary, contain programs that are strictly Marian. The special reverence and intimacy that the citizens of these two cities felt for the mother of Christ perhaps goes far to explain this focus. In Siena she was not only the patron of the cathedral but protectress of the city itself. In Simone Martini's fresco in the Great Council Hall of the Palazzo Pubblico she sat enthroned with her court of saints and angels presiding over government deliberations and decisions. Even in Florence, whose patron saint is John the Baptist, she played a special role. It was she who bestowed honor upon the Baptist by her visit to Elizabeth: When the two pregnant women embraced, John jumped for joy in his mother's womb in recognition of the presence of the Savior (Luke 1:39–56), a moment that is alluded to on the baptistry door (see Fig. 169). But can the personal and intimate relationship that the citizens of these communes felt toward Mary fully explain the concentration on a single theme in the program of the cathedrals?

Two other factors surely come into play, both of which militate against the exposition of vast and complex iconographies such as appear on French cathedrals. The first is the Italian predisposition to maintain the autonomy of the figural sculpture in relation to the architecture, and the second is the related tendency to conceive of those figures as individuals rather than as types. On French Gothic facades sculpture and architecture are so closely related – though the former is subordinate to the latter – that the entire visible fabric of the edifice is virtually equatable with its sculptural and decorative embellishment. The French Gothic cathedral was thus infinitely receptive to the encyclopedic content of Scholastic thinking: Cycles of saints and prophets, angels and elders, Virtues and Vices, Labors and Arts could be adequately accommodated by the rows or tiers of columns, socles, lintels, and voissoirs, not to mention the lunettes and niches.

For the Italian sculptor-architect, this architectonic use of sculpture – whereby sculptural form takes on the role of architectural members – could work only in monuments of relatively small scale, and when so used the relationship of sculpture to architecture was inverted. In the pulpits and in the fountain by Nicola and Giovanni Pisano numerous figures substitute for architectural members, but due to the scale, bulk, and in many cases freedom of movement, the individual figures (particularly on the pulpits) dominate the architecture.

Siena cathedral was begun c. 1226 but the facade did not get under way until c. 1284. Despite the controversy surrounding the original design of Giovanni's facade, there is not the slightest doubt about his conception of the relationship of sculpture to architecture.[11] When Giovanni had to apply his knowledge of the Pisa Baptistry pulpit and his experience on the Siena pulpit, on which he had worked as a youth, to the monumental scale of the Siena Duomo facade (Fig. 85), he was faced with the problem of maintaining the integrity and individuality of the sculptural components. Clearly, he could neither establish that close affinity between architectural and sculptural scale that was possible on the pulpits, nor permit the almost total integration of architectonic function and sculptural form that was the invention of the French architects. Giovanni found an extraordinary solution, which makes little concession to French prototypes. It is true that architecture and sculpture are visually interlocked but only to the extent that the figure heights determine the scale of some of the architectural elements (or vice versa). But here, the architecture serves as backdrop against which the figures perform in dynamic interaction: Both physically and psychologically the figures project out toward the observer and convey a powerful sense of individual character and presence (Figs. 85–90).

The Siena facade originated as an independent structure added to the preexisting Duomo body of the earlier thirteenth century. Work on the facade proceeded, largely under the direction of Giovanni Pisano, between 1285 and 1297, when Giovanni left Siena to return to

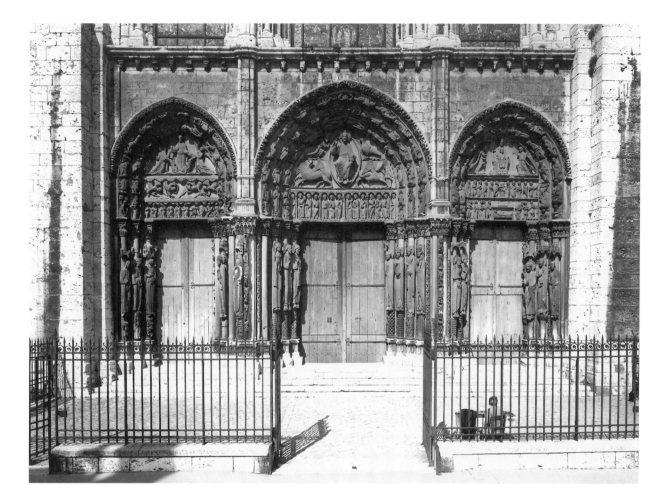

375. Chartres, Royal Portal lunette [Giraudon/Art Resource, New York].

Pisa. As this facade was rising, the Florentines, seeing their rivals exult in a new enlarged cathedral with a grandiose sculptured frontispiece, embarked upon their own expansion; but the Florentines chose to build from west to east, thus *beginning* with the facade and slowly encasing the old cathedral of Sta. Reparata in a new shell. Clearly, the Florentines wanted a showpiece that would rival that of Siena, and it had to rise with all deliberate speed (Figs. 79–83).

Unfortunately, Arnolfo di Cambio's Florentine Duomo facade is all but lost. We can gain some idea of his design, however, from sixteenth-century representations and descriptions and the few extant sculptures and architectural fragments.[12] The drawing of the facade just prior to its destruction in 1587, attributed to Poccetti (Fig. 79), has formed the most important basis for a reconstruction of Arnolfo's design, although even this rendering incorporates some elements, such as the deep niches, that appear

to date from the early fifteenth century when they served to shelter the seated figures of Donatello, Nanni di Banco, and others.[13] Notwithstanding this loss, enough information is available to reveal the completely contrary approach to architectural sculpture on the part of the Florentine designer. For one thing, the presence of the venerable Baptistry opposite the facade, with its insistent mural patterns of dark and light marble, demanded visual acknowledgment. Thus, in contrast to the strong chiaroscural plasticity, sparkling colorism, and sense of texture that characterizes the Siena facade, the Arnolfian facade emphasizes line and plane, with surfaces more subtly differentiated in their projections and enhanced by mosaic accents in selected areas, such as the blind arcade of the lowest story; these play against the dark green and white marble stripes that reflect the geometry of the Baptistry exterior. Baptistry and cathedral are further linked by the frontality of the monumental seated Madonna, originally in the lunette over the main portal of the Duomo, with her direct but scintillating expression (Fig. 81); her glass eyes must have seemed riveted upon the

building across the piazza, perhaps even upon some iconographically significant image carved over the wooden doors[14] – notwithstanding the blessing gesture of the Christ Child addressed, of course, to the observers in the piazza. Thus the Incarnation iconography of the facade sculptures is linked with John the Baptist, who played a crucial role in the salvation of humankind. Three decades later that link was made even more explicit when the *Madonna and Child* faced the story of John the Baptist on the new bronze Baptistry doors (Fig. 167), originally on the east side, by Andrea Pisano.

The lunettes to the left and right of the central lunette with the *Madonna and Child* flanked by *Saints Reparata* and *Zenobius* and curtain-holding angels contained sculptured images of the *Nativity of Christ* and the *Death of Mary* (Figs. 82, 83). Other events in the Virgin's life were presumably carved in reliefs between the lunettes while figure sculptures inhabited niches elsewhere on the facade. Indeed, Arnolfo's major innovation with respect to the Florentine tradition of geometric intarsia design – and here the influence of Siena must have been decisive – was precisely the introduction of sculpture on a vast scale. If Arnolfo demonstrates a completely different artistic temperament than Giovanni, he was no less insistent upon maintaining a strict separation between sculpture and architecture. But whereas the Siena cathedral facade serves as backdrop for Giovanni's aggressively projecting figures, the Florentine facade provides a stage – inhabitable spaces, to again employ Angiola Romanini's term – for Arnolfo's figures: Statues and reliefs never extend beyond the plane of the wall fabric, enclosing niche, or lunette but are always contained within these, which serve, one might say, as proscenium between actor and observer. With far more decorum and restraint but no less drama – witness the open curtains that dramatically revealed the Madonna, as well as the side portal reliefs of the Nativity and Dormition – Arnolfo's figures act out their destinies or communicate their messages as powerful and highly individualized plastic forms, and it is this predilection to give each figure an insistent autonomy that necessarily, and quite simply, limited the number of figures that each of these facades could accommodate.

At Orvieto, in turn responding to the new projects of Siena and Florence, plans were under way for a new facade as early as the 1290s although work was begun – controversy exists regarding the precise beginning of actual building activity – a decade or two later.[15] The Orvieto facade design (Fig. 156) would seem to be a response to (and criticism of) the iconographic paucity that the mode of thinking and design indicated earlier necessitated. Like the new cathedrals of Florence and Siena, that of Orvieto is dedicated to the Virgin Mary, but for the first time a Marian program is placed within a universal context. As we have seen, in addition to Mary enthroned with angels, and scenes from her life, the facade program offers a Genesis cycle (which includes the Liberal Arts), a Tree of Jesse, a New Testament cycle, and the Last Judgment.[16]

The desire to expand the illustrative material provoked a highly original solution to the facade problem: A tapestry of sculptured reliefs winds about the apparent structural scaffolding of the facade. There are no immediate sources in either Italy or France for such an extensive and compacted program, nor for its unusual relief treatment. The spreading out of reliefs along or between facade buttresses does have an Umbrian precedent on the church of San Pietro in Spoleto (Fig. 155), limited, however, to the lower and upper fields of the central bay; but other regional practices also come into play as do, possibly, some examples of ancient monuments in Rome.[17] In particular, the flattened relief mode, the continuous narrative reading, and the puzzlelike piecing together of the marble slabs may well have been suggested by the reliefs on ancient columns, such as the Column of Trajan in Rome.[18] The classical tradition, it should be noted, had been revitalized by the recent papal restorations of the great mosaic and fresco cycles in Rome, and these may have spurred an interest in narrative in Orvieto, a papal residence during the thirteenth and fourteenth centuries.[19] Indeed, the facade project received support from Nicholas IV, who laid the foundation stone in 1290, and from Boniface VIII. Furthermore, not too far from Orvieto the extensive painting cycle at San Francesco, Assisi, had recently been or was in the process of being completed. Finally, one should consider the possible influence of Duccio's *Maestà* commissioned in 1308, with its extensive narrative cycle unprecedented on an altarpiece. Though not set on the altar until 1315, the Sienese Lorenzo Maitani may well have known the work, even in an unfinished state. Evident in frescoes, panel painting, and sculpture, then, as well as sermons and apocryphal literature, there was a hunger not only for a macrocosmic encyclopedic vision but for the microcosmic nuances of human and divine action as intimated if not explicitly verbalized in the sacred scripture, and the Orvieto facade responds forcefully to these needs. The price paid for the enriched program, however, was a

diminution of the scale of the individual elements so that from afar the reliefs tend to merge into a uniform texture – an effect that would have been quite unacceptable to Nicola and Giovanni as well as to Arnolfo – and only from close proximity to the surface of the pier do the individual vignettes come into focus.

The desire to reconcile two conflicting demands – an enrichment of iconographic content and the autonomy of the figural elements with respect to the architecture – clearly demanded new and unorthodox approaches. Indeed, when it proved impossible to realize on a single building, Italian planners and advisers were not averse to incorporating earlier programs and encroaching upon not yet fully constructed edifices, as was done in Florence where the Scholastic (and indeed humanistic) enrichment of the cathedral program could only be achieved by encouraging the spread of iconographic content beyond the confines of the Duomo itself.

The phenomenon of an organically expanding iconography was already implicit in the historical and cultural topography of Florence: God's universal plan of world history had been magnificently expressed inside the Baptistry in the mosaics, largely executed in the Duecento, while a Marian and typological program had been initiated by Arnolfo c. 1300 on the new facade of Sta. Maria del Fiore.[20] Giotto had introduced the novel idea of including Genesis reliefs on the western face of the belltower (Figs. 173–75); it was not an illogical step to continue the program of hexagonal reliefs around the other sides. The introduction of a second zone of reliefs resulted in a pointed reference, moreover, not only iconographically but also formally – compare the double row of medallions on the socle of Amiens cathedral – to French Gothic decorative schemes.[21] Thus, to the Genesis scenes were added the Labors of Mankind, followed by the lozenge-shaped reliefs above with the Planets, the Virtues and Liberal Arts, and the Sacraments, all necessary or determinant factors in the salvific plan. The niches in the next zone contain figures of Prophets, Sibyls, and Kings. Prefigurations or heralds of Christ, they address the observer below who awaits His second coming. There is little doubt, then, that the Campanile reliefs and niche figures conform to the general scheme of the Scholastic compendia of the thirteenth century, thus completing and complementing the iconographic programs of Baptistry and cathedral.

The creative competition between Siena, Florence, and Orvieto – which can be seen in the context of a European-wide "facade fever"[22] – is manifest thus in an especially dynamic way in the different solutions to the problem of the facade and its sculptural embellishment. Such entirely new construction, which could accommodate modern designs and expanded iconographies, was the exception rather than the rule in Italy (in contrast to France, where dozens of new or redesigned cathedrals sprung up during the twelfth and thirteenth centuries). Although the mendicants put up vast new churches, their exterior decoration tended to be sparse, and few cities on the peninsula experienced the conjunction of circumstances, economic and otherwise, that permitted such expensive projects as newly designed cathedrals. Yet even given that limitation, the impulse toward narrative embellishment by way of facade sculpture finds expression in unexpected venues: A case in point, as we have seen, is the cathedral of Altamura (Figs. 252–54).[23] This impressive narrative ensemble clearly attempts to match in extensiveness the Pisano pulpits and the narrative cycles in Florence and Siena, suggesting that centers outside the mainstream of artistic production were also sensitive to the new narrative visuality that had become so much a part of facade design.

The one city that embarked on an elaborate new cathedral project – and this had to await the end of the century – was increasingly prosperous and powerful Milan. If the facade solutions of Siena, Florence, and Orvieto are bracketed on one chronological end by Genoa's qualified acceptance of the *opus francigenum*, they are bracketed on the other end – despite having opted for a northern-style cathedral – by the qualified rejection of transalpine Gothic aesthetics and its consequent restrictions.[24] The cathedral project initially involved a rebuilding of Sta. Maria Maggiore whose campanile had collapsed in the 1350s. But in 1386 it was decided to build a new, enormous edifice from scratch, five aisles wide. Begun in the traditional brick masonry of Lombardy, the following year Gian Galeazzo Visconti, probably cognizant of the great stone structures that had risen in Europe and the marble cathedrals in Italy, decided that nothing less than a grandiose cathedral of marble in a European Gothic style would signify the prestige and power of the *signore*, who, as we have seen, had the ambition of becoming imperial vicar; and to further the project he gave considerable material support (literally, in offering the marble quarries of Candoglia). Building activity began at the apse and transepts and moved forward toward the facade.[25] Although the basic ground plan was decided early on, there were numerous controversies and changes of direction even after the

foundation had been built and the piers begun; documents record in some detail the arguments advanced and responses given by members of the Fabbrica and the advisers called from abroad. Despite this, and notwithstanding the *centuries* that it took to complete the building and its external embellishment (up to the nineteenth century), the basic shape and form and decorative abundance belongs to the original plan and represents to a surprising degree a homogeneous conception. Thus, unlike the earlier Trecento cathedrals, in which the facades are virtually independent screens (in the case of Siena a structurally separate fabric), the facade, flanks, and eastern end of the exterior of Milan cathedral provide a continuous envelope for a northern Gothic five-aisled plan with Lombard features and a decidedly Lombard facade profile.[26] Sculpture, however, as in French Gothic buildings, is subordinate to architecture, indeed so much so that the individual sculpted parts have virtually no autonomy. Indeed, sculpture neither takes on architectonic functions as in France, nor do the figures have plastic independence (except when viewed in the isolation of photographic details) as they do in Florence, Siena, and Orvieto. If the disputes between the members of the Fabbrica and their northern advisers concerning architectural and sculptural design are symptomatic of Milanese contentiousness, such was almost inevitable given the fundamentally diverse visual cultures of north and south (see earlier discussion, pp. 228ff.). The final results show the mark of an independence as original as it was obstinate.

TOMBS

There are less than a handful of notable Italian Gothic facades, and less than a dozen pulpits, making the task of exploring the typology of facades and pulpits a manageable one. But monumental sculptured tombs were executed in the hundreds if not thousands; indeed, the design and erection of sepulchers was probably the major source of employment – aside from the cathedral works – for a sculptor of the late Duecento and Trecento. However, unlike cathedral facades, many tomb monuments really do fit into an evolutionary or narratological development.[1] Although the most important individual tombs have been well studied, tomb types have received far less attention. Recently, however, with an increased interest in patronage of all sorts, the tomb types commissioned by various classes of individuals – cardinals, saints, doges, and princes – have begun to receive more systematic

treatment.[2] We shall touch here on only a few of the iconographic themes and formal structures that developed during the late thirteenth and fourteenth centuries to commemorate the deceased, and indicate some of the directions that require further exploration.

A survey of medieval tombs from the fifth to the twelfth century in Italy reveals the rarity of monumental sculptured sepulchers, whether for saints or ordinary mortals. For the latter, site, preferably near a saint's tomb whose location might be marked only by an inscription, was far more important than artistic form and size. During the twelfth century, however, a number of popes and princes became concerned with the form of their future resting places. It was then that the practice of employing antique sarcophagi became common.[3] A mason might be called upon to add an inscription or some other type of embellishment but not to carve a tomb monument *ab initio*.

All of this was to change during the second half of the thirteenth century when Nicola Pisano designed the tomb of a saint, Dominic Guzmàn, founder of the Order of Preachers (Fig. 34). Begun c. 1264, this was the first newly carved monumental sculptured tomb (in contrast to monuments incorporating reused antique sarcophagi) in Italy since late antiquity. Shortly after its erection in the church of San Domenico, Bologna, in 1267, and after a hiatus of almost eight hundred years, a sudden flurry of commissions given to stonemasons and sculptors resulted in the erection of numerous and influential monumental sculptured tombs. Equally noteworthy is the fact that this activity took place primarily within mendicant circles, in particular, Dominican and Franciscan convents. Indeed, despite Dominican restrictions on elaborate funerary monuments,[4] Nicola's Arca was the first of a large number of grandiose tombs that rose in the friars' convents during the last decades of the thirteenth century. Once the barriers were broken, new, magnificent sculptured tombs were erected everywhere, including Bologna, Viterbo, and Rome, soon followed by Florence, Siena, and Naples. By the turn of the fourteenth century, with flourishing urban economies increasing the wealth of the middle classes and ecclesiastical holders of benefices, and an increase in pious and commemorative options (see Chapter 1, pp. 3ff.), monumental tombs appeared everywhere in Italy, characterized by increasingly large-scale, spatially aggressive architectonic forms with rich sculptural embellishments and assertive iconographical programs.

Tino di Camaino's monument of c. 1321 for Bishop

Orso in Florence (Figs. 141, 142) may be taken as an example. Below the seated effigy the consoles illustrate what appears to be a figure of Death shooting arrows at people from all walks and ranks of life, ecclesiastical and lay, male and female, young and old. With the prominence of such a tomb in the cathedral of Florence, and the illustration of such a theme, small wonder that increasingly people from all walks of life – clergy, merchants, professors of Law, and soldiers – insisted on manifesting their hopes for the afterlife by way of conspicuous sepulchral monuments, to remind clergy and family that their prayers were needed to assure swift entrance to Paradise.

Saints' Tombs

Whereas tombs for ordinary mortals invited prayers and funerary masses for the benefit of the deceased, those of saints ostensibly benefited the worshiper, desirous of the healing capabilities of the relics and the intercession of the saint; but saints' tombs also served to promote the cult and increase the financial resources of the church in which the shrines were kept.

We have seen (in Chapter 2, pp. 31ff.) that the Arca di San Domenico (Figs. 34–40), conceived as a monumental, freestanding historiated sarcophagus supported by telamones and caryatids (Figs. 35, 36), was strikingly innovative in its form and structure, although its sources are found in a wide variety of medieval ecclesiastical furnishings; in addition, numerous elements on the Arca derive from antique sculpture, sometimes filtered through medieval tradition. The most important fourteenth-century descendants of the Bolognese monument are the shrines of San Pietro Martire (Fig. 263) in Milan by Giovanni di Balduccio and Sant'Agostino (Fig. 269) in Pavia by a follower of Balduccio (see Chapter 6, pp. 203ff. and 209ff.). More than any other examples of the period, these monuments expanded and amplified the formal and iconographic possibilities inherent in the prototypical Arca di San Domenico. Both are freestanding and include biographical reliefs and cycles of Virtues. Both were originally placed in spaces or at heights that enabled the worshiper to view in close proximity the narratives that offered a model of pious existence.

Extensive relief cycles that rival the exhaustiveness of frescoed mural programs, such as we have observed on the tombs of Saints Dominic, Peter Martyr, and Augustine, became distinctive features of saints' tombs and appear, for example, on the Arca di San Cerbone (c. 1330)

by Goro di Gregorio in Massa Marittima (Figs. 144, 145), a freestanding tomb that may originally have been raised on columns;[5] and on the monument of San Donato (after 1362) in the Duomo of Arezzo (Figs. 221, 223), which is freestanding with reliefs on four sides, rests on elaborate columns, and serves as a giant *pala* for the high altar (see Chapter 4, pp. 170f.). This complex monument originated as a marble altarpiece for the main altar of Arezzo cathedral. As mentioned earlier, after the discovery of the relics of St. Donatus, second bishop of Arezzo, in 1262, conflicts arose between the clerics of the Pieve of Arezzo and the canons of the Duomo regarding possession of the sacred remains. The transformation into a huge freestanding arca, by the addition of a large sarcophagus raised on colonettes and attached to the back of the ancona, and the consequent enlargement of the original fabric to unite the disparate parts served to establish the definitive home of the saint's remains in the Duomo.[6]

Indeed, saints' tombs are frequently raised on figural or columnar supports; examples include the Arca di San Luca (c. 1316) in Padua and the Arca del Beato Bertrando (1343) in Udine, which has standing saints supporting a sarcophagus with reliefs on all four sides.[7] The fact that so many of the tombs of saints and *beati* are raised accords with their function both as a focus of veneration and as a site where the thaumaturgic powers of the relics were particularly effective. The raised tomb made it possible for the faithful to see the monument from a distance before coming near it; it then gave the worshiper easy access to the reliefs on the sarcophagus. The representation of exemplary actions in the life of the holy person clearly was intended not only to remind the worshiper of the saint's miraculous powers but also to commemorate the saint's piety and to serve as affective models of behavior. Finally, such a monument, if raised on columns or figural supports, enabled the faithful to touch the bottom of the sarcophagus, a physical contact that activated the effectiveness of the relic's healing powers.

On rare occasions an entire enclosed chapel was erected or transformed to honor a saint's relics. After the rediscovery of the mortal remains of the Alexandrian military saint Isidore – they had been translated to Venice from Chios in 1124 by an earlier doge but were then hidden in San Marco[8] – Doge Andrea Dandolo (1343–54) commissioned not just a tomb but an entire chapel, one of the first in which the program of both tomb and the architectural space containing it is entirely dedicated to the saint (Figs. 376, 377).[9] The chapel is of

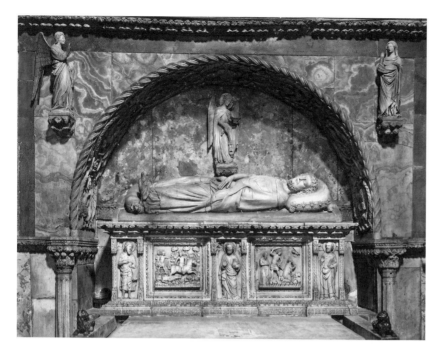

376. Chapel of Sant'Isidoro, after 1343. Venice, San Marco [Alinari/Art Resource, New York].

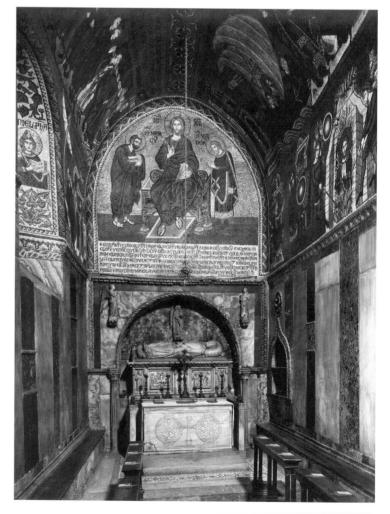

377. Chapel of Sant'Isidoro. Venice, San Marco [Alinari/Art Resource, New York].

extremely simple form: flat unarticulated walls on a rectangular plan, covered by a barrel vault. The wall surfaces are composed of large slabs of marble alternating with broad strips of porphyry and a green marble called *verde antico*, while the vault is embellished with an extensive mosaic cycle of scenes from Isidore's life, including two seen again on the sarcophagus, all labeled by inscriptions.[10] Was it inspired by the barrel-vaulted and frescoed Arena Chapel in nearby Padua but reinterpreted in terms of local tradition? The tomb itself, composed of a figurated sarcophagus upon which rests an effigy of the saint – in emulation of the earlier tomb of San Simeone (see Fig. 303)[11] but by no means of comparable quality – is set within an arcosolium-like niche whose surfaces bear revetment of a beautiful veined alabaster. Two scenes from the saint's Vita – Isidore dragged by a horse and the decapitation of Isidore – fill the two narrative panels, while standing saints flank the reliefs. Finally, three statuettes on consoles, Annunciatory figures on either side of the niche arch, and a censing angel over the effigy complete the sculptured tomb.[12] Many of the devices employed to commemorate saints and promote the cult – the raised sarcophagus, the biographical reliefs, and the dedication of an entire chapel to the holy individual – were taken over by nonsaints. On at least one occasion, a tomb monument that was placed prominently in the center of an Oratory but housed the remains of an ordinary mortal, a *condottiere*, was mistaken for the tomb of a "corpo santo."[13]

Tombs of Lawyers and Professors

The immediate impact of the Arca di San Domenico was more generic than formal and stylistic: It helped break down the barriers that had inhibited the development of sepulchral art in Italy, and it opened up a new way to commemorate the dead. Since elaborate tomb monuments were formally forbidden in the churches of the friars, one way to go around the restriction was to have a prominent tomb erected outside rather than within the church. Whatever the initial motivation, such siting could be exploited to establish a relationship between tomb and urban fabric.[14] Beginning in 1268 a series of large sepulchral monuments was raised for the Glossators, those professors and interpreters of Roman and canon law for which the city was well known, in the courtyards and piazze of the Dominican and Franciscan churches of Bologna.[15] The first of these, the Odofredo Denari tomb at San Francesco (Fig. 378), is a raised, freestanding mon-

ument. With its baldacchino-like sheltering of the sarcophagus, however, and its pyramidal roof, the monument of Odofredo makes an explicit visual allusion to the dynastic sepulchers of Palermo, including that of Frederick II, as well as to ancient symbols of eternal fame. The autonomy and authority of the Bologna Studio (or School of Law) had been challenged by Frederick II, and the Glossators responded with invectives affirming the concept of separation of state administration and jurisprudence that they claimed was based on Roman law. Odofredo was a staunch supporter of the anti-imperial party of Bologna, and the tomb commissioned by his son Alberto enunciates in clear terms the elevated, if threatened, status of the "dottor" of jurisprudence.[16]

Within the next three decades one after another of these impressive structures was erected in Bologna, notably and exclusively in Franciscan and Dominican convents: Rolandino de' Romanzi was buried in San Francesco in 1285; Egidio de' Foscherari in San Domenico c. 1289, and Accursio, who died in 1263 and was initially buried in San Domenico, probably in an unobtrusive tomb, was "translated" sometime before 1293 to San Francesco where his remains were placed, together with those of his son, in a large pyramidal tomb of this type. Finally, c. 1300, the largest, most impressive, and stylistically most advanced of the group was erected in the Piazza San Domenico. The monument of Rolandino Passaggeri (Fig. 379) was based on that of Odofredo but introduced several important new elements: the Gothic baldacchino and sculptured reliefs, including images of Rolandino reclining in pious death and again seated *in cattedra* before a group of students. The Gothic canopy had appeared earlier in several tombs in the Dominican convent in Viterbo, while the seated Rolandino, referring to his earthly activities, appropriates the biographical sarcophagus relief that had been restricted primarily to the tombs of saints. The professor *in cathedra* became a characteristic motif of Bolognese tombs of the fourteenth century (see, for example, the tomb of Legnano by the dalle Masegna brothers of 1383, Fig. 337) and was taken over elsewhere when the desire of the heirs was to highlight the academic and legal career of the deceased. An alternative convention developed in Padua, also a major university town, where the professor is shown not among his students but seated in isolation with his books.[17] In Tuscany, for the tomb of the notary, teacher, and judge Cino Sigibuldi da Pistoia, attributed to Agostino di Giovanni and completed in 1339,[18] instead of a reclining effigy there is a seated

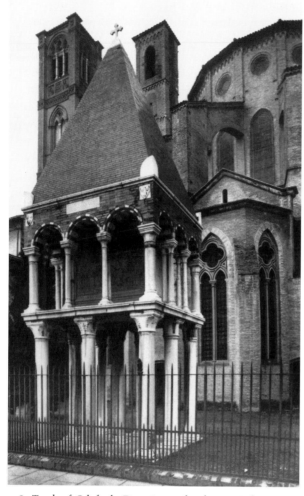

378. Tomb of Odofredo Denari, completed 1285. Bologna, San Francesco [Alinari/Art Resource, New York].

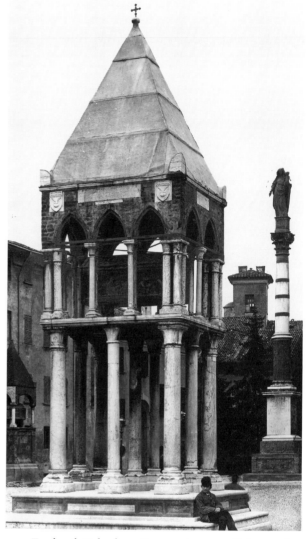

379. Tomb of Rolandino Passaggeri, 1300. Bologna, San Domenico [Alinari/Art Resource, New York].

statue of Cino, larger than the figures surrounding him, on his sarcophagus (Fig. 380). The accompanying standing figures may be students, or more likely petitioners at his court of law, while the relief on the sarcophagus shows the lawyer seated *in cattedra* among his students. This substitution of an image of the living man for the more conventional supine effigy recalls such commemorative images seen on the Beltramo del Porrina monument (Fig. 126) in Casole d'Elsa, while the sarcophagus relief takes up the motif common on the Glossator tombs in Bologna. The individual in his professional role is thus eulogized on his tomb.

Tombs of Clerics

The Dominican convent of Sta. Maria in Gradi in the papal residence town of Viterbo had early on been the burial site of a number of wealthy and influential ecclesiastics who were interred in front of the altar, evidently in the pavement, and so without a visible monument.[19] Bishop Paul of Paphos (Cyprus), in contrast, who died in 1268, had a tomb (not extant but known from an eighteenth-century drawing) composed of a bier raised on columns, an effigy, and a baldacchino.[20] But the earliest fully salient effigy on an Italian tomb, according to almost universal agreement by scholars, is that of Pope Clement IV (Fig. 59), who also died in 1268.[21] In addition to the effigy, Clement IV's monument is the earliest extant wall tomb to include a Gothic canopy. The tomb is further notable for its extraordinary height.

The sculptured effigy on the tomb of Clement IV may

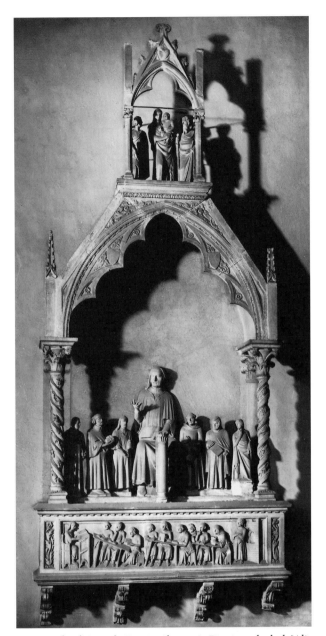

380. Tomb of Cino da Pistoia (d. 1337). Pistoia cathedral [Alinari/Art Resource, New York].

well reveal the influence of northern Gothic sepulchral art on Pietro Oderisio, whose signature on the monument was recorded in the seventeenth century. In contrast to the northern portrayals, however, which show the effigy with eyes open, eternally young and alive, Clement IV is portrayed as elderly and deceased, with a striking portraitlike realism.[22] Above, on the back wall of the aedicula, there was an image of the Madonna and Child and nearby a kneeling and praying saint acting as intercessor.[23] Thus, the reality of physical death, as

expressed in the effigy, is mitigated by the hope of eternal life, a theme soon to be repeated on Arnolfo's de Bray monument.

Each of these elements – the Gothic canopy, the sculptured effigy, and the dramatic juxtaposition of death with eternal life – first seen in the Dominican church of Sta. Maria in Gradi, were innovations taken up later, to become characteristic of Italian Gothic tombs. Another motif to reappear frequently is first seen on the monument of Cardinal Vicedomini (d. 1276), a wall tomb with a Gothic canopy, also originally in Santa Maria in Gradi.[24] On its rear plane, there was painted in fresco a group of clerics engaged in obsequies for the deceased.[25] This motif was later translated into sculpture by Arnolfo di Cambio for the tomb of the papal notary Riccardo Annibaldi in Rome, composed after 1289 (Fig. 60).[26] While the closest source for the motif is north of the Alps,[27] clerics holding objects used in the Mass are highlighted, in a different form but in a related context, on the Arca di San Domenico in Bologna, a considerable portion of which was carved by Arnolfo.

Sculptured acolytes appear on the tomb that Arnolfo designed for Cardinal De Braye (d. 1282) (Figs. 56–58) in San Domenico, Orvieto, but their context differs somewhat from the examples just cited. Instead of holding liturgical implements, here the acolytes, in what may have been intended as a reenactment of a specific moment in the funerary ceremonial, pull open the curtains to reveal the deceased cardinal on the bier, again naturalistically shown as aged.[28] Two censer-swinging angels (in the Museo dell'Opera del Duomo, Orvieto) have been plausibly associated with the tomb, and thus it would appear that there are both human and angelic participants in the Mass for the dead. In the upper zone the cardinal is seen a second time, alive and kneeling before the Virgin and Child, accompanied by two intercessory saints, Mark and Dominic. Here, too, Arnolfo translated into the medium of sculpture a motif that had appeared earlier in fresco. Thus, the eye moves upward from the funeral ceremony on earth to the *commendatio anima*, in which the hoped-for salvation finds expression,[29] and finally to the merciful Mother of Christ. A similar program contrasting the mundane reality of death and the hoped for reward in the afterlife, corruptible body and eternal soul, appears on the tomb of the Dominican pope Benedict XI (d. 1304) in San Domenico, Perugia (Fig. 164).[30]

Around 1343 another Dominican tomb, that of Archbishop Saltarelli (Fig. 182) in Sta. Caterina, Pisa, from the

workshop of Andrea and Nino Pisano, presents an escha-tological drama even more evolved and complex than that seen on the De Braye and Benedict XI monuments. The Saltarelli monument is one of the earliest tombs of a non-canonized ecclesiastic to include biographical reliefs.[31] The sarcophagus reliefs celebrate the archbishop's politi-cal and ecclesiastical career, implying a meritoriousness (he was referred to as *Beato*) that virtually assures his entrance to heaven.[32] Here the element of time is intro-duced in the sequence of images that includes the inter-cession of saints and the participation of angels. A veritable journey from life to death to the salvation of the archbishop's soul is seen in a composition and in images that move upward from the earthly realm of his biogra-phy to the raising of his soul, and finally to the heavenly realm of the Virgin and Child. The biographical reliefs, then, like those illustrating the Vita of a saint, allude to the pious-political acts that are the basis for the arch-bishop's heavenly reward seen above.[33]

The effigies of thirteenth- and early-fourteenth-cen-tury prelates, with their ceremonial shoes, meticulously appropriate attire, and elegantly appointed biers sur-rounded by clerics and angels were models of the *ars moriendi*. Late-thirteenth-century Wills attest to a self-conscious concern with the act of dying and may go some way in explaining the appearance of individualized effi-gies in replicated funeral ceremonial on Italian Gothic tombs.[34] The salient effigy, which originated in an eccle-siastical context for the recently deceased, is appropriated in the early fourteenth century for saints, as in the tombs of San Simeone (Figs. 303, 304) and Sant'Isidoro (Figs. 376, 377) in Venice, and the Arca di Sant'Agostino in Pavia (Figs. 269, 270).

Many cardinals' Testaments express both first and second choices for burial sites: typically, the cathedral of the city in which they die or if that is not possible, a Dominican or Franciscan convent.[35] These individuals preferred to be buried in an urban location and in the most important church of the town, where the large number of worshipers would assure abundant suffrage for the dead. Such considerations motivated their second choice, as well. Indeed, the promise of clerical solicitude for the soul of the deceased, by way of daily or weekly prayers for the dead, which neither relatives nor secular clergy were, in general, in a position to promise, seems to have been a major factor in the popularity of mendi-cant convents as burial sites. The painted or sculptured friars and acolytes were comforting reminders that the convent was meeting the obligations incumbent upon

acceptance of the donor's legacy; and this undoubtedly encouraged potential donors, as well. Franciscan and Dominican convents were the chosen burial sites, to be sure, not only for the rich and important but also for people of lower social rank who, however, were not so frequently accommodated. Evidence from the Wills of ordinary people attest to the numerous legacies left to the mendicants for the salvation of the donor's soul, and in order to hedge one's bets, legacies were often left to several houses.[36]

By the late 1260s, then, Dominican and Franciscan houses showed increasing willingness to accept, and even encouraged, burial within the walls of their convents and churches. Indeed, the oversize monuments in late-thir-teenth- and early-fourteenth-century mendicant churches clearly served the interests of both layman and friar: They helped assure clerical suffrage for the souls of the donors, but they were also instruments in the competi-tion, both ideological and financial, between the orders.[37]

Fourteenth-Century Secular Tombs: Merchants, Bankers, Soldiers

Early in the fourteenth century, with increasing pros-perity among the merchant class, Florentine families began to support the construction of chapels, as at Santa Croce, Florence, and pay for extensive mural decoration and the erection of tombs. The tombs of these middle-class laymen began to take over the prerogatives of ecclesiastic and ruler tombs, although they remained faithful to the "prospective" tradition of funerary mon-uments, that is, iconographic programs that emphasized the hope for salvation.[38] An example is the Baroncelli family chapel with its tomb of 1327 that includes Taddeo Gaddi's frescoed *Madonna and Child* above and reliefs of the Madonna and John the Evangelist flanking a Man of Sorrows on the sarcophagus (Fig. 188) (see earlier dis-cussion, p. 147). In the Bardi di Vernio Chapel also in Santa Croce, dated in the mid-1330s, a painted image above the carved sarcophagus shows the deceased rising from his tomb and praying to the resurrected Christ (Fig. 381). The idea may derive from the tomb of Mar-garet of Luxemburg, but whereas the distinctly corpo-real figure of the emperor's consort indicates actual bodily resurrection (Fig. 116), the Bardi di Vernio Chapel fresco is more likely a *vision* expressing the deceased banker's hoped-for salvation at the Last Judg-ment. A similar conceit may originally have related the standing figure of Enrico Scrovegni to the frescoed *Last*

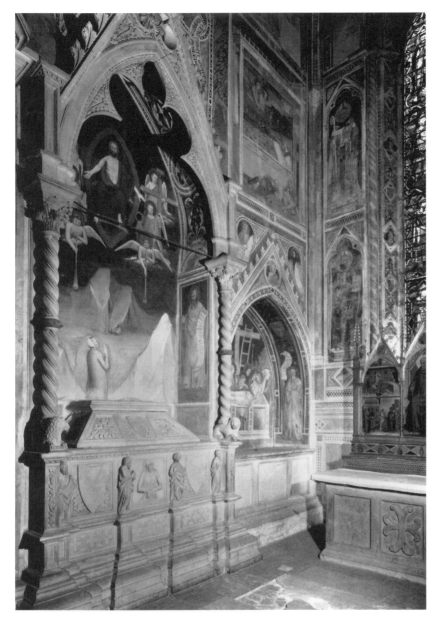

381. Bardi di Vernio Chapel, mid-1330s. Florence, Santa Croce [Scala/Art Resource, New York].

Judgment in the Arena Chapel (see earlier discussion, pp. 238ff.).

The size, spatial aggressiveness, and degree of elaboration of a tomb monument was almost entirely dependent on the wealth of the patron. If sufficiently affluent and influential, a layman could even take over an entire building and have a tomb constructed with features that so closely recalled those of a saint's tomb it could be mistaken for a shrine. Such was the case with the tomb of the

condottiere Raimondino de' Lupi (d. 1379) in the Oratory of S. Giorgio in the Santo, Padua, which was composed of a sarcophagus on marble columns with a pyramidal canopy that nearly touched the ceiling; the whole ensemble was surrounded by statues of members of the de' Lupi family. Because of its huge size and, more important, the fact that it included a sarcophagus on supports and was freestanding in or near the center of a chapel, visitors to the Oratory, assuming that it contained holy relics, mistakenly venerated and kissed the monument.[39]

Rulers' Monuments

During a period when neither emperor, king, nor *signore* could feel secure in the legitimacy, acceptance, or dynastic continuity of his rulership, the public display of pomp and power, as well as theoretical proclamations in its defense, impelled the establishment of tomb monuments that expressed the political agendas of the heirs or followers of the deceased; such agendas were directed toward demonstrating the achievements of the latter in the political, military, and sometimes spiritual realms, and the legal and theoretical bases for a continuity of rulership generally in the person of the heir.[40] In addition to appropriating many of the elements previously reserved for saints or clerics, the tombs of rulers and princes pointedly incorporated figures that made reference to earlier rulers, both ancient and more recent. Unfortunately, we do not know whether the seated figure of Henry VII and his standing councillors originally belonged to his tomb monument set up over the altar of St. Bartholomew in the apse of Pisa Duomo. If so, or if a gateway figure was given a new context after the emperor's death (see earlier discussion, pp. 104ff.), the inclusion of a life-size seated image of the deceased on the tomb incorporated a traditional commemorative image into a sepulchral con-

text. As a commemorative figure, it brings to mind the seated emperor Frederick II (Fig. 15) from Capua and Arnolfo's Charles d'Anjou portrait in Rome, both of which in turn allude to ancient imperial portraits. It is significant that the commemorative seated portrait, such as that of Frederick II (Fig. 15), originating during the lifetime of the ruler – obviously shown alive and well – became a major motif on a funerary monument, often replacing, or shown in addition to, the effigy as deceased and reclining on a bier or sarcophagus (see Figs. 241, 247, 255). Indeed, the portrait shown alive – enthroned, standing, or on horseback – became characteristic (although not exclusively) of a certain class of secular subjects: those adhering to the Ghibelline cause. An example is the Porrina monument (Fig. 126) dated c. 1313.[41] The appearance of such a figure so early in the century has not been adequately explained; the idea may derive from the tomb of Emperor Henry VII, although as indicated earlier, we cannot be sure the seated figure and the councillors originated in a tomb setting. A seated figure shown alive is included, as we have seen, on the tomb of Cino da Pistoia (Fig. 380). Known as a poet of the *dolce stil nuovo* and a friend of Dante, since 1310 Cino had been a passionate supporter of Henry VII and the Ghibelline cause (although it is not certain that he remained a Ghibelline until the end of his life).[42]

It is possible that the empty space beneath the barrel-vaulted arch of the Tarlati monument of 1330, signed by the Sienese Agostino di Giovanni and Agnolo di Ventura, sheltered a seated image of Arezzo's Lord and Bishop, as has been plausibly suggested.[43] The propensity to appropriate motifs from other contexts is apparent, however, in the decision on the part of Tarlati's heirs to include one of the most extensive relief cycles concerning the deceased's life and achievements seen on a tomb – even saints' tombs – to that date.

Notwithstanding the Ghibelline association of a seated monarch, similar figures appear on the tombs of the papacy-aligned rulers in Naples, such as on the sarcophagi of Queen Mary of Valois and King Charles of Calabria (Figs. 241 and 243), where dynastic continuity is emphasized. But the relatively reticent images on these tombs are transformed on the monument of Robert of Anjou (Fig. 247) in Sta. Chiara, Naples. Here the monarch appears four times: seated among his family to emphasize dynastic continuity; dead and garbed in the robes of a Franciscan tertiary on his *lit-de-parade*; carved (seemingly) in the round as the enthroned monarch, majestic and eternal, surrounded by his coun-cillors and by saints (in fresco); and finally, kneeling before the Virgin Mary.[44]

Again shown alive, and taking over the equestrian images of antiquity, are the figures of Cangrande, Mastino II, and Cansignorio Della Scala on their respective monuments in Verona and Bernabò Visconti in Milan (Figs. 353, 356, 364, 280, 281). Cangrande was one of the leading Ghibellines of Dante's time; the relief cycle on the sarcophagus front showing his military feats is related perhaps to such scenes appearing on the tomb of his fellow Ghibelline, Bishop Tarlati (Figs. 148–50).[45] In most of these tombs the religious element is severely reduced while the retrospective allusions to lifetime achievements and power are emphasized. Furthermore, whether the dynasty was aligned with the pope or emperor, the dual representation of the deceased – as a reclining effigy, and enthroned and alive, as for example on the tombs of Robert of Anjou and Cangrande della Scala – expresses a duality inherent in the medieval concept of rulership: There exists both the mortal ruler and the eternal *Dignitas* of rulership, embodying all past and successive individual rulers. The individual may die but his office is eternal.[46]

Tombs of Women and Children

Least studied of all have been the tombs of women and children. It is not clear, for example, whether female monuments – less numerous to be sure – are in any way distinguished from those of men, aside from the fact, significant as it is, that female effigies tend to be more idealized than those of men, which are often characterized by a "warts and all" realism.[47] A comparison of the tomb of Mary of Valois with that of her husband Charles of Calabria shows that although both have Tino's characteristic slightly puffy ovoid faces, she is represented without any flaws, while he is shown with double chin and pendulous cheeks (Figs. 242, 244). It is interesting to note that although the caryatids supporting her sarcophagus include the Theological Virtues (Faith, Charity, and possibly a lost figure of Hope), those on his tomb are the more masculine Cardinal Virtues. These differences may well be related to the fact that the female must be presented in her role as attractive but pious child-bearer who will further her husband's dynastic ambitions. In contrast, male pretensions to physical and political strength were not advanced by physical attractiveness. However, there exist female effigies lacking in conventional beauty: The figure of

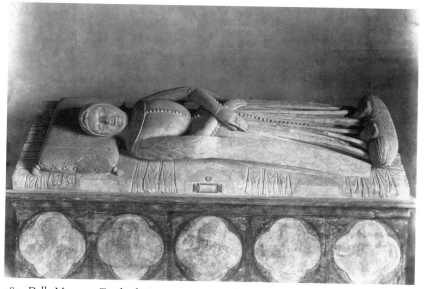

382. Dalle Masegna: Tomb of Margaret Gonzaga (d. 1399). Mantua, Palazzo Ducale [Mantua. Soprintentenza per i beni artistici e storici per le provincie di Brescia, Cremona e Mantova].

383. Dalle Masegna: Tomb of Margaret Gonzaga, detail. Mantua, Palazzo. Ducale [author].

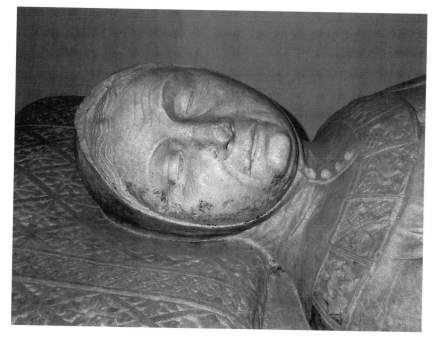

practice: Records dating from the 1370s to the early fifteenth century show that adult males enjoyed the highest funerary honors and involved the greatest expenditures.[49] Married women less frequently were accorded expensive funerals, especially if their husbands predeceased them. Unmarried girls were deemed low on the scale of funerary pomp. Young males, even those from families who gave adult members expensive funerals, but who died before their full entrance into the social community by way of achievements in commerce or government, received much more modest funerary display than did their fathers and uncles.[50]

Considering the mortality rate of children during the Middle Ages it is perhaps surprising that so few of their tombs are extant and perhaps very few were made. The rare surviving examples of children's tombs (or fragments of them) are all for members of noble or ruling families who were potential heirs of hereditary titles. The tomb of Guarnerio degli Antelminelli (Figs. 186, 187) by Giovanni di Balduccio is an unusually elaborate and complete example (see earlier discussion, pp. 146f.). Guarnerio was the son of Castruccio Castracani, tyrant of Lucca who, having been elected *signore* in 1325, had been slowly building up his territorial dominions in Tuscany and north in the Lunigiana, and had succeeded in acquiring from the emperor Ludwig of Bavaria the imperial vicariate of territories gained (and even some not yet acquired). One of his main ambitions during the last years of his life had been to transform his elected rulership and appointed vicariate into a hereditary dynasty. His children, both male and female, were increasingly important instruments in this goal: For his first three daughters he arranged favorable marriage

Margaret Gonzaga (d. 1399) by the dalle Masegna brothers[48] shows a middle-aged, fleshy, and round-faced woman with swollen hands, head and body rigidly enclosed in her garments (Figs. 382, 383). The eyebrows are angular and there are wrinkles on the forehead.

The discrepancy in numbers of male and female monuments probably is related to differences in funerary

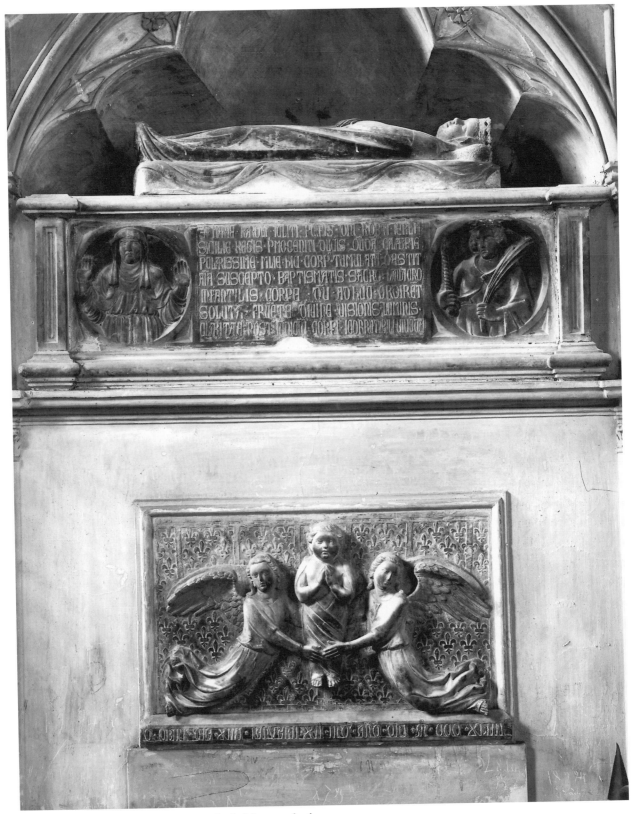

384. Effigy of Mary of Anjou (d. 1328) and relief from tomb of
Ludovico Durazzo (d. 1344). Naples, Sta. Chiara [Alinari/Art
Resource, New York].

alliances that linked the Castracani with neighboring territories under his dominion. But to make his rulership hereditary he needed to receive the title of duke from the emperor; this, together with other important titles, was granted in 1327.[51] The tomb of his young son is a canopied, sculptured wall monument (probably dated sometime between 1327 and Castruccio's death in September 1328) with an effigy of the little boy. If it was an expression of a father's personal grief at the loss of son, it also served to assert his dynastic claims by the prominent display of the stemma of both the Castracani and the Wittelsbach, the ruling imperial house.

The tomb of Castruccio Castracani's young son in Sarzana and a child's tomb fragment in Sta. Chiara, Naples, are the earliest extant Italian sepulchers with child gisants.[52] The latter shows a poignant effigy of Mary of Anjou (Fig. 384, top), daughter of Mary of Valois and Charles of Calabria, who died as an infant in 1328. The (destroyed) inscription beneath the effigy informed the viewer that the child was baptized and made reference to the Beatific Vision, suggesting, as King Robert himself had argued in a treatise on the subject, that the sinless soul of an infant is blessed with an immediate vision of God.[53]

These children's tombs, as well as that of Ludovico di Durazzo, who died as an infant in 1344, were most likely dynastic statements. Only a fragment of this last is extant: a relief slab showing the swaddled baby, or more likely his soul (Fig. 384, bottom), being carried to heaven. The relief has been attributed to Giovanni and Pacio Bertini, and it does appear to be by one of the major sculptors working on the Robert the Wise monument.[54] The transport of a soul to heaven, seen in the contemporary tomb of Archbishop Saltarelli in Pisa by the Andrea Pisano workshop (Fig. 182), would seem to express the clear vindication of Pope Benedict XII's definitive statement concerning the possibility of purified souls having a face-to-face vision of God.

As we have seen, tomb types ranged from simple floor slabs to elaborate wall and floor monuments, to entire chapels, depending on the wealth and status of the deceased and/or the patron. While the societal rank of adults for whom tombs were commissioned ranged from merchant layman to pope and royalty, in the case of children only those whose tombs might somehow express the signorial, royal, and dynastic ambitions of their survivors seem to have been considered worthy of commemoration and the associated expenses. In all cases, sepulchral monuments – then as now – were vehicles for public statements expressing commemoration of the deceased and the very real concerns of the living. Clearly, however, much work on tomb typology, and in particular that of women and children, remains to be done.

9

Some Problems in
Italian Gothic Sculpture:
Case Studies

Scholarship in the field of Italian Gothic sculpture has been dominated, to a large extent, by problems of attribution, that is, the assigning of works lacking documentation to an artist whose work is known with near certainty. The basis for such certainty is either a signature, a contract, or other legal or quasi-legal reference to the work,[1] and contemporary or at least early references to the monument, patron, or artist. The number of works for which we have such information is considerably smaller than the number of those for which there is no signature, the contracts and other documents are lost, and no specific early references are available. But since architectural and sculptural projects were major occupations, fulfilling an increasing demand for artistic production of every kind, the number of persons engaged in making sculpture was large. In the fifteenth century, and this probably holds for the fourteenth as well, records indicate, for example, that the number of wood-carvers exceeded the number of butchers in Florence![2] Indeed, membership lists in the various guilds to which artists belonged name many more individuals than the number of artists whose works are documented. Thus, on the one hand there exists an enormous group of

material objects for which no early references or documentary sources are known; on the other, there is a large number of artists' names not associated with extant works of art. The temptation is strong to make such associations.

The scholar who is faced, then, with a sculpture or sculptural ensemble of interest for its iconography, its grandeur, its relationship to other works, and in particular, its similarity to a work or works by a known master, and who confronts an attributional void, seeks, by visual analyses, to find close stylistic or morphological connections to works of known provenance and authorship. The art of connoisseurship is the means by which an experienced eye attempts to support or contradict the limited information available from historical and documentary sources. But the method, as has been recognized more fully by specialists in painting than in sculpture, has many pitfalls. For one thing, in a given comparison what appear to be "striking similarities" of morphology, fold forms, contours, or expressive content in the eyes of one observer, may appear totally incompatible, a completely different artistic handwriting in the eyes of another. One critic's characterization of a "noble severity" of form may be expressed by another as a "rigid and mechanical" carving technique.[3] Sometimes evaluations are prejudiced by the state of preservation and the dirtiness or cleanliness of an object. Biases also result from the work's appearance in photographs, which can enhance or destroy a sculpture, and which often provide one's initial acquaintance with the object. And these same photographs are the tools employed in the final analysis at the scholar's desk and in the process of writing.

Of course, connoisseurship is not the only method employed by scholars when documents are lacking. Occasionally and increasingly, scientific methods such as radiocarbon dating in the examination of organic materials such as wood and ivory, and ultraviolet radiation to analyze stone surfaces, are employed to support or negate other types of investigation. For instance, carbon-14 dating of the wood from which an Annunciation group in the National Gallery of Art, Washington, D.C., was carved, attributed to Nino Pisano and about which some doubts had been expressed, has established that the polychromed Gabriel and Mary were executed from logs that date somewhere between the early twelfth and the late fourteenth century. This means only that the figures *could* be dated in the Trecento, but not necessarily that they were, for a later sculptor, even a modern

forger, might well have used an old log. Of course, had the carbon-14 dating placed the life of the wood in a much later century, then an attribution to Nino Pisano would have been precluded.[4] In the case of sculpture in stone, including marble, examination under ultraviolet radiation can help establish that a surface has been worked on recently, but this does not eliminate the possibility of an old sculpture undergoing cleaning or abrasion in modern times. In the absence of documentation, but when such laboratory testing is favorable to the proposed attribution, the role of the connoisseur again comes to the fore.

But the determination of authorship is not the only – and sometimes the least – area of interest to many scholars. Tools other than connoisseurship are often needed to determine the origin, form, or meaning of a work. A promising field of inquiry is one that has been employed for medieval limestone sculpture of France but not yet, to my knowledge, on Italian objects: The technique involves trace element analysis by neutron activation, and petrographic thin sections and mineralogical analyses, which can match the stone of a sculpture of unknown provenance with a monument or a known medieval quarry.[5] Finally, a project is currently under way employing computerized images, sometimes taken from the object with the help of mirrors, that permit viewing and analysis of portions of a sculpture virtually impossible as well as impracticable to see standing in front of it. Such images can show *and graphically document*, for example, breaks and cracks in otherwise inaccessible places.[6] Scientific techniques such as these, however, which sometimes require taking minute samples of the material, are time-consuming and expensive, and most museums and galleries do not have the resources for full investigations.

Archaeological investigations, which include the precise measurement of objects and analyses of the type of stone used, can be useful in determining the relationship of an errant object (for instance, a sculptural fragment in a museum) to its hypothetical provenance, say a tomb or an altar in a church. Such methods are frequently used as an aid in the hypothetical reconstruction of an entirely dismantled or fragmentary monument. Fruitful results of this type of investigation have been achieved in the study of Arnolfo di Cambio's monuments in Florence, Orvieto, and Rome.[7] However, it must be said that the large majority of scholars working in the field remain without access to the scaffolding, the lighting, the possibility of hands-on measurement, and the taking

of photographs of Italian monuments, all of which generally require large financial resources as well as permission from the Church (as an institution), individual churches, museums, and government authorities. In addition to the usual skills of art historical research, such as knowledge of languages, paleography for archival work, and connoisseurship, the scholar depends, then, on cooperative governmental and ecclesiastical bureaucracies, and it is the rare investigator who succeeds in overcoming all hurdles to such access. But even under the best of circumstances, the challenges, if deeply rewarding, are formidable and the conclusions are by their very nature tentative. An open mind and a willingness to be convinced, tempered by a healthy dose of skepticism, are the attributes necessary for the kind of detective work involved in the study of Italian Gothic sculpture.

DEVELOPING A MASTER'S OEUVRE: THE PROBLEM OF NINO PISANO

The sculptor Nino Pisano, son of Andrea, is the author of three signed works and two documented monuments, one of which is not extant.[1] The works signed by Nino are the *Madonna and Child* in Sta. Maria Novella, Florence; a *Madonna and Child* on the Cornaro monument in Santi Giovanni e Paolo in Venice; and a *Bishop Saint* in San Francesco, Oristano (Sardinia) (Figs. 204–6). Vasari, in the second edition of his *Lives*,[2] wrote that the Madonna in Sta. Maria Novella was begun by Andrea and completed by Nino and that it was Nino's first work. He then assigned to Nino the *Madonna and Child* (the so-called Madonna della Rosa) in Sta. Maria della Spina, the *Madonna del Latte* now in the Museo di San Matteo, and the Annunciation group in Sta. Caterina, all in Pisa (Figs. 184, 185, 209, 210). Vasari's assertions present serious problems: Whereas the three Pisan sculptures that he gave to Nino bear some stylistic relation to each other, any connection to the signed figures in Florence, Venice, and Oristano is remote. For this reason, some scholars have rejected one or another of the signed works, while others have rejected the Vasarian tradition and have attributed one or more of the Pisan sculptures to Andrea Pisano or others.[3] In addition, a host of other statues and reliefs have been attributed to Nino, to Andrea, to Nino in collaboration with his father, or to his brother Tommaso (who executed a large marble altarpiece in San Francesco, Pisa, probably c. 1370). The issue of attribution is compounded by extreme differences in the perception of the quality of individual works of art signed by Nino

or traditionally associated with his name. A scholar's assessment of a given sculpture naturally affects his or her view of its proximity to the master's own hand. To one observer the *Madonna del Latte* is second-rate, displaying as it does a "leaden dullness of expression,"[4] while to another it is the work upon which Nino's "claim to be considered a great sculptor must ultimately rest."[5] Variations on the themes of style and chronology have been numerous and contradictory, and they range from a very restricted number of sculptures attributed to Nino by one scholar to fifty or so works given to the master by another. In Chapter 4 I have offered my own conclusions regarding the development of Nino's style. The signed *Bishop Saint* would seem to be his earliest work: Not only does it reveal a number of awkward passages suggesting that the carver has not mastered every detail of his craft, but the basic conception of the human figure – the combination of an impulse toward a graceful Gothic torsion and a restraint upon that impulse that is physical as well as psychological – is closest to the ideals of Andrea. Nino then seems to have moved way from his father's classicizing style toward one highly receptive to northern Gothic influences, culminating in the *Madonna* in Sta. Maria Novella and in the Detroit Institute of Arts (Figs. 206, 208).

Nevertheless, none of the three recent monographs, each insisting on the correctness of their attributions, adequately takes into account the limitations of stylistic analysis in the absence of firm documentation.[6] Unfortunately, not every problem has a solution, and the assigning of this or that anonymous work to a known master eventually becomes a sort of game that can border on the absurd.[7] Nino Pisano, author of only two documented monuments, one of which is not extant (the Agnello monument), and three signed works – these, in my opinion, being the only reliable basis for further attributions – will remain "a problem" until and unless further documentation is discovered.

AN APPARENT FORGERY AND A NOTEWORTHY IMITATION

Occasionally works believed to be authentic turn out to be forgeries, and even the most experienced connoisseur can be misled. Here, too, documentation is generally nonexistent and one must rely on intimate knowledge not only of style but of working techniques and historical facts that might make for a plausible provenance. It has been justly claimed that to accept as authentic some-

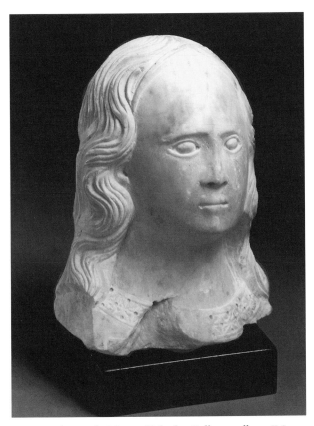

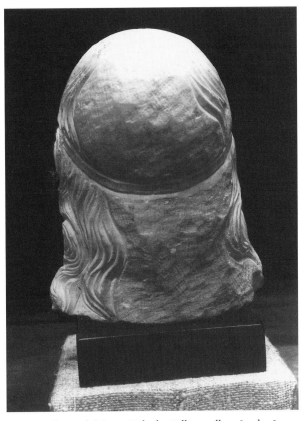

385. Female Head. Mount Holyoke College gallery [Mount Holyoke College Art Museum].

386. Female Head. Mount Holyoke College gallery [author].

thing that is a fake is an error, but to call something a fake that is authentic is a sin! Thus, works about which one has suspicions must be approached in much the same way as works about which one feels absolute certainty: with an open mind, caution, and even some humility.

A marble female head in the gallery at Mount Holyoke College (Figs. 385, 386) catalogued as an Italian work of the fourteenth century is a work whose authenticity was first questioned when it was included in a checklist for "The Census of Gothic Sculpture in America."[1] The piece is in fairly good condition although it is broken below the collar; damage extends to the lower portion of the hair on the left and the garment with collar on the left front. The head is finished on three sides but remains in the rough on the back with the exception of the hairband that continues completely around the head. Given carving practices during our period, this work on the hairband required unnecessary labor, thus raising minor doubts about its authenticity. Could one argue that the work was intended to be seen from all

sides but was simply not finished? The rough but careful chiseling of the back surface combined with the finished hairband strongly indicates that this is not so. Another curious element is the extremely high forehead, which is uncharacteristic of medieval art although it appears in Italy in the mid to late fifteenth century; however, our figure has few other affinities with this later period. The overlapping of the hairband by hair toward the front of the figure (visible in the side views) is also unusual if not unique. The planar surface of the break below the neck and the fact that in the back the edge tends toward a geometric curve could mean either that a broken surface was recarved to make it more regular or that there was an unconvincing attempt to create a "broken" statue.

The head is suspiciously close to that of an Annunciate Virgin in the Victoria and Albert Museum that had been labeled "Lombard, second half of the fourteenth century" (Fig. 387).[2] Although the upper part of the forehead and the hair are covered in the London work, the facial features with bulging eyes, thin nose, and

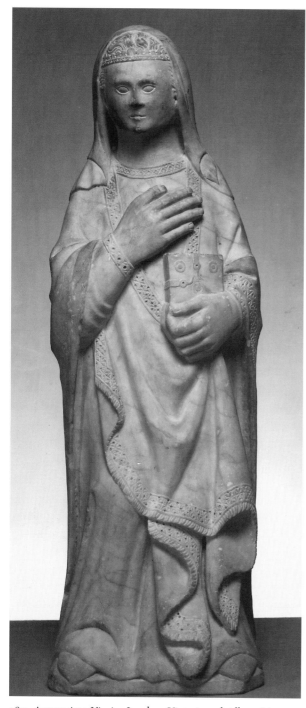

387. Annunciate Virgin. London, Victoria and Albert Museum [The Victoria and Albert Museum].

Italian Gothic and Renaissance sculpture confirmed initial doubts about the head. The weight of current opinion, then, favors rejecting the work as an authentic fourteenth-century Italian object; no alternative date and provenance have been suggested. The Head of a Woman and probably also the figure in London may very well be modern forgeries.[3]

It is important, however, to distinguish between a forgery, whose intent is to deceive for monetary gain, and a pre-twentieth-century imitation, motivated by the desire to restore a damaged work to its original splendor. (Although this was accepted practice in earlier centuries, during our own era such restorations have been under fire.) Arnolfo di Cambio's ciborium in San Paolo fuori le mura is a monument whose authenticity and integrity had never been questioned even though in 1823 a terrible fire destroyed a considerable portion of the basilica (cf. Figs. 62 and 388): The roof collapsed almost entirely, all but a few bays of the northern nave wall and its columns fell, and sections of the arcade even on the south side were damaged. Parts of the eastern end were

388. Luigi Rossini, post-fire view from transept of San Paolo fuori le mura, detail. Le antichità Romane, 1823 [Rome. Bibliotheca Hertziana].

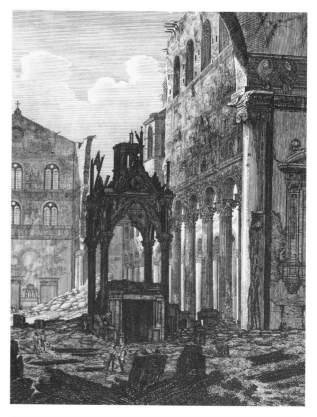

small mouth are virtually identical. Although the two sculptures resemble each other in certain details, no comparisons to authenticated Lombard works – or, for that matter, any other fourteenth-century sculptures – are convincing. Consultations with several specialists of

preserved, however, including the four columns and por-
tions of the superstructure of the ciborium, all of which
in turn helped to protect the relics of the apostle in the
confessio below. In the eyes of contemporaries the dra-
matic contrast between the extremely damaged basilica
and the preserved area of the *confessio* bespoke a mirac-
ulous intervention to preserve the relics. Not only did
contemporary witnesses and later nineteenth-century
writers reiterate the miraculous preservation of this area
with its precious relics, comparing it to the miracle of the
Three Hebrews in the Fiery Furnace,[4] but almost all
twentieth-century scholars writing on the ciborium
have maintained that little damage was done to the
monument and what we see today is essentially what
Arnolfo created in 1285.[5]

Let us take another look at the ciborium (Fig. 62). Sus-
picions might first be aroused by its apparently pristine
condition, for neither the architectural nor the sculp-
tural sections show any sign of charring or extensive
breakage, and the contours and edges of almost all the
architectural portions are sharp. Nevertheless, since the
corner niches, as revealed in all postfire illustrations
(Figs. 62, 388), appear to have remained intact, there
seems little reason to doubt that the figures in the niches
were not significantly damaged by the fire. But what
about the tympanum and spandrel reliefs? All four tym-
pana show flying angels holding roundels, derived from
Roman Victories supporting a *clipeus*. The angels on
three of the four tympana, including that on the western
face (Fig. 62), which is the least damaged from the evi-
dence of the engravings, are all of similar form. But
those on the eastern side present a number of anomalies:
First, this pair alone displays three-quarter rear views
with faces in profile (cf. Figs. 389, 390). Second, not only
do the wings not hug the roundel to form a contrived if
pleasing decorative symmetry as in antique prototypes,
but the closer wing projects in high relief while the rear
wing is pressed almost parallel to it against the back-
ground mosaic. This is not the formation employed by
Arnolfo in his slightly later ciborium of Sta. Cecilia (Fig.
68), where once again, on all four sides, the angels' wings
conform in an abstract, decorative manner to the general
shape of the roundel and the sloping field of the tympa-
num. Nor are the fleshy faces, the almost impressionis-
tic carving of the upturned pompadours, and the open
mouths easy to reconcile with any productions from
Arnolfo's workshop. Finally, one is struck by the posi-
tion of the legs: In contrast to the other three pairs, here
each angel has one knee sharply bent and the other,

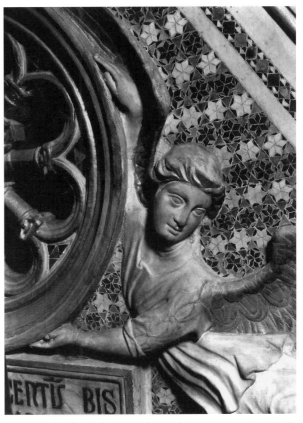

389. Arnolfo di Cambio: Angel on Ciborium. Rome, San Paolo
fuori le mura [Istituto Centrale per il Catalogo e la Documen-
tazione].

bulging slightly, presses hard against the drapery that
stretches tautly between the feet. Indeed, the drapery
lacks that favorite feature of Gothic painted and sculp-
tured garments, the zigzag or arabesque hemline, which
Arnolfo adapted from ancient sculpture and which
appears on all the other angels on the ciborium. If com-
parisons to autograph Arnolfo designs are difficult to
come by, a number of features of our questionable
angels do appear frequently in sculptures and paintings
of the Ottocento (cf. Figs. 390 and 391). Thus, there are
good reasons to doubt that all the angel reliefs on the
ciborium originate in the thirteenth century.

Turning to the mosaic background behind the angels
on the east face, one notes that while the effect of the pat-
terning is plausible from afar, closer examination shows a
rigid vertical and horizontal grid (Fig. 390) that contrasts
with the more variegated and irregular pattern behind
the western reliefs (Figs. 62, 389), which on both stylis-
tic grounds and the evidence of the postfire illustrations
must be considered authentic. These same differences can
be seen when we turn to the spandrels below: a complex,

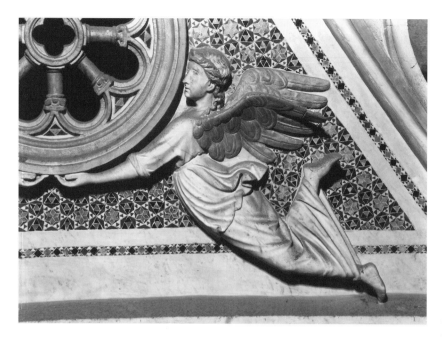

390. Angel on Ciborium, after 1823. Rome, San Paolo fuori le mura [Istituto Centrale per il Catalogo e la Documentazione].

somewhat irregular pattern behind Adam and Eve (Figs. 64, 65), versus a geometrically regular, unwavering pattern behind Abel and Cain with what appears to be a laborsaving expediency of scale (Figs. 392, 393). The figures of Adam and Eve are set against original mosaic backgrounds, and there is no reason to question that they were executed in Arnolfo's workshop. The figures of Cain and Abel, against the restored mosaic backgrounds, are of very different bodily proportions and anatomical struc-

391. Thorvaldsen: *Night and Day*. Copenhagen, Thorvaldsens Museum [Thorvaldsens Museum, Copenhagen].

ture. Although not especially masterly – the upper arms are disproportionately thin – they bespeak a more developed tradition, suggesting, in fact, study of the nude male figure.[6] Such study is indicated, first, by the proportions of Cain and Abel, which are considerably more attenuated than those of Adam and Eve, closer to the norm established in the Renaissance. The smoothly curved, anatomically correct contours of the thighs and the bent, spread toes also seem to be drawn from life (cf. Fig. 394) and appear in no other work by Arnolfo (cf. the rendering of the feet in Figs. 62 and 68, as well as in other analogously posed figures, such as the kneeling prophets over the entrance to the Presepio Chapel in Santa Maria Maggiore).[7] The flexibility of the toes of Cain and Abel is not, however, uncommon on nineteenth-century figures based on the study of the human body (Fig. 394, left). Furthermore, the drapery on Cain and Abel is a schematic simplification of Arnolfo's classicizing forms and does not resemble that of the figures on any other side. The facial features lack the classicizing stamp that characterizes both autograph and workshop productions, and the loosely falling, stringy hair is completely alien to the style of Arnolfo and his workshop.

Suspicions having now been strongly aroused, one seeks more information about the fate of the ciborium. In fact, it turns out that after the fire the tabernacle was completely dismantled and the parts temporarily set aside.[8] In 1840, almost two decades after its dismantling, the ciborium was reassembled and the high altar reconsecrated.[9] That same year an official of the basilica's restoration campaign, Luigi Moreschi, published a report concerning events related to the ciborium, a description of its reliefs, and a series of drawings showing both its state prior to the fire and several of the dismantled pieces. From the report we learn that the columns were scarred and cracked by the fire, necessitating reinforcement

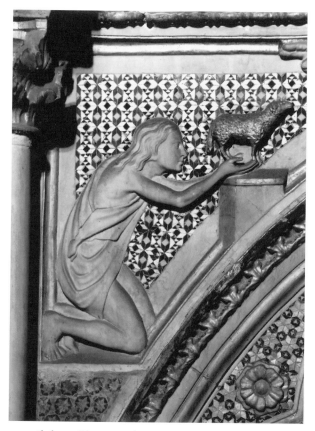

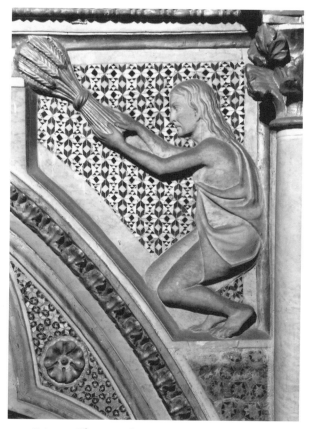

392. Abel on Ciborium, after 1823. Rome, San Paolo fuori le mura [Istituto Centrale per il Catalogo e la Documentazione].

393. Cain on Ciborium, after 1823. Rome, San Paolo fuori le mura [Istituto Centrale per il Catalogo e la Documentazione].

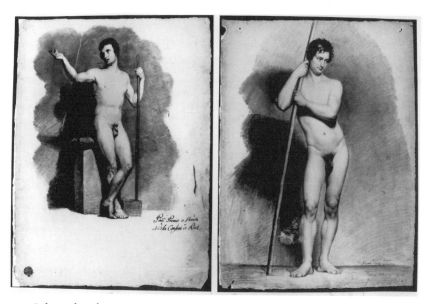

394. Life studies, between 1830 and 1840. Rome, Scuola del Nudo, Accademia di San Luca [Rome. Biblioteca Nazionale di San Luca].

with iron bands.[10] The present porphyry supports have no iron bands and show no evidence of fire damage; they must therefore be modern replacements.[11]

A search through published and archival reports in the Archivio di Stato in Rome related to the basilica's restoration informs us that during a visit by Pope Gregory XVI on 29 October 1836, one of several for the purpose of observing work in progress on the basilica's reconstruction and renovation, the pontiff entered the area where the preserved sections of the ciborium had been kept and noted that the architectural, sculptural, and ornamental parts, including the mosaics and the gilding, had been perfectly restored "con nuove opere imitanti strettamente il loro antico esemplare."[12] Thus, while the ciborium was still in its dismantled state in 1836, portions of it had undergone restoration in perfect imitation of the original damaged sections, and the pope was duly impressed.

Both visual and documentary evidence, then, strongly indicate that some portions of Arnolfo's ciborium underwent restoration after the fire of 1823. Although the nineteenth-century restorers made every attempt to emulate the style of Arnolfo and to reproduce the ciborium in a form as close as possible to the original, the motivation was not financial gain. Fame rather than fortune impelled the Benedictines of San Paolo and their designated restoration officials to restore to the Christian community a renowned and venerable monument that had miraculously preserved the relics of St. Paul.

A HYPOTHETICAL RECONSTRUCTION: NICOLA PISANO'S ARCA DI SAN DOMENICO

A vast number of monuments executed throughout history have come down to us in fragmentary form, with portions destroyed, altered, and/or dispersed. A major challenge for the art historian or archaeologist is to reconstruct, physically when possible and appropriate, but far more often hypothetically, the form and structure of the original work. Complicating matters, especially if a physical reconstruction is desired, is the fact that alterations are part of any monument's history, and a fifteenth-century change can hardly be justification for restoring a monument to its fourteenth-century condition.

The Arca di San Domenico, in the church of Bologna dedicated to the founder of the Dominican order, was originally executed c. 1264 by Nicola Pisano and his workshop but in subsequent centuries underwent exten-

sive alterations (Fig. 395).[1] Several scholars have attempted to reconstruct the original form by eliminating (in the imagination) the parts that clearly belong to later periods, by analyzing later monuments that seem to be based on Nicola's design, and by connecting to it various errant fragments that by measurement and on stylistic grounds can be associated with the saint's tomb. One fourteenth-century and one seventeenth-century document have also aided in a reconstruction, although the latter presented a major difficulty. Nevertheless, it has been possible to propose a plausible reconstruction based on all these factors.

The original form of the Arca is suggested (at least in a general way) by a document of 1335, in which the General Chapter of the Dominican Order (the Order of Preachers) stipulated that the projected Arca di San Pietro Martire (see Fig. 263), to be built in Sant'Eustorgio, Milan, must be of a form similar to that of the founder's tomb. The monument in Milan consists of a sarcophagus embellished with reliefs narrating the life of the saint; the sarcophagus is raised on pillars against which stand allegories of Virtues, and on its sloped cover there is a tabernacle with the Virgin and Child flanked by saints.

In the seventeenth century Michele Piò, author of a book on illustrious persons associated with the church of San Domenico, recorded the existence of several telamones lying around in San Domenico, Bologna, and commented that the sarcophagus of the tomb (which had already been extensively altered and was supported on a solid base) had originally been supported by "dodici Angeli, tre per ogni quadro,"[2] that is, twelve angels, three on each side. It had thus been assumed that the sarcophagus was originally supported by six caryatids (three beneath each longitudinal side of the sarcophagus). But John Pope-Hennessy proposed a different reconstruction (see Fig. 34a).[3] Accepting an earlier suggestion of Gnudi that a pair of trifigured supports, one in the Bargello and one in the Boston Museum of Fine Arts (Fig. 35) representing friars holding liturgical objects, belonged to the thirteenth-century Arca, Pope-Hennessy associated another three supports, the Archangels Gabriel and Michael (Fig. 36) in the Victoria and Albert Museum, London, and a figure of Faith in the Louvre, with the original tomb. He suggested that the sarcophagus was sustained not by six but by eight supports: the pair of three-figured telamones served as internal supports beneath the central axis of the sarcophagus while six single-figured angels (including the three in London and

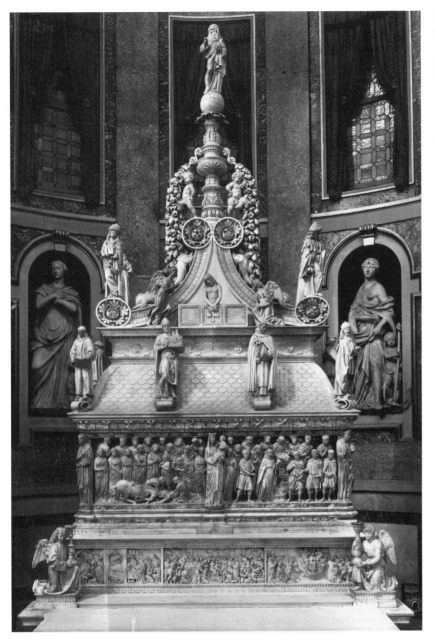

395. Arca di San Domenico, thirteenth to seventeenth centuries. Bologna, San Domenico [Alinari/Art Resource, New York].

Nicola's pulpit of Siena and the three bronze figures atop the Perugia fountain (Fig. 48). He also pointed out that the base of the London Gabriel corresponds to the form of a lower corner of the sarcophagus and thus probably supported that corner. How, then, does one explain the seventeenth-century statement regarding twelve angels, three on each side, since not all the extant figures, in fact, represent angels? Could the seventeenth-century writer have been mistaken? Indeed, Pope-Hennessy argued that Michele Piò had erred, and that his own reconstruction (Fig. 34a) comes closest to Piò's description; for while it includes eight supports, with three beneath the outer face (two at the corners and one in the middle) of each long side of the sarcophagus ("tre per ogni quadro"), and the two trifigured groups beneath the interior of the sarcophagus, there is, in fact, a total of twelve individual figures (albeit not all are angels).

Following Pope-Hennessy's published reconstruction, doubts were raised as to whether there was enough room beneath the sarcophagus for the placement of eight supporting elements. The present author then took measurements of the sarcophagus in San Domenico, which previous writers, including Pope-Hennessy, had failed to do. These measurements, and those of the extant figures, became the basis of a reconstruction of the original ground plan (Fig. 34b) that showed that eight figures could easily be accommodated, and indeed work well as supports for the saint's sarcophagus. If the basic reconstruction of Pope-Hennessy remains valid,[4] still open to discussion is the question of how the tomb terminated: Did the Arca di San Domenico have a sloped cover like the later Arca di San Pietro Martire, or a flat cover to associate the tomb visually with a preacher's pulpit – an appropriate symbol for the founder of the Order of Preachers?

Paris) stood beneath the outer surfaces of the two long sides of the sarcophagus (Fig. 34a). Missing still are two more Virtues (probably Hope and Charity) and the Archangel Raphael. Pope-Hennessy argued that freestanding multifigured groups, such as those in the Boston and Bargello museum, tend to be employed in the interior rather than at the periphery of the monuments to which they belong – as for example the Liberal Arts on

10

Conclusion

Our study of Italian sculpture spanning the second half of the thirteenth century through the end of the fourteenth has shown that the complex dialectic produced by the absorption, adaptation, rejection, and reinvention of diverse stylistic and iconographic currents, when combined with a creatively eclectic openness to everything that could serve local needs, resulted in an art that was neither a provincial branch of northern European Gothic nor a mere proto-Renaissance. Rather we have witnessed the flourishing of a unique artistic language, albeit one with many regional accents. Perhaps the most distinguishing characteristic of the sculpture of our period is precisely this creative eclecticism in which the balance of classical, northern Gothic, Italian Romanesque, and other influences – sometimes in harmony, sometimes in tension – shifted according to need and tradition. Yet, despite the forcefulness of regional imperatives, Italian Gothic sculpture is also characterized by the remarkable independence and individuality of personalities and workshops.

The remains of antiquity, virtually a constant on Italian soil, imposed standards of solidity and gravity in the expressive no less than the material

look of sculptured forms. The classical past profoundly informed both the individual and the civic identity of patron as well as creator; but that past was nevertheless filtered through historical circumstance and local tradition. Sculpture (no less than architecture) was called upon to fulfill the needs of the most varied urban societies, each with differing political and social traditions and customs; as a result, Italian sculpture remained highly site-specific (taken in the broadest sense). Where the status quo proved satisfactory, change was slow: In Lombardy, sculptors working early in the century persisted in the classicizing plastic ideals that had become the common language of both elite and vernacular production and paid scant attention to the more superficial decorative aspects of northern art so avidly accepted elsewhere. If at first there was little tension between local and foreign modes, toward the end of the century, at Milan cathedral, for instance, the pressures of potential incompatibility between the indigenous and the imported were keenly felt. The urban, cosmopolitan, and intellectual centers of Tuscany and Rome, where the classical impact remained strongest, were also more open early on to the seductions of transalpine influences. Impressed by northern achievements, sculptors quickly learned to invigorate traditional forms (and iconography) both internally and externally: internally, by conveying a sense of spiritual volition and reaction through physical movement and facial signs; and externally, through the adaptation of dynamic decorative and structural motifs deriving from French architecture and sculpture. At the same time, Central Italian masters, like their more conservative Campionese colleagues, tended to preserve the fundamental *gravitas* of the classical ideal. Venice, in contrast, almost immune from the straightjacket that classicism potentially imposed, privileged an alternative paradigm, one that spoke directly to a community whose adherence to traditional moral and governmental values was essential to civic order and the continuity of the republic. In Venetian sculpture, the human figure – whose actions, rather than being sublimated as exalted classical restraint, conveyed the complexities and dilemmas of the human condition – remained approachable, encouraging emotional and even psychological identification. Where society was dominated by the dynastic concerns of ruling families, such as in Naples and Milan, a particularly rich development in tomb sculpture is witness to those preoccupations. Where competition among rising urban commercial societies was keen, such as in Siena, Florence, and Orvieto, and commercial and ecclesiastical wealth could further civic

pride, we find an almost rampant inventiveness in new facade designs. Provincial areas as always remained more traditional, but they were hardly impervious to external influences. The result, as we have seen in several examples, was often a refreshing vernacular interpretation of modes of representation favored by powerful civil or princely authorities in the urban centers.

Notwithstanding – or, rather, in addition to – regional distinctions, almost all of Italy during our period is characterized by stylistic distinctions in the work of individual masters. More than in other regions of Europe, the head of a late thirteenth- and fourteenth-century Italian workshop imposed an individual identity – or perhaps more accurately, a "bottega" identity – on the productions coming forth from that shop; both in documents and through the works of art, one senses individual personalities sharply distinguished from others in neighboring or competing workshops. This holds true not just regarding the canonical artists such as Nicola and Giovanni Pisano but also masters whose names may never be securely known, such as the sculptor of the Crucifixion group in Verona, the master of the corner narratives on the Palazzo Ducale in Venice, or the creator of the works associated with Bonino da Campione in Lombardy. Each of these impresses us as a discrete artistic personality who in the end not only responds to local needs and patronage demands but also is capable of transcending collective identity.

Despite the numerous investigations and revelations of recent decades, the field of Italian Gothic remains extremely fertile ground for further research. Cultural studies and investigations of social and religious contexts will continue to enrich our understanding of developments in tomb monuments and devotional objects. Monographic approaches to individual artists, considered by many art historians to be out of date, will in my view be revived. New research, however, will be informed by our increased understanding of the collaborative nature of workshops during this period. Acknowledging the virtual inevitability of various hands in a complex project, close examination of monuments associated with a particular name, when combined with archival research and investigations into patronage, will surely have fruitful results. Finally, just as in other disciplines, multicultural studies and reevaluations of marginalized locales and productions have enlarged the canon, in ours, too, a willingness to explore the art produced outside the mainstream centers will offer unexpected and rewarding discoveries.

Notes

ONE. INTRODUCTION

Geography and Politics

1 Petrarch, *Canzioneri*, cxlvi, cited in John Larner, *Italy in the Age of Dante and Petrarch 1216–1380*, London and New York, 1980, 1.
2 Larner, *Age of Dante*, 1980; Lauro Martines, *Power and Imagination. City-States in Renaissance Italy*, New York, 1979, 111.
3 A trenchant description of the conditions of civic life in Florence during the Trecento is offered by Marvin Trachtenberg, *Dominion of the Eye. Urbanism, Art and Power in Early Modern Florence*, Cambridge, 1997, 3–8.
4 Despite the designation Papal States, the entity remained, according to J. K. Hyde, *Society and Politics in Medieval Italy*, New York, 1973, 125f., "a ramshackle confederation of independent communes rather than a state." On the history of the Papal States see also Peter Partner, *The Lands of St Peter. The Papal State in the Middle Ages and the Early Renaissance*, London, 1972.
5 Yves Renouard, *The Avignon Papacy. 1305–1403*, Hamden, Conn., 1970 (trans. Denis Bethell; orig. publ. 1954), 17.

6 In addition to the references in note 2, a useful survey of the history of Italy during our period is Brian Pullan, *A History of Early Renaissance Italy from the Mid–Thirteenth to the Mid–Fifteenth Century*, London, 1973.

Economic Growth, Socioreligious Factors, and the Intellectual Milieu

1 See Richard Goldthwaite, *Wealth and the Demand for Art in Italy 1300–1600*, Baltimore and London, 1993.
2 Goldthwaite, *Wealth and the Demand for Art*, 99.
3 Goldthwaite, *Wealth and the Demand for Art*, 81f. Goldthwaite, 131–34, notes that prior to the Black Death Florence had 126 institutions associated with church buildings, including about 50 parish churches. Even after the decline of population following the plague, ecclesiastical building and the production of liturgical apparatus continued to expand. On the competition regarding cathedrals, see Goldthwaite, 137–38.
4 Goldthwaite, *Wealth and the Demand for Art*, 140.
5 Richard Kieckhefer, "Major currents in late medieval devotion," in *Christian Spirituality. High Middle Ages and Reformation*, New York, 1987, 75–108.

6 On fundamental changes in outlook that began around the turn of the fourteenth century, see Gordon Leff, *The Dissolution of the Medieval Outlook. An Essay on Intellectual and Spiritual Change in the Fourteenth Century*, New York, 1976.

7 Kieckhefer, "Major currents."

8 Paul Oskar Kristeller, *Renaissance Thought and Its Sources*, New York, 1979, 99–101.

9 Quoted in Charles Trinkaus, *The Poet as Philosopher: Petrarch and the Formation of Renaissance Consciousness*, New Haven, 1979, 106.

10 It is interesting to note that although the humanist program, directed toward the revival of the culture of the ancients, is a Trecento phenomenon, the classicism of Italian Gothic sculpture had its origins earlier: As we shall see, Nicola Pisano's reinterpretations of ancient prototypes, beginning with his Pisa Baptistry pulpit of c. 1260, were informed by his earlier experience of the archaeological classicism promoted by the court of Frederick II, and were invigorated by new contact with the ancient remains prominently visible in Pisa itself.

The Practice of Sculpture

1 On the organization of workshops and guilds in Siena see Antje Middeldorf Kosegarten, *Sienesische Bildhauer am Duomo Vecchio. Studien zur Skulptur in Siena 1250–1330*, Munich, 1984, 13–22.

2 On Venetian guilds, and on the differences in the training and practice in the crafts in Tuscany and Venice, see Susan Connell, *The Employment of Sculptors and Stonemasons in Venice in the Fifteenth Century*, New York and London, 1988 (thesis, Warburg Institute, 1976), 222f. and passim.

3 Kosegarten, *Sienesische Bildhauer*, 16.

4 Because of the intimately collaborative nature of artistic production, it is frequently impossible to separate the hands of master and assistants. In the present study, only clearly divergent styles or documentary evidence for such separation is the basis for such designations as "assistant" or "follower." An assistant is to be understood as one who closely imitates the style and technique of the master but whose own artistic idiosyncracies emerge; a follower, in contrast, refers to a sculptor not in the master's workshop and thus further removed either stylistically or chronologically from the secure work of the master. In general, when a named artist is given, that name signifies both direct execution by the master and his closest supervision of and/or collaboration with a member of the bottega.

5 Kosegarten, *Sienesische Bildhauer*, 14f.

6 W. Wolters, *Scultura veneziana gotica*, Venice, 213.

7 See Louis Frank Mustari, "The Sculptor in the Fourteenth Century Florentine Opera del Duomo," Ph.D. dissertation, University of Iowa, 1975 (University Microfilms International, Ann Arbor, 1979), 29f. and passim.

8 Kosegarten, *Sienesische Bildhauer*, 121f.

9 A thorough discussion of the process of stone carving, from quarrying to installation and completion, is found in Peter Rockwell, *The Art of Stoneworking: A Reference Guide*, Cambridge, 1993. For a recent discussion of Tuscan marble carving and its civic context, see Francis Ames-Lewis, *Tuscan Marble Carving 1250–1350. Sculpture and Civic Pride*, Hants, England, and Brookfield, Vt., 1997.

10 On a "contract drawing" for a (destroyed) chapel for the Baroncelli family see Hannelore Glasser, *Artists' Contracts of the Early Renaissance*, New York, 1977, 121–25. The contract made between the executors of the Last Will of Archbishop Giovanni Scherlatti and Nino Pisano gives a rather precise description of the motifs and form of the tomb and refers to a "pictura" that the sculptor had furnished to the patrons. The document is published in Gert Kreytenberg, *Andrea Pisano und die toskanische Skulptur des vierzehnten Jahrhunderts*, Munich, 1984, 184, and Anita Fiderer Moskowitz, *The Sculpture of Andrea and Nino Pisano*, Cambridge and New York, 1986, 207.

11 Mustari, "The Sculptor in the Fourteenth Century Florentine Opera del Duomo," 181–236, on sculptural and architectural drawings or models, with bibliographical references.

12 Indeed, for the Duomo project in Milan, begun in 1387, there seems to have been a strict separation between design and execution of individual figures, capitals, and so on. See Francesca Tasso, "I Giganti e le vicende della prima scultura del Duomo di Milano," *Arte Lombarda*, 92/93, 1990, 1–2, 55–62.

13 On bronze casting, see Harry Jackson, *Lost Wax Bronze Casting*, Flagstaff, Ariz., 1972; Jennifer Montagu, *Bronzes*, London, 1963; Nicholas Penny, *The Materials of Sculpture*, New Haven, 1993; R. J. C. Rich, *The Materials and Methods of Sculpture*, New York, 1947; and Richard Stone, "Antico and the development of bronze casting in Italy at the end of the Quattrocento," *Metropolitan Museum Journal*, 1981, 87–116. For the casting of Andrea Pisano's bronze doors in Florence see Moskowitz, *Andrea and Nino Pisano*, 177f.

14 A useful discussion of the meaning and function of wood figures, with relevant bibliography, is given in John T. Paoletti, "Wooden sculpture in Italy as sacral presence," *Artibus et Historiae*, 26 (XIII), 1992, 85–100; it should be noted, however, that contrary to the author's statement, there are notable examples of wood figures that are less than life-size, for example, those associated with Lorenzo Maitani (see p. 146), and that within a particular iconographic type, wood was not necessarily the exclusive medium, for all subjects could be rendered in wood, ivory, stone, and so on.

15 Deborah Strom, "Studies in Quattrocentro Tuscan Wood Sculpture," Ph.D. dissertation, Princeton University, 1979, 1–7.

16 On ivory during the Middle Byzantine period, see Anthony Cutler, *The Hand of the Master. Craftsmanship, Ivory, and Society in Byzantium (9th–11th Centuries)*, Princeton, 1994. Although this book is not concerned with ivory carving in the West, it has a wealth of information applicable to the subject, for instance, the fact that medieval craftsmen chose, whenever possible, to work

with rather than against the grain. See also Anthony Cutler, *The Craft of Ivory. Sources, Techniques, and Uses in the Mediterranean World: A.D. 200–1400*, Washington, D.C., 1985.

17 Danielle Gaborit-Chopin, in Peter Barnet, *Images in Ivory* (exhibition catalogue), Princeton, 1997, 47f.

18 John Cherry, *Medieval Craftsmen. Goldsmiths*, Toronto, Buffalo, 1992; Michael Pinder, "Gold," *Dictionary of Art*, v. 12, London, 1996, 864–70.

19 See Irene Hueck, "Ugolino di Vieri e Viva di Lando," in *Il Gotico a Siena* (exhibition catalogue, 24 July–30 October 1982, Siena, Palazzo Pubblico), Florence, 1982, 190–95.

Italian Gothic Sculpture: The Background

1 M. F. Hearn, *Romanesque Sculpture*, Ithaca, 1981, 170. As noted frequently, however, closer connections are found between Italian works and contemporary sculpture in Provence.

2 C. D. Sheppard, "Classicism in Romanesque sculpture in Tuscany," *Gesta*, 15 (Essays in Honor of Sumner McKnight Crosby), 1976, 185–92. On portal sculpture see Dorothy Glass, *Portals, Pilgrimage and Crusade in Western Tuscany*, Princeton, 1997.

3 Rossana Bossaglia, "Un tracciato geografico per l'attività dei campionesi," in Rossana Bossaglia and Gian Alberto Dell'Acqua, eds., *I Maestri Campionesi*, Lugano, 1992, 23–33. Further subdivisions into families or schools are offered by Gian Alberto Dell'Acqua, "Fortuna critica dei maestri Campionesi," in this same volume, 9–21.

4 Dell'Acqua, "Fortuna critica dei maestri Campionesi," 9–21. On Antelami, see also Geza de Francovich, *Benedetto Antelami*, Milan, Florence, 1952; George H. Crichton, *Romanesque Sculpture in Italy*, London, 1954, 57–79; A. C. Quintavalle, *Il Battistero di Parma*, Parma, 1988, and now Chiara Frugoni, ed., *Benedetto Antelami e il Battistero di Parma*, Turin, 1995.

5 Paul Williamson, *Gothic Sculpture 1140–1300*, New Haven and London, 1995, 126f.

6 Compare Crichton, *Romanesque Sculture*, who asserts a Provençal influence, and Carl D. Sheppard, "Romanesque sculpture in Tuscany: A problem of methodology," *Gazette des Beaux-Arts*, 1959, 98–108, and George Zarnecki, *Art of the Medieval World*, Englewood Cliffs, N.J. and New York, 1975, 278, who are of the opposite opinion. See also Dorothy Glass, *Portals*, 66, who rejects arguments concerning the primacy of France or Italy, postulating instead a "Mediterranean Romanesque" that is one among many coexisting styles during the period.

7 On Biduino see Carmen Gomez-Moreno, "The doorway of San Leonardo al Frigido and the problem of master Biduino," *Bulletin of the Metropolitan Museum*, XXIII, 1964–65, 349–61; Thomas Hoving, "Italian Romanesque sculpture," *Bulletin of the Metropolitan Museum*, XXIII, 1964–65, 345–48; Lisbeth Castelnuovo Tedesco, "Romanesque sculpture in North American collections," *Gesta*, XXIV, 1985, 71–73, with preceding bibliography, and now Dorothy Glass, *Portals*, 32–36, who suggests a date for the portal between 1175 and 1185 and rejects the attribution to Biduino.

8 On Guido Bigarelli, see Maria Teresa Olivari, "Le opere autografe di Guido Bigarelli da Como," *Arte Lombarda*, X/2, 1965, 33–44; V. Ascani in *Enciclopedia d'Arte Medievale*, v. 3, Rome, 1992, 508–13.

9 Antonino Caleca, *La Dotta Mano. Il Battistero di Pisa*, Bergamo, 1991, 71–95 (including excellent color illustrations).

10 Guido's pulpit is alone, however, among the Tuscan Romanesque pulpits inspired by Guglielmo's, in taking up the articulation in two registers of historiated reliefs. See also the discussion of pulpits in Chapter 8.

11 On the Capuan Gate, see the essays by Meredith, Pace, and Sauerländer, with bibliographical references, in William Tronzo, ed., *Intellectual Life at the Court of Frederick II Hohenstaufen*, Washington, D.C., Hanover, and London, 1994.

12 The literature on the art of the Frederick II era is voluminous. Recent studies include the essays in Theo Kölzer, ed., *Die Staufer im Süden. Sizilien und das Reich*, Sigmaringen, 1996; *Federico II e l'antico* (atti del convegno – Foggia 30 Marzo 1995), Foggia, 1997; and *Federico II e l'Italia*, Rome, 1995. (Concerning the issues raised here see in particular the essays in each of these volumes by Valentino Pace.)

13 On the practice of transferring martyrs' bones from the catacombs to within the city and in antique sarcophagi, see R. Lanciani, *Storia degli Scavi di Roma*, 4 vols., Rome, 1902–12; Ingo Herklotz, "Sepulcra" e "Monumento" del Medioevo, Rome, 1985, 85ff.

14 On Venice's creation of civic history with an ancient pedigree, see now Patricia Fortini Brown, *Venice and Antiquity. The Venetian Sense of the Past*, New Haven and London, 1996.

15 J. J. Pollitt, *Art and Experience in Classical Greece*, Cambridge, 1972, 195.

16 Frederick Antal, *Florentine Painting and Its Social Background*, London, 1948, 12ff.; John Larner, *Culture and Society in Italy, 1290–1420*, New York, 1971, 22ff.

17 Cesare Gnudi, "Il Reliquiario di San Luigi Re di Francia in S. Domenico a Bologna," *Critica d'Arte*, n.s. 3, 1956, 535–39; Ulrich Middeldorf and Martin Weinberger, "Französische Figuren des Frühen 14. Jahrhunderts in Toskana," *Pantheon*, 1, 1928, 187–90; Max Seidel, "Die Elfenbeinmadonna im Domschatz zu Pisa," *Mitteilungen des Kunsthistorischen Institutes in Florenz*, 16, 1972, 1–50; R. Wallace, "L'influence de la France gothique sur deux des précurseurs de la Renaissance Italienne: Nicola et Giovanni Pisano," Ph.D. thesis, University of Geneva, 1953. See also the essays in Valentino Pace and Martina Bagnoli, eds., *Il Gotico europeo in Italia*, Naples, 1994.

18 Julian Gardner, "Il patrocinio curiale e l'introduzione del gotico: 1260–1305," in Pace and Bagnoli, eds., *Il Gotico europeo in Italia*, 85–88.

19 E. Mâle, *The Gothic Image. Religious Art in France of the Thirteenth Century*, trans. by D. Nussey, New York, Evanston, Ill., London, 1958, 23.

20 For instance, the Mirror of Instruction begins with the Fall of Man, the immediate consequence of which is the necessity for toil, and the ultimate consequence of which is the need for redemption. The Mechanical Arts are invented to fulfill man's physical needs while the Liberal Arts develop his intellectual capacity to distinguish good from evil and assist in making him worthy of grace. The fourth book, the Speculum Morale, although written by Vincent, was added after 1310 by an anonymous compiler. For more on this see the section on *The Companile* in Chapter 4 and "The Sculptured Cathedral Facade" in Chapter 8.

21 See the sections on Andrea Pisano in Chapter 4 and on the Cathedral facade in Chapter 8.

22 Willibald Sauerländer, "Dal Gotico europeo in Italia al Gotico italiano in Europa," in Pace and Bagnoli, eds., *Il Gotico europeo in Italia*, 8–21.

TWO. CENTRAL ITALY C. 1250–C. 1310

Nicola Pisano

1 On this issue as it concerns Italian Gothic architecture, see Marvin Trachtenberg, "Gothic/Italian 'Gothic': Toward a Redefinition," *Journal of the Society of Architectural Historians*, L/1, 1991, 22–37.

2 Documentary references to the sculptor as Nicholas of Apulia indicate that his origins lie in southern Italy, in the region embraced by Frederick II's Holy Roman Empire. The documents relative to Nicola Pisano were published by G. Nicco Fasola, *Nicola Pisano*, Rome, 1941, 207–18. For discussions and bibliographic references concerning the cultural milieu of southern Italy during the time of Frederick II, and Nicola's probable origins there, see Ferdinando Bologna, *I Pittori alla Corte Angoina di Napoli*, Rome, 1969, 26–36, and Maria Laura Testi Cristiani, *Nicola Pisano architetto scultore*, Pisa, 1987, 9–26.

3 The association of these heads with Nicola Pisano was suggested by Enzo Carli, *Il Duomo di Siena*, Siena, 1979, 17f., and following restorations on the Duomo in 1980, elaborated on by Alessandro Bagnoli, "Novità su Nicola Pisano scultore nel Duomo di Siena," *Prospettiva*, 27, October 1981, 27–46; see also Testi Cristiani, *Nicola Pisano*, 69–84.

4 Emblematic of the intellectual climate promoted by Frederick II is his expressed aim, in his book on birds, *manifestare ea quae sunt sicut sunt* ("to reveal those things which are, as they are"). Quoted in John Larner, *Culture and Society in Italy. 1290–1420*, New York, 1971, 37f. See also the chapter "Science at the Court of the Emperor Frederick II" in Charles Homer Haskins, *Studies in the History of Mediaeval Science*, New York, 1927 (reprinted 1967), 242–71. For a less sympathetic view of science at Frederick's court see David Abulafia, *Frederick II. A Medieval Emperor*, London, 1988, 252–70.

5 For the bear and lion console see Bagnoli, "Novità su Nicola Pisano," fig. 29. Precedents for the heads are seen in the capitals at Troia and in the Metropolitan Museum of Art, which show a comparable but less developed mimesis of the natural world. On the capitals see Cesare Gnudi in Angiola Maria Romanini, ed., *Frederico II e L'Arte del Duecento Italiana*, Galatina, 1980, 1–17; Bologna, *I Pittori alla Corte Angionia di Napoli*; and Vera K. Ostoja, "To Represent What Is as It Is," *Metropolitan Museum of Art Bulletin*, 23, June 1965, 367–72. Regarding the Siena console heads, as in the case of the Isaac Master and the author of the upper-story frescoes in San Francesco, Assisi, the art historian is faced with an attributional void: Specific Morellian comparisons are difficult to make between Nicola's known work and this attributed series; yet there is no other comparable master whose name has come down to us or to whom we can attribute other sculptures. Thus, the attribution to Nicola is an art historical convenience not, however, lacking in plausibility. On the methodological problems of attribution see Chapter 9.

6 Richard Kieckhefer, "Major Currents in Late Medieval Devotion," in *Christian Spirituality. High Middle Ages and Reformation*, New York, 1987, p. 77.

7 Kieckhefer, "Major Currents."

8 According to some scholars, Nicola may have been the architect responsible for the second phase of construction of the Baptistry of Pisa, which includes work on the interior second-story ambulatory vault and exterior gallery, as well as the sculpture embellishing that gallery. Affinities between some of the heads on the exterior gallery of the Pisa Baptistry and the console heads beneath the cupola of Siena cathedral have suggested either that the former are contemporary with the latter, executed during Nicola's putative sojourn in Siena beginning c. 1245 (Antonio Caleca, *La Dotta Mano. Il Battistero di Pisa*, Bergamo, 1991, 97–99), or c. 1270 following the completion of the Siena pulpit (Antje Kosegarten, "Die Skulpturen der Pisani am Baptisterium von Pisa," *Jahrbuch der Berliner Museen*, X, 1968, 14–100).

9 The pulpit bears the inscription ANNO MILLENO BIS CENTUM BISQQUE TRICENO / HOC OPUS INSINGNE SCULPSIT NICOLA PISANUS / LAUDETUR DINGNE TAM BENE DOCTA MANUS. (In the year 1260 Nicola Pisano carved this noble work. May so greatly gifted a hand be praised as it deserves; translation in John Pope-Hennessy, *Italian Gothic Sculpture*, London and New York, 1972, 170). The Pisan year began on the day of the conception of Christ; thus 1260 extended from 25 March 1259 to 24 March 1260.

10 On the symbolism inherent in the choice of circle, octagon, and hexagon see Eloise M. Angiola, "Nicola Pisano, Federico Visconti, and Classical Style in Pisa," *Art Bulletin*, LIX, 1977, 1–27.

11 The Phaedra sarcophagus was reused in 1076 for the burial of Countess Beatrice of Tuscany. See Isa Ragusa, "The Re-use and Public Exhibition of Roman Sarcophagi during the Middle Ages and the Early Renaissance," M.A. thesis, Institute of Fine Arts, New York University, 1951. Angiola, "Nicola Pisano," argues that given Pisa's strong classical traditions and highly visible ancient remains, Nicola's classicism served to reinforce Pisa's historical

consciousness of its ancient origins, a consciousness fostered by the Archbishop Federico Visconti as part of the political and civic renewal of the commune. Although this argument is persuasive, her conclusion that Nicola's classicism must be seen entirely as retrospective, a stylistic anachronism, fails to fully acknowledge the revolutionary use for which such classicism was employed.

12 Compare Angiola, "Nicola Pisano," who offers an alternative identification for the nude figure as Daniel, as well as giving alternatives for other of the corner figures below the reliefs, basing her interpretations on the Archbishop Visconti's sermons; her reidentifications have not been widely accepted. See John White, *Art and Architecture in Italy*, 3rd ed., New Haven and London, 1993, 78.

13 The differences in scale between figure and field from the first to the later narratives have generally been attributed to Nicola's development from a more classicizing mode to one more open to the expressive and pictorial elements of northern Gothic art. While this is undoubtedly true, the shift in scale on the Pisa pulpit must also derive from Nicola's sensitivity to the position of the spectator.

14 Unfortunately, as noted by Marvin Trachtenberg (*Dominion of the Eye. Urbanism, Art and Power in Early Modern Florence*, Cambridge, 1997, 185–94), most photographs of the narrative reliefs are taken from too high a viewpoint, for they were clearly conceived, and are certainly most effective, from below. For instance, the spectator standing on the ground below the *Crucifixion* is confronted, as from no other viewpoint, with the faces of the two companions of the swooning Mary, so their sorrowful expressions become evident.

15 Testi Cristiani, *Nicola Pisano*, 290ff.

16 David Herlihy, *Pisa in the Early Renaissance. A Study of Urban Growth*, New Haven, 1958, 41 and passim.

17 Herlihy, *Pisa*, 162ff.

18 Angiola, "Nicola Pisano," 1–27; Caleca, *La Dotta Mano*, 123f.

19 On the use of pulpits for preaching see Adriani Götz, *Der mittelalterliche Predigtort und seine Ausgestaltung*, Stuttgart, 1966 (Ph.D. dissertation, University of Tubingen).

20 Fasola, *Nicola Pisano*, 207ff.

21 The fundamental study is that of Cesare Gnudi, *Nicola, Arnolfo, Lapo. L'Arca di San Domenico a Bologna*, Florence, 1948.

22 As seen today (Fig. 395) in a chapel built in the fifteenth century, the Arca di San Domenico is an elaborate monument that comprises sculptural and decorative components extending from the thirteenth through the sixteenth centuries, including contributions by Niccolò dell'Arca and Michelangelo. The tomb has been moved and extensively altered several times; the sarcophagus and five of the originally eight caryatids are extant, these last in the Boston Museum of Fine Arts, the Louvre, and the Bargello. On the Arca see pp. 322f. and Anita Fiderer Moskowitz, *Nicola Pisano's Arca di San Domenico and Its Legacy*, University Park, 1994.

23 On the use of gilt and polychromed glass as background for relief sculpture, which seems to have been introduced in Italy by Nicola Pisano on the Arca di San Domenico and the contemporary pulpit in Siena, see Georg Swarzenski, "Das Auftreten des Églomisé bei Nicolo Pisano," *Festschrift zum Sechzigsten Geburtstag von Paul Clemen*, Düsseldorf, 1926, 326–28.

24 Zauner, *Die Kanzeln Toskanas aus der romanischen Stilperiode*, Leipzig, 1915, 11.

25 Moskowitz, *Arca*, 22.

26 Moskowitz, *Arca*, 15–23.

27 See Moskowitz, *Arca*, Fig. 30.

28 Fasola, *Nicola Pisano*, 209–14; Enzo Carli, *Il pulpito di Siena*, Bergamo, Milan, Rome, 1943, 41–43.

29 See Carli, *Il pulpito di Siena*, 48f., and Carli, *Il Duomo di Siena*, 33f., for the alterations and location changes of the pulpit. On the internal arrangement of the dome area during the thirteenth century and in particular the position of the pulpit, see Kees Van der Ploeg, *Art, Architecture and Liturgy. Siena Cathedral in the Middle Ages*, Groningen, 1993, 94f. In 1543 the pulpit was moved to its present location on the north side; its original emplacement can be seen in a panel dated 1483; see L. Borgia et al., eds., *Le Biccherne. Tavole Dipinte delle Magestrature Senesi (secoli XIII–XVIII)*, Rome, 1984, Pl. 72.

30 Carli, *Il Duomo di Siena*, 33.

31 Max Seidel, "Die Verkündigungsgruppe der Siena Domkanzel," *Münchner Jahrbuch der Bildenden Kunst*, XXI, 1970, 18–72; cf. Carli, *Il Duomo di Siena*, 34, who offers an alternative, less convincing, reconstruction of the placement of the Berlin Angel of the Annunciation.

32 The social context for the inclusion of the Liberal Arts is suggested by two factors: the power and influence of the Dominican Order in Siena, and the requirements for a high level of literacy in a particularly well-developed and extraordinarily record-prone civil bureaucracy. This aspect of Sienese society (without reference to the pulpit) is discussed by Daniel Waley, *Siena and the Sienese in the Thirteenth Century*, Cambridge, New York, 1991, 128f., 155–59.

33 On the representation of race in medieval art, see Wolfram Prinz, "I Tatari nella pittura italiana del Trecento," in *Studi di storia dell'arte sul medioevo e il rinascimento nel centenario della nascità di Mario Salmi*, v. 1, Flor. 1992, 415–29; J. Devisse and M. Mollat, *The Image of the Black in Western Art*, v. II, *From the Early Christian Era to the "Age of Discovery*," Cambridge, Mass., 1979. On Frederick II's travels, including a trip of 1247 to Siena, see E. Kantoriwicz, *Kaiser Friedrich der Zweite*, Berlin, 1927, 286ff.

34 On the sculptures for the Baptistry exterior, see Kosegarten, "Die Skulpturen der Pisani am Baptisterum von Pisa," 36–100, extensively illustrated. Here collaboration between father and son, and the increasingly expressive quality of Nicola's work, make the problem of attribution difficult. Concerning another work by Nicola, a document of 1273 describes a (lost) altar for the cathedral of Pistoia; see Peleò Bacci, *Documenti Toscani per la Storia dell'Arte*, v. 1, Florence, 1910, 74–78.

35 On the ideological and civic importance of the intersection

of the main roads of a city and the choice of such a site for civic fountains, see Ulrich Schulze, *Brunnen im Mittelalter. Politische Ikonographie der Kommunen in Italien*, Frankfurt am Main, 1994, 13–16.

36 On Perugia's urban development see Sarah Rubin Blanshei, *Perugia, 1260–1340: Conflict and Change in a Medieval Italian Urban Society* (Transactions of the American Philosophical Society), n.s. 66/2, Philadelphia, 1976, 25; Jonathan B. Riess, *Political Ideals in Medieval Italian Art. The Frescoes in the Palazzo dei Priori, Perugia (1297)*, Ann Arbor, 1981, 8ff.

37 The history of the project is given by Giusta Nico Fasola, *La Fontana di Perugia*, Rome, 1951, 7–11; see also G. N. Fasola, "Gli inizi della Fontana di Perugia," *Studi Medievali*, 17, 1951, 124–30. Other aspects of the fountain are discussed in Francesco Cavallucci, *La Fontana Maggiore di Perugia*, Perugia, 1993; and John White, "The reconstruction of Nicola Pisano's Perugian Fountain," *Journal of the Warburg and Courtauld Institute*, 33, 1970, 71–83.

38 These associations are discussed by Kathrin Hoffmann-Curtis, *Das Programm der Fontana Maggiore in Perugia*, Düsseldorf, 1968, and Schulze, *Brunnen im Mittelalter*.

39 For example, see Schulze, *Brunnen im Mittelalter*, Figs. 42–44.

40 A similar off-beat rotational rhythm is seen in the relationship of the two upper stories of the exterior of the Pisa Baptistry cupola: The gables of the second and third level are not lined up, resulting in a syncopated pattern. This part of the design has been ascribed to Nicola Pisano on the basis of the sculptural style and his presumed extended sojourn in Pisa (which justified his Pisan citizenship, mentioned in a document of 1258, and his signature as a Pisan on the pulpit of 1260). On the upper stories of the Baptistry, see Kosegarten, "Die Skulpturen der Pisani," 1969.

41 See Ottorino Gurrieri, *Il Palazzo dei Priori di Perugia*, Perugia, 1985, 10f.; Riess, *Political Ideals*, 17f.; Carlo Martini, "Il Palazzo dei Priori a Perugia," *Palladio*, 20, 1970, 39–72; for the thirteenth-century Palazzo del Popolo, see Martini's Fig. 20, p. 57.

Arnolfo di Cambio

1 A proposal, first made by Karl Frey (in Ulrich Thieme and Felix Becker, *Allgemeines Lexikon der bildenden Künstler von der Antike bis zur Gegenwart*, v. 2, Leipzig, 1908, 135–44) and based on the wording in different documentary references, that there were two Arnolfos, one an architect (who designed the cathedral, Sta. Croce, and the Badia of Florence) and the other a sculptor, has been universally discarded. Arnolfo di Cambio has been the subject of intensive stylistic and archaeological study by Angiola Maria Romanini: *Arnolfo di Cambio e lo Stil Novo del Gotico Italiano*, Milan, 1968, Florence, 2nd ed., 1980; "Arnolfo e gli 'Arnolfo' apocrifi," *Roma Anno 1300*, Rome, 1983, 27–51; "Nuove ipotesi su Arnolfo di Cambio," *Arte Medievale*, no. 1, 1983, 157–220; "Ipotesi ricostruttive per i monumenti sepolcrali di Arnolfo di Cambio," in *Skulptur und Grabmal des Spätmittelalters in Rom und Italien*,

Vienna, 1990, 107–28. A recent overview and bibliography is given in Enzo Carli, *Arnolfo*, Florence, 1993.

2 On the attributions to Arnolfo and others of portions of the Arca di San Domenico, see Cesare Gnudi, *Nicola, Arnolfo, Lapo. L'Arca di San Domenico a Bologna*, Florence, 1948; on the Siena pulpit, see Enzo Carli, *Il pulpito di Siena*, Bergamo, 1943; Carli, *Arnolfo*, 7–17.

3 For a history of the attributions of the Charles of Anjou statue, see Valentino Pace, "Questioni arnolfiane: l'Antico e la Francia," *Zeitschrifte für Kunstgeschichte*, 54/3, 1991, 335–73. The radical reworking of surfaces, removal of polychromy, and modern additions came to light during a recent restoration; see Giovanna Martellotti, "Il Carlo d'Angiò Capitolino. Riflessioni dopo il Restauro," *Arte Medievale*, II Serie, Anno V, n. 2, 1991, 127–47.

4 Documents regarding Arnolfo have been gathered together in Harry Mayfield Dixon, II, "Arnolfo di Cambio: Sculpture," Ph.D. dissertation, SUNY Binghamton, 1977, 149–58; the problems regarding Arnolfo's death date are summarized on pp. 17–19.

5 Distressing as it appears to modern sensibilities, the practice of employing *spolia*, the remains of ancient sculpture and architecture, not for reuse as architectural members such as columns for churches but as quarry to be carved anew on the rear surfaces, was common during the Middle Ages. It is documented, in particular, for Arnolfo di Cambio: The portrait of Charles d'Anjou in the Capitoline was carved from a colossal fragment of an ancient molding (Martellotti, "Il Carlo d'Angiò Capitolino," 127–47); many parts of the ciborium in San Paolo fuori le mura are carved from blocks of *spolia* (A. Moskowitz, "Arnolfo, non-Arnolfo: New (and some old) observations on the Ciborium in San Paolo fuori le mura," *Gesta*, XXXVII/1, 1998, 88–102, with earlier references); and a portion of the sarcophagus of Boniface VIII in the Vatican grotto is a reworked antique sarcophagus slab (Romanini, "Ipotesi," 122; Julian Gardner, *The Tomb and the Tiara. Curial Tomb Sculpture in Rome and Avignon in the Later Middle Ages*, Oxford, 1992, 108 n. 95). It would seem that Charles is offering this labor- and cost-saving opportunity to the Perugians. On Arnolfo's use of *spolia*, see Anna Maria D'Achille, "La Scultura," in Angiola Maria Romanini, ed., *Roma nel Duecento. L'arte nella città dei papi da Innocenzo III a Bonifacio VIII*, Turin, 1991, 145–235; more generally on the reuse of antique remains see Salvatore Settis, "Tribuit sua marmora Roma: sul reimpiego di sculture antiche," *Lanfranco e Wiligelmo. Il Duomo di Modena*, Modena, 1984, 309–17; idem, "Continuità, distanza, conoscenza. Tre usi dell'antico," in *Memoria dell'antico nell'arte italiana*, vol. 3, *Dalla tradizione all'archeologia*, Turin, 1986, 375–486.

6 The most recent complete discussion of the fountain is found in Gustavo Cuccini, *Arnolfo di Cambio e la fontana di Perugia "Pedis Platee,"* Perugia, 1989. For interpretations of the fountain program see Maria Di Fronzo, "I modelli degli 'Assetati' di Arnolfo di Cambio," *Arte Medievale*, III/2, 1989, 93–113. See also Adolf Reinle, "Zum Programm des Brunnens von Arnolfo di Cambio in Perugia 1281," *Jahrbuch der Berliner Museum*, 22, 1980, 121–51.

7 Compare the figure to that of Mary Magdalene of the *Noli Me Tangere* in the Arena Chapel, Padua.

8 For Early Christian and Roman models for the "Thirsty Ones," see Di Fronzo, "I modelli."

9 The reasons for its destruction are not known. They may have had to do with the continuing problem of bringing enough water to the site, the failure of which made the fountain more of an embarrassment than a cause for celebration. See Cuccini, *La Fontana*, 114–16.

10 It has been suggested (Cuccini, *Fontana*) that there were two superimposed basins with the seated figures on a different level from the "Assetati." From the evidence of their glances it would seem, indeed, that the latter looked toward an intermediary element on a higher level, a figure or perhaps the water spout that filled the basin.

11 The place of the Arca di San Domenico in the history of sepulchral art is discussed in Moskowitz, *Arca di San Domenico*.

12 On Arnolfo's tomb designs, see most recently Gardner, *Tomb and Tiara*, 95–109. Gardner points out that the previously employed spelling of the cardinal's name (de Braye), which refers to his place of origin, is incorrect; Guillaume came from Bray-sur-Somme. The church of San Domenico was built in 1234, enlarged in the 1260s during the height of Dominican activity, but radically altered in the late sixteenth century; see Renato Bonelli, "La chiesa di San Domenico in Orvieto," *Palladio* VI (1943), 139–51.

13 Angiola Maria Romanini, "Une statue romaine dans la Vierge De Braye," *Revue de l'Art*, 105, 1994, 9–18. Given Arnolfo's assimilation and reuse of the antique, it is not surprising that more than one "Arnolfian" figure has been the subject of lively controversy regarding an antique vs. a thirteenth-century origin, e.g., the stone and bronze enthroned figures of St. Peter in the Vatican basilica. See A. M. Romanini, "Nuovi dati sulla statua bronzea di San Pietro in Vaticano" (pp. 1–49); S. Angelucci, "Primi risultati di indagini tecnico-scientifiche sul San Pietro di bronzo della Basilica Vaticana" (pp. 51–58); P. Refice, "Le chiavi del Regno: analisi documentarie e iconografiche sul San Pietro bronzeo vaticano" (pp. 59–64); R. Caglianmone and A. Iazeolla, "Note sul relievo della statua bronzea di San Pietro nella Basilica Vaticana" (pp. 65–71), all in *Arte Medievale*, II s., IV/2, 1990; also A. M. Romanini, "I colori di San Pietro," *Aachener Kunstblätter*, 60, 1994, 267–74.

14 According to Romanini, "Une statue romaine," later restorations include the head of Christ and the left hand of the Madonna, probably inserted after damage in the seventeenth century.

15 Gardner, *Tomb and Tiara*, 98–102.

16 Romanini, "Ipotesi," 112f.

17 Above, on the back wall of the aedicula of the Clement IV tomb, there was an image of the Madonna and Child and nearby a kneeling and praying saint acting as intercessor. Peter C. Claussen, *Magistri Doctissimi Romani. Die Römischen Marmorkünstler des Mittelalters*, Stuttgart, 1987, 185–99.

18 Although the motion of the acolytes has most often been interpreted as one of drawing the curtains closed on the car-

dinal's earthly life (see Angiola Maria Romanini, "Nuove ipotesi su Arnolfo di Cambio," *Arte Medievale*, v. 1, 1983, 157–220; Herklotz, "Sepulcra," 193–99; John White, *Art and Architecture in Italy*, 1993, 96), the curtain rings, as Gardner has noted ("Arnolfo di Cambio and Roman tomb design," *Burlington Magazine*, cxv/844, 1973, 420–39), are clearly in the process of being compressed.

19 On the relationship between tomb effigies with their funerary paraphernalia and real-life ceremonial procedures, see Herklotz, "Sepulcra," 193, and Robert Brentano, *Rome before Avignon*, New York, 1974, 68.

20 Herklotz, "Sepulcra," 191; Max Seidel, "Adsit ei angelus Michael. Eine neu Entdeckte Skulptur von Giovanni Pisano," *Pantheon*, 46, 1988, 5–12.

21 The tomb, previously believed to belong to the Cardinal Riccardo Annibaldi della Molara (d. 1276), is probably that of his nephew, the papal notary Riccardo Annibaldi, who died in 1289; this discovery has necessitated a revision of Arnolfo's traditional chronology. See Herklotz, "Sepulcra," 179ff. On the tomb see Gardner, *Tomb and Tiara*, 104–6.

22 ". . . tenentur missam cotidie celebrare." A reconstruction of the tomb, proposed by Romanini, "Ipotesi," 107–28, has been rejected by Gardner, *Tomb and Tiara*, 105f.

23 Paul Hetherington, *Pietro Cavallini. A Study in the Art of Late Medieval Rome*, London, 1979 (esp. 81–106); Valentino Pace, "Committenza benedettina a Roma: il caso di San Paolo fuori le mura nel XIII secolo," *Zeitschrifte für Kunstgeschichte*, 54/3, 1991, 181–89; Pace, "Questioni arnolfiane," 335–73; Pace, "Il Ciborio di Arnolfo a Santa Cecilia: Una nota sul suo stato originario e sulla sua Committenza," *Studi di Storia dell'Arte sul Medioevo e il Rinascimento nel Centenario della Nascita di Mario Salmi*, vol. 1, Florence, 1992, 389–95. See also John White, "Cavallini and the lost frescoes in S. Paolo," *Journal of the Warburg and Courtauld Institute*, XIX, 1956, 84–95; Julian Gardner, "San Paolo fuori le mura, Nicholas III and Pietro Cavallini," *Zeitschrift für Kunstgeschichte*, XXXIV, 1971, 240–48.

24 Various hypotheses have been offered for the identity of this associate, including Pietro Oderisio, author of the Clement IV tomb. See Romanini, *Arnolfo di Cambio*, 57f.

25 The niche figures suffered no significant damage during the fire, although they were removed temporarily during the restoration. Drawings of these figures after their removal reveal that despite the fact that they give the impression of being carved in the round, the figures are actually carved on only three sides, on ancient *spolia*, which still preserve their original Roman carvings. The drawings are published in Luigi Moreschi, *Descrizione del Tabernacolo Che Orna la Confessione della Basilica di San Paolo sulla Via Ostiense*, Rome, 1840. Several of the reliefs on the ciborium, in particular Cain and Abel, and at least one pair of flying angels, are nineteenth-century reconstructions. See pp. 318ff.

26 Whether or not the Palazzo Vecchio in Florence can be attributed to Arnolfo is still an open question. One might note that a similar illusion of structural impossibility is one of the Palazzo's most striking features, i.e., the pro-

jecting ballatoio that appears, implausibly, to carry the weight of the tall, solid tower. On Arnolfo as the possible architect of the Palazzo Vecchio, see Marvin Trachtenberg, *The Campanile of Florence Cathedral. "Giotto's Tower,"* New York, 1971, 171 n. 77, and idem, *Dominion of the Eye. Urbanism, Art, and Power in Early Modern Florence,* Cambridge, 1997, 306 n. 266.

27 Pace, "Committenza benedettina a Roma," 181–89; Carli, *Arnolfo,* 122.

28 On the history of ciboria see A. M. D'Achille, "Ciborio," in *Enciclopedia dell'Arte Medioevale,* v. 4, Rome, 1993, 718–35; Carli, *Arnolfo,* 119–26.

29 The inscription HOC OPUS – FECIT ARNOLFUS and the date 20 November 1293, on a pilaster were rediscovered during excavations in 1980; see Romanini, *Arnolfo di Cambio,* 75, and idem, "Introduzione," *Roma Anno 1300,* Rome, 1983.

30 Serena Romano, "Alcuni fatti e qualche ipotesi su S. Cecilia in Trastevere," *Arte Medievale,* II/1, 1988, 105–19.

31 Pace, "Il Ciborio di Arnolfo a Santa Cecilia: Una Nota sul suo Stato Originario e sulla sua Committenza," 389–95.

32 Until the discovery of the column base with inscription, and in most photographs, the structure appeared even less slender since the lowest section was hidden beneath the seventeenth-century pavement; see note 29.

33 Previously thought to represent St. Tiburzio, the figure on horseback has now been convincingly identified as Valeriano; on the identification of the figures, and on the probable displacement of the corner figures from their original niches, see Pace, "Il ciborio di Arnolfo a Santa Cecilia," 389–95.

34 Pace, "Il ciborio di Arnolfa a Santa Cecilia."

35 Vasari, *Vite,* 1568, ed. C. L. Ragghianti, Milan-Roma, 1945, 243.

36 Francesco Pomarici, "Il presepe di Arnolfo di Cambio: nuova proposta di ricostruzione," *Arte Medievale,* s. 2, II/2, 1983, 155–75.

37 On the possible influence of Arnolfo's Praesepe see A. Moskowitz, "What Did Leonardo Learn from Arnolfo di Cambio?" *Studi in onore di Angiola Maria Romanini. Arte d'Occidente,* v. 3, Rome, 1991, 1079–1086.

38 Rudolf Berliner, "The origins of the crèche," *Gazette des Beaux Arts,* 30, 1946, 249–78.

39 See the remains of an *Adoration* with St. Joseph of the first half of the thirteenth century from San Marco, Venice, now in the Seminario Patriarcale. Herbert Huse, "Uber ein Hauptwerk der venezianischen Plastik um 13. Jahrhundert," *Pantheon,* XXVI, 1968, 95–103; W. Wolters, *Skulpturen von S. Marco,* Berlin, 1979 (Centro Tedesco di Studi Veneziani, Rome), 39.

40 That the ensemble could stimulate the senses and encourage a personal identification with the biblical event is evident from the recorded experience of St. Cajetan (1480–1547), a founder of the Theatine order: One Christmas night he stood before Arnolfo di Cambio's group in Sta. Maria Maggiore and had a vision of the Virgin putting the Christ Child into his arms. R. Berliner, "Origins," 249–69; Berliner, "Arnolfo di Cambio's Praesepe," *Essays*

in Honor of Georg Swarzenski, Berlin, 1951, 51–56; Berliner, *Die Weihnachtskrippe,* Munich, 1955.

41 On the group in Bologna see Massimo Ferretti, *Rappresentazione dei Magi. Il gruppo ligneo di S. Stefano e Simone dei Crociffissi,* exhibition catalogue, Bologna, 1981.

42 The inscription, HOC OPUS FECIT ARNOLPHUS ARCHITECTUS, was recorded in the sixteenth century; see Romanini, "Ipotesi," 119.

43 For the drawings see Giacomo Grimaldi, *Descrizione della basilica antica di S. Pietro in Vaticano Codice barberini Latino 1733,* ed. R. Niggl (Codices Vaticanis Selecti, 32), Vatican City, 1972.

44 The raised arms and a portion of the lower drapery on the angels are more recent additions, for these areas would have been obscured by the curtain and the effigy within the niche. Romanini, "Ipotesi," 124f.

45 Michele Maccarrone, "Il seppolcro di Bonifacio VIII nella Basilica Vaticana," in *Roma Anno 1300,* ed. Angiola Maria Romanini, Rome, 1983, 753–71.

46 Julian Gardner, "Boniface VIII as Patron of Sculpture," in *Roma Anno 1300,* 513–21; Gardner, *Tomb and Tiara,* 107–9.

47 Romanini, "Ipotesi," 127.

48 Walter and Elisabeth Paatz, *Die Kirchen von Florenz,* v. 3, Frankfurt am Main, 1952; Romanini 1980.

49 The decision to rebuild the small (Carolingian) cathedral of Sta. Reparata was made c. 1293–94; work began on 8 September 1296. Arnolfo is mentioned as Capomaestro in a document of 1 April 1300 (Cesare Guasti, *Santa Maria del Fiore. La Costruzione della Chiesa e del Campanile secondo I Documenti,* Florence, 1887, p. 20, doc. 24, where he is noted as "famosior magister et magis expertus in hedificationibus ecclesiarum"). The consensus of modern scholarship has it that the essential lines of Arnolfo's plan for the body of the cathedral – three aisles ending with a triconch surmounted in the center by an octagonal cupola rising on pointed arches – remained unchanged through the tenures of Giotto, Andrea Pisano, and Francesco Talenti in the fourteenth century (Romanini, "Arnolfo di Cambio," in *Enciclopedia dell'Arte Medievale,* v. 2, Rome, 1991, 512). The present facade, by Emilio de Fabris, dates from the nineteenth century; see Luigi Del Moro, *La facciata del duomo di Firenze,* Florence, 1888.

50 On Florentine history during this period see Ferdinand Schevill, *History of Florence,* 2nd ed., New York, 1961, 133ff.; Brian Pullan, *A History of Early Renaissance Italy from the Mid–Thirteenth to the Mid–Fourteenth Century,* London, 1973, 106f.

51 On the economy of Florence and its effect on urban construction, see Richard Goldthwaite, *The Building of Renaissance Florence. An Economic and Social History,* Baltimore and London, 1980.

52 On Sta. Reparata and its transformation into Sta. Maria del Fiore, see most recently the essays in Christine Smith, *Retrospection. Baccio Bandinelli and the Choir of Florence Cathedral,* Cambridge, Mass., 1997 (in particular, pp. 37–45).

53 Other graphic and written sources also exist; for a summary, see A. F. Moskowitz, in *Census of Gothic Sculpture*

in America. New England Collections, ed. Dorothy Giller-man, New York and London, 1989, 168f.

54 On Arnolfo's facade design see Peter Metz, "Die Florentiner Domfassade des Arnolfo di Cambio," *Jahrbuch der preuszischen Kunstsammlungen,* 95, 1938, 121–60; Paatz, *Die Kirchen von Florenz,* 392ff.; L. Becherucci and G. Brunetti, *Il Museo dell'Opera del Duomo a Firenze,* v. 1, Florence, 1969, 7ff., 219f.; Karen Christian, "Arnolfo di Cambio's Sculptural Project for the Duomo Facade in Florence: A Study in Style and Context," Ph.D. Dissertation, New York University, 1989; Romanini, *Arnolfo di Cambio;* Enrica Neri Lusanna, "La Decorazione e le sculture arnolfiane dell'antica facciata," in *La Cattedrale di Santa Maria del Fiore a Firenze,* v. 2, ed. Cristina Acidini Luchinat, Florence, 1995, 31–72; and Gert Kreytenberg, *Der Dom zu Florenz. Untersuchungen des Baugeschichte im 14. Jahrhundert,* Berlin, 1974. On the calculus involved in the planning of the dimensions of the facade, its distance from the Baptistry, and its optimal viewpoints (including that of its sculpture), see Trachtenberg, *Dominion of the Eye,* 55–62, 190f.

55 Lusanna, "La Decorazione," 31–72.

56 Becherucci and Brunetti, *Il Museo dell'Opera del Duomo,* 215–19, 226f.

57 On the extant censing angel see Moskowitz, in *Census,* 168f.

58 On the type see Ilene H. Forsythe, *The Throne of Wisdom,* Princeton, 1972.

59 Undoubtedly other examples exist, but I have found only one Madonna figure that adopts this device of Arnolfo's: the standing *Madonna and Child* in the church of San Lorenzo, Laino (Lombardy), by an anonymous carver from the Como region; see Oleg Zastrow, *Scultura Gotica in Pietra nel Comasco,* Como, 1989, Pl. VI, Figs. 246–49.

60 See note 21.

61 On this concept of "classic," see Pollitt, *Art and Experience in Classical Greece,* 195f.

Giovanni Pisano

1 On the inscriptions see also pp. 74, 83, 100, and 337 n. 43. The full inscriptions with translations are given in John Pope-Hennessy, *Italian Gothic Sculpture,* London, 2nd ed., London, 1972, 177f. A concise discussion of all works documented or attributed to Giovanni, with a full bibliography, is offered by G. Jaszai, in *Enciclopedia dell'Arte Medievale,* v. 6, Rome, 1995, 740–54.

2 The documents are published in G. Milanesi, *Documenti per la Storia dell'Arte Senese,* v. 1, Siena, 1854; P. Bacci, *Documenti e Commenti per la Storia dell'Arte,* Florence, 944; P. Bacci, "Documenti e commenti per la Storia dell'Arte," *Le Arti,* IV, 1941–42, 98–106, 185–92, 268–77, 329–40; E. Carli, *Il Pulpito di Siena,* Bergamo, Milan, Rome, 1943, 41–45.

3 Harold Keller, *Giovanni Pisano,* Vienna, 1942, 66; Antje Kosegarten, "Nicola und Giovanni Pisano 1268–78," *Jahrbuch der Berliner Museen,* XI, 1969, 36–80. See also text discussion, pp. 41ff.

4 Pope-Hennessy, *Italian Gothic Sculpture,* 174; Carli, *Giovanni Pisano,* 24f.

5 The document is published in Milanesi, *Documenti,* 161f.

6 H. Keller, "Die Bauplastik des Sieneser Doms," *Kunstgeschichtliches Jahrbuch der Biblioteca Hertziana,* I, 1937, 139–220; E. Carli, *Giovanni Pisano,* Pisa, 1977, 43–45; John White, *Art and Architecture in Italy,* New Haven and London, 1993, 45f.; idem, review of Antje Middeldorf Kosegarten's *Sienesische Bildhauer,* in *Art History,* 8, 1985, 484–87. See now Tim Benton, "The design of Siena and Florence duomos," in *Siena, Florence and Padua: Art, Society and Religion 1280–1400,* v. 2, ed. Diana Norman, New Haven, 1995, 129–43. The view that the entire facade reflects Giovanni's design is, in my opinion, more persuasive. Examination of the facade and its relationship to the interior reveals that it is not the upper section that is "displaced," a disconcerting aspect of the design in the view of some observers; rather, the side portals are, so to speak, pushed inward by the flanking buttresses. While they therefore do not align axially with the aisles behind them, the three portals form a more compact balanced unit framed by and contrasting to the flatter surfaces of the flanking walls and buttresses. The second-story buttress towers and pinnacles that flank the rose window return then to "proper" alignment with the walls of the clerestory section behind them, built in the late thirteenth century and thus requiring a wider facade screen. The tension between upper and lower section, the unexpected contrast between the pull inward of the lower and outward of the upper stories is quite consistent with Giovanni Pisano's artistic temperament and even has strong precedents in the disjunction of axes creating syncopated rhythms in Nicola Pisano's contribution to the exterior of the Pisa Baptistry and his design of the Fontana Maggiore in Perugia (see pp. 41ff). Finally, the figures around the rose window are stylistically consistent with a date around 1300, whereas other figures of the upper facade would seem to date from the first two decades of the century. See Antje Kosegarten, "Einige sienesische Darstellungen der Muttergottes aus dem frühen Trecento," *Jahrbuch der Berliner Museen,* VIII, 1966, 96–118; Kosegarten, *Sienesische Bildhauer am Duomo Vecchio,* Munich, 1984, 119–22.

7 Shortly thereafter, Ghibellinism collapsed in Siena and in much of Tuscany. William M. Bowsky, *A Medieval Italian Commune. Siena under the Nine, 1287–1355,* Berkeley, Los Angeles, London, 1981, 35f.

8 The present figures in roundels are of the seventeenth century. On restorations and alterations of the facade see Kosegarten, *Sienesische Bildhauer,* 69ff.

9 Kosegarten, *Sienesische Bildhauer,* 77–102.

10 In an inscription on his Pisa cathedral pulpit Giovanni claims to have "encircled all the rivers and parts of the world endeavoring to learn much . . ." (translation in Pope-Hennessy, *Italian Gothic Sculpture,* 178), and a documentary lacuna exists for such a sojourn sometime between 1268, upon completion of the Siena pulpit, and 1278, when the Fontana Maggiore was begun, about seven years before Giovanni's appearance in Siena. Nevertheless, it is not clear that the inscription reference should be

taken literally. However, documents show that a Sienese collaborator for work on the facade, Ramo di Paganello, had in fact lived in France for some time before returning to his native city. Conflicts arose between Giovanni and Ramo, who was eventually forced to disengage from the facade project, but it is possible that he returned from France with drawings of some French cathedrals. See Michael Ayrton, *Giovanni Pisano Sculptor*, London, 1969, 86f.; Carli, *Giovanni Pisano*, 39.

11 The original extant sculptures of the facade are now housed in the cathedral museum; those seen on the facade are copies. The original siting is known from inscriptions on the facade itself.

12 References to the Incarnation appear on the scrolls that the figures carry. These inscriptions, originally filled with black paste, were legible from the ground. Kosegarten, *Sienesische Bildhauer*, 101.

13 These communicating figures perhaps find their closest precedents in the Annunciation and Visitation groups on the jambs of the center doorway of the west facade of Reims cathedral of the 1230s (Willibald Sauerländer, *Gothic Sculpture in France 1140–1250*, New York, 1970, Pl. 198, 199); the retro facade of Reims datable to the 1250s (Sauerländer, Pl. 229), where some of the figures, while physically contained within their niches, appear to address a neighboring figure; the donor figures that stand around the wall at Naumberg cathedral (Williamson, Pl. 270–72) and seem to be aware of one another's presence across space (1260s); and the Strasbourg portal and Judgment pillar (Sauerländer, Pls. 132–39). See also n. 17.

14 Marvin Trachtenberg, *Dominion of the Eye. Urbanism, Art and Power in Early Modern Florence*, Cambridge, 1997, 185–94. The Siena facade figures in the Museo dell'Opera del Duomo, placed close to ground level, have lost much of their dramatic effect. The apparent distortions disappear when the figures are viewed, in the mind's eye, looking upward from ground level (as when viewing the modern copies on the Duomo facade).

15 Max Seidel, "Studien zur Antikenrezeption Nicola Pisanos," *Mitteilungen des Kunsthistorischen Institutes in Florenz*, XIX, 1975, 303–92; idem, "Die Rankensäulen der Sieneser Domfassade," *Jahrbuch der Berliner Museen*, v. 11, 1968/69, 80–160. For the original siting of the columns see Adolfo Venturi, *Giovanni Pisano sein Leben und sein Werk*, Florence, Munich, 1927, v. 1, Pl. 50; Kosegarten, *Sienesische Bildhauer*, Figs. 111–19.

16 Sauerlaender, *Gothic Sculpture in France 1140–1250*, Pls. 130–40.

17 In a review of John White's Pelican book, *Art and Architecture in Italy 1250–1400*, Andrew Martindale ("The 'Pelican' Early Italian Art," *Burlington Magazine*, 109, September 1967, 538–42) overestimates the degree of dependence of Giovanni Pisano (and other Italian Gothic artists) on northern precedents and puts a negative spin on the Italians' rejection of orthodox Gothic values. More plausible is Kosegarten's suggestion that Giovanni's large figures standing above engaged columns and rhythmically dispersed against the architectural fabric owe a debt to the

projecting attic figures of the Arch of Constantine; A. Middeldorf Kosegarten, *Die Domfassade in Orvieto. Studien zur Architektur und Skulptur 1290–1330*, Munich, Berlin, 1996, 20.

18 He visited Pisa briefly on business in 1295; Carli, *Giovanni Pisano*, 40.

19 Antonio Caleca, *La Dotto Mano. Il Battistero di Pisa*, Bergamo, 1991, Figs. 242–64.

20 Erwin Panofsky, *Renaissance and Renascences in Western Art*, 2nd ed., New York and Evanston, Ill., 1969 (originally published in Stockholm, 1960), 6of.

21 The events are recounted in Carli, *Giovanni Pisano*, 38–42.

22 Carli, *Giovanni Pisano*, 38–40.

23 Nicola himself (or members of his workshop) had worked in Pistoia in 1273, in the Chapel of San Jacopo in the Duomo. Pèleo Bacci, *Documenti Toscani per la storia dell'Arte*, v. 1, 73–83. See also Albino Secchi, "La Cappella di S. Jacopo a Pistoia e la 'Sacrestia dei Belli Arredi,'" in *Il Gotico a Pistoia nei suoi Rapporti con L'Arte Gotica Italiana*, Pistoia, 1966, 85–92; Giuseppe Marchini, "L'Altare Argenteo di S. Iacopo e L'Oreficeria Gotica a Pistoia," in *Il Gotico a Pistoia nei suoi Rapporti con L'arte Gotica Italiana* (Atti del 2 Convegno internazionale di studi), Pistoia, 1966, 135–47.

24 L. Gai, *L'Altare di San Jacopo nel Duomo di Pistoia. Contributo alla storia dell'oreficeria gotica e rinascimentale italiana*, Turin, 1984, 33ff.; David Herlihy, *Medieval and Renaissance Pistoia. The Social History of an Italian Town, 1200–1430*, New Haven and London, 1967, 254.

25 Herlihy, *Medieval and Renaissance Pistoia*, 142. On the factional struggles of unusual ferocity around the turn of the century, 199f.

26 Enzo Carli, *Giovanni Pisano. Il pulpito di Pistoia*, Milan, 1986, 12; Valerio Ascani, "La bottega dei Bigarelli. Scultori ticinesi in Toscana e in Trentino nel duecento sulla scia degli studi di Mario Salmi," in *Mario Salmi. Storico dell'Arte e Umanista. Atti della giornata di studio, Roma – Palazzo Corsini, 30 novembre 1990*, Spoleto, 1991, 107–34, especially 125–27.

27 M. Baetano Beani, *La Pieve di S.Andrea Ap. in Pistoia*, Pistoia, 1907, 28.

28 Vasari (*Le Vite de' più eccellenti pittori, scultori e architettori, nelle redazioni del 1550 e 1568*, ed. Rosana Bettarini and Paola Barocchi, v. 2, 1967, 68) records a tradition that the pulpit took four years to complete; if so, it was begun in 1297 shortly following Giovanni's departure from Siena.

29 Translation from Pope-Hennessy, *Italian Gothic Sculpture*, 177.

30 Geza Jaszai, *Die Pisaner Domkanzel*, Ph.D. dissertation, Munich, 1968, 27ff. See also Carli, *Giovanni Pisano. Il Pulpito di Pistoia*, 12f. Carli's book, which carries side-by-side English and Italian versions, should *not* be read in English due to the numerous mistranslations and incomprehensibility. However, its photographs, by Aurelio Amendola, are superb.

31 Anita Moskowitz, "A Late Dugento Male Nude Studied from Life," *Source. Notes in the History of Art*, XVI/4,

32 In the Pistoia *Nativity*, the figures in the lower half remain attached to the background while those in the upper section have deep undercutting, giving the impression of forms detached from the fabric of the slab.

33 White, *Art and Architecture*, 128f.

34 Keller, *Giovanni Pisano*, 13.

35 Keller, *Giovanni Pisano*, 30, 66.

36 Keller, *Giovanni Pisano*, 66; alternatively, if the original gesture of Christ was one of blessing, Christ may have faced the worshiper entering the portal. A clumsily carved and incorrectly set replacement of the Child's head seen in old photographs has been removed in the present installation in the Museo dell'Opera del Duomo.

37 Ayrton, *Giovanni Pisano Sculptor*, 107.

38 The head of Christ in the ivory Madonna (Fig. 105) is a seventeenth-century replacement, and its position is also incorrect. The right arm, hand, and left foot are also replacements dating from the seventeenth to the nineteenth century. See Carlo Lodovico Ragghianti, "La Madonna eburnea di Giovanni Pisano," *Critica d'Arte*, n.s., I, 1954, 385–96; Max Seidel, "Die Elfenbeinmadonna im Domschatz zu Pisa. Studien zur Herkunft und Umbildung Franzöischer Formen im Werk Giovanni Pisanos in der Epoche der Pistoieser Kanzel," *Mitteilungen des Kunsthistorischen Institutes in Florenz*, XVI, 1972, 1–50.

39 These are discussed by Max Seidel, *La Scultura Lignea di Giovanni Pisano*, Florence, 1971; idem, "'Opus Herburneum.' Die Entdeckung einer Elfenbeinskulptur von Giovanni Pisano," *Pantheon*, XLII, 1984, 219–29; idem, "Un 'Crocifisso' di Giovanni Pisano a Massa Marittima," *Prospettiva*, 62, 1991, 67–77. See also *Scultura Dipinta. Maestri di Legname e Pittori a Siena 1250–1450* (exhibition catalogue), Florence, 1987, 22–29.

40 Magrit Lisner, *Holzkruzifixe in Florenz und in der Toskana von der Zeit um 1300 bis zum frühen Cinquecento*, Munich, 1970, 18; Geza de Francovich, "L'origine e la diffusione del Crocifisso gotico doloroso," *Kunstgeschichtlichtliches Jahrbuch der Biblioteca Hertziana*, 2, 1938, 143–261. An example of the type of northern Crucifixion that might have influenced Giovanni is that on a diptych, mid–thirteenth century, in the Metropolitan Museum of Art. See Robert G. Calkins, *Monuments of Medieval Art*, New York, 1975, Fig. 161.

41 See the evocative description of its (hypothetical) effect on a pious crowd in Seidel, "Un 'Crocifisso,'" 72.

42 P. Bacci, *La Ricostruzione del Pergamo di Giovanni Pisano nel Duomo di Pisa*, Milan, Rome, 1926, 108 n. 21. For an exhaustive photographic documentation with superb color illustrations, see Adriano Peroni, ed., *Il Duomo di Pisa*, v. 2, Modena, 1995, 546–641 (in the Italia Mirabilia series).

43 The inscriptions, in leonine verse, run immediately below the reliefs and on the socle on which the whole monument stands. They read as follows (the translations are from Pope-Hennessy, *Italian Gothic Sculpture*, 177f.): "I praise the true God, the creator of all excellent things, who has permitted a man to form figures of such purity. In the year of our Lord thirteen hundred and eleven the hands of Giovanni, son of the late Nicola, by their own art alone, carved this work, while there ruled over the Pisans, united and divided, Count Federigo da Montefeltro, and at his side Nello di Falcone, who has exercised control not only of the work but also of the rules on which it is based. He is a Pisan by birth, like that Giovanni who is endowed above all others with command of the pure art of sculpture, sculpting splendid things in stone, wood and gold. He would not know how to carve ugly or base things even if he wished to do so. There are many sculptors, but to Giovanni remain the honors of praise. He has made noble sculptures and diverse figures. Let any of you who wonders at them test them with the proper rules. Christ have mercy on the man to whom such gifts were given. Amen."

The shorter verse on the step beneath the pulpit (the step and the inscription are modern reconstructions; see note 46) reads: "Giovanni has encircled all the rivers and parts of the world endeavoring to learn much and preparing everything with heavy labor. He now exclaims: 'I have not taken heed. The more I have achieved the more hostile injuries have I experienced. But I bear this pain with indifference and a calm mind.' That I (the monument) may free him from this envy, mitigate his sorrow and win him recognition, add to these verses the moisture (of your tears). He proves himself unworthy who condemns him who is worthy of the diadem. Thus by condemning himself he honors him whom he condemns." That Giovanni was a man highly conscious of his own superior abilities but difficult to deal with is suggested not only by this inscription but by documentary references to troubles in Siena and a conflict in Pisa with the Operaio Burgundio di Tado. See pp. 73f.

44 Giorgio Vasari, *Le Vite de' più eccellenti pittori, scultori e architettori, nelle redazioni del 1550 e 1568*, ed. Rosanna Bettarini and Paola Barocchi, v. 2, Florence, 1967, 69; Gaston du C. De Vere, trans., *Lives of the Most Eminent Painters, Sculptors and Architects by Giorgio Vasari*, London, 1912–14, 41.

45 A summary of the events is found, most recently, in Henry Moore, Gert Kreytenberg, and Crispino Valenziano, *L'Ambone del Duomo di Pisa*, Milan, 1993.

46 Some elements were lost or found their way elsewhere (including several fragments now in the Metropolitan Museum of Art). In 1630 a new, much reduced pulpit was made using some parts of Giovanni's original pieces, including the lions and several figures, as well as floral consoles, all employed in ways rather unrelated to the original form of the pulpit. In the late nineteenth and early twentieth centuries there were deliberations and sometimes acrimonious debates regarding a possible physical reconstruction of the pulpit's original form. Finally, in 1926, Peleò Bacci, the Superintendent of Monuments in Pisa, on the basis of exhaustive study of all the relevant material, including documents and measurements, reconstructed the pulpit in the form and in the

place where we see it today (Fig. 107). Newly carved pieces were substituted for missing elements. Indeed, not only is the base with its inscription not original, but the upper cornice, at least three of the freestanding columns, Hercule's lion, the seraphs above the statue column of Christ, and three of the sibyls of the middle register, among other elements, are modern carvings. The restorer, noting that seven of the panels had convex surfaces and two were flat, deduced that the pulpit was octagonal and that the two flat ones were the balustrades for an entrance platform onto which the stairs opened. For losses and restorations, see Keller, *Giovanni Pisano*, 68.

47 White, *Art and Architecture*, 135.

48 Carli, *Giovanni Pisano*, 103.

49 Caleca, *La Dotta Mano*, 39f.

50 M. Warner, *Alone of All Her Sex*, London, 1976, 8f.

51 The functions of Baptistry and cathedral were more interchangeable than is generally recognized. The Baptistry could serve as a parish church, and the cathedral, at least by 1311 when Tino di Camaino made a baptismal font (of which only fragments remain; see p. 104), also functioned as the site for baptism. It may be, indeed, that the use of the cathedral as baptistry is signaled even earlier by the inclusion of scenes from the Baptist's life on the pulpit. On the iconographic program of the Pisa Baptistry, see A. Kosegarten, "Die Skulpturen der Pisani am Baptisterium von Pisa," *Jahrbuch der Berliner Museen*, X, 1968, 14–100, especially 24–27.

52 Ayerton, *Giovanni Pisano*, Pl. 179.

53 As cogitated as Bacci's reconstruction was, it did not remain uncontested. It has been noted, in particular, that not only is the location of the pulpit incorrect, as is known from a 1595 ground plan, but the present relationship of its parts makes little theological, not to speak of visual, sense. The most recent hypothetical reconstruction is offered by Gert Kreytenberg (see Kreytenberg, in Moore, Kreytenberg, and Valenziano, *L'Ambone del Duomo di Pisa*, with the author's photomontage), who argues that given the function of the pulpit visually as a manifestation of Christian doctrine, and liturgically for the reading of the Epistles and the Gospels to the assembly of worshipers in the nave, the theologically most significant parts would have faced the viewers. Thus, in its original location under the cupola and in front of the choir to the right, the pulpit was oriented along the same axis as the church and thus was accessible to the priest from the choir, while the most important figures faced the community of believers. All the figural columns, according to this view, belong to the forward half of the polygonal-cum-circular pulpit. Facing it one would have seen the Evangelist lectern on the left and the Epistles lectern on the right (these flanking the Massacre of the Innocents). Serving as the central support were the three Theological Virtues visible between Christ supported below by the Evangelists, and Ecclesia supported below by the Cardinal Virtues, each of the latter groups relating visually and logically to the lecterns above them. In a plane farther back, thus closer to that of the centralized statue column, one would have seen the last two fig-

ures: St. Michael on the left and Hercules on the right. The unadorned, freestanding columns, then, would have served as rear supports on the choir side of the pulpit. This arrangement creates a "facade" that is totally sculptural and could be considered a development of solutions conceived earlier for the lower section of the facade of the cathedral of Siena. The hypothetical reconstruction, indeed, does seem to make more visual and theological sense than does the present arrangement.

54 On the cult and the tomb's chronology see Max Seidel, *Giovanni Pisano a Genova*, Genoa, 1987, 152–56.

55 Max Seidel has offered a partial reconstruction of the tomb as a wall monument that includes a sarcophagus supported by four caryatids representing the Cardinal Virtues (attributes appropriate to royalty) and, high above eye level, the group of Margaret and the angels representing an *elevatio animo*. In this reconstruction, the extant figure of Justice is placed at the left corner of the sarcophagus and faces toward the observer's right while three other Virtues (based on extant fragments and copies of Giovanni's original figures) face toward the left. Seidel, "Studien zu Giovanni di Balduccio und Tino di Camaino," *Städel-Jahrbuch*, 42–49; idem, *Giovanni Pisano a Genova*, 89f. John Pope-Hennessy, "Giovanni Pisano's Tomb of Empress Margaret: A Critical Reconstruction," *Apollo*, September 1987, 223, points out that the extant figures are finished in the back and were evidently meant to be seen from all sides; this suggests that the tomb was a double-sided monument. Furthermore, the fact that one supporting figure faces toward the right while three face toward the left (which, in a wall tomb, would result in a lack of symmetry), is readily explained if one assumes that the monument was freestanding and that there were eight caryatids comprising four pairs of confronting Virtues. For a recent and provocative discussion concerning lost elements of the tomb, which appeared in print too late to be fully considered here, see Clario Di Fabio, "*Depositum cum statua decumbente*. Recherches sur Giovanni Pisano à Gênes et le monument de Marguerite de Brabant," *Revue de l'Art*, n. 123/1999–1, 13–26.

56 Quoted in Seidel, *Giovanni Pisano a Genova*, 137, with reference to Sacramentario di Amiens (W. Dürig, *Imago, ein Beitrag zur Terminologie und Theologie der römischen Liturgie*, Munich, 1952, 161); J. A. Jungmann, *Missarum Sollemnia*, v. 1, Wien, Freiburg, Basel, 1962, 370–71.

THREE. PISAN AND SIENESE SCULPTURE TO 1330

Alternative Currents

1 This point is emphasized with respect to Siena by Antje Middeldorf Kosegarten, *Sienesische Bildhauer am Duomo Vecchio. Studien zur Skulptur in Siena 1250–1330*, Munich, 1984, 160.

2 Enzo Carli, *Gli Scultori Senesi*, Milan, 1980, 15; Kosegarten, *Sienesische Bildhauer*, 344f.; Gert Kreytenberg, "Giovanni Pisano oder Tino di Camaino?" *Jahrbuch der Berliner Museen*, 20, 1978, 29f.; Kreytenberg, *Tino di*

Camaino, Florence, 1986, 8f. Compare N. Dan, "Riconsiderazioni sul periodo pisano di Tino di Camaino," *Annuario dell'Istituto Giapponese di Cultura in Roma,* IX, 1983–84, 7–58, especially 17).

3 Enzo Carli, *Il Museo di Pisa,* Pisa, 1974, 22f. and Figs. 17–20; Carli has recently attributed the reliefs to Lupo di Francesco; *Arte Senese e Arte Pisana,* Turin, 1996, 50–52.

4 Carli, *Il Museo di Pisa,* 22 and Fig. 16; idem, "Un tabernacolo Trecentesco e altre questioni di scultura pisana," *La Critica d'arte,* XIII, February 1938, 16–22.

5 Max Seidel, "Skulpturen am Aussenbau von S. Maria della Spina in Pisa," *Mitteilungen des Kunsthistorischen Institutes in Florenz,* XVI, 1972, 269–92; Mariagiulia Burresi, *Santa Maria della Spina in Pisa,* Milan, 1990.

6 The mounting on a strip of red damask dates from the eighteenth century. For a summary of the literature, see Andriano Peroni, ed., *Il Duomo di Pisa,* Modena, 1995, v. 1, 636–38, and for beautiful color illustrations, see v. 2 (Photo-Atlas), 907.

7 The ensemble was not completed until 1456. On the Silver Altar see E. Steingraber, "The Pistoia Silver Altar: A Re-examination," *Connoisseur,* 138, 1956, 148–54; Marchini, "L'Altare argenteo di S. Jacopo e l'oreficeria gotica a Pistoia," *Il Gotico a Pistoia nei suoi Rapporti con L'arte Gotica Italiana,* Pistoia, 1966, 135–47; Lucia Gai, *L'Altare Argenteo di San Jacopo nel Duomo di Pistoia. Contributo alla storia dell'oreficeria gotica e rinascimentale italiana,* Turin, 1984.

8 See note 24 in the next section, on Tino di Camaino. On Sta. Maria della Spina, see Burresi, *Santa Maria della Spina in Pisa.*

9 On the Duomo sculptures produced following Giovanni's departure, see Carli, *Gli Scultori Senesi,* 13f., and Kosegarten, *Sienesische Bildhauer,* 113–28.

10 The response to Arnolfo's style is further support for an early rather than late Trecento dating of the upper facade. See A. Middeldorf Kosegarten, "Einige sienesische Darstellungen der Muttergottes aus dem frühen Trecento," *Jahrbuch der Berliner Museen,* VIII, 1966, 96–118; idem, *Sienesische Bildhauer,* 72–74; 113–28. Compare Tim Benton, "The Design of Siena and Florence Duomos," in *Siena, Florence and Padua: Art, Society and Religion 1280–1400,* v. 2, *Case Studies,* ed. Diana Norman, New Haven and London, 1995, 129–43.

11 Antje Middeldorf Kosegarten, *Die Domfassade in Orvieto. Studien zur Architektur und Skulptur 1290–1330,* Munich, Berlin, 1996, 13; Roberto Bartalini, "Spazio scolpito. La novità del relievo 'pittorico' di Giovanni d'Agostino," *Prospettiva,* 45, 1986, 19–34. On the development of space in Roman and Tuscan painting see John White, *The Birth and Rebirth of Pictorial Space,* 3rd ed., Cambridge, Mass., 1987, 23–102.

12 On Casole see Lea Cimino et al., eds., *Casole d'Elsa e il suo Territorio,* Radda in Chianti, 1988, 13–17. On Gano di Fazio see Carli, *Gli Scultori Senesi,* 12f.; C. Bardotti Biason, in *Enciclopedia dell'Arte Medievale,* v. 7, 1995, 475–77.

13 On the question of portraiture in late-thirteenth- and fourteenth-century tombs, see Julian Gardner, *The Tomb and the Tiara. Curial Tomb Sculpture in Rome and Avignon in the Later Middle Ages,* Oxford, 1992, 172–75, who argues that there is little evidence that sculptors copied features from life at this period and that the "assumption of a 'portrait' quality in tomb effigies" must be seen rather "as a compliment to the creative talent of their sculptor rather than as an objective judgement." This may be generally true for tomb monuments; but Arnolfo, for example, executed the enthroned Charles of Anjou as well as the half-length portrait and the effigy of Boniface VIII during the respective patrons' lifetimes, and if one cannot claim that the individuals "sat" for Arnolfo in the modern sense of the term, a gifted sculptor, whose powers of observation are manifest with regard to ancient art, would surely have fixed those powers on his living patrons as well.

14 The new attribution, provocative but not entirely convincing, was proposed by Giovanni Previtali, "Alcune opere 'fuori contesto.' Il caso di Marco Romano," *Bolletino d'Arte,* 22, 1983, 43–68. The only secure work of Marco Romano is the signed tomb of San Simeone in Venice; see the section on Venetian sculptured portraits, pp. 237ff.

15 Carli, *Gli Scultori Senesi,* 12.

16 Helen Ronan, "The Tuscan Wall Tomb, 1250–1400," Ph.D. dissertation, Indiana University, 1982, 19–24.

17 A. Middeldorf Kosegarten, "Grabmäler von Ghibellinen aus dem frühen Trecento," *Skulptur und Grabmal des Spätmittelalters in Rome und Italien,* Vienna, 1990, 317–29, argues that the Porrina tomb belongs to (indeed, is probably the first of) a series of tombs or cenotaphs memorializing Ghibelline leaders that emphasize the living presence and mortal deeds of the deceased. This group includes the monuments for Henry VII of 1315 by Tino, Tarlati of 1330 by Agostino di Giovanni and Agnolo di Ventura, Cangrande in Verona of c. 1330, and Cino da Pistoia of 1339. The inclusion of a commemorative statue of the living may have been inspired by the nontomb figure of Charles I d'Anjou as Senator of Rome by Arnolfo di Cambio, and the practice ultimately goes back to the Capuan portal seated figure of Frederick II (Fig. 15).

18 Kosegarten, "Beiträge zur Sienesischen Reliefkunst des Trecento," *Mitteilungen des Kunsthistorischen Institutes in Florenz,* XIII 1965–66, 206–24; E. Carli, *L'Arte nella Basilica di S. Francesco a Siena,* Siena, 1971, 13. The relief was originally inserted to the left of the facade in the wall that separated the cloisters of the Confraternity S. Gherardo from the church piazza; in the eighteenth century it was inserted into the inner north wall of the basilica.

19 Kosegarten, *Sienesische Bildhauer,* 127.

Tino di Camaino in Tuscany

1 On the issue of the elder Camaino's role, see Antje Middeldorf Kosegarten, *Sienesische Bildhauer am Duomo Vecchio. Studien zur Skulptur in Siena 1250–1330,* Munich, 1984, 31. Enzo Carli, *Gli Scultori Senesi,* Milan,

1980, 13f., refers to him as though he were, indeed, the Capomaestro of Siena cathedral. The still fundamental early study of Tino di Camaino is that of W. R. Valentiner, *Tino di Camaino: A Sienese Sculptor of the Fourteenth Century*, Paris, 1935. Incorporating scholarship to 1986 is Gert Kreytenberg's concise book, *Tino di Camaino*, Florence, 1986.

2 That he was trained in his father's shop is suggested not only by the tradition of family apprenticeship but also by an inscription on the Orso tomb in Florence, in which he states his refusal to be called Master during his father's lifetime. Valentiner, *Tino di Camaino*, 4, 157. His association with Giovanni Pisano is argued on the basis of style and of probability – the fact that he received the important commission for the San Ranieri altarpiece seems unlikely without the recommendation and approval of Giovanni, who was engaged on the Duomo pulpit during the first decade of the Trecento. Collaboration with Giovanni has been argued by Max Seidel, "Studien zu Giovanni di Balduccio und Tino di Camaino: Die Rezeption des Spätwerks von Giovanni Pisano," *Städel-Jahrbuch*, 5, 1975, 37–84. An attempt has been made to see Tino working under Giovanni on the Pistoia pulpit; see Kreytenberg, *Tino di Camaino* (Lo Specchio del Bargello), 30. The architrave over the main portal of the Siena Duomo, much influenced by the older master's style, has also been attributed to Tino. Carli, *Sculture del Duomo di Siena*, Turin, 1941, 23ff.; idem, *Il Duomo di Siena*, Siena, 1979, 50. Compare Kosegarten, *Sienesische Bildhauer*, 111–13, 344f., who, among others, does not accept the attribution.

3 The attribution has been universally accepted. Carli, *Gli Scultori Senesi*, 14.

4 Valentiner, *Tino di Camaino*, 8; Carli, *Gli Scultori Senesi*, 14.

5 See, for example, Helmut Häger, *Die Anfänge des italienischen Altarbildes*, Munich, 1962, Figs. 130–33.

6 On the origins and development of the painted predella see A. Preiser, *Das Entstehen und die Entwicklung der Predella in der italienischen Malerei*, dissertation Würzburg, 1973, published in Hildesheim, 1973, and summarized in *Das Münster*, v. 27, 1974, 320f.

7 Naoki Dan, "Riconsiderazione sul periodo pisano di Tino di Camaino," *Annuario dell'Istituto Giapponese di Cultura in Roma*, 19, 1983–84, 7–58.

8 W. R. Valentiner, *Tino di Camaino*, 12, 156. The font was destroyed by fire in 1595 and only six fragments are extant. For sources and documents see Peleò Bacci, "Il 'Fonte Battesimale' di Tino di Camaino per il Duomo di Pisa," *Rassegna d'Arte*, 1920, 97–101. For a hypothetical reconstruction of the font see Dan, "Riconsiderazione sul periodo pisano di Tino di Camaino," 7–58, especially 26–35.

9 In the event, the pope, Clement V, already residing in Avignon, did not return to Rome for the coronation and Henry had to content himself with coronation by cardinals. William M. Bowsky, *Henry VII in Italy*, Lincoln, 1960, 167.

10 Bowsky, *Henry VII in Italy*, 203–11, 218 n. 9.

11 Peleò Bacci, "Monumenti danteschi. Lo scultore Tino di Camaino e la Tomba dell' 'alto Arrigo' per il Duomo di Pisa," *Rassegna d'Arte Antica e Moderna*, VIII, 1921, 73–84; Valentiner, *Tino di Camaino*, 42.

12 Carli, *Gli Scultori Senesi*, 15.

13 The association of these figures with the tomb was first made by Emile Bertaux, "Le mausolée de l'empereur Henri VII à Pise," in *Paul Fabre, Mélanges*, Paris, 1902, 365–79. A summary of the various hypotheses is given in Carli, *Gli Scultori Senesi*, 15. The identification of the enthroned figure as Henry VII and the accompanying figures as his councillors has been strongly challenged by Volker Herzner ("Herrscherbild oder Grabfigure? Die Statue eines thronenden Kaisers und das Grabmal Heinriches VII. von Tino di Camaino," in *Ikonographia. Anleitung zum Lesen von Bildern [Festschrift Donat de Chapeurarouge]*, ed. B. Brock and A. Preiβ, Munich, 1990, 27–77) but has not been widely accepted. The head is visibly separate from the body with plaster infilling (see Fig. 133). The issue of its original pertinence to the rest of the statue, however, remains unresolved.

14 Enzo Carli, *Arnolfo di Cambio*, Florence, 1993, Fig. 39.

15 The fifth head has been identified by Max Seidel, "Studien zu Giovanni di Balduccio und Tino di Camaino," 71ff. On the sixth head, discovered in a private collection, see Guido Tigler and Gunter Passavant, "Una Testa a Marlia," *Mitteilungen des Kunsthistorischen Institutes in Florenz*, XXXV/2–3, 1991, 287–96.

16 The scholar who has argued most vigorously against the attribution to Tino is Gert Kreytenberg. His attempts to assign the group of councillors to Lupo di Francesco (see Gert Kreytenberg, "Das Marmorbildwerk der Fundatrix Ettalensis und die Pisaner Skulptur zur Zeit Ludwigs des Bayern," in *Wittelback und Bayern, I,1. Die Zeit der frühhen Herzöge. Beiträge zur bayerischen Geschichte und Kunst 1180–1350*, Munich, 1984, 446ff.), Tino's successor as Capomaestro of Pisa for whom there is no extant documented work, are not persuasive. The attribution of both enthroned figure and councillors to Tino is, with qualifications, rejected by Herzner, "Herrscherbild oder Grabfigure?"

17 The literature is summarized by G. Kreytenberg, "Das Grabmal von Kaiser Heinrich VII in Pisa," *Mitteilungen des Kunsthistorischen Institutes in Florenz*, XXVIII, 1984, 33–35.

18 Noaki Dan, "Ricostruzione della Tomba di Arrigo VII di Tino di Camaino," *Michelangelo*, XXII, 1977, 24–37; Noaki Dan, *La Tomba di Arrigo VII di Tino di Camaino e il Rinascimento*, Florence, 1982; Gert Kreytenberg, "Das Grabmal von Kaiser Heinrich VII in Pisa," 33–64. Compare Enzo Carli, in Guglielmo De Angelis d'Ossat, ed., *Il Museo dell'Opera del Duomo a Pisa*, Milan, 1986, 95–101. See also note 13.

19 See G. Kreytenberg, "Fragments of an altar of St. Bartholomew by Tino di Camaino in Pisa Cathedral," *Burlington Magazine*, CXXIV, 1982, 349ff.

20 Bacci, "Monumenti danteschi," 78.

21 If Kreytenberg's reconstruction is correct, and if the sug-

gestion that the figures of emperor and councillors were *originally* designed for a city gate, then the Pisans may have conceived here an overt reference, in the triumphal arch motif, to the city gate through which the emperor marched in glory after his coronation. Herzner, "Herrscherbild oder Grabfigure?" 64, notes that even Boniface VIII, papal rival of the Ghibellines, had to content himself with a funerary monument on the *inner* wall of St. Peter's, since the baldacchino over the tomb of the prince of the apostles was in the apse.

22 Josef Deér, *The Dynastic Porphyry Tombs of the Norman Period in Sicily*, Cambridge, Mass., 1959.

23 Dante, "Letter V," quoted in Bowsky, *Henry VII in Italy*, 50.

24 On the complex factors that led to Pisa's precocious economic and urban development during the thirteenth century, and its subsequent decline in the early fourteenth, see David Herlihy, *Pisa in the Early Renaissance. A Study of Urban Growth*, Port Washington, New York, and London, 1973, passim.

25 On Petroni, see W. M. Bowsky, *A Medieval Italian Commune. Siena under the Nine, 1287–1355*, Berkeley, Los Angeles, London, 1981, 17, 73; Kreytenberg, *Tino di Camaino*, 22f. On the tomb's history and reconstruction, see Carli, *Il Duomo di Siena*, 56–58.

26 Valentiner, *Tino di Camaino*, p. 47; Julian Gardner, *The Tomb and the Tiara. Curial Tomb Sculpture in Rome and Avignon in the Later Middle Ages*, Oxford, 1992, 113f.

27 Valentiner, *Tino di Camaino*, 48.

28 R. Munman, *Sienese Renaissance Tomb Monuments*, Philadelphia, 1993, 7–11.

29 Valentiner, *Tino di Camaino*, 157.

30 Valentiner, *Tino di Camaino*, 59; Kreytenberg, *Tino di Camaino*, 32; idem, "Tino di Camainos Grabmäler in Firenze," *Städel Jahrbuch*, VII, 1979, 33–60.

31 A summary of opinions is given in Carli, *Gli Scultori Senesi*, 16.

32 In its modern installation the narrative sequence has been altered: the *Noli Me Tangere*, which takes place prior to the Resurrection, should be (as on the Petroni monument) on the left and the *Doubting Thomas*, which follows the Resurrection, on the right. Kreytenberg, "Tino di Camainos Grabmäler in Firenze," 33–60.

33 The caryatids have been dispersed, but several, including the figure in the Liebieghaus in Frankfurt (Fig. 139), have been identified as coming from the tomb. Kreytenberg, "Tino di Camaino's Grabmäler in Firenze," 33–60.

34 On a possible transalpine precedent for the pose see Anita F. Moskowitz, *Andrea and Nino Pisano*, Cambridge and New York, 1986, 135.

35 In Kreytenberg's reconstruction ("Tino di Camainos Grabmäler in Firenze," 33–60), in contrast to the Petroni monument with its tripartite tabernacle at the apex, the tomb was surrounded by an overarching baldacchino and at the edges of the gable there stood an Annunciation. The Madonna, however, is placed too low; the flanking figures are directing their glances slightly upward and thus her throne should be placed upon a low pedestal.

36 This designation generally refers to a class of Romanesque sculptures, frequently carved in wood, showing a seated frontal Madonna with the Child rigidly placed on her lap. The connection to the Delle Torre tomb is proposed by Kreytenberg, "Tino di Camainos Grabmäler in Firenze." Valentiner, *Tino di Camaino*, in contrast, had earlier connected the Madonna with the Orso tomb ("Tino di Camaino in Florence," *Art Quarterly*, XVII, 1954, 117–32).

37 A summary of the older literature may be found in Helen Ronan, "The Tuscan Wall Tomb, 1250–1400," Ph.D. dissertation, Indiana University, 1982, 83–91. Graphic reconstructions have been offered by Valentiner, *Tino di Camaino*, Fig. 27; Kreytenberg, "Tino di Camaino's Grabmäler in Firenze," 33–60; and Naoki Dan, "Intorno alla Tomba d'Orso di Tino di Camaino," *Annuario dell'Istituto Giapponese di Cultura*, XIV, 1977–78.

38 Noaki Dan, "Intorno alla Tomba d'Orso," suggests that Tino wished to call special attention to the fact that the consoles are carved on all sides by recording this in the inscription (TINUS SCULPSIT O(MN)E LAT(US)).

39 Francesco da Barberino, poet and notary, was the executor of Orso's Will. See Kreytenberg, "Tino di Camainos Grabmäler in Firenze" and Kreytenberg, *Tino di Camaino*, 35.

40 Kreytenberg, "Tino di Camainos Grabmäler in Firenze," 40.

41 This most unusual way of representing the deceased finds no following until the High Renaissance when, perhaps influenced by Etruscan tombs, reclining effigies are portrayed in a comparably ambiguous state of being.

42 Dan, "Intorno alla Tomba d'Orso," 68f.

43 Kreytenberg, "Tino di Camainos Grabmäler in Firenze," p. 45.

44 Even the lion suppports derive from another context, for they are more common on pulpits and church portals. It is possible, however, that the tomb of Henry VII included lions supporting the sarcophagus as indicated in the Codex Balduini. See Bowsky, *Henry VII in Italy*, Fig. 29.

45 The scholarship on the project is cited *in extenso* by Gert Kreytenberg, "Tino di Camainos Statuengruppen von den drei Portalen des Florentiner Baptisteriums," *Pantheon*, LV, 1997, 4–12.

46 Kreytenberg, "Tino di Camainos Statuegruppen," argues that this Charity is one of three Virtues executed for the east door of the Baptistry. For a summary of scholarship on this figure, see Enrica Neri Lusanna and Lucia Gaedo, eds., *Il Museo Bardini a Firenze*, Milan, 1986, 225–27.

Sienese Sculpture after Tino

1 Enzo Carli, *Goro di Gregorio*, Florence, 1946, 21.

2 On Goro di Gregorio, see Carli, *Goro di Gregorio*; Carli, *Gli Scultori Senesi*, Milan, 1980, 23f.; Marco Pierini, *L'Arca di San Cerbone* (Quaderni del Centro Studi Storici), Siena, 1995.

3 Originally built in the chapel of the Sacrament, the monument was moved to its present location along the wall of the left aisle of the Duomo in 1783. A summary of the older literature may be found in Helen Ronan, "The Tus-

can Wall Tomb, 1250–1400," Ph.D. dissertation, Indiana University, 1982, 11–16. The signature has been almost universally presumed to refer to Agnolo di Ventura, documented only in connection with architectural works.

4 Carli, *Gli Scultori Senesi*, 18–21.

5 A. Garzelli, *Sculture Toscane nel Dugento e nel Trecento*, Florence, 1969, 79.

6 Garzelli, *Sculture Toscane*, 1969, 87f.

7 Doubts about the authenticity of the upper section with the barrel vault have been expressed several times; see, in particular, Volker Herzner, "Herrscherbild oder Grabfigure? Die Statue eines thronenden Kaisers und das Grabmal Heinriches VII. von Tino di Camaino," in *Ikonographia. Anleitung zum Lesen von Bildern (Festschrift Donat de Chapeuarouge)*, ed. B. Brock and A. Preiß, Munich, 1990, 27–77, especially 34f. The issue can probably be resolved only by way of close archaeological examination.

8 John White, *Art and Architecture in Italy*, New Haven and London, 1987, 447.

9 Garzelli, *Sculture Toscane*, 79.

10 Gert Kreytenberg, "Das Grabmal von Kaiser Heinrich VII in Pisa," *Mitteilungen des Kunsthistorischen Institutes in Florenz*, XXVIII, 1984, 33–35.

11 On the Siena relief, see Alessandro Bagnoli in *Il Gotico a Siena* (exhibition catalogue), Florence, 1982, 210. On the Cleveland tabernacle see Anita F. Moskowitz, in Dorothy Gillerman, ed., *Census of Gothic Sculpture in America*, v. 3, *Midwestern Collections*, forthcoming.

12 The first to outline the artistic career of Giovanni d'Agostino was W. Cohn Goerke, "Giovanni d'Agostino," *Burlington Magazine*, LXXV, November 1939. On Sienese reliefs see R. Bartalini, in "Spazio scolpito. La novità del rilievo 'pittorico' di Giovanni d'Agostino," *Prospettiva*, XLV, 1986, 19–34.

13 Bartalini, "Spazio scolpito," Fig. 2; see also Garzelli, 107f.

14 The relief has been attributed both to Agostino di Giovanni and his son Giovanni d'Agostino; without any documentation, and possessing qualities that may be seen in both but also in neither sculptors, we prefer to consider it by an anonymous master. On this relief, see Bartalini, "Spazio scolpito."

15 See Gert Kreytenberg, "Drei Gotische Grabmonumente von Heiligen in Volterra" *Mitteilungen des Kunsthistorischen Institutes Florenz*, XXXIV, 1990, 69–100.

Orvieto and "Lorenzo Maitani"

1 Daniel Waley, *Mediaeval Orvieto. The Political History of an Italian City-State 1157–1334*, Cambridge, 1952.

2 Antje Middeldorf Kosegarten, *Die Domfassade in Orvieto. Studien zur Architektur und Skulptur 1290–1330*, Munich, Berlin, 1996, 17. Documents for Orvieto cathedral are published by L. Fumi, *Il Duomo di Orvieto e i Suoi Restauri*, Rome, 1891; see also Gaetano Milanesi, *Documenti per la Storia dell'Arte Senese*, v. 1, Siena, 1854, 172–98.

3 Marvin Trachtenberg, in lectures at the Institute of Fine Arts, New York University.

4 This connection has been emphasized most recently by E. Carli, "Il Duomo come architettura e scultura" *Il Duomo di Orvieto e le Grandi Cattedrali del Duecento*, (Atti del Convegno Internazionale di Studi, Orvieto, 12–14 novembre 1990), Turin, 1995, 27–51.

5 David Gillerman, "La facciata: introduzione al rapporto tra scultura e architettura," in Lucio Riccetti, ed., *Il Duomo di Orvieto*, Bari, 1988, 81–100. For the *Meditations*, see Isa Ragusa, *Meditations on the Life of Christ. An Illustrated Manuscript of the 14th Century*. Paris, Bibliothèque Nationale, Ms. ital 115, trans. from the Latin, Princeton, 1961, 1977.

6 Compare the similar effect of fabric stretched across a structural armature in Nicola Pisano's Siena pulpit (Fig. 41).

7 This is a rejection of the iconographic paucity seen on the facades of Siena and Florence. See Chapters 2, pp. 63ff, 68ff, and 8, pp. 294ff. A comparison of the Sienese and Orvietan programs is offered by Kosegarten, *Domfassade in Orvieto*, 47–52.

8 Gillerman, "La facciata"; Max Seidel, "Die Rankensäulen der Sieneser Domfassade," *Jahrbuch der Berliner Museen*, 1968/69, 80–160.

9 Enzo Carli, *Gli Scultori Senesi*, Milan, 1980, 8–10, with bibliography through 1976.

10 See note 9.

11 The sculpture of the cathedral of Orvieto, above all that on the facade, has been the subject of contradictory theses. On the one hand Giovanni Previtali, following earlier discussions by Pico Cellini, has isolated it from the major currents of Sienese and Tuscan sculpture, maintaining that there is an Umbrian school of sculpture whose filiation derives ultimately from Nicola Pisano's (and Arnolfo di Cambio's) sojourn in Perugia and the resultant influence on local masters, which produced an idiosyncratic Umbrian style (Previtali, "Sulle tracce di una scultura umbra del Trecento," *Paragone*, 181, March 1965, 16–25; idem, "Secondo studio sulla scultura umbra del Trecento," *Paragone*, 241, March 1970, 9–27). On the other hand, most scholars, including Enzo Carli (*Gli Scultori Senesi*, 8f.), continue to believe that masters from Siena were called to Orvieto and that the style of the pier reliefs and the lunette statues is, if highly personal, essentially Sienese, designed by a Sienese master and for the most part executed both by Sienese and local masters.

12 John White, "The reliefs on the facade of the duomo at Orvieto," *Journal of the Warburg and Courtauld Institutes*, XXII, 1959, 254–302.

13 But this is an intrinsic characteristic of "Italian Gothic" art in contrast to French Gothic: The personal, individualized character of its major monuments often makes it difficult to define a "Pisan" in contrast to a "Sienese," a "Florentine" in contrast to a "Pisan," and an "Orvietan" in contrast to a "Sienese" school. For one thing, as we have seen, the masters traveled and worked outside their native cities; for another, personalized styles merge with or become the embodiment of local ones, often making such distinctions rather artificial.

14 Magrit Lisner, *Holzkruzifixe in Florenz und in Toskana von der Zeitum 1300 bis zum frühen Cinquecento*, Munich, 1970, 26f.; Figs. 51–54.

15 The work is one among several sculptures often attributed to Ramo di Paganello, who is documented in Siena and Orvieto (and who had been "de partibus ultramontanis" – which could mean across the Alps or, for the Sienese, the Appenines) but to whom no secure work can be ascertained. On "the enigmatic Ramo di Paganello" see Carli, *Gli Scultori Senesi*, 7.

16 Julian Gardner, *The Tomb and the Tiara. Curial Tomb Sculpture in Rome and Avignon in the Later Middle Ages*, Oxford, 1992, 59f., 115–18.

17 Gardner, *The Tomb and the Tiara*.

18 A. R. Garzelli, *Sculture Toscane nel Dugento e nel Trecento*, Florence, 1969, 207–11; Gardner, *Tomb and Tiara*, 117.

19 Roberto Bartalini, "Spazio scolpito. La novità del rilievo 'pittorico' di Giovanni d'Agostino," *Prospettiva*, XLV, 1986, 19–34.

FOUR. TRECENTO FLORENCE AND PISA

Andrea Pisano

1 Anita F. Moskowitz, *The Sculpture of Andrea and Nino Pisano*, Cambridge, London, New York, 1986, 134–48.

2 A full biographical sketch, with documentary references, is given in Gert Kreytenberg, *Andrea Pisano und die Toskanische Skulptur des Vierzehnten Jahrhunderts*, Munich, 1984, 15–18.

3 Richard Goldthwaite, *The Building of Renaissance Florence. An Economic and Social History*, Baltimore and London, 1980, 1–4. Paris at the time had 80,000 inhabitants, while it is believed that Rome had only 15,000 to 20,000. Antonio Paolucci, "I Rilievi del Campanile: Una Teologia del Lavoro," in Timothy Verdon, ed., *Alla Riscoperta di Piazza del Duomo in Firenze*, v. 2 (La Cattedrale di Santa Maria del Fiore), Florence, 1993, 65–87.

4 See p. 63. The economic factors underlying Florence's growth are outlined by Goldthwaite, *The Building of Renaissance Florence*, 31ff. The inherent civic and civil tensions in the development of Florence's capitalist economy are emphasized in Marvin Trachtenberg, *Dominion of the Eye. Urbanism, Art and Power in Early Modern Florence*, Cambridge, 1997.

5 Christine Smith, *Retrospection. Baccio Bandinelli and the Choir of Florence Cathedral*, Cambridge, Mass., 1997 (in particular, pp. 37–45).

6 Diane Finiello Zervas, ed., *Orsanmichele a Firenze/Orsanmichele Florence*, Modena, 1996, 2 vols.

7 This was the first of eventually three bronze doors on the Baptistry; the second and third doors were executed by Lorenzo Ghiberti in the fifteenth century.

8 Marvin Trachtenberg, *The Campanile of Florence Cathedral: Giotto's Tower*, New York, 1971; cf. Gert Kreytenberg, "Der Campanile von Giotto," *Mitteilungen des Kunsthistorischen Institutes in Florenz*, XXII, 1978, 147–84.

9 Luisa Becherucci, "La bottega pisano di Andrea da Pontedera," *Mitteilungen des Kunsthistorischen Institutes in Florenz*, 1963–65, 227–62.

10 Three monographs, all of which publish (or republish) the documents concerning Andrea and Nino Pisano, and which list the earlier bibliography but which differ in attributions to these sculptors, appeared in the 1980s: M. Burresi, *Andrea, Nino e Tommaso. Scultori Pisani* (exhibition catalogue), Milan, 1983; Kreytenberg, *Andrea Pisano*; Moskowitz, *The Sculpture of Andrea and Nino Pisano*. For illustrations of all the Baptistry and Campanile reliefs, the reader may turn to any of these monographs. On Andrea's death date see the discussion in Becherucci, "La bottega," 244f.

11 A summary of scholarship regarding the Annunziata is offered by Roberto Bartalini in *Scultura Dipinta, Maestri di Legname e Pittori a Siena 1250–1450* (exhibition catalogue), Florence, 1987, 56–60. See also Kreytenberg, *Andrea Pisano*, 129f.

12 The statue came to the museum from the convent of San Domenico, Pisa, which was founded, however, only in the late Trecento. The inscription, carved on a separate base, reads: A.D. MCCCXXI / AUGUSTINUS QUONDAM GIOVANI E STAFANUS ACOLTI / DE SEN (A) . . . Roberto Bartalini, "Cinque postille su Giovanni d'Agostino," *Prospettiva*, 73–74, 1994, n. 2, states that a letter F (which would imply the word "fecerunt") precedes the phrase "DE SEN"; this letter appears neither in the published inscription of his reference, Mariagiulia Buressi, *Restauro di sculture lignee nel Museo di S. Matteo*, Pisa, 1984, cat. 1, nor in his essay in *Scultura Dipinta*, 58; nor have I been able to discern it on the base of the statue. The insistence on the authorship of the Sienese Agostino di Giovanni, co-author of the Tarlati monument, continues to puzzle me because it suggests a certain blindness to the extraordinary expressive quality of the Annunziata, which, to my eyes, cannot be found in any work securely associated with the Sienese sculptor. Having said this, however, see the discussion, pp. 314ff., on conflicting appraisals of stylistic and expressive characteristics leading to contradictory attributions. In any case, there must have been many Agostinos who were sons of diverse Giovannis in early Trecento Pisa and Siena; the names could refer to the patron who commissioned the work and the painter who polychromed it.

13 The arms and wrists are movable and thus amenable to several poses. The plainness of her garment, which lacks a mantle, is to be explained by the not uncommon addition of real cloth and accoutrements on wooden figures.

14 Andrea's relationship to the whole of the earlier Tuscan Gothic tradition is explored by Moskowitz, *Andrea and Nino Pisano*, 94–118.

15 For which reason a caster from Venice was sought; see p. 132

16 The general scheme follows that of the doors of the Duomo of Pisa, sketches of which had been brought to Florence; see p. 132, and Moskowitz, *Andrea and Nino Pisano*, 95f. The framework of Andrea's doors also indicates that

the sculptor was aware of other medieval bronze doors extending beyond Tuscany to northern and southern Italy, including doors in Monreale, Trani, and Ravello. Anita F. Moskowitz, "The framework of Andrea Pisano's bronze doors: Some possible non-Tuscan sources," *Source. Notes in the History of Art*, 2, 1983, 1–4.

17 This sensitivity to a continuum of viewing sites, from the more distant, in which the object as architectural fabric dominates one's perceptions, to the close-up stance, when one perceives and contemplates the narrative vignettes, may have been informed by Andrea's putative experience in Orvieto; see Moskowitz, *Andrea and Nino Pisano*, 99–108.

18 On the biblical and apocryphal stories on which these narratives are based, see Moskowitz, *Andrea and Nino Pisano*, 18–30.

19 Moskowitz, *Andrea and Nino Pisano*, Figs. 19, 25, 47.

20 On the influence of French Gothic art on Andrea, see Moskowitz, *Andrea and Nino Pisano*, 135–48.

21 Moskowitz, *Andrea and Nino Pisano*, 9–18.

22 Moskowitz, *Andrea and Nino Pisano*, 38–48; see also the illustrations in Appendix B, 188–95.

23 This dating became clear when the reliefs were transferred to the Museo dell'Opera del Duomo (then replaced by copies) and it was seen that those on the west face had been inserted into the fabric of the wall simultaneously with the incrustation, and therefore before the death of Giotto, who supervised this phase of the construction. See Becherucci, "La bottega," 261; Trachtenberg, *The Campanile of Florence Cathedral. "Giotto's Tower,"* 49. All other reliefs were attached after the revetement had been installed.

24 On the influence of classical art on the work of Andrea, see Moskowitz, *Andrea and Nino Pisano*, 119–33.

25 John White, *The Birth and Rebirth of Pictorial Space*, Boston, 1967, 27f. and passim.

26 Compare Kreytenberg, *Andrea Pisano*, 65–77, who attributes, on the basis of visual comparisons that elude this observer, various of these reliefs to Andrea, to Nino, to a sculptor named Gino Micheli da Chastello, and to Maso di Banco, among others.

27 On the bridge (later removed) linking the Duomo to the Campanile, see Trachtenberg, *The Campanile of Florence Cathedral*, 66–69. On the niche figures and lunette Madonna see Moskowitz, *Andrea and Nino Pisano*, 48–50.

28 Trachtenberg, *The Campanile of Florence Cathedral*, 99f.

29 Architecture appears in its dual aspect: as the art of building and, as is the case on the north porch of Chartres, as a mathematical art in the relief representing Geometry.

30 On the relationship of the Campanile program to Thomistic philosophy see Emma Simi Varanelli, *Artisti e dottori nel Medioevo. Il campanile di Firenze e la revalutazione delle "arti belle"* (Il pensiero italiano), Rome, 1996. Although one could raise many objections to the art historical (particularly chronological and stylistic) analyses of the author, she offers a number of acute observations concerning both individual reliefs and the sequential ordering

of the hexagons in a program emphasizing the progress of civilization's inventions, a progress that culminates in the arts of Painting, Sculpture, and Architecture.

31 On the Trecento humanists, see Michael Baxandall, *Giotto and the Orators*, Oxford, 1971, 1–50.

32 Trachtenberg, *The Campanile of Florence Cathedral*, 94, 104f.

33 The effects of the changing climate in Florence already prior to the Black Death would seem to be apparent in several reliefs on the lowest zone; see pp. 138f. and 151f. and Moskowitz, *Andrea and Nino Pisano*, 44–48; 131f.

34 Trachtenberg, *The Campanile of Florence Cathedral*, 54–57, suggests dissatisfaction on the part of the Operai with the unclassical, non-Florentine aspects of Andrea's Campanile design that altered Giotto's more traditional "stack of cubes."

35 Moskowitz, *Andrea and Nino Pisano*, 60.

36 A summary biography of Simone Saltarelli is given in Elisa W. Harrison, "A Study of Political Iconography on Six Italian Tombs of the 14th Century," Ph.D. dissertation, Northwestern University, 1988, 200–11.

37 The Saltarelli monument is undocumented, but a Sepoltuario of 1620, with addenda postdating 1651, gives a vivid description. See Moskowitz, *Andrea and Nino Pisano*, 80f. For an annotated bibliography on the Saltarelli monument to 1983, see Helen Ronan, "The Tuscan Wall Tomb 1250–1400," Ph.D. dissertation, Indiana University, 1982, 154–57.

38 The left relief depicts the seated archbishop refusing a sack or purse offered to him. Harrison, "A Study of Political Iconography," 209, plausibly suggests that this action refers to his staunch opposition to usury, the laws against which he vehemently enforced; cf. Moskowitz, *Andrea and Nino Pisano*, 82. In the center he sits on an episcopal seat giving the gift of a chalice to a kneeling Dominican, as he had in fact done for his convent of Sta. Maria Novella, in Florence. To the right he receives the homage of faithful Pisans.

39 J. Lanyì, "L'ultima opera di Andrea Pisano," *L'Arte*, XXXVI, 1933, 204–27; P. Cellini, "Appunti orvietani per Andrea e Nino Pisano," *Rivista d'Arte*, XV, 1933, 1–20. The figure has received an alternative attribution to Nino but finds its most plausible locus within the framework of Andrea's rather than Nino's evolving style. See p. 316.

40 He first successfully achieves this goal in the marble Madonna at the apex of the facade of the Duomo of Pisa. On this figure, probably to be associated with a document of 1345, see Moskowitz, *Andrea and Nino Pisano*, 71, and Figs. 114–16.

41 The history of the half-length image and its psychological impact are discussed by Sixten Ringbom, *Icon to Narrative. The Rise of the Dramatic Close-up in Fifteenth-Century Devotional Painting*, Abo, 1965; see especially 39–52. It is not to be entirely excluded that the figure was cut down from a standing image, although such a figure too would be very rare; this can only be determined by archaeological examination of the statue's underside.

42 Simone's painting is discussed by Millard Meiss, "The Madonna of Humility," *Art Bulletin*, XVIII, 1936, 435–64.

Giovanni di Balduccio in Tuscany

1 On the decline of Pisa's fortunes in the early Trecento see pp. 96, 109.

2 Enzo Carli, "Sculture pisane di Giovanni di Balduccio," *Emporium*, XCVII, 1943, 143ff. On Sta. Maria della Spina, see Mariagiulia Burresi, *Santa Maria della Spina in Pisa*, Milan, 1990.

3 On Balduccio's possible activity in Genoa see Max Seidel, "Studien zu Giovanni di Balduccio und Tino di Camaino," *Städel-Jahrbuch*, V, 1975, 37–84.

4 On Castruccio, see Louis Green, *Castruccio Castracani. A Study on the Origins and Character of a Fourteenth-Century Italian Despotism*, Oxford, 1986. The political motivations are underlined by Carla Benocci, "La tomba di Guarnerio Castracani degli Antelminelli nella chiesa di S. Francesco a Sarzana: ricerche e contribuiti," *Rivista di Archeologia, Storia, Costume del Istituto Storico Lucchese*, IX, 1981, 9–22. On the tomb, see most recently Enrico Castelnuovo, ed., *Niveo de Marmore. L'uso artistico del marmo di Carrara dall'XI al XV secolo*, Genoa, 1992, 324–27. The Madonna and Child is a copy, of which the original is in the Johnson Collection, Philadelphia.

5 The dating offered by Benocci, "La tomba di Guarnerio," based on the dates that Castruccio received the titles proudly celebrated in the inscription, seems convincing. See also Green, *Castruccio Castracani*, 188f.; Enzo Carli, "Giovanni di Balduccio a Milano," *Il Millennio Ambrosiano*, v. 3, ed. Carlo Bertelli, Milan, 1989, 70–103 (in that article a typographical error refers to Castruccio becoming imperial vicar of Ludwig of Bavaria in 1337 instead of 1327).

6 The chapel is the subject of a dissertation by Robert J. H. Janson-La Palme, "Taddeo Gaddi's Baroncelli Chapel: Studies in Design and Content," Ph.D. dissertation, Princeton University, 1975.

7 Janson-LaPalme, "Taddeo Gaddi's Baroncelli Chapel," 133; Andrew Ladis, *Taddeo Gaddi*, Columbia, Mo., and London, 1982, 22f., 88.

8 Giorgio Vasari, *Le Vite de' più eccellenti pittori, scultori e architettori, nelle redazioni del 1550 e 1568*, eds. Rosanna Bettarini, Paola Barocchi, v. 2, Florence, 1967, 67.

9 Francesco Filippini, "L'anitco altare maggiore in S. Domenico attribuito a Giovanni Pisano," *Commune di Bologna*, XIII/4, 1935, 19–23. For subsequent bibliography see Massimo Medica, "Un San Domenico per l'altare bolognese di Giovanni di Balduccio," in *Arte a Bologna*, v. 1, 1990, 11–20. A plausible reconstruction of the altarpiece is suggested by Massimo Medica, "Giovanni di Balduccio *Natività*, *Ospiti* 3, Bologna, 1996.

10 See W. R. Valentiner, "Giovanni di Balducci a Firenze e una scultura di Maso," *L'Arte*, n.s., VI, 1935, 3–29.

11 The exception among the scholars is Toesca, *Il Trecento*, Turin, 1951, 268, who believes that the San Casciano

reliefs postdate the Baroncelli monument, but he offers no reasons. Scholars have not questioned the present form of the pulpit; the balustrade and cornice with which the reliefs are enframed do not appear to be of the fourteenth century. The church was completely altered during the Baroque period; see Franco Lumachi, *Guida di Sancasciano Val di Pesa*, Milan, n.d.(1959?), 37.

12 Thus, the pulpit may have been similar in structure to such Florentine Romanesque examples as that in San Miniato al Monte (Toesca, *Il Medioevo*, v. 2, Torino, 1965, fig. 533) or the one now in S. Leonardo in the suburb of Arcetri on the south bank of the Arno but originally made for the (destroyed) church of S. Piero Scheraggio in the center of Florence (for this pulpit see Guido Carocci, "I Pulpiti del Medioevo e del Rinascimento in Toscana." *Arte Italiana Decorativa e Industriale*, 10, 1901, 7–10; 16–19; 25–27).

13 Frederick Hartt, *Italian Renaissance Art*, 3rd. ed., Englewood Cliffs, N.J., 1987, Figs. 59, 60, and Pl. 14.

The Second Half of the Trecento

1 The Siena Baptistry facade, begun in 1316, is significant in our context precisely because of its *lack* of major sculptural embellishment.

2 Gene Brucker, *Florentine Politics and Society 1343–1378*, Princeton, 1962, 8, 14; Ferdinand Scheville, *History of Florence*, 2nd ed., New York, 1961, 224. On the continuously declining population after successive waves of pestilence during the second half of the century see Samuel K. Cohn, Jr., *The Cult of Remembrance and the Black Death. Six Renaissance Cities in Central Italy*, Baltimore and London, 1992, 5f.

3 M. Becker, *Florence in Transition*, v. 1, Baltimore, 1967, 226–9; Schevill, *History of Florence*, 265–66.

4 Millard Meiss's thesis in *Painting in Florence and Siena after the Black Death*, Princeton, 1951, that there is a direct cause and effect relationship between the crisis of the Black Death and a change of style in painting, has for some time now been called into question. In particular, redating of works used by him for evidence and new data on the social and economic realities of the second half of the Trecento have led to a reevaluation concerning the effect that the outbreak of plague had on artistic style. For a summary of current research see Diana Norman, "Change and Continuity: Art and Religion after the Black Death," *Siena, Florence and Padua: Art Society and Religion 1280–1400*, v. 1, ed. Diana Norman, New Haven and London, 1995, 177–95. On evidence from testamentary demands for art, reflecting both economic exigencies and the spiritual, social, and ideological contexts of artistic production during the Trecento, see Cohn, *The Cult of Remembrance and the Black Death*, passim (especially 271–80).

5 Regarding Siena, Van Os states that a commission such as Duccio's Maestà is inconceivable after 1348, the days of the great commissions being over and with them the era

of great masters leading large workshops. H. W. van Os, "Tradition and innovation in some altarpieces by Bartolo di Fredi," *Art Bulletin*, LXVII/1, March 1985, 50–66; repeated in *Sienese Altarpieces*, Grönigen, 1984–90, 30.

6 On the development of perspective systems see John White, *The Birth and Rebirth of Pictorial Space*, 3rd ed., Cambridge, Mass., 1987.

7 Marvin Trachtenberg, *The Campanile of Florence Cathedral, "Giotto's Tower,"* New York, 1971, 95f.

8 The original attribution is due to Luisa Becherucci, "I Rilievi dei sacramenti nel campanile del Duomo di Firenze, *L'Arte*, XXX, 1927, 214–23; see also L. Becherucci and G. Brunetti, in *Il Museo dell'Opera del Duomo a Firenze*, v. 1, Florence, 1969, 239–40. Compare G. Kreytenberg, "The Sculpture of Maso di Banco," *Burlington Magazine*, 121, 1979, 72–76, who ascribes the series to Maso. While Kreytenberg is correct in the discrepency between the monumental Madonna inside the Bigallo and the exterior relief, his rejection of the attribution of the Sacraments to Arnoldi is based primarily on comparisons with the larger Madonna, and not with the documented exterior relief whose style is so close to the Campanile Consecration relief.

9 In addition to the references in note 8, see G. Kreytenberg, "Alberto Arnoldi e i rilievi della Loggia del Bigallo a Firenze," *Prospettiva*, October 1977, 27–33; W. R. Valentiner, "Orcagna and the Black Death of 1348," *Art Quarterly*, XII, 1949, 48–59. The documentation on Arnoldi is recorded in M. L. De Sanctis, "Alberto di Arnoldo," *Enciclopedia dell'Arte Medievale*, v. 1, Rome, 1991, 318–20.

10 Giovanni Poggi, I.B.Supino, "La compagnia del Bigallo," *Rivista d'Arte* 2, 1904, 189–244; Luisa Becherucci, "I Rilievi dei sacramenti nel campanile del duomo di Firenze, *L'Arte*, XXX, 1927, 214–23.

11 Poggi, "La Compagnia del Bigallo," 225f.; Ugo Procacci, "L'affresco dell'Oratorio del Bigallo ed il suo maestro," *Mitteilungen des Kunsthistorischen Institutes in Florenz*, XVII, 1973, 307ff. The present setting of the interior figures is of later date.

12 On the bridge (later destroyed) see Trachtenberg, *The Campanile of Florence Cathedral*, 66–69.

13 Anita F. Moskowitz, *The Sculpture of Andrea and Nino Pisano*, Cambridge, London, New York, 1986, Fig. 24.

14 See Moskowitz, *Andrea and Nino Pisano*, 49 and Figs. 83, 84.

15 Moskowitz, *Andrea and Nino Pisano*, Fig. 74.

16 Moskowitz, *Andrea and Nino Pisano*, 163f.

17 Not to be excluded is the possiblity that what remains of Nino's work is an accident of history, and that much has been lost.

18 See Moskowitz, *Andrea and Nino Pisano*, 80–90, and Chapter 9. A summary of the literature and attributional issues is offered in Anita Moskowitz, "Nino Pisano," *Enciclopedia dell'Arte Medievale*, v. 8, Rome, 1997, 707–12.

19 Moskowitz, *Andrea and Nino Pisano*, 5 n. 27 and doc. 61.

20 Moskowitz, *Andrea and Nino Pisano*, 161f. Gert Kreytenberg, *Andrea Pisano und die Toskanische Skulptur des Vierzehnten Jahrhunderts*, Munich, 1984, has developed an extensive corpus, expanded further by A. Bagnoli, "Da Goro di Gregorio a Nino Pisano," *Prospettiva*, 41, April 1985, 52–54, for this "Andrea di Nino"; there is, however, not the slightest evidence that Nino's son was a sculptor.

21 See p. 316. Compare Martin Weinberger, "Nino Pisano," *Art Bulletin* LXX, 1937, 58–91, who sees a growing, rather than a diminishing, influence of Andrea's sculpture on Nino. M. Burresi, *Andrea, Nino e Tommaso. Scultori Pisani*, Pisa, 1983, and Kreytenberg, *Andrea Pisano*, 1984, respectively, offer differing, alternative chronologies.

22 Moskowitz, *Andrea and Nino Pisano*, 150.

23 On the Scherlatti tomb, contracted to Nino in 1362, and the Moricotti tomb (undocumented, and possibly by a faithful imitator of Nino), see Moskowitz, *Andrea and Nino Pisano*, 157–61.

24 See S. Sponza, "Il monumento al Doge Marco Corner ai Santi Giovanni e Paolo restaurato: osservazione e proposte," *Ateneo Veneto*, n.s., 25, 1987, 77–105, who offers the intriguing hypothesis that some of the figures for the Cornaro monument were originally intended for the Agnello tomb, left incomplete after the doge's expulsion.

25 The statue's original site, whether for a tomb or altar, is not known. Moskowitz, *Andrea and Nino Pisano*, 64.

26 Giorgio Vasari, *Le Vite de' più eccellenti pittori, scultori e architettori, nelle redazioni del 1550 e 1568*, eds. Rosanna Bettarini, Paola Barocchi, II, Florence, 1967, 159; Gaston du C. De Vere, trans., *Lives of the Most Eminent Painters, Sculptors & Architects by Giorgio Vasari*, London, 1912–14, 141.

27 Anita Moskowitz, "A Madonna and Child Statuette: Reversing a Reattribution," *Bulletin of the Detroit Institute of Arts*, 61/4, 1984, 34–47.

28 Moskowitz, *Andrea and Nino Pisano*, 156. On the attribution cf. Burresi, *Andrea, Nino e Tommaso*; Kreytenberg, *Andrea Pisano*, 1984, 111–15. On copies of the Trapani Madonna see H. W. Kruft, "Die Madonna von Trapani und ihre Kopien. Studien zur Madonnen-Typologie und zum Begriff der Kopie in der Sizilianischen Skulptur des Quattrocento," *Mitteilungen des Kunsthistorischen Institutes in Florenz*, XIV, 1969–70, 297–332.

29 Moskowitz, *Andrea and Nino Pisano*, 155f.

30 Klara Steinweg, *Andrea Orcagna. Quellengeschichtliche und stilkritische Untersuchung*, Strasbourg, 1929. A summary of recent scholarship is found in Gert Kreytenberg, "Andrea di Cione," *Enciclopedia dell'Arte Medievale*, v. 1, 602–8.

31 Meiss, *Painting in Florence and Siena after the Black Death*. Compare Bruce Cole, "Some Thoughts on Orcagna and the Black Death Style," *Antichità Viva*, XXII/2, 27–37; Gert Kreytenberg, "Image and Frame," *Burlington Magazine*, 134, 1992, 634–38; Nancy Rash Fabbri and Nina Rutenburg, "The Tabernacle of Orsanmichele in Context, *Art Bulletin*, 63, 1981, 385–405; Kathleen Giles, "The Strozzi Chapel in Santa Maria Novella: Florentine Painting and Patronage 1340–55," dissertation, New York University, 1977; John Paoletti: "The Strozzi Altarpiece Reconsidered," *Memorie Domenicane*, n.s., 20, 1989, 279–300.

32 The work was first attributed to Orcagna by Margrit Lisner, who offered numerous morphological and stylistic comparisons to the figures on the Tabernacle and in the Strozzi Altarpiece; see *Holtzkruzifixe in Florenz und in der Toskana von der Zeit um 1300 bis zum frühen Cinquecento*, Munich, 1970, 36f. See also Diane Finiello Zervas, ed., *Orsanmichele a Firenze/Orsanmichele Florence*, Modena, 1996, v. 2, 610–12.

33 Orcagna's entrance into the Arte dei Medici e Speziali in 1344 precedes by eight years his enrollment in the sculptor's guild.

34 Giovanna Rasario, ed., *Il Cristo di San Carlo restaurato*, Florence, 1996, 14, 37–40. Already during the course of carving fissures began to appear; these were repaired with nails and infilling, and the surfaces covered with prime, as was the entire statue. On the problems of wood carving see p. 9.

35 Other examples conforming to this type are two wood crucifixes in Pescia and an impressive marble Crucifix in San Michele in Borgo, in Pisa; see Anita Moskowitz, "A Sienese Crucifix: Context and Attribution," *Bulletin of the Detroit Institute of Arts*, 64/4, 1989, 40–53.

36 The monastery of San Michele in Orto, from which the present building takes its name, was destroyed in 1239; in 1285 the site was taken over by the city as a public square, after which an open marketplace for grain was built on the grounds. Here, an image of the Madonna and Child on one of the interior piers began performing miracles in 1292 and became the focus of an important cult. Early in the next century a fire destroyed the loggia and apparently also the miraculous image so that both a new building and a new image, a copy of the original one, was made; an illustration in Giovanni Villani's *Nuova Cronica* of 1340–48 depicts the panel housed in an architectural frame (see Zervas, *Orsanmichele*, v. 1, 33–35 and Fig. 16). From this and other visual evidence, one gains an idea of what the enclosing shrine that preceded Orcagna's looked like. However, the loggia soon needed replacement. Bernardo Daddi's panel painting housed in Orcagna's tabernacle, thus, may actually be the third in the series of images on the site. On Orsanmichele and Orcagna's tabernacle, see, most recently, Gert Kreytenberg, *Orcagna's Tabernacle in Orsanmichele*, Florence, New York, 1994; Zervas, *Orsanmichele*, 2 vols., which offers an extensive history of the building and its context, as well as superb photographic documentation. The present Orsanmichele is attributed to Andrea Pisano by Trachtenberg, *The Campanile of Florence Cathedral*, whereas Kreytenberg, 24, suggests Maso di Banco.

37 Brendan Cassidy, "The financing of the Tabernacle of Orsanmichele," *Source. Notes in the History of Art*, VIII/1, 1988, 1–6.

38 The arches of Orsanmichele were closed in only later in the century. Zervas, *Orsanmichele*, 80f.

39 Claudio Pisetta and Giulia Maria Vitali, "New knowledge of Andrea Orcagna's Tabernacle through an interpretive study," in Zervas, *Orsanmichele*, v. 1, 365–99.

40 Nancy Rash Fabbri and Nina Rutenburg, "The Tabernacle of Orsanmichele in Context, *Art Bulletin*, 63, 1981, 385–405; Brendan Cassidy, "Orcagna's Tabernacle in Florence: Design and Function," *Zeitschrift für Kunstgeschichte*, 61/2, 1992, 180–211.

41 Conventionally designated a Death or Dormition of the Virgin, the scene actually represents her Entombment three days later, since she is on her sarcophagus and not her deathbed; Zervas, *Orsanmichele*, 602.

42 The focus on human interaction is emphasized by Fabbri and Rutenburg, "The Tabernacle of Orsanmichele," 385–405.

43 As can be seen in Bernardino Poccetti's drawing in the Museo dell'Opera del Duomo; for a very legible reproduction, see Glenn Andres, John M. Hunisak, and A. Richard Turner, *The Art of Florence*, New York, 1988, v. 1, 122.

44 Ghiberti, *Commentari*, ed. O. Morisani, Naples, 1947, 36.

45 The ingenious controlling mechanisms, which are still fully functional, are housed behind the triangular gables; access to them was by means of a miniature staircase set into the upper space between the painting and the Dormition and Assumption relief. Zervas, *Orsanmichele*, 88, and Pisetta and Vitali, "New knowledge of Andrea Orcagna's Tabernacle," in Zervas, *Orsanmichele*, 365–99 (especially 391–98, on the mechanics of the moving parts). These authors also speak of the possibility that a simple curtain was most often used to hide the image from view. Compare Cassidy, "Orcagna's Tabernacle," 180–211, who does not mention metal grilles and writes of a curtain, possibly of leather, as screening the image.

46 Cassidy, "Orcagna's Tabernacle."

47 This complex structure, revealing the hand of several sculptors, originated as a marble altarpiece for the main altar of Arezzo cathedral. Alessandro Del Vita, "L'Altar maggiore del duomo d'Arezzo," *Rassegna d'Arte*, XI/8, 1911, 127–40; Ersilia Agnolucci, "L'arca-altare di San Donato nella cultura artistica del Trecento Aretino," *Antichità Viva*, XXVII/1, 1988.

48 Although many individual studies have been done on all the documented sculptors in the cathedral workshop during the last decades of the century, there is as yet no synthetic overview that might suggest a programmatic vision or the specific aims of the Operai (beyond the filling in of niches and blanks in the decorative fabric).

49 Compare the statuettes in Fig. 224 and St. Stephen from Andrea Pisano's workshop, Moskowitz, *Andrea and Nino Pisano*, Fig. 101.

50 Becherucci and Brunetti, *Museo*, 249. On the Loggia dei Lanzi, see Carl Frey, *Die Loggia dei Lanzi zu Florenz*, Berlin, 1885.

51 The fundamental work on wood sculpture of the Abruzzi remains Enzo Carli, "Per la scultura lignea del trecento in Abruzzo," *Le Arti*, III, 1941, 435–43. See also O. Lehmann Brockhaus, *Abruzzen und Molise*, Munich, 1983, 356–62. On Italian wood sculpture in general see Enzo Carli, *La Scultura Lignea Italiana*, Milan, 1960.

52 *Scultura Dipinta. Maestri di legname e pittori a Siena 1250–1450* (exhibition catalogue), Florence, 1987, 42–44.

53 On the imitation of favored models see Enrica Neri

Lusanna, "Invenzione e replica nella scultura del Trecento: il Maestro dei Magi di Fabriano," in *Studi di Storia dell'Arte*, v. 3, 1992, 45–66.

54 Carli, *Scultura Lignea Italiana*, Pl. 20.

55 Enrica Neri Lusanna, "Per la scultura marchigiana del '300. Il Maestro dei Magi di Fabriano e il Maestro della Madonna di Campodonico," in Giampiero Donnini, ed., *I Legni Devoti*, Fabriano, 1994, 26–37. In this same volume see also Giampiero Donnini, "Una bottega lignea fabrianese del secondo '300," 38–45.

56 See note 53.

57 Enrica Neri Lusanna, "Il gruppo ligneo della Natività di S. Nicola a Toletino e la scultura marchigiana," in *Arte e spiritualità degli ordini mendicanti* (Acts of Congress), Tolentino, 1992, 105–24.

58 Ugo Procacci, "Opera d'Arte inedite alla Mostra del Tesoro di Firenze Sacra," II, *Rivista d'Arte*, XV, 1933, 429–47; Carli, *Scultura Lignea Italiana*, 58 and Pls. 32–34; Clara Baracchini, ed., *Scultura Lignea, Lucca 1200–1425* (exhibition catalogue), Florence, 1995, 3.

FIVE. ANGEVIN PATRONAGE IN NAPLES AND SOUTHERN ITALY

Tino di Camaino in Naples

1 Ottavio Morisani, *Tino di Camaino a Napoli*, Naples, 1945, 30f. A list of documents and outline of their contents is published by W. R. Valentiner, *Tino di Camaino: A Sienese Sculptor of the Fourteenth Century*, Paris, 1935, 156–61.

2 Valentiner, *Tino*, 91; Lorenz Enderlein, *Die Grablegen des Hauses Anjou in Unteritalien. Totenkult und Monumente 1266–1343*, Worms, 1997, 76–78.

3 Valentiner, *Tino*, 94; Morisani, *Tino di Camaino a Napoli*, 2ff. See also F. Bologna, *I pittori alla corte Angioina di Napoli. 1266–1414*, Rome, 1969.

4 Aldo De Rinaldis, *Naples Angevine*, Paris, n.d., 107.

5 De Rinaldis, *Naples Angevine*, passim; R. Causa, "Precisione relativa alla scultura dell '300 a Napoli," in *Scultura Lignea nella Campania*, Naples, 1950, 63–73; Valentiner, *Tino*, 83–90; Pierluigi Leone de Castris, *Arte di Corte nella Napoli Angioina*, Florence, 1986, 155–73.

6 Caroline Bruzelius, "Ad modum Franciae, Charles of Anjou and Gothic architecture in the Kingdom of Sicily," *Journal of the Society of Architectural Historians*, L, 1991, 402–20.

7 Pierluigi Leone de Castris, "Napoli 'capitale' del gotico europeo: il referto dei docmenti e quello delle opere sotto il regno di Carlo I e Carlo II d'Angiò," in Valentino Pace and Martina Bagnoli, eds., *Il Gotico Europeo in Italia*, Naples, 1994, 239–64; see Pl. 12.

8 Connections to the architecture of Provence are noted by Aldo De Rinaldis, *Santa Chiara*, Naples, 1920, 92–97; P. Gaudenzio dell'Aja, *Per la Storia del Monastero di Santa Chiara in Napoli*, Naples, 1992, 23–26.

9 The artistic culture at the Angevin court is discussed extensively by de Castris, *Arte di Corte nella Napoli Angioina*, which includes an exhaustive bibliography.

10 W. R. Valentiner, "Observations on Sienese and Pisan Trecento Sculpture," *Art Bulletin*, IX, 1926–27, 177–220; Enzo Carli, *Gli Scultori Senesi*, Milan, 1980, 7f.

11 Carli, *Gli Scultori Senesi*, 24f.

12 Valentiner, *Tino*, 83–90. Compare John Pope-Hennessy, *Italian Gothic Sculpture*, 2nd ed., London and New York, 1972, 17, who comments that the aesthetically "relaxing" atmosphere was "prejudicial to Tino's art"; and Kreytenberg, *Tino*, 45.

13 On Angevin tombs in southern Italy, including displacements and measurements, see Lorenz Enderlein, *Grablegen*.

14 This shift in typology may be related to local tomb traditions as well as to the bearing capacity of the soft tufa with which Neapolitan buildings are constructed; see Enderlein, *Grablegen*, 81.

15 With the exception of Valentiner most scholars have accepted the attribution to Tino, at least of the sculptural components, of the Catherine of Austria tomb. Valentiner, *Tino*, 93f., believes that the Neapolitan architect Gagliardo Primario, who collaborated with Tino on the tomb of Queen Mary of Hungary, designed the architectural elements of the tomb. Compare Julian Gardner ("A princess among prelates: A fourteenth-century Neapolitan tomb and some Northern Relations," *Römisches Jahrbuch für Kunstgeschichte*, XXIII–XXIV, 1988, 30–60), who finds the design of Catherine's monument consistent with Tino's activity elsewhere. Indeed, given Tino's earlier inventive tomb designs, his probable passage through Rome, and the need to accommodate to local tradition, there is no reason to attribute the architectural design of the tomb to anyone other than Tino. At the least, no independent structure securely by Gagliardo supports a claim in his favor.

16 Bruzelius, "Ad modum Franciae."

17 Gardner, "Princess among prelates."

18 Gardner, "Princess among prelates," 31. Compare the tomb of Cardinal Guglielmo Longhi in Bergamo (Fig. 256).

19 Enderlein, *Grablegen*, 80.

20 See Chapters 3 and 4. It is worth recalling that Giotto, returning to Florence from Naples in 1333 shortly after which he became Capomaestro of the Duomo, initiated, with the help of Andrea Pisano, the designs of the hexagons on the west side of the Campanile. In these reliefs the depiction of landscape is far more advanced in terms of spatial and atmospheric effects than is seen on the immediately preceding doors of the Baptistry designed in 1330.

21 Valentiner, *Tino*, 158; Morisani, *Tino di Camaino a Napoli*, 40–57; Enderlein, *Grablegen*, 92–98. Scholars have not agreed on the specific roles of Gagliardo and Tino with respect to the architectural component of the tomb of Mary of Hungary, although the consensus is moving in the direction of assigning the entire design to Tino with Gagliardo responsible for the less creative aspects of its execution. See Ersilia Carelli and Stella

Casiello, *Santa Maria Donnaregina in Napoli*, Naples, 1975, 45–50.

22 Erwin Panofsky, *Tomb Sculpture*, New York, 1964, Fig. 246.

23 She had thirteen children, eight of whom were male but one died at an early age. Valentiner, *Tino*, 100f.

24 Valentiner, *Tino*, 159–60; Morisani, *Tino di Camaino a Napoli*, 58–68.

25 Valentiner, *Tino*, 109–19.

26 Carolyn Bruzelius, "Queen Sancia of Mallorca and the convent church of Sta. Chiara," *Memoires of the American Academy in Rome*, XL, 1995, 69–100.

27 Pope-Hennessy, *Italian Gothic Sculpture*, and Kreytenberg, *Tino*, comment on a decline of artistic accomplishment (see note 12). The connection to Modernism is suggested by Valentiner, *Tino di Camaino Sculptor*, Paris, 1935, 33 and 34, Fig. 6; 145. Recently Naoki Dan, in numerous and often useful studies of Tino's sculpture (see Bibliography), has overemphasized Tino's contributions to fifteenth- and sixteenth-century sculpture and painting.

28 Valentiner, *Tino*, 161.

Giovanni and Pacio Bertini da Firenze

1 He had sent a treatise on the subject to John XXII; see M. Dykmans, trans. and ed., *Robert d'Anjou: La Vision Bienheureuse*, Rome, 1970. For more on the Beatific Vision controversy, see comments on pp. 207ff.

2 For the documents see E. Bertaux, "Magistri Johannes et Pacius de Florentia. Marmorarii fratres," *Napoli Nobilissima*, IV, 1895, 134–38. Whether the brothers were already present in Naples working in Tino's bottega or arrived for this commission is not known.

3 Aldo De Rinaldis, *Santa Chiara*, Naples, 1920, 126. The tomb's size exceeds that of the Tarlati monument in Arezzo (Fig. 148), which reaches to 12.90 m. The Angevin monument was greatly damaged during World War II; so much was destroyed that only a partial reconstruction has been possible: Much of the upper sections of the baldacchino and many of its sculptures are missing. On the reconstruction of the monument see P. Gaudenzio Dell'Aja, *Il Restauro della Basilica di Santa Chiara in Napoli*, Naples, 1980, 194–208, 227–32.

4 See earlier, pp 104ff.

5 Stanislao Fraschetti, "I sarcofagi dei Reali Angioini in S. Chiara di Napoli," *L'Arte*, I, 1898, 385–438, offers a detailed description of the monument and a drawing that suggests its original effect without the baroque altar that currently obscures its view. See also Anita F. Moskowitz, "Four sculptures in earch of an author: The Cleveland and Kansas City Angels, and the problem of the Bertini brothers," *Cleveland Studies in the History of Art*, I, 1996, 98–115. On the Beatific Vision controversy, see the discussion and references concerning Giovanni di Balduccio's Arca di San Pietro Martire in Chapter 6.

6 The Bertini style has not been well defined in the scholarly literature and many of the attributions have been contested. A summary of attributions and extensive bibliography regarding these masters is given in S. Fabiano, in *Enciclopedia dell'Arte Medievale*, v. 3, Rome, 1992, 441–44. Indeed, from this synopsis the absurdity of playing the attributional game becomes apparent, as the contrary opinions assigning some works to Giovanni and others to Pacio (although nothing is known of the respective responsibilities of these masters) of Bertaux, Carcano, Causa, Dell'Aja, Fraschetti, De Rinaldis, and Valentiner are cited.

7 Bertaux, *Napoli Nobilissima*, 148–52.

8 On the damage and restoration see Dell'Aja, *Il Restauro della Basilica di Santa Chiara*, 102–5.

9 See earlier, pp. 134ff.

The Second Half of the Trecento and Beyond

1 On the cathedral of Altamura see Pina Belli d'Elia, "La facciata e il portale della Cattedrale di Altamura. Riletture e riflessioni," offprint from *"Altamura" – Rivista Storia Bollettino dell'Archivio – Biblioteca – Museo Civico*, n. 33/34, 1991–92, 19–47, who suggests that the portal might have been built under a later Angevin, either Robert of Taranto or his brother Filippo. See also Heinrich Schultz, *Denkmäler der Kunst des Mittelalters in Unteritalien*, Dresden, 1860, 83ff.; Giuseppe Pupillo, *La Cattedrale di Altamura*, Altamura, 1978; Giuseppe Pupillo, "La Cattedrale, segno del medioevo," in *"Altamura" – Rivista Storia Bollettino dell'Archivio – Biblioteca – Museo Civico*, n. 36, 1994–95, 169–73.

2 The lions date from 1533 and are by master Antonio di Andrea; they probably imitate the original thirteenth-century ones. Pupillo, *La Cattedrale di Altamura*, 29f.

3 The scenes include the Voyage to Jerusalem, the Nativity, the three Kings following the star, the Adoration of the Magi, the Presentation, the Flight, the Massacre in two scenes (Herod enthroned above gives the order to the soldiers; the soldiers below kill the infants), Christ in the Temple, the Marriage at Cana, the Resurrection of Lazarus; Jesus Led Away; the Flagellation, the Crucifixion, the Resurrection, Noli Me Tangere, the Incredulity of Thomas, the Ascension, Angels in chorus that sustain the aureole of Christ in Glory, and the Descent of the Holy Spirit; see Pupillo, *La Cattedrale di Altamura*, 29ff.

4 Francesco Negri Arnoldi, "Scultura trecentesca in Calabria: Apporti esterni e attività locale," *Bollettino d'Arte*, 68, 1983, 1–48.

5 An inscription on a tomb in Ancona cites an "Andreas de Florentia" as author of the tomb of King Ladislao. Known from documents to have been born in 1388 and active in Ancona in 1428, this Florentine Andrea more likely arrived in Naples well after the monument was begun. On the tomb, which deserves a monographic study, see O. Surfaro, N. Panza, and B. de'Sivo, *Chiesa di S. Giovanni a Carbonara*, Naples, 1969; Antonio Filangieri Di Candida, *La Chiesa ed il Convento di S. Giovanni a Carbonara*, Naples, 1924, 33ff.; and Ottavio Morisani, "Aspetti della

'regalità' in tre monumenti Angioini," *Cronache di Archeologia e di Storia dell'Arte*, IX, 1970, 88–122.

6 Di Candida, *La Chiesa*, 42.

SIX. LOMBARDY

Lombard Sculpture before 1334

1 A summary of the activity of the Campionesi may be found in P. Rossi, "Campionesi," in *Enciclopedia dell'Arte Medievale*, v. 4, Rome, 1993, 111–17. A fuller discussion is in Rossana Bossaglia and Gian Alberto Dell'Acqua, eds., *I Maestri Campionesi*, Lugano, 1992.

2 The present ensemble is basically an eighteenth-century reconstruction, although the architectural frame about the tomb dates from its transfer to Sta. Maria Maggiore. The sarcophagus, effigy, and four figures surrounding the bier, as well as the telamones supporting the forward columns, are original. A seventeenth-century drawing of the tomb shows the frieze of monks carrying liturgical instruments behind the effigy; see Donato Calvi, *Effemeride Sagro Profana di Quanto di Memorabile Sia Successo in Bergamo*, v. 3, Milan, 1677 (republished Bologna, 1974), 36. Further on the tomb see Alfred Gotthold Meyer, *Lombardische Denkmäler des Vierzehnten Jahrhunderts*, Stuttgart, 1893, 51–53; Julian Gardner, *The Tomb and the Tiara. Curial Tomb Sculpture in Rome and Avignon in the Later Middle Ages*, Oxford, 1992, 115f.

3 Matteo was granted the imperial vicarship by Henry VII in July 1311. On the history of the Visconti dynasty see Maria Bellonci, "I dodici Cesari lombardi," in *I Visconti a Milano* (text by Maria Bellonci, Gian Alberto Dell'Acqua, Carlo Perogalli), Milan, 1977, 7–121. On the architecture of the Loggia degli Osii, see A. M. Romanini, *L'Architettura Gotica in Lombardia*, v. 1, Milan, 1964, 283f.

4 On Campionese sculptors and the Loggia degli Osii, see Costantino Baroni, *Scultura Gotica Lombarda*, Milan, 1944, 41–43; Gianguido Belloni et al., *Arte Lombarda dai Visconti agli Sforza* (exhibition catalogue), Milan, 1958, 7f.; Carlo Bertelli, ed., *Il Millennio Ambrosiano. La Nuova Città dal Comune alla Signoria*, v. 3, Milan, 1989, 8; *Arte Lombarda dai Visconti agli Sforza*, Milan, 1959, 40f.; G. Previtali, "Una scultura lignea in Lombardia e la loggia degli Osii," *Prospettiva*, I, 1975, 18ff.

5 On the Chicago Madonna see C. Baroni, "La scultura gotica," in *Storia di Milano*, 5, Milan, 1955, 751; Maria Teresa Fiorio, "Una scultura Campionese trascurata: La 'Madonna Litta,'" *Paragone*, 457, March 1988, 3–14; A. Moskowitz in Dorothy Gillerman, ed., *Gothic Sculpture in America*, v. 2 (the Midwest), in press.

Azzone Visconti and Giovanni di Balduccio in Milan

1 On Visconti patronage, see Gian Alberto Dell'Acqua in *Arte Lombarda dai Visconti agli Sforza*, Milan, 1959, 7–35; Peter Seiler, "La trasformazione gotica della magnificenza signorile. Committenza viscontea e scaligera nei monumenti sepolcrali dal tardo Duecento alla metà del Trecento," in Valentino Pace and Martina Bagnoli, eds., *Il Gotico Europeo in Italia*, Naples, 1994, 119–40; Maria Bellonci, "I dodici Cesari lombardi," in *I Visconti a Milano* (text by Maria Bellonci, Gian Alberto Dell'Acqua, Carlo Perogalli), Milan, 1977, 7–121.

2 As Louis Green, has argued, "The creation of an image of the benevolent ruler concerned with the interests of his subjects demanded more, however, than the physical signs of his munificence. To produce the right effect, these had to be accompanied by a suitable degree of display, carefully calculated to make the desired impact on a community which had to be persuaded of the advantages of the belonging to a large and wealthy state." See Louis Green, "Galvano Fiamma, Azzone Visconti and the revival of the classical theory of magnificence," *Journal of the Warburg and Courtauld Institutes*, LIII, 1990, 98–113.

3 Bellonci, *I Visconti a Milano*, 137; cf. Enzo Carli, "Giovanni di Balduccio a Milano," in Carlo Bertelli, ed., *Il Millennio Ambrosiano. La Nuova Città dal Comune alla Signoria*, v. 3, Milan, 1989, 70–103.

4 On the facade of Sta. Maria di Brera, see Angiola Maria Romanini, *L'Architettura Gotica in Lombardia*, Milan, 1964, v. 1, 116f., 286–88; v. 2, Pl. 126.

5 Maria Teresa Fiorio ("Uno scultore Campionese a Porta Nuova," in *La Porta Nuova delle Mura Medievali di Milano*, Milan, 1991, 107–28) attributes the Porta Nuova Madonna to the master of the Viboldone lunette.

6 Anita Moskowitz, "Giovanni di Balduccio's Arca di San Pietro Martire. Form and function," *Arte Lombarda*, 96/97, 1991, 7–18.

7 Max Seidel, "Studien zu Giovanni di Balduccio und Tino di Camaino," *Städel-Jahrbuch*, 5, 1975, 37–84; idem, *Giovanni Pisano a Genova*, 1987, 84–90. For the tomb of Margaret of Luxemburg, see also earlier discussion in Chapter 2.

8 Anita Fiderer Moskowitz, *Nicola Pisano's Arca di San Domenico and Its Legacy*, University Park, 1994, 28.

9 Moskowitz, *Arca*, 29–31.

10 The monument was oriented, however, perpendicular to the main axis of the church, so that one of its long sides was also visible through the first four aisle bays when one entered the basilica from the left-hand portal of the facade. L. Beltrami ("La Capella di San Pietro Martire," *Archivio Storico dell'Arte*, V, 1892, 267–91) publishes a seventeenth-century plan of the basilica that shows the tomb's position in the fifth bay. See also idem, "Vicende delle tomba di S. Pietro Martire in Milano," *Emporium*, XIV, 1901, 188–201; Venturino Alce, "La tomba di San Pietro Martire e la Cappella Portinari in Sant'Eustorgio di Milano," *Memorie Domenicane*, I, 1952, 5f.

11 In fact, to this day popular belief has it that by tapping the undersurface with one's head headaches are prevented. Rafaele Bagnoli, *Festività e Tradizioni Popolari Milanese*, Rome, 1973, 97. This contemporary practice is confirmed by the sacristan of Sant'Eustorgio.

12 On the tomb see Peter Seiler, "Das Grabmal des Azzo Visconti in San Gottardo in Mailand," *Skulptur und Grabmal des Spätmittelalters in Rom und Italien*, Vienna,

1990, 368–92 (for the attribution see note 2); Carlo Bertelli, ed., *Il Millennio Ambrosiano. La Nuova Città dal Comune alla Signoria,* v. 3, Milan, 1989, 6; Bellonci, *I Visconti a Milano,* 145.

13 Seiler, "Das Grabmal," Fig. 9.

Masters of the Mid-Trecento in Lombardy

1 On the tomb, see Moskowitz, *Nicola Pisano's Arca di San Domenico and Its Legacy,* University Park, 1994, 31–35.

2 The Hermits had already managed to gain the financial support of the communal authorities, which had agreed in 1335, and renewed the agreement in 1342, to assign annual funds for expenses incurred in hosting visiting friars come to Pavia to celebrate the feast of St. Augustine. This *festa* had previously been celebrated under the direction of the Canons and had been a relatively simple and solemn affair; the Augustinians introduced a new splendor into the celebrations, which now even included a trade fair attracting people and products from distant places. G. Romani, "Eremitani e Canonici Regolari in Pavia nel secolo XIV," *Archivio Storico Lombardo,* XVIII, 895, 5–42.

3 The two religious communities themselves were divided into opposing camps. Coming from the higher echelon, the Canons Regular were tied to the more powerful of the city's families, which had strong ties with the Visconti of Milan; the Hermits, in contrast, remained staunchly republican and anti-Visconti. Moskowitz, *Arca,* 32.

4 On Sant'Eustorgio as the Visconti mausoleum see S. Vigezzi, "Catalogo descrittivo, ragionata e critica delle sculture esistenti nella basilica di Sant'Eustorgio in Milano," *Archivio Storico Lombardo,* 60/12, 1933, 219–89.

5 The measurements of the tomb are as follows: height, 3.94 m; length, 3.07 m; depth, 1.68 m. There are 50 bas reliefs, 95 statues and animals, and 420 heads, all with metal eyes except those on the top story. R. Maiocchi, *L'Arca di Sant'Agostino in S. Pietro in Ciel d'Oro,* Pavia, 1900, 19.

6 The illustrated Vita is based on Augustine's *Confessions,* the saint's first biography by Possidius, and Jacobus de Voragine's *Golden Legend* (much of it based on Possidius). Jeanne Courcelle and Pierre Courcelle, *Iconographie de Saint Augustin: Les Cycles du XIVe Siècle,* Paris, 1965. Possidius's text, edited and with an English translation, is found in Herbert T. Weiskotten, *Sancti Augustini Vita Scripta a Possidio Episcopo,* Princeton, 1919.

7 I. Herklotz, *"Sepulcra" e "monumenta" del Medioevo,* Rome, 1985, 143–210; Julian Gardner, *The Tomb and the Tiara.* Oxford, 1992, passim. An exception exists, however, in the tomb of San Simeone in Venice (see pp 237f.).

8 On Pavia's claim to its Roman connections, see Moskowitz, *Arca,* 34f.

9 *Arte Lombarda dai Visconti agli Sforza,* Milan, 1959, 43; Alfred Gotthold Meyer, *Lombardische Denkmäler des vierzehnten Jahrhunderts,* Stuttgart, 1893, 384f.; Louis Green, "Galvano Fiamma, Azzone Visconti and the revival of the classical theory of magnificence," *Journal of the Warburg and Courtauld Institutes,* LIII, 1990, 105f.

10 A. Pinetti, "Cronistoria artistica di S. Maria Maggiore," in *Bollettino della Civica Biblioteca di Bergamo,* XIX, n. 4, 1925, 168ff.; Pasino Locatelli, *Illustri Bergamaschi. Studi Critico-Biografici,* v. 3 (intarsiatori, architetti e scultori), Bergamo, 1879, 208.

11 Meyer, *Lombardische Denkmäler,* 63. According to Meyer, p. 61, the statue probably originally belonged to the old cathedral of Sant'Alessandro, destroyed in 1561, and was only later brought to Sta. Maria Maggiore.

12 "Master John son of master Ugo Campione made this work in 1353." On the sculptor, see P. Rossi, "Campionesi," in *Enciclopedia dell'Arte Medievale,* v. 4, Rome, 1993, 111–17; Meyer, *Lombardische Denkmäler,* 57. In 1360–67 Giovanni is recorded as directing the restoration of the church and the execution of the southern portal, as well as the minor door of the northern side, this last in collaboration with his son Niccolino. C. Baroni, "La scultura gotica," in *Storia di Milano,* v. 5, Milan, 1955, 784.

13 The signature on the tabernacle of 1353 enclosing the equestrian statue of Sant'Alessandro suggests that Giovanni da Campione executed the severely frontal figure, yet the figure's style bears little relation to the two pairs of saints that flank the equestrian figure; nor is it close to the Madonna and Child with flanking saints, and other statues in the upper tabernacle, with their sometimes overelaborate cascades of drapery; nor to the slender Virtues of the Baptistry. The equestrian group clearly descends from the statues of Cangrande (1330s) and Mastino II (1340s) in Verona (see Chapter 7, pp. 275ff.), although it is far more rigid even than the latter, permitting no peripheral views due to its height and present placement between the two saints. It is impossible to say whether the almost total lack of internal modeling of both figure and horse is due to the persistence of the Campionese stone-carving tradition or, as Baroni believes (Baroni, *Scultura Gotica Lombarda,* 59, n. 66), to the abrasion of deteriorated surfaces that were at some earlier time completely recarved.

14 Baroni, *Scultura Gotica Lombarda,* 132, 147, n. 10. See later discussion, pp 229f.

15 He also signed a (lost) tomb or shrine of St. Omobono in the Duomo of Cremona, whose inscription with Bonino's name and the date 1357 was still extant in 1893; see Giuseppe Merzario, *I Maestri Comacini,* Milan, 1893, 248. For a summary of documented and attributed works see R. Bossaglia, "Bonino da Campione," in *Dizionario Biografico degli Italiani,* v. 12, Rome, 1970, 224–26.

16 See, for instance, the introduction by Gian Alberto Dell'Acqua in *Arte Lombarda dai Visconti agli Sforza,* Milan, 1959, 142f., who characterizes Bonino da Campione as a sculptor of "a facile and rather eclectic vein . . . [sometimes] sober and natural and powerful . . . [sometimes] elegant and gorgeous, capable of formalistic virtuosity . . ." and in his late work exhibiting a "serene plastic equilibrium . . . a pious and simple religiosity," 42f. We see here in a nutshell the problem of Bonino: He appears to be capable of a diversity of style almost incredible for the fourteenth century. On general problems of attribution in Italian Gothic sculpture see Chapter 9, and Anita

Moskowitz, "Four sculptures in search of an author: The Cleveland and Kansas City Angels, and the problem of the Bertini brothres," in *Cleveland Studies in the History of Art*, v. 1, Cleveland, 1996, 98–115.

17 On Folchino degli Schizzi, a military man of noble lineage, see G. Tiraboschi, *La Famiglia Schizzi di Cremona*, Parma, c. 1817, cited in Alfredo Puerari, *Il Duomo di Cremona*, Milan, 1971, 118f. I would like to thank Alberto Faliva for this reference.

18 See Gian Alberto Dell'Acqua, ed., *La Basilica di Sant' Eustorgio in Milano*, Milan, 1984, Figs. 108–111; Baroni, *Scultura Gotica Lombarda*, 108 and Figs. 219 and 220.

19 See note 18.

20 See Baroni, *Scultura Gotica Lombarda*, 109 and Fig. 225.

21 The drapery treatment, carving of details such as hair, and highly polished surfaces of the Valentina and Stefano Visconti sarcophagus reliefs, however, bespeak a more subtle artist – or at least a more developed one – than the carver of the Schizzi tomb. It seems odd that the modest example in Cremona has Bonino's name, whereas several works of superior quality are unsigned. Possibly some of the latter are from dismantled monuments, whose signatures are lost.

22 See Bossaglia, *Dizionario*. Baroni, *Scultura Gotica Lombarda*, 110, and 120f., note 58, quotes the description of the equestrian figure in the chronicle of Pietro Azario (*Rerum Italicarum Scriptores*, ed. Francesco Cognasso, Bologna, 1939), which reaches to the year 1363.

23 On doubts that have been raised concerning the identification of this figure and its relevance to the tomb of Henry VII, see earlier discussion, pp 104ff.

Lombard Assimilation of Tuscan Style

1 Enrico Castelnuovo, ed., *Niveo de Marmore. L'Uso Artistico del Marmo di Carrara dall'XI al XV Secolo*, Genoa, 1992, 309–12. Here the carver of the Montedivalli figures is designated "Master of the Galeotto Malaspina Tomb," dated after 1367, on the basis of stylistic similarities to that monument in San Remigio, Fosdinovo.

2 The facade was completed in 1348 as attested by an inscription; see Liana Castelfranchi Vegas, *L'Abbazia di Viboldone*, Milan, 1959, 6. On the sculptures see Costantino Baroni, *Scultura Gotica Lombarda*, Milan, 1944, 101; Roberto Longhi, in *Arte Lombarda dai Visconti agli Sforza* (exhibition catalogue), Milan, 1958, xxv; Maria Teresa Donati, "L'architettura degli ordini monastici in area milanese tra XII e XIV secolo," in Carlo Bertelli, ed., *Il Millennio Ambrosiano. La Nuova Città dal Comune alla Signoria*, v. 3, Milan, 1989, 265f., 288–75.

3 On the series, see Baroni, *Scultura Gotica Lombarda*,110; *Arte Lombarda dai Visconti agli Sforza*, Milan, 1959, 7–35, 43f.

Gian Galeazzo Visconti and the International Gothic Current

1 Costantino Baroni, *Scultura Gotica Lombarda*, Milan, 1944, 123. Licisco Magagnato, "La città e le arti a Verona al tempo di Dante," *Dante e la Cultura Veneta*, Florence, 1966, 285–97.

2 On Gian Galeazzo Visconti see *Storia di Milano*, v. 6 (Il Ducato Visconteo e La Repubblica Ambrosiano), Milan, 1955.

3 On the altarpiece, see A. G. Meyer, *Lombardische Denkmäler des Vierzehnten Jahrhunderts*, Stuttgart, 1893, 129f.; Rossana Bossaglia, "La scultura," in Gian Alberto Dell'Acqua, ed., *La Basilica di Sant'Eustorgio in Milano*, Milan, 1984, 93–125, especially 106–11.

4 On the narrative sequence of the back of the *Maestà*, see John White, *Duccio, Tuscan Art and the Medieval Workshop*, London, 1979, 119–34.

5 On sculpture within a Dominican milieu, see Anita Moskowitz, "Domenicani/Scultura," in *Enciclopedia dell'Arte Medievale*, v. 5, Rome, 1994, 691–94.

6 The Embriachi workshop might well have appeared in our chapter on Venice, since the bottega was located there; it is included in this chapter because of its most important patron, Gian Galeazzo Visconti, and because of the figural style of the Certosa altarpiece.

7 Richard Trexler, "The Magi enter Florence. The Ubriachi of Florence and Venice," *Studies in Medieval and Renaissance History*, v. 1, Vancouver, 1978, 129–218. On the "Embriachi workshop," see most recently G. A. Dell'Acqua, *Embriachi. Il Trittico di Pavia*, Milan, 1982 (to whom one should turn for excellent color reproductions of a large number of the panels); Luciana Martini, "Alcune osservazioni sulla produzione di confanetti 'embriacheschi' e sulla loro storiografia," in *Oggetti in Avorio e osso nel Museo Nazionale di Ravenna, Sec. XV–XIX*, ed. L. Martini, Ravenna, 1993; Elena Merlini, "Il trittico eburnea della Certosa di Pavia: Iconografia e committenza. Parte I," *Arte Cristiana*, v. 73, 1985, 369–84; part II, v. 74, 1986, 139–54.

8 The subject of the panels is discussed by Merlini, "Il trittico eburnea," *Arte Cristiana*, v. 73, 369–84. Trexler, *The Magi Enter Florence*, 169. The hypothesis that the altarpiece was commissioned to celebrate the investiture of Gian Galeazzo Visconti as duke, and the consequent establishment of Milan as a duchy, is offered by Richard C. Trexler, "Triumph and Mourning in North Italian Magi Art," in Charles M. Rosenberg, ed., *Art and Politics in Late Medieval and Early Renaissance Italy: 1250–1500*, Notre Dame and London, 1990, 38–66, especially 45–48.

9 Martini, *Oggetti in Avorio e Osso*, Pl. 1, cat. no. 12, 63–65.

10 A summary of the role played by Gian Galeazzo Visconti in the construction of the Duomo of Milan is found in *Il Duomo di Milano. Dizionario Storico Artistico e religioso*, Milan, 1986, 575ff., and 643ff. For the origins and multiple responsibilities of the Fabbrica, see 239ff. See also Giacomo C. Bescapé and Paolo Mezzanotte, *Il Duomo di Milano*, Milan, 1965, 97ff.

11 Ugo Nebbia, *La Scultura nel Duomo di Milano*, Milan, 1910, 22f. On Giacomo and other Campionesi working on the Duomo, see, in addition to the final chapter in Baroni, *Scultura Gotica Lombarda*, most recently Ernesto Brivio,

"La presenza dei Maestri Campionesi nel Duomo di Milano," in Rossana Bossaglia and Gian Alberto Dell'Acqua, eds., *I Maestri Campionesi*, Lugano, 1992, 199–221.

12 James Ackerman, "'Ars sine scientia nihil est.' Gothic theory of architecture at the Cathedral of Milan," *Art Bulletin*, XXXI/2, 1949, 84–111. Compare Elizabeth B. Smith, "'Ars mechanica.' Problemi di struttura gotica in Italia," in Valentino Pace and Martina Bagnoli, eds., *Il Gotico Europeo in Italia*, Naples, 1994, 57–70.

13 *Storia di Milano*, v. 6, Milan, 1955, 884; Nebbia, *La Scultura nel Duomo di Milano*, 15f. For a summary of Fernach's activities, see "Fernach, Hans," in *Il Duomo di Milano. Dizionario*, 255f. Although referred to in some documents as *teutonico*, at least once he is designated with other stone-carvers *de loco Campillini*. Nebbia, *La Scultura del Duomo di Milano*, 16, conjectures that he may originally have been from the Campionese region, but after an extended sojourn working north of the Alps he brought back to Milan the taste and techniques of the northern carvers. On Fernach's presence in Bergamo, see earlier discussion, p. 215.

14 Baroni, *Scultura Gotica Lombarda*, 132, citing the *opus designamenti facti et incepti per Johannem de Fernach*.

15 "Giacomo son of Sir Bonino Campione made this work."

16 Nebbia, *La Scultura del Duomo di Milano*, 23.

17 Nebbia, 25.

18 On Gian Galeazzo as commissioner of lavish illuminated manuscripts, see Edith W. Kirsch, *Five Illuminated Manuscripts of Giangaleazzo Visconti*, University Park, 1991.

19 On the documentation, see Nebbia, *La Scultura del Duomo di Milano*, 10. On the separation of design and execution at the Duomo see Francesca Tasso, "I Giganti e le vicende della prima scultura del Duomo di Milano," *Arte Lombarda*, 92/93, 1990, 55–62.

20 On the theme in art, but without reference to the relief in Milan, see Gertrude Schiller, *Ikonographie der Christlichen Kunst*, v. 1, Kassel, 1966, 168f. See also Donald Alexander McColl, "Christ and the Woman of Samaria. Studies in Art and Piety in the Age of the Reformation," Ph.D. dissertation, University of Virginia, May 1996, in particular Chapter 2, "The Samaritan Woman and Late Medieval Piety," 42–86.

21 Marco Rossi, *Giovannino de Grassi. La corte e la cattedrale*, Milan, 1995, 98f. On the baptismal and eucharistic associations of the story of the Samaritan woman, see McColl, "Christ and the woman of Samaria," 45–55.

22 Rossi, *Giovannino*, 129.

23 Rossi, *Giovannino*, 97f. for attributions.

24 Antonio Cadei, "I capitelli più antichi del Duomo di Milano," *Il Duomo di Milano* (Acts of Congress, I), Milan, 1969, 77–88. This prototype has been identified, via a careful reading of the documentation, as the one resting on the northeast pillar of the crossing, shown in the plan illustrated by Cadei.

25 During a meeting of 2 February 1392, a council discusses the criticism of Heinrich Parler regarding the "opus incohandum super capitello"; see Cadei, "I capitelli," 77–88.

26 If the capital as such is unprecedented, the sources for the individual elements, such as the teardrop motif, have been found in northern Europe; see Cadei, "I capitelli," 86f.

SEVEN. VENICE, THE VENETO, AND VERONA

Venetian Sculpture, c. 1300–c. 1340

1 On the problems of classifying, interpreting, and dating medieval Venetian sculpture, in particular the sculpture of San Marco, see Otto Demus, *The Church of San Marco in Venice*, Washington. D.C., 1960, 109–15. For a detailed analysis of the function, style, and dating of the facade sculptures see Demus, *Le Sculture Esterne di San Marco*, Milan, 1995 (catalogue by Guido Tigler), 12–23.

2 In Milan, it was not until Giovanni di Balduccio was called to the capital and physically transferred his workshop there that Tuscan influence becomes discernable locally. See earlier discussion, pp. 201ff.

3 Wolfgang Wolters, *Scultura Veneziana Gotica*, Venice, 1976, 18.

4 Demus, *The Church of San Marco*, 1960, 188f.

5 The Antenor monument was executed in 1284 but believed to be the remains of the original tomb. Wolfgang Wolters, "Appunti per una storia della scultura padovana del Trecento," in L. Grossato, ed., *Da Giotto al Mantegna* (exhibition catalogue, Padua), Milan, 1974, 36–42; Wolters, "Il Trecento," in Giovanni Lorenzoni, ed., *Le Sculture del Santo di Padova*, Vicenza, 1984, 5–30.

6 Demus, *The Church of San Marco*, 1960, 56–59; Wolters, in Lorenzoni, ed., *Le Sculture del Santo di Padova*, 5–7; Patricia Fortini Brown, *Venice and Antiquity. The Venetian Sense of the Past*, New Haven and London, 1996.

7 Wolters, *Scultura Veneziana Gotica*, v. 1, 20, 136, n. 13; Debra Pincus, "Venice and the two Romes: Byzantium and Rome as a double heritage in Venetian cultural politics," *Artibus et Historiae*, XIII/26, 1992, 101–14. On Venice's patron saints Mark and Theodore, see Demus, *The Church of San Marco*, 1960, 19–30.

8 See Sandro Sponza, "Pittura e scultura a Venezia nel Trecento: Divergenze e convergenze," in *La pittura nel Veneto. Il Trecento*, v. 2, Milan, 1992, 409–41, as well as the other essays in these volumes.

9 Wolters, *Scultura Veneziana Gotica*, 152f.

10 Wolters, *Scultura Veneziana Gotica*, 153. For an unconvincing attempt to ascribe several other works to Marco Romano see Giovanni Previtali, "Alcune opere 'fuori contesto': Il caso di Marco Romano," *Bollettino d'Arte*, XXII, November–December 1983, 43–68.

11 Ingo Herklotz, "Sepulcra" e "monumenta" del medioevo, Rome, 1985, 143–210; Julian Gardner, *The Tomb and the Tiara*, Oxford, 1992, passim.

12 The relics preserved in Zara are contained in a late Duecento sarcophagus carved in relief, whose front, incidentally, shows a relief image of the saint generally disposed in a manner similar to that of the Venetian tomb: The bearded saint with long wavy hair reclines (with his head likewise on the left) on a pillow and his arms are crossed. The relics were later translated to a splendid silver gilt

shrine, dated 1377 and contracted to one Franco of Milan. On the Zara tomb see G. Praga, "Documenti intorno all'arca di S. Simeone in Zara e al suo autore Francesco da Milano," *Archivio Storico per la Dalmazia*, V, 1930, 211–34; C. Cecchelli, *Catalogo delle Cose d'Arte e di Antichità d'Italia*, Rome, 1932, 107ff.; and for good illustrations, Ivo Petricioli, *St. Simeon's Shrine in Zador*, Zagreb, 1983. The Venetians believed, as indicated by an inscription now on a slab behind the effigy, that the saint's remains were transferred from Constantinople to Venice in 1203.

13 Wolters, *Scultura Veneziana Gotica*, 22f., 153f.

14 On this monument see earlier, pp. 99f.

15 The standing figure of Enrico, in contrast to the later reclining effigy (compare Figs. 305, 306, and 310)), is represented at about the same age as or slightly older than the painted image in the *Last Judgment*. Since Enrico's last will, dated shortly before his death in 1336, refers to a tomb in existence in his chapel, and since he was exiled from Padua in 1320, that date offers a *terminus ante quem* for the standing portrait, assuming it was a tomb sculpture. On the dating of the figure see Wolters, *Scultura Veneziana Gotica*, 22f.

16 Volker Herzner, "Giottos Grabmal für Enrico Scrovegni," *Münchner Jahrbuch für Bildenden Kunst*, XXXIII, 1982, 39–66.

17 One of the Bardi family tombs in Sta. Croce, Florence, includes a painted image of the deceased patron kneeling but in a praying posture not unsimilar to that of Enrico Scrovegni (see Fig. 381). Possibly influenced by the Arena Chapel conceit, the figure turns toward an image of the Last Judgment. Jane Long, in "Salvation through meditation: The tomb frescoes in the Holy Confessors Chapel at Santa Croce in Florence," *Gesta*, XXXIV/1, 1995, 77–88, argues that the scene is not to be read as a literal representation of the resurrection of the deceased, as has often been thought, but rather as a vision experienced by the humble yet hopeful donor.

18 The thesis has not received widespread acceptance, and many questions remain unanswered.

19 Rodolfo Gallo, "Contributi alla storia della scultura veneziana, I. Andreolo de Santi," *Archivio Veneto*, s. V/44–45, 1949, 1–40; Wolters, *Scultura Veneziana Gotica*, 1976, 25f. Enrico Scrovegni had fled Padua for Venice when Cangrande della Scala moved against the city in 1320. He was able to return to Padua briefly only to learn that all his possessions had been taken by Cangrande's ally, Marsilio da Carrara. Believing his life to be in danger, Enrico returned to Venice where he died on 20 August 1336. In his Last Will he stipulated burial in the Arena Chapel built by him; he was, however, temporarily buried on Murano, and several months later his remains were transferred to Padua. The naturalistic features of the face with its sunken cheeks, fleshy tear sacks, and furrowed brow suggest the possibility that it is based on a death mask.

20 On this relief see Wolters, *Scultura Veneziana Gotica*, 28, 160, and Figs. 78, 83.

21 See p. 303.

22 On the tomb see Wolters, *Scultura Veneziana Gotica*, 28f.; cat. 28, 160f.

23 Wolters, *Scultura Veneziana Gotica*, v. 1, 16; Susan Connell, *The Employment of Sculptors and Stonemasons in Venice in the Fifteenth Century*, New York and London, 1988 (thesis, Warburg Institute, 1976), 117–19.

24 For a brief explanation of the ingenious system employed see Moskowitz, "A Venetian well-head in Toledo," *Source. Notes in the History of Art*, XIV/2, Winter 1995, 1–4, with relevant bibliography. For further bibliography, with illustrations of examples extant in the Veneto, see Alberto Rizzi, "Le vere da Pozzo pubbliche di Venezia e del suo Estaurio," *Supplemento del Bollettino dei Musei Civici Veneziani*, XXI, 1976.

25 Jolan Balogh, "Studi sulla collezione di sculture del Museo di Belle Arti di Budapest." VI, pte. I. Pozzi veneziani, in *Acta Historiae Artium Academiae Scientiarum Hungaricae*, XII, 1966, 211–78. Also Balogh, *Katalog der ausländischen Bildwerke des Museums der Bildenden Kunst in Budapest*, IV–XVIII. Jahrhundert, Budapest, 1975.

Andriolo de Santi

1 For Andriolo and references to documents, see Wolfgang Wolters, *Scultura Veneziana Gotica*, Venice, 1976, 32–39, 166; a summary of his career is given by Wolters in *Enciclopedia dell'Arte Medievale*, v. 1, Rome, 1991, 623f. The statue of the Baptist on the facade of the San Felice chapel in the Santo, Padua, bears the initials ASVF, i.e., 'Andriolus Sanctus Venetus Fecit. . . .' Antonio Sartori, "La capella di S. Giacomo al Santo," *Il Santo*, VI, 1966, 267–359, especially p. 296.

2 The will is published in Rodolfo Gallo, "Contributi alla storia della scultura veneziana, I. Andreolo de Santi," *Archivio Veneto*, s. 5. XLIV–XLV, 1949, 1–40, especially 20f. On Pietro da Marano see Giovanni Mantese, *Memorie Storiche della Chiesa Vicentina*, v. 3, pt. 1, "Il Trecento," Vicenza, 1958, 604–6, and (with a fuller biography and documentary references), Natascia L. Carlotto, "Pietro 'Nan' da Marano: Ritratto di un cortigiano scaligero," in Gian Maria Varanini, ed., *Gli Scaligeri 1277–1387* (exhibition catalogue), Verona, 1988, 143–48.

3 Anita F. Moskowitz, "An inversion of viewpoint: The lunette of San Lorenzo, Vicenza," *Source. Notes in the History of Art*, forthcoming. I have found no comparable image of a dwarf as protagonist, rather than as accessory to aristocratic pretensions or royal attribute (albeit often portrayed sympathetically and affectionately) or as an object of derision or pity, in medieval and Renaissance art. I wish to thank Robin O'Bryan for fruitful correspondence on this issue. On dwarf iconography, see Robin Leigh O'Bryan, "The Dwarf in Italian Renaissance Iconography," M.A. thesis, San Diego State University, 1991, with exhaustive bibliography; J. M. Charcot and P. Richer, *Les difformes et les malades dans l'art*, Paris, 1889 (reprinted, Amsterdam, 1972). Also of interest is Ruth

Mellinkoff, *Outcasts: Signs of Otherness in Northern European Art of the Late Middle Ages*, 2 vols., Berkeley, Los Angeles, Oxford, 1993, 113–15 and passim.

4 Precedents for representing nonsaints on church portals exist: The main portal of Siena cathedral included a marble Madonna and Child with the figure of the Sienese knight Bonaguida Lucari, recommended to the Madonna by an angel. This image was motivated by the fact that Mary became the city's regent on the eve of the battle of Montaperti in Septempter 1260, prior to Siena's successful siege against the Florentines. This group, in turn, is probably related to the appearance of the figure of Henry VII on a portal of Pisa cathedral. These examples, however, have profound civic significance and do not represent private aspirations more appropriate for a sepulchral monument. On the Sienese and Pisan facade sculptures see A. Middeldorf Kosegarten, *Sienesische Bildhauer am Duomo Vecchio. Studien zur Skulptur in Siena 1250–1330*, Munich, 1984, 77f., 160.

5 On the facade of Sta. Maria di Brera, see Angiola Maria Romanini, *L'Architettura Gotica in Lombardia*, Milan, 1964, v. 1, 116f., 286–88; v. 2, Pl. 126. On the Perugia portal see Ottorino Gurrieri, *Il Palazzo dei Priori di Perugia*, Perugia, 1985, 44–46. The connection between the Perugia and Vicenza portal was noted by Gallo, "Contributi alla storia della scultura veneziana," 1–40.

6 On the history of Padua see J. K. Hyde, *Padua in the Age of Dante*, New York, 1966.

7 G. Biscaro, "Le tombe di Ubertino e Jacopo da Carrara," *L'Arte*, II, 1899, 88–97; Wolters, *Scultura Veneziana Gotica*, 168f. By May 1995 the frescoes had been removed from the Eremitani while in June 1998 the tomb was entirely under scaffolding, for the purpose, it is hoped, of returning the fresco.

8 Compare the tombs of Beato Enrico in Treviso and of Doge Giovanni Soranzo in San Marco, Venice (Wolters, *Scultura Veneziana Gotica*, figs. 21 and 51, respectively).

9 Mary D. Edwards, "The Chapel of S. Felice in Padua as Gesamtkunstwerk," *Journal of the Society of Architectural Historians*, 47/2, June 1988, 160–76.

10 The documents are published in A. Sartori, *Documenti per la storia dell'arte di Padova*, ed. C. Fillarini (Fonti e Studi per la Storia del Santo a Padova, Fonti 3), Vicenza, 1976, 7–11. Andriolo's originality and break with tradition is stressed by Francesca d'Arcais, "La Decorazione della Cappella di San Giacomo," in Camillo Semenzato, ed., *Le Pitture del Santo di Padova*, Vicenza, 1984, 15–42; see also Edwards, "Gesamtkunstwerk"; Wolters, in Giovanni Lorenzoni, ed., *Le Sculture del Santo di Padova*, Vicenza, 1984.

11 On the probable appearance of the Chapel of Saint Anthony during the Trecento, see Giulio Bresciani-Alvarez, "L'architettura e l'arredo della Cappella di S. Giacomo ora detto di S. Felice al Santo," *Il Santo*, V, no. 2, May–August 1965, 131–41, especially 131f.

12 Strong doubts that Andriolo actually designed the chapel have been expressed by Bresciani-Alvarez, "L'architettura

e l'arredo," 131–41, who attributes the total conception of architecture and painting to Altichiero. The comparisons to the painted architecture in the latter's fresco in Sant'-Anastasia, Verona (for the fresco see illustration [unnumbered] in Bresciani-Alvarez, or Gian Lorenzo Mellini, *Altichiero e Jacopo Avanzi*, Milan, 1965, Fig. 52), while suggestive, are not entirely convincing. Furthermore, Altichiero is not documented as an architect. One might also question the methodological validity, in the absence of other evidence, of comparing architectural representations in painting with concrete structures.

13 It is not known exactly how Andriolo's facade terminated, for the present upper section ends in a classicizing cornice, clearly of later date. See Mellini, *Altichiero e Jacopo Avanzi*, 42; Antonio Sartori, "La capella di S. Giacomo al Santo," *Il Santo*, VI, 1966, 267–359, especially 294–97.

14 Antonio Sartori believes, however, that these statues were originally composed for the Arca of Sant'Antonio; see "La capella di S. Giacomo," 267–359, especially p. 296f.

15 Edwards, "Gesamtkunstwerk." For a summary of the work of Altichiero, see F. Flores d'Arcais, in *Enciclopedia dell'Arte Medievale*, v. 1, Rome, 1991, 458–63. Mellini, *Altichiero e Jacopo Avanzi*, attributes several of the lunette frescos to Avanzi. In 1503 when the chapel was rededicated to S. Felice, the Trecento altar was replaced, reusing four of its original figures; more recently these figures have been exhibited in the Museo del Santo.

16 Andriolo de Santi and a certain Giovanni received payment for the tombs in 1376; Wolters, *Scultura Veneziana Gotica*, 211.

17 During the years that construction of the chapel was begun, Altichiero was working for the da Carrara family with whom Bonifacio was closely tied. A useful discussion of the chapel in the context of signorial Padua is found in Diana Norman, ed., *Siena, Florence and Padua: Art, Society and Religion 1280–1400*, 2: *Case Studies*, New Haven and London, 1995, 179–91.

18 Attempts to develop an oeuvre for Andriolo de Santi have failed, in my opinion, because the three documented works by him are of completely divergent typology – a portal, a tomb, and a chapel – and the individual figures show only the most general stylistic commonalities. It is thus not possible to speak, as Wolters does, of "typical qualities of Andriolo." The portal figures, the earliest documented work, are qualitatively the highest in terms of figure sculpture, and presuming that the commission was given relatively early in the master's career, when he was perhaps still proving himself, one can assume that the sculptures are by his hand. The figures on the da Carrara tombs reveal several distinct hands. If we assume – although this is methodologically somewhat risky – that the best figures are by the master, then the effigies are by Andriolo. However, the Madonna and Child on the Jacopo da Carrara tomb is also of very high quality and is clearly by another hand, probably a Lombard sculptor from the circle of Bonino da Campione. Again, it seems most reasonable to assume that the master provided designs and

relegated the carving of the figures to assistants. We must be content to think of a workshop rather than an individual style.

The Sculpture of the Palazzo Ducale

1 On 28 December 1340 it was decided to build a new and enormous council hall over one (or possibly more) preexisting structure(s) that served various government functions, and to unify the exterior facades on the south and west sides. One of the capitals of the west facade bears a date of 1344, and work on the exterior of the palace seems to have been suspended in 1348, the year of the Black Death. The building was enlarged after 1424. The Trecento palazzo included the two windows on the piazzetta nearest the Molo and five of the seven windows facing the waterfront. See E. Bassi, "Appunti per la storia del Palazzo Ducale di Venezia," 2, *Critica d'Arte*, IX/52, 1962, 41–53; Eduardo Arslan, *Venezia Gotica*, 2nd ed., Milan, 1986, 111f.; a summary of the still controversial building history is given in Deborah Howard, *The Architectural History of Venice*, New York, 1981, 79–81.

2 Wolfgang Wolters, *Scultura Veneziana Gotica*, Venice, 197 40–48; 178f. On the definition of *tajapiera* and its variants, see "Preface to the Garland Edition" (unpaginated) in Susan Connell, *The Employment of Sculptors and Stonemasons in Venice in the Fifteenth Century*, New York and London, 1988 (thesis, Warburg Institute, 1976).

3 John White, *Art and Architecture in Italy*, New Haven and London, 1987, 610; John Pope-Hennessy, *Italian Gothic Sculpture*, London and New York, 1972, 47f.; Arslan, *Venezia Gotica*, 146f.

4 One capital, beneath the Solomon relief and dating from the fifteenth century, is not octagonal but reflects the shape of the pier, a half column attached to a rectangular pier. Some of the capitals on the facade are nineteenth-century replacements whose originals are in the palace museum. The restorations and substitutions are reported in A. Forcellini, "Del restauro delle principali facciate del Palazzo Ducale di Venezia," in *L'ingegneria a Venezia dell'ultimo ventennio, pubblicazione degli ingegneri veneziani in omaggio ai colleghi del VI congresso*, Venice, 1887, 4–21. Useful descriptions and illustrations of all the capitals (although without scholarly apparatus) are found in Gino Rossi and Giovanni Salerni, *I Capitelli del Palazzo Ducale di Venezia*, Venice, 1952.

5 If not unassailable, plausible interpretations of all the capitals are offered by Rossi and Salerni, *I Capitelli*, which any visitor could well use as a first guide to the capital program.

6 The Campanile of Florence with its hexagonal reliefs including Old Testament scenes as well as the Labors of Man has been suggested as a possible source (Wolters, *Scultura Veneziana Gotica*, v. 1, 175). It is significant that the Campanile can be viewed as both an ecclesiastical and a civic structure (Marvin Trachtenberg, *Giotto's Tower:*

The Campanile of Florence Cathedral, New York, 1971, 104, 173–79).

7 Staale Sinding-Larsen, "Christ in the Council Hall. Studies in the Religious Iconography of the Venetian Republic," *Acta ad Archaeologiam et Artium. Historiam Pertinentia*, V, 1974, 167–75, explores Venice's political ideology and self-image as expressed in the program of the Ducal Palace (as well as the church of San Marco).

8 Sinding-Larsen, "Council Hall," 169.

9 Sinding-Larsen, "Council Hall," 170, 173f.

10 The Solomon group (Wolters, *Scultura Veneziana Gotica*, Figs. 813–21) is attributed to Bartolomeo Bon by Wolters, p. 120, and to the Florentine sculptor Nanni di Bartolo by Anne Markham Schulz, *The Sculpture of Giovanni and Bartolomeo Bon*, Philadelphia, 1978, 66.

11 The self-image of Venice and its governing bodies is epitomized in the representation of "Venice" as Justice in the tondo of the perforated gallery above the loggia that faces onto the Piazzetta. This relief is at the corner where the Trecento palace terminated. As is true of the capitals and corner narratives, the dating has been disputed. Wolters, *Scultura Veneziana Gotica*, 46 and 178f., considers it to be by Calendario and dates it to the middle of the century. Sinding-Larsen, "Council Hall," 174f., believes it can date only in 1422 when the palace was extended toward San Marco.

Jacobello and Pierpaolo dalle Masegna

1 W. Wolters, *Scultura Veneziana Gotica*, Venice, 1976, 62ff.; 213ff., with complete references to documentation.

2 On the partnership of Jacobello and Pierpaolo dalle Masegne, see Susan Connell, *The Employment of Sculptors and Stonemasons in Venice in the Fifteenth Century*, New York and London, 1988 (thesis, Warburg Institute, 1976), 47f., according to whom the documentary evidence implies that virtually all commissions were accepted jointly, even when only one brother actually signed the contract.

3 On the Glossator tombs in Bologna, see R. Grandi, *I Monumenti dei Dottori e la Scultura a Bologna, 1267–1348*, 72, and passim, and later discussion, pp. 304f. On the Legnano fragments, see Wolters, *Scultura Veneziana Gotica*, 64; Grandi, *Monumenti*, 100f., n. 131.

4 Wolters, *Scultura Veneziana Gotica*, 63f., 214f., favors Jacobello as the author, whereas Renato Roli, *Pier Paolo e Jacobello dalle Masegne*, Milan, 1966 (I maestri della scultura) unpaginated, pointing out that Pierpaolo was residing in the Legnano family's home in 1386, proposes Pierpaolo as the author. The tomb is mentioned in Vasari's brief reference to the dalle Masegne; Vasari-Milanesi, *Vite*, Florence, 1878, 444. Vasari must have seen the signature, today virtually illegible but recorded (in differing versions) in the seventeenth and eighteenth centuries.

5 On differences in the training and practice of craftsmen in Tuscany and Venice, see Connell, *Employment of Sculptors*, 222f. and passim.

6 On the basis of similarities with the modeling of the Legnano relief, a small and very finely carved marble figure of a kneeling doge in the Museo Correr, whose identification, provenance, and dating has not been ascertained, has been accepted into the oeuvre of Jacobello dalle Masegne. The attribution was first proposed by Richard Krautheimer, "Zur Venezianischen Trecentoplastik," *Marburger Jahrbuch für Kunstwissenschaft*, V, 1929, 193–212. Cesare Gnudi, "Jacobello e Pierpaolo da Venezia," *La Critica d'Arte*, II, 1937, 26–38, identified the figure as Doge Antonio Venier (in office 1382–1400). See also Wolters, *Scultura Veneziana Gotica*, 220 and figs. 432, 433. The main problem the portrait statuette poses, especially given its diminutive size (50 cm high), is one of context: A kneeling doge appears on the tomb of Bartolomeo Gradenigo in San Marco (Wolters, *Scultura Veneziana Gotica*, Fig. 110), but the Correr statuette is carved in the round and I know of no comparable Trecento tomb figure. Wolters implausibly suggests a very small interior portal setting but offers no example for comparison. In the fifteenth century a large relief portrait of Doge Francesco Foscari, in a pose similar to that of the Correr statuette, was placed over the architrave of the Porta della Carta of the Palazzo Ducale. The figure was partially destroyed in the late eighteenth century, although the head, 36 centimeters high, is extant in the Museo dell'Opera del Palazzo Ducale. The present outdoor relief is a reconstruction. See John Pope-Hennessy, "The Forging of Italian Renaissance Sculpture," *The Study and Criticism of Italian Sculpture*, New York and Princeton, 1980, 223–70. In any case, not only the small dimensions but also the excellent state of preservation of the Correr figure excludes an outdoor setting.

7 The most complete study of the ancona is found in Lutz Heusinger, *Jacobello und Piero Paolo dalle Masegne*, dissertation, Munich, 1967. Although the ancona was to be completed within two years, work was protracted and there are records of dissatisfaction and litigation between the dalle Masegne and the Franciscan patrons. A final payment was received in 1396. The ancona was moved several times and radically restored in 1843 when some figures were replaced. According to Wolters, a recent cleaning eradicated some of the original surfaces and even some contours, giving a false impression of the sculptures. Thus the distinction between the smooth and malleable surfaces of the ancona and the harder, more linear surfaces of the San Marco choir screen, which have led to attributional controversies, has been exaggerated. Wolters, *Scultura Veneziana Gotica*, 216–19. On the alterations to the pala see also Renato Roli, *La Pala Marmorea di San Francesco in Bologna*, Bologna, 1964, 14–18.

8 On Giovanni di Balduccio's Bologna altarpiece, see pp. 147f., with notes. On the Three Magi ancona, dated 1347, see pp. 213f. Sculptured altarpieces as a genre are discussed by Roberto Paolo Novello, "La pala d'altare," in Enrico Castelnuovo, ed., *Niveo de Marmore*, Genoa, 1992, 221.

9 The Franciscans themselves, however, could also boast a marble altarpiece, that by Tommaso Pisano in San Francesco Pisa of c. 1370. Anita Fiderer Moskowitz, *The Sculpture of Andrea and Nino Pisano*, Cambridge, London, New York, 1986, 163f. The erection of a large marble altarpiece in San Francesco, Bologna, in turn, may have motivated the Dominican friars of Sant'Eustorgio to commission the Passion altarpiece for the high altar of their basilica. On the latter, see p. 224.

10 The sources are discussed by Heusinger, *Dalle Masegna*, 56f. On the tradition of Venetian Gothic altarpieces see Peter Humpfrey, *The Altarpiece in Renaissance Venice*, New Haven and London, 1993, 164f.

11 Heusinger, *Dalle Masegna*, 45. A small opening with indications for hinges for a door can be seen in the rear of the retable for storage of the host.

12 The Madonna and Child were carved in 1884 by Carlo Chelli; Heusinger, *Dalle Masegna*, 75.

13 Roli, *Pier Paolo e Jacobello Dalle Masegne*.

14 Heusinger, *Dalle Masegna*, 50–53.

15 During a restoration in 1590, the altarpiece was moved from a location somewhat more within the nave to its present location. Roli, *La Pala Marmore*.

16 A statue of St. John the Baptist in Sto. Stefano, Venice, has been attributed to Jacobello (Wolters, *Scultura Veneziana Gotica*, cat. 145, 222); cf. Heusinger, *Dalle Masegna*, 165ff., who calls it "circle" of Andrea Pisano. If it is by one of the brothers, the St. John virtually proves a direct acquaintance with Tuscan sculpture, for it is so close to the Baptist in Sta. Maria della Spina, Pisa (which has received alternate attributions to Tommaso [Moskowitz, *Andrea and Nino Pisano*, 164 and Fig. 294] and Andrea Pisano [Gert Kreytenberg, *Andrea Pisano und die Toskanische Skulptur des Vierzehnten Jahrhunderts*, Munich, 1984, 86–89 and Figs. 103–4, 111–12], that it presupposes a trip to Pisa with drawings brought back as the basis for the Venetian figure.

17 Many photographs give the misleading impression that these figures are carved in rather low relief. The reliefs contain, in fact, figurines, disposed in two or more layers, that look almost as though they are carved in the round.

18 Baldacchino niches appear earlier in one of the San Marco Sacrament Tabernacles of the late 1380s, which Heusinger, *Dalle Masegna*, 60f., ascribes to the Dalle Masegne workshop. See also Giulia Rossi Scarpa, "La scultura nei secoli XIV e XV," in Renato Polacco, *San Marco. La Basica d'Oro*, Milan, 1991, 161–88.

19 Five reliefs now set into the wall of the north facade seem originally to have come from the thirteenth-century iconostasis. See Franz Kieslinger, "Le transenne della basilica di San Marco del secolo XIII," *Ateneo Veneto*, CXXXI, 1944, 57ff.; the author reconstructs the former iconostasis and believes it was built during restorations after a fire of 1231, though according to Otto Demus, *The Church of San Marco in Venice*, Washington, D.C., 1960, 137f., there is no proof of this.

20 Scarpa, "La scultura," 171.

21 The metal crucifix is signed by Jacopo di Marco Benato and dated 1394. Wolters, *Scultura Veneziana Gotica*, 1976, 223.

22 On San Marco as an *apostolic* church, see Demus, *San Marco*, 7ff.

23 Heusinger, *Dalle Masegne*, 122, attributes the side screens to a highly qualified assistant.

24 Wolters, *Scultura Veneziana Gotica*, 88f. See also Anne Markham Schulz, *The Sculpture of Giovanni and Bartolomeo Bon*, Philadelphia, 1978, 67.

25 Wolters, *Scultura Veneziana Gotica*, 1976, 88f.

Verona

1 The origins and rise of the seignorial government is discussed by Lauro Martines, *Power and Imagination. City-States in Renaissance Italy*, New York, 1979. The quotation is on p. 103.

2 Licisco Magagnato, *Arte e Civiltà a Verona*, ed. Sergio Marinelli and Paola Marini, Vicenza, 1991, 48f.

3 This lack of narrative impulse contrasts with the earlier productions, as evident for example in the remarkable Arca di SS. Sergio e Bacco, dated 1179, in the Castelvecchio Museum, with its extremely lively narratives on the sarcophagus as well as the cover. See later discussion, p. 273.

4 Fernanda De Maffei, "Il Maestro di S. Anastasia a Verona," *Commentari*, July 1953, 221–27, first referred to the sculptor by this designation but attributes to him too wide a range of stylistic modes. Gian Lorenzo Mellini, *Scultori Veronesi del Trecento*, Milan, 1971, 11f., has connected this group with the only documented Veronese artist's name of the period, a *magister* Regino di Enrico. There is no record, however, of any extant work by this master, so the association, as the author admits, is one of convenience rather than validity. Mellini augments still further the corpus of attributions in "Problemi di storiografia artistica tra Tre e Quattrocento, I: gli scultori veronesi," *Labyrinthos*, I–XII, 21/24, 1992–93, 9–99.

5 In addition to Mellini, cited in the previous note, discussions of the oeuvre of the Master of Sant'Anastasia are offered in L. Cuppini, "Il caposcuola della scultura veronese al tempo di Dante e di Cangrande," *Annuario del Liceo Ginnasio S. Maffei di Verona*, Verona, 1965, and summarized in Maria Teresa Cuppini, "L'Arte Gotica a Verona nei secolo XIV–XV," *Verona e il Suo Territorio*, v. III/2, Verona, 1969, 213–366.

6 Mellini, *Scultori Veronesi*, 13f. For discussion and illustrations of the Duecento nursing Madonnas, see Edoardo Arslan, *La Pittura e la Scultura Veronese dal Secolo VIII al Secolo XIII*, Milan, 1943, 146–48 and Figs. 182–85. Arslan comments that the nursing Madonnas are so similar as to suggest that they belong to a canon peculiar to Verona.

7 Mellini, *Scultori Veronesi*, 20. For an illustration of such a German example, see Paul Williamson, *Gothic Sculpture*, New Haven and London, 1995, Fig. 274. For other examples see the illustrations in R. Haussherr, "Triumphkreuzgruppen der Stauferzeit," *Die Zeit der Staufer*, Stuttgart, 1977, v. 5, 131–68. However, none of these groups attempts the expression of wrenching pain seen in the Verona examples.

8 It has recently been argued with great conviction but insufficient anatomical analysis and historical support that several works by the so-called Regino di Enrico, including the Castelvecchio Christ, indicate that the sculptor was direct witness to anatomical dissections, which were being performed in the Studium of Bologna and possibly also in Verona. I am not qualified to take a position on the question, but it remains an intriguing one requiring considerably more study. See Paola Salvi, "'Regina di Enrico' e l'esordio della 'anatomia' nell'arte," *Labyrinthos*, I–XII, 21/24, 1992–93.

9 Mellini, *Scultori Veronesi*, 19.

10 On the Arca see Arslan, *La Pittura e la Scultura Veronese*, 104–5.

11 For the opposite side of the sacrophagus see Mellini, *Scultori Veronesi*, Fig. 9. The sarcophagus type, based on the Paduan tomb of the legendary Antenor mentioned earlier, was common during the late thirteenth and early fourteenth centuries and is seen, for example, on the tomb of Ottone Visconti in the Duomo of Milan, Berardo Maggi in the Duomo Vecchio in Brescia, and in a tomb in S. Giovanni in Canale in Piacenza. The Byzantine quality of the reliefs is noted by Costantino Baroni, *Scultura Gotica*, 39; F. De Maffei, *Le Arche Scaligere di Verona*, Verona, 1955, 14.

12 Arslan, *La pittura e la scultura Veronese*, 151, Fig. 198. De Maffei, *Arche Scaligere*, Pls. V, LXIV; the author suggests a dating in the 1290s (p. 20).

13 Castelbarco was the Podesta of Verona for several terms of office and was a decisive promoter of the new building of Sant'Anastasia. On Castelbarco see Giulio Sancassani, "I Documenti," in *Dante e Verona* (exhibition catalogue), Verona, 1965, 3–163, especially 18f. A. Amadori, in "Guglielmo di Castelbarco. L'unico vero gran signore nella storia della Vallagarina," *Atti della Accademia Roveretana degli Agiati*, 231, 1981, s. VI, v. 21, 1983, 79–130, publishes Castelbarco's Last Will and Testament.

14 See later discussion, pp. 302ff. See also Anita Moskowitz, in *Enciclopedia dell'Arte Medievale*, v. 5, Rome, 1994, 691–94.

15 For the face of Castelbarco, see Mellini, *Scultori Veronesi*, fig. 51. Mellini has suggested that the Cangrande expression belongs to a specific tradition in Verona, to which the thirteenth-century statue of the smiling San Zeno, in San Zeno, Verona, belongs; Mellini, "Verona e l'oriente in epoca gotica," in Licisco Magagnato, ed., *Le Stoffe di Cangrande*, Florence, 1983, 49–71.

16 Ingo Herklotz, "Grabmalstiftungen und städtische Öeffentlichkeit im spätmittelalterlichen Italien," in *Materielle Kultur und Religiöse Stiftung im Spätmittelalter* (Internationales Round-Table-Gespräch, Krems an der Donau, 26 September 1988), Vienna, 1990, 233–71.

17 Mellini, *Scultori Veronesi*, attributes the tombs of Cangrande and Mastino II and various other sculptures to Giovanni di Rigino, son of "Regino di Enrico" (see note 4, earlier), for whom several documents are known, on the basis of two signed works, a small tabernacle with reliefs surmounting a column on the exterior of S. Pietro Incarnario, Verona (Mellini, Figs. 129–31), and a seated statue

of S. Procolo, signed and dated 1392, in San Zeno, Verona. These works by no means support the development of an entire oeuvre for Giovanni di Rigino.

18 R. Manselli, "Cangrande e il mondo ghibellino nell'Italia settentrionale alla venuta di Arrigo VII," in *Dante e la cultura Veneta*, Florence, 1966; Magagnato, *Arte e Civiltà a Verona*, 37f. John White, *Art and Architecture in Italy. 1250–1400*, New Haven and London, 1993, 490, has described Cangrande thus: "Personally brave, a bold and clever military leader and despite his youth an invariably skilled and often wise politician, as well as a patron of the arts and sciences . . . [Cangrande] represents the finest of the class of despots who, in the late 13th c., gradually gained power in the once free Lombard and Emilian communes."

19 Magagnato, *Arte e Civiltà a Verona*, 44; Herklotz, "Grabmalstiftungen."

20 A brief biography, and a description and interpretation of each of these reliefs, is given by Elisa W. Harrison, "A Study of Political Iconography on Six Italian Tombs of the 14th Century," Ph.D., dissertation, Northwestern University, 1988, 155–73.

21 On this point, see Antje Middeldorf Kosegarten, "Grabmäler von Ghibellinen aus dem frühen Trecento," *Skulptur und Grabmal des Spätmittelalters in Rom und Italien*, Vienna, 1990, 317–29.

22 This audacious, freestanding equestrian figure can be considered the precedent for a whole series of Italian knights in northern Italy, including the Sant'Alessandro in Bergamo (1353), Bernabò Visconti in Milan (1363), and the Cansignorio in Verona (1376).

23 Mellini, *Scultori Veronesi*, 102.

24 Peter Seiler, "La trasformazione gotica della magnificenza signorile. Committenza viscontea e scaligera nei monumenti sepolcrali dal tardo Duecento alla metà del Trecento," in Valentino Pace and Martina Bagnoli, eds., *Il Gotico Europeo in Italia*, Naples, 1994, 119–40, especially 132.

25 The heads are probably restorations.

26 De Maffei, *Arche Scaligere*, 62; Baroni, *Scultura Gotica Lombarda*, 53.

27 (The most excellent master sculptors and architects to be found in Italy at that time.) De Maffei, *Arche Scaligere*, 73ff. The monument underwent considerable restorations in the nineteenth century. Gian Lorenzo Mellini, "L'Arca di Cansignorio di Bonino da Campione a Verona," in Rossana Bossaglia and Gian Alberto Dell'Acqua, eds., *I Maestri Campionesi*, Lugano, 1992, 173–97, especially 187.

28 On the problematic attribution of the Bernabò tomb see Chapter 6, pp. 218ff.

29 (Not only to be comparable to but to be superior to and outdo the one made by his father Mastino.) The passage, by the chronicler Torello Saraina, is quoted in De Maffei, *Arche Scaligere*, 73.

30 For a scathing critique of the Cansignorio tomb, see Baroni, *Scultura Gotica Lombarda*, 112f.

31 The materials are red Verona mable for the supporting structure, white Carrara marble for the casket, the reliefs, the saints in the round within the tabernacle, the female

figures in niches, and the medallions in the tympana; the reclining figure is carved from tufa; the angels' wings and the heraldic devices are of iron as is the surrounding fence. It must have had copious gilding and paint, completely lost but still visible in the early nineteenth century. Mellini, "L'Arca di Cansignorio," 187.

32 Baroni, *Scultura Gotica Lombarda*, 104–8, Fig. 219. Although much altered from its original form, the tomb in Sant'Eustorgio, dated to the mid–fourteenth century, has been attributed to Bonino Campione.

33 Nude putti are rare but not unprecedented in the fourteenth century. Examples include those embellishing a console in the Museo Bardini, Florence (Enrica Neri Lusanna and Lucia Gaedo, eds., *Il Museo Bardini a Firenze*, Milan, 1986), and those scrambling along the spiral columns of the Benedict XI tomb in Perugia (Fig. 164).

34 As mentioned, the tomb carries inscriptions recording two names: Bonino da Campione and Gaspare, a Veronese name. The two inscriptions run around a fillet of the base of the platform on two separated sides. The first part reads HOC OPUS FECIT ET SCULPSIT BONINUS DE CAMPOLIONE MEDIOLANENSIS DIOCESIS; thus Bonino asserts that he is not local and names his hometown. The second inscription reads UT FIERET PULCRU POLLES NITIDUQUE SEPULCRUM / VERE BONINUS ERAT SCULPTOR GASPARQUE RECULTOR. For contrary interpretations of the inscriptions see Baroni, *Scultura Gotica Lombarda*, 112f., and De Maffei, *Arche Scaligere*, 73–76; and note 35 below.

35 Magagnato, *Arte e Civiltà a Verona*, 47, interprets the word *recultor* as "reconstructor" and calls Gaspare the architect. De Maffei, *Arche Scaligere*, 74–76, analyzes the inscriptions and concludes that the sculptural parts are by Bonino whereas Gaspare organized the enterprise and perhaps designed the architecture. It has also been suggested (Mellini, "L'Arca di Cansignorio," 183–88) that the architect of the Cansignorio tomb is none other than Altichiero, active as a painter in Padua, but the lack of any documentary evidence or other work of architecture attributable to him makes this identification problematic.

36 De Maffei, *Arche Scaligere*, 84, intending a reference to the "closed garden" of the Song of Songs, often shown in images of Mary.

EIGHT. CHARACTERISTIC FORMS: TRADITION AND INNOVATION

Pulpits

1 The ambo on the left (north), the major one, was for the reading of the Gospels and the minor one to the right (south) for the reading of Epistles. The term "pulpit" (*pulpito*), though often used interchangeably with "ambo," generally refers to the preaching structure that came into use during the thirteenth century with the rise of the mendicant orders and their preaching functions. A philological distinction between the words *pergamo, pulpito, cantoria,* and *ambone* is made by Roberto Paolo Novello, "Il pergamo di Giovanni Pisano," in Adriano Peroni, ed., *Il Duomo di*

Pisa, Modena, 1995, v. 1, 225. The author states that the correct term in our context is *pervium* or *pergamo*, with *pulpito* properly reserved for preaching platforms rather than for those used for the readings of scripture; however, in the English-language scholarly literature little distinction is made between functions, and all the structures discussed in this book are commonly referred to as "pulpits." On the history of ambos and pulpits, see Marco Rosci, "I pulpiti: strutture e sculture," *Le Chiese dal Paleocristiano al Gotico*, Novara, 1987, 272–81. On Tuscan pulpits see Franz Paul Zauner, "Die Kanzeln Toskanas aus der romanischen Stilperiode," Liepzig, 1915; H. Bodmer, "Die skulpierten romanischen Kanzeln in der Toskana," *Belvedere*, XII, 1928, 12–14; Clara Baracchini and Maria Teresa Filieri, "I pulpiti," in Enrico Castelnuovo, ed., *Nivea de Marmore*, Genoa, 1992, 120–25; Antonino Caleca, "I pergami," in Enrico Castelnuovo, ed., *Nivea de Marmore*, Genoa, 1992, 208–11.

2 On an inventory reference to a wooden pulpit, probably of the Trecento, in the cathedral of Siena, see Piero Morselli, "Corpus of Tuscan Pulpits 1400–1550," Ph.D. dissertation, University of Pittsburgh, 1978. Donatello's outdoor Prato pulpit was preceded by a wooden one for the display of the relic of the girdle of the Virgin; see H. W. Janson, *The Sculpture of Donatello*, Princeton, 1964, 112f. An illustration of a wooden pulpit is seen in a fresco in the Portinari Chapel, Sant'Eustorgio, Milan, by Vincenzo Foppa.

3 On this phenomenon, see Adriani Götz, *Der Mittelalterliche Predigtort und Sein Ausgestaltung*, Stuttgart, 1966 (Ph.D. dissertation, University of Tübingen), 43–48.

4 Götz *Der Mittelalterliche Predigtort*, 43–48.

5 Guglielmo's pulpit was removed to Cagliari to make way for Giovanni Pisano's pulpit of 1310. Early descriptions suggest that it was initially set up in the cathedral of Cagliari as a single pulpit near the third column of the nave, but during an enlargement of the church in the seventeenth century the components were separated to make up two wall pulpits. The fundamental study of the pulpit remains Dionigo Scano, *Storia dell'Arte in Sardegna*, Cagliari, 1907, 77–94. Some scholars hold that Guglielmo created two pulpits; see Zauner, *Kanzeln*, 50; Reinhard Zech, *Meister Wilhelm von Innsbruck und die Pisaner Kanzel im Dome zu Cagliari*, 1935. Martin Weinberger ("Nicola Pisano and the tradition of Tuscan pulpits," *Gazette des Beaux Arts*, 1960, LV, 129–46), alluding to a Tuscan tradition for a single pulpit and to the inscription on Guglielmo's tombstone that states that he made *a* pulpit (qui fecit pergamum), offers a convincing reconstruction of a single pulpit.

6 Dorothy F. Glass, *Portals, Pilgrimage, and Crusade in Western Tuscany*, Princeton, 1997, 9.

7 But the question of whether Guglieomo's pulpit was originally a single freestanding pulpit or two wall pulpits remains controversial; see note 5, and Baracchini and Filieri, in *Niveo de Marmore*, 120–25; 138, with bibliography.

8 G. H. and E. R. Crichton, *Nicola Pisano and the Revival of Sculpture in Italy*, Cambridge, 1938, 38ff., cite numerous polygonal and round pulpits, commenting that they are more common in northern than in southern Italy and appear to be of Byzantine origin. Mention is made of a hexagonal pulpit at Spoleto, centrally planned pulpits at Torcello and in St. Mark's, Venice, and two early polygonal pulpits in S. Giovanni Maggiore near Borgo S. Lorenzo, and at Fagna, both in Tuscany, among others. On this issue see also E. Bertaux, *L'Art dans l'Italie Meridionale*, Paris, 1904, 795–801; H. Swarzenski, *Nicola Pisano*, Frankfurt-am-Main, 1926, 10; and R. D. Wallace, "L'influence de la France Gothique sur Deux des Précurseurs de la Renaissance Italienne: Nicola et Giovanni Pisano," Ph.D. thesis, University of Geneva, 1953, 50–55.

9 Crichton, *Nicola Pisano and the Revival of Sculpture in Italy*, 38.

10 John Pope-Hennessy, *Italian Gothic Sculpture*, London and New York, 1972, p. 170.

11 On the symbolism inherent in the choice of circle, octagon, and hexagon see Eloise M. Angiola, "Nicola Pisano, Federico Visconti, and classical style in Pisa," *Art Bulletin*, LIX, 1977, 1–27. On Guido Bigarelli's font see Valerio Ascani, "La bottega dei Bigarelli. Scultori ticinesi in Toscana e in Trentino nel duecento sulla scia degli studi di Mario Salmi," in *Mario Salmi. Storico dell'Arte e Umanista. Atti della Giornata di Studio, Roma – Palazzo Corsini, 30 novembre 1990*, Spoleto, 1991, 107–34, especially 125–26.

12 Round-headed trefoils, possibly of Islamic origin, between the columns and the casket of pulpits are found also in the Abruzzi at Sta. Maria in Valle Porcianeta, Rosciolo (mid–twelfth century), and Sta. Maria del Lago in Moscufo (Anderson Photograph nos. 31218 and 31209, respectively). Also of French origin, as noted by Frances Ames-Lewis, *Tuscan Marble Carving 1250–1350. Sculpture and Civic Pride*, Hants (England) and Brookfield, Vt., 1997, 109, on the Pisa pulpit is the first appearance in Tuscany of the motif of the single-nail Crucifixion, with the Savior's feet crossed.

13 Anita Moskowitz, *Nicola Pisano's Arca di San Domenico and Its Legacy*, University Park, 1994, 16, 20.

14 This point is emphasized by Swarzenski, *Nicola Pisano*, 10.

15 Rosci, "I pulpiti," 272–81.

16 See note 5.

17 Roberto Salvini, *Il Duomo di Modena*, Modena, Milan, 1972, 127f. The *pontile* was erected c. 1170 and contains polychromed sculptured reliefs with scenes from the Passion of Christ, including an extremely wide representation of the Last Supper. The semicircular pulpit jutting out on the left side of the rood screen was added in the early thirteenth century. A preaching pulpit was erected against a pier in the nave in 1322, using earlier medieval *spolia*; see Giordana Trovabene, "Il reimpiego di Marmi Altomedioevali nel pulpito della Cattedrale di Modena," in *Studi in Memoria di Giuseppe Bovini*, Ravenna, 1989, 705–20.

18 Rosci, "I pulpiti," 272–81.

19 Max Seidel, "Studien zur Antikenrezeption Nicola Pisano," *Mitteilungen des Kunsthistorischen Institutes in Florenz*, XIX, 1975, 360.

20 The archbishop Federigo Visconti's sermons in the Baptistry are discussed by Angiola, "Nicola Pisano, Federigo Visconti," 1–27

21 Richard Krautheimer, "Introduction to an 'iconography of medieval architecture,'" *Journal of the Warburg and Courtauld Institutes,* V, 1942, 1–33. See also Angiola, "Nicola Pisano, Federigo Visconti," 8f., and Charles Seymour, Jr., "Invention and revival in Nicola Pisano's "heroic style," in *Studies in Western Art* (Acts of the XX International Congress of the History of Art), v. 1, Princeton, 1963, 207–26.

22 Angiola, "Nicola Pisano, Federigo Visconti." On medieval number symbolism see Krautheimer, "Iconography."

23 See earlier, pp. 35ff.

24 To be sure, a century earlier Wiligelmo had transferred a biblical cycle, such as conventionally seen on capitals and architraves, onto continuous slabs on the facade (see figure 6), but this solution had only a limited following; it has been suggested that the legacy appears instead on pulpits. See Baracchini and Filieri, "I pulpiti," 120–25.

25 See pp. 148ff.

26 Another rectangular marble pulpit, with reliefs showing the Death of the Virgin, the Assumption with St. Thomas, the Coronation, and the Recovery of the Virgin's Girdle, was executed in the mid-Trecento on the exterior of Prato cathedral; it was later dismantled and replaced by the polygonal pulpit of Donatello and Michelozzo. Janson, *The Sculpture of Donatello,* 112f.

27 On the hypothetical reconstruction, see Antonio Fascetti, "Ipotesi di ricostruzione del pergamo gotico della chiesa di San Michele in Borgo a Pisa," *Commentari,* XXIX, 1978, 169–74. See also Caleca, "I pergami," 208–11.

28 A. E. Popham and Philip Pouncey, *Italian Drawings in the Department of Prints and Drawings in the British Museum* (the fourteenth and fifteenth centuries), v. 1, London, 1950, 167f. On the drawings see further B. Degenhart and A. Schmitt, *Corpus der Italienischen Zeichnungen 1300–1450,* v. 1, Berlin, 1968 (Katalog 1–167), 99–102; and A. Garzelli, *Museo di Orvieto,* Bologna, 1972, 39–41.

29 Moreover, in the drawing the piers supporting the arcade beneath the parapet reliefs are octagonal, and although hexagons and octagons are extremely common shapes during the late Duecento and Trecento, pentagons remain rare.

30 The ratios of width to height are approximately as follows: Pisa Baptistry pulpit: 0.468; Siena Cathedral pulpit: 0.377; Sant'Andrea, Pistoia pulpit: 0.415; Pisa cathedral pulpit: 0.396. The Orvieto drawing yields a ratio of 0.692 of distance between columns to height of arch.

31 Another polygonal pulpit, based on a dodecagonal plan with seven sides visible, abutting a pillar and supported on a sort of console, was erected toward the end of the fourteenth century in San Fermo, Verona. The pulpit was commissioned from Antonio da Mestre in 1396 by the jurist Barnaba da Morano. However, the present form is not original; the parapet was raised and enlarged in the sixteenth century. L. Simeoni, "Il giurista Barnaba da Morano e gli artisti Martino da Verona e Antonio da Mestre," *Nuovo Archivio Veneto,* n.s. 10, v. XIX/1, 1919, 218–36; Carla Perez Pompei, *La Chiesa di San Fermo Maggiore,* Verona, 1954.

32 See note 28.

33 Even as late as c. 1518, Michelangelo designed a large octagonal pulpit with pilasters and niches, never executed but offering an intriguing glimpse, as was true of the 1505 design for the Julius II tomb, into the continuing legacy of Nicola Pisano's achievements. On the drawing for an octagonal ambone by Michelangelo and its possible relationship to the Pisano pulpits, see Morselli, "Tuscan Pulpits," 20f. The drawing is discussed in Frederick Hartt, *Michelangelo Drawings,* New York, 1969, Figs. 196, 197; J. Wilde, *Italian Drawings in the Department of Prints and Drawings in the British Museum: Michelangelo and His Studio,* London, 1953, 45–47. On the possible relationship of Michelangelo's design for the Julius tomb to the Arca di San Domenico, see Moskowitz, *Arca di San Domenico,* 45.

The Sculptured Cathedral Facade

1 James S. Ackerman, *The Architecture of Michelangelo,* first published London, 1961; reprinted 1995, 53.

2 Marvin Trachtenberg, "Gothic/Italian 'Gothic': Toward a redefinition," *Journal of the Society of Architectural Historians,* L/1, March 1991, 22–37.

3 Paul Frankl, *Gothic Architecture,* Baltimore, 1962, 251.

4 See earlier, pp. 43f.

5 Trachtenberg, "Gothic/Italian 'Gothic,'" 22–37. Trachtenberg makes a further claim that on a "deeper level" Italians perceived the inherent spirituality of the Gothic and employed Gothic devices (together with other iconographic means) to convey spirituality. One could argue the opposite: The application of Gothic devices as referents to spirituality was a superficial rather than profound response to the latter; and indeed, the aspects most expressive of spirituality in French architecture, the soaring, linear skeletal structures, were rejected by the Italians. Mendicant spirituality induced a far more down-to-earth architecture, and the problem of the Italian architect was to reconcile the energy and modernity of northern Gothic design with his native traditions.

6 Clario Di Fabio, "Il cantiere duecentesco della cattedrale," in *Il Niveo de Marmore,* Genoa, 1992, 181–89.

7 Peter Cornelius Claussen, "Il portale del Duomo di Genova. Lo stile internazionale all'antica a Genova e Milano," in Valentino Pace and Martina Bagnoli, eds., *Il Gotico Europeo in Italia,* Naples, 1994, 89–108.

8 Willibald Sauerländer, "Dal Gotico europeo in Italia al Gotico italiano in Europa," in Valentino Pace and Martina Bagnoli, eds., *Il Gotico Europeo in Italia,* Naples, 1994, 8–21.

9 Another ingenious attempt to amalgamate French formulas and local traditions is seen on the facade of the cathedral of Ferrara. The building was begun c. 1135, but significant additions were superimposed on its Romanesque fabric between c. 1200 and 1260. These include a series of

galleries of pointed arcades culminating in three gables of equal height and an arcaded and gabled section placed atop the earlier porch projecting from the facade's central bay. A Last Judgment – or, more properly, a *Maestas Domini* of the Apocalypse – closely dependent on Paris and Reims is illustrated in the gable and architrave in a style transitional between Romanesque and Gothic. See A. Giglioli, "Il Duomo di Ferrara nella storia dell'arte," *La Cattedrale di Ferrara. Nella Ricorrenza delle Manifestazioni Celebrative del VIII Centenario della Cattedrale. 1135–1935,* s.l. v. 1, Verona, 1937, 139ff., especially 199ff.; Shirley Anne Zavin, "Ferrara Cathedral Facade," Ph.D. dissertation, Columbia University, 1972; Sauerländer, "Dal Gotico europeo," 8–21, especially p. 16. For the identification of the subject as the *Maestas Domini* see W. R. Valentiner, "Il Giudizio Finale della Cattedrale di Ferrara," *Critica d'Arte,* II, 1954, 119–24.

10 Of the two extant competition drawings for the design of the Orvieto cathedral facade, one (Design B) is closer to French prototypes but it was ultimately rejected. John White, "I disegni per la facciata del Duomo di Orvieto," in Guido Barlozzetti, ed., *Il Duomo di Orvieto e le Grandi Cattedrali del Duecento* (Atti del Convegno Internazionale di Studi, Orvieto 12–14 November 1990), Turin, 1995, 69–98.

11 For a summary of issues concerning the reconstruction of Giovanni's facade design, see Tim Benton, "The design of Siena and Florence Duomos," in Diana Norman, ed., *Siena, Florence and Padua: Art, Society and Religion 1280–1400,* v. 2: *Case Studies,* New Haven and London, 1995, 129–43.

12 Enrica Neri Lussana, "La Decorazione e le sculture arnolfiane dell'antica facciata," in Cristina Acidini Luchinat, ed., *La Cattedrale di Santa Maria del Fiore a Firenze,* v. 2, Florence, 1995, 31–72. From the drawing we know that the facade remained incomplete; its marble revetment and sculpture reached only to the third register.

13 Ibid.

14 Francis Ames-Lewis, *Tuscan Marble Carving. 1250–1350,* Hants (England) and Brookfield, Vt., 1997, 160. The Theological Virtues by Tino di Camaino later placed above the Baptistry portal were carved only in 1321.

15 Antje Middeldorf Kosegarten, *Die Domfassade in Orvieto. Studien zur Architektur und Skulptur 1290–1330,* Munich, Berlin, 1996, passim; David Gillerman, "The Evolution of the Design of Orvieto Cathedral, ca. 1290–1310," *Journal of the Society of Architectural Historians,* LIII, September 1994, 300–21.

16 Enzo Carli, "Il Duomo come architettura e scultura," in *Il Duomo di Orvieto,* Turin, 1995, 27–51; Michael D. Taylor, "The Iconography of the Facade Decoration of the Cathedral of Orvieto," Ph.D. dissertation, Princeton University, 1969 (University microfilms, 1970), 76–78. The facade programs of Siena and Orvieto are compared by Middeldorf Kosegarten, *Die Domfassade in Orvieto,* 47–52.

17 The appearance of reliefs is common on northern Italian Romanesque facades, such as those of San Zeno in Verona, San Michele in Pavia, and the Duomo of Modena. But such ample spreading out along a major portion of the facade's surface would seem related to that on San Pietro, which is also geographically closest to Orvieto. See David Gillerman, "La facciata: Introduzione al rapporto tra scultura e architettura," in Lucio Riccetti, ed., *Il Duomo di Orvieto,* Bari, 1988, 81–100.

18 Middeldorf Kosegarten, *Die Domfassade in Orvieto,* 116ff.

19 On Orvieto as a "bastion" of the papal state, see Middeldorf Kosegarten, *Die Domfassade in Orvieto,* 17f.

20 Trachtenberg, *Giotto's Tower,* 1971, 99f.

21 Trachtenberg, *Giotto's Tower,* 1971, 101.

22 Middeldorf Kosegarten, *Die Domfassade in Orvieto,* 19ff.

23 On the cathedral, see above, 195ff., and Heinrich Wilhelm Schultz, *Denkmäler der Kunst des Mittelalters in Unteritalien,* Dresden, 1860, 4 vols. (v. 1, 81–89; v. 4, for cathedral documents in the Grande Archivio di Napoli); Giuseppe Pupillo, *La Cattedrale di Altamura,* Altamura, 1978; as well as a journal volume reprinting several earlier articles devoted to the cathedral: *"Altamura" – Rivista Storica Bollettino dell'Archivio – Biblioteca – Museo Civico,* 33/34, 1991–92.

24 See John White, *Art and Architecture in Italy,* New Haven and London, 1987, 517–31, for a summary and analysis of the debate between the Milan Fabbrica and its successive foreign advisers.

25 *Il Duomo di Milano. Dizionario storico artistic e religioso,* Milan, 1986, 575–78; *Storia di Milano,* v. 6, Milan, 1955, 86off.

26 White, *Art and Architecture,* 517–31.

Tombs

1 See pp. 294ff.

2 Recent studies include Renzo Grandi, *I Monumenti dei dottori e la Scultura a Bologna, 1267–1348,* Bologna, 1982; D. Pincus, "The fourteenth-century Venetian ducal tomb and Italian mainland traditions," in *Skulptur und Grabmal des Spätmittelalters in Rom und Italien,* Vienna, 1990, 393–400; J. Garms, "Gräber von Heiligen und Seligen," *Skulptur und Grabmal des Spätmittelalters in Rom und Italien,* Vienna, 1990, 83–105; A. Moskowitz, *Nicola Pisano's Arca di San Domenico and Its Legacy,* University Park, 1994; for a more complete bibliography on the subject, see Moskowitz, *Arca,* 48, n. 8. The tombs of professors in Padua is the subject of a recent dissertation: Jill Emilee Carrington, "Sculpted Tombs of the Professors of the University of Padua, c. 1358–c. 1557," Syracuse University, 1996. General comments concerning tomb typology are found in Frances Ames-Lewis, *Tuscan Marble Carving 1250–1350. Sculpture and Civic Pride,* Hants (England) and Brookfield, Vt., 1997, 167–206, and Catherine King, "Effigies: Human and divine," in Diana Norman, ed., *Siena, Florence and Padua: Art, Society and Religion 1280–1400,* vol. 2: *Case Studies,* New Haven and London, 1995, 105–27.

3 Ingo Herklotz, *"Sepulcra" e "monumenta" del medioevo,* Rome, 1985, 85–128.

4 On such prohibitions see R. A. Sundt, "Mediocres domos et humiles habeant fratres nostri: Dominican legislation on architecture and architectural decoration in the thirteenth century," *Journal of the Society of Architectural Historians*, XLVI, no. 4, December 1987, 394–407.

5 See pp. 116f.

6 Alessandro Del Vita, "L'Altar maggiore del duomo d'Arezzo," *Rassegna d'Arte*, XI/8, 1911, 127–40; Ersilia Agnolucci, "L'arca-altare di San Donato nella cultura artistica del Trecento Aretino," *Antichità Viva*, XXVII/1, 1988.

7 Moskowitz, *Arca*, Figs. 80–83.

8 P. Saccardo, *La cappella di S. Isidoro nella basilica di S. Marco, Venezia, 1887*, ed. Procuratoria di S. Marco, Venice, 1987.

9 The establishment of an elaborate chapel dedicated to an eastern military saint has been seen as part of a program, vigorously promoted by Doge Andrea Dandolo, to enhance Venice's sense of its dual heritage with respect to the two Romes, i.e., western imperial Rome and eastern Byzantine "Rome," with its own imperial traditions. This program was realized in part by bringing eastern military saints to new prominence. The erection of the composite figure of St. Theodore, referred to earlier, p. 237, atop the column of the piazzetta took place in 1329 when Dandolo was procurator of S. Marco. See Debra Pincus, "Venice and the two Romes: Byzantium and Rome as a double heritage in Venetian cultural politics," *Artibus et Historiae*, XIII, no. 26, 1992, 101–14, especially 105. On Dandolo's artistic patronage, including the chapel of Sant'Isidoro, see Debra Pincus, "Doge Andrea Dandolo and visual history: The San Marco Projects," in Charles M. Rosenberg, ed., *Art and Politics in Late Medieval and Early Renaissance Italy: 1250–1500*, Notre Dame, Ind., 1990, 191–206.

10 Saccardo, *La cappella di S. Isidoro*, 20–25. The mosaics, of a lively style that departs noticeably from Byzantine tradition, are briefly discussed by Sergio Bettini, *Mosaici Antichi di S. Marco*, Bergamo, 1944, 27ff.

11 See pp. 237f.

12 On the tomb see W. Wolters, *Scultura Veneziana Gotica*, Venice, 1976, 53, 189f.; Giulia Rossi Scarpa, "La scultura nei secoli XIV e XV," in Renato Polacco, *San Marco. La Basilica d'Oro*, Milan, 1991, 161–88. A full study of the chapel of Sant'Isidore and its program is lacking. It would be interesting to investigate the relationship of the chapel to several other examples of a *total chapel environment*, a concept that seems to develop around the middle of the century, witness the Cappellone of St. Nicholas of Tolentino. The walls of the chapter house of the Augustinians of Tolentino, transformed into a chapel dedicated to the not yet canonized St. Nicholas, was completely frescoed and has received a wide range of dating, from the early to the late fourteenth century; see Miklos Boskovits, "La decorazione pittorica nel Cappellone di San Nicola," in *San Nicola, Tolentino, le Marche* (Convegno Internazionale di Studi), Tolentino, 1985, 245–52. Not until the early sixteenth century does a comparable all-encompass-

ing program emerge, in the chapel of the Santo in Padua, with its extensive cycle of monumental reliefs of the life of St. Anthony covering the walls; on this last see Sarah Blake McHam, *The Chapel of St. Anthony at the Santo and the Development of Venetian Renaissance Sculpture*, Cambridge, 1994. I wish to thank Debra Pincus for fruitful correspondence on this subject.

13 M. Edwards, "The tomb of Raimondino de' Lupi and its setting," *Rutgers Art Review*, II, January 1982, 37–49; H. Saalman, "Carrara burials in the Baptistery of Padua," *Art Bulletin*, XIX/3, 1987, 376–94; Moskowitz, *Arca*, 43f. See also later discussion, p. 309.

14 For example, worshipers entering or leaving San Domenico from its north flank or from the main portals could not avoid confronting the tombs of Egidio del Foscherari and Rolandino Passaggeri, respectively. Ingo Herklotz, "Grabmalstiftungen und städtische Öffentlichkeit im spätmittelalterlichen Italien," *Materielle Kultur und Religiöse Stiftung im Spätmittelalter*, Vienna, 1990, 233–57, highlights the importance of the larger urban context in the choice of siting.

15 On the tombs of the Glossators, see Grandi, *Monumenti*, 71f. and 107–20.

16 See Grandi, *Monumenti*, 23–29, 57–59, 107–9, 118–21.

17 Carrington, "Sculpted tombs."

18 Enzo Carli, *Gli Scultori Senesi*, Milan, 1980, for relevant documentation and bibliography.

19 Herklotz, "*Sepulcra*," 163f.

20 Herklotz, "*Sepulcra*," 169f.

21 Herklotz, "*Sepulcra*," 170, has proposed that the Paul of Paphos tomb may have predated that of Clement IV. On the intractable problem of dating the Clement IV tomb see, most recently, Anna Maria D'Achille, "Sulla datazione del monumento funebre di Clemente IV a Viterbo: Un riesame delle fonti," *Arte Medievale*, III, 1989, 85–89, with an exhaustive bibliography, 89, n. 1. For attributions to Pietro Oderisio and the relationship of the tomb to Roman traditions and French currents, see Peter Cornelius Claussen, *Magistri Doctissimi Romani. Die Römischen Marmorkünstler des Mittelalters*, Stuttgart, 1987, 185–202. On the problem of reconstructing in detail the original form of the tomb see Anna Maria D'Achille, "Il monumento funebre di Clemente IV in S. Francesco a Viterbo," *Skulptur und Grabmal des Spätmittelalters in Rom und Italien*, Vienna, 1990, 129–42.

22 Compare J. White, *Art and Architecture in Italy 1250–1400*, 2nd ed., New Haven and London, 1987, 97f., who believes that the portraitlike aspect is actually a "modification of a studio pattern in the direction of portraiture." A. Monferini, "Pietro di Oderisio e il rinnovamente tomistico," *Monumenti del Marmo. Scritti per i Duecenti Anni dell'Accademia di Carrara*, Rome, 1969, 39–61, relates the realism of the effigy to Thomistic philosophy. On the Clement IV tomb, see Claussen, *Magistri Doctissimi Romani*, 185ff.

23 Claussen, *Magistri Doctissimi Romani*, 199.

24 Francesco Cristofori, *Le Tombe dei Papi in Viterbo*, Siena, 1887, 185–91.

25 There may also have been an effigy on the bier, although such a figure is not extant (the present relief dates from the seventeenth century). Herklotz, "Sepulcra," 185f.

26 Herklotz, "Sepulcra," 170–80, reidentifies the effigy of the Annibaldi tomb as that of the papal notary Riccardo Annibaldi instead of the latter's uncle, the homonymous cardinal who died in 1274. Herklotz casts doubt on the provenance of the frieze of clerics, claiming that their association with the effigy and the tomb dates only from the seventeenth century. This is not the place to resolve the complex issue of the Annibaldi tomb; that the frieze of clerics belonged to a funerary monument of the last decades of the thirteenth century, however, is beyond doubt. On the Annibaldi tomb see also A. M. Romanini, "Ipotesi ricostruttive per i monumenti sepulcrali di Arnolfo di Cambio," in *Skulptur und Grabmal des Spätmittelalters in Rom und Italien* (Atti del Convegno a cura dell'Accademia Austriaca delle Scienze e dell Istituto dell' Enciclopedia Italiano), Vienna, 1990.

27 J. Gardner, "Arnolfo di Cambio and Roman tomb design," *Burlington Magazine,* CXV, 1973, 420–39.

28 On the relation between late Duecento tombs and funerary ritual, see Herklotz, "Sepulcra," 193–99.

29 Herklotz, "Sepulcra," 191; Max Seidel, "Adsit ei angelus Michael. Eine neu Entdeckte Skulptur von Giovanni Pisano," *Pantheon,* XLVI, 1988, 5–12.

30 Angelo Lupattelli, *Benedetto XI in Perugia. Suo Monumento Sepolcrale, Sue Reliquia,* Rome, 1903; Gerhard Ladner, *Die Papstbildnesse des Altertums und des Mittelalters,* v. 2, Vatican City, 1970, 143–59. Benedict XI had apparently expressed the wish for a humble burial ". . . ne in alto poneretur, sed sub terra, ex magna humilitate quam habebat." Quoted in Herklotz, "Sepulcra," 230. But the belief that he was a *beato* – miracles had occurred near his remains – and Dominican pride that one of theirs had worn the papal tiara (he was in fact the second Dominican to be elected pope) resulted in a tomb in the Dominican church of Perugia that was anything but humble.

31 Anita Moskowitz, *The Sculpture of Andrea and Nino Pisano,* Cambridge, London, New York, 84f. An earlier example is the colossal tomb of Bishop Guido Tarlati in the Duomo of Arezzo, whose biographical relief cycle rivals, as perhaps does none other, the extensive cycles on saints' tombs.

32 This point is emphasized by Elisa Harrison, "A Study of Political Iconography on Six Italian Tombs of the 14th Century," Ph.D. dissertation, Northwestern University, 1988, 226–30. On the Saltarelli tomb see earlier discussion, pages 162ff.

33 This conception is anticipated, as far as I know, only in the tomb of the Duke of Calabria, son of Robert of Anjou, by Tino di Camaino in Santa Chiara, Naples, dated 1332–33 (Fig. 241). Here, three of these four stages appear. On a single, continuous field on the sarcophagus, the enthroned monarch is represented, surrounded by his ecclesiastical and secular councillors. On the sarcophagus lies the effigy, and high above there are two saints, one of which presents the duke to the Virgin. On the tomb see pp. 186f.

34 On the relationship between the tomb effigy with its funerary paraphernalia and the real-life ceremonial, see Herklotz, "Sepulcra," 193, and Robert Brentano, *Rome before Avignon,* New York, 1974, 68.

35 A. Paravicini Bagliani, *I Testamenti dei Cardinali del Duecento,* Rome, 1980, civ–cvii.

36 Brentano, *Rome before Avignon,* 263–88, especially 373ff.

37 Moskowitz, *Arca,* passim.

38 On the concept of "retrospective" versus "prospective" tomb iconographies, see Erwin Panofsky, *Tomb Sculpture,* New York, 1984, 19f., 23f., 68f.

39 The tomb was dismantled and reduced in size in the sixteenth century. See Edwards, "Raimondino de' Lupi"; also the remarks by Saalman, "Carrara Burials," 376–94. A hypothetical reconstruction is offered by G. L. Mellini, *Altichiero e Jacopo Avanzi,* Milan, 1965, 52–53.

40 Harrison, "Political Iconography."

41 Antje Middeldorf Kosegarten, "Grabmäler von Ghibellinen aus dem frühen Trecento," in J. Garms and G. M. Romanini, eds., *Skulptur und Grabmal des Spätmittelalters in Rom und Italien,* Vienna, 1990, 317–29.

42 Middeldorf Kosegarten, "Grabmäler von Ghibellinen," 317–29.

43 G. Kreytenberg, "Das Grabmal von Kaiser Heinrich VII in Pisa," *Mitteilungen des Kunsthistorischen Institutes in Florenz,* XXVIII, 1984, 33–64. See earlier discussion, pp. 117ff.

44 See earlier discussion, pp. 190ff. The imposing seated statue may also be a reference to papal commemorative statues; seated figures of Boniface VIII had been carved for numerous sites, including the exterior of the cathedral of Florence and two gateways to the city of Orvieto, residence of the papal curia numerous times prior to its transfer to Avignon.

45 On the Visconti and della Scala tombs see earlier discussions, pp. 218ff. and 275ff. A brief biography of Cangrande emphasizing his Ghibelline connections is found in Harrison, "Political Iconography," 155–64.

46 Ernst H. Kantorowicz, *The King's Two Bodies: A Study in Medieval Political Thought,* Princeton, 1957, 387–401.

47 King, "Effigies: Human and divine," 105–27. Compare Julian Gardner, "A princess among prelates: A fourteenth-century Neapolitan tomb and some Northern relations," *Römisches Jahrbuch für Kunstgeschichte,* XXIII–XXIV, 1988, 46, who argues that "the design of medieval tombs was unisex."

48 Pietro Torelli, "Jacobello e Pierpaolo dalle Masegne a Mantova," *Rassegna d'Arte,* XIII, 1913, 67ff.

49 Sharon Strocchia ("Death rites and the ritual family in Renaissance Florence," in M. Tetel, R. Witt, and R. Goffen, eds., *Life and Death in Fifteenth-Century Florence,* Durham, N.C., 1989, 120–45) points out, for example, that purchases from the commune of Florence of exemptions from sumptuary laws for funerals were more common for male than for female burials. Catasto records show, furthermore, that expensive funerals for fathers put many sons of wealthy men into debt.

50 Sharon Strocchia, "Funerals and the politics of gender in

Early Renaissance Florence," in M. Migiel and J. Schiesari, eds., *Refiguring Woman: Perspectives on Gender and the Italian Renaissance,* Ithaca, 1991, 155–68 (reprinted, Baltimore, 1992).

51 Louis Green, *Castruccio Castracani. A Study on the Origins and Character of a Fourteenth-Century Italian Despotism,* Oxford, 1986, 188–92.

52 W. R. Valentiner, *Tino di Camaino: A Sienese Sculptor of the Fourteenth Century,* Paris, 1935, 124.

53 Lorenz Enderlein, *Die Grablegen des Hauses Anjou in Unteritalien. Totenkult und Monumente 1266–1343,* Worms, 1997, 124–126. On the controversy, see the discussion and references concerning Giovanni di Balduccio's Arca di San Pietro Martire in Chapter 6, pp. 203ff.

54 Emile Bertaux, "Magistri Johannes et Pacius de Florentia. Marmorarii fratres," I, II, *Napoli Nobilissima,* IV, 1895, 147f.; Giuletta Chelazzi Dini, *Pacio e Giovanni Bertini da Firenze e la Bottega Napolitana di Tino di Camaino,* Prato, 1996, 30.

NINE. SOME PROBLEMS IN ITALIAN GOTHIC SCULPTURE: CASE STUDIES

1 On artists' contracts of the Renaissance, with some material pertaining to the Trecento, see Hannelore Glasser, *Artists' Contracts of the Early Renaissance,* New York, 1988.

2 Martin Wackernagel, *The World of the Florentine Renaissance Artist,* trans. Alison Luchs (originally published in German, 1938), Princeton, 1981, 300f.

3 As far as I know no comparative study has been made of psychoperceptual responses to works of art.

4 Anita Moskowitz, *The Sculpture of Andrea and Nino Pisano,* Cambridge, London, New York, 76, n. 44.

5 See the issue of *Gesta,* XXXIII/1, 1994, devoted to this subject.

6 Jack Wasserman, with IBM technology, is producing such a documentation of Michelangelo's *Pieta* in the Museo dell'Opera del Duomo, Florence, to be published by Princeton University Press.

7 See in particular the references to A. M. Romanini in Chapter 2, pp. 48ff.

Developing a Master's Oeuvre: The Problem of Nino Pisano

1 See pp. 156ff.

2 G. Milanesi, ed., *Le Vite de' Più Eccellenti Pittori, Scultori ed Architettori, Scritte di Giorgio Vasari,* v. 1, 1878, 489.

3 These issues are discussed more fully in Anita Moskowitz, *The Sculpture of Andrea and Nino Pisano,* Cambridge, London, New York, 1986, 60–93.

4 Martin Weinberger, "Nino Pisano," *Art Bulletin,* 19, 1937, 89.

5 John Pope-Hennessy, *Italian Gothic Sculpture,* London and New York, 1972, 23.

6 M. Buressi, *Andrea, Nino e Tommaso. Scultori Pisani,* Pisa, 1983; G. Kreytenberg, *Andrea Pisano und die*

Toskanische Skulptur des Vierzehnten Jahrhunderts, Munich, 1984; Moskowitz, *Andrea and Nino Pisano.*

7 I would consider in this category the attribution of works that are vaguely Nino-like, but not to be identified with his hand, to his son named Andrea (thus "Andrea di Nino," to distinguish him from the grandfather Andrea Pisano). Connected to this Andrea is only one document, completely unconnected with art. The reasoning is that since sons often practiced the profession of their fathers, a son of Nino might well be a sculptor, so in the absence of information to the contrary we will call him a sculptor and assign to him works that could well have been executed by a son of Nino. On "Andrea di Nino" see Kreytenberg, *Pisano,* 1983, passim, especially 106–27; Alessandro Bagnoli, "Da Goro di Gregorio a Nino Pisano," *Prospettiva,* 41, April 1985, 52–54; Gert Kreytenberg, "Un crocifisso sconosciuto di Andrea di Nino Pisano," *Antichita Vivà,* XXVIII/2–3, 1989, 73–79.

An Apparent Forgery and a Noteworthy Imitation

1 Dorothy Gillerman, ed., *Census of Gothic Sculpture in America,* v. 1, The New England Museums, New York, 1989, 384, Fig. 293. The purpose of this project is to investigate, catalogue, and publish sculptures of the Gothic period in American collections. Each catalogue entry provides information concerning the piece's provenance (often going back no earlier than its immediately preceding owner), condition, style, and historical, stylistic, or iconographic significance.

2 See J. Pope-Hennessy, *Catalogue of Sculptures in the Victoria and Albert Museum,* London, 1964, v. 1, 46; v. 2, Fig. 5.

3 Responding to the doubts I had raised about the works, Anthony Radcliffe, then Keeper of Sculpture at the Victoria and Albert Museum, wrote in a personal communication of 7 November 1985: "[T]hey are quite clearly from the same hand. The face [of the London figure] corresponds absolutely both full face and profile, the treatment of the physical features is the same, and the pattern on the border of the dress is identical. The uncertain tooling on the unfinished back is also precisely the same." He concluded that "[O]ur piece has all the marks of being a crude forgery," and wondered how no less a scholar than John Pope-Hennessy could have accepted it as genuine. But, let us note, without Pope-Hennessy's publication of the London figure it would have been more difficult to support the contention that the Mt. Holyoke head is false. The doubts raised about the latter, in turn, helped confirm certain earlier suspicions regarding the London piece.

4 Encyclical of Leo XII of 25 January 1825, quoted by Luigi Moreschi, *Descrizione del Tabernacolo che Orna la Confessione della Basilica di San Paolo Sulla Via Ostiense,* Rome, 1840, 1: "tamquam tres illi adolescentes Babylone in fornace ignis ardentis incolumes, integrum apostoli paulli sepulcrum servatum est." Repeated in *Diario di Roma,* num. XX, Roma, sabato 12 marzo 1825, 22–23: ". . . il sepolcro del grande apostolo, come i tre fanciulli nell' ardente fornace di Babilonia, per una specie di prodi-

gio è rimasto intatto . . ."; and again in A. Nibby, *Roma nel 1838, Parte Moderna*, v. 1, Rome, 1839, 577–85: "e frattanto, al pari dei tre fanciulli ebrei illesi nella babilonica fornace, INTEGRO SI CONSERVÒ; E MANTENNE IL SEPOLCRO DEL SANTO APOSTOLO." [. . . like the three Hebrew boys unharmed by the Babylonian furnace, the tomb of the holy apostle was preserved whole." See also Anita Moskowitz, "Arnolfo, Non-Arnolfo: New (and Some Old) Observations on the Ciborium in San Paolo fuori le mura," *Gesta*, XXXVII/1, 1998, 88–102.

5 Much as Arnolfo's masterpiece has been the object of intensive scholarly study, the integrity of all of its parts has not been questioned. See the monographs on Arnolfo by V. Mariani (*Arnolfo e il Gotico Italiano*, Naples, 1967), A. M. Romanini (*Arnolfo di Cambio e lo Stil Novo del Gotico Italiano*, Milan, 1968, 2nd ed., Florence, 1980), and E. Carli, *Arnolfo* (Florence, 1993). See also C. Pietrangeli, ed., *San Paolo Fuori le Mura a Roma*, Florence, 1988, 159, where the intactness of the ciborium is again asserted; A. M. Romanini, "Arnolfo e gli 'Arnolfo' Apocrifi," in *Roma Anno 1300*, Rome, 1983, 40, n. 17, who writes that a photographic campaign sponsored by the (then) Gabinetto Fotografico Nazionale confirmed the correctness of the claim that the ciborium was not substantially damaged by the fire of 1823; and M. Mercalli in M. Fagiolo and M. L. Madonna, eds., *Roma 1300–1875. La Città degli Anni Santi. Atlante*, Rome, 1985, 72. In her brief catalogue entry she asserts that only traces of the operation of dismantling and the succeeding reassemblage are visible from close range, revealing nothing more than the simple realigning of pieces. A. M. Romanini, "Arnolfo *architectus*," *Studi in onore di Giulio Carlo Argan*, Florence, 1994, 72, again repeats the conventional wisdom, referring to the "incendio . . . che lambì ma lasciò 'miracolosamente' intatto il ciborio arnolfiano."

6 A number of prize drawings dating between 1830 and 1840 from the Scuola del Nudo, in the Archivio of the Accademia di San Luca (e.g., Fig. 394), offer comparative material for such details as the feet bent at the toes and the curvature of thighs. I would like to thank Dott.ssa Angelica Cipriani, director of the Accademia di San Luca and author (with Enrico Valeriani) of *I Disegni di Figura nell'Archivio Storico dell'Accademia di San Luca*, 3 vols., Rome, 1988–91 (vol. 4 forthcoming), and Professor Italo Faldi, author of *Galleria Borghese. Le Sculture dal Secolo XVI al XIX*, Rome, 1954, both of whom agreed to examine my photographs and confirmed my view that Cain and Abel reveal a nineteenth-century sensibility.

7 Carli, *Arnolfo*, Figs. 166, 167.

8 Archivio di Stato di Roma, Camerale III, busta 1910 (no. 145, 21 novembre 1825). A description of work done on the basilica includes "Calati, separati, ed ammagazzinati tutti i marmi, e colonne, appartenenti alla confessione, e gli altri attrezzi, ricoperti quindi di un muro in fango." [All the marbles and columns belonging to the confessione, and other apparatuses were taken down, separated, stored, and then sheltered in a mud wall.] See also Moreschi, *Descrizione del Tabernacolo*, 36.

9 L. Moreschi, "Relazione della Consecrazione fatta da sua Santità Papa Gregorio XVI della nave traversa della basilica di S. Paolo fuori delle mura di Roma, il dì 5 di ottobre 1840," extract from supplement to no. 83 of *Diario di Roma*, of 17 October 1840.

10 Moreschi, *Descrizione del Tabernacolo*, 35. The damage is also noted by G. Marocchi, *Dettaglio del terribile incendio accaduto il di' 15 luglio 1823 nella famosa basilica di S. Paolo di Roma*, Rome, 1823, 9–11. See also Archivio di Stato di Roma, Camerale III, busta 1911 (no. 319): "Collezione degli articoli pubblicati nel diario di Roma e nelle notizie del giorno relativi alla nuova fabbrica della Basilica di S. Paolo sulla via Ostiense dal giorno dell' infausto suo incendio nel di 15 luglio al di 31 dicembre 1845" (Rome, 1845). In an entry for 1836, we read about the "quattro colonne di porfido destinate a sorreggere il tabernacolo stesso . . . sebbene di quel durissimo marmo, pure furono oltremodo offese e danneggiate dal non mai abbastanza deplorato incendio del 1823." [four columns of porphyry destined to support the tabernacle itself . . . even though made of that very hard marble, also were greatly harmed and damaged by the forever to be deplored fire of 1823.] Newly carved porphyry columns for the ciborium are referred to in an entry of 1838 labeled Supplem. al Diario, no. 60.

11 The columns show some very thin cracks but they are otherwise completely undamaged. That they are modern has been confirmed by sculptor and conservation expert Peter Rockwell; see Moskowitz, "Arnolfo, Non-Arnolfo."

12 "Essi marmi ora sono stati perfettamente restaurati e nella parte architettonica, e nella scultura delle statue, de' bassorilievi e degli ornati, e nella pittura in mosaico e nelle dorature, con nuove opere imitanti strettamente il loro antico esemplare." [These marbles have been perfectly restored both in the architectural parts and the sculptures including statues, bas-reliefs and ornaments, as well as the mosaic paintings and the gilding, with new works closely imitating their ancient models.] "Supplemento al Diario num. 87 dell' anno 1836. Sabato 29 ottobre 1836. Relazioni della visita fatta alla basilica di San Paolo dalla Santità di Nostro Signore Gregorio XVI per osservarvi i lavori della sua riedificazione." The passage continues: "[E]ssendo stato volere della Santità Sua, che quel tabernacolo, il quale nella massima parte rimase prodigiosamente illeso dalle fiamme divoratrici del 1823, fosse riparato in ogni sua parte e conservato, secondo i voti comuni, nella sua piena integrità, nella sua prisca magnificenza. Non è facile ad esprimere a parole la sovrana degnazione e la bontà con la quale piacque a Sua Beatitudine approvare il restauro di esso tabernacolo. . . ." [It was the desire of his Holiness that the tabernacle, most of which miraculously remained unscathed by the devouring flames of 1823, should be repaired in all its parts and preserved, according to common agreement, in its full integrity and pristine magnificence. It is not easy to express with words the pontiff's esteem and the good-

ness with which it pleased his Beatitude to approve the restoration of the tabernacle. . . .]

A Hypothetical Reconstruction:
Nicola Pisano's Arca di San Domenico

1 Anita Moskowitz, *Nicola Pisano's Arca di San Domenico and Its Legacy*, University Park, 1994. See also earlier discussion, pp. 31ff.

2 Michele Piò, *Delle Vite degli Huomini Illustri di San Domenico*, Bologna, 1620, col. 119.

3 John Pope-Hennessy, "The Arca of Saint Dominic: A hypothesis," *Burlington Magazine*, XCIII, 1951, 347–351; reprinted in John Pope-Hennessy, *Essays on Italian Sculpture*, London and New York, 1968, 11–15.

4 This is not to say that the reconstruction hasn't been questioned again; cf. Paul Williamson, *Gothic Sculpture*, New Haven and London, 1995, 290, n. 19.

Bibliography

Abulafia, David, *Frederick II. A Medieval Emperor,* London, 1988.

Ackerman, James, "'Ars sine Scientia nihil est'. Gothic theory of architecture at the Cathedral of Milan," *Art Bulletin,* XXXI/2, 1949, 84–111.

Agnolucci, Ersilia, "L'arca-altare di San Donato nella cultura. artistica del Trecento Aretino," *Antichità Viva,* XXVII/1, 1988, 32–38.

Angelucci, S., "Primi risultati di indagini tecnico-scientifiche sul San Pietro di bronzo della Basilica Vaticana," *Arte Medievale,* s. II, IV/2, 1990, 51–58.

Alce, P. Venturino, "La tomba di San Pietro Martire e la Cappella Portinari in Sant'Eustorgio di Milano," *Memorie Domenicane,* I, 1952, 3–34.

Amadori, A., in "Guglielmo di Castelbarco. L'unico vero gran signore nella storia della Vallagarina," *Atti della Accademia Roveretana degli Agiati. Contributi della classe di scienze umane, di lettere ed arti,* 231 (1981), s. VI, 21, 1983, 79–130.

Andres, Glenn, John M. Hunisak and A. Richard Turner, *The Art of Florence,* New York, 1988.

Ames-Lewis, Frances, *Tuscan Marble Carving 1250–1350. Sculpture and Civic Pride,* Hants (England) and Brookfield, Vt., 1997.

Angiola, Eloise M., "Nicola Pisano, Federico Visconti, and classical style in Pisa," *Art Bulletin,* LIX, 1977, 1–27.

Antal, Frederick, *Florentine Painting and Its Social Background,* London, 1948.

Arte Lombarda dai Visconti agli Sforza (exhibition catalogue; introduction by Roberto Longhi), Milan, 1958.

Arte Lombarda dai Visconti agli Sforza (exhibition catalogue; introduction by Gian Alberto Dell'Acqua), Milan, 1959.

Arnoldi, Francesco Negri, "Scultura trecentesca in Calabria: Apporti esterni e attività locale," *Bollettino d'Arte,* XX, 1983, 1–48.

Arslan, Eduardo, *La Pittura e la Scultura Veronese dal Secolo VIII al Secolo XIII,* Milan, 1943.

Venezia Gotica, 2nd ed., Milan, 1986.

Ascani, Valerio, "Bigarelli," in *Enciclopedia dell'Arte Medievale,* v. 3, Rome, 1992, 508–13.

"La bottega dei Bigarelli. Scultori ticinesi in Toscana e in Trentino nel duecento sulla scia degli studi di Mario Salmi," in *Mario Salmi. Storico dell'Arte e Umanista. Atti della giornata di Studio, Roma – Palazzo Corsini, 30 novembre 1990,* Spoleto, 1991, 107–34.

Ayrton, Michael, *Giovanni Pisano Sculptor,* London, 1969.

Bacci, Peleò, "Documenti e commenti per la storia dell'Arte," *Le Arti,* IV, 1941–42, 98–106, 185–92, 268–77, 329–40.

Documenti Toscani per la Storia dell'Arte, v. 1, Florence, 1910, 74–78.

Documenti e Commenti per la Storia dell'Arte, Florence, 1944.

"Il 'Fonte Battesimale' di Tino di Camaino per il Duomo di Pisa," *Rassegna d'Arte Antica e Moderna,* VII, 1920, 97–101.

La Ricostruzione del Pergamo di Giovanni Pisano nel Duomo di Pisa, v. 8, Milan, Rome, 1926.

"Monumenti danteschi. Lo scultore Tino di Camaino e la tomba dell' 'alto Arrigo' per il Duomo di Pisa," *Rassegna d'arte antica e moderna,* VIII, 1921, 73–84.

Bagnoli, Alessandro, "Da Goro di Gregorio a Nino Pisano," *Prospettiva,* 41, April 1985, 52–54.

"Novità su Nicola Pisano scultore nel Duomo di Siena," *Prospettiva,* 27, October 1981, 27–46.

Bagnoli, Rafaele, *Festivita e Tradizioni Popolari Milanese,* Rome, 1973.

Balogh, Jolan, *Katalog der Ausländischen Bildwerke des Museums der Bildenden Künst in Budapest, IV–XVIII, Jahrhundert,* Budapest, 1975.

"Studi sulla collezione di sculture del Museo di Belle Arti di Budapest." VI, pte. I. Pozzi veneziani, in *Acta Historiae Artium Academiae Scientiarum Hungaricae,* XII, 1966, 211–278.

Baracchini, Clara, ed., *Scultura Lignea, Lucca 1200–1425* (exhibition catalogue), Florence, 1995.

Barnet, Peter, *Images in Ivory* (exhibition catalogue), Princeton, 1997.

Baroni, Costantino, "La scultura gotica," in *Storia di Milano,* v. 5, Milan, 1955.

Scultura Gotica Lombarda, Milan, 1944.

Bartalini, Roberto, "Cinque postille su Giovanni d'Agostino," *Prospettiva,* 73–74, 1994, 49–73.

"Spazio scolpito. La novità del rilievo 'pittorico' di Giovanni d'Agostino," *Prospettiva,* 45, 1986, 19–34.

in *Scultura Dipinta, Maestri di Legname e Pittori a Siena 1250–1450* (exhibition catalogue), Florence, 1987, 56–60.

Bassi, E., "Appunti per la storia del Palazzo Ducale di Venezia," 2, *Critica d'Arte,* IX/52, 1962, 41–53.

Baxandall, Michael, *Giotto and the Orators,* Oxford, 1971.

Beani, M. Baetano, *La Pieve di S. Andrea Ap. in Pistoia,* Pistoia, 1907.

Becherucci, Luisa, "I Rilievi dei sacramenti nel campanile del duomo di Firenze, *L'Arte,* XXX, 1927, 214–23.

"La bottega pisano di Andrea da Pontedera," *Mitteilungen des Kunsthistorischen Institutes in Florenz,* XI, 1965, 227–62.

Becherucci, L., and G. Brunetti, *Il Museo dell'Opera del Duomo a Firenze,* 1, Florence, 1969.

Becker, M., *Florence in Transition,* v. 1, Baltimore, 1967.

Bellonci, Maria, "I dodici Cesari lombardi," in *I Visconti a Milano* (text by Maria Bellonci, Gian Alberto Dell' Acqua, Carlo Perogalli), Milan, 1977, 7–121.

Bellonci, Maria, Gian Alberto Dell'Acqua, and Carlo Perogalli, *I Visconti a Milano,* Cassa di Risparmio delle Provincie Lombarde, 1977.

Belloni, Gianguido, et al., *Arte Lombarda dai Visconti agli Sforza* (exhibition catalogue), Milan, 1958.

Beltrami, L., "La Capella di San Pietro Martire," *Archivio Storico dell'Arte,* V, 1892, 267–91.

"Vicende della tomba di S. Pietro Martire in Milano," *Emporium,* 14, 1901, 188–201.

Benocci, Carla, "La tomba di Guarnerio Castracani degli Antelminelli nella chiesa di S. Francesco a Sarzana: ricerche e contributi," *Rivista di archeologia, storia, costume del Istituto Storico Lucchese,* IX, 1981, 9–22.

Benton, Tim, "The design of Siena and Florence duomos," in Diana Norman, ed., *Siena, Florence and Padua: Art, Society and Religion 1280–1400,* v. 2: *Case Studies,* New Haven and London, 1995, 129–43.

Berliner, Rudolf, "Arnolfo di Cambio's Praesepe," in *Essays in Honor of Georg Swarzenski,* Berlin, 1951, 51–56.

Die Weihnachtskrippe, Munich, 1955.

"The origins of the crèche," *Gazette des Beaux Arts,* 30, 1946, 249–78.

Bertaux, Emile, *L'Art dans l'Italie Méridionale,* Paris, 1904.

"Le mausolée de l'empéreur Henri VII à Pise," in *Paul Fabre, Mélanges,* Paris, 1902, 365ff.

"Magistri Johannes et Pacius de Florentia. Marmorarii fratres," I, II, *Napoli Nobilissimia,* IV, 1895, 134–38.

Bertelli, Carlo, ed., *Il Millennio Ambrosiano. La Nuova Città dal Comune alla Signoria,* v. 3, Milan, 1989.

Bescapè, Giacomo C., and Paolo Mezzanotte, *Il Duomo di Milano,* Milan, 1965.

Bettini, Sergio, *Mosaici Antichi di S. Marco,* Bergamo, 1944.

Biasion, G. Bardotti, "Gano da Siena," in *Enciclopedia dell'Arte Medievale,* v. 7, Rome, 1995, 475–77.

Biscaro, G., "Le tombe di Ubertino e Jacopo da Carrara," *L'Arte,* II, 1899, 88–97.

Blanshei, Sarah Rubin, *Perugia, 1260–1340: Conflict and Change in a Medieval Italian Urban Society* (Transactions of the American Philosophical Society), n.s., v. 66/2, Philadelphia, 1976.

Bodmer, H., "Die skulpierten romanischen Kanzeln in der Toskana," *Belvedere,* 12 (1928), 12–14.

Bologna, Ferdinando, *I Pittori alla Corte Angioina di Napoli. 1266–1414.* Rome, 1969.

Bonelli, Renato, "La chiesa di San Domenico in Ovieto," *Palladio,* VI, 1943, 139–51.

Borgia, L., et al., eds., *Le Biccherne. Tavole Dipinte delle Magestrature Senesi (Secoli XIII–XVIII),* Rome, 1984.

Boskovits, Miklos, "La decorazione pittorica nel Cappellone di San Nicola," in *San Nicola, Tolentino, le Marche* (Convegno Internazionale di Studi), Tolentino, 1985, 245–52.

Bossaglia, Rossana, "Bonino da Campione," in *Dizionario Biografico degli Italiani,* v. 12, Rome, 1970, 224–26.

"Un tracciato geografico per l'attività dei campionesi," in Rossana Bossaglia and Gian Alberto Dell'Acqua, eds., *I Maestri Campionesi,* Lugano, 1992, 23–33.

"La scultura," in Gian Alberto Dell'Acqua, ed., *La Basilica di Sant'Eustorgio in Milano,* Milan, 1984, 93–125.

Bossaglia, Rossana, and Gian Alberto Dell'Acqua, eds., *I Maestri Campionesi,* Lugano, 1992.

Bowsky, William M., *Henry VII in Italy,* Lincoln, Nebr., 1960.

A Medieval Italian Commune. Siena under the Nine, 1287–1355, Berkeley, Los Angeles, London, 1981.

Brentano, Robert, *Rome before Avignon,* New York, 1974.

Bresciani-Alvarez, Giulio, "L'architettura e l'arredo della Cappella di S. Giacomo ora detto di S. Felice al Santo," *Il Santo*, V, no. 2, May–August 1965, 131–41.

Brock, B., and A. Preiß, eds., *Ikonographia. Anleitung zum Lesen von Bildern (Festschrift Donat de Chapeaurouge)*, Munich, 1990.

Brockhaus, O. Lehmann, *Abruzzen und Molise*, Munich, 1983.

Brown, Patricia Fortini, *Venice and Antiquity. The Venetian Sense of the Past*, New Haven and London, 1996.

Brucker, Gene, *Florentine Politics and Society 1343–1378*, Princeton, 1962.

Bruzelius, Caroline, "Ad modum Franciae, Charles of Anjou and Gothic architecture in the Kingdom of Sicily," *Journal of the Society of Architectural Historians*, L, 1991, 402–20.

"Queen Sancia of Mallorca and the Convent Church of Sta. Chiara," *Memoires of the American Academy in Rome*, XL, 1995, 69–100.

Burresi, Mariagiulia, *Andrea, Nino e Tommaso. Scultori Pisani*, Pisa, 1983.

Restauro di Sculture Lignee nel Museo di S. Matteo, Pisa, 1984.

Santa Maria della Spina in Pisa, Milan, 1990.

Cadei, Antonio, "I capitelli più antichi del Duomo di Milano," *Il Duomo di Milano* (Acts of Congress, I), Milan, 1969.

Caglianmone, R., and A. Iazeolla, "Note sur relievo della statua bronzea di San Pietro nella Basilica Vaticana," *Arte Medievale*, s. II., IV/2, 1990, 65–71.

Caleca, Antonio, *La Dotta Mano. Il Battistero di Pisa*, Bergamo, 1991.

Calkins, Robert G., *Monuments of Medieval Art*, New York, 1975.

Calvi, Donato, *Effemeride Sagro Profana di Quanto di Memorabile Sia Successo in Bergamo*, v. 3, Milan, 1677 (republished Bologna, 1974).

Carelli, Ersilia, and Stella Casiello, *Santa Maria Donnaregina in Napoli*, Naples, 1975.

Carli, Enzo, *Arnolfo di Cambio*, Florence, 1993.

Arte Senese e Arte Pisana, Turin, 1996.

"Giovanni di Balduccio a Milano," in Carlo Bertelli, ed., *Il millennio Ambrosiano*, v. 3, Milan, 1989, 70–103.

Giovanni Pisano, Pisa, 1977.

Giovanni Pisano. Il pulpito di Pistoia, Milan, 1986.

Gli Scultori Senesi, Milan, 1980.

Goro di Gregorio, Florence, 1946.

"Il Duomo come architettura e scultura," in Guido Barlozzetti, ed., *Il Duomo di Orvieto e le Grandi Cattedrali del Duecento* (Atti del Convegno Internazionale di Studi, Orvieto, 12–14 November 1990), Turin, 1995, 27–51.

Il Duomo di Siena, Siena, 1979.

Il Museo di Pisa, Pisa, 1974.

Il Pulpito di Siena, Bergamo, Milan, Rome, 1943.

in Guglielmo De Angelis d'Ossat, ed., *Il Museo dell'Opera del Duomo a Pisa*, Milan, 1986, 95–101.

L'Arte nella Basilica di S. Francesco a Siena, Siena, 1971.

La Scultura Lignea Italiana, Milan, 1960.

"Per la scultura lignea del trecento in Abruzzo," *Le Arti*, III, 1941, 435–43.

Sculture del Duomo di Siena, Turin, 1941.

"Sculture pisane di Giovanni di Balduccio," *Emporium*, XCVII, 1943, 143ff.

"Un tabernacolo trecentesco e altre questioni di scultura pisano," *La Critica d'Arte*, XIII, February 1938, 16–22.

Carlotto, Natascia L., "Pietro 'Nan' da Marano: Ritratto di un cortigiano scaligero," in Gian Maria Varanini, ed., *Gli Scaligeri 1277–1387* (exhibition catalogue), Verona, 1988, 143–48.

Carocci, Guido, "I pulpiti del medioevo e del Rinascimento in Toscana," *Arte Italiana Decorative e Industriale*, v. 10, 1901.

Carrington, Jill Emilee, "Sculpted Tombs of the Professors of the University of Padua, c. 1358–c. 1557," Syracuse University, 1996.

Cassidy, Brendan, "The financing of the Tabernacle of Orsanmichele," *Source. Notes in the History of Art*, VIII/1, 1988, 1–6.

"Orcagna's Tabernacle in Florence: Design and function," *Zeitschrift für Kunstgeschichte*, 61/2, 1992, 180–211.

Castelnuovo, Enrico, ed., *Niveo de Marmore. L'Uso Artistico del Marmo di Carrara dall'XI al XV Secolo*, Genoa, 1992.

Causa, R., "Precisione relativa alla scultura del '300 a Napoli," in *Scultura Lignea nella Campania*, Naples, 1950, 63–73.

Cavallucci, Francesco, *La Fontana Maggiore di Perugia*, Perugia, 1993.

Cecchelli, C. *Catalogo delle Cose d'Arte e di Antichità d'Italia*, Rome, 1932.

Cellini, P., "Appunti orvietani per Andrea e Nino Pisano," *Rivista d'Arte*, XV, 1933, 1–20.

Charcot, J. M., and P. Richer, *Les Difformes et les Malades dans l'Art*, Paris, 1889 (reprinted, Amsterdam, 1972).

Cherry, John, *Medieval Craftsmen. Goldsmiths*, Toronto, Buffalo, 1992.

Christian, Karen, "Arnolfo di Cambio's Sculptural Project for the Duomo Facade in Florence: A Study in Style and Context," Ph.D. dissertation, New York University, 1989.

Cimino, Lea, et al., eds., *Casole d'Elsa e il suo Territorio*, Radda in Chianti, 1988.

Cipriani, Angelica, and Enrico Valeriani, *I Disegni di Figura nell'Archivio Storico dell'Accademia di San Luca*, 3 vols., Rome, 1988–1991.

Claussen, Peter C., *Magistri Doctissimi Romani. Die Römischen Marmorkünstler des Mittelalters*, Stuttgart, 1987.

Cohn, Samuel K., Jr., *The Cult of Remembrance and the Black Death. Six Renaissance Cities in Central Italy*, Baltimore and London, 1992.

Cole, Bruce, "Some thoughts on Orcagna and the Black Death style," *Antichità Viva*, XXII/2, 27–37.

Connell, Susan, *The Employment of Sculptors and Stonemasons in Venice in the Fifteenth Century*, New York and London, 1988 (thesis, Warburg Institute, 1976).

Courcelle, Jeanne, and Pierre Courcelle, *Iconographie de Saint Augustin: Les Cycles du XIVe Siècle*, Paris, 1965.

Crichton, George H., *Romanesque sculpture in Italy*, London, 1954.

Crichton, G. H., and E. R. Crichton, *Nicola Pisano and the Revival of Sculpture in Italy*, Cambridge, 1938.

Cristiani, Maria Laura Testi, *Nicola Pisano architetto scultore*, Pisa, 1987.

Cristofori, Francesco, *Le Tombe dei Papi in Viterbo*, Siena, 1887.

Cuccini, Gustavo, *Arnolfo di Cambio e la Fontana di Perugia "Pedis Platee,"* Perugia, 1989.

Cuppini, L., "Il caposcuola della scultura veronese al tempo di Dante e di Cangrande," *Annuario del Liceo Ginnasio S. Maffei di Verona*, Verona, 1965.

Cuppini, Maria Teresa, "L'Arte Gotica a Verona nei secolo XIV–XV," *Verona e il suo Territorio*, v. III/2, Verona, 1969, 213–366.

Cutler, Anthony, *The Craft of Ivory. Sources, Techniques, and Uses in the Mediterranean World: A.D. 200–1400*, Washington, D.C., 1985.

The Hand of the Master. Craftsmanship, Ivory, and Society in Byzantium (9th–11th Centuries), Princeton, 1994.

D'Achille, Anna Maria, "Ciborio," in *Enciclopedia dell'Arte Medievale*, v. 4, Rome, 1993, 718–35.

"Sulla datazione del monumento funebre di Clemente IV a Viterbo: Un riesame delle fonti," *Arte Medievale*, 1989, 85–89.

"La Scultura," in Angiola Maria Romanini, ed., *Roma nel Duecento. L'arte nella Città dei Papi da Innocenzo III a Bonifacio VIII*, Turin, 1991, 145–235.

"Il monumento funebre di Clement IV in S. Francesco a Viterbo," *Skulptur und Grabmal des Spätmittelalters in Rom und Italien*, Vienna, 1990, 129–42.

Dan, Naoki, "Intorno alla tomba d'Orso di Tino di Camaino," *Annuario dell'Istituto Giapponese di Cultura*, XIV, 1977–78, 3–60.

La Tomba di Arrigo VII di Tino di Camaino e il Rinascimento, Florence, 1982.

"Riconsiderazioni sul periodo pisano di Tino di Camaino," *Annuario dell'Istituto Giapponese di Cultura in Roma*, 9, 1983–84, 7–58.

"Ricostruzione della tomba di Arrigo VII di Tino di Camaino," *Michelangelo*, XXII, 1977, 24–37.

Dante, "Letter V," quoted in W. M. Bowsky, *Henry VII in Italy*, Lincoln, Nebr., 1960, 50.

d'Arcais, Francesca, "La decorazione della Cappella di San Giacomo," in Camillo Semenzato, ed., *Le Pitture del Santo di Padova*, Vicenza, 1984, 15–42.

d'Arcais, F. Flores, "Altichiero," in *Enciclopedia dell'Arte Medievale*, v. 1, Rome, 1991, 458–63.

de Castris, Pierluigi Leone, *Arte di Corte nella Napoli Angioina*, Florence, 1986.

"Napoli 'capitale' del gotico europeo: Il referto dei documenti e quello delle opere sotto il regno di Carlo I e Carlo II d'Angiò," in Valentino Pace and Martina Bagnoli, eds., *Il Gotico Europeo in Italia*, Naples, 1994, 239–64.

Deér, Josef, *The Dynastic Porphyry Tombs of the Norman Period in Sicily*, Cambridge, Mass., 1959.

de Francovich, Geza, *Benedetto Antelami*, Milan, Florence, 1952.

"L'origine e la diffusione del crocifisso gotico dolorosa," *Kunstgeschichtliches Jahrbuch der Biblioteca Hertziana*, II, 1938, 143–261.

d'Elia, Pina Belli, "La facciata e il portale della cattedrale di Altamura. Riletture e riflessioni," in *"Altamura" – Rivista Storica Bollettino dell'Archivio – Biblioteca – Museo Civico*, n. 33/34, 1991–92, 19–47.

Dell'Acqua, Gian Alberto, *Embriachi. Il trittico di Pavia*, Milan, 1982.

"Introduzione," in *Arte Lombarda dai Visconti agli Sforza*, Milan, 1959.

"Fortuna critica dei maestri Campionesi," in Rossana Bossaglia and Gian Alberto Dell'Acqua, eds., *I Maestri Campionesi*, Lugano, 1992, 9–21.

Dell'Acqua, Gian Alberto, ed., *La Basilica di Sant'Eustorgio in Milano*, Milan, 1984.

Dell'Aja, P. Gaudenzio, *Il Restauro della Basilica di Santa Chiara in Napoli*, Naples, 1980.

Del Moro, Luigi, *La Facciata del Duomo di Firenze*, Florence, 1888.

Del Vita, Alessandro, "L'Altar maggiore del duomo d'Arezzo," *Rassegna d'Arte*, XI/8, 1911, 127–40.

De Maffei, Fernanda, "Il Maestro di S. Anastasia a Verona," *Commentari*, IV/3, July–September 1953.

Le Arche Scaligere di Verona, Verona, 1955.

Demus, Otto, *Le Sculture Esterne di San Marco*, Milan, 1995 (catalogue by Guido Tigler).

The Church of San Marco in Venice, Washington, D.C., 1960.

De Rinaldis, Aldo, *Naples Angevine*, Paris, n.d. passim.

Santa Chiara, Naples, 1920.

De Sanctis, M. L., "Alberto di Arnoldo," *Enciclopedia dell'Arte Medievale*, v. 1, Rome, 1991, 318–20.

De Vere, Gaston du C., trans., Lives of the Most Eminent Painters, Sculptors and Architects by Giorgio Vasari, London, 1912–14.

Devisse, J., and M. Mollat, *The Image of the Black in Western Art*, v. 2, *From the Early Christian Era to the "Age of Discovery,"* Cambridge, Mass., 1979.

Diario di Roma, num. XX, Roma, sabato 12 marzo, 1825.

Di Candida, Antonio Filangieri, *La Chiesa ed il Convento di S. Giovanni a Carbonara*, Naples, 1924.

Di Fabio, Clario, "Il cantiere duecentesco della cattedrale," in Enrico Castelnuovo, ed., *Il Niveo de Marmore*, Genoa, 1992, 181–89.

"*Depositum cum statua decumbente*. Recherches sur Giovanni Pisano à Gênes et le monument de Marguerite de Brabant," *Revue de l'Art*, n. 123/1999-1, 13–26.

d'Ossat, Guglielmo De Angelis, ed., *Il Museo dell'Opera del Duomo a Pisa*, Milan, 1986.

Di Fronzo, Maria, "I modelli degli 'Assetati' di Arnolfo di. Cambio," *Arte Medievale*, III/2, 1989, 93–113.

Dini, Giulietta Chelazzi, *Pacio e Giovanni da Firenze e la Bottega Napolitana di Tino di Camaino*, Prato, 1996.

Dixon, Harry Mayfield, II, "Arnolfo di Cambio: Sculpture," Ph.D. dissertation, SUNY Binghamton, 1977, 149–58.

Donnini, Giampiero, "Una bottega lignea fabrianese del secondo '300," in Giampiero Donnini, ed., *I Legni Devoti*, Fabriano, 1994, 38–45.

Dürig, W., *Il Duomo di Milano. Dizionario storico artistic e religioso*, Milan, 1986.

Imago, ein Beitrag zur Terminologie und Theologie der Römischen Liturgie, Munich, 1952.

Edwards, Mary D., "The Chapel of S. Felice in Padua as Gesamtkunstwerk," *Journal of the Society of Architectural Historians*, 47/2, June 1988, 160–76.

"The tomb of Raimondino de' Lupi and its setting," *Rutgers Art Review*, II, January 1982, 37–49.

Enderlein, Lorenz, *Die Grablegen des Hauses Anjou in Unteritalien. Totenkult und Monumente 1266–1343*, Worms, 1997.

Fabbri, Nancy Rash, and Nina Rutenburg, "The Tabernacle of Orsanmichele in context," *Art Bulletin*, 63, 1981, 385–405.

Fabiano, S., "Bertini," in *Enciclopedia dell'Arte medievale*, v. 3, Rome, 1992, 441–44.

Faldi, Italo, *Galleria Borghese. Le Sculture dal Secolo XVI al XIX*, Rome, 1954.

Fascetti, Antonio, "Ipotesi di ricostruzione del pergamo gotico della chiesa di San Michele in Borgo a Pisa," *Commentari*, XXIX, 1978, 169–74.

Fasola, Giusta Nico, "Gli inizi della Fontana di Perugia," *Studi Medieval*, 17, 1951, 124–30.

La Fontana di Perugia, Rome, 1951.

Nicola Pisano, Rome, 1941.

Federico II e l'Antico (Atti del Convegno – Foggia 30 Marzo 1995), Foggia, 1997.

Federico II e l'Italia, Rome, 1995.

Ferretti, Massimo, *Rappresentazione dei Magi. Il Gruppo Ligneo di S. Stefano e Simone dei Crociffissi* (exhibition catalogue), Bologna, 1981.

Filippini, Francesco, "L'antico altare maggiore in S. Domenico attribuito a Giovanni Pisano," *Commune di Bologna*, XIII/4, 1935, 19–23.

Fiorio, Maria Teresa, "Una scultura Campionese trascurata: La 'Madonna Litta,'" *Paragone*, 457, March 1988, 3–14.

"Uno scultore Campionese a Porta Nuova," in *La Porta Nuova delle Mura Medievali di Milano*, Milan, 1991, 107–28.

Forcellini, A., "Del restauro delle principali facciate del Palazzo Ducale di Venezia," in *L'Ingegneria a Venezia dell'Ultimo Ventennio, Pubblicazione degli Ingegneri Veneziani in Omaggio ai Colleghi del VI Congresso*, Venice, 1887, 4–21.

Forsyth, Ilene H., *The Throne of Wisdom*, Princeton, 1972.

Fraschetti, Stanislao, "I sarcofagi dei reali Angioini in S. Chiara di Napoli," *L'Arte*, I, 1898, 385–438.

Frey, Karl, *Die Loggia dei Lanzi zu Florenz*, Berlin, 1885.

in Ulrich Thieme and Felix Becker, *Allgemeines Lexikon der bildenden Künstler von der Antike bis zur Gegenwart*, v. 2, Leipzig, 1908, 135–44.

Frugoni, Chiara, ed., *Benedetto Antelami e il Battistero di Parma*, Turin, 1995.

Fumi, L., *Il Duomo di Orvieto e i suoi Restauri*, Rome, 1891.

Gai, Lucia, *L'Altare Argenteo di San Jacopo nel Duomo di Pistoia. Contributo alla Storia dell'Oreficeria Gotica e Rinascimentale Italiana*, Turin, 1984.

Gallo, Rodolfo, "Contributi alla storia della scultura veneziana, I. Andreolo de Santi," *Archivio Veneto*, s. 5, XLIV–XLV, 1949, 1–40.

Gardner, Julian, "Arnolfo di Cambio and Roman tomb design," *Burlington Magazine*, CXV, 1973, 420–39.

"Boniface VIII as Patron of Sculpture," in Angiola Maria Romanini, ed., *Roma Anno 1300*, Rome, 1983, 513–21.

"Il patrocinio curiale e l'introduzione del gotico: 1260–1305," in Valentino Pace and Martina Bagnoli, eds., *Il Gotico Europeo in Italia*, Naples, 1994, 85–88.

"A Princess among prelates: A fourteenth-century Neapolitan tomb and some northern relations," *Römisches Jahrbuch für Kunstgeschichte*, XXIII–XXIV, 1988, 31–60.

"San Paolo fuori le mura, Nicholas III and Pietro Cavallini," *Zeitschrift für Kunstgeschichte*, XXXIV, 1971, 240–48.

The Tomb and the Tiara. Curial Tomb Sculpture in Rome and Avignon in the Later Middle Ages, Oxford, 1992.

Garms, Jörg, "Gräber von Heiligen und Seligen," in *Skulptur und Grabmal des Spätmittelalters in Rom und Italien*, Vienna, 1990, 83–105.

Garzelli, A. R., *Sculture Toscane nel Dugento e nel Trecento*, Florence, 1969.

Ghiberti, *Commentari*, ed. O. Morisani, Naples, 1947.

Giglioli, A., "Il Duomo di Ferrara nella storia dell'arte," in *La Cattedrale di Ferrara. Nella Ricorrenza delle Manifestazioni Celebrative del VIII Centenario della Cattedrale. 1135–1935*, s.l. v. 1, Verona, 1937.

Giles, Kathleen, "The Strozzi Chapel in Santa Maria Novella: Florentine Painting and Patronage 1340–55," Ph.D. dissertation, New York University, 1977.

Gillerman, David, "The evolution of the design of Orvieto Cathedral, ca. 1290–1310," *Journal of the Society of Architectural Historians*, LIII, September 1994, 300–321.

"La facciata: Introduzione al rapporto tra scultura e architettura," in Lucio Riccetti, ed., *Il Duomo di Orvieto*, Bari, 1988, 81–100.

Gillerman, Dorothy, ed. *Census of Gothic Sculpture in America. The New England Museums*, New York and London, 1989.

Census of Gothic Sculpture in America. II. Midwest Collections, New York and London, in press.

Glass, Dorothy, *Portals, Pilgrimage and Crusade in Western Tuscany*, Princeton, 1997.

Glasser, Hannelore, *Artists' Contracts of the Early Renaissance*, New York, 1977.

Gnudi, Cesare, "Il reliquiario di San Luigi Re di Francia in S. Domenico a Bologna," Critica d'Arte, n.s., III, 1956, 535–39.

in Angiola Maria Romanini, ed., *Frederico II e l'Arte del Duecento Italiana*, Galatina, 1980, 1–17.

"Jacobello e Pierpaolo da Venezia," *La Critica d'Arte*, II, 1937, 26–38.

Nicola, Arnolfo, Lapo. L'Arca di San Domenico a Bologna, Florence, 1948.

"Relations between French and Italian sculpture of the Gothic period," in *Romanesque and Gothic Art* (Acts of the 20th International Congress of the History of Art, v. 1), Princeton, 1963, 161–67.

Goerke, W. Cohn, "Giovanni d'Agostino," *Burlington Magazine,* LXXV, November 1939, 180–94.

Goldthwaite, Richard, *The Building of Renaissance Florence. An Economic and Social History,* Baltimore and London, 1980.

Wealth and the Demand for Art in Italy 1300–1600, Baltimore and London, 1993.

Gomez-Moreno, Carmen, "The doorway of San Leonardo al Frigido and the problem of master Biduino," *Bulletin of the Metropolitan Museum,* XXIII, 1964–65, 349–61.

Götz, Adriani, *Der Mittelalterliche Predigtort und seine Ausgestaltung,* Stuttgart, 1966 (Ph.D. dissertation, University of Tübingen).

Grandi, Renzo, *I Monumenti dei Dottori e la Scultura a Bologna, 1267–1348,* Bologna, 1982.

Green, Louis, *Castruccio Castracani. A Study on the Origins and Character of a Fourteenth-Century Italian Despotism,* Oxford, 1986.

"Galvano Fiamma, Azzone Visconti and the revival of classical theory of magnificence," *Journal of the Warburg and Courtauld Institutes,* LIII, 1990, 98–113.

Grimaldi, Giacomo, *Descrizione della Basilica Antica di S. Pietro in Vaticano Codice Barberini Latino 1733,* ed. R. Niggl (Codices Vaticanis Selecti, 32), Vatican City, 1972.

Grossato, L., ed., *Da Giotto al Mantegna* (exhibition catalogue, Padua), Milan, 1974.

Guasti, Cesare, *Santa Maria del Fiore. La Costruzione della Chiesa e del Campanile Secondo I Documenti,* Florence, 1887.

Gurrieri, Ottorino, *Il Palazzo dei Priori di Perugia,* Perugia, 1985.

Häger, Helmut, *Die Anfänge des Italienischen Altarbildes,* Munich, 1962.

Harrison, Elisa W., "A Study of Political Iconography on Six Italian Tombs of the 14th Century," Ph.D. dissertation, Northwestern University, 1988.

Hartt, Frederick, *Italian Renaissance Art,* 3rd ed., Englewood Cliffs, N.J., 1987.

Michelangelo Drawings, New York, 1969.

Haskins, Charles Homer, *Studies in the History of Mediaeval Science,* New York, 1927 (reprinted 1967).

Haussherr, R., "Triumphkreuzgruppen der Stauferzeit," *Die Zeit der Staufer,* v. 5, Stuttgart, 1977, 131–68.

Hearn, M. F., *Romanesque Sculpture,* Ithaca, 1981.

Herklotz, Ingo, "Grabmalstiftungen und städtische Öffentlichkeit im spätmittelalterlichen Italien," in *Materielle Kultur und Religiöse Stiftung im Spätmittelalter* (Internationales Round-Table-Gespräch. Krems an der Donau, 26 September 1988), Vienna, 1990, 233–71.

"*Sepulcra" e "Monumenta" del Medioevo,* Rome, 1985.

Herlihy, David, *Medieval and Renaissance Pistoia. The Social History of an Italian Town, 1200–1430,* New Haven and London, 1967.

Pisa in the Early Renaissance. A Study of Urban Growth, New Haven, 1958 (reprinted Port Washington, New York, and London, 1973).

Herzner, Volker, "Giottos Grabmal für Enrico Scrovegni," *Münchner Jahrbuch für bildenden Kunst,* XXXIII, 1982, 39–66.

"Herrscherbild oder Grabfigure? Die Statue eines thronenden Kaisers und das Grabmal Heinriches VII. von Tino di Camaino," in B. Brock and A. Preiß, eds., *Ikonographia. Anleitung zum Lesen von Bildern (Festschrift Donat de Chapeuarouge),* Munich, 1990, 27–77.

Hetherington, Paul, *Pietro Cavallini. A Study in the Art of Late Medieval Rome,* London, 1979.

Heusinger, Lutz, *Jacobello und Piero Paolo dalle Masegna,* Munich, 1967.

Hoffmann-Curtis, Kathrin, *Das Programm der Fontana Maggiore in Perugia,* Düsseldorf, 1968.

Hoving, Thomas, "Italian Romanesque sculpture," *Bulletin of the Metropolitan Museum,* XXIII, June 1965, 345–48.

Howard, Deborah, *The Architectural History of Venice,* New York, 1981.

Hueck, Irene, "Ugolino di Vieri e Viva di Lando," in *Il Gotico a Siena* (exhibition catalogue, 24 July–30 October 1982, Siena, Palazzo Pubblico), Florence, 1982, 190–95.

Humpfrey, Peter, *The Altarpiece in Renaissance Venice,* New Haven and London, 1993.

Huse, Herbert, "Uber ein Hauptwerk der venezianischen Plastik um 13. Jahrhundert," *Pantheon,* XXVI, 1968, 95–103.

Hyde, J. K., *Padua in the Age of Dante,* New York, 1966.

Society and Politics in Medieval Italy, New York, 1973.

Jackson, Harry, *Lost Wax Bronze Casting,* Flagstaff, Ariz., 1972.

Janson, H. W., *The Sculpture of Donatello,* Princeton, 1964.

Janson-La Palme, Robert J. H., "Taddeo Gaddi's Baroncelli Chapel: Studies in Design and Content," Ph.D. dissertation, Princeton University, 1975.

Jászai, Geza, *Die Pisaner Domkanzel,* Munich, 1968.

"Giovanni Pisano," in *Enciclopedia dell'Arte Medievale,* v. 6, Rome, 1995, 740–54.

Jungmann, J. A., *The Mass of the Roman Rite,* v. 1, New York, 1951.

Missarum Sollemnia, v. 1, Vienna, Freiburg, Basel, 1962.

Kantoriwicz, E., *Kaiser Friedrick II,* Berlin, 1927.

The King's Two Bodies: A Study in Medieval Political Thought, Princeton, 1957.

Keller, Harald, "Die Bauplastik des Sieneser Doms," *Kunstgeschichtliches Jahrbuch der Biblioteca Hertziana,* I, 1937, 139–220.

Giovanni Pisano, Vienna, 1942.

Kieckhefer, Richard, "Major currents in late medieval devotion," in Jill Raitt, ed., *Christian Spirituality. High Middle Ages and Reformation,* New York, 1987.

Kieslinger, Franz, "Le transenne della basilica di San Marco del secolo XIII," *Ateneo veneto,* CXXXI, 1944, 57ff.

Kirsch, Edith W., *Five Illuminated Manuscripts of Giangaleazzo Visconti*, Penn State Press, 1991.

Kölzer, Theo, ed., *Die Staufer im Süden. Sizilien und das Reich*, Sigmaringen, 1996.

Kosegarten, Antje Middeldorf, "Beiträge zur Sienesischen Reliefkunst des Trecento," Mitteilungen des Kunsthistorischen Institutes in Florenz, XIII, 1965–66, 206–24.

Die Domfassade in Orvieto. Studien zur Architektur und Skulptur 1290–1330, Munich, Berlin, 1996.

"Die Skulpturen der Pisani am Baptisterium von Pisa," *Jahrbuch der Berliner Museen*, X, 1968, 14–100.

"Einige sienesische Darstellungen der Muttergottes aus dem frühen Trecento," *Jahrbuch der Berliner Museen*, VIII, 1966, 96–118.

"Grabmäler von Ghibellinen aus dem frühen Trecento," in J. Garms and G. M. Romanini, eds., *Skulptur und Grabmal des Spätmittelalters in Rom und Italien*, Vienna, 1990, 317–29.

"Nicola und Giovanni Pisano 1268–78," *Jahrbuch der Berliner Museen*, XI, 1969, 36–80.

Sienesische Bildhauer am Duomo Vecchio. Studien zur Skulptur in Siena 1250–1330, Munich, 1984.

Krautheimer, Richard, "Introduction to an 'iconography of medieval architecture'," *Journal of the Warburg and Courtauld Institutes*, V, 1942, 1–33.

"Zur venezianischen Trecentoplastik," *Marburger Jahrbuch für Kunstwissenschaft*, V, 1929, 193–212.

Kreytenberg, Gert, "Alberto Arnoldi e i rilievi della Loggia del Bigallo a Firenze," *Prospettiva*, 11, October 1977, 27–33.

"Andrea di Cione," in *Enciclopedia dell'Arte Medievale*, v. 1, Rome, 1991, 602–8.

Andrea Pisano und die Toskanische Skulptur des Vierzehnten Jahrhunderts, Munich, 1984.

"Das Grabmal von Kaiser Heinrich VII in Pisa," *Mitteilungen des Kunsthistorischen Institutes in Florenz*, XXVIII, 1984, 33–64.

"Das Marmorbildwerk der Fundatrix Ettalensis und die pisaner Skulptur zur Zeit Ludwigs des Bayern," in *Wittelback und Bayern, I, 1. Die Zeit der frühen Herzöge. Beiträge zur bayerischen Geschichte und Kunst 1180–1350*, Munich, 1984.

"Der Campanile von Giotto," *Mitteilungen des Kunsthistorischen Institutes in Florenz*, XXII, 1978, 147–84.

Der Dom zu Florenz. Untersuchungen des Baugeschichte im 14. Jahrhundert, Berlin, 1974.

"Drei gotische Grabmonumente von Heiligen in Volterra," *Mitteilungen des Kunsthistorischen Institutes in Florenz*, XXXIV, 1990, 69–100.

"Fragments of an altar of St. Bartholomew by Tino di Camaino in Pisa Cathedral," *Burlington Magazine*, CXXIV, 1982, 349ff.

"Giovanni Pisano oder Tino di Camaino?" *Jahrbuch der Berliner Museen*, XX, 1978, 291–38.

"Image and Frame," *Burlington Magazine*, CXXXIV, 1992, 634–38.

Orcagna's Tabernacle in Orsanmichele, Florence, New York, 1994.

"The sculpture of Maso di Banco," *Burlington Magazine*, CXXI, 1979, 72–76.

Tino di Camaino, Florence, 1986.

"Tino di Camainos Grabmäler in Firenze," *Städel Jahrbuch*, VII, 1979, 33–60.

"Tino di Camainos Statuengruppen von den drei Portalen des florentiner Baptisteriums," *Pantheon*, LV, 1997, 4–12.

"Un crocifisso sconosciuto di Andrea di Nino Pisano," *Antichità Viva*, XXVIII/2–3, 1989, 73–79.

Kristeller, Paul Oskar, *Renaissance Thought and Its Sources*, New York, 1979.

Kruft, H. W., "Die Madonna von Trapani und ihre Kopien. Studien zur Madonnen-Typologie und zum Begriff der Kopie in der Sizilianischen Skulptur des Quattrocento," *Mitteilungen des Kunsthistorischen Institutes in Florenz* XIV, 1969–70, 297–332.

Ladis, Andrew, *Taddeo Gaddi*, Columbia, Mo., and London, 1982.

Ladner, Gerhard, *Die Papstbildnesse des Altertums und des Mittelalters*. II, Vatican City, 1970.

Lanciani, R., *Storia degli Scavi di Roma*, 4 vols., Rome, 1902–12.

Lanyi, J., "L'ultima opera di Andrea Pisano," *L'Arte*, XXXVI, 1933, 204–227.

Larner, John, *Culture and Society in Italy, 1290–1420*, New York, 1971.

Italy in the Age of Dante and Petrarch 1216–1380, London and New York, 1988.

Leff, Gordon, *The Dissolution of the Medieval Outlook. An Essay on Intellectual and Spiritual Change in the Fourteenth Century*, New York, 1976.

Lisner, Magrit, *Holzkruzifixe in Florenz und in der Toskana von der Zeit um 1300 bis zum frühen Cinquecento*, Munich, 1970.

Litta, P., "Scaligeri di Verona," in *Famiglie Celebri Italiane*, XIV, parts I and II, Milan, 1824.

Locatelli, Pasino, *Illustri Bergamaschi. Studi Critico-biografici*, v. 3 (intarsiatori, architetti e scultori), Bergamo, 1879.

Long, Jane, in "Salvation through meditation: The tomb frescoes in the Holy Confessors Chapel at Santa Croce in Florence," *Gesta*, XXXIV/1, 1995, 77–88.

Longhi, Roberto, "Introduzione," in *Arte Lombarda dai Visconti agli Sforza* (exhibition catalogue), Milan, 1958.

Lorenzoni, Giovanni, ed., *Le Sculture del Santo di Padova*, Vicenza, 1984.

Luchinat, Cristina Acidini, ed., *La Cattedrale di Santa Maria del Fiore a Firenze*, 2, Florence, 1995.

Lumachi, Franco, *Guida di Sancasciano Val di Pesa*, Milan, n.d. (1959?).

Lusanna, Enrica Neri, "Il gruppo ligneo della Natività di S. Nicola a Toletino e la scultura marchigiana," in *Arte e Spiritualità degli Ordini Mendicanti* (Acts of Congress), Tolentino, 1992, 105–24.

"Invenzione e replica nella scultura del Trecento: Il Maestro dei Magi di Fabriano," in *Studi di Storia dell'Arte*, 3, 1992, 45–66.

"La decorazione e le sculture arnolfiane dell'antica facciata," in Cristina Acidini Luchinat, ed., *La Cattedrale di Santa Maria del Fiore a Firenze*, v. 2, Florence, 1995, 31–72.

"Per la scultura marchigiana del '300. Il Maestro dei Magi di Fabriano e il Maestro della Madonna di Campodonico," in Giampiero Donnini, ed., *I Legni Devoti*, Fabriano, 1994, 26–37.

Lusanna, Enrica Neri, and Lucia Gaedo, eds., *Il Museo Bardini a Firenze*, Milan, 1986.

Maccarrone, Michele, "Il seppolcro di Bonifacio VIII nella Basilica Vaticana," in Angiola Maria Romanini, ed., *Roma Anno 1300*, Rome, 1983, 753–71.

Magagnato, Licisco, *Arte e Civiltà a Verona*, ed. Sergio Marinelli and Paola Marini, Vicenza, 1991.

Magagnato, Licisco, "La città e le arti a Verona al tempo di Dante," *Dante e la Cultura Veneta*, Florence, 1966, 285–97.

Maiocchi, R., *L'Arca di Sant'Agostino in S. Pietro in Ciel d'Oro*, Pavia, 1900.

Mâle, E., *The Gothic Image. Religious Art in France of the Thirteenth Century*, trans. D. Nussey, New York, Evanston, London, 1958.

Manselli, R., "Cangrande e il mondo ghibellino nell'Italia settentrionale alla venuta di Arrigo VII," in *Dante e la cultura Veneta*, Florence, 1966.

Mantese, Giovanni, *Memorie Storiche della Chiesa Vicentina*, v. 3, pt. 1, "Il Trecento," Vicenza, 1958, 604–6.

Marchini, Giuseppe, "L'Altare argenteo di S. Iacopo e l'Oreficeria gotica a Pistoia," in *Il Gotico a Pistoia nei suoi Rapporti con l'Arte Gotica Italiana* (Atti del 2 convegno internazionale di studi), Pistoia, 1966, 135–47.

Mariani, Valerio, *Arnolfo e il Gotico Italiano*, Naples, 1967.

Marocchi, G., *Dettaglio del Terribile Incendio Accaduto il di' 15 Luglio 1823 nella Famosa Basilica di S. Paolo di Roma*, Rome, 1823.

Martellotti, Giovanna, "Il Carlo d'Angiò Capitolino. Riflessioni dopo il restauro," *Arte Medievale*, II Serie, Anno V, n. 2, 1991, 127–47.

Martindale, Andrew, "The 'Pelican' Early Italian Art," *Burlington Magazine*, CIX, September 1967, 538–42.

Martines, Lauro, *Power and Imagination. City-States in Renaissance Italy*, New York, 1979.

Martini, Carlo, "Il Palazzo die Priori a Perugia," *Palladio*, XX, 1970, 39–72.

Martini, Luciana, "Alcune osservazione sulla produzione di confanetti 'embriacheschi' e sulla loro storiografia," in *Oggetti in Avorio e Osso nel Museo Nazionale di Ravenna, Sec. XV–XIX*, L. Martini, ed., Ravenna, 1993.

McColl, Donald Alexander, "Christ and the Woman of Samaria. Studies in Art and Piety in the Age of the Reformation," Ph.D. dissertation, University of Virginia, May 1996.

McHam, Sarah Blake, *The Chapel of St. Anthony at the Santo and the Development of Venetian Renaissance Sculpture*, Cambridge, 1994.

Medica, Massimo, "Giovanni di Balduccio *Natività*," *Ospiti*, 3, Bologna, 1996.

"Un San Domenico per l'altare bolognese di Giovanni di Balduccio," in *Arte a Bologna*, v. 1, 1990, 11–20.

Meiss, Millard, "The Madonna of Humility," *Art Bulletin*, XVIII, 1936, 435–64.

Painting in Florence and Siena after the Black Death, Princeton, 1951.

Mellini, Gian Lorenzo, *Altichiero e Jacopo Avanzi*, Milan, 1965.

"L'Arca di Cansignorio di Bonino da Campione a Verona," in Rossana Bossaglia and Gian Alberto Dell'Acqua, eds., *I Maestri Campionesi*, Lugano, 1992, 173–97.

"Problemi di storiografia artistica tra Tre e Quattrocento, I: gli scultori veronesi," *Labyrinthos*, I–XII, 21/24, 1992–93, 9–99.

Scultori Veronesi del Trecento, Milan, 1971.

"Verona e l'oriente in epoca gotica," in *Le stoffe di Cangrande*, Licisco Magagnato, ed., Florence, 1983, 49–71.

Mellinkoff, Ruth, *Outcasts: Signs of Otherness in Northern European Art of the Late Middle Ages*, 2 vols., Berkeley, Los Angeles, Oxford, 1993.

Mercalli, M., in M. Fagiolo and M. L. Madonna, eds., *Roma 1300–1875. La Città degli Anni Santi. Atlante*, Rome, 1985.

Merlini, Elena, "Il trittico eburnea della Certosa di Pavia: Iconografia e committenza. Parte I," *Arte Cristiana*, LXXIII, 1985, 369–84; Parte II, LXXIV, 1986, 139–54.

Merzario, Giuseppe, *I Maestri Comacini*, Milan, 1893.

Metz, Peter, "Die florentiner Domfassade des Arnolfo di Cambio," *Jahrbuch der preuszischen Kunstsammlungen*, 95, 1938, 121–160.

Meyer, Alfred Gotthold, *Lombardische Denkmäler des vierzehnten Jahrhunderts*, Stuttgart, 1893.

Middeldorf, Ulrich, and Martin Weinberger, "Französische Figuren des Frühen 14. Jahrhunderts in Toskana," *Pantheon*, I, 1928, 187–90.

Milanesi, Gaetano, *Documenti per la storia dell'Arte Senese*, Siena, *1854*.

ed., *Le Vite de' Più Eccellenti Pittori, Scultori ed Architettori, Scritte di Giorgio Vasari*, v. 1, Florence, 1878.

Miner, Barbara J., P. T. Van Nuis, and Cornelis Van Nuis, M.D., "Letter to the Editor," *Source. Notes in the History of Art*, XVII/3, Spring 1998, 36.

Monferini, A., "Pietro di Oderisio e il rinnovamente tomistico," *Monumenti del Marmo. Scritti per i Duecenti Anni dell'Accademia di Carrara*, Rome, 1969, 39–61.

Montagu, Jennifer, *Bronzes*, London, 1963.

Moore, Henry, Gert Kreytenberg, and Crispino Valenziano, *L'Ambone del Duomo di Pisa*, Milan, 1993.

Moreschi, Luigi, *Descrizione del Tabernacolo che Orna la Confessione della Basilica di San Paolo sulla Via Ostiense*, Rome, 1840.

Morisani, Ottavio, "Aspetti della 'regalità' in tre monumenti Angioini," *Cronache di Archeologia e di Storia dell'Arte*, IX, 1970, 88–122.

Morisani, Ottavio, *Tino di Camaino a Napoli*, Naples, 1945.

Morselli, Piero, "Corpus of Tuscan Pulpits 1400–1550," Ph.D. dissertation, University of Pittsburgh, 1978.

Moskowitz, Anita F., "Arnolfo, non-Arnolfo: New (and some

old) observations on the Ciborium in San Paolo fuori le mura," *Gesta*, XXXVII/1, 1998, 88–102.

in *Census of Gothic Sculpture in America. New England Collections*, ed. Dorothy Gillerman, New York and London, 1989.

"Four sculptures in search of an author: the Cleveland and Kansas City Angels, and the problem of the Bertini brothers," *Cleveland Studies in the History of Art*, I, 1996, 98–115.

"The framework of Andrea Pisano's bronze doors: Some possible Non-Tuscan Sources," *Source. Notes in the History of Art*, II, 1983, 1–4.

"Giovanni di Balduccio's Arca di San Pietro Martire: Form and function," *Arte Lombarda*, 96/97, 1991, 7–18.

"Domenicani/Scultura," in *Enciclopedia dell'Arte Medievale*, v. 5, Rome, 1994, 691–94.

"An inversion of viewpoint: The lunette of San Lorenzo, Vicenza," *Source. Notes in the History of Art*, forthcoming.

"A late Dugento male nude studied from life," *Source. Notes in the History of Art*, XVI/4, Summer 1997, 1–7.

"A Madonna and Child statuette: Reversing a reattribution," *Bulletin of the Detroit Institute of Arts*, 61/4, 1984, 34–47.

Nicola Pisano's Arca di San Domenico and Its Legacy, Univ. Park, 1994.

"Nino Pisano," in *Enciclopedia dell'Arte Medievale*, v. 8, Rome, 1997, 707–12.

The Sculpture of Andrea and Nino Pisano, Cambridge, London, New York, 1986.

"A Sienese Crucifix: Context and attribution," *Bulletin of the Detroit Institute of Arts*, 64/4, 1989, 40–53.

"A Venetian well-head in Toledo," *Source. Notes in the History of Art*, XIV/2, Winter 1995, 1–4.

"Virgin and Child," in Dorothy Gillerman, ed., *Census of Gothic Sculpture in America. II. Midwest Collections*, New York and London, in press.

"What did Leonardo learn from Arnolfo di Cambio?" *Studi in Onore di Angiola Maria Romanini*, v. 3, Rome, 1999, 1079–86.

Munman, Robert, *Sienese Renaissance Tomb Monuments*, Philadelphia, 1993.

Mustari, Louis Frank, "The Sculptor in the Fourteenth Century Florentine Opera del Duomo," Ph.D. dissertation, University of Iowa, 1975 (University Microfilms International, Ann Arbor, 1979).

Nebbia, Ugo, *La Scultura nel Duomo di Milano*, Milan, 1910.

Negri Arnoldi, Francesco, "Scultura trecentesca in Calabria: Apporti, esterni e attività locale," *Bollettino d'Arte*, LVIII, 1983, 1–48.

Nibby, A., *Roma nel 1838, Parte Moderna*, v. 1, Rome, 1839.

Norman, Diana, "Change and continuity: Art and religion after the Black Death," in Diana Norman, ed., *Siena, Florence and Padua: Art Society and Religion 1280–1400*, v. 1, New Haven and London, 1995, 177–95.

Norman, Diana, ed., *Siena, Florence and Padua: Art Society and Religion 1280–1400*, 2 vols., New Haven and London, 1995.

Novello, Roberto Paolo, "La pala d'altare," in Enrico Castelnuovo, ed., *Niveo de Marmore*, Genoa, 1992.

O'Bryan, Robin Leigh, "The Dwarf in Italian Renaissance Iconography," M.A. thesis, San Diego State University, 1991.

Olivari, Maria Teresa, "Le opere autografe di Guido Bigarelli da Como," *Arte Lombarda*, X/2, 1965, 33–44.

Ostoja, Vera K., "To represent what is as it is," *Metropolitan Museum of Art Bulletin*, XXIII, June 1965, 367–72.

Paatz, Walter, and Elisabeth Paatz, *Die Kirchen von Florenz*, v. 3, Frankfurt am Main, 1952.

Pace, Valentino, "Committenza benedettina a Roma: Il caso di San Paolo fuori le mura nel XIII secolo," *Zeitschrifte für Kunstgeschichte*, 54/3, 1991, 181–89.

"Il ciborio di Arnolfo a Santa Cecilia: Una nota sul suo stato originario e sulla sua committenza," in *Studi di Storia dell'Arte sul Medioevo e il Rinascimento nel Centenario della Nascita di Mario Salmi*, v. 1, Florence, 1992, 389–95.

"Questioni arnolfiane: l'Antico e la Francia," *Zeitschrifte für Kunstgeschichte*, 54/3, 1991, 335–73.

Pace, Valentino, and Martina Bagnoli, eds., *Il Gotico Europeo in Italia*, Naples, 1994.

Panofsky, Erwin, *Renaissance and Renascences in Western Art*, 2nd ed., New York and Evanston, 1969.

Tomb Sculpture, New York, 1964.

Paoletti, John, "The Strozzi Altarpiece reconsidered," *Memorie Domenicane*, n.s. 20, 1989, 279–300.

"Wooden sculpture in Italy as sacral presence," *Artibus et Historiae*, 26 (XIII), 1992, 85–100.

Paravicini Bagliani, A., *I Testamenti dei Cardinali del Duecento*, Rome, 1980.

Partner, Peter, *The Lands of St. Peter. The Papal State in the Middle Ages and the Early Renaissance*, London, 1972.

Penny, Nicholas, *The Materials of Sculpture*, New Haven, 1993.

Peroni, Adriano, ed., *Il Duomo di Pisa*, 2 vols., Modena, 1995.

Petricioli, Ivo, *St. Simeon's Shrine in Zador*, Zagreb, 1983.

Pierini, Marco, *L'Arca di San Cerbone* (Quaderni del Centro Studi Storici "A. Gabrielli"), Siena, 1995.

Pietrangeli, Carlo, ed., *San Paolo fuori le Mura a Roma*, Florence, 1988.

Pincus, Debra, "Doge Andrea Dandolo and visual history: The San Marco projects," in Charles M. Rosenberg, ed., *Art and Politics in Late Medieval and Early Renaissance Italy: 1250–1500*, Notre Dame, Ind., 1990, 191–206.

"The fourteenth-century Venetian ducal tomb and Italian mainland traditions," *Skulptur und Grabmal des Spätmittelalters in Rom und Italien*, Vienna, 1990, 393–400.

"Venice and the two Romes: Byzantium and Rome as a double heritage in Venetian cultural politics," *Artibus et Historiae*, XIII/26, 1992, 101–14.

Pinder, Michael, "Gold," *Dictionary of Art*, v. 12, London, 1996, 864–70.

Pinetti, A., "Cronistoria artistica di S. Maria Maggiore," *Bollettino della Civica Biblioteca di Bergamo*, XIX, n. 4, 1925, 168ff.

Piò, Michele, *Delle Vite degli Huomini Illustri di San Domenico*, Bologna, 1620.

Pisetta, Claudio, and Giulia Maria Vitali, "New Knowledge of Andrea Orcagna's Tabernacle through an Interpretive Study," in Dianne Finiello Zervas, ed., *Orsanmichele a Firenze/Orsanmichele Florence*, v. 1, Modena, 1996, 365–99.

Poggi, Giovanni, "La Compagnia del Bigallo," *Rivista d'Arte*, II, 1904, 225ff.

Polacco, Renato, *San Marco. La Basilica d'Oro*, Milan, 1991.

Pollitt, J. J., *Art and Experience in Classical Greece*, Cambridge, 1972.

Pomarici, Francesco, "Il presepe di Arnolfo di Cambio: Nuova proposta di ricostruzione," *Arte Medioevale*, s. 2, II/2, 1983, 155–75.

Pompei, Carla Perez, *La Chiesa di San Fermo Maggiore*, Verona, 1954.

Pope-Hennessy, John, "The Arca of Saint Dominic: A hypothesis," *Burlington Magazine*, XCIII, 1951, 347–51.
 Catalogue of Sculptures in the Victoria and Albert Museum, 2 vols., London, 1964.
 Essays on Italian Gothic Sculpture, London and New York, 1968.
 "Giovanni Pisano's tomb of Empress Margaret: A critical reconstruction," *Apollo*, September 1987, 223.
 Italian Gothic Sculpture, London and New York, 1955, 1972; Oxford, 1986; London and New York, 1996.

Popham, A. E., and Philip Pouncey, *Italian Drawings in the Department of Prints and Drawings in the British Museum* (the fourteenth and fifteenth centuries), v. 1, London, 1950.

Praga, G., "Documenti intorno all'arca di S. Simeone in Zara e al suo autore Francesco da Milano," *Archivio Storico per la Dalmazia*, V, 1930, 211–34.

Preiser, A., *Das Entstehen und die Entwicklung der Predella in der italienischen Malerei* (Ph.D. dissertation, Würzburg, 1973), published in Hildesheim, 1973, and summarized in *Das Münster*, v. 27, 1974, 320f.

Previtali, Giovanni, "Alcune opere 'fuori contesto': il caso di Marco Romano," *Bollettino d'Arte*, XXII, 1983, 43–68.
 "Secondo studio sulla scultura umbra del Trecento," *Paragone*, CCXLI, March 1970, 9–27.
 "Sulle tracce di una scultura umbra del Trecento," *Paragone*, CLXXXI, March 1965, 16–25.
 "Una scultura lignea in Lombardia e la loggia degli Osii," *Prospettiva*, I, 1975, 18ff.

Prinz, Wolfram, "I Tatari nella pittura italiana del Trecento," in *Studi di Storia dell'Arte sul Medioevo e il Rinascimento nel Centenario della Nascita di Mario Salmi*, v. 1, Florence, 1992, 415–29.

Procacci, Ugo, "L'affresco dell'Oratorio del Bigallo ed il suo maestro," *Mitteilungen des Kunsthistorischen Institutes in Florenz*, XVII, 1973, 307ff.
 "Opera d'Arte inedite alla Mostra del Tesoro di Firenze Sacra," II, *Rivista d'Arte*, XV, 1933, 429–47.

Puerari, Alfredo, *Il Duomo di Cremona*, Milan, 1971.

Pullan, Brian, *A History of Early Renaissance Italy from the Mid-Thirteenth to the Mid-Fifteenth Century*, London, 1973.

Pupillo, Giuseppe, *La Cattedrale di Altamura*, Altamura, 1978.

"La cattedrale, segno del medioevo," in *"Altamura" – Rivista Storica Bollettino dell'Archivio – Biblioteca – Museo Civico*, n. 36, 1994–95, 169–73.

Quintavalle, A. C., *Il Battistero di Parma*, Parma, 1988.

Ragghianti, Carlo Lodovico, "La Madonna Eburnea di Giovanni Pisano," *Critica d'Arte*, n.s., I, 1954, 385–96.

Ragusa, Isa, and Rosalie B. Green, *Meditations on the Life of Christ. An Illustrated Manuscript of the 14th Century. Paris, Bibliothèque Nationale, Ms. ital 115*, trans. from the Latin, Princeton, 1961, 1977.
 "The Re-use and Public Exhibition of Roman Sacophagi during the Middle Ages and the Early Renaissance," M.A. thesis, Institute of Fine Arts, New York University, 1951.

Rasario, Giovanna, ed., *Il Cristo di San Carlo Restaurato*, Florence, 1996.

Refice, P., "Le chiavi del Regno: Analisi documentarie e iconografiche sul San Pietro bronzeo vaticano," *Arte Medievale*, s. II., IV/2, 1990, 59–64.

Reinle, Adolf, "Zum Programm des Brunnens von Arnolfo di Cambio in Perugia 1281," *Jahrbuch der Berliner Museen*, XXII, 1980, 121–51.

Renouard, Yves, *The Avignon Papacy. 1305–1403*, trans. Denis Bethell, Hamden, Conn., 1970 (orig. publ. 1954).

Riccetti, Lucio, ed., *Il Duomo di Orvieto*, Bari, 1988.

Rich, R. J. C., *The Materials and Methods of Sculpture*, New York, 1947.

Riess, Jonathan B., *Political Ideals in Medieval Italian Art. The Frescoes in the Palazzo dei Priori, Perugia (1297)*, Ann Arbor, 1981.

Ringbom, Sixten, *Icon to Narrative. The Rise of the Dramatic Close-up in Fifteenth-Century Devotional Painting*, Abo, 1965.

Rizzi, Alberto, "Le vere da Pozzo pubbliche di Venezia e del suo Estuario," *Supplemento del Bollettino dei Musei Civici Veneziani*, XXI, 1976.

Rockwell, Peter, *The Art of Stoneworking: A Reference Guide*, Cambridge, 1993.

Roli, Renato, *La Pala Marmorea di San Francesco in Bologna*, Bologna, 1964.
 Pier Paolo e Jacobello Dalle Masegne, Milan, 1966 (I maestri della scultura).

Romanini, Angiola Maria, "Arnolfo *architectus*," in *Studi in Onore di Giulio Carlo Argan*, Florence, 1994, 71–94.
 Arnolfo di Cambio e lo stil novo del gotico italiano, Milan, 1968; 2nd ed., Florence, 1980.
 "Arnolfo e gli 'Arnolfo' Apocrifi," in *Roma Anno 1300*, Rome, 1983, 27–51.
 "Arnolfo di Cambio," in Romanini, ed., *Enciclopedia dell'Arte Medievale*, v. 2, Rome, 1991, 504–14.
 "I colori di San Pietro," *Aachener Kunstblätter*, LX, 1994, 267–74.
 "Introduzione," *Roma Anno 1300*, Rome, 1983.
 "Ipotesi ricostruttive per i monumenti sepolcrali di Arnolfo di Cambio," in *Skulptur und Grabmal des Spatmittelalters in Rom und Italien*, Vienna, 1990, 107–28.
 L'Architettura Gotica in Lombardia, v. 1, Milan, 1964.
 "Nuovi dati sulla statua bronzea di San Pietro in Vaticano," *Arte Medievale*, s.II, IV/2, 1990, 1–49.

"Nuove ipotesi su Arnolfo di Cambio," *Arte Medievale*," no. 1, 1983, 157–220.

"Une statue romaine dans la Vierge De Braye," *Revue de l'Art*, CV, 1994, 9–18.

ed., *Frederico II e l'Arte del Duecento Italiana*, Galatina, 1980.

ed., *Roma nel Duecento. L'Arte nella Città dei Papi da Innocenzo III a Bonifacio VIII*, Turin, 1991.

Romano, G., "Eremitani e Canonici Regolari in Pavia nel secolo XIV," *Archivio Storico Lombardo*, XVIII, 1895, 5–42.

Romano, Serena, "Alcuni fatti e qualche ipotesi su S. Cecilia in Trastevere," *Arte Medievale*, II/1, 1988, 105–19.

Ronan, Helen, "The Tuscan Wall Tomb, 1250–1400," Ph.D. dissertation, Indiana University, 1982.

Rosci, Marco, "I pulpiti: Strutture e sculture," *Le Chiese dal Paleocristiano al Gotico*, Novara, 1987, 272–81.

Rosenberg, Charles M., ed., *Art and Politics in Late Medieval and Early Renaissance Italy: 1250–1500*, Notre Dame, Ind., and London, 1990.

Rossi, Gino, and Giovanni Salerni, *I Capitelli del Palazzo Ducale di Venezia*, Venice, 1952.

Rossi, Marco, *Giovannino de Grassi. La Corte e la Cattedrale*, Milan, 1995.

Rossi, P., "Campionesi," in *Enciclopedia dell'Arte Medievale*, v. 4, Rome, 1993, 111–17.

Saalman, Howard, "Carrara burials in the Baptistery of Padua," *Art Bulletin*, XIX/3, 1987, 376–94.

Saccardo, P., *La Cappella di S. Isidoro nella Basilica di S. Marco, Venezia*, 1887, ed, Procuratoria di S. Marco, Venice, 1987.

Salvi, Paola, "'Regino di Enrico' e l'esordio della 'anatomia' nell'arte," *Labyrinthos*, I–XII, 21/24, 1992–93.

Salvini, Roberto, *Il Duomo di Modena*, Modena, 1972.

Sancassani, Giulio, "I Documenti," in *Dante e Verona* (exhibition catalogue), Verona, 1965, 3–163.

Sartori, A. *Documenti per la Storia dell'arte di Padova*, ed. C. Fillarini (Fonti e Studi per la Storia del Santo a Padova, Fonti 3), Vicenza, 1976, 7–11.

"La capella di S. Giacomo al Santo," *Il Santo*, VI, 1966, 267–359.

Sauerländer, Willibald, "Dal Gotico europeo in Italia al Gotico italiano in Europa," in Valentino Pace and Martina Bagnoli, eds., *Il Gotico europeo in Italia*, Naples, 1994, 8–21.

Gothic Sculpture in France 1140–1250, New York, 1970.

Scano, Dionigi, *Storia dell'Arte in Sardegna dal XI al XIV Secolo*, Cagliari-Sassari, 1907.

Scarpa, Giulia Rossi, "La scultura nei secoli XIV e XV," in Renato Polacco, ed., *San Marco. La Basilica d'Oro*, Milan, 1991, 161–188.

Schevill, Ferdinand, *History of Florence*, 2nd ed., New York, 1961.

Schiller, Gertrude, *Ikonographie der Christlichen Kunst*, v. 1, Kassel, 1966.

Schultz, Heinrich, *Denkmäler der Kunst des Mittelalters in Unteritalien*, Dresden, 1860.

Schulze, Ulrich, *Brunnen im Mittelalter. Politische Ikonographie der Kommunen in Italien*, Frankfurt am Main, 1994.

Schulz, Anne Markham, *The Sculpture of Giovanni and Bartolomeo Bon*, Philadelphia, 1978.

Scultura Dipinta. Maestri di Legname e Pittori a Siena 1250–1450 (exhibition catalogue), Florence, 1987.

Secchi, Albino, "La Cappella di S. Jacopo a Pistoia e la 'Sacrestia dei Belli Arredi'" in *Il Gotico a Pistoia nei suoi Rapporti con L'Arte Gotica Italiana*, Pistoia, 1966.

Seidel, Max, "Adsit ei angelus Michael. Eine neu Entdeckte Skulptur von Giovanni Pisano," *Pantheon*, 46, 1988, 5–12.

"Die Elfenbeinmadonna im Domschatz zu Pisa. Studien zur Herkunft und Umbildung Französischer Formen im Werk Giovanni Pisanos in der Epoche der Pistoieser Kanzel," *Mitteilungen des Kunsthistorischen Institutes in Florenz*, XVI, 1972, 1–50.

"Die Rankensäulen der Sieneser Domfassade," *Jahrbuch der Berliner Museen*, XI, 1968–69, 80–160.

"Die Verkündigungsgruppe der Siena Domkanzel," *Münchner Jahrbuch der bildenden Kunst*, XXI, 1970, 18–72.

Giovanni Pisano a Genova, Genoa, 1987.

La Scultura Lignea di Giovanni Pisano, Florence, 1971.

"'Opus Herburneum.' Die Entdeckung einer Elfenbeinskulptur von Giovanni Pisano," *Pantheon*, XLII, 1984, 219–29.

"Skulpturen am Aussenbau von S. Maria della Spina in Pisa," *Mitteilungen des Kunsthistorischen Institutes in Florenz*, XVI, 1972, 269–92.

"Studien zu Giovanni di Balduccio und Tino di Camaino: Die Rezeption des Spätwerks von Giovanni Pisano," *Städel-Jahrbuch*, V, 1975, 37–84.

"Studien zur Antikenrezeption Nicola Pisanos," *Mitteilungen des Kunsthistorischen Institutes in Florenz*, XIX, 1975, 303–92.

"Un 'Crocifisso' di Giovanni Pisano a Massa Marittima," *Prospettiva*, LXII, 1991, 67–77.

Seiler, Peter, "Das Grabmal des Azzo Visconti in San Gottardo in Mailand," in *Skulptur und Grabmal des Spätmittelalters in Rom und Italien*, Vienna, 1990, 368–92.

"La trasformazione gotica della magnificenza signorile. Committenza viscontea e scaligera nei monumenti sepolcrali dal tardo Duecento alla metà del Trecento," in Valentino Pace and Martina Bagnoli, eds., *Il Gotico Europeo in Italia*, Naples, 1994, 119–40.

Settis, Salvatore, "Continuità, distanza, conoscenza. Tre usi dell'antico," in *Memoria dell'Antico nell'Arte Italiana*, v. 3, *Dalla Tradizione all'Archeologia*, Turin, 1986, 375–486.

"Tribuit sua marmora Roma: sul reimpiego di sculture antiche," in *Lanfranco e Wiligelmo. Il Duomo di Modena*, Modena 1984, 309–17.

Seymour, Charles Jr., "Invention and revival in Nicola Pisano's "heroic style," in *Studies in Western Art* (Acts of the XX International Congress of the History of Art), v. 1, Princeton, 1963, 207–26.

Sheppard, C. D., "Classicism in Romanesque sculpture in Tuscany," *Gesta* (Essays in Honor of Sumner McKnight Crosby), 15, 1976, 185–92.

"Romanesque sculpture in Tuscany: A problem of methodology," *Gazette des Beaux-Arts,* LIV, 1959, 98–108.

Simeoni, L., "Il giurista Barnaba da Morano e gli artisti Martino da Verona e Antonio da Mestre," *Nuovo Archivio Veneto,* n.s. 10, XIX/1, 1919, 218–36.

Sinding-Larsen, Staale, "Christ in the Council Hall. Studies in the religious iconography of the Venetian Republic," *Acta ad Archaeologiam et Artium. Historiam Pertinentia,* V, 1974, 167–75.

Smith, Christine, *Retrospection. Bacco Bandinelli and the Choir of Florence Cathedral,* Cambridge, Mass., 1997.

Smith, Elizabeth B., "'Ars mechanica.' Problemi di struttura gotica in Italia," in Valentino Pace and Martina Bagnoli, eds., *Il Gotico Europeo in Italia,* Naples, 1994, 57–70.

Sponza, S., "Il monumento al Doge Marco Corner ai Santi Giovanni e Paolo restaurato: osservazione e proposte," *Ateneo Veneto,* n.s. XXV, 1987, 77–105.

"Pittura e scultura a Venezia nel Trecento: Divergenze e convergenze," in *La Pittura nel Veneto. Il Trecento,* 2, Milan, 1992, 409–41.

Steingraber, E., "The Pistoia Silver Altar: A re-examination," *Connoisseur* CXXXVIII, 1956. 148–54.

Steinweg, Klara, *Andrea Orcagna. Quellengeschichtliche und stilkritische Untersuchung,* Strasbourg, 1929.

Stone, Richard, "Antico and the development of Bronze casting in Italy at the end of the Quattrocento," *Metropolitan Museum Journal,* 1981, 87–116.

Storia di Milano, vol. V. La Signoria dei Visconti (1310–1392), Milan, 1955.

Storia di Milano, vol. VI. Il Ducato Visconteo e la Repubblica Ambrosiana (1392–1450), Milan, 1955.

Strocchia, Sharon, "Death rites and the ritual family in Renaissance Florence," in M. Tetel, R. Witt, and R. Goffen, eds., *Life and Death in Fifteenth Century Florence,* Durham, N.C., 1989, 120–45.

"Funerals and the politics of gender in Early Renaissance Florence," in M. Schiesari and J. Schiesari, eds., *Refiguring Woman: Perspectives on Gender and the Italian Renaissance,* Ithaca, 1991, 155–68 (reprinted, Baltimore, 1992).

Strom, Deborah, "Studies in Quattrocentro Tuscan Wood Sculpture," Ph.D. dissertation, Princeton University, 1979, 1–7.

Sundt, R. A., "Mediocres domos et humiles habeant fratres nostri: Dominican legislation on architecture and architectural decoration in the thirteenth century," *Journal of the Society of Architectural Historians,* XLVI, no. 4, December 1987, 394–407.

Surfaro, O., N. Panza, and B. de'Sivo, *Chiesa di S. Giovanni a Carbonara,* Naples, 1969.

Swarzenski, Georg, "Das Auftreten des Églomisé bei Nicolo Pisano," *Festschrift zum Sechzigsten Geburtstag von Paul Clemen,* Düsseldorf, 1926, 326–28.

Swarzenski, Hans, *Nicola Pisano,* Frankfurt-am-Main, 1926.

Tasso, Francesca, "I Giganti e le vicende della prima scultura del Duomo di Milano," *Arte Lombarda,* 92/93, 1990, 55–62.

Taylor, Michael D., "The Iconography of the Facade Decoration of the Cathedral of Orvieto," Ph.D. dissertation, Princeton University, 1969 (University microfilms, 1970).

Tedesco, Lisbeth Castelnuovo, "Romanesque sculpture in North American collections," *Gesta,* XXIV, 1985, 71–73.

Thieme, Ulrich, and Felix Becker, *Allgemeines Lexikon der bildenden Künstler von der Antike bus zur Gegenwart,* v. 2, Leipzig, 1908.

Tigler, Guido, and Gunter Passavant, "Una Testa a Marlia," *Mitteilungen des Kunsthistorischen Institutes in Florenz,* XXXV/2–3, 1991, 287–96.

Toesca, Pietro, *Il Medioevo,* Turin, 1927.

Il Trecento, Turin, 1951.

Torelli, Pietro, "Jacobello e Pierpaolo dalle Masegne a Mantova," *Rassegna d'Arte,* XIII, 1913, 67–71.

Trachtenberg, Marvin, *Dominion of the Eye. Urbanism, Art and Power in Early Modern Florence,* Cambridge, 1997.

The Campanile of Florence Cathedral: Giotto's Tower, New York, 1971.

"Gothic/Italian 'Gothic': Toward a Redefinition," *Journal of the Society of Architectural Historians,* L/1, 1991, 22–37.

Trexler, Richard, "The Magi enter Florence. The Ubriachi of Florence and Venice," *Studies in Medieval and Renaissance History,* v. 1, Vancouver, 1978, 129–218.

"Triumph and mourning in North Italian Magi art," in Charles M. Rosenberg, ed., *Art and Politics in Late Medieval and Early Renaissance Italy: 1250–1500,* Notre Dame, Ind., and London, 1990, 38–66.

Trinkaus, Charles, *The Poet as Philosopher: Petrarch and the Formation of Renaissance Consciousness,* New Haven, 1979.

Tronzo, William, ed., *Intellectual Life at the Court of Frederick II Hohenstaufen,* National Gallery of Art, Washington, D.C., Hanover, and London, 1994.

Trovabene, Giordana, "Il reimpiego di marmi altomedioevali nel pulpito della Cattedrale di Modena," in *Studi in Memoria di Giuseppe Bovini,* Ravenna, 1989.

Valentiner, W. R., "Giovanni di Balducci a Firenze e una scultura di Maso," *L'Arte,* n.s., VI, 1935, 3–29.

"Observations on Sienese and Pisan Trecento sculpture," *Art Bulletin,* IX, 1926–27, 177–220.

"Orcagna and the Black Death of 1348," *Art Quarterly,* XII, 1949, 48–59.

Tino di Camaino: A Sienese Sculptor of the Fourteenth Century, Paris, 1935.

"Tino di Camaino in Florence," *Art Quarterly,* XVII, 1954, 117–32.

Van der Ploeg, Kees, *Art, Architecture and Liturgy. Siena Cathedral in the Middle Ages,* Groningen, 1993.

van Os, H. W., "Tradition and innovation in some altarpieces by Bartolo di Fredi," *Art Bulletin,* LXVII/1, March 1985, 50–66.

Sienese Altarpieces, 1215–1460: Form, Content, Function, 2 vol., Grönigen, 1984–90.

Varanelli, Emma Simi, *Artisti e Dottori nel Medioevo. Il Campanile di Firenze e la Revalutazione delle "Arti Belle"* (Il pensiero italiano), Rome, 1996.

Vasari, Giorgio, *Le Vite de' Più Eccellenti Pittori, Scultori e Architettori, nelle Redazioni del 1550 e 1568,* ed. Rosana Bettarini and Paola Barocchi, v. 2, Florence, 1967.

Le Vite de' Più Eccellenti Pittori, Scultori ed Architettori, Scritte di Giorgio Vasari, G. Milanesi, ed., 8 vol. Florence, 1878–85.

Le Vite de' Più Eccellenti Pittori, Scultori ed Architettori, ed. C. L. Ragghianti, Milan and Rome, 1945.

Le Vite de' Più Eccellenti Pittori, Scultori ed Architettori, Scritte da Giorgio Vasari, Pittore Aretino, con Nuove Annotazioni e Commenti di Gaetano Milanesi . . . Ultima Impressione, Florence, 1906.

Vegas, Liana Castelfranchi, *L'Abbazia di Viboldone,* Milan, 1969.

Venturi, Adolfo, *Giovanni Pisano sein Leben und sein Werk,* Florence, Munich, 1927.

Vigezzi, S., "Catalogo descrittivo, ragionata e critica delle sculture esistenti nella basilica di Sant'Eustorgio in Milano," *Archivio Storico Lombardo,* 60/12, 1933, 219–89.

Villani, Giovanni, *Cronica,* 8 vols., Florence, 1823.

Wackernagel, Martin, *The World of the Florentine Renaissance Artist* (trans. Alison Luchs; originally published in German, 1938), Princeton, 1981.

Waley, Daniel, *Mediaeval Orvieto. The Political History of an Italian City-State 1157–1334,* Cambridge, 1952.

Siena and the Sienese in the Thirteenth Century, Cambridge, 1991.

Wallace, R., "L'influence de la France gothique sur deux des précurseurs de la Renaissance Italienne: Nicola et Giovanni Pisano," Ph.D. thesis, University of Geneva, 1953.

Warner, M., *Alone of All Her Sex: The Myth and the Cult of the Virgin Mary,* London, 1976.

Weinberger, Martin, "Nicola Pisano and the tradition of Tuscan pulpits," *Gazette des Beaux Arts,* LV, 1960, 129–46.

"Nino Pisano," *Art Bulletin* XIX, 1937, 58–91.

Weiskotten, Herbert T., *Sancti Augustini Vita Scripta a Possidio Episcopo,* Princeton, 1919.

White, John, *Art and Architecture in Italy,* 3rd ed., New Haven and London, 1987 (reprinted 1993).

The Birth and Rebirth of Pictorial Space, Boston, 1967 (revised 1987).

"Cavallini and the lost frescoes in S. Paolo," *Journal of the Warburg and Courtauld Institutes,* XIX, 1956, 84–95.

Duccio. Tuscan Art and the Medieval Workshop, London, 1979.

"I disegni per la facciata del Duomo di Orvieto," in Guido Barlozzetti, ed., *Il Duomo di Orvieto e le Grandi Cattedrali del Duecento* (Atti del Convegno Internazionale di Studi, Orvieto, 12–14 November 1990), Turin, 1995, 69–98.

"The reconstruction of Nicola Pisano's Perugian Fountain," *Journal of the Warburg and Courtauld Institutes,* XXXIII, 1970, 71–83.

"The reliefs on the facade of the Duomo at Orvieto," *Journal of the Warburg and Courtauld Institutes,* XXII, 1959, 254–302.

review of Antje Middeldorf Kosegarten's *Sienesische Bildhauer,* in *Art History,* VIII, 1985, 484–87.

Wilde, J. *Italian Drawings in the Department of Prints and Drawings in the British Museum: Michelangelo and His Studio,* London, 1953.

Williamson, Paul, *Gothic Sculpture, 1140–1300,* New Haven and London, 1995.

Wolters, Wolfgang, "Andriolo de Santi," in *Enciclopedia dell'Arte Medievale,* v. 1, Rome, 1991, 623f.

"Appunti per una storia della scultura padovana del Trecento," in L. Grossato, ed., *Da Giotto al Mantegna* (exhibition catalogue, Padua), Milan, 1974, 36–42.

Scultura Veneziana Gotica, Venice, 1976.

Skulpturen von S. Marco (Centro Tedesco di Studi Veneziani, Rome), Berlin, 1979.

"Il Trecento," in Giovanni Lorenzoni, ed., *Le Sculture del Santo di Padova,* Vicenza, 1984, 5–30.

Zarnecki, George, *Art of the Medieval World,* Englewood Cliffs, N.J. and New York, 1975.

Zastrow, Oleg, *Scultura gotica in Pietra nel Comasco,* Como, 1989.

Zauner, Franz Paul, *Die Kanzeln Toskanas aus der romanischen Stilperiode,* Leipzig, 1915.

Zavin, Shirley Anne, "Ferrara Cathedral facade," Ph.D. dissertation, Columbia University, 1972.

Zech, Reinhold, *Meister Wilhelm von Innsbruck und die Pisaner Kanzel im Dome zu Cagliari,* Koenigsberg, 1935.

Zervas, Diane Finiello, ed., *Orsanmichele a Firenze/Orsanmichele Florence,* 2 vols., Modena, 1996.

Index

Note: Page numbers in *italics* refer to illustrations. Endnote citations indicate (a) or (b) for left or right columns, respectively, to distinguish notes with the same number on a single page.